GOYA AND HIS CRITICS

GOYA
AND HIS CRITICS

NIGEL GLENDINNING

YALE UNIVERSITY PRESS
NEW HAVEN AND LONDON
1977

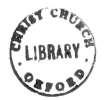

Designed by John Nicoll and set in Monophoto Bembo

Filmset and printed in Great Britain by
BAS Printers, Wallop, Hampshire

Published in Great Britain, Europe, Africa, the Middle East,
India and South East Asia by Yale University Press, Ltd., London

Distributed in Latin America by Kaiman & Polon, Inc., New York City;
in Australasia by Book & Film Services, Artarmon, N.S.W., Australia;
in Japan by Harper & Row, Publishers, Tokyo

Library of Congress Cataloging in Publication Data

Glendinning, Oliver Nigel Valentine.
 Goya and his critics.

 Bibliography: p.
 Includes index.
 1. Goya y Lucientes, Francisco José de, 1746–1828. I. Title.
ND813.G7G53 759.6 76-49693
ISBN 0-300-02011-2

Contents

List of Plates

Acknowledgements

I AM grateful to the following for permission to reproduce copyright material:

Rafael Alberti and Editorial Losada S.A., for permission to print an English translation of the poem 'A Goya'; Geoffrey Bles Ltd. and G. P. Putnam's Sons for passages from Paul Selver's translation of Karel Čapek's *Letters from Spain* (1932); the Vice-Chancellor of the University of York, Professor G. M. Carstairs, for extracts from his article 'Art and Psychotic Illness' (1963); Piper Verlag for passages from Max Dvořák's 'Eine Illustrierte Kriegschronik', published in *Gesammelte Aufsätze zur kunstgeschichte* (Munich 1929); Professor François Lafitte, trustee of the Havelock Ellis Estate, for quotations from *The Soul of Spain* (1908); Doña Pilar Zubiaurre y Aguirrezábal for passages from Juam de la Encina's *Goya en zig-zag* (1928); Don Eduardo A. Guioldi for extracts from Ramón Gómez de la Serna's *Goya* (1928); Srta Isabel García Lorca and Aguilar S.A. de Ediciones, for permission to print a translation of a passage from Federico García Lorca's lecture 'Teoría y juego del duende' (1930); the directors of the *Gazette des Beaux-Arts* for extracts from articles by José López-Rey (1944) and Mrs Eleanor Font (1958); Bruno Cassirer (Publishers) Ltd for permission to quote from Tomás Harris's *Goya. Engravings and Lithographs* (1964); Revista de Occidente S.A. for extracts from Mrs Edith Helman's *Trasmundo de Goya* (1963) and José Ortega y Gasset's *Goya* (1958); Jonathan Cape Ltd and Charles Scribner's Sons for an extract from Ernest Hemingway's *Death in the Afternoon* (1932); the Institut für Österreichische Kunstforschung, Vienna, and E. A. Seemann VEB, Leipzig, for extracts from Theodor Hetzer's essay 'Francisco Goya und die Krise der Kunst um 1800', first published in *Wiener Jahrbuch für Kunstgeschichte* (1950); Mrs Laura Huxley, Chatto & Windus Ltd and Harper & Row Publishers, Inc. for passages from Aldous Huxley's 'Variations on Goya' from *Themes and Variations* and *Collected Essays* (1959), and for permission to reprint 'Morning Scene' (1920) and 'Picture by Goya' (1931) from *The Collected Poetry of Aldous Huxley* edited by Donald Watt (1971); Dumont Schauberg and Peter Owen Ltd for extracts from the English edition of the *Diaries of Paul Klee*, published by Peter Owen (London 1965); Sidgwick & Jackson Ltd for passages from F. D. Klingender's *Goya in the Democratic Tradition* (1948), and to Mrs Winifred Klingender for permission to print extracts from the same author's article 'Realism and Fantasy in the Art of Goya' (1938); Professor Enrique Lafuente-Ferrari for extracts from his essay 'La situación y la estela del arte de Goya' (1947); Professor José López-Rey for a passage from *Goya's Caprichos. Beauty, Reason and*

Caricature (1953); Phaidon Press Ltd for extracts from C. W. Chilton's translation of André Malraux's *Saturn. An Essay on Goya* (1957), Enriqueta Harris's *Goya* (1969) and Professor Sir Ernst Gombrich's article 'Imagery and Art in the Romantic Period' first published in *The Burlington Magazine* (1949); Editorial Plenitud and the heirs of Manuel Machado for permission to print translations of his sonnets 'La Reina María Luisa' and 'Los fusilamientos de la Moncloa'; J. M. Dent & Sons Ltd for passages from Richard West's translation of A. L. Mayer's *Francisco de Goya* (London 1924); Jonathan Cape Ltd and Harcourt Brace Jovanovich Inc. for quotations from J. Holroyd Reece's translation of *The Spanish Journey* by J. Meier-Graefe (1926); the editors of *Revue d'Esthétique* for an extract from Noël Mouloud's article 'L'Évolution du style de Goya' (1956); the Institutionen för Kunstvetenskap, University of Uppsala, for a passage from Folke Nordström's *Goya. Saturn and Melancholy* (1962); Mr Hugh Noyes for extracts from Alfred Noyes' *Rada. A Belgian Christmas Eve* (1915); A. D. Peters & Co. Ltd for an extract from V. S. Pritchett's *The Spanish Temper* published by Chatto & Windus (1954); Routledge & Kegan Paul Ltd. for a passage from Francis Reitman's *Psychotic Art* (1950); Sir John and Mr Michael Rothenstein for permission to quote from Sir William Rothenstein's article in *The Saturday Review* (1896) and his book entitled *Goya* (1900); The Bodley Head for extracts from *Art in Crisis. The Lost Centre* by Hans Sedlmayr, translated by Brian Battershaw, published by Hollis & Carter Ltd (1957); Oxford University Press and Basic Books Inc. for Stanley Kunitz's translation of Andrei Voznesensky's poem 'I am Goya' from *Antiworlds and The Fifth Ace* (1968); Jonathan Cape Ltd and the Houghton Mifflin Company for extracts from Blamire Young's *The Proverbs of Goya* (1923); Metro Goldwyn Mayer for a still from Henry Koster's film *The Naked Maja* (1958); S.P.A.D.E.M., Paris, for the right to reproduce Picasso's *Massacre de Corée* (1951) and the Board of Trinity College Dublin for permission to use a photograph from the copy of J. Callot's *Les Misères et les Malheurs de la guerre* (1633) in the University Library.

Foreword

MONTAIGNE, in one of his *Essays*, felt the need to defend himself against possible criticism on the grounds that he had made a collection of other people's flowers— and had only contributed the twine that bound them together. The charge could more obviously be made against the present book, for if I have picked and tied much of the material myself, friends and colleagues have frequently helped me.

I owe a particular debt of gratitude to two leading Goya scholars: Mrs Frankfort (Enriqueta Harris), and the Director of the Prado Museum, Professor Xavier de Salas. They forestalled a number of errors and misconceptions on my part, and provided me with much valuable information. Mrs Frankfort lent me a copy of F. D. Klingender's early article on Goya (1938), and brought to my attention the reference to the *Caprichos* in a letter from Joseph de Maistre, and Count de la Gardie's description of his visit to Goya's studio. She also generously read the completed manuscript and helped me to improve it in a number of ways. Professor Salas sent me details about the Goyas in the Prado catalogues published before 1828, advised me to consult the manuscript of Ceán Bermúdez's *History of Painting*, and guided my searches in the Real Academia de San Fernando.

I am also indebted to many others for references and expert assistance: to Professor G. A. Carstairs for Frank Reitman's comments on Goya; to Valentina Coe and Ian Press for help with Russian texts; to Professor Lawrence Gowing and Hilary Diaper for dealing with some of the problems posed by early photographs of Goya paintings; to Helen Grant for interviewing Salvador Dalí on my behalf, aided and abetted by Rosa Leveroni; to Professor C. A. Hackett, for telling me about comparisons between Goya and Rimbaud in Verlaine's *Les Poètes maudits*; to Professor Francis Haskell, for showing me the letter from Count Brunetti criticizing Goya (1818); to Professor Robert Leslie for his comments on a book in Polish; to Caroline Lippincott, for noticing Boyce Rensberger's article in *The New York Times* (1972); to Professor E. C. Riley, for information about Buñuel's projected film about Goya; to Nicholas Roddick, for general advice on film bibliography; to Professor Arthur Terry, for Voznesensky's poem 'I am Goya' and David Wevill's 'Goya's "The Snowfall"'; and to Professor Barbara Wright, for the Goya reference in Eugène Fromentin's correspondence.

A colleague who has helped me in a wide variety of ways in connection with the present book is Philip Deacon. He discovered the comment on Goya's etchings after Velázquez in the dispatches of Pietro Pauli Giusti; led me to a copy of the

poem José Mor de Fuentes dedicated to Goya; copied extracts from some Spanish manuscripts for me, and sent me José F. Pérez Gállego's article on Goya films and plays. I am also in his debt for frequent help in locating copies of rare books, articles and other material. Others who have kindly assisted me in a similar way are Juliet Wilson in Paris, who lent me G. Rouanet's medical interpretation of Goya and obtained photographs of paintings by Saura for me; Doña María Brey de Rodriguez-Moñino, Shelagh Ellwood, Sara Saz, Professor John R. Polt and Bruce Taylor in Madrid; Paula Dowling and Armand Van Assche in Brussels; Carmen Benjamin, Geraldine Scanlon, Dr Henry Ettinghausen and the late Professor R. O. Jones in London; and Priscilla Muller in New York.

I must also thank the curators and staffs of a number of libraries and archives for their assistance: Doña Elena Páez in the Print Room of the Biblioteca Nacional, Madrid, and Doña Carmen Niño de Lafuente Ferrari in the Real Academia de San Fernando; Don Martín Costa in the library of the Palacio de Perelada; and the personnel of the Municipal Archives in Saragossa. M. J. P. Avisseau, the Director of the Archives Municipaux de Bordeaux, provided me with Xerox copies of newspaper articles relating to Laurent Mathéron and certain of his rarer publications. Mme F.-C. Legrand, Director of the Musées Royaux des Beaux-Arts de Belgique, generously sent me a selection of Lucien Solvay's reviews of Impressionist exhibitions.

I am grateful to the Universities of Southampton and Dublin for facilitating my research in several ways. The book was largely written while I was at Trinity College Dublin, and I owe much to librarians and colleagues there. I am more particularly indebted to Gilbert Carr, who translated the extracts from Max Dvořák and Theodor Hetzer for me, and allowed me to use his excellent versions in this book. The other translations I have made myself, except where I have taken a quotation from an existing English source. Frequently my wife has helped me with these translations. Her comments and criticisms on the manuscript as a whole have been invaluable.

Finally I must pay the warmest possible tribute to John Fleming and Hugh Honour, who first suggested I should write the book. They read my original manuscript and revisions with knowledge and taste as well as attention to detail. They made good some serious omissions and greatly improved the text. I am deeply grateful to them.

Nigel Glendinning

References to books and articles to be found in the bibliography are given in an abbreviated form in the text and notes. Abbreviations give the name of the author, the short title and the year of publication in brackets. The complete reference will be found under that date in the bibliography on pages 255–277.

I. Introduction: The Critical Context

Les artistes font des yeux neufs, les critiques d'art, des lunettes

Paul Éluard

THE first published comment on Goya's work appeared more than two hundred years ago in 1771. Since then there have been well over a thousand references to his art in books and articles. The range of views and interpretations has been astounding. The variety of Goya's drawings, paintings and engravings, both in style and content, is partly responsible. The ambiguity of some of his work has helped. But Goya's critics have matched his scope and ambivalence in their opinions. At worst they weave complicated webs around him that make the artist hard to see. At best they provide spectacles that set his vision in sharper focus.

In any survey of criticism there are a great many different pairs of glasses from which to choose. The reader will want to know where they come from, and who the optician was. He will also need information about the period and aesthetic climate in which the maker worked. Only in this way can the rose-tinted lenses of one critic be distinguished from the bi-focals, dark glasses, or lorgnettes of others.

However alien some views may seem, different ways of looking at an artist are always interesting. Inevitably we tend to appreciate the critics most like ourselves, and the judgements nearest our own. Yet, at the same time, an interpretation with which we disagree, or which does not seem to add much to our understanding of an artist, serves to make us reconsider our own position, ask questions about ourselves, or think again about the ways in which critical opinions are formed. Furthermore, the views we reject now may seem entirely relevant and 'true' ten years hence.

The main object of the present book is to analyse the major patterns in Goya criticism, chronologically and conceptually. Goya's work will be seen in the light of shifts in aesthetic taste and fashion, and viewed from political and psychological, even pathological, standpoints.

The first priority is to examine some external variables which affect the ways in which critics react. Of major importance is the changing appearance of works of art themselves. Paintings and drawings grow old as man himself grows old. Their environment can alter as significantly as their appearance. Blake's ironic dig at Reynolds' connections with the establishment—

> When Sir Joshua Reynolds died
> all Nature was degraded;
> the King dropped a tear
> into the Queen's ear,
> and all his pictures faded—

has elements of literal truth in it. Colours and tones *are* modified by time. Paint surfaces darken with dust; they crack and flake. The paper of wash drawings disintegrates. Restoration alters appearances radically for a while, sometimes permanently. Furthermore, works of art changed as much in the past as they do today through cleaning. Goya himself expressed concern about the effects of restoration on some of the paintings in the Royal collection at Madrid, and said that the retouching process in some cases had 'completely destroyed the life and boldness of brushwork, the superbly delicate and skilful strokes of the original'.[1] Six years after Goya's death, Captain S. E. Cook held the 'gang of restorers' in the Prado to be the 'worst part' of that 'noble institution'. Some of the pictures were 'painted completely over'; and the restoration of a Titian would 'scarcely leave a touch of the master uncovered'.[2]

Goya's own work was, in more than one instance, 'covered' in his lifetime, and several of his paintings have changed considerably as a result of cleaning since his death. The *Allegory of the City of Madrid* (completed by the end of February 1810), for instance, originally had a portrait of Joseph Buonaparte on the medallion in the composition where the words *Dos de Mayo* (2 May 1808) appear today. When the French evacuated Madrid in 1812 the portrait was replaced by the word *Constitución*, in honour of the Liberal constitution worked out in the Cortes at Cadiz that year. In November 1812, however, King Joseph returned, and on 30 December the City Fathers requested Goya to restore the painting to its original state. This he did in the next two days. But the portrait only lasted half a year, and the word *Constitución* had to be slapped on again by a pupil of Goya after Joseph's final withdrawal from the capital in May 1813. When Ferdinand VII came to the throne in 1814 *his* portrait was hurriedly inserted, and in 1823 Vicente López made a less hasty version of the royal head. Even that only survived the king himself by less than ten years. In 1841 the phrase *El libro de la constitución* (The Book of the Constitution) was painted on the medallion, and finally in 1872, after an abortive attempt to resurrect Goya's original painting of Joseph Buonaparte, the legend 'Dos de Mayo' came to stay.[3]

Other Goyas changed less obviously perhaps, but no less spectacularly from the point of view of the observer. The small paintings of tapestry subjects which belonged to the Dukes of Osuna were 'washed and revarnished' in 1862,[4] and the tapestry cartoons themselves, which were kept rolled up in the Tapestry Factory in Madrid for nearly a century, were extensively restored in the 1870s. The frescoes in San Antonio de la Florida in Madrid and the Pilar Cathedral in Saragossa have had their inevitable layers of candle grease, smoke and dust removed on more than one occasion in the last hundred years. At the end of the nineteenth century

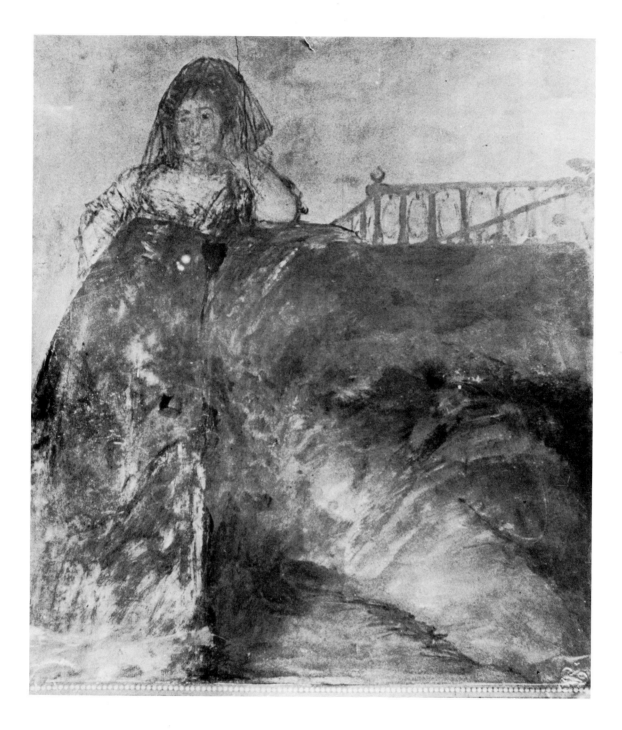

1. J. Laurent: Photograph of Goya's *Doña Leocadia* [Weiss] (or *La Manola*), *c.* 1820–3, probably from a negative made *c.* 1873, before the painting was removed from the Quinta del Sordo by the double transfer process. The Witt Photographic Collection, The Courtauld Institute.

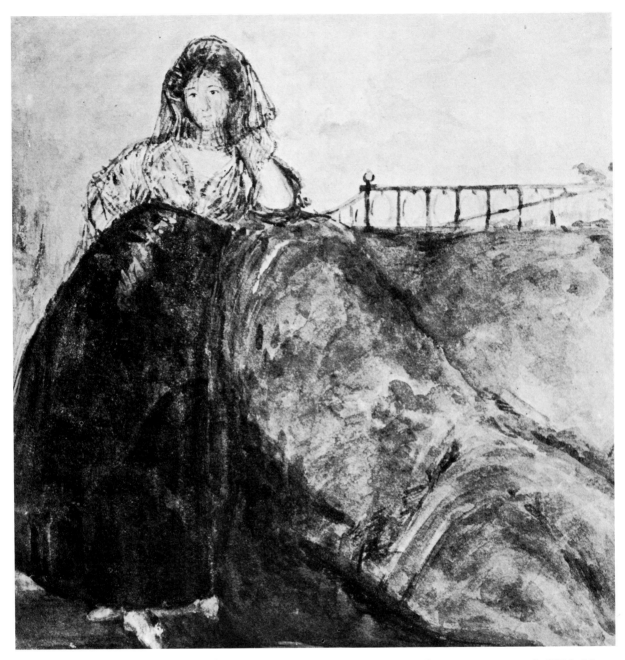

2. J. Laurent: Photograph of a watercolour copy, perhaps by Eugenio Lucas, of Goya's *Doña Leocadia* [Weiss] (or *La Manola*), 1820–3. The painting was still on the walls of the lower room in the Quinta del Sordo when the copy was made. The photograph probably dates from 1864–73.

3. Goya: *Doña Leocadia* [Weiss] (or *La Manola*), 1820–3. Madrid, Prado.

the light in San Antonio was so bad, and the effect of damp so serious, that the German critic von Loga thought it was better to look at engravings of the frescoes than at the paintings themselves.[5] In 1904, a contributor to the first volume of the Barcelona art periodical *Forma* complained that most Spaniards had only glimpsed paintings like Goya's two scenes from the life of San Francisco Borja in Valencia cathedral 'by the flickering light of candles which cover the canvases in smut and fail to illuminate them'.[6] In a similar way the Pilar frescoes have not always been so clearly visible as they were in the eighteenth century when first completed. Their surprisingly bright colour and impressionist effects have been revealed afresh after two restorations within living memory, yet are all too soon submerged under grime and forgotten.[7] Other notable examples of paintings by Goya that have been transformed by cleaning in the recent past are the portrait of the *Duchess of Alba* (Plate 23) in the collection of the Hispanic Society of America in New York, and *The Royal Family* in the Prado. When the *Duchess* was restored in the late 1950s the inscription to which she points was found to read '*Sólo Goya*' ('Goya alone') and not just 'Goya'.[8] The discovery lent new substance to longstanding theories about the intimate relationship between the artist and sitter, and comments were made which were remarkably like those of Baron Taylor in the 1830s, when the portrait was first on show in the Spanish Gallery of the Louvre. When the *Royal Family* was cleaned in 1967, a picture hanging on the wall in the shadows suddenly loomed into view. Priscilla Muller was able to identify the subject as *Lot and His Daughters*, arguing that Goya may have seen an ironic parallel between the life of the Spanish court and that of the city of Gomorrah.[9]

The most important works of Goya to change significantly as a result of restoration were the Black Paintings, originally painted in oils on the walls of the artist's house across the Manzanares river from Madrid. They were certainly in need of repair before their removal, and retouching was inevitable. When the artist's grandson had the paintings valued before selling the property in 1855, the walls and murals were already in poor condition, and experts in the 1860s thought it would be impossible to move them.[10] Those who knew the pictures at that period and saw them again after their transfer to canvas must have noticed innumerable minor differences.

The extent to which they were altered can only be roughly assessed. But it is not comforting to know that Salvador Martínez Cubells, the young artist who carried out the restoration (perhaps with the aid of his brothers) had a reputation for personalized retouching in his time.[11] Early reproductions and more particularly photographs taken before the removal of the paintings from Goya's house, make it possible to gauge the quality of his surgery. And although it was mostly quite good, there are a number of instances in which he clearly improvised.

The *Manola* (or *Leocadia Weiss*) is an interesting case in point. A photograph taken by J. Laurent (Plate 1) before the painting was removed from the wall by the double transfer process, shows that the surface was then very worn in parts.[12] The restored painting seems to have lost some of the lines of the original, more particularly in the bank of earth in the foreground. Martínez Cubells has also

repainted the ball at the corner of the railings at the left so that it no longer lies in line with the upright beneath it. Some of the repainting of the ironwork is equally inaccurate, and the pompoms on the slippers which P. L. Imbert noted when he paid a visit to Goya's house in 1873 are almost entirely gone.[13] A copy made at an earlier date, probably in watercolour, gives another artist's impression of the patterns in the earth and the pompoms on the shoes as they may have appeared in the early 1860s. Laurent made a negative of the copy at that period, and it was included in the catalogue of some of his photographs published in 1879 and offered for sale in Paris and Stuttgart as well as in Madrid (Plate 2).[14] Some books on Goya have even reproduced this version as if it were the original: Calvert's book on Goya (1908), for instance, and the *Colección de 449 reproducciones de cuadros, dibujos y aguafuertes de Don Francisco de Goya* (1924). Although it is less 'Goya' in general than the restored painting, in certain details it may well be nearer the truth of the artist's original.★ It is hardly surprising that the Spanish critic Beruete thought that 'the [Black Paintings] suffered a good deal' as a result of being transferred to canvas.[15] (Plate 3.)

If restoration inevitably affects the critic's approach, so, of course, does a change in a painting's context. The Black Paintings are again a paradigm case for Goya. Originally their size related to the walls of the two rooms in the small suburban house for which they were intended. How could those who saw them in their original environment react to them in the same way as those who have seen them since they were framed and hung in the Prado, arranged in a different order, juxtaposed in a different way, and struggling against the large windows, high ceilings and unintimate spaces to be found in too many public galleries?

A critic's understanding of an artist also varies according to the amount of work he has actually seen. From our present position, surrounded by reproductions of nearly every aspect of Goya's work, it is difficult to imagine the varying states of knowledge of those who wrote about him in the past. There is obviously a conspicuous difference between Spaniards and non-Spaniards where Goya's work is concerned, but even for Spaniards the accessibility of the artist's work changed with the passing years.

Those actually living in Spain in the late eighteenth century and early nineteenth century would have been chiefly aware of Goya as a personality, as a religious

★There are a number of significant additions, subtractions and alterations in the other Black Paintings. The *Witches' Sabbath*, for instance, has clearly been cut down on both sides, and more particularly at the right, where there was once rather more dark and shadowy space beyond the girl sitting on the chair than can be seen today. According to Yriarte she should be nearer the centre of the picture; she is now at the extreme right. In the *Pilgrimage to the Spring of San Isidro* (or *The Holy Office*, Plates 4–7) the restorer has stacked neat trees on the side of the mountain in the middle of the picture where the paint had flaked off, and had to improvise some of the centre of the painting. In the mysterious picture of a *Dog* (Plate 8), a looming shape to the right of the animal has almost entirely vanished in the restoration process. And while more of the legs of the two men fighting with clubs can be seen in the early photographs than survives today, other paintings have acquired precise detail they did not originally have. (Cf. Nigel Glendinning, 'The Strange Translation of Goya's "Black Paintings"', *The Burlington Magazine*, cxvii, No. 868, 1975, 465–79.)

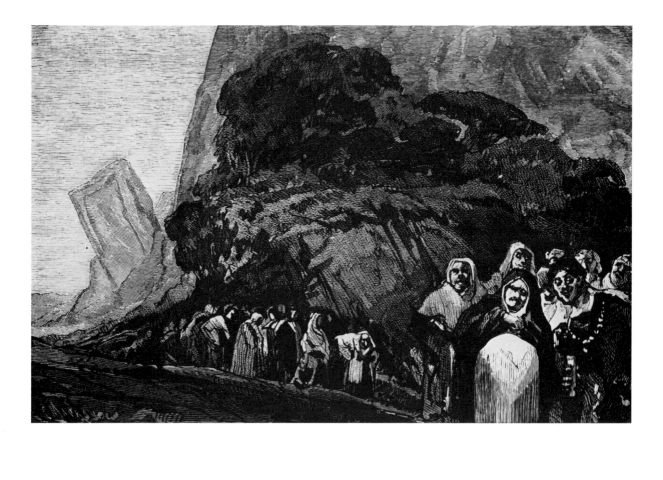

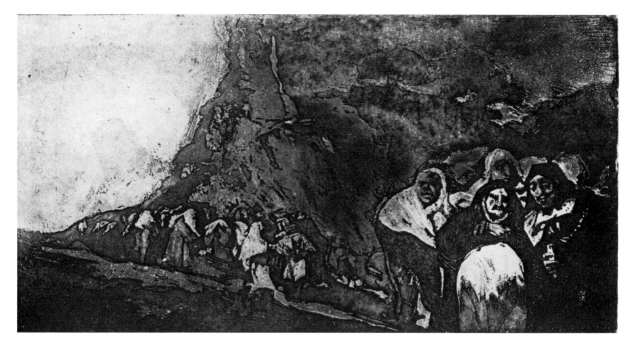

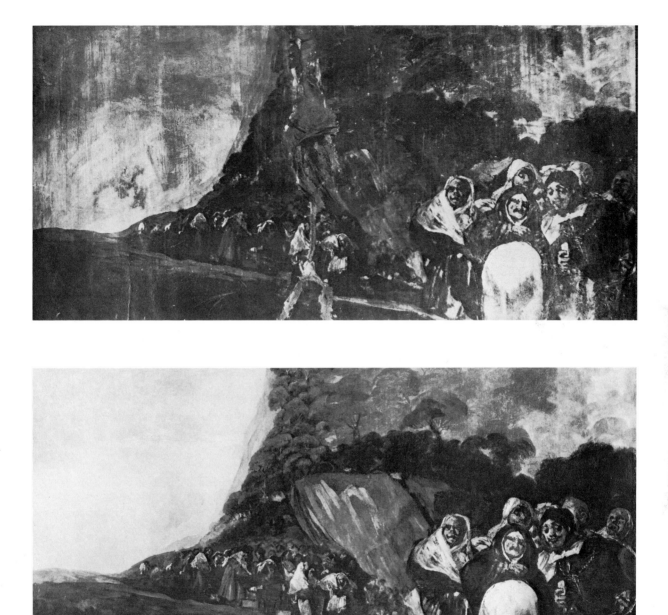

4. (above left) C. Maurand: Woodcut based on an early photograph of Goya's *The Holy Office*, 1820–3, taken when the painting was still on the walls of the upstairs room in Goya's house. The wood-cut was made *c.* 1866 for Charles Yriarte's *Goya*, Paris, 1867.

5. (below left) E. Gimeno: Etching after Goya's *The Holy Office*, 1820–3, made in 1868 before the removal and restoration of the painting, for publication in *El Arte en España*.

6. (above right) J. Laurent: Photograph of Goya's *The Holy Office*, 1820–3, made *c.* 1873, before the painting's removal and restoration. The Witt Photographic Collection, The Courtauld Institute.

7. (below right) Goya: *The Holy Office*, 1820–3. Recent photograph. Madrid, Prado.

8. J. Laurent: Photograph of Goya's *Dog*, 1820–3, probably taken *c.*1873, before the painting's removal and restoration. Re-photograph made from an illustration in *Colección de 449 reproducciones de cuadros, dibujos y aguafuertes de Don Francisco Goya* (Madrid, 1924).

painter and portraitist, and perhaps, also, for those who had access to Royal and ducal palaces, as a tapestry designer and painter of decorative pictures. People who were interested could have known about his *Caprichos* and *Tauromaquia* etchings as soon as they appeared (1799 and 1816 respectively), as well as his earlier prints after Velázquez (1778), since these were all advertised in the Madrid newspapers. On the other hand, unless they were amongst the artist's intimate acquaintances, they are unlikely to have known much of his more imaginative work as a painter, his satirical drawings on religious and political subjects, or his *Disasters of War* and *Disparates* series of engravings, of which editions were only 'published' posthumously in 1863 and 1864 respectively. On public view were the frescoes in the Pilar cathedral at Saragossa (1772 and 1781), the painting of *San Bernardino Preaching* in the Church of San Francisco el Grande, Madrid (1782–3), the murals

for San Antonio de la Florida (1798), and religious paintings in other churches in the Saragossa area, Valencia, Valladolid, Toledo, Seville, Cadiz and Salamanca. When the Prado opened as the Royal Gallery in 1819 there were only two Goyas among the 311 paintings in it: the equestrian portraits of María Luisa and Charles IV. The small painting of a *picador* joined these by 1821, and the *Charge of the Mamelukes* and *The Third of May 1808* were apparently added during the 1830s.

The Academy of San Fernando had a more interesting collection of Goyas on view in Madrid in the first half of the nineteenth century than the Prado. Several of his portraits had been temporarily exhibited there during the artist's lifetime—including *Andrés del Peral* and *Doña Isabel Lobo de Porcel*, both now in the National Gallery, London, and the equestrian portrait of the Duke of Wellington, today in the Wellington Museum at Apsley House. The equestrian portrait of Ferdinand VII, the paintings of Godoy, the architect Villanueva and the actress La Tirana, were given to the Academy or acquired by it while the artist was alive: the first two in 1808, and the others in 1811 and 1816 respectively. And the two *Majas*, naked and clothed, removed from Godoy's palace after his disgrace and exile, were also there from 1815 or 1816, although the naked maja was kept in a special room and not on open display until the last third of the nineteenth century. Portraits of the dramatist Leandro Fernández de Moratín and the translator of Blair, Munárriz, were donated in 1828 and 1831, the self-portrait on wood was acquired in 1829, and four small paintings of *An Inquisition Scene*, a *Village Bull-fight*, a *Procession of Flagellants*, and the *Burial of the Sardine* were added in 1839.

Other Goya paintings bought by the Government later in the century were divided between the National 'Trinity' Museum in Madrid, which was opened in a suppressed convent in the Calle Atocha in July 1838, and the Royal Museum in the Prado, until the two were amalgamated in 1872. The contents of the Trinity Museum fluctuated. The only Goya to be hung there as a result of the suppression of convents was the painting of *Christ Crucified* from San Francisco el Grande. But paintings confiscated from the Infante Don Sebastián because he gave his allegiance to the Carlist pretender rather than to Isabel II, went to swell the collection between 1842 and the early 1860s. The Infante's Goyas included *Majas on a Balcony* (the version now in the Metropolitan Museum, New York (Plate 10)) and two late paintings of a *Nun* and a *Monk*, signed and dated 1827; perhaps also two paintings of *Disasters of War*, related in subject matter to Nos. 5 and 18 of the series of etchings.[16] In the late 1860s, two new acquisitions increased the Museum's holdings of paintings by Goya. Both came from the collection of Don Román Garreta and ultimately from Goya's family: a *Portrait of a Lady*, believed to be the artist's wife, Josefa Bayeu; and the self-portrait by Goya on canvas which is rather similar to the one on panel in the Academy of San Fernando.

The 1860s and 1870s brought a marked increase in the number of Goyas in the Prado. The fourth edition of the official catalogue (1854) only recorded the three Goyas which had been in the royal gallery since 1819 and 1821, but of course there were several unlisted. Mathéron saw some still lifes there before 1858, although the two now in the Prado were not catalogued until 1900. Charles Yriarte cited

9. (above) Delacroix: Watercolour sketches after Nos. 3, 5 and 12 of the *Caprichos*, c. 1824. Paris, Cabinet des Dessins du Musée du Louvre, No. RF 10178 and 10181.

10. (right) Goya: *Majas on a Balcony*, c. 1800–14. In the collection of the Infante Don Sebastián de Borbón, and on show in the National or Trinity Museum, Madrid, c. 1842–60. New York, The Metropolitan Museum of Art. Bequest of Mrs H. O. Havemayer, 1929. The H. O. Havemayer Collection.

twelve Goyas in the museum in his book (1867), and there were as many as fifty-nine by 1885 when the fifth edition of the museum catalogue appeared. Fifty-seven of these already figured in a catalogue published in 1878: thirteen Goyas were listed under the Spanish School; thirty-seven of his tapestry cartoons and a portrait of the actor *Máiquez* hung in a special Goya room on the second floor; and nine other paintings could be found in the ex-Trinity Museum and miscellaneous section. The total should have been further augmented in 1881 by Baron D'Erlanger's gift of the fourteen Black Paintings. But, in fact, these were not exhibited at once. Five were listed for the first time in the 1889 catalogue—they had been placed on view a year or two previously; four hung for several years in government offices in the 1890s, and the rest must have been stored.[17] Nine more paintings by Goya were acquired before the end of the century, including three from the Duke of Osuna's collection, and eighty-eight were listed altogether in the 1910 edition of the Prado catalogue.

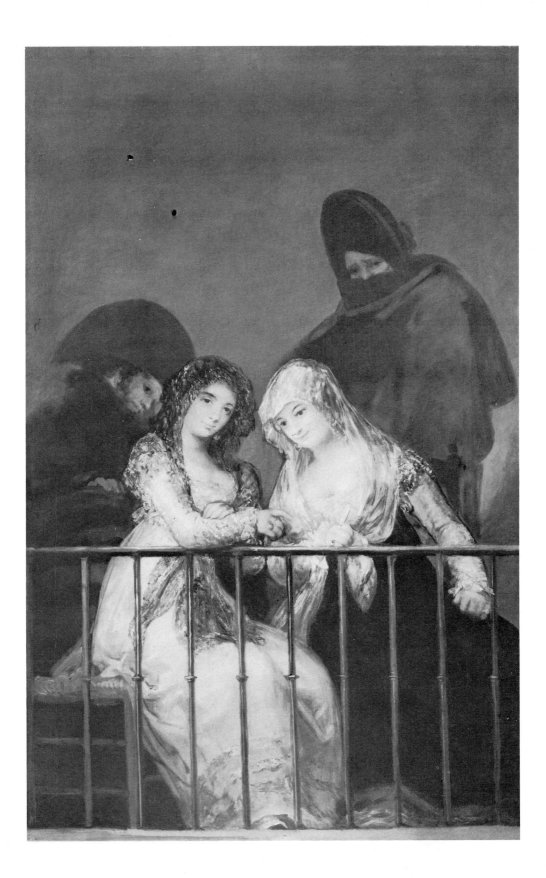

By comparison with his Spanish contemporaries, a non-Spanish critic would have known Goya's work in a different sequence and with a very different emphasis. Those who did not spend long periods in the peninsula must inevitably have been most familiar with Goya's work as an etcher. Goya himself remarked on the interest foreigners showed in his *Caprichos* when they first appeared.[18] It was pleasanter for them, no doubt, than for Spaniards, to savour criticism of the corruption of Spanish society and the attacks on religious orders and the Inquisition that the work was held to contain. Several copies were in English hands by 1825, and a unique copy of the *Tauromaquia* with manuscript title page and list of contents, and two plates in proof state, was also in an English collection by that time.[19] A similar situation existed in France, and some early French articles suggest that Goya was hardly known as a painter there at all, although his ability as a graphic artist and satirist was widely recognised in artistic and literary circles. Delacroix, at the time of his death, owned at least six plates from the *Caprichos*, the etching of *A Garrotted Man*, two of the series after paintings by Velázquez, two of the Bordeaux Bullfight lithographs and two other lithographs.[20] But as early as 1824 when Goya was still alive and living in France, Delacroix was familiar with the *Caprichos*. He saw a copy in March that year, and the following month refers in his diary to his thoughts of drawing 'caricatures after the style of Goya' ('charges dans le genre de Goya').[21] At that period he notes as 'people of the present time': 'Michelangelo and Goya. Lemercier, not Charlet', associating them with 'the lash of satire'.[22] He actually copied large portions of many of the early *Caprichos* (Nos. 3, 5, 6, 7 and 8) perhaps from a copy belonging to Guillemardet—the French ambassador to Spain whom Goya had painted and whose relationship to Delacroix may have been closer than that of protector (Plate 9).[23] Later Delacroix copied details of many more of the *Caprichos*, and was showing 'Goyas' to George Sand in 1834. In the meantime, Antoine Fontaney had acquired a copy of the *Caprichos* in Spain in 1831, and showed it to Nodier's circle at the Arsenal.[24] For those in France who did not have access to original engravings by Goya, a printer called Motte provided an edition of ten lithographs with the title *Spanish caricatures* which he put on sale in Paris in 1824. The prints were based on Nos. 10, 14, 15, 18, 24, 32, 40, 43, 52 and 55 of the *Caprichos*: one Inquisition plate and one attack on religious superstition, but otherwise moral rather than political satire.[25]

In the middle of the century foreign and Spanish critics were less far apart. English and French enthusiasts for Goya's work bought the *Disasters of War* and the *Proverbs* (or *Disparates*) at much the same time as their Spanish contemporaries, when they were first published. Indeed, the De Goncourt brothers were already looking through the eighty plates of the *Disasters* in Paris on 4 January 1863 and exclaiming, riveted by No. 39, about the Spanish genius for horror. Since the first edition was not completed in Spain until March that year, they must have got hold of a copy of the trial proofs made in 1862 or earlier proofs made by the artist himself. Connoisseurs outside Spain might even have known some bull-fight prints and one or two of the etchings before the Spaniards did. The bull-fight *lithographs* had, of course, been published in Bordeaux in 1825 when Goya was

living there. Much later, plates not used by Goya for the *Tauromaquia* series were printed for the first time in Paris by Loizelet in 1876, and the English diplomat John Savile Lumley published several etchings which did not belong to the main series from plates which he had bought in 1859. The same period saw a growing exodus of Goya's paintings from Spain. Foreigners could buy Goyas at the Paris and London sale-rooms as well as in the Peninsula. In England, the Duke of Wellington already had three paintings by Goya, and Lord Clarendon, who had been ambassador at Madrid in the 1830s, had more; in Scotland, William Stirling, later Sir William Stirling-Maxwell, formed an important collection of Goya prints and acquired two of his paintings in Seville after travelling extensively in Spain; John Bowes, who built the museum at Barnard Castle after the death of his first wife in 1874, bought two genuine Goyas and two others then attributed to him, partly at the sale of the Conde de Quinto's collection in Paris in 1862.[26] In France, Louis-Philippe had twelve paintings by Goya, eight of which could be seen in the Louvre between 1838 and 1853.[27] Prosper Mérimée wrote to the Countess of Montijo in March 1843 expressing delight at the prospect of her buying him 'something very beautiful by Goya and particularly rare'.[28] And in May 1859 Baudelaire was urging friends to buy—or at least photograph—a clothed and naked *maja* by Goya owned by the dealer Moreau: 'archi-Goya, archi-authentique'.[29] Also in Paris, in the 1860s, the Levantine banker Edwards collected at least six Goya portraits at the Hotel Drouot sales; while, in the south of France, the artist Briguiboul had acquired on visits to Spain a fine self-portrait by Goya, and the vast scene of Ferdinand VII presiding over a meeting of the Philippine Trading Company.[30] This last painting is the largest Goya canvas in the world, and together with two other Goyas from Briguiboul's collection, has been in the museum at Castres since 1892. Five Goya paintings given to the Agen Museum in 1899, which were also bought in Spain, came from Count Chaudorny. He had been French ambassador in Madrid from 1874 to 1881, and had acquired paintings which had originally been in Javier Goya's collection from Federico de Madrazo. More mysterious in origin were the scenes of cannibalism by Goya that the painter Gigoux—friend of Gautier and Daumier and admirer of Delacroix—bought before 1867 and left to the Besançon museum in 1894.

By the end of the nineteenth century some Goyas had found their way much further afield. Two small paintings of *A Knife Grinder* and *A Water-Carrier* were in the Budapest museum, having reached Vienna by 1820 before passing from Prince Kaunitz's collection to that of the Esterhazys. American millionaires were beginning to make their corners in Goya, and continued to do so in the early years of the twentieth century. The Havemayers, aided and abetted by Mary Cassatt and a fortune in sugar, bought twelve Goyas in all, including the *Majas on a Balcony* now in the Metropolitan Museum, New York (Plate 10) and *Bartolomé Sureda and his wife* (National Gallery of Art, Washington). Henry Frick, the coke and steel king, purchased amongst other Goyas a fine late portrait of a lady called María Martínez de Puga, and the superb *Forge* which had once belonged to Louis-Philippe.[31]

Knowledge of Goya's work outside Spain was obviously fostered by private

acquisitions such as these; also by the appearance of Goyas in public galleries. After the sale of Louis-Philippe's pictures the Louvre had to start from scratch in the middle of the century. The portraits of the *Marquesa de las Mercedes* and the French Ambassador to Spain, *Guillemardet*, were both given by the latter's son in 1863; and the *Lady with a Fan*, which was in the Edwards collection in 1870, was bought by the Louvre in 1898.[32] The British Museum, which had no Goya etchings or drawings at all in January 1848, built up a fine collection in the second half of the century; and the National Gallery in London acquired three important Goyas in 1896, including two small scenes from the Duke of Osuna's country house near Madrid, sold in the Osuna auction on 11 May that year. Nineteenth- and early twentieth-century exhibitions both contributed to, and reflected, rising interest in Goya. In Spain itself the cycle began with the exhibition in the Liceo Artístico y Literario of Madrid in 1846 (12 Goyas); and continued with the Goya exhibition organized by the Ministry of Education and Fine Arts in Madrid in May 1900, celebrating the return of Goya's body from France (146 Goyas, including attributed works); the Exhibition of Spanish Painting of the First Half of the Nineteenth Century, Madrid 1913 (which had a number of 'unknown' Goyas from private collections); and the Centenary Exhibition in the Prado in 1928 (which originally listed 92 Goyas, but included two others and seven tapestries in the printed catalogue). In England, four Goya paintings of children playing from Stirling-Maxwell's collection were shown in Manchester in 1857;[33] two unidentified paintings in South Kensington in 1872[34]; eleven at the New Gallery in Regent Street in 1895–6; seventeen at the Guildhall in 1901; twelve at the Grafton Galleries in 1913–14; twenty at the Winter Exhibition of Spanish Painting at the Royal Academy of Arts, 1920–1; and a total of fifty-four Goya items, although only ten paintings, at the Burlington Fine Arts Club exhibition in 1928. In France, the Great Exhibition of 1878 in Paris gave the general public the opportunity to see the Black Paintings for the first time, and some of the tapestries; and there were twenty-two Goyas in the Exhibition of Modern Spanish Painting in the Palais des Beaux-Arts in 1919 (tapestries being shown in the Petit Palais in April the same year). In the United States, there was an exhibition of the *Caprichos* and the *Proverbs* in New York in 1911; and a Loan Exhibition of paintings by El Greco and Goya for the benefit of the American War Relief Fund and the Belgian Fund at Knoedler's in 1915.

Such was the growth of interest in Goya that the demand for his work soon exceeded the supply. Copies and imitations were increasingly produced. In the Prado itself permission was not obtainable in the nineteenth century for copies of paintings the same size as the original, but as H. O'Shea reported in his *A Guide to Spain* (1865), 'there are several good copyists and the charges are moderate'.[35] In the middle of the century a number of Spanish artists made versions of Goya paintings which have passed for originals. In 1856 versions in oils of Goya's eighty *Caprichos* were offered for sale by auction in Paris, and only withdrawn when serious doubts were cast on their authenticity. Between 1867 and 1870 Eugenio Lucas is known to have been invited to Orense in Galicia by the Marcial Torres Adalid family expressly to paint pictures in the Goya (and Teniers) manner.[36] Some such

pastiches undoubtedly passed into public collections as Goyas at a subsequent period. Critics have sometimes studied or written about them in good faith believing them to be genuine. A slightly caricaturesque painting of María Luisa bought by the Munich gallery in 1911 has been used to support the theory that Goya mocked Charles IV and his queen; yet Lafuente Ferrari has shown that the painting in question was in fact the work of Angel Lizcano (1846–1929) and based on two authentic Goyas in the Prado.[37] The self-portrait in the Vienna Museum, based on the first plate of the *Caprichos* in reverse, has been reproduced in more than one book on Goya since the Second World War, although Lafuente has rightly denounced it as 'an unworthy *croûte*'.[38] Questions of doubtful attribution constantly arise, changing the apparent range and character of the artist's work. In 1900, William Rothenstein reproduced as by Goya a *maja* now generally accepted to be by Eugenio Lucas. On the other hand, two bull-fight paintings in the Ashmolean Museum at Oxford attributed to Lucas for years, are now very plausibly judged on the authority of Xavier de Salas to be by Goya himself.[39]

Given the difficulty of access to Goya's work for many people, reproductions obviously had an important role to play in aiding the recollection of paintings seen or in giving some idea of those unseen. At least twenty-five Spanish books published between 1786 and 1845 contained single plates based on portraits or paintings by Goya. William Stirling included a Goya among the early photographs (Talbot-types) illustrating a limited number of copies of his *Annals of the Artists of Spain* (1848); and *Caprichos* Nos. 1 (the self-portrait) and 49 ('Duendecitos') were engraved and reproduced for that work.[40] Versions of three *Caprichos* (Nos. 1, 39 and 51) had earlier illustrated the article on Goya in the *Magasin Pittoresque* in 1834, and in the 1860s and 1870s photographic reproductions of works by Goya became more widely available. An amateur in Bordeaux apparently made a series of Goya photographs at that period, and G. Brunet's *Étude sur Francisco Goya* (1865) had sixteen photographic illustrations, all of etchings: nine *Caprichos*, four *Tauromaquia* plates, two *Disasters of War* and *The Garrotted Man*.[41] Between 1863 and late 1866 photographs of the Black Paintings were made in Madrid, apparently to illustrate a monograph which does not seem to have been written; and J. Laurent, who was probably responsible for the set, also offered for sale in the 1870s photographs of the Goyas in the Alameda palace of the Dukes of Osuna outside Madrid, and in the Duke of Montpensier's collection in Seville as well as other works.[42] Books on Goya gradually improved the number and quality of their illustrations. Charles Yriarte's book on Goya reproduced forty-seven of the artist's paintings and etchings; William Rothenstein's book (1900) carried twenty full-page plates, including three photogravures and nine tinted prints. The Conde de la Viñaza's book (1887), which was not illustrated at all, listed engravings of between sixty and seventy paintings by Goya, many of them available in more than one version, and executed more particularly in the mid 1870s. Eduardo Gimeno y Canencia (1838–68), who had some success as a painter of nightmare and witchcraft subjects, engraved four of the Black Paintings for the periodical *El Arte en España* in the last year of his life.[43] José M. Galván y Candela, who was responsible for a number of engravings after

11. (above) Set of Spanish Airmail stamps based on flying subjects from Goya etchings (Nos. 61 and 64 of the *Caprichos*; Nos. 5 and 13 of the *Disparates*), 1930. Barcelona, Jordí de Torre collection.

12. Tableau vivant: *Majas on a Balcony* by Goya performed by the daughter of the German ambassador in Madrid, Fraulein Radowitz, Sol Stuart, the Duke of Medinaceli and the son of the Count and Countess Villagonzalo in 1900. Original photograph published in *Blanco y Negro*, No. 466, 7 April 1900.

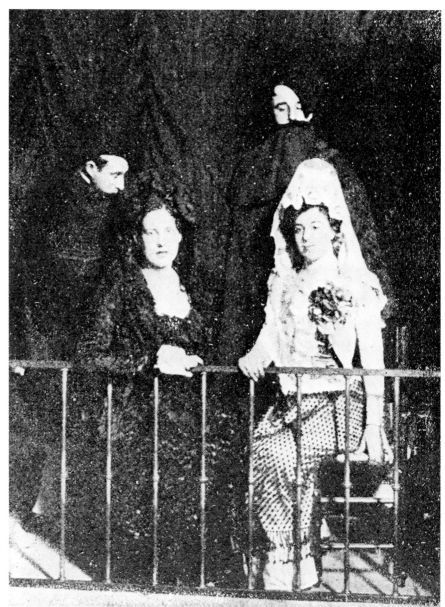

Goya, published his version of the frescoes in San Antonio de la Florida in 1888.[44] Thereafter the most significant contribution in quantity to second-hand knowledge of Goya's work was the publication of 449 reproductions of Goya paintings, etchings and drawings by the Calleja press at Madrid in 1924, until Pierre Gassier and Juliet Wilson gave us 2,148 illustrations in their monumental *Goya. His Life and Work* (1970). On a more popular level, Goya's works have featured on Spanish stamps in 1930, 1946, 1958, 1959, 1961 and 1967 (Plate 11),[45] and the etchings were reproduced on cigarette cards in Spain when C. Gasquoine Hartley was collecting material for her *Things seen in Spain* (1916).[46] A still more curious form of reproduction at the turn of the century was the *tableau vivant*. No less than four of Goya's paintings were presented in that guise in Madrid in 1900: *The Picnic, Blind-Man's Buff, Majas on a Balcony* (Plate 12) and the portrait of the *Condesa Duquesa de Benavente*. The spectacle was put on by keen young lords and ladies to raise money for good works; it was watched by the Spanish royal family and 'the élite of the aristocracy', and photographs of two of the *tableaux* appeared in the periodical *Blanco y Negro* on the 7 April.

Despite books and reproductions of various kinds, knowledge of Goya's art remained very uneven in the second half of the nineteenth century and early years of the twentieth. In 1903 C. S. Ricketts wrote that 'after the neglect and the hesitation of the art world for about a century, Goya as an original and potent fact "has come to stay"'; yet he went on to assert that in England Goya was still 'hardly known'.[47] Certain facts are, however, clear. The etchings were increasingly available in new editions, although few of these were comparable with the earliest printings in quality, and a table of all editions made from Goya's plates shows a dramatic rise between 1850 and 1928.

Table I

	1775–99	1800–24	1825–49	1850–74	1875–99	1900–28
Velázquez	1	1	–	1	–	–
Caprichos	1	–	–	2	3	4
Tauromaquia	–	1	–	1	1	3
Disasters	–	[1]★	–	1	1	3
Disparates	–	[1]★	–	1	2	4
Totals	2	2+[2]★	–	6	7	14

★Figures in brackets refer to first editions limited to two or three sets, and not offered for sale or published at the time.

Certain aspects of Goya's work, on the other hand, were very little studied. The Black Paintings are an obvious case in point. There was a brief reference to them in print in an article by the Spaniard Carderera in 1838, and a short piece from G. Cruzada Villaamil in 1868; Charles Yriarte described them in his book (1867), and another Frenchman, P. L. Imbert, gave a description of them in some detail after seeing them in 1873. They were on show in the Paris exhibition of 1878 and thereafter given by their owner to the Prado, which failed, however, to exhibit

them for a number of years. Even when the first monograph on them appeared in the 1930s their location in the Museum was still not easy to find.[48]

Still less well known were the miniatures on ivory which Goya painted in the last years of his life at Bordeaux. Two little bull-fight scenes were exhibited from the group at the Liceo artístico y literario in Madrid in 1846; and Laurent Mathéron gave a vague idea of their nature in his book (1858). But none of these was reproduced until William Rothenstein included a photograph of *The Monk and the Witch* from his own collection in *Goya* (1900), and they are rarely exhibited and little studied even today.[49]

As for Goya's drawings, few Spaniards, let alone anyone else, can have known much about them until the second half of the nineteenth century. In 1858 Mathéron said they were numerous but not very accessible. At that time they were concentrated in four main collections: more than three hundred belonged to 'D.R.G.' in Madrid, and another group, which had been authenticated by Madrazo, was owned by 'Mme. W'.★ Valentín Carderera, the Aragonese artist and collector, also had a considerable number; and drawings which had previously belonged to Ceán Bermúdez were 'in an English collection'. Unfortunately Mathéron does not describe any of these drawings at all, and the first important information about them came from Carderera in an article in the *Gazette des Beaux-Arts* (1860).[50] In 1867 Charles Yriarte described some of the pages from what is now called the Sanlúcar notebook, then belonging to Carderera, and he appears to have seen pages which have subsequently been lost: one with a note of Goya's travelling expenses; drawings of the Duchess of Alba reading and writing (a copy of the latter survives); sketches of the carriage in which she made the journey to Andalusia, the horses or mules which drew it, and the inn where they stayed a night. Twenty years later, the Conde de la Viñaza gave details of some of the preliminary drawings for the etchings, and listed the Carderera collection in general terms;† he also referred to some of the late Bordeaux period drawings, forty of which then belonged to Bernardino Montañés, director of the School of Fine Arts in Saragossa. Finally, some more information about Goya as a draughtsman was given by Araujo Sánchez in his study of the artist (1895), based on the examination of a 'book with 178 drawings' then in the Prado. Yet at that time only six or seven drawings were actually exhibited in the Museum: less than 1% of Goya's known production in that medium. In 1904, Don José Villegas decided to make 228 Goya drawings in the Prado more readily available for study, and they were soon displayed on a stand with twenty-four revolving wings. A further 161 preliminary drawings for the etchings were subsequently arranged in eleven frames to judge from the 1910

★ 'D.R.G.' is clearly Don Román Garreta. He had bought the copperplates of *The Disasters of War* from Goya's family and several paintings from the same source, including the *Portrait of a Lady* usually identified with Goya's wife Josefa Bayeu, the *Self-portrait* on canvas and *The Exorcism*, all now in the Prado. 'Mme. W' is Rosario Weiss.

† Carderera's collection, apparently comprising more than two hundred and sixty of Goya's drawings, contained many of the preliminary sketches for the four main series of Goya's etchings. Some of these were bought from him by the Spanish state in 1866 or 1867; others in 1886.

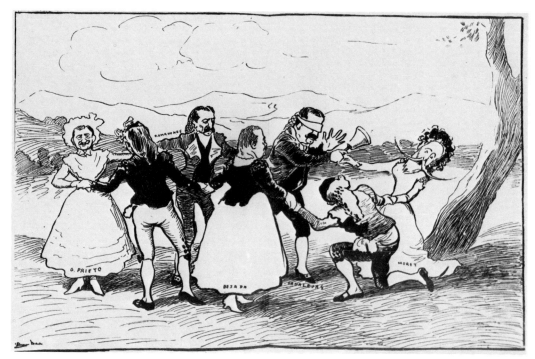

13. Caricature from *Gedeón*, 1910. Madrid, Biblioteca Nacional.

edition of the Prado catalogue. The Prado now has 478 drawings in all, and the only other group of any size is the collection of forty which was bought by the Metropolitan Museum of New York in the 1930s.

The spread of knowledge and the increased accessibility of Goya's work is clearly reflected in the Catalogues raisonnés. Mathéron (1858) listed approximately 130 paintings; Yriarte (1867), 229; Viñaza (1887), 403; Araujo Sánchez (1895), 280; Von Loga (1903 and 1921), 605; Mayer (1924), 732; Desparmet-FitzGerald (1928–50), 556; Gassier and Wilson (1970), 669; and Gudiol (1970), 768. The same process of development can be followed in publications which refer to Goya's life and art. Using Agustín Ruiz Cabriada's *Aportación a una bibliografía de Goya* (Madrid, 1946) as a guide, we find twenty-seven items listed between 1828 and 1849; forty-one between 1850 and 1869; sixty-four between 1870 and 1889; and one hundred and twelve between 1890 and 1909. There are interesting peaks in the 1860s and 1880s which it is tempting to link with waves of Realism and Impressionism. The number of items for the 1890s and early 1900s can be contrasted with the total of 309 entries in Jutta Held's bibliography of Goya literature between 1950 and 1962.[51]

These are the broad contextual patterns which need to be borne in mind when reading the chapters that follow. Inevitably many new references remain to be discovered, particularly in nineteenth-century publications. The study of Goya's life and work continues unabated; the interest he arouses develops and multiplies. Few painters seem to have remained so constantly relevant. A model Romantic for the Romantics; an Impressionist for the Impressionists, Goya later became an

Expressionist for the Expressionists and a forerunner of Surrealism for the Surrealists.
Artists have constantly found Goya a kindred spirit. Some have used his paintings
and etchings as starting points for their own creations. Notable cases in Spain are
the two Lucases and Fortuny in the nineteenth century, Picasso and Saura in the
twentieth. In France, Delacroix, Manet and Odilon Redon more particularly
admired him; in England and Ireland, Sargent and Jack Yeats. Creative artists in
other fields, more particularly in literature have also felt his attraction. There have
been poems, novels, even plays, operettas and films about him. To the politically
involved Goya has seemed to offer political commitment, and political caricaturists
or committed artists have naturally drawn on his work (Plate 13).[52] Equally, in the
present century, doctors and psychiatrists have commented on Goya and taken as
much interest in his visions and obsessions as have lovers of art and social historians.
In this way, although art lasts longer than life, Goya's life has itself lived long.
The creative powers of his later years have recently helped to document Simone
de Beauvoir's study of old age (*La Vieillesse*, Paris 1970, and English translation
1972). In all these as well as in art criticism the artist's work takes on its inevitable
Protean forms.

Sometimes we feel that it would be good to reach a still centre that we could
call Goya. A flawless diamond of his life and art that could only be fitted into one
particular gold circle. But art is not like that. It exists in the eye of the beholder
as well as on the canvas, paper, copper or wood. We only know it in that way.
And as Wittgenstein tells us: 'Whatever we see could be other than it is. Whatever
we can describe at all could be other than it is.'[53]

II. Goya's Life: A Brief Sketch

GOYA's lifetime spanned eighty-two years; half one century and a quarter of another. During that period there were radical shifts in Spain's political and social system. Goya lived to see the enlightened despotism of the Bourbons—the king as father of the Spanish people—questioned, then modified by the Cortes of Cadiz in 1812, and finally the constitutional monarchy proposed in its place set aside by Ferdinand VII in 1814. He was in Madrid during the constitutional triennium between 1820 and 1823, and his health gave him an excuse to leave Spain for France when Ferdinand resumed an absolutist position, and liberals went into exile, hiding or prison. Political change was a surface manifestation of social change. There was a considerable population increase in the course of the eighteenth century, and the percentage of aristocrats declined. The old hierarchical powers of church and monarchy were inevitably challenged though not broken while Goya was alive, and the Inquisition typically waxed and waned.

Goya pushed his way up in this changing society. His forebears were a mixture of craftsmen in the main on his father's side and country *hidalgos* on his mother's.[1] Unlike his father, he was entitled to use the courtesy title 'Don'[2] as an artist; and by 1779 he was ready to add a 'de' to his surname and sign himself Francisco de Goya.[3]

Born in a country village called Fuendetodos near Saragossa in 1746, he was the fourth child and second son in a family with five children, and brought up almost entirely in the provincial capital itself. Saragossa was a rich and important centre in the eighteenth century: the second city in Spain after Madrid for the nobility. The arts and crafts traditionally flourished there, and since Goya's father was a gilder by trade he may well have encouraged his son's artistic inclinations and recognised his ability. Gilding and painting had, after all, been practised jointly in the sixteenth century, so a gilder would naturally feel that painting was an accessible and desirable career for his children. Painters were gentlemen, and gilders merely craftspeople. Art would enhance the family's standing.

After a period probably spent as a pupil of the Piarist Fathers,[4] who ran one of the two major schools in Saragossa, Goya began to study art with the Italian-trained Aragonese artist, José Luzán. He worked with Luzán at the local academy from the age of thirteen. Later he tried unsuccessfully for the prizes offered by the Royal Academy of San Fernando in Madrid, competing first in 1763 and again in the first class category in 1766.

Total failure to secure any of the judges' votes on these occasions did not deter him from pursuing his chosen career. He left for Italy in the late 1760s, living for a period in Rome 'at his own expense'.[5] While there he submitted a work for the painting prize of the Royal Academy of Fine Arts in Parma, and was runner-up in 1771.

On his return to Saragossa the same year at the age of twenty-five, he quickly secured valuable commissions; one of the first being a ceiling fresco for the small choir of the Church of Our Lady of the Pillar, or the Pilar cathedral as it is usually called. The local tax books chart his early successes,[6] and he then moved to Madrid, encouraged no doubt by his compatriot, Francisco Bayeu, who may have taught him at an earlier stage,[7] and whose sister he married in 1773. He was also the protégé at this period of A. R. Mengs, who had met him and seen some of his work in Rome.[8]

From 1775, thanks to Mengs, he began to produce cartoons for the weavers in the Royal Tapestry Factory, which was under Flemish direction. The Factory of Santa Bárbara primarily made hangings for the royal palaces, several of which had been rebuilt in the first half of the eighteenth century and required decoration. It was the normal practice in Charles III's reign for artists in the royal employ to paint the cartoons that the factory required. These preliminary paintings were usually carried out on a similar scale to the tapestries themselves, and the weavers worked with this large version of their subject behind them. A number of the earlier eighteenth-century cartoons had been copies of seventeenth-century masters such as Teniers, Luca Giordano and Wouvermans. But Goya's designs were all of his own invention. This was no doubt important to Goya as a source of status. A man who copied the work of others was a craftsman or artisan rather than an artist or gentleman. There were also financial advantages in originality, since more work had to be put into original cartoons, and this meant more pay.

In 1778, while he was still primarily working on tapestry cartoons, Goya began a series of etchings after paintings by Velázquez. Nine of these were offered for sale in an advertisement in the Madrid Gazette on 28 July, and another two on 22 December 1778. Ceán Bermúdez implies that Goya made drawings and plates for seven others, totalling eighteen in all.[9] Seventeen etchings are now known, and there are four additional drawings unrelated to existing prints. The work was well received.

In the next few years Goya received further commissions for frescoes in the Pilar cathedral, although he was not always on the friendliest terms with the authorities, and began to establish a reputation as a portrait painter. He became a member of the San Fernando Academy in 1780, was Vice-Director in 1785 and Director ten years later. From 1786 he drew a salary as one of the King's painters. His painting of *St Bernardino Preaching* for the church of San Francisco el Grande in Madrid (begun in 1781) evoked a favourable response at court, and in 1783 he received commissions for portraits from the king's brother, the Infante Don Luis, and the chief minister, the Conde de Floridablanca. The Infante, formerly Cardinal-Archbishop of Toledo, had married an Aragonese gentlewoman in 1776, and lived

away from Madrid at Arenas de San Pedro. He was an extremely cultivated person who played organ duets with Padre Soler, employed Boccherini, and was friendly with the artists, architects and sculptors who worked for him. Goya not only painted his family, he went shooting with him—gun-dogs seem to play an important part in Goya's life at this period. Other portraits and commissions for the aristocracy followed: notably for the Dukes of Osuna—the Duchess (who also hunted) was a friend of poets and musicians as well as of artists[10]—in Valencia and Madrid.

Despite a serious illness in 1792–3 which left him deaf, Goya's fame continued to grow. There was further work for the Dukes of Osuna, who were decorating their country-house outside Madrid at this period, and also for the Osunas' great rivals as patrons of the arts, the Duke and Duchess of Alba. The latter was soon on the most familiar, indeed intimate, terms with Goya, and he spent some time with her on the Alba estates at Sanlúcar de Barrameda. Then, in October 1799, Goya was accorded the highest honour possible for an artist in Spain. He was made First Painter to the King, in appreciation of his 'talent and knowledge . . . in the noble art of painting'.[11] A number of royal commissions of major importance followed at the turn of the century: the frescoes for the little church of San Antonio de la Florida had already been completed in 1798; and there were several portraits of the king and queen, the favourite Godoy and his wife, and the group of *Charles IV and his Family* in 1799 and 1800. New commissions in Saragossa also occurred: portraits of friends like Martín Zapater (1790) and Juan Martín de Goicoechea (1789) led on to work for the chapel of the Aragonese Canal at Monte Torrero (1798–1800).

From the time of his illness in 1793 Goya began to produce a new kind of painting: small works depicting real or imaginary subjects which the artist recalled or invented. These would henceforth constitute a significant proportion of his output. At much the same time he started to fill albums with drawings. Some of these eventually led to the etchings in the *Caprichos* series published in 1799, a highly original work which shows how far he had developed emotionally and intellectually as well as technically since his first engraved work in the 1770s. Later in his drawings he drew subjects which obsessed him or caught his eye, together with themes that concerned him politically or socially yet could not be expressed in more public works of art.

Goya's success as an artist was naturally reflected in financial terms. In the 1780s and 90s he made a good deal of money and thought about founding his family's fortunes. He bought shares in the Bank of San Carlos and attended the shareholders' meeting on at least one occasion.[12] After reselling the shares in November and December 1788 he took out a policy in favour of his son in May 1794 to produce 9 per cent a year on 84,000 *reales*.[13] He also acquired property: a house in the Calle de los Reyes in Madrid, and No. 15 in the Calle de Valverde for which he paid 234,260 *reales* in June 1800.[14] Later, in 1819, he was to buy a house on the outskirts of Madrid known as the Quinta del Sordo, or the Deaf Man's Estate. Some seventeen and a half acres of land went with the property.[15]

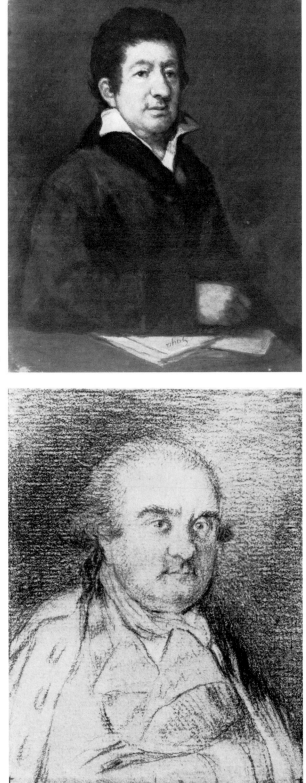

14. Goya: *Leandro Fernández de Moratín*,
1824. Bilbao, Museum.

15. Goya: *Drawing of Juan Antonio
Ceán Bermúdez*, 1798–9. Carderera
Collection, Madrid.

Also in the 1780s and 90s he formed close friendships with a number of leading Spanish intellectuals. The distinguished writer and lawyer Gaspar Melchor de Jovellanos was quick to recognize his ability and gain his confidence. A mutual friend compared their relationship to that of Aretino with Raphael, Giulio Romano or Titian.[16] Jovellanos was probably responsible for a commission for religious paintings for the College of Calatrava, belonging to the Council of the Military Orders, in Salamanca (1783–4); Goya certainly gave his friend a copy of one of this series.[17] The artist later used a line from one of Jovellanos' verse satires as a caption for No. 2 of the *Caprichos*. Other literary friends included the poet and lawyer Meléndez Valdés and the dramatist Leandro Fernández de Moratín (Plate 14), who often went sight-seeing with Goya in Madrid. Moratín had a civil service post as Official Translator and he seems to have been closer to Goya over a longer period than almost any of his friends, apart perhaps from Juan Antonio Ceán Bermúdez (Plate 15). The latter was also a civil servant, and a member of the San Fernando Academy. He devoted much of his time to art, amassed an important collection of prints, and published a fundamental *Dictionary of Spanish Artists* in 1800. Goya constantly looked to him for advice.

Through men such as these Goya came into contact with the ideas of the Enlightenment. He came to share his friends' opposition to religious fanaticism and superstition, and was, like them, particularly critical of the Inquisition and some of the monastic orders. On some other issues, though not all, he was in broad agreement with them. They favoured a better distribution of land, more equitable laws and constitutional rights; also an education system which would bring out the qualities of the individual instead of forcing him to conform.

When a constitutional crisis arose in 1808 and Napoleon intervened, sending his brother Joseph Buonaparte to take the Spanish throne, Goya's friends took different positions. He must have felt the tensions within himself, since he accepted the Order of Spain (the famous egg-plant) from Joseph, yet donated canvas for the war-effort against the French and went to Saragossa to draw official pictures of the city's heroic resistance during the first siege.[18] Meléndez Valdés and Leandro Fernández de Moratín were both content to accept office under Joseph, and the latter saw the French intervention as a means of achieving a revolution in Spanish society. Jovellanos, on the other hand, and younger proponents of change like the poet Manuel Quintana, hoped that the Spanish monarchy could be liberalized without a French occupation.

Jovellanos died in 1811, and few of Goya's friends survived the war unscathed. Quintana was persecuted, Meléndez Valdés went into exile in France, Moratín followed after a few years spent in hiding in Spain. Goya, now an old man, had to submit to the process of 'purification' which all who were suspected of collaborating with Joseph Buonaparte had to undergo.[19] In March 1815 Dr Zorrilla de Velasco, of the Secret Chamber of the Inquisition in Madrid, was to summon Goya to explain the *Naked Maja*; 'why he had painted it, who commissioned it and for what purpose'.[20] It was also hoped that he might give evidence against another artist, since he was to be asked 'what he knew about the painter Manuel Palomino who had . . . painted a naked Venus'.[21]

In some degree Goya came to terms with the new régime. His livelihood, after all, depended on it. He painted some official portraits of Ferdinand VII and ministers like the Duke of San Carlos; he recorded at least one royal occasion—the King presiding over a meeting of the Royal Philippine Company. But his drawings and the late etchings in the *Disasters of War* series show that he must have been totally out of sympathy with the policies of Ferdinand's reign.

In the circumstances it is not surprising that he became increasingly solitary at this stage. His wife Josefa had died in 1812, and his only child Javier[22] had married in 1805. Age and deafness made their inevitable contribution to his isolation,[23] and his finances were perhaps less secure than had formerly been the case. Although he was still on the royal pay-roll, he made several attempts to obtain the 150 doubloons which the Academy owed him for his equestrian portrait of the king.[24] A Swedish diplomat wrote in July 1815 that Goya was 'living in straightened circumstances', and that he was 'threatened by blindness' as well as deafness.[25] According to the same source he had brought poverty on himself. 'One day he suddenly got the idea of writing a letter giving away his whole fortune, which was considerable, to his son and daughter-in-law', and the diplomat went on to report that Javier's wife behaved 'badly towards her father-in-law, often denying him the modest sufficiency he craves and needs for a living'. Legally, his property and assets had been equally divided with Javier after his wife's death, father and son having 178,864 *reales* each. Can he subsequently have given his own share to Javier too?

This coldness on María Gumersinda Goicoechea's part may well have reflected moral disapproval. For Goya's closest companion at this period was a married lady, Doña Leocadia Zorrilla y Galarza. The latter was a distant connection of his daughter-in-law on her mother's side. She had married a merchant of German extraction, Isidoro Weiss, but in September 1811, only four years after her wedding, her husband was taking steps to obtain legal evidence about her 'conduct and illicit relationship'.[26] What this relationship was and who it involved is still a matter for conjecture. A daughter, Rosario, was born to Doña Leocadia in October 1814, and registered as legitimate, so conceivably the marriage was patched up.[27] An alternative hypothesis suggests that the child was really Goya's. Certainly Rosario Weiss was entrusted to his care in 1821, and he asked a friend to treat her 'as is she were his daughter'.[28]

A possible source of new income at this difficult moment came from another series of etchings, the last to be published in Goya's lifetime: the *Tauromaquia*. The bull-fighting subject may have seemed apposite at the time since Ferdinand VII's reign saw a revival in the sport, which had been banned under Charles IV in 1805, although resumed in 1810 under Joseph Buonaparte. The new series was advertised in the *Diario de Madrid* on 28 October 1816, and again in the Madrid Gazette in December. The etchings could be bought separately for 10 *reales* each; the complete set was priced at 300 *reales*. There were doubtless continued receipts from portraits, and as an artist generally his work still commanded a high price. He was paid 8,000 *reales* for the portrait of Ferdinand VII commissioned by the city of Santander in

1814, and offered 20,000 for a painting of *The Last Communion of St Joseph of Calasanz*. He generously returned some of the money in this last case, but was pleased to earn 28,000 *reales* for his painting of the two Seville martyrs, *St Justa and St Rufina* (Plate 22) in 1817.

1819 was a year of great activity and crisis for Goya. He made his first experiments with lithography, bought the Quinta del Sordo across the river Manzanares from the palace, but late in the year fell ill and nearly died. After his recovery in 1820 he may well have embarked on the fourteen paintings for the two principal reception rooms in his new house, which were certainly completed by 1823 when he made over the much improved estate to his grandson Mariano Goya. These three years coincided with a brief phase of political liberalism in Spain, during which the king was compelled to accept the constitution of Cadiz (originally drafted in 1812), after Riego's proclamation early in 1820. When the constitution was again set aside by Ferdinand in 1823, as a result of monarchist pressure from other European countries and the invasion of the Hundred Thousand Sons of St Louis, Goya's liberal friends and relatives left the country to take up residence in exile in France or England.[29] It seems that Leocadia Weiss may have fled to France in 1823 out of fear of persecution for her radical opinions, and Goya, no doubt, felt equally threatened. Between January and April 1824 he took refuge in the house of Don José Duaso y Latre, a priest from Aragon whom Goya would have known since 1805 when he became one of the Royal Chaplains.[30]

When a political amnesty was announced in May 1824 Goya hastened to apply to the king for six months leave, and permission to take the waters at Plombières in France. Leave was granted on 30 May, and an application to prolong his stay in France for a further six months was made, on his behalf, by Javier Goya on 28 November. Permission for the extension came through in January 1825, and Goya submitted medical certificates as evidence of his treatment in May. All this was, of course, necessary if the artist was to remain on the royal pay-roll. But there is little evidence that Goya spent any time taking the waters. Once in France in June 1824 he paid a brief visit to Moratín and other friends in Bordeaux and then set off for two months in Paris. Back in Bordeaux—Doña Leocadia and two of her children were with him and not in the most harmonious of moods it would appear[31]—he spent the winter in a flurry of activity, producing forty miniatures on ivory. The following year he made the admirable set of four lithographs called *The Bulls of Bordeaux*, despite the fact that he was acutely ill in the spring.

In 1826 he further amazed his contemporaries by returning briefly to Spain in the middle of the year. He asked the king's leave to retire on this occasion and permission was granted on 17 June. Goya was also allowed to return to France once more, and he was back in Bordeaux by the middle of November, with 'his family' according to Moratín[32]—that is to say Doña Leocadia and her children. Even that trip was not his last to Spain, and he made a visit in the summer of 1827. Finally he died in Bordeaux in April 1828: at 2 a.m. on the morning of the 16th of the month.

The years Goya spent in Bordeaux saw no slackening off in the quantity or

quality of his work. In addition to his bull-fight lithographs he painted some fine portraits of Spanish exiles, and the uncategorizable picture of *The Milkmaid of Bordeaux* (Plate 39). The miniatures on ivory show that he was still ready to try his hand in a new medium, and the remarkable series of Bordeaux drawings— street scenes and fair scenes side by side with dream images—show that his ability to represent what his eye saw or his mind imagined was undiminished.

III. Goya and His Contemporaries

AESTHETIC principles and artistic criteria were modified in Goya's lifetime. As pressure for change was exerted on the monarchical system, writers abandoned the rigid hierarchies of neoclassical values in literature. The idea that artists should seek 'Correct Taste' ('*buen gusto*') was less widely held at the beginning of the nineteenth century than when Mengs propounded his theories in Spain in the 1760s and 70s. It was no longer imperative to express an idealized beauty in art or follow slavishly the models of classical antiquity. Greater importance came to be attached to the personal vision of the artist, who was increasingly seen, as Abrams puts it,[1] as a lamp rather than as a mirror. Goya himself contributed to the change in attitudes in Spain. His serious illness in 1792–3, and ensuing deafness, made it inevitable that he should look inside himself at precisely the time when the artist's imagination became the touchstone for the arts.[2]

The biographical sketch which Goya wrote in the 1820s for the catalogue of the Prado (or the Royal Museum as it then was), reflects the shift of conventions that occurred in his time, and provides a useful introduction to the changing atmosphere in which reactions to his work were first formulated. In it Goya attaches more importance to his independent development than to his early efforts to copy approved models in the academy at Saragossa. This was only to be expected in the 1820s, when originality was widely accepted in Europe as the hall-mark of genius. But his claims to early independence may well have been exaggerated. In Goya's youth the basic skills of drawing and rules of artistic decorum took precedence over personal style and approach. Goya would frequently have to compromise his bent towards originality in order to satisfy the exactingly academic taste of many of his contemporaries. There will be evidence to show that his mastery of traditional techniques and conventions was respected in the early stages of his career, as much as his ability to break the rules later.

> He was a pupil of Don José Luzán in Saragossa, and acquired the principles of drawing at his hand, being set to copy the best prints that he had. After spending four years with Luzán, he began to paint subjects of his own devising, and then went to Rome. He learnt a great deal from observing the ways in which painters work, and studying the outstanding paintings in Spain and Rome. This proved, in fact, the most valuable part of his training.[3]

Goya did not meet academic standards easily at the beginning of his career, but he

evidently tried. Although he was unsuccessful in two competitions organized by the San Fernando academy in Madrid, the painting he submitted for a competition during his stay in Italy between 1769 and 1771 won him his first qualified praise in print.

The painting in question was sent to the Royal Academy of Fine Arts in Parma in April 1771. The subject of the picture, which has not survived, was Hannibal crossing the Alps into Italy, and the academy had given fairly specific instructions about it when the contest was announced on 29 May 1770. Hannibal was to be shown 'lifting the visor of his helmet and turning towards a Spirit, who takes him by the hand and points out the beautiful plains of Italy, lying at his feet and stretching into the distance'. The general's eyes and his whole person were to exude 'inner joy and a noble confidence in approaching victory'.[4]

The prizegiving was held on 27 June and was reported in the Rome *Diario* on 3 August 1771.[5] Goya's painting was referred to in the following terms:

> The painting which was countersigned with a line from Virgil—*Jam tandem Italiae fugientis prendimus oras*—won six votes. The jury had been pleased to note the fluent handling of the brush, the warmth of expression in Hannibal's countenance, and the nobility of character conveyed in his whole demeanour. If its colouring had been truer to life and its composition had followed the subject laid down more closely, it would have brought into question the laurels conceded to the prizewinner. The author is Sig. Francesco Goja of Rome, a pupil of Sig. Francesco Vajeu, Painter in Ordinary to His Catholic Majesty [the King of Spain].[6]

Goya's painting came second to that of a local artist, Paul Borroni, which obviously met academic criteria more satisfactorily. Borroni's painting combined many qualities: accuracy of drawing, idealized beauty in the overall composition and the harmonious use of colours, variety of pose in groups of figures, powerfully expressed emotions giving an illusion of life through art and appropriateness of style to content. Goya lacked some of these desirable qualities, although the boldness of his brushwork and the interest and ability he displayed in representing emotionally charged situations (which would mark much of his latter work) could already be appreciated.

Similar criteria were applied to Goya's work when he returned to Saragossa in 1771. His most important early commission was for frescoes in the Pilar cathedral. He submitted sketches for a choir ceiling in October, and the meeting of the Board of Works in the cathedral on 11 November found his terms very much to their liking. Goya clearly undersold an older and more experienced competitor, as a young artist often must. Yet the Board minutes show that local connoisseurs in Saragossa thought well of Goya's sketch from the point of view of technique, even if there were some doubts about employing an artist with few previous commissions (Plate 16).

The Administrator reported that Goya had painted a sample fresco painting to prove that he had the necessary experience to undertake this type of work,

16. Goya: Detail from *The Adoration of the Name of God*, fresco for the Basilica of El Pilar, Saragossa, 1771.

and this had earned the approval of experts. When he was questioned about the price he would ask for the ceiling of the *coreto* (small choir), he replied that he would undertake it for 15,000 *reales* [£165 in money of the period and fifteen to twenty times as much today] and pay for his own assistant and materials. When the members of the Board had heard this statement and noted how advantageous were the terms by comparison with those of Don Antonio Velázquez (whose letter was also read) who asked 25,000 *reales* [£275] including carriage to and from Madrid, they accepted Goya's estimate. However, so as to proceed with proper caution, he was to produce sketches for the *Gloria* and send them to Madrid for the Academy's approval. When this was forthcoming, the agreement would be confirmed and the contract signed.[7]

At the next meeting of the Board on 27 January 1772, Goya's sketch was approved.

The criterion was typically 'buen gusto'—the standard term for the international classical style in the period.

Goya presented his preparatory sketch for the ceiling of the *Coreto*. The members of the Board had already been told it was a skilful piece of work and very much in accord with 'Correct Taste'. The Board accepted it therefore, and notwithstanding the resolution passed at the previous meeting to send it to the Royal Academy at Madrid for approval, decided the work could begin as soon as the contract was signed, which the Administrator would arrange.[8]

The same classical style was expected of Goya when he began to work for the Royal Tapestry Factory in Madrid three years later. The artist's immediate superior in this instance was A. R. Mengs, a favourite of Charles III and a leading proponent of neoclassicism in Europe. Goya's early cartoons certainly have the stamp of Mengs' theories on them in their pyramided groups and variety of pose. Mengs was a cautious individual, conventional in his life and in his art, and highly embarrassed by the antics of his friend Casanova (the Great Lover) when the latter stayed with him in Madrid. Mengs nevertheless recognized Goya's ability and seems to have respected the artist's dash, to judge from the formal report he wrote about Goya's work on 18 June 1776: 'Don Francisco Goya has also worked for the Royal Tapestry Factory. He is a man of talent and spirit, who should make great progress in art if he continues to receive financial support from the Crown. He is already proving useful in the royal service.'[9] Mengs wrote reports on two other artists in the Tapestry Factory at much the same time: José del Castillo and Ramón Bayeu, Goya's brother-in-law; and it is interesting that he reserved the word 'spirit' ('espíritu') for Goya alone. Castillo was a worthy person, skilful, hardworking and good at keeping to his deadlines; Bayeu had talent and application. Yet Mengs encouraged them to work from sketches produced by other artists, or made them copy famous paintings, whereas he allowed Goya to work on his own. Mengs seems to have noticed a difference between Goya and the others. Something more than just a question of technical competence.

Goya's subsequent work on tapestries continued to satisfy his superiors. Care and attention to detail were their prime concern. Calleja, in 1778, thought Goya's cartoons were 'very diligently wrought, all necessary time and care being put into them and into preparatory sketches'.[10] Although his *Blind Man Playing a Guitar* in April that year needed 'correcting and finishing' before it could be reproduced as a tapestry,[11] even the king approved of six cartoons he presented in January 1779.[12]

Other work on which Goya was engaged in the 1770s also fitted into the neo-classical tradition, notably his series of etchings after paintings by Velázquez. These were undertaken by Goya on his own initiative and were not commissioned,[13] although the set was the first instalment of a project to reproduce all the best paintings in the Spanish royal collections, and copies of frescoes by Luca Giordano were made the same year under the aegis of the Conde de Floridablanca. In making these etchings Goya was following the taste of Spanish court circles as well as his own inclination. Despite the fact that Mengs placed Velázquez and other masters of

the 'Natural Style' below those who were capable of creating idealized beauty and had studied the art of classical antiquity, like Raphael, he thought highly of Velázquez's work. Mengs particularly admired his ability to create a style [or character] of his own, based on the imitation of nature and the most precise study of the causes and effects of *chiaroscuro*'.[14] Goya, in copying Velázquez, was showing a proper respect for fine draughtsmanship and a studious approach. His etchings were judged on these criteria and were not found wanting.

Eight of Goya's Velázquez plates were presented to the San Fernando academy in the summer of 1778, so the artist obviously looked for official approval. The quality of the etchings excited favourable comments at that time from the Viennese representative in Madrid, P. P. Giusti. Giusti was an important person at the court. He had played a significant role in the settlement of Bavarians in the Sierra Morena region in the 1770s—one of the Spanish attempts to repopulate their country. He was to become a corresponding member of the Royal Academy of History in Madrid from 1781. Giusti spoke of Goya's promise in a letter accompanying a set of the prints which he sent to the Austrian Grand Chancellor. He also implied that the engraving process used by Goya broke new ground in Spain.★

> An event which is not without significance for the development of the Fine Arts in this country is the long-awaited start which a Spanish artist has made on the project for engraving the best paintings in the Royal Collection. Paintings by Velázquez are the first to be attempted, and etching is the process used to reproduce them. I have the honour to send you the eight plates which have been presented to the Academy. If the author, who is a painter and not an engraver, and the first to try this particular manner of engraving in Spain, continues to improve and has the courage to persevere, the set will make an important contribution to the world of the arts. It will also prove instructive to other artists, who are almost entirely ignorant of the priceless treasures to be found in the Royal Palace at Madrid, the Retiro palace, the Escorial and La Granja.[15]

Goya may also have made some copies in oils of Velázquez's paintings at this period. Prolonged study evidently gave him a deep knowledge of the latter's work, and his connoisseurship was recognized by his friend and patron, the Spanish lawyer, politician, poet and dramatist, Jovellanos. Jovellanos was basically neoclassical in his approach to art; he certainly disliked anything that lacked organization or was unclassically 'Gothic'. This did not prevent him from appreciating emotional qualities in literature nor flights of fancy, and later he was to recognize Goya's exceptional powers of imagination.[16] In December 1789, however, when he wrote his 'Reflections on the original sketch for Velázquez's *Las Meninas* (The Maids of

★It is conceivable that Giusti was referring to Goya's use of etching and drypoint. The burin was the tool most commonly used in earlier Spanish engravings, although Bernardo Albistur had etched fourteen plates depicting feats of horsemanship in Madrid in 1768. Can Giusti have known that Goya was experimenting with aquatint? It does not seem likely since that medium was not employed in any of the plates offered for sale in July. But the possibility cannot be entirely dismissed.

Honour)', Goya's perceptive understanding of Velázquez and mastery of his style were uppermost in his mind. He could think of no-one more suitable than Goya to undertake a comparative study of Velázquez's sketch and the finished painting:

> It must be understood that not many artists are suitable for this task. It must be done by someone who knows Velázquez well, who has studied his works and analysed them deeply, and appreciates the hidden details that his bold style of painting conceals from ordinary eyes. An appropriate person, for example, would be Don Francisco Goya, for in drawing and engraving the works of Velázquez he has come to imbibe his very spirit and is the most distinguished imitator of his manner.[17]

Goya's work continued to satisfy neoclassical aesthetic canons and technical standards for many of his patrons in the ensuing years. There was a favourable reaction to his picture of *San Bernardino Preaching* for the church of San Francisco el Grande in Madrid, which had a pyramidal composition, in the approved Mengs manner, as Goya explained to the Conde de Floridablanca.[18] It was one of a group of paintings by leading Spanish artists for the church, and was a relative success according to the artist when it was first displayed to the court public in 1784. Goya wrote to his friend Martín Zapater on 11 December that 'my painting for San Francisco has been fortunate so far as the opinion of connoisseurs and general public is concerned, since everyone is indisputably in my favour, although, up to now, I haven't heard of any reaction from the Royal Family, and we shall have to see what happens when the king returns from the country'.[19] Equally gratifying, no doubt, was Jovellanos' letter to Goya in October 1784, thanking him on behalf of the Council of the Military Orders, for the four religious paintings he had done for the College of Calatrava in Salamanca. Jovellanos noted 'the care and diligence which [he] had put into the execution of these paintings', and spoke of their 'outstanding merit'.[20]

In the 1780s and 90s Goya's portraits as well as his religious paintings and tapestry cartoons acquired aesthetic respectability. Like the tapestries they were particularly admired for their truth to nature. Jean François Bourgoing, a French envoy in Madrid, who published a book about Spain in 1788 (reprinted in 1789, with a second edition in 1797 and a third in 1803), emphasized precisely these qualities. Maella and Francisco Bayeu seemed to Bourgoing the chief proponents of the style of Mengs in the Spanish School. It was their work primarily that made up for the loss of Mengs himself. But 'one of their confrères, Don Francisco de Goya, also deserves an honourable mention for his talent in rendering faithfully and in a pleasing fashion the customs, dress and pastimes of his country.'[21] A note added in the third edition, when the Goya reference was marginally compressed to make way for comments on other artists, stated: 'Goya also excels as a portrait painter, and so do Asensi and Esteve.'[22]

Published comments by Goya's contemporaries on his portraits are rare; mostly they merely praise his ability to obtain a good likeness. Francisco Gregorio de Salas

was a case in point, to judge from the epigram he wrote 'on seeing several excellent portraits painted by Goya'. In this poem, which was probably written at the turn of the century, Salas employed a conceit that is very familiar in eulogies of realistic art, making nature herself envy the artist's creative ability.[23] Another common hyperbole involves mistaking portraits for real people. And something of this sort occurs in Goya's career in connection with his portrait of the architect Ventura Rodríguez (1784). The king's brother, the Infante Don Luis, who commissioned Goya to paint this picture, indicated that 'he took great pleasure in having Rodríguez always within his sight'.[24] Presumably the Infante knew that the realistic quality of the portrait would be adequate to meet his demands, since Goya had painted his own family the previous year.

One sitter whose comments on Goya's portraits have survived is María Luisa, wife of Charles IV (Plate 17). The queen's remarks occur in letters she wrote to the favourite Godoy in 1799 and 1800. Accuracy and good workmanship seem her fundamental criteria, and she was anxious about the likeness of her horse ('Martial') as about her own. The rigours of posing are referred to, and the favourable opinions of the queen's circle are reported. It is noticeable that María Luisa refrains from giving her own views on the fidelity of the portraits. Perhaps this is just a polite convention, but maybe she recognized that the portraits flattered her, incredible though this may seem. Certainly Goya made her very much better looking than Carnicero, for instance, and she was probably delighted that the court thought his portraits accurate. The court, in its turn, no doubt told her what she wanted to hear.

The first extract is taken from a letter written to Godoy on 24 September 1799; it refers to the portrait (now in the Royal Palace at Madrid) of the queen in a black dress and wearing a *mantilla*. Subsequent passages speak of the equestrian portrait now in the Prado and the group portrait of *Charles IV and the Royal Family* (Prado) painted in 1880.

> Goya is painting a full length portrait of me in a *mantilla*, and they say it is coming out well. When we go to the Escorial he will paint me on horseback, as I want him to do a portrait of Martial [the Queen's horse] . . .
>
> (Letter of 24 September 1799)
>
> I've had a good ride today and also spent two and a half hours mounted on a plinth with five or six steps leading up to it, with my hat on, wearing a cravat and cloth dress so that Goya can get on with his painting. They say it is going well. He is working on it in the King's apartments rather than downstairs, in the first of the entrance chambers, since the proportions are right and we are not disturbed there . . .
>
> (Letter of 5 October 1799)
>
> The equestrian portrait—with three sittings—has exhausted me, and it is said to be an even better likeness than the one in the *mantilla* . . .
>
> (Letter of 9 October 1799)
>
> We are very glad that your wife is having her portrait painted. If Goya can do the

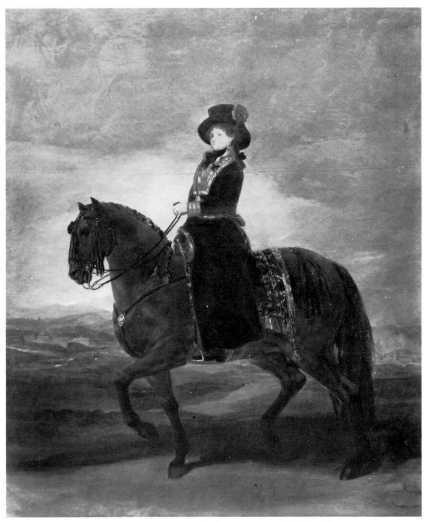

17. Goya: *Queen María Luisa on Horseback*, 1799. Madrid, Prado.

copy of my portrait there too, and do it carefully and make it a good likeness, so much the better, for then we won't have any more trouble with it. But if it doesn't turn out right he had better come and torment us again . . . The King says that when Goya has finished your wife's portrait he must come and paint the portrait of us all here together . . .

(Letter of 22 April 1800)

To-morrow Goya is beginning another portrait of me. He has finished all the others [for the Family Portrait] and they are all very well done.

(Letter of 9 June 1800)

Goya has finished my portrait and they say it is the best of them all. He is doing one of the King in the Farmer's House (Casa del Labrador), and I think it will also come out well.

(Letter of 14 June 1800)[25]

A few Spaniards now felt Goya to be an artist of international calibre, and an anonymous article in the *Diario de Madrid* for 17 August 1798 said as much. The author, who signs himself 'Jealous Defender of the Nation's Honour', took Goya as an outstanding example of Spanish ability. The article is by no means a blind eulogy of all Spanish art and is quick to criticize inadequacies in technique. It underlines traditional virtues in Goya, but also finds his boldness or freedom, and (by implication) his harmonious treatment of colour worthy of praise. The passage also shows that, in some of his countrymen's eyes Goya was now ripe for superlatives. For the first time in print he is held to be unique: 'The portrait of Don Andrés del Peral, painted by the incomparable Goya, would be enough by itself to bring credit to a whole Academy, to a whole nation, to a whole contemporary period with respect to posterity, so sure is its draughtsmanship, its taste in coluring, its freedom, its use of chiaroscuro; in short, so great is the skill with which this artist carries out his works.' (Plate 18)[26]

Despite this high assessment of Goya's taste and technique, and the evidence of the court and the academy's approval at the same period, his work did not always meet his patron's expectations. Two main grounds for disapproval emerge. First the artist's departure from accepted conventions. Secondly, the signs of haste or slovenly execution that were sometimes found in his work.

The Italian prize painting gave an early indication of Goya's willingness to take a line of his own. Conservative patrons were wary of this propensity and in the 1780s Goya's audacity received a sharp knock in Saragossa when he was working for the Pilar cathedral. 'Thinking of Saragossa and painting together is enough to make my blood boil', Goya would write later to his friend Zapater.[27]

The modernization and redecoration of the Pilar cathedral was still in train. But the major project for painting the domes had been held up for several years as a result of the multifarious activities of the artist responsible: Goya's brother-in-law, Francisco Bayeu. Bayeu had accepted a commission to paint the domes himself in March 1776, but in 1780, after numerous exchanges of letters with the Board of Works of the Cathedral, he suggested that Goya and his younger brother Ramón Bayeu should undertake two of the domes. He would be responsible for the sacristy of the Holy Chapel and the Chapel of St Anne himself.[28] When a low price of 3000 *pesos* was mentioned, the Board naturally accepted.

The preliminary sketches for all the domes were scrutinized 'with close attention and satisfaction' when they were submitted in October 1780.[29] But in December that year the Board and the artist began to disagree. Goya did not wish to be bound by his brother-in-law's approach to the set subjects, nor have his work 'corrected' by him. He had just been unanimously elected a member of the Royal Academy of San Fernando (5 July 1780), and was in no mood to be treated as an inexperienced assistant to Francisco Bayeu. The Board, on the other hand, was more ready to rely on Bayeu's judgement than on Goya's. Bayeu was already the Apelles of Saragossa to his compatriots. So the unfortunate Administrator of the cathedral was asked to keep an eye on the progress of Goya's work and 'point out any defects he noticed'.[30] The defects in question would presumably have been the improper

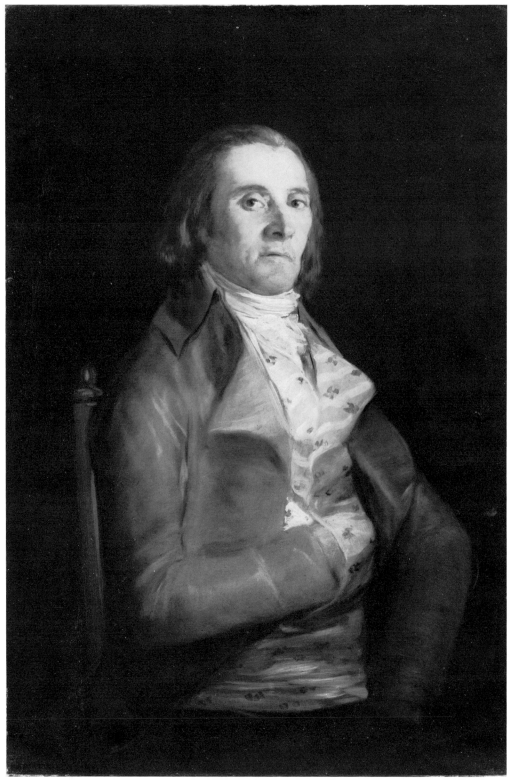

18. Goya: *Andrés del Peral, c.*1797–8. London, National Gallery.

treatment of religious subjects, or inconsistencies of style between Goya's work and Bayeu's.

When the dome itself was finished, Goya was asked to prepare sketches for the four pendentives, and the Board was frankly not pleased with these when they saw them at their meeting on 10 March 1781. Apparently the general public had 'not liked the style of clothing, the colouring or basic conception' of Goya's dome.[31] The Board no doubt feared further adverse comments from the same quarter.

The sketches Don Francisco Goya had made for the four pendentives adjoining the main dome which he had painted for the Chapel of St Joachim, were shown by the artist to the Board in the cathedral Chapter House. The subjects were the virtues of Faith, Fortitude, Charity and Patience, which related to the theme of the main dome: the Most Holy Virgin Mary as Queen of Martyrs. When the members of the Board had seen the preliminary sketches they failed to express the approval which had been expected. There were several reasons for their dissatisfaction, notably the fact that the figure of Charity was less adequately clothed [less decent] than was proper. Furthermore, the background of the other figures were both poorly executed [or, lacking in detail] and darker than was desired, and not of the style and quality which the Board had anticipated. It was agreed that Don Mathías Allué should tell the artist that the Board, having heard the unfavourable reaction of the public to his painting for the dome, and noting that the sketches for the pendentives showed no sign of greater care or taste than the previous work; and not wishing to expose itself to further criticism, nor desiring to be accused of negligence and inadequate supervision of the work, had decided to put the matter into the hands of Don Francisco Bayeu, in view of the confidence which the Board and, indeed, the whole Chapter, placed in him. The Board hoped that Bayeu would examine Goya's sketches to see whether the Board's criticism was justified or not, and that he would arrange for the pendentives to be painted in such a way that they could be shown to the public without fear of censure.[32]

Goya was obviously enraged by the Board's attitude and wrote a long memorandum, complaining that his honour as an established painter had been impugned.[33] He attributed criticisms of his work to 'fancy or ignorance', and went on to state that he had changed his approach in one design on the advice of Bayeu, and had in fact obtained his brother-in-law's prior approval in Madrid for his plans for the pendentives. He demanded that the Madrid Academy should be asked for its opinion. After several efforts to persuade him to change his mind by a friendly monk from the Charterhouse in Saragossa, Goya backed down, and new designs were approved by the Board on 17 April. Bayeu was to supervise their execution and also the retouching of the dome. By the end of May there was trouble again, and the Board's minutes of 28 May express its final state of exasperation. They also throw much light on Goya's character as it appeared to those who met him at this period.

The Administrator of the Works reported that Don Francisco Goya had been to see him, to tell him that he had a mind to return to Madrid as soon as possible;

that he felt he was only losing credit by remaining in Saragossa, and would like steps to be taken for a final settlement of his account. The Administrator, having had to bear with conversation and arguments, whose tenor was neither respectful nor polite, replied that he would tell the Board about the matter at once, so that their decision could be put into immediate effect. Having heard the report the Board decided: Firstly, to pay the artist for his work; and secondly, to prevent him by all possible means from carrying out any further work on paintings in the church. The Administrator was not to contemplate giving any medallions to Goya's wife, even though she was the sister of Don Francisco Bayeu, who deserved this and other considerations from the Board for his successful work in this cathedral.[34]

So Goya was dismissed and his pride wounded. Conservative ecclesiastical authorities and the general public, which is not always responsive to novelty, were happier with the more traditional design, more finished (and less impressionistic) sketches and orthodox colouring of Bayeu. Goya no doubt felt particularly humiliated since his brother-in-law came from a slightly higher social background than he. Probably the Board exaggerated public opposition to the dome; the voices of reaction are always the loudest. Certainly when there was a ceremony in the Pilar on 5 December 1783 to unveil the *Regina Virginum* dome of Ramón Bayeu, a local chronicler complacently declared that the cathedral, with Ventura Rodríguez's alterations and the frescoes by the two Bayeus and Goya, was 'unrivalled for the quality of its art and architecture in the whole of Spain'.[35]

Dissatisfaction with Goya's work as a portrait painter could sometimes be as strong as the criticism of his religious work. The apprehensive observations of a prospective sitter will serve to put the favourable reactions of the queen, Jean-François Bourgoing and the anonymous critic of the *Diario de Madrid* into perspective. The sitter in question, José Vargas Ponce (Plate 19), was an active member of the San Fernando Academy★ and a close friend of people in Goya's circle. He was also a member of the Academy of History, and had to have his portrait painted in 1805 when he became Director. He wanted it painted by Goya, but was obviously afraid of his rapid and sometimes careless workmanship. He wrote to a mutual friend, Ceán Bermúdez, whom he had helped with notes on artists and architects when the latter was engaged on his *Historical Dictionary of the most famous artists in Spain* (Madrid, 1800), asking him to write to Goya on his behalf:

[8 January 1805]

Pepe to Juan:

Volta supito [Turn over quickly]: I nearly forgot the main thing I had to say to you, and my chief reason for writing today. (A Director's work is never done!) Since I *am* Director, one of these days, willy nilly, I've got to have my portrait painted. I want Goya to do it. He's been approached and has given his consent. But I also want *you* to drop him a line—I beg you to do it—telling him who I am,

★He was one of eight members to vote for Goya as Director of the Academy in September 1804, when twenty-nine voted for Gregorio Ferro.

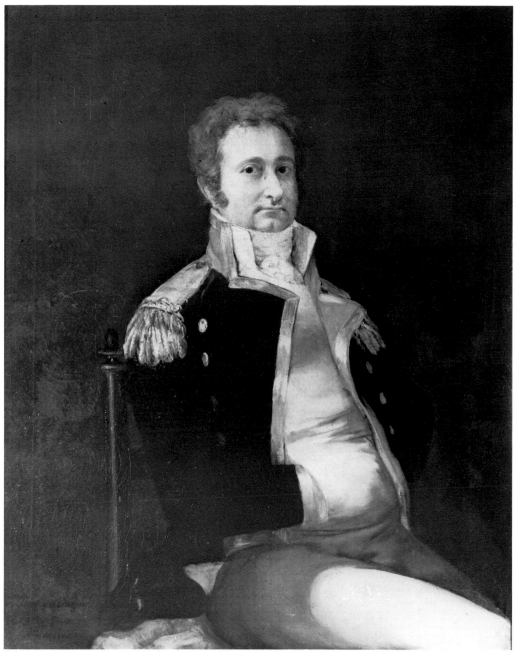

19. Goya: *José de Vargas Ponce*, 1805. Madrid, Royal Academy of History.

and our mutual connections, so that, since the Academic barrel has to be filled, it won't just be with a hasty horror, but the way Goya can do it when he really wants.

Will you do this for me, and recommend me, so that my portrait will be as good as the ones of X and Y?[36]

At a later date it is possible to find very much stronger qualifications expressed about Goya's work, though not by Spaniards. A particularly dismissive comment came from an Italian Diplomat, Count Brunetti, in 1818. The Count was the Minister Plenipotentiary representing Tuscany and Austria in Madrid from August 1817 to April 1822, and took a patronizing interest in Spanish culture. A year after his arrival he was deploring the low standard of paintings exhibited in the San Fernando Academy. In September 1818 Brunetti picked on the 'appalling colouring' of Aparicio, and the 'French style' of Madrazo, before going on to castigate a whole school of painting—headed by Goya—which, in his view, seriously neglected proper academic standards of draughtsmanship. The sketchy and impressionistic manner criticized by Vargas Ponce is the centre point of the attack.

There is also another sect—if I may call it that—of painters here, which believes that everything should be sacrificed to effect. Thus, falling into the opposite excesses [to those of Aparicio and Madrazo], they merely sketch out a painting, taking no greater pains over heads and limbs, and think it a finished work. They call rashness, freedom; negligence they hold to be boldness. I cannot describe to you any samples of the work this school produces. Its head is a man called Goya. He has the innate ability to be a great painter (especially of scenes from ordinary life), if only he had as much taste and judgment as he has imagination. Nearly all the *dilettanti* in Madrid belong to this school. Since its guiding principles are so accommodating, it could hardly lack for proselytes. But the real trouble lies in the Academy itself, which is appallingly badly run. In my view none of the painters it produces could even remotely approach any of the great masters of previous centuries.[37]

Obviously purists could not approve of loose brushwork and sketchy effects. Lovers of fine line would never wholeheartedly admire Goya's work. But some Spaniards during Goya's lifetime, and some foreigners too, explained his technique in terms of innovation rather than inadequacy, and thought that his personal approach and vision opened up new directions in art.

The earliest references to Goya's originality, and the individual power of his imagination, date from the 1790s. At that time stylistic independence was increasingly favoured in the arts. Goya himself argued persuasively for it in a submission to the San Fernando Academy on the revision of the teaching programme in 1792. He felt stylistic freedom to be necessary for great art. Those who sought to impose a style on others created 'tyranny' and 'subjection'; those who submitted to the style of others were 'servile'. The terms reflect Goya's general concern with the liberty of the individual artist. They also reflect his awareness of the arguments advanced in seventeenth-century Spain to raise the status of painting to that of a Liberal Art from that of a craft. Goya's language is reminiscent of Francisco Pacheco's *Arte de la pintura* (finished in 1638) on these topics.[38]

In his submission to the Academy Goya holds that everything possible should be done to encourage the individual of talent to develop his own particular skills and manner. The opposition to formalized teaching and 'rules' suggests that Goya now

openly opposed the Mengsian principles to which he had been forced to subscribe earlier. The document is uniquely important for the light it throws on Goya's aesthetic position.

Academies should not be restrictive. Their only purpose should be to help those who, of their own free will, seek to study in them. They should banish the pattern of compulsion and servility which is found in schools for children, get rid of mechanical precepts and monthly prizes, and also grants in aid, which make the art of painting, which is liberal and noble, into something mean, base and effeminate. There should be no fixed periods for studying Geometry or Perspective in order to overcome the difficulties of drawing. Those who have the talent and inclination will be forced to learn these things by drawing itself when the time is right. The more advanced in drawing students are, the easier it will be for them to acquire the skills they need for other branches of art, as the examples of outstanding draughtsmen show—they are too well known to need quoting. There are no rules for Painting, as I shall prove, supporting my case with facts. To make every one study in the same way and follow the same path compulsorily, seriously impedes the development of those young people who practise this difficult art: an art which is nearer to the divine than any other, since it is concerned with everything God created. Even the artist who has achieved more than most is hard put to it to explain how he reaches that deep understanding and appreciation of things, which is necessary for great art. Even he can give very few rules, and is unable to say why his least careful work may possibly be more successful than the one on which he laboured longest. The imitation of Divine Nature is truly a deep and impenetrable mystery! Without it there is nothing good in painting (whose whole aim is Nature's exact imitation), nor in any of the other branches of learning.

Annibale Caracci revived Painting from the decadent state into which it had fallen since the time of Raphael. His generous and liberal disposition brought him more pupils, and better ones, than any other teacher there has ever been. He allowed each one to follow his own bent, not forcing anyone to accept his personal style or method, and the only corrections he made were those that rendered the representation of nature more faithful. In consequence, Guido Reni, Guercino, Andrea Sacchi, Lanfranco, Albano and others, all had styles of their own.

I cannot omit a still clearer proof of my point. How many pupils have followed the most able teachers of our own times, despite the efforts they have made to inculcate their painstaking styles. What progress has resulted from their work? What has become of their methods? What have their writings achieved other than to encourage those who are not and never will be artists to praise their work excessively? Their writings give these people authority and confidence to criticize, even when they are in the presence of real experts in the Divine Science. And this science is one that even those with innate aptitude must labour hard to master.

I cannot say how painful it is for me to watch eloquent pens writing about art with very little restraint, as they tend to do when the persons concerned are not themselves artists, and obviously lack a thorough knowledge of the subject they

are writing about. How can one not be shocked when one hears Greek statues praised above Nature herself by someone who knows nothing about either, by someone who does not realise that the smallest part of Nature is a source of awe and marvel to the *cognoscenti*? What statue or form of sculpture can there be that is not copied from Divine Nature? However great the artist who copies her, will not the work cry out when put beside Nature herself, that the one is the work of God, and the other of the feeble hands of man? Will the person who tries to forget reality and improve on it, without seeking out what is best in Nature herself, be able to avoid a reprehensible monotony in his style of painting when he bases it on plaster casts, as has happened in so many cases with which we are familiar? I seem to have strayed from the main object I had in writing, but what could be more important, if a solution is to be found for the present decline in the arts, than to point out the dangers of being too much influenced by powers and knowledge that are proper to other branches of learning, although it is right to respect them. This has always been the case when there are men of real genius about. In the face of true values blind enthusiasts cease to dominate the arts and a generation of prudent art lovers arises. These appreciate, respect and encourage outstanding artists, giving them the kind of commissions in which they can use their abilities to the full, helping them as best they can to fulfil their promise. This is the true way to protect and foster the arts, for it is always by their works that great men become great. Finally, I know of no better ways to advance the arts, nor believe there could be more satisfactory alternatives, than by rewarding and protecting the outstanding; by holding the artist who teaches in high regard; and by allowing students of art to develop their own abilities in their own way, without forcing them to go in one particular direction, and without making them adopt a particular style of painting if it is against their inclination.

I have stated my views as Your Excellency requested. If my hand does not wield the pen as I would wish to convey my understanding of this question, I trust Your Excellency will forgive me. All my life my hand has endeavoured to put my theories on this subject into practice.

Madrid, 14 October 1792.[39]

The concern for the independence of the artist expressed in this letter from Goya to the Minister of State (who was also ex-officio Protector of the San Fernando Academy), is also reflected in a letter Goya wrote to the Vice-Protector, Bernardo de Iriarte, just over a year later, on 4 January 1794. In the document just quoted, Goya makes a plea for artists in general. In the letter to Iriarte he is concerned with his own personal situation. Between the two letters Goya had been ill, and no doubt his infirmity drove him to an obsession with his own feelings. It is natural that he should have sought an emotional outlet in painting, just as poets from classical times sought it in poetry.

In order to use my imagination which has been painfully preoccupied with my illness and my misfortunes, and to offset the expenditure I have inevitably incurred, I set out to paint a group of small pictures, in which I have managed

to include observations of subjects which would not normally fall within the scope of commissioned work, in which there is no room for the inventive powers and inspiration of the imagination. I thought of sending them to the Academy, knowing, as Your Excellency does, the profitable results I might expect from the criticism of the artists there. But so as not to lose any possible advantage I have decided to send the paintings to Your Excellency first so that you can see them. Your position of authority and exceptional knowledge will ensure that they are looked at seriously and without envy. Take them, Your Excellency, and me too under your protection, for I am at present sorely in need of the favour you have always shown me.[40]

Iriarte evidently took the group of paintings to the Academy. The minutes of the corporation's meeting on 5 January refers to eleven pictures 'sent in by Goya' consisting of 'various subjects drawn from national pastimes'. The meeting was 'very pleased to see them, praising their qualities and those of Señor Goya'.[41] It is generally thought that the group must have included a set of bull-fight paintings, the *Strolling Players* (now in the Prado), a small scene of an *Attack on a Coach*, a *Fire* and a *Flood*. A second letter from Goya to Iriarte, dated 7 January, speaks of another painting in the series on which the artist was still at work: a courtyard in a madhouse (Plate 20). Iriarte himself, as well as the Academy, seems to have liked these scenes, and he was no mean connoisseur, having paintings by Murillo and Mengs in his own collection, including fine self-portraits by both these artists. The letter reads as follows:

I wish I could adequately express to Your Excellency my thanks for the many favours you have done me, and for the esteem which the professors and members of the San Fernando Academy have shown me, not only in their concern for my health, but also in their generous reaction to my works. I have been greatly encouraged, and am fired anew to fulfil my hopes of presenting works more worthy of that august body.

I am also very pleased that the pictures should remain in Your Excellency's house as long as you wish, and when I have finished the one on which I am working at present—depicting a courtyard in a madhouse, with two madmen fighting naked, while the keeper strikes them on the head and others are in their sacks (a sight I have seen in Saragossa)—I shall send it to you so that you have the whole group . . .[42]

In a third letter to Iriarte, dated 9 January, Goya asked for the paintings to be taken to the house of the Marqués de Villaverde and his daughter.[43] He may have hoped to sell them. The reaction of the *marqués* is not recorded, but it is clear that this vein of imaginative work appealed strongly to some people in court circles since the Dukes of Osuna commissioned a set of witchcraft paintings from Goya between 1795 and 1798. The witchcraft scenes in the *Caprichos* no doubt had a similar attraction, and in 1805, when Jovellanos was describing imaginary knights in a satirical poem, he wrote: 'Not even Goya could have invented them'.[44]

Further evidence of the appeal of Goya's more original and imaginative com-

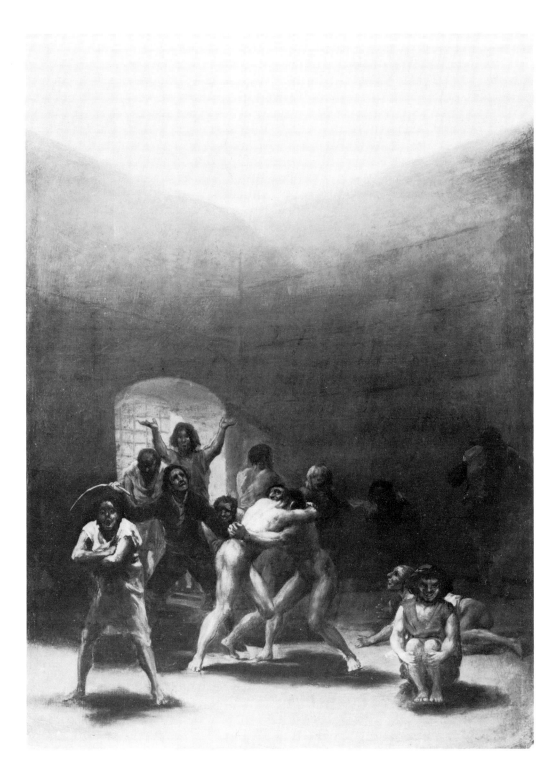

20. Goya: *Yard in a Madhouse*, 1794. Dallas, Meadows Museum, Southern Methodist University.

positions can be found at this period. The artist himself, or whoever wrote the advertisement for the *Caprichos* which was inserted in the *Diario de Madrid* in February 1799, clearly expected these qualities to be appreciated, and emphasised the originality of that series of etchings. The whole advertisement runs as follows:

A collection of prints of imaginary subjects, invented and etched by Don Francisco Goya. The author is convinced that it is as proper for painting to criticize human error and vice as for poetry and prose to do so, although criticism is usually taken to be exclusively the province of literature. He has selected from amongst the innumerable foibles and follies to be found in any civilized society, and from the common prejudices and deceitful practices which custom, ignorance or self-interest have hallowed, those subjects which he feels to be the most suitable material for satire, and which, at the same time, stimulate the artist's imagination.

Since most of the subjects depicted in this work are not real, it is not unreasonable to hope that connoisseurs will readily overlook their defects.

The author has not followed the precedents of any other artist, nor has he been able to copy Nature herself. It is very difficult to imitate Nature, and a successful imitation is worthy of admiration. He who departs entirely from Nature will surely merit high esteem, since he has to put before the eyes of the public forms and poses which have only existed previously in the darkness and confusion of an irrational mind, or one which is beset by uncontrolled passion.

The public is not so ignorant of the Fine Arts that it needs to be told that the author has intended no satire of the personal defects of any specific individual in any of his compositions. Such particularized satire imposes undue limitations on an artist's talents, and also mistakes the way in which perfection is to be achieved through imitation in art.

Painting (like poetry) chooses from universals what is most apposite. It brings together in a single imaginary being, circumstances and characteristics which occur in nature in many different persons. With such an ingeniously arranged combination of properties the artist produces a faithful likeness, but also earns the title of inventor rather than that of servile copyist.[45]

Two years after this advertisement appeared, in 1801, Goya's friend Jovellanos praised four paintings by Goya he had seen in the Saragossa area, in terms which underlined the singularity of his work, and perhaps its originality. Jovellanos speaks first of a copy of Goya's portrait of Ramón de Pignatelli in the offices of the Aragonese Canal, which somehow retained the 'inventive ability of the original'.[46] The precise term he used was 'valentía', and in a painting this would normally imply 'extraordinary skill and accuracy in the portrayal of reality'. But it could also mean 'brilliant use of the imagination applied in some novel way to a subject', and it is difficult to say which is the more appropriate interpretation in this instance. Later in the same diary Jovellanos refers to 'original paintings' by Goya in a way that is also ambiguous. Most probably he meant that the paintings were originals, not copies. Yet the other sense of 'original' cannot be ruled out since the paintings

had only recently been completed and are known to have provoked opposition.
The paintings in question were those for the Canal Chapel at Monte Torrero,
not far from Saragossa. There were three of them,★ and they were all destroyed
during the Peninsular War; only preliminary sketches survive today. The entry
in Jovellanos' diary for 7 April 1801 describes them thus:

> In the aisles there are three altars with very beautiful paintings—original
> works by Don Francisco Goya. The largest depicts St [Isidore], flying through
> the air in his papal vestments, to grant protection to King James during the
> conquest of Valencia. The monarch gazes upon him with awe, while a youth
> offers him the crown, and some of his soldiers stand around him, forming an
> admirable and harmonious group in the picture. On the gospel side, St Elizabeth
> tends a poor sick woman's sores; and on the Epistle side, St Ermengild is shown
> in prison and being put into chains. Admirable works not so much for their
> composition as for the strength of their chiaroscuro, the inimitable beauty of
> the colouring, and a certain magic of light and tinting which no other artist
> seems capable of achieving. We were sorry to leave these beautiful objects.[47]

Jovellanos clearly felt that Goya's painterly qualities were unrivalled, even if it
is not absolutely certain that he recognized his originality. A description of a painting
by Goya from much the same period which certainly picks out the latter quality
appears in a poem written by José Moreno de Tejada, a fellow artist and engraver,
who was also a member of the San Fernando Academy. Moreno de Tejada's poem
was entitled *The Excellence of the Paintbrush and the Graver* (*Excelencias del pincel y
del buril*), and was printed in Madrid in 1804. A passage from it evidently refers to
Goya's tapestry cartoon of a winter scene. Not all the details are recorded exactly
in the poem, probably because Moreno was relying on his memory. The description
occurs at a point where Moreno is discussing allegory. The normal conventions
for representing Winter, according to Moreno, required an allegorical deity, a
bearded man sleeping in a grotto, an old man by a fire, or an old woman well
wrapped in furs. Goya's *Winter* (Plate 21), which Moreno then describes, departs
from these conventions, and the poet sees the work as a reflection of the painter's
imaginative power, independence of approach, and emotional force. There is a
hint of the Sublime and the Picturesque in the passage too. These theories were
much discussed at the time and germain to the revaluation of the artist's imagination:

> A Spanish artist, famed among his kind,
> Painted a winter scene capriciously,
> Whose subtle colours captured perfectly
> The marvellous invention of his mind.

★ Local sensibilities were offended (for the second time in Saragossa) by a bare bosom in one of
the canvases: that of the sick woman being tended by St Elizabeth of Hungary. Goya had to
paint over the lady's uncovered breasts before the Vicar General of Huesca could bless the chapel
at the opening. It is not clear whether Jovellanos saw the paintings before their benediction or not.
(Cf. E. Pardo Canalís, 'La iglesia zaragozana de San Fernando y las pinturas de Goya', *Goya*,
No. 84, Madrid, 1968, 360.)

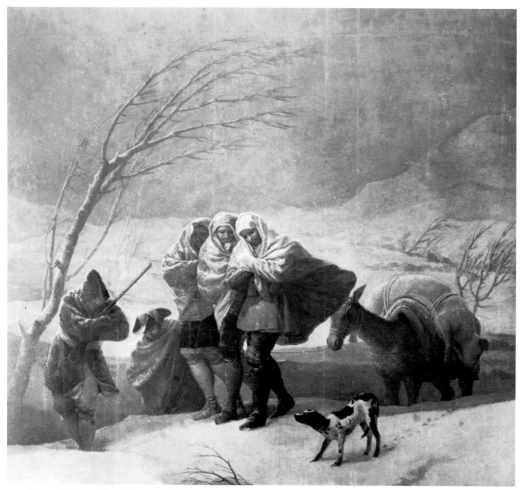

21. Goya: *Winter* (or *The Snowfall*), 1786–7. Madrid, Prado.

No beast nor bird in this bleak scene we find.
The mountain thickets make the landscape drear.
A deathly solitude fills all with fear,
And yet the painting leaves delight behind,
Because the upper atmosphere and sky
Are joined to earth by snowflakes from on high.
 Three rustics walk together, close aligned,
With homespun cloak to cover up the face,
Hurrying forward at a pressing pace,
And huddling together against the wind.
These are the painting's subject which we see,
And constitute its singularity.[48]

Other poets, and rather better poets than Moreno de Tejada, also wrote about Goya's imagination. The first of any note was an Aragonese acquaintance of the artist, José Mor de Fuentes, best known as the author of a novel in epistolary

form, *La Serafina*, in the manner of Rousseau and Richardson. The poem he dedicated
to Goya was originally published in a Saragossa periodical, the *Semanario de Zaragoza*,
on 25 February 1799. Its title was 'The Kinship of Painting and Poetry' ('Hermandad
de la pintura y la poesía')—a subject which interested Goya himself as his advertise-
ment for the *Caprichos* shows. The central topic of the poem, in fact, seems a direct
response to the sentiments expressed in Goya's announcement. It can hardly have
been chance that the poem was published just nineteen days after the advertisement
for the *Caprichos* appeared in the *Diario de Madrid*.

In his poem, Mor de Fuentes alludes to the rich sensory descriptions of Thomson
and Gessner which correspond to the Picturesque in painting, and he finds Goya's
work exceptional in a period bedevilled by ignorance and corruption in life and
art. In other times, art had reflected 'the passionate heart bursting with human
feeling; the vast imagination [and] all the sublime qualities of inspiration'.[49] In
his own, only Goya seemed to have emotional depths and an adequate ideal of
beauty. The pictures he describes Goya painting may well be generalized examples
of the picturesque rather than real works by the artist. But the beginning of
the passage quoted could relate to the painting of *Hannibal crossing the Alps*,
which Goya submitted to the Parma Academy's competition in 1771; there could
conceivably be references to some of the cabinet pictures and portraits of the
1790s; and the end of the section seems palpably to refer to the *Caprichos*. The
poem also contains allusions to Goya's handling of light, couched in terms that
recall descriptions of Velázquez's naturalistic skills. The emotional power of
Goya's work, however, is the most striking concern of the poet:

> Unrivalled Goya, when I see you paint the rugged Alps, or the dark, dank
> depths of an impenetrable forest; or the tranquil greenery of a garden; or when
> I see you depict the sea, whether flat and calm, or raging in a fearful storm
> around a boat while lightning leaps from the implacable sky through a rent
> in the clouds; when I see you capture the spirit which shines from the warlike
> features of a victorious general's face; or paint the wondrous whiteness of a
> beautiful woman showing through a muslin or transparent dress; or when I
> see you mocking foolish pride in comic vein; heightening the vagueness of the
> atmosphere, and capturing the light which gives things life with brushstrokes
> brimming with colour, beauty, magic . . . Oh, then do I yearn to reach the
> same ineffable heights of ideal excellence as you! Would I could fittingly sing
> the Elysean delight of genuine love, the deeds of an incomparable hero, and the
> noble distinction of true learning! Would that I could—mocking in humorous
> vein low and capricious morals, delighting the human heart with pleasing
> variety—free man's heart from the tyranny of blind ignorance and infamous
> vice, and endue it with the glories of the soul![50]

A poem with some similar points to make about Goya was written by Manuel
Quintana some five years later. Given that Quintana was particularly interested
in theories of the sublime and was also a liberal in politics, it is hardly surprising
that he should have found the audacity and fire of Goya's work especially admirable.

Quintana would have met Goya in the Duchess of Alba's palace at Piedrahita, and both the poet and the artist drew or described the Duchess's young negro protégée. They would also presumably have coincided in Madrid at the San Fernando Academy. Quintana had written an ode for one of the Academy's prizegivings and may have studied there in 1787; he was certainly a member in the early nineteenth century. He wrote a poem addressed to Goya to send with a copy of a collection of his poems to the artist. The edition was probably that of 1802, and the poem was most likely written late in 1805 or in 1806, since it has one line and a number of phrases in common with Quintana's poem on the Battle of Trafalgar ('Al combate de Trafalgar'). The central portion alone is quoted here, in a prose translation. Quintana is speaking of the way the English buy up Italian art, and he goes on to suggest that they would do well to turn to Spain:

> The swimming prows of British ships shatter the breast of the angry sea, conquering wind and waves. And the world rewards their pains by paying art in tribute to the Thames. But this alone will not suffice to light the sacred Torch of Art in England's clime. For art has fled her fog-bound shores in fright, vowing never to return. Already the barbarous Briton often hies to worship at great Raphael's happier shrine, beneath Italian skies. Yet the day will come when the foreigner will bow in ecstasy at the sound of your name too, oh Goya! I swear to you he will. The marvellous boldness of your fiery brush, the dash, the stroke that brims with beauty, gentle grace, the brilliant and the magic harmony with which the colours of light, dawn, the East, triumph superbly in your subtle tints: these promise Eternity. Oh foreigner, leaving your paternal hearth and home, breasting the waves to see and to admire, bend your steps hither in haste and come to Spain. Two centuries of ignorance have not quite doused the flame of heavenly fire that blazed in Murillo and Velázquez. See, with the selfsame flame, Nature bedecks the brow of Goya too, and feels once more surprise at all his daring and his enterprise.[51]

Quintana's advice to foreigners was soon taken. Count Brunetti's scorn seems to have been untypical. Others not only bought Goya's prints and pictures—as did the Duke of Wellington, and, in the 1830s, the Earl of Clarendon—but also put pen to paper to express their admiration for his original technique and lively fantasy. A foreign comment that was as warm as any Spaniard's came from the Swedish envoy in Madrid after Ferdinand vii's restoration, Count Jacob Gustaf de la Gardie (1768–1842). The latter was a distinguished soldier and diplomat from a prominent Swedish family of French origin. He was also a person of both creative ability and taste, who had a four-act play published (under an alias) in 1795 and who produced the Swedish translation of the first part of Haydn's *Creation* when in Vienna in 1800. Although he was only in Spain for a year (August 1814 to September 1815) he evidently made his cultural interests felt, and later became, at the same time as Robert Southey, an honorary member of the Spanish Royal Academy. He was quick to appreciate Goya's bold imagination and skill as a caricaturist. He had bought a copy of the *Caprichos* by 21 January 1815, only six

months after his arrival in Madrid, and paid a visit to Goya's studio on 2 July that year. Afterwards he committed some observations about Goya's technique and temperament to his diary:

> Goya ... was not at home, but we were nevertheless able to see his studio as well as his collection of paintings, nearly all of them by his own hand. His particular style is exceedingly similar to that of our skilful and much lamented Desprez.★ The imagination equally lively, the execution equally bold and peculiar—several paintings were done without using a brush, only with his fingers or the spattle. His caricatures are outstanding—La Marquise d'Arizza of the greatest likeness ... Goya, who is almost deaf, is threatened by blindness as well, which does not, however, affect his satirical vein. He is living in straightened circumstances, and this is also attributable to his curious state of mind and caprices. One day he suddenly got the idea of writing a letter giving away his whole fortune, which was considerable, to his son and daughter-in-law.[52]

Between the favourable response of some foreigners and Spaniards and the critical views of others it was obviously possible to strike a balance, and several writers did so. One of the earliest was the anonymous editor of works by a minor Aragonese poet, Father Basilio Boggiero, who drew a lively parallel between Goya and that writer in 1817, a year before Brunetti's attack on the artist and his school. This editor spoke enthusiastically of the skill, imagination and originality of Goya and Boggiero, but noted in passing (rather like Vargas Ponce a few years previously) their occasional hastiness and unwillingness to polish their productions: 'Boggiero with the pen is like the famous Goya with his brush. Inventiveness, imagination, stylishness, novelty, singularity and that unknown quantity that makes original artists unique: this is what we find in the writings of the former and the paintings of the latter. Goya and Boggiero are also much alike in their impatience or inertia, their unwillingness to polish their works.'[53]

But the most delicately balanced references to Goya's work at this period come from one of the people who knew him best: the art historian Ceán Bermúdez. Ceán held certain minor government appointments but his real interest lay in the theory and practice of art. Ceán himself described art as his 'insatiable passion'.[54] Unfortunately, he held rather rigidly to the neoclassical principles of the period, translated the Italian Milizia, and idolized Mengs. So he found it difficult to stomach art which did not result from years of training and patient study, or was not kept under tight control and imbued with a proper reverence for classical antiquity.[55]

Ceán was ambiguous in his approach to originality in Goya and everyone else. Sometimes he equated originality with ignorance, and he was patronizing about

★ It was not unnatural that de la Gardie should compare Goya's work to that of Louis-Jean Desprez (1743–1804): a French painter who had died in Stockholm, having been invited to the Swedish capital by the King of Sweden who had met him in Italy. No doubt de la Gardie recalled Desprez's paintings of battles from the war between Sweden and Russia, his caricatures and scenes from ordinary life, when he saw Goya's pictures on similar themes. Desprez's religious interiors, views of castles and picturesque subjects in general (reflecting his architectural training), would have been less comparable.

Rembrandt, as Mengs had been too. Although that artist 'certainly had great ability', and was a 'living proof of the lengths to which genius can go when not bound by the rules of art', he had not known the higher beauties of antiquity, so ended up by being some kind of extraordinarily gifted country bumpkin.[56] At other times Ceán pushed originality impatiently on one side, as was the case with El Greco. He approved of the more academic side of El Greco—his 'knowledge, mastery and freedom'—but disliked his individualistic approach to colour, his angular lines and exaggeration: everything, in fact, that was a departure from nature.[57]

Goya aroused in Ceán alternately wonder and dismay. He praised anything which suggested that Goya took pains and thought about what he was doing, since that made him a 'philosopher artist'—an intellectual and rational person—and not just a man of raw sensibility or instinctive skill. The hours Goya spent poring over a bas-relief by Torrigiani in Seville are noted down for posterity, as a good example for the impatient art student.[58] The etchings after Velázquez, which revealed Goya's deep knowledge of a recognised master and proved that he could copy accurately, are unreservedly admired. Perhaps for the same reason, in his little known and only partially published *History of Painting*, Ceán explains how he had given Goya a number of Rembrandt etchings 'when he was engaged in engraving his admirable *Caprichos*'.[59] What great artist can afford to be without models or precedents! On several occasions he speaks of Goya's powers of concentration when faced with an artistic problem, attributing his ability to his deafness. 'The deaf and dumb are usually notable painters', he remarked *à propos* of Quinto Pedio, 'and our own Goya, whom God preserve for the glory of Spanish painting, was not particularly outstanding until he lost his hearing'.[60]

When Ceán catches Goya throwing his academic principles overboard he is quick to admonish him. However good the results, painting with the fingers or in some other unorthodox fashion is not to be recommended. In a foot-note to a passage about a French artist who used his fingers—Bon Boullonge—he gives us the following exemplary anecdote: 'I have seen my friend Don Francisco Goya paint with his fingers and with the point of a knife, and although he obtained a good effect I told him frankly what Michelangelo said when he saw a panel painting in the Santa Scala in Rome which Ugo da Carpi had painted with his fingers: "It would have been better if he had painted it with brushes".'[61] It is not surprising that when Ceán came to sum up his opinion of his friend in his *History of Art* he gave rather more space to his skill than to his independent personality:

> Goya, Bayeu's brother-in-law, is still alive and in his eighties. He is the first Painter to our sovereign Lord King Ferdinand VII, an original artist of remarkable temperament and imagination, and exceptional for his skill in handling colour, and his use of brush, burin, aquafort and, recently, lithography. He seeks his effects in everyday things in nature and produces an inimitable sense of illusion, suspense and truth to life.[62]

In private Ceán must have had many aesthetic tussles with Goya, and fortunately

one such argument is documented in a letter from Ceán about Goya's painting of
St Justa and St Rufina (Plate 22) for Seville Cathedral. Ceán himself seems to have
been responsible for the commission by the Chapter, and he wanted to make sure
that Goya produced an acceptable piece of work. The difficulties he encountered
are graphically related to Tomás de Verí in a letter from Seville dated 27 September
1817:

> At the moment I am busy trying to instil into Goya the requisite decorum,
> humility and devotion, together with a suitably respectable subject, simple yet
> appropriate composition and religious ideas, for a large painting that the Chapter
> of Seville Cathedral has asked me to obtain for their church. Since Goya has
> been with me to look at the fine paintings that already hang in that beautiful
> building, he has been working on his own picture with a proper sense of re-
> sponsibility. It will have to hold its own beside all these other great works,
> and Goya's rank and quality as an artist will be judged by the result. The subject
> is the two Holy Martyrs: Justa and Rufina.
>
> The Chapter, although it left all the details to me, wanted the painting to
> represent the act of martyrdom itself or some other historic occasion in the lives
> of these saints. But I decided that it would be more appropriate to depict the
> two saints on their own, full length, since the canvas is to fill a space above the
> altar three yards high by two wide, which is not big enough for a historical
> painting. In any case, a painting with a large number of figures might distract
> the attention of the priest celebrating Mass (since it will not be hung very high
> up), and the congregation too. The tender postures and virtuous expressions of
> the saints must move people to worship them and pray to them, since this is
> the proper object of such paintings.
>
> You know Goya and will realise the efforts I have had to make to instil ideas
> into him which are so obviously against his grain. I gave him written instructions
> on how to paint the picture, and made him prepare three or four preliminary
> sketches. Now at last he is roughing out the full size painting itself, and I trust
> it will turn out as I want. If I am successful it will be entirely worthy of a place
> beside the others in the cathedral.[63]

On the whole it looks as if Goya followed Ceán's suggestions, since the latter
was delighted with the finished work. In a letter to Verí on 14 January 1818, he
wrote:

> The painting turned out marvellously well, and is the best work that Goya
> has ever done, or will do in the future come to that. It is already hanging in its
> place and the Chapter and the whole city are wild with joy at having the best
> picture to be painted in Europe so far this century and superior to any earlier
> work, according to Señor Saavedra, who is living in Seville at present. Its author
> is happy too. The Chapter paid him 28,000 *reales* for it.[64]

At the time Ceán Bermúdez wrote this letter he had already contributed to the

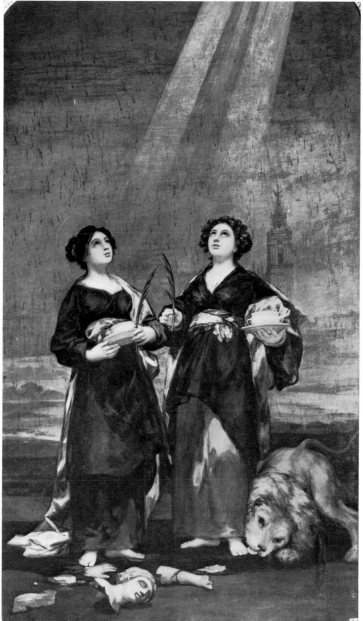

22. Goya: *St Justa and St Rufina*, 1817. Seville Cathedral.

work's success himself, by writing an article about it for a Madrid periodical. In the light of the correspondence with Verí we can see that there is an element of self-congratulation in Ceán's essay which was first printed on 9 December 1817. Posterity has not shared Ceán's commitment to the painting, and has often taken it to show Goya's lack of ability or vocation for religious subjects. Some have even thought it cynical. Yet Delacroix looked at it carefully one morning in 1832, and Gautier thought it a picture of great merit.[65] In 1916 Margarita Nelken held it to be 'one of the most beautiful paintings there are'.[66]

Ceán's article, which was praised as widely as the painting by people in Seville, develops at length his idea of Goya's originality and the philosophical character of his work.[67] It is the longest essay on the artist to be published in his lifetime and is quoted in full in an appendix. It certainly touches many of the points to which subsequent criticism has returned. Apart from considering Goya's brushwork and the handling of the palette, Ceán also presents us with an artist who shares the ideas of the Enlightenment and views religion primarily in human terms, shunning myth, sticking to historical fact, playing down the supernatural and avoiding angels. Ceán's obsession with verisimilitude and the studious approach is very much of his time, and perhaps a truer reflection of his own personality than of Goya's. But the range and detail of the article are exceptional in the artist's lifetime, and certainly the essay fulfils a major function of criticism at any period—to make us look at the painting again.

An aspect of Goya on which Ceán throws no light at all is the artist's politics. Naturally one would not expect him to do so in an article on a religious painting, and he could hardly have referred to liberal views (if Goya had had them) in his *History of Painting*, since this work was written during Ferdinand VII's second period of absolute rule, after the constitutional interlude from 1820 to 1823. Much of the *History* was in fact written during the difficult period of transition from constitutional to absolutist rule, when the French intervened, riots took place, and there was some particularly fierce repression under Calomarde as Minister of Justice. Ceán refers to those years as 'the most agitated and dangerous period the kingdom has known'. He was in his seventies, and his main aim was 'to keep away from riots'.[68] Perhaps he was never as deeply involved in politics as some of Goya's other friends.

In fairness to Ceán Bermúdez, it must be said that Goya's social and political views were, in any case, difficult to tie down. He was circumspect and rarely explicit in expressing radical opinions. His drawings are more plainly outspoken than any of his published work, and some of the more specific references in the etchings were expunged before editions were made from the plates. Ceán must have been one of the few acquaintances of the artist who knew about all this, but no doubt he felt the same inhibitions as Goya himself about publishing such material.

The *Caprichos* (1799) was the first work of Goya's to provoke some kind of political response, and an interesting cross-section of views has come down to us about it. Many of the comments are directed to the style of the work rather than its content, and when Ceán Bermúdez tells us that his contemporaries laughed at Goya's work, he fails to tell us why.[69] The caricaturesque manner, and the flights of imagination are referred to on several occasions. When the Osuna family's administrator, Manuel Ascargorta, first donned the uniform to which he was entitled as a member of the Company of Well-born Gentlemen of Madrid (Caballeros hijosdalgo) in 1799, he thought that the red coat with its gold braid and other adornments, together with his own 'white hair, winking mouth and liberally pock-marked skin' were good enough 'to add to the collection of the *Caprichos* of Goya'.[70] Jovellanos, six years later, in a satirical poem, underlined the extravagant

appearance of ghostly knights in armour, by saying that 'not even Goya could have invented them'.[71] Later still Vargas Ponce, in a poem mocking the female pursuit of bachelors like himself, suggested that exaggerated attacks of the vapours (powerful weapons in the armoury of the fair sex) were beyond even Goya's powers of imagination.[72] And in 1834, Mariano José Larra, describing a rickety carriage, with a scrawny horse and equally scrawny driver, wrote that 'when the coach moved it was a miracle, and when it stopped, a *Capricho* by Goya'.[73]

Fortunately at least one general article on the *Caprichos* appeared in Goya's lifetime, and this had something, though not very much, to say about the subject matter. The article in question was written by a scientist and not an art historian: Gregorio González Azaola.[74] Azaola, like Goya, was on the palace pay-roll, since he had a post as chemistry professor to the royal pages. Presumably he knew the artist personally. Certainly he was a friend of a friend of Goya's, the French professor to the pages, Bartolomé José Gallardo, with whom he is said to have been associated in a witty satirical work in 1821: the *Condiciones y semblanzas de los señores diputados a Cortes en la legislatura de 1820–21* (Madrid and Gibraltar, 1821). González Azaola clearly combined a sense of humour with an equiring mind, and he believed in using his scientific knowledge for the benefit of his country. He translated one of the most modern general books on chemistry and its use in relation to the crafts (A. F. Fourcroy's *Système des connaissances chimiques*, 1801); invented a double-barrelled mortar during the Peninsular War; and accepted a commission from the Spanish Government to study iron smelting in England and Belgium in 1828–9. Other contributions to the welfare of his people were his papers on grape sugar and the conservation of vines in 1807 and 1808, and his involvement in a plan to make the Guadalquivir river navigable from Córdoba to the sea (protecting the Seville area from floods and creating new towns) in 1814. But it was his interest in the religious and political ideas of the Enlightenment that must have brought him close to many of Goya's friends. He translated Pope's *Essay on Man* into Spanish, and sought to publish a version of the *Discourse* by the French lawyer J. E. M. Portalis on the convention between the French Republican Government and Pope Pius VII in 1802.[75] In this instance González Azaola's work fell foul of the censors since Portalis, while recognising the social utility of religious belief and the power of catholicism in France, cast doubts on papal infallibility, positively encouraged freedom of conscience and worship, and saw no need for religious orders whatsoever. Such topics may have disturbed the censor, but, at the same time, they explain why some of Goya's *Caprichos* would have appealed to Azaola. He was also a liberal in politics and a member of the Spanish parliament during the constitutional period from 1820. So Goya's digs at the Spanish court may well have attracted him too.

Azaola's article on the *Caprichos* was published in the *Semanario patriótico* in Cadiz on 27 March 1811, and in part acted as an advertisement for copies of the work which were then on sale in the city. The time and the place is significant, for only during the period of the Cortes of Cadiz, in the Peninsular War, and after the death of Ferdinand VII, do a few of Goya's contemporaries appear to have felt

able to refer openly to the social and political aspects of his work. The editor of the *Semanario* made a few cuts in Azaola's piece, according to a note, but we quote all that was published:

Satires By Goya

All those who love the Fine Arts know of the celebrated painter Don Francisco de Goya y Lucientes. Many will have admired his fine frescoed ceilings, his Venuses and his portraits. But not everyone knows his masterpiece of drawing and engraving: the famous satirical prints which are called the *Caprichos of Goya*. The majority of ordinary people who have seen them take them to be merely absurd extravaganzas of their author. But those who have more intelligence naturally realize that each and every one of them contains some enigmatic meaning. In fact, this collection of eighty prints with more than four hundred figures of all kinds in it, is no more and no less than a didactic work of eighty engraved moral poems, or a satirical treatise on eighty of the prejudices and vices that most afflict society. All the vices are perceptively ridiculed in this extraordinary work—from those of the highest level of society down to those of the criminal classes. Misers, lechers, blustering cowards, ignorant doctors, skittish old ladies, dirty old men, layabouts and laggards, prostitutes and hypocrites, in short, all manner of fools, idlers and picaroons are so skilfully portrayed in the work that they give much food for thought to the reader, as he works out the subtle ideas underlying each satire, and in his own way and according to his own lights, finds more or less appropriate interpretations.

What more relevant satire could there be than No. 49, about the *Duendecitos* (Little Ghosts)! What truer or sadder picture of the effects of bad education than No. 72, in which we see vile men chasing and dishonouring a beautiful girl— one who seemed destined to be the delight of some family circle! What more fearful lesson than No. 59, in which a group of vicious people watches a tombstone of death in the act of falling upon them, as a result of their excesses. And yet no one mends their ways! But what is the point of picking out this plate or that when, if one has seen them all, and studied them hundreds of times, one still finds it impossible to choose a favourite? Their subtlety is such that even the sharpest minds do not perceive the whole of their moral point at the first perusal. Less perceptive persons need time and help to understand them at all. If I am not mistaken it is the most suitable work to sharpen the minds of the young, and an appropriate touchstone by which to judge the percipience and intellectual agility of all kinds of people.

. I feel that no other nation has a work of moral satire of this kind, or of comparable quality. Giordano's facility with the brush, or Ribera's anatomical knowledge, would not enable one to excel in this genre or compose eighty satires like these. One must have been born with an unusual mind, have had a wide experience of life, and have plumbed the depths of the human heart. Goya might have painted eight hundred portraits in the time he took to imagine and engrave this inestimable collection. Hence the unusually favourable reception which he received from the *cognoscenti* of both Spain and abroad. From the

ambassadors down to artists and travellers there is no recent arrival in Madrid who has not tried to meet Goya and obtain a copy of this work. All praise to Goya, who is an honour to his nation! . . .

Many different uses could be made of this wonderful collection of prints. For beginners who wished to study Art, it could provide a superb introduction to drawing, since it contains a selection of ordinary human figures that are difficult to copy, and many distorted forms. There are more than four hundred figures of men and animals in the work, executed with Goya's unrivalled facility and wit.

Painters and engravers will find it a veritable text-book of their professions, given its infinite variety of heads, unusual situations, well-drawn dress, original faces, emotional expression and anatomical knowledge. Who else has engraved anything like this for mastery and dash? Who can rival Goya for audacity? Who has made better use of chiaroscuro?

Poets and men of letters will find in each satire a rich mine of ideas, to stimulate their minds and spark off an infinite number of moral reflections. Since it keeps alive and before their eyes the chief springs of human action, it can help them to maintain the level of inspiration they need for their own writings.

Finally, and most valuable of all, these satirical engravings reveal our vices in all their hideousness, and fustigate our errors as they deserve. From them we can learn to suppress the former and avoid the disastrous consequences of the latter. What greater use could there be in this veritable comedy of human existence?[76]

Both the intellectual and artistic qualities of Goya's work excite González Azaola; so does the force of the artist's imagination. In seeing the *Caprichos* as a collection of 'moral poems', Azaola follows the artist himself, who claimed in his advertisement for the work that he wished to do in art what had long been common in poetry and prose.[77] Azaola follows the artist again when he picks out the broad range of the social satire—Goya himself had spoken of the 'extravagances and errors which are common in the whole of society'—and sees the vices clearly in their social context. The enthusiasm he expresses for the didactic or educational value of the work could be a reflection of neoclassic principles, and it is interesting to note that the first *Capricho* he cites (No. 49) is an anticlerical one, very much in the spirit of the Enlightenment. But the political points he draws from the work are general rather than particular. He speaks of No. 72, for instance, as a satire on lack of education, rather than on the immorality of Godoy, which was a possible interpretation according to some commentaries of the period. So presumably he accepted the statements on this point made by the original advertisement for the *Caprichos*, and agreed with his friend Gallardo when he wrote in the *Mercure de France* in February 1817, that 'ephemeral political events, and the ridicule of this individual or that, are beneath Goya, who has sought to give a course of instruction in universal morality'.[78]

At odds with these views are some of the manuscript 'explanations' of the

Caprichos that circulated with early copies of the work. The commentary of which two copies survive in Goya's handwriting (one in the Prado, the other formerly in the possession of the Duke of Wellington) is very general in the moral points it makes. Two other manuscript commentaries, on the other hand, emphasise anti-clerical elements and find a number of allusions to leading Spanish personalities in the plates. Some of Goya's contemporaries clearly thought that satire of a specific nature was intended in the *Caprichos*. According to one commentary, for instance, No. 5 ('Tal para cual'), was 'María Luisa and Godoy'; No. 27 ('Quién más rendido?'), the Duchess of Alba and Goya; and No. 55 ('Hasta la muerte'), the Dowager Duchess of Osuna.[79] That these commentaries were taken seriously in Goya's lifetime is plain from more than one source. It is particularly noteworthy that one of the more specific commentaries is quoted in a discussion of two plates which refer ambiguously to the Inquisition in a book by Antonio Puigblanch, first published in Cadiz under the pseudonym Nataniel Jomtob in 1811. In a footnote to a passage which describes the financial advantages which Inquisitors, Kings and the Papal Curia derived from religious persecution, Puigblanch writes as follows:

> In the famous collection of satirical engravings by Don Francisco Goya y Lucientes, painter to Charles IV, known as the *Caprichos*, two are intended to attack the Inquisition. In the first of these, No. 23, which represents a minor Inquisitorial trial, the author reprehends the greed of the Inquisitors in the following manner. He depicts the accused sitting on a step or small bench on top of a platform wearing the scapulary and pointed hat put on by those who were tried by the Inquisition. His crossed hands and the position of his head resting on his chest are a sign of his sense of shame. The secretary reads out the sentence from a pulpit in the presence of a large gathering of ecclesiastics, and the caption at the bottom of the plate reads: 'Aquellos polvos' ('That dust'). The second half of the proverb from which this is taken needs to be added, namely, 'traxeron estos lodos' ('brought this mud'). The manuscript explanation which is available is in the following terms: 'The minor trials of the Inquisition are minor harvests, and the diversion of a certain class of people'. From this it is plain that the caption refers not to the accused, as at first sight appears to be the case, but to the Tribunal of the Inquisition itself.
>
> The second of the two plates, No. 24, represents a woman condemned to be whipped as a witch, riding on an ass, and stripped from the waist up, wearing the scapulary which the Inquisition requires, surrounded by the forces of law and order, and followed by the populace. The caption is: 'No hubo remedio' ('There was no alternative'). The manuscript explanation reads: 'Era pobre y fea; no hubo remedio' ('She was poor and ugly; there was no alternative'). We have already seen in the previous section that ugliness and a poor appearance were taken as infallible signs of witchcraft by the Inquisition. Goya's work, despite the veil which the author drew over his subjects, using caricature and making vague or indirect comments in the captions, was denounced to the Inquisition. The plates were not lost, however, since Señor Goya immediately

offered them to the king, who ordered them to be placed in the Chalcographic Institute.[80]

Puigblanch's view makes it clear that the artist's contemporaries thought that Goya's *Caprichos* were critical of one establishment institution at least: the Inquisition. The Holy Office itself took the innuendo seriously, and obviously Goya felt that there was danger from that quarter. An authority on the Inquisition in Spain, one of Goya's sitters Juan Antonio Llorente, later expressed his belief when in exile in France, that there was a wider attack on religious orders in the *Caprichos*, in plates like No. 52 ('Lo que puede un sastre'), which he read as a satire on 'monks who fake miracles'.[81] But what of the possible satires on Godoy, Charles IV's favourite, and on the Queen herself, which are also explicitly referred to in the manuscript commentary which Puigblanch quoted? It is by no means improbable that Goya meant to imply these too. Godoy, in his *Memoirs*, it is true, expressed considerable satisifaction at the publication of the *Caprichos*.[82]* Yet behind Godoy's back Goya's attitude might well have been antagonistic.

Some foreigners certainly believed that Goya's satire on Godoy and María Luisa was blatant. Count Joseph de Maistre reacted strongly against the *Caprichos* in January 1808 for its anti-establishment overtones and apparent attacks on the Queen. De Maistre, who favoured change within the monarchical system, and who defended the utility of the Spanish Inquisition in 1815, could hardly be expected to approve of anything which smacked of revolution.[83] And it was natural enough to assume that there were attacks on María Luisa and Godoy in a work which he believed to have been published in 1807, when the confrontation between Prince Ferdinand's party and the reigning monarchs and their favourite was rapidly developing. Writing from Moscow to the Chevalier de Rossi, de Maistre speaks of the *Caprichos* in the following terms:

A book of English-style caricatures on Spanish subjects has passed through my hands out here. It was published in Madrid about a year ago. There are eighty plates in all. One ridicules the Queen in the most forceful manner possible, and the allegory is so transparent that even a child could see it. In one of them a wall is falling, with a number of men underneath it, who are trying to hold it up by main force. At the bottom of the engraving the caption reads: 'And these madmen will not leave' (Plate 24). A third plate shows a tree-trunk clothed in a monk's habit. The sleeves have been slipped over two uncut branches simulating arms. The hood is pulled over the top of the trunk, and a group of good folk raise their clasped hands to this fine little god in an attitude of fervent prayer. At the bottom is the epigraph, 'This is what a tailor is like'. We might add, 'This is what Spain is like', where compliments of the sort are paid by Goya, who is painter to the king, and whose portrait has been placed at the front of the work.[84]

*Goya certainly accepted his protection, and even painted a portrait of him in 1805 with a particularly flattering inscription, referring to his title as Prince of the Peace: 'Por amor del bien amo la paz, pero no admito ley que sea en ofensa de mi rey' ('Out of love for the general good I love peace; but I accept no law which can give offence to my king'). (Cf. BAE, lxxxix, 83, Note 82.)

Other foreigners, less enamoured of the institutions of church and state, took more delight in satire at the expense of the Spanish court. An anonymous Frenchman who was in Spain during the reign of Charles IV is a case in point. He wrote down his impressions of the scope of the *Caprichos* shortly after it was first published in a document whose authenticity has not been seriously challenged, and which is very close in spirit to the more particularised Spanish commentaries on the work. These French interpretations were discovered in a copy of the *Caprichos* by the nineteenth-century French scholar Lefort, and published by him in his book on Goya in 1877.[85] The present whereabouts of the manuscript are unknown. Assuming that the manuscript is genuine it must have been written sometime between 1802 (the Duchess of Alba's death) and 1808 (the abdication of Charles IV) to judge by the references in the work.[86] Information given in the manuscript certainly supports the view that its text was written by somebody who knew Spain at first hand. It runs as follows:

Goya has been making caricatures for more than twenty years. A sort of malicious exuberance in him and the nature of his talent as a painter combine to make him completely suited to this kind of work. He must have had a firm inclination from a very early age to use his pencils to mock the ridiculous and exaggerated side of the manners and customs of his people, like Hogarth formerly and now Bunbury in England. Nobody has studied these manners more carefully, nor knows them better than he.

There must be a great many of these caricatures, and it is evident that Goya has not published them all, since several pieces which he produced for the Duchess of Alba in the past (whose friend he was, as well as being in her employ) are not included among his etchings. Doubtless the high rank of the personages involved and the nature of the scenes represented prevented him from engraving them. Nevertheless, Goya cannot be accused of being lacking in courage, since in the collection he has published there is a fairly large number of scenes which seem to make specific allusions, and which can only refer to the highest persons in Spanish society, and well-known episodes in the anecdotal history of the present reign.

Plate 19, for instance, in which women are shown busy plucking the feathers from small persons who fly up into the air only to fall back to earth immediately, what else can it allude to but the long succession of lovers which the Queen has taken from the time of Don Juan Pignatelli (if not before him) down to the Prince of the Peace, all of whom have drawn ridicule upon themselves as a result of the scandalous nature of their vain follies. The disgrace of these numerous favourites is more particularly depicted in Plate 20, and it seems obvious that the four plates which follow, in one of which an *autillo* (or trial before the Inquisition) can be seen, allude to the revenge which the princess took on more than one occasion on the women who aroused her jealousy.

Plate 36 would seem to recall the Queen's jollifications on frequently stormy nights. There was a fairly reliable rumour in the past that the princess had re-

turned home on more than one occasion with her clothes in complete disorder, giving rise to all kinds of conjectures.

It is plain that Plate 37 can only refer to the Prince of the Peace when he first came into favour. Presumably acquiring then the role he certainly played later, his political education was entrusted to Acuña, now archbishop of Santiago, and immediately afterwards to Barradas and to Mollinedo. The latter had grown old in the Department of Foreign Affairs, and his long service was supposed to have made him very knowledgeable. He must have been rather surprised to be asked to teach a subject he had certainly never known.

Godoy's education did not last long, and the basest flattery soon took its place, which is the subject of Plate 38. In the following plate, Goya has made fun of the long and absurd genealogical tree which was prepared for the Prince of the Peace, making him out to be a descendant of the ancient Gothic Kings of Spain, connected who knows by what marriages, to the reigning family.

'It is obvious', said the king à propos this subject, 'that Godoy is very close to us.' 'I've known it for a long time', said the Queen, who was present.

Galinsoya, the Prince of the Peace's doctor, and Carnicero his painter, are probably the persons Goya had in mind in Plates 40 and 41. In No. 43, it can be assumed that he wanted to show the two kingdoms of Castile and Aragon groaning under the weight of the royal favourite and his protégés.

The Count Palatine in Plate 33 seems to me to be Urquijo. He is identifiable by his general air, his charlatan's dress and the various drugs which surround him. These symbolize his diplomatic trickery. He is pulling out teeth—probably the ones which are quite all right—and this is another characteristic trait of this former minister, who set out to do everything as violently, noisily and intemperately as possible. No. 56 may well refer to the same person. He is shown in circus costume, momentarily lifted up in the arms of folly, and hurling his little bolts at all around him.

The eternal coquetry of the last Countess of Benavente, mother of the Duchess of Osuna, is the subject of Plate 55. In No. 29, Goya may have intended to ridicule the Marquis of Revillagigedo, or perhaps the Duke of Parque, who was believed in Madrid to read to improve his mind while his valet dressed his hair. As a result of this method of study the Duke acquired a considerable store of knowledge from which the Spanish government has sought to profit on more than one occasion, by sending him on diplomatic missions.

It is not clear which military gentleman is referred to in No. 76 unless it be Don Thomas Morla, lieutenant general in the artillery and at present governor of Andalusia. The insignificant loquaciousness expressed by the four or five words at the bottom of the plate, and the air of complete vacuity in those around him, fit perfectly the character and circumstances of this protégé of the Prince of the Peace.

So much for the personal allusions in this series of caricatures. In the other plates, Goya seems to have wished to depict in general terms a large number of common failings and all the kinds of political abuse which have so far been

found in his country. The veil of allegory hardly conceals the author's intentions in these cases, and they are obvious almost at a glance.

In Plate 52, the masses kneel before a tree-trunk dressed in something like a monk's habit, with the words 'What cannot the tailor's art achieve!' Nothing could be less enigmatic than this scene and the same is true of No. 70, which shows a personification of Spain standing on the shoulders of Ignorance, and humbly dedicating itself to the worship of Fanaticism and Superstition. In No. 71, Ignorance and Superstition with their attendant vices take counsel in the middle of the night and cry: 'Si amanece nos vamos' ('We must be ready to fly as soon as the dawn breaks').

Plate 11 refers to the roguery practised by various members of the government, here represented in the guise and dress of gipsies. These Bohemians, who have the reputation of being the cunningest rogues in Spain, hold a meeting in the middle of a wood and prepare for the fray.

The theological waffle, greed, general filth and rapacity of monks is clearly reflected in Plates 49, 53, 58, etc., and in general all the witchcraft scenes, which are numerous in this collection, allude to the cunning of churchmen and the ignorance they encourage in the mass of the people.

In Spain aristocrats are plebeian too, and Goya has not spared them either. In Plate 50 two men of this class are depicted, their swords by their sides, as it were enmeshed in their coats of arms. With padlocks on their ears and their eyes covered by heavy lids they are fed by Ignorance and are too stupid to make a shift for themselves.

The last plate of the collection represents all these different kinds of people— monks, aristocrats etc. awakening out of their profound lethargy; yawning hideously, they shout: 'Ya es hora!' ('At last the time has come!'). This expresses Goya's own wishes and hopes. Many others will no doubt feel the same in the future, but it will be a long time perhaps before these wishes are realized.

Many of the details of this French interpretation may seem far-fetched. Nowadays we would be less confident in claiming to know an author's intentions. But some of the political satire which the Frenchman purports to find in the work would not be out of character with Goya, to judge from other contemporary information about him. His friend Bartolomé José Gallardo certainly told the Scottish art historian Stirling-Maxwell that he had seen Goya make caricatures of the royal favourite.[87]

During morning visits to his friends, he would take the sandbox from the inkstand [sand was used in lieu of blotting-paper at the period], and strewing the contents on the table amused them with caricatures, traced in an instant by his ready finger. The great subject, repeated with ever new variations in these sand-sketches, was Godoy, to whom he cherished an especial antipathy, and whose face he was never weary of depicting with every ludicrous exaggeration of its peculiarities, that quick wit and ill-will could supply.

Gallardo may have been creating Goya in his own image, and have exaggerated

slightly his dislike of the Prince of the Peace. Yet there is no doubt that he knew Goya well, and he certainly admired the quality of his mind. Like other contemporaries of Goya, he saw the artist as a shrewd and subtle intellect, as well as an original and imaginative personality. This view is clearly reflected in some lines he published in his periodical *El Criticón* in the 1830s.

> Goya was a philosopher painter. I well remember how he sent a message to me in London by the hand of an English gentleman now living in Seville, saying that he had thought of producing some original Caprichos with the title *Don Quixote's Visions*, in which he painted the fantasies of the mad knight of La Mancha in a new style. The mere idea is an artistic creation in itself, and a typical Goya dodge.[88]

When Gallardo called Goya a philosopher painter, what did he mean? A painter of ideas, or, as Ceán implied when he used the same term, a painter who spent time in careful preparation and study before embarking on a work of art, employing his head as well as his hands? Most probably the latter. A 'Discourse on the Philosophy of the Arts and Sciences in General and Literature in particular', published in a periodical called *El Censor* on 23 December 1820 certainly gives a similar definition and Mengs had used the phrase earlier in this sense. 'In painting and sculpture, if the artist only knows how to copy the models he has studied, he will never become more than a mere copyist, or if you like, a mere painter or sculptor; but if, when he has studied nature herself patiently and learnt from her what is truly beautiful and why, he shows that his compositions are not just the products of chance or servile imitation, but of reflection and a reasoned conviction that they must be as they are because of the nature of the event or object they depict, then he will be a philosopher painter, or a philosopher sculptor'.[89] But how rational and reflective was Goya in the eyes of his contemporaries? Apart from Vargas Ponce's comment on his occasionally slapdash portraits, there is a remark from the artist's friend Leandro Fernández de Moratín, the dramatist, in a letter from Bordeaux written in 1825, to the effect that Goya still lacked 'the slightest inclination to correct anything he paints'.[90] Probably, however, it would be a mistake to assume that the two views of a philosophical painter are incompatible in the case of Goya. He was not an easily definable person. Moratín tells us that in 1825, he was 'pretty pleased with himself', having just recovered from a serious illness ('he has escaped from the Styx this time').[91] Yet, as numerous critics have thought, the caption of the late drawing of an old man—'Aun aprendo' ('I am still learning')—may well have been applied by Goya to himself. The artist seems to have been genuinely dissatisfied with much of his work, though he was still capable of painting with careless bravado when the mood caught him. The two sides are reflected in Javier Goya's biographical sketches of his father written shortly after his death.

He studied drawing under Don José Luzán at the Saragossa academy from the age of thirteen, and finished his training in Rome. The first works to reveal his genius were the pictures he painted for the Royal Tapestry Factory. These

came under the scrutiny of Mengs, for his formal approval and valuation, and he was astonished at the artist's extraordinary facility . . . Portrait painting came quite easily to him, and the most felicitous were those of his friends which he finished in a single sitting. He only worked for one session each day, sometimes ten hours at a stretch, but never in the afternoon. The last touches for the better effect of a picture he gave at night, by artificial light.

He lacked confidence in his paintings, and on one occasion, when somebody ventured a criticism, he said 'I have forgotten how to paint' He looked with veneration at Velázquez and Rembrandt, but above all he looked at Nature, whom he called his mistress, and studied her. What contributed not a little to this was his loss of hearing at the age of forty-three [forty-seven].

The pictures which he made for the Church at Monte-Torrero in Saragossa, those for Valencia cathedral, the *Taking of Christ* in Toledo, the *Virgin* in the parish church at Chinchón, *St Justa and St Rufina* in Seville, a *St John and St Francis* commissioned for America, the *Venuses* which belonged to the Prince of the Peace, the equestrian portraits of the Duke of Wellington and His Excellency General Palafox, some portraits such as that of Her Excellency the Marquesa de Santa Cruz, and several other works (most particularly those which he kept in his own possession)—all demonstrated clearly that there were few conquests left for him to make in painting, and that he knew how to create the magic of the atmosphere of a picture, to use an expression which he often employed himself.

His own predilection was for the paintings he kept in his house, since he was free to paint them as he pleased. In this way he came to paint some of them with a palette knife instead of brushes. These were always his special favourites and he looked at them every day. He also made three [four] series of etchings, one of which belongs to His Majesty, comprising about three hundred plates in all. [The *Caprichos*] which he engraved about 1796–7, is the series for which he is famous in the principal capitals of Europe. It has won praise for its artistic merit and satirical ideas, which do credit to the enlightenment of Spaniards in his times. He spent the last ten years of his life drawing ceaselessly.[92]

IV. Romantics and Realists

ROMANTICISM was a new word in the Spanish vocabulary before Goya died. In 1814, A. W. Schlegel's revaluation of Gothic as an alternative to the classical style was beginning to be discussed in Spain, and his idea that art should aspire to be national rather than universal appealed to many Spaniards after the Peninsular War. Spanish neoclassicism had mainly been derived from France, and the war—known as the War of Independence in Spain— encouraged Spaniards to throw out French aesthetic doctrines as if they were hostile invaders. It was inevitable that Goya's work should be seen as a reflection of national character in the 1830s, after the artist's death. His personal dynamism and fondness for breaking conventions also had a special appeal for the Romantics who put a premium on the personality of the artist and his direct experience of life.

An early illustration of the tendency of Spanish Romantics to look upon Goya as one of themselves is an article by José Somoza, published in one of the leading Spanish Romantic periodicals, the *Semanario Pintoresco Español*, in 1838, ten years after Goya's death. Somoza, like a number of Spanish Romantics, had known Goya slightly, and he exploited his limited knowledge to the full. He wrote a sympathetic description of Goya's half-length portrait of the bull-fighter Pedro Romero, which appeared to idealize this hero of the national sport,[1] and he was particularly interested in picking out the individualistic qualities of Goya the man. He possessed a certain flair for inflating information he had at second hand, and it is unlikely that anyone took this minor prophet's word for gospel.

The story of the angry exchanges between Goya and the Duke of Wellington when the latter was sitting for his portrait, is a typically Romantic snowball to which Somoza appears to have given the first push in print. The Duke is supposed to have made disparaging remarks about the likeness in French and English, and violence was only averted by the artist's son and by a Spanish general who happened to be present when the altercation took place. In the same article Somoza sets the seal on Goya's Romantic temperament by recounting tales of his supposed prowess as duellist and steeple-jack, and stories of his physical assault on Mengs (perhaps a garbled version of the attack made by Don Cosme Acuña, one of the professors of painting at the San Fernando Academy, on Maella in 1806, which led to Acuña's dismissal).[2]

> The famous painter Goya was one of the most irascible men in Europe. He was impetuous and strong, and skilled in the use of arms. His obstinate Aragonese

temperament was already apparent in his youth, and his body bore innumerable sword scars. In Rome he was determined to climb the cornice of the Church of S. Andrea della Valle, and carve his name on a higher place than any previous adventurer. In Madrid, the learned Mengs was nearly killed by him, when he began one day to criticize one of his pictures.[3]

Aspects of Goya's biography which the Romantics found particularly sympathetic were the artist's interest in bull-fighting and passion for the Duchess of Alba. They also believed that he wanted to record nature as it actually was and not in the idealized forms preferred by the neoclassics. Hence the desire to prove that Goya had drawn from life events like those of 2 and 3 May 1808, and hence also the tendency to take the caption of No. 44 of *The Disasters of War*—'I saw it myself' ('Yo lo vi')— literally, although the phrase is a rhetorical commonplace in the poetry of the period.[4]

Goya's first and most influential biographer in the Romantic period was Valentín Carderera (1795–1880). He came, like Goya, from Aragon, and was both artist and historian. Like Somoza, he had met the artist, having been introduced to him by General Palafox, and he amassed a considerable collection of Goya's work after his death: a few paintings, a large number of prints (with many copies in proof state) and, above all, drawings. He learned a great deal about Goya's methods from studying his own and other people's collections, and augmented his knowledge with the reminiscences of Goya's son Javier, and notes from acquaintances like Father Tomás López, a Carthusian monk from Saragossa.[5] He also knew Ceán Bermúdez well, and much of his Goya material ultimately derived from him.

Carderera's first article on Goya appeared in *El Artista* in 1835, and is a straightforward account of the artist's life and stylistic development.[6] There are also some comments in it about the impact of Goya's work on the 'new Romantic school of French painters', and Carderera claims that in 'quite a number of small paintings and numerous lithographs and etchings illustrating works by Victor Hugo and other well-known contemporaries, you can sense the artist's attempt to imitate Goya by echoing the latter's original and Romantic "Duendecitos" (Little ghosts) from his eighty *Caprichos*. A second article, published like Somoza's piece in the *Semanario Pintoresco* in 1838, embroiders considerably on the earlier study. The embroidery brings out the anti-academic, Romantic quality of Goya's work: his realism, originality and passion; also his understanding of, and identification with, the Spanish people and their customs. In relation to this last point the second article includes a prominent passage about Goya's reasons for appreciating popular subjects in his tapestry cartoons. The earlier essay merely spoke of the 'liveliness and natural facility with which [Goya] represented popular Spanish scenes, a genre in which he was outstanding, his passionate and imaginative temperament guiding his brush'. Despite the general reliability of Carderera's information, he did not mind bending the truth on occasion to make Goya's life and art more consistent with Romantic values. He asserts, for example, that Goya had scorned social and academic status on his return from Rome, whereas, in reality, Goya took the petty noble title 'Don'

when he established himself as an artist in Saragossa.[7] When he speaks of Goya's lack of interest in the San Fernando Academy at the same period, he forgets that Goya entered for more than one of the academy's competitions in the 1760s and was glad to become an academician later. Since the article in question is the source of many later studies of Goya, it is quoted in full in an appendix.[8]

One Romantic claim that Carderera hardly makes at all is that of Goya's involvement in liberal politics. The artist's criticism of the hierarchy in some of his etchings is obliquely referred to, but Carderera makes much of the generosity of those whom Goya attacked. There is almost nothing at all about his more advanced religious views.

In part this was inevitable in the Spanish context. Romanticism was a movement which began at the conservative end of the spectrum in Spain, and was dominated by establishment colours. Romantic painters like Alenza and Eugenio Lucas the Elder drew most inspiration from Goya's nationalistic or imaginative subjects: the bull-fights, *majas* on a balcony, carnival scenes and witchcraft pictures. Although Lucas copied Goya's etchings of prisoners and painted some Inquisition scenes, a more widespread and open appreciation of Goya as an anti-establishment figure had to wait until the fall of Isabel II in 1868. Carderera was certainly too morally timid and too closely connected with aristocratic circles to approve of the whole of Goya's *œuvre*. He literally 'clothed' some of the more exposed female figures in works in his own collection,[9] and he collected paintings of 'illustrious Spanish and foreign personages of both sexes'—mainly pictures of European royalty and the nobility.[10] He was a candidate for ordination as a young man and remained an ardent church-goer all his life: hardly the person to trumpet forth Goya's espousal of the liberal cause and Enlightenment ideas, or his criticism of the church and the ruling classes.

Although Somoza's and Carderera's articles in the 1830s appeared after the earliest French essays on Goya they have been mentioned first because they reflect the common concept of Goya's personality and art circulating in Madrid during his stay in Bordeaux and after his death: the source material for French critics who travelled in Spain or met Spaniards (like Carderera) in Paris. Carderera, in fact, was particularly influential in France. He helped Piot with his catalogue of Goya engravings in 1842; was respected by Prosper Mérimée as a connoisseur, except, of course, when he doubted the authenticity of a 'Velázquez' Mérimée thought he had acquired.[11] Given Carderera's 'extensive repertoire' of Goya reminiscences, it was essential, according to Charles Yriarte, for anyone writing about Goya in France or in Spain 'to go and knock on the door of Don Valentín's study'.[12]

Outside Spain it was the satirical Goya, challenging the hierarchy and moral values of his society, that first captured the Romantic imagination. Delacroix's early admiration for this aspect of his work is well known. He was already copying figures from the *Caprichos* in the 1820s and associating Goya with the 'lash of satire'. An article signed 'Ad. M.' published in 1831, probably by Adelaïde de Montgolfier, also picked out the satirical side of Goya's work and especially discussed his anti-clericalism in a review of a book called *A Year in Spain by a Young American* (Alexander

Slidell Mackenzie). The way in which the subject is tackled reflects the current view
that Goya was important as a national rather than a universal artist.

Perhaps one man, Francisco Goya, has managed to give a true idea of his
country. He fully understood the vices which undermined Spain. He painted
them because he hated them: with bitter and biting passion. He is a Rabelais
with pencil or brush in hand, but a Spanish Rabelais, basically serious, whose
jokes make one shudder. Laughter is too lukewarm a sensation for him, and when
he writes a satire in his magnificent sketches, he does it with the steely point of a
dagger, which gives you goose-flesh and makes you shiver. A Goya drawing has
more to say about Spain than the scribblings of all the travellers put together; but
his work is very little known.

The moral part of religion is all we preserve and respect in France. In Spain,
on the other hand, only the outward forms of religion survive. These spread and
swell even though there are no principles or spirit behind them. Goya's art reveals
this in a thousand different ways. In one etching he mounts a miserable idiot, with
hands joined and eyes lowered and a devout look on his face, on the back of a stupid-
looking beast, with a cretinous head, donkey's ears and legs. Two bishops with
asses' ears, borne aloft on the back of some bird of prey, use strong pincers to
hold a great book open in front of him; and at the bottom of this, the Spanish
philosopher has written the words *Devota profesión* (Devout profession). The scene
is a symbolic one, representing someone taking a vow to be devout, or the
beginnings of devotion—I cannot find an exact equivalent for the Spanish expres-
sion. In another plate, Goya dresses the forked trunk of a tree in clerical garb,
symbolizing fairly obviously a preacher in one of his commoner postures, with
arms flung wide. There is a hood over the head of this figure, and a mesmerized
woman, a mindless general public, kneels before it. Goya's powerful imagination
has peopled the air with demons, and at the bottom one reads 'Lo que puede un
sastre' ('What a tailor can do!'). What could be more horrifying than Goya's
picture of a penitent woman being led off to an auto-da-fe. With her neck tight
in an iron collar, she is compelled to hold her head erect despite the inevitable
ebbing of her strength. Her hands are tied together to the metal bar that supports
the collar, and she rides on an ass. Torture and interrogation have left their mark
on her face, which is cowed as a result of pain, humiliation and fear. Expression-
less constables escort her on either side, and you can hear the ferocious cries of the
populace. Their mouths hurl insults, they shake their fist, and their mocking
laughter is full of religious ire. 'There was no alternative', says the painter coolly;
and one shivers at the thought of a country where the scaffold is the strongest
proof of religious conviction.

When Goya depicts monks, idleness, ignorance and the bestial physical
passions that are consequent upon them, loosen and soften every feature. Greed
makes this old man half close his eyes, as he comes forward smacking his lips,
savouring and sipping some exquisite drink, to say, as he strokes his glass: 'No
one has seen us!' And when this admirable moralist hits out at morals, it is not

elegant skirts, delicate feet and attractive shapes he draws. Decorative elements like that are a frivolous distraction. Physical attractions that are part of the beauty of life are shown by Goya soiled, poisoned by vice, yet an incitement to it. The bejewelled and bedecked breasts of a beautiful woman are surrounded by starlings with male faces and dazed and bewildered expressions. Her bosom is a lure, a sign advertising a brothel. In the next plate the interior of the place opens before our eyes: the loose women are driving the unfortunate starlings to the door with brooms, having plucked their feathers. Trailing their wings, and dragging their feet they go, naked and shivering, tumbling over one another as the brush pushes them inexorably along. One of the most striking of Goya's compositions in my view portrays a young girl. A thin dress clings to her body; she sits on a stool and has just washed one of her delicate feet in a basin. A servant voluptuously and coquettishly combs the young beauty's long, black hair, and her slender bare leg is exposed to view. Before her stands the bent figure of a wizened old crone: avarice marks every line in her face. She holds a rosary with fat beads in her hand and watches greedily over the charms in which she has a commercial interest. 'Ruego por ella' ('I pray for her'—[sic, for 'Ruega por ella'—'Pray for or ask for her', or 'She asks or prays for her]), says this duenna, as if prostitution were the object of her devotion, while the young girl preserves a certain dignity and pride in her looks and bearing, as if her beauty and insouciance could restore her purity.[13]

Obviously the author of this article based her idea of Goya solely on the *Caprichos*. Equally obviously she knew the whole work, and not just the group of ten versions of *Caprichos* which had been published by Motte in Paris, and advertised in the *Bibliographie de la France* on 8 January 1825.[14] Only Nos. 24 and 52, 'No hubo remedio' and 'Lo que puede un sastre', of those 'Ad.M.' discusses are in Motte's collection; the others (Nos. 19, 20, 31, 70 and 79) must have been seen in a copy of the original work itself. There is certainly exaggeration in some of her interpretations, and she reads a great deal more anti-clericalism into No. 70, 'Devota profesión', than the witchcraft subject would appear to warrant. But her essay clearly stimulated interest in Goya as a true reflection of Spanish society and as a master of the Romantic juxtaposition of beauty and ugliness, and it was quoted by more than one French critic later in the century.

The earliest general study of Goya's work in France seems to have been the article on him in *Le Magasin Pittoresque* in 1834.[15] Again the *Caprichos* are discussed at greater length than any other work, and three woodcuts—of Nos. 1, 39 and 51—illustrate the essay. The political aspect of the work is given pride of place, and *Capricho* No. 39, in which an ass studies his genealogical tree and finds that his progenitors had been true donkeys back to his grandparents, is picked out as a reference to 'the famous Manuel Godoy, Prince of the Peace, the unfortunate politician who attempted to prove his descent from the line of the ancient kings of Spain'. As the article says, 'people in Madrid tell a host of stories about Goya', and there is no way of knowing the reliability of the author's sources, He listened chiefly to those who identified the artist with his people, and gives us an almost republican sense of Goya

as 'a man of the people', mocking authority and the palace circles in which he lived, mixing for preference with more ordinary folk. But some points about Goya's revolutionary technique as a painter were also caught, and his originality was emphasised. The paintings on the walls of the artist's Quinta, for instance, are mentioned, and the writer comes up with the tale that Goya began some of these by a method resembling action painting: 'he threw a mixture of colours into a pot, and hurled them violently on to a large whitewashed wall'. The anecdote that Goya painted a scene from the Peninsular War with a spoon instead of a brush also appeared for the first time in the article. It forms part of the essential Romantic stock for many later French writers on Goya.

Another early French comment on Goya's work, apparently independent of the previous two, came from a writer who was close to the leaders of the Romantic movement in France: Isidore Justin Severin Taylor, usually called Baron Taylor. Taylor was one of the regular members of Charles Nodier's circle, which held meetings in the latter's house in the Arsenal in Paris from 1824 and included men such as Victor Hugo, Vigny, Delacroix and Alexandre Dumas *père*. Taylor's reference to Goya occurs in his *Voyage pittoresque en Espagne*; and the passage was also repeated in the published catalogue of Louis-Philippe's Spanish Gallery. It was probably written between March 1826 (when the first engravings for the *Voyage pittoresque* were available to the subscribers) and the opening of the Spanish Gallery in the Louvre in 1838.[16]

Taylor first discovered Goya during his earliest visits to Spain in 1820 and 1823, and some of the information he gives about the artist certainly dates from that period. References to paintings by Goya in the Louvre collection which Taylor himself had been instrumental in buying on a trip to Spain in the 1830s, belong to 1838 when the King's Spanish pictures first went on show. His remarks about Goya begin with a reference to current French interest in the *Caprichos*. Then he goes on to stress the fine quality of his paintings. The admiration expressed for *St Justa and St Rufina* (Plate 22; a painting which the author may not have studied very carefully since he gets the title wrong) may well owe something to the article by Ceán Bermúdez quoted in Appendix I; other comments, however, are more original and linked to the Louvre pictures Taylor knew really well. The imaginative side of Goya and his strong personality impressed Taylor; his fantasy is referred to in terms which later Romantic writers were to echo. The inspirational quality of Goya's art and its ability to rouse a passionate response are also emphasized, and in an obvious allusion to a painting depicting a scene from a picaresque novel and the *Majas on a Balcony* (Plate 10), both in Louis-Philippe's collection, Taylor speaks of the way in which Goya captured 'the morals of the *Celestina* and *Lazarillo de Tormes*'. Finally he notes Goya's love for the Duchess of Alba, *à propos* the portrait now in the Hispanic Society of America and then in the Louvre (Plate 23), and describes an allegorical painting of the Peninsular War which has dropped from sight since it was sold for £4. 10s. with Louis-Philippe's other paintings in 1853.

The Spanish School may not be right in the forefront in the history of art, but

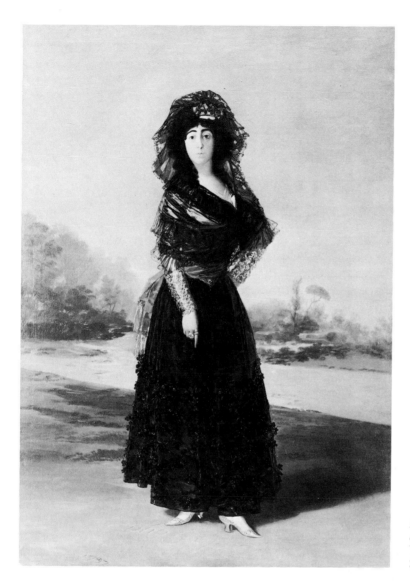

23. Goya: *The Duchess of Alba*, 1797. New York, the Hispanic Society of America.

for faith and originality it even surpasses the immortal productions of the Italian School. The latest painter from this dynamic and sublime Spanish background is Don Francisco de Goya. This sombre and imaginative genius was only known in France as the author of a very curious collection of caricatures in aquatint, until the Spanish Museum was opened in the Louvre. And as yet not all the works we possess of this master have been put on view. His most skilful and finished pictures are *St Rufina* and *St Marina* [*sic*] which are to be found in the sacristy of Seville Cathedral, and the paintings of *St Louis Borgia* bidding farewell to the world, and a *Man possessed*, which hang in one of the chapels of Valencia cathedral. No other painter has taken his personal character and individuality further than Goya. His manner is as eccentric as his temperament. He is Rembrandt and Watteau, Hogarth and Callot all at once. He captures the morals of the Celestina,

Lazarillo de Tormes and Quevedo's picaroon Pablos in the *Buscón*. He is Cervantes too. Yet he lacks the Attic salt, the polish and the charm of the famous novelist. He is a sad, melancholy and sometimes violent Cervantes. He is Cervantes turned Voltairean: a sceptic. Old Spanish art dies with Goya. The light of Velázquez, the diabolical colours of El Greco whose imagination drove him mad, the manners and customs of bullfighters, *majas*, *manolas*, police, smugglers, thieves, gypsies, and finally witches—those Spanish witches, so much more Satanic than ours—all these meet and die with Goya.

There is only one work of Goya's in the Museum at Madrid: an equestrian portrait of María Luisa, the wife of Charles IV. During the Peninsular War, he painted a portrait of Ferdinand VII which was hung from a balcony of the Town Hall in Madrid to encourage the people to enlist under the Spanish colours and fight Napoleon. This picture awoke the enthusiasm of the people, and they formed battalions in front of it, like the people of Paris in former times, when they formed up in regiments at the Place de l'Opéra, after singing the *Marseillaise*.

In the Spanish Gallery in the Louvre there is a fine portrait by Goya of the Duchess of Alba. He was in love with her, and in the painting her hand is shown pointing towards the name of the artist written at her feet. Also in the Louvre there is a large sketch depicting Napoleon's invasion of Spain in allegorical form. A huge eagle hovers over the Pyrenees overshadowing all the peoples of the Peninsula with his outspread wings, as they flee in terror before him. This last work is one of the largest and most sublime compositions ever conceived in the history of painting. And Goya himself is the most unusual artist ever born in Spain.[17]

Details of the French comments so far mentioned had considerable currency in France later in the century. There are elements from *Le Magasin Pittoresque* and the review of Slidell Mackenzie in G. Brunet's entry on Goya for Volume 21 of the *Nouvelle Biographie Générale* (1857), and the spoon story may well have passed from there into relatively unexpected places like the brothers De Goncourt's comparison of Goya and Fragonard in *L'Art au dix-huitième siècle* (1856–75).[18] But the current from the *Magasin Pittoresque* article about Goya had to pass through a Romantic transformer of major potential in France before reaching Brunet, and the new sparks which cluster round the earlier points are principally those of Théophile Gautier.

Gautier's most important contributions to Goya criticism were his articles in *La Presse* (1838) and *Le Cabinet de l'Amateur et de l'Antiquaire* (1842), although there were also references to Goya in the first edition of his *Travels in Spain* (published as a book in 1843),[19] and the whole *Cabinet* piece was incorporated into Chapter XI in the 1845 edition. Gautier's views thus reached a very wide readership, and his *Voyage* was soon available outside France in translation (in English, *Wanderings in Spain*, from 1851). Gautier, to be sure, had an appreciative eye for technique, but the way in which Goya could be remodelled like clay in his hands is well illustrated by his version of Goya as an action painter. Spanish sources like Ceán Bermúdez and the artist's family provided the underlying facts: Goya painting with his fingers

(Ceán), with a palette knife (Javier Goya), or with 'little bamboo or cane knives he made himself and was proud of inventing' (Father Tomás López). No doubt Gautier's *cicerone* in Madrid, the *costumbrista* writer Mesonero Romanos (editor of the *Semanario pintoresco*), would have ensured that the Frenchman had access to all the proper authorities.[20] Mesonero mentioned in an article in 1838, for instance, that he knew academicians who had been to bull-fights with Goya.[21] But Gautier either heard a more elaborate version of the action painting episode than is found in Spain or given in *Le Magasin Pittoresque*, or he enjoyed himself in decorating the story further. The humorous structure of the second sentence in the passage we quote, and Gautier's fondness for metaphor generally, suggest that the elaboration may well have been his own.

> His method of painting was as eccentric as his talent. He drew his colour from buckets, applying it with sponges, brooms, rags, whatever came to hand. He laid his tints on with a trowel, and chiselled his tones like mortar, adding emotional touches with great strokes of his thumb. With the help of these improvised and makeshift techniques he covered thirty feet of wall in a couple of days. This seems to me to pass the bounds of normal inspiration. Even the artists who are most carried away by their work seem polished and punctilious by comparison. Using a spoon instead of a brush he painted a scene about the events of the Second of May, in which the French are shooting at Spaniards; it is a work of incredible verve and violence. Today this curious painting has been relegated to a dishonourable place in the entrance hall to the Prado.[22]

Gautier's version of the spoon-work of Goya differs from his most likely source. The *Magasin pittoresque* article found it in a Peninsular War subject on the walls of Goya's house, i.e. in one of the Black Paintings. Gautier's reference, however, does not apply to a painting on a wall at all, and clearly alludes to the *The Third of May 1808*. Although Charles Yriarte's book on Goya (1867) rejected Gautier's theory with respect to this particular painting, the bastardized half-truths of the Romantics often acquired respectability, as imprecise information passed from mouth to mouth, or from one book to the next.[23]

Many of Gautier's views are made up from stock Romantic material, but the cut and the tailoring are rather better than those of other writers. Central to his observations about Goya is the familiar Romantic idea of the artist's understanding of his people and sense of identity with them. In the first edition of his *Voyage en Espagne* he notes how Goya had caught the reality of the features of old women with frightening precision in works which he had taken for 'nightmares and monstrous chimaeras' before he had actually seen old Spanish women for himself.[24] Goya in the same work is 'the national painter, par excellence, who seems to have been born on purpose to record the last vestiges of the country's ancient customs, which were about to disappear'.[25] Other indications of Goya's Spanishness for Gautier lay in his sharp sense of the debased and his ability to render it. Gautier felt that all Spanish painters had this quality, although he found it particularly in the *Caprichos*. Naturally the bull-fighting Goya and creator of the *Tauromaquia* fitted a national

image supremely well, yet Gautier's comments on that particular collection were also influential for another reason. Gautier noted the presence of the more imaginative side of Goya in the *Tauromaquia*: he found in it the mixture of fantasy and reality which later impressed Baudelaire and other critics. He also picked out the technical audacity of the etchings in a typically Romantic anti-academic manner, and underlined the artist's first-hand knowledge of his subject—a *sine qua non* for so much Romantic art.

> The *Tauromaquia* is a collection of scenes depicting various bull-fighting episodes from the time of the Moors down to our own day. Goya was a consummate *aficionado* and spent much of his time with *toreros*. Naturally there was no more competent person to deal with the subject in depth. Although the attitudes and postures, attacks and defences, or, to use the technical language of the bull-ring, the various *suertes* and *cogidas* are irreproachably accurate, Goya has put into these scenes his own mysterious shadows, and colours from his own imagination. What strange and ferocious heads! What savagely strange angles, what furious movement! His Moors, treated somewhat like Mamelukes as far as their costume is concerned, have the most typical physiognomies imaginable. A scratched stroke here, a black blot there, and a white line, make up a person who lives and dies, and whose face is forever engraved in the memory.[26]

The darker side of Goya's work did not escape Gautier's attention either. He found it more particularly in the *Caprichos*, and in the painting of *The Betrayal of Christ* in Toledo cathedral, which he initially took for a Rembrandt. He plays down the political implications of the etchings, and gives most space to the description of Goya's witches and fantastic atmosphere.[27] No. 59—'Y aun no se van' (Plate 24)— struck him forcibly, as it later did Baudelaire, but he tricks out his description of it with powerful images which ultimately distract rather than illuminate the reader. One cannot help feeling that Delacroix caught Gautier's qualities and failings as a critic all too accurately in some comments he wrote on Gautier's essays on the English School in his *Journal* (17 June 1855): 'He takes a picture, describes it in his own way, and so makes a charming picture of his own; but he has not done the work of a true critic. Provided he can find words that will tickle his reader, that will dazzle him with the macaronic expressions he invents (with a pleasure that is sometimes contagious) . . . he is satisfied'.[28] In Gautier's comments on the *Caprichos* these principles seem to be operating as he struggles to pin down the suggestive power of the work, and trace the effects of Goya's bold technique.

> Goya carries out his drawings in aquatint, reworking and sharpening them by biting the plate with acid. Nothing could be simpler, freer or more direct. A single line indicates a whole face and its character; a trail of shadow takes the place of a background, or suggests half-sketched, sombre landscapes, mountain gorges in the *sierras*, settings for a murder, a witches' coven or a gipsy *tertulia*. Yet even such hints as these are rare, for backgrounds simply do not exist in Goya's work. Like Michelangelo, he has no regard for nature's externals, and only takes the

bare minimum to create an environment for human figures. He even puts some of his figures among the clouds. A stretch of wall bisected by a huge angle of shadow; a black prison arch, or a barely suggested hedgerow: nothing else is needed. We have called Goya a caricaturist for want of a better word. But these caricatures of his are in the manner of Hoffmann—always mixing fantasy with their criticism, and frequently having an atmosphere of terror or gloom about them. One would say that these grimacing faces were scratched by Smarra on the wall of some awesome cavern, by the intermittent light of a guttering candle. One is transported into an unheard of world: unbelievable yet real. Tree-trunks seem like ghosts; men like hyenas, owls, cats, donkeys or hippopotomi. Finger-nails may turn out to be talons; cloven hooves are shod in shoes bedecked with pompoms; this, apparently young cavalier is really old, dead even, and his be-ribboned hose covers a barebone femur, and two fleshless tibias. No more mysterious and sinister apparitions ever emerged from behind the stove of Dr Faustus

The type of go-between or procuress is marvellously caught by Goya, who has the typically sharp eye for squalor that all Spanish artists have. You can imagine nothing more grotesquely repulsive, or more viciously deformed. Each of his hags has the ugliness of all the seven deadly sins. The devil himself is handsome by comparison. Imagine lines and furrows in a face which sink as deep as trenches and rise like embankments; eyes like coals which have been extinguished in blood; noses like alembic flutes, studded with boils and warts. Imagine muzzles like that of the hippopotamus, prickling with stiff hairs, tigers' whiskers, gaping mouths twisted in hideous, mocking laughter. Imagine something which is a cross between a spider and a wood-louse; something that makes you feel revulsion, like putting your foot on the bare belly of a toad. All this gives you an idea of the reality in Goya's work. But his power of demonographic invention is still more remarkable. No-one knows better than he how to make dark clouds scud through the hot atmosphere of a stormy night, heavy with vampires, night-hags, demons; or how to throw a cavalcade of witches into relief against a ribbon of sinister horizons.

A plate which is wholly fantastic in conception is certainly more fearful than any nightmare I have ever dreamed. The title is *Y aun no se van* [And still they do not go]. It is horrifying. Even Dante himself never achieved such an effect of suffocating terror. Visualise a bare, lugubrious plain. In the sky above it a deformed cloud drags itself painfully along, like a crocodile ripped open. A great stone looms: a tombstone which a sickly, emaciated phantom struggles to lift. The stone, which is too heavy for the skinny arms holding it up (now near breaking point), falls back despite the phantom's efforts, aided by other small ghosts who stiffen vainly, together, their shadowy sinews. Several of them are already pinned beneath the stone, which was shifted only for a moment. There is something profoundly tragic about the expression of despair in all these cadaverous faces, in the empty sockets of all their eyes, as they realise that they have striven in vain. It is the most painful symbol of impotent effort, the most

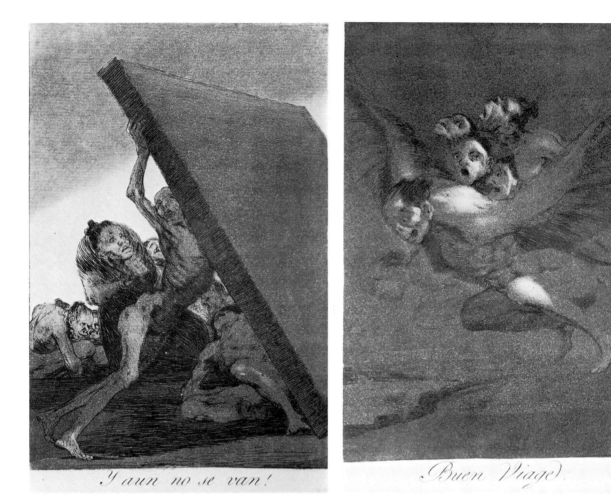

24. Goya: 'Y aun no se van!', *Capricho* No. 59, 1799. Oxford, Ashmolean Museum. Francis Douce Collection.

25. Goya: 'Buen Viage', *Capricho* No. 64, 1799. Oxford, Ashmolean Museum. Francis Douce Collection.

sombre piece of poetry and bitter derision ever produced on the subject of the dead. In the plate entitled *Buen viage* [Have a good journey (Plate 25)] demons are flying—pupils from the seminary for witches in Barahona, beating their wings in flight, and hurrying towards some nameless labour. The vigour and energetic sense of movement is remarkable. One can almost hear the furry membranes, from which their talons emerge, beating the heavy night air like bats' wings. The collection ends with the following words: *Y es hora* [sic, for *Ya es hora*]—'The time has come'. The cock crows, the phantoms disappear, for dawn is breaking.[29]

Latent in much of Gautier's writing about Goya is a characteristically Romantic appreciation of contrasting moods and colours. The idea that different styles could be mixed in art and literature was an important part of the reaction against neo-classicism. The grotesque was particularly appreciated in conjunction with the sublime, and Goya's contribution in that area was felt to be like that of Callot, 'the Michelangelo of the grotesque' as Hugo called him. Gautier, who had linked

Goya and Callot in his *Albertus* in 1830 obviously approved of the mixture of realism and fantasy in the *Tauromaquia*. Another Frenchman, the historian Jules Michelet, saw the portrait of the Duchess of Alba in Louis-Philippe's collection as the expression of a similar synthesis of opposites. Michelet visited the Spanish Gallery on 23 June 1839 and made the following note in his diary: 'I went into the Louvre via the Spanish Gallery. The pictures bizarre and absurd: fantasy that is brutal and charming by turns. I noticed some Goyas there for the first time: a monk being buried in a cave, with strong reddish lights, the whole work brimming with energy; a modern Spanish lady, elegantly beautiful, queen and tart at one and the same time.'[30]

No one in France in the nineteenth century had a better understanding of the paradoxes of Goya's art than Charles Baudelaire. He was also more ready than Gautier to accept the indescribable in the *Caprichos*, although both were especially fascinated by the plates with mysterious black backgrounds. Baudelaire did not need, as Gautier did, to give his own shape to the shapeless cloud, and he wrote eloquently and penetratingly of Goya's mystery in both poetry and prose.

The single verse about Goya in Baudelaire's *Phares* ('Beacons'), which first appeared in *Les Fleurs du Mal* in 1857, is often quoted. Poetry speaks best for itself, and so there is a natural reluctance to talk about it.

The context of the verse is important, however, and some observations about the particular *Caprichos* which Baudelaire obviously had in mind are relevant to an understanding of his view of the Spanish artist.

Two points about art are central to *Phares*: the enduring quality of the visions of great artists, and the artist's perception of the paradoxical nature of man. Among Baudelaire's chosen few, Leonardo and Rembrandt most clearly preserve, in the traditional way, a brief moment of beauty and hope. But that beauty or hope is placed in a dark, unalleviated setting. It is a sun-ray on the sordid wall of a hospital in Rembrandt; and a Mona Lisa-like angelic smile surrounded by a world of shadows, mountains and forests in Leonardo. Other artists—and Goya is one of these—create art, and therefore beauty, out of the foulest and most degraded elements of human life. Art, because it sees and understands the misery of the human condition, is able to transcend it and provide 'for earthly hearts a heavenly opiate'. In some cases Baudelaire creates a synthesis of an artist from a number of paintings or general characteristics. This seems to be what he does with Rubens, Puget, Watteau and Delacroix. In stanzas on other artists, specific works rather than poetic images are the source of evocative material. In the case of Goya, lines 2, 3 and 4 of the stanza in question obviously call to mind the *Caprichos* in which witches are using children for their nefarious purposes (Nos. 44, 45 and 47, 'Hilan delgado', 'Mucho hay que chupar' and 'Obsequio al maestro'); the one in which an old hag looks at her face in a mirror (No. 55, 'Hasta la muerte'), a traditional emblem of the fleeting nature of human beauty; and those in which a seductive stocking is a lure to vice (No. 17, 'Bien tirada está', or No. 31, 'Ruega por ella'). The juxtaposition of beauty and ugliness is particularly powerful in the Goya stanza, but I quote the poem in full so that the context is clear, and append a translation.

Les Phares

Rubens, fleuve d'oubli, jardin de la paresse,
Oreiller de chair fraîche où l'on ne peut aimer,
Mais où la vie afflue et s'agite sans cesse,
Comme l'air dans le ciel et la mer dans la mer;

Léonard de Vinci, miroir profond et sombre,
Où des anges charmants, avec un doux souris
Tout chargé de mystère, apparaissent à l'ombre
Des glaciers et des pins qui ferment leur pays;

Rembrandt, triste hôpital tout rempli de murmures,
Et d'un grand crucifix décoré seulement,
Où la prière en pleurs s'exhale des ordures,
Et d'un rayon d'hiver traversé brusquement;

Michel-Ange, lieu vague où l'on voit des Hercules
Se mêler à des Christs, et se lever tout droits
Des fantômes puissants qui dans les crépuscules
Déchirent leur suaire en étirant leurs doigts;

Colère de boxeur, impudences de faune,
Toi qui sus ramasser la beauté des goujats,
Grand cœur gonflé d'orgueil, homme débile et jaune,
Puget, mélancholique empereur des forçats;

Watteau, ce carnaval où bien des cœurs illustres,
Comme des papillons, errent en flamboyant,
Décors frais et légers éclairés par des lustres
Qui versent la folie à ce bal tournoyant;

Goya, cauchemar plein de choses inconnues,
De fœtus qu'on fait cuire au milieu des sabbats,
De vieilles au miroir et d'enfants toutes nues,
Pour tenter les démons ajustant bien leurs bas;

Delacroix, lac de sang hanté des mauvais anges,
Ombragé par un bois de sapins toujours vert,
Où, sous un ciel chagrin, des fanfares étranges
Passent, comme un soupir étouffé de Weber;

Ces malédictions, ces blasphèmes, ces plaintes,
Ces extases, ces cris, ces pleurs, ces *Te Deum*,

Sont un écho redit par mille labyrinthes;
C'est pour les cœurs mortels un divin opium!

C'est un cri répété par mille sentinelles,
Un ordre renvoyé par mille porte-voix;
C'est un phare allumé sur mille citadelles,
Un appel de chasseurs perdus dans les grands bois!

Car c'est vraiment, Seigneur, le meilleur témoignage
Que nous puissions donner de notre dignité
Que cet ardent sanglot qui roule d'âge en âge
Et vient mourir au bord de votre éternité!

Beacons

Rubens, Lethean stream, garden of ease;
Cool pillow of flesh, inimical to love,
Yet tense with restless life, like seaswept seas
In constant flux, or winds in the sky above.

Da Vinci, deep reflections in a glass
In which with gentle smiles angels divine
From time to time mysteriously pass
Dark frontiers of ice and forest pine.

Rembrandt, sad hospital of endless sighs,
With only a crucifix to deck the wall;
Where tearful prayers amid the filth arise,
Where wintry sunbeams momentary fall.

Michelangelo, uncertain land,
Where Christ and Hercules merge into one;
Where muscled ghosts amid the halflight stand
And tear their shrouds with outstretched finger-bone.

Boxers' aggression, faunlike impudence,
Thine that saw the grace in human grime;
With haughty pride, with sickly impotence,
Puget, sad emperor of the world of crime.

Watteau, a carnival for noble peers—
Moths that are fluttering in a fiery dance—
With delicate décor, lit by chandeliers,
That pour down folly where they circling prance.

Goya, nightmare world of the unknown,
Foetuses cooking where the witches meet;
Hags at mirrors; children bare; girls shown
For devils stretching stockings on their feet.

Delacròix, pool of blood where angels lie,
Shaded by pine-woods of dark evergreen;
Strange trumpets sound a stifled Weber sigh
And die away, beneath the sky's dark spleen.

These curses, blasphemies, laments for fate,
Ecstasies, cries, tears, hymns of praise,
Bring earthly hearts a heavenly opiate
Resounding down their labyrinthine ways.

A thousand sentinels take up the cry;
A thousand megaphones transmit the call;
A thousand forts have lit their beacons high;
Huntsmen sound in the woods an echoing fall.

For it is truly, Lord, the greatest gage
Mankind can give of human dignity,
This ardent sigh which lasts from age to age,
Dying at the frontiers of Eternity.

Baudelaire's vision of beauty in ugliness goes much deeper than any previous concept of the ugly in art. Applied to Goya's work it represents a considerable advance. Originally ugliness had been understood as an indication of moral inferiority or positive evil; in caricature or grotesque it made laughable what was evil or reprehensible. Only occasionally could ugliness be moving, and then only when placed in an idealised environment, as in Murillo's painting of *St Elizabeth of Hungary* tending a beggar's sores: a case that was often quoted by Spanish art critics in Goya's time. Baudelaire, with the Romantic's acceptance of the whole of reality as a fit subject for art, naturally rejected earlier preoccupations. He was moved by Goya's perception of paradoxical beauty in, for example, the prostitute's legs in *Capricho* No. 17, which had earlier appealed to Musset.[31] In an essay on Goya he also penetrated further than Gautier into Goya's use of fantasy in the *Caprichos*, and showed how political material in that work could have an impact on those who failed to appreciate the specific allusions. His article was first published in a periodical, *Le Présent*, in October 1857. Inserted in *L'Artiste* in September 1858, it was subsequently collected amongst his *Curiosités esthétiques* (1868), and so brought his views on Goya's modernity to a wide readership. It is quoted in full in an appendix.[32]

After Baudelaire, it is hard to find a Romantic or post-Romantic commentator

on Goya who does not merely repeat what others have said. Most of them appear superficial by comparison, and seem to avoid the discussion of fundamentals. The first three books on Goya—all of them written in France—certainly suffer when their views are compared with Baudelaire's, although none of them is negligible as a contribution to knowledge of Goya's work.

The first of these three books to appear earned its author the Spanish Order of Charles III. It was written by Laurent Mathéron (1823–1905), a local government official in Bordeaux with a taste for art and literature. Mathéron contributed to a number of Bordeaux newspapers from 1849 onwards, and wrote on prisons and the treatment of prisoners as well as on the arts. His reviews of the Bordeaux exhibitions in 1852 and 1853 reveal him as an admirer of the original technique and dramatic power of Delacroix (to whom he dedicated his book on Goya); also of the poetic light of Boudin and Corot; of realism in general, and emotional subject-matter. So far as Goya was concerned, his place of residence gave him ready access to anecdotes about the last years of the artist's life, and the three or four paintings and copies of paintings by Goya which were in Bordeaux collections.* He was also able to obtain a good deal of new material from the Spanish painter Antonio de Brugada. Brugada, who was made an academician on the basis of his proficiency in landscape and marine subjects in 1841, had been the constant companion of Goya in Bordeaux as a young and aspiring artist in exile, and knew a lot about his technique and theories.

In addition to his artistic and professional interests, Mathéron wrote some amusing occasional poems and a number of love lyrics; he was also keen on fencing.[33] Perhaps these pursuits predisposed him towards a Romantic view of Goya, with special amorous, satirical and duelling skills. It is certainly no surprise that there are two pages on the artist's ability with the foils in Chapter VI, and that he saw Goya's life through the rebel-coloured spectacles of Somoza and the anti-academic ones of Carderera. He also drew largely from Gautier, both in vocabulary (Goya 'laying on colour as if with a *trowel*'), and in the more general matter of the Spanish-ness of his art. But Mathéron fitted realism into the category of Spanishness too, making the artist a Romantic twice over. Goya's realism on the one hand was part of the revolt against neoclassicism, embracing objects which were not con-ventionally beautiful, or which were even ugly, as proper subjects for art. On the other, this realism was also Romantic in Schlegel's sense: a reflection of a national spirit rather than a universal one, as the following passage suggests:

> Nearly all the Spanish masters, above all the most Spanish of them, have a penchant for realism, and they adopted this harsh manner at a time when there was not even a name for it, at the expense of style and character. In this respect, Goya is a man of his people, and is a realist even in his most imaginative and Hoffmannesque pictures In his fantastical vein, as a painter of human behaviour, as an historian, Goya is the national painter *par excellence*, with no forerunners or followers.[34]

*Mathéron was already actively working on the biography of Goya in January 1856, although it was not published until two years later.

Such extensions of the nineteenth-century view of Goya as we find in Mathéron are to some extent the result of distortion. Above all, he lards the biography of the artist with unverifiable anecdotes, many of which are given a spurious and novelesque vitality by being put in dialogue form. A conversation between Goya at the age of fifteen and a mysterious monk from Saragossa is, for instance, 'reported'. The monk sees the infant prodigy drawing a pig on a wall when on his way with a sack of wheat to a mill in Fuendetodos. Somoza's story about Goya climbing on the cornice of S. Andrea della valle is characteristically escalated. Mathéron would have him climb higher on a larger building: up the dome of St Peter's itself. Further-more, in the best realist tradition Mathéron appears to bring documentary evidence to support the story: 'Only a very few years ago', he says, 'students at the French school in Rome were showing new arrivals some letters which had been written on one of the most inaccessible points of the dome of St Peter's. It was Goya's signature'.[35] Thirty years later, however, even more extraordinary documentary evidence relating to Goya's life would be published, and believed by some.

A more significant departure from earlier views of Goya relates to his religious beliefs, or rather, lack of them. For Mathéron, Goya was a complete sceptic, and not merely 'an artist who had little liking for monks' which was Baudelaire's assumption, and a not uncommon one. Mathéron suggests that Goya had clashed with the Inquisition long before his *Caprichos* were published. As a youth he had taken part in inter-parish battles in Saragossa, according to the Frenchman, and was in danger of being imprisoned by the Inquisitor General of the city. Even before Mathéron inserts this presumably apocryphal episode into Goya's life-story, he relates an anecdote about a supposed interview between the artist and the Bishop of Granada in the Quinta, which appears to support the theory of his scepticism.

On a number of occasions the artist made an explicit declaration of faith [in scepticism]. One of these took place in the presence of the Bishop of Granada who went to visit him one day in the studio of his country house. The worthy prelate had hardly entered when his attention was drawn to a picture in which a ghost could be seen rising out of his tomb and writing the word 'Nothing!' on a page which his vacant eyes would never read. Various phantoms of un-certain shape filled the background of the canvas, one of which stood out, holding a balance with empty pans facing downwards. The bishop spent some time contemplating this composition and then exclaimed:

—Nothing! Nothing! What a sublime conception: Vanity of vanities all is vanity.

Goya, who was old and deaf, asked one of those who were present what the bishop had said.

—Ah!—he exclaimed, when he had been told. 'Ah, poor Lord Bishop, how he misunderstands me! My ghost really implies that he has been to eternity and found nothing there.

This explanation cannot be refuted. But the painting was not enough. A picture must stay where it is put, while sheets of paper with engravings on them can

26. Goya: 'Nada. Ello dirá', *The Disasters of War*, No. 69. Working proof, *c.* 1812–20. Madrid, Biblioteca Nacional. Carderera Collection.

reach the four corners of the earth. So this daring sceptic etched the same sad and disturbing scene so that everyone might know what he felt. The age of blind belief and conventional acceptance had long past for him, and his extreme views make us realise that even the sun has spots on it.[36]

Mathéron's story is basically an elaborate commentary on No. 69 of *The Disasters of War* ('Nada. Ello dirá'. Plate 26). Was the painting which is supposed to have preceded the etching (a canvas and not therefore a preliminary wash drawing) a fiction, and, like the Bishop of Granada's visit, simply Mathéron's own invention? Alternatively, was this one of the countless anecdotes about Goya which all French enthusiasts mention as going round Madrid at the period? There is no way of telling. Carderera certainly spoke of three of the *Disasters* as having 'a saddening scepticism' in them in the *Gazette des Beaux-Arts* in 1863.[37] So Mathéron was probably only elaborating what was taken for the truth by Spaniards at the time. No. 77 is certainly open to sceptical interpretation. The preliminary drawing

shows the Pope walking a tight-rope in a way which seems to echo a phrase of Voltaire. On the other hand, we would be just as likely today to see a political reference in 'Nada', in view of the symbol of Justice, although it is by no means certain that such an interpretation would be any more correct than that of Mathéron.

Mathéron's contribution was less valuable on the interpretative or general biographical side than on the broader question of the range of the artist's work and his techniques. We have already seen that outside Spain Goya was primarily, and often solely, known as the author of the *Caprichos*. Mathéron sought to ensure that he did not continue to be taken as 'merely a humourist philosopher, a malicious caricaturist and a mediocre satirist'. His book did a great deal in the mid-nineteenth century to widen knowledge of the artist's output. His tentative catalogue of Goya's work listed some seventy-one paintings, most of the etchings (though not the *Proverbios* or *Disparates*), and eight lithographs. It also gave an indication of the large quantity of drawings left by Goya: a considerable advance in fact on Carderera's articles of the 1830s.[38]

Mathéron's *Goya* provided basic material for a number of subsequent French books. M. G. Brunet's *Étude sur Francisco Goya. Sa vie et ses travaux* (Paris, 1865) is the first obvious example, although that critic was thoroughly familiar with other publications in French and Spanish. Brunet's main novelty was his detailed description of the *Disasters of War*, drawn largely from M. E. Mélida's commentary on the series which had appeared in *El Arte en España* in 1863, and which had thrown new light on specific references and allusions in many of the plates. Brunet also had access to other new sources in French, notably the articles which Carderera had written and which Philippe Burty had revised for the *Gazette des Beaux-Arts* in 1860 and 1863.[39]

Carderera's new contributions to the Romantic Goya mostly concerned his drawings, etchings and lithographs. He emphasised the spontaneity and vitality of the preliminary drawings which he found greater than that of the etchings themselves—perhaps because they were in his own collection. Writing about the *Tauromaquia*—a work in which 'the genius and temperament of Goya could most easily take flight', and in which 'the impassioned artist reached the peak of his achievement'—Carderera referred to the fifty drawings he owned (fifteen more than were made into etchings) and their expressive quality: 'One can have no idea of the fire, the energy, the violence ('furia') of this beautiful set, much superior to the majority of the engravings.'[40]

The myth about Goya's involvement with bull-fighting also advanced at this period. Carderera contributed to it by describing Goya's special attire for going to *corridas* and by opining that the drawings made one feel 'that Goya himself was a skilful *matador*'. A few years later, when the dramatist Moratín's letters were published, Romantic fancy appeared to acquire a certain basis of fact. In one of the letters from Bordeaux, the dramatist wrote (in typically humorous vein) that 'Goya has fought bulls in his time, and is quite fearless with a sword in his hand'.[41] Small wonder that in Mathéron's next successor, Charles Yriarte, Goya was not only a Don Juan (Brunet), with a more extraordinary life than Benvenuto Cellini

(Carderera), and a certain duellistic and mountaineering ability (Somoza), but had actually joined a *cuadrilla* and killed in the bull-ring.

Charles Yriarte (1832–98) was of Spanish descent, though born and bred in France. He was originally destined to be an architect, and was a fair draughtsman, but he ultimately made his career in the civil service, journalism and the Fine Arts. Apart from writing widely and sensitively on the arts he acquired a considerable reputation as a connoisseur. In the second half of his life he was a valued advisor to Sir Richard Wallace of Hertford House and Wallace Collection fame.

His first important contact with Spanish affairs seems to have occurred in 1859, when he went to Morocco to follow the Spanish campaigns as a reporter. In this way he met not only the Spanish Liberal General O'Donnell, but also the novelist Pedro Antonio de Alarcón, with whom he shared a tent, and the artist Fortuny, on whom he was later to write a book. It was probably Alarcón who introduced him into cultural circles in Madrid in the 1860s.[42] At that period Goya was increasingly seen as an expression of the liberal aspirations of Spanish people, and a protagonist of this view whom Yriarte must have met since he was a close friend of Alarcón, was Gregorio Cruzada Villaamil, Sub-Director of the Prado and editor of *El Arte en España*. Yriarte's emphasis on the political significance of Goya and his revolutionary overtones would be a natural by-product of these circumstances. His personal interest in the social and historical context of art gave him another reason for approaching Goya from a political standpoint.

Yriarte first mentioned Goya in *La Société Espagnole* (1861) which he wrote in 1860. There he described him, very much in Gautier's terms, as the sole survivor of Spanish art: 'a wild genius, half angel and half Satan',[43] painting picturesque Spain while it still lasted. In his book on Goya published in 1867, the Romantic view of the artist persisted in Yriarte's account of Goya's life. But his excellent Spanish contacts enabled him to see many letters and paintings which had not been studied previously, and he made an attempt to approach Goya's art and its interpretation more systematically than his predecessors.

In his view, there were three different artists at work in Goya: the monumental painter (responsible for the frescoes and historical subjects); the portraitist; and the engraver. Like Mathéron, Yriarte recognized that only the third of this trinity in unity was well known outside Spain. He tried to right the balance by describing many of the paintings in detail and by including fifty reproductions in his book. Furthermore, Yriarte departed from the common conception of Goya as an anti-academic, inspired, but often reckless, artist. 'Manque de conscience', and lack of care over detail, were not qualities that Yriarte or his public entirely respected. He realized that Goya was sometimes guilty of careless workmanship, but drew the attention of the public to instances of Goya's polish and skill. 'We shall show all the aspects of Goya's art and all his various faces in this study', Yriarte claimed. 'Readers in France', he went on, 'will perhaps be surprised by the incredible variety of his work. He has always been thought of as a daring, rapid, fiery and careless artist, yet he can on occasion turn out to be as refined and polished as the great French masters of the last century.'[44]

So far as Goya's technique is concerned, Yriarte for the most part quite simply goes back to Carderera. Much of what he says about it in his general survey of Goya's work is either manifestly or silently borrowed from the Spaniard's articles. He adds much of the stock French view to that of Carderera—Goya the social critic and religious sceptic—and then embellishes this with a Goya familiar with the ideas of the Enlightenment and the French revolution: Goya 'philosophe'. In the following description of the artist it is easy to see how Yriarte builds on a new wing to Carderera's and Mathéron's earlier edifice.

> Goya is above all else a temperament: a human being who is both seductive and corrupt. He believed in nothing and held nothing sacred. Although we have often found invocations to the Virgin, pious reflections, prayers and vows in his letters, we are unable to see them as anything more than a persistent habit, a mechanical return to childhood ways. The man who engraved the plate *Nada* (Nothing) in the *Caprichos* [sic], could not have been a believer, not even a lapsed one, and everything about him seems to give evidence of his deep scepticism. But from a literary and philosophical point of view there are few men of his calibre in the history of art. Leaving his painting on one side, the mind of Goya is unfathomably deep and extraordinarily disturbing. The virtually unknown engraving the *Giant dreaming in solitude* [Plate 27], suggests a whole range of new ideas. Goya has divined everything, foreseen everything; and whether he speaks or writes, paints or draws, he is pure intelligence. He was a man of the Enlightenment, a *philosophe*; the representative in Spain of the great iconoclastic movement of the French Revolution. He attacked everything which stifled free thought; he was the Juvenal of his times, although he was also guilty of some of the false values and moral turpitude he attacked. He respected neither the family, nor the monarchy, nor the God of his fathers; and yet his *Caprichos*, according to the artist himself—and this is pure irony—was a course of high morality. He never gave up the attack, even when he seemed most fervently to pursue the very social status he castigated with his graver's tool. Although he lived among princes and high society, he never abdicated his right to criticize, and the hand which one day was accepting favours, was the next hurling bolts of steel at the very person who dispensed them. He appears to have made a distinction between a person's character and the person himself. And he was capable of feeling warmly disposed towards an individual whose vices he attacked.[45]

Yriarte in this passage states one of the fundamental paradoxes of Goya. In extreme terms, perhaps, but it had never been so clearly stated before. Furthermore, no previous critic had investigated Goya's life and work so thoroughly. Yriarte was familiar with many of the drawings in private hands—those in the collections of Carderera and Federico Madrazo more particularly—and he had read the correspondence between Goya and his Saragossa friend Martín Zapater, which was to be published in part by a relative in 1868 as a refutation of Yriarte's and Mathéron's conception of the artist. He sometimes irons out difficulties too easily, and on occasion certainly distorts, when one of his stronger prejudices about the artist is involved.

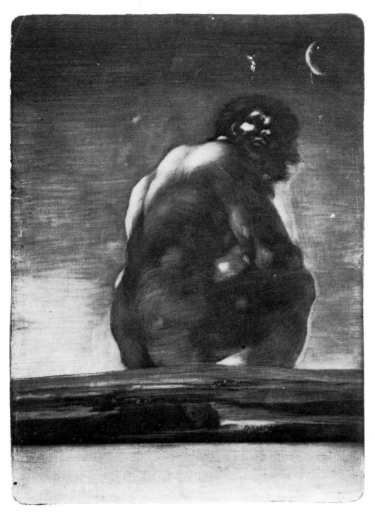

27. Goya: *The Colossus* (or *The Giant*), Mezzotint, *c.* 1810–18. New York, Metropolitan Museum. The Harris Brisbane Dick Fund, 1935.

This is particularly the case with Goya's religious ideas, and it is interesting to see the biased terms in which he discusses Ceán Bermúdez's article on *St Justa and St Rufina*. His bias is aided and abetted by mistranslations italicized in the passage below.

The worthy Ceán Bermúdez, Goya's faithful friend, as soon as the painting was in place, hastened to write an article on the new work in No. 73 of the *Scientific and Literary Chronicle*, a small periodical which was then being published in Madrid. It is a curious article, published anonymously, with the words 'Artículo remitido' ('Article sent to the editor') instead of a signature at the end. The whole piece is a pompous eulogy of Goya by Ceán, and it contains the following naive lines: 'Steeped in the faith in God, love and constancy which guided *him*, Goya endeavoured to find forms, expressions and poses which would *prove* these high virtues.'

One can hardly suppress a smile when one recalls that Goya had used as his models two ladies of ill repute, and that the old sceptic had told those who had ears to hear: 'I am going to make them worship vice!'[46]

Yriarte has swallowed whole the nineteenth-century tale that Goya used prosti-
tutes as models for his religious paintings, and then takes this as proof of the artist's
scepticism. Richard Ford had heard the same story about the models of *St Justa and
St Rufina*★ and recorded it in his *Hand-Book for Travellers in Spain* (1845), some
twenty years earlier.[47] Yriarte perhaps took the first half of his thesis from this
source and added the anecdote about Goya's cynical desire to make religious people
'worship vice' from some other informant.

Despite distortions of this kind, the usefulness of Yriarte's work in its time should
not be underestimated. He wrote about the *majas*—both of them—and publicly urged
the San Fernando Academy to bring the naked *maja* out of her hiding-place in a
dark room, where she found a 'shameful' home. He also incidently related a rumour
that the clothed *maja* was a portrait of the Duchess of Alba, and then rebutted it.[48]
Baudelaire had believed that both were the Duchess and had described the undraped
aristocrat as 'une bizarre fouterie'.[49] Yriarte also did much to awaken interest in the
Disasters of War which had only recently been published. He clearly felt the work to
be superior to both the *Caprichos* and *Tauromaquia* etchings, previously high-points
of Goya's art in Romantic eyes. Finally, he described in some detail the Black
Paintings and seems to have had the intention of writing a short pamphlet about
them, illustrated by photographs.

Yriarte places the Black Paintings, surprisingly, in the realist tradition. He
believed that Goya had taken epic or mythological subjects and denuded them of
their conventional poetry, painting man-made horrors rather than poetic or sublime
ideas. The treatment might not be realistic but the underlying concept was, and
Yriarte's descriptions of *Saturn* and *Judith* bring out his point very clearly.

The *Saturn* is terrifying. (See the oval reproduction at the end of the chapter).
He stuffs his gaping mouth with food, tears at the flesh, and blood flows. He holds
the child by the middle with his tense fingers. The scene is one of cannibalism
which has nothing to do with mythology. This murderer is no god, but a fearful
being with a villainous face, and the piece of flesh representing the victim is
ghastly. One turns away in horror, yet must admire the energy with which
Goya has transferred one of the most ingenious inventions of classical fable into
real life terms, stripping the subject of any historical quality. This figure with its
burning eyelids lingers in the mind like a bad dream. A pendant to it is *Judith* who is
shown holding out the head of Holophernes to the old woman. Once again, there
are no epic touches here. The same realism, the same standpoint. The daughter of
Bethulia is a known model, Ramera Morena, and looks like a slut from some inn.
She was one of Goya's regular models, whose name has been preserved. As for
the old woman, she is like one of those Spanish duennas which one finds in Goya's
etchings, accompanying a young girl for a walk in the Prado, or giving her
lessons in vice.[50]

★According to Ford the ladies were supposed to have been called Ramona and Sabina, and Ford
remarked sardonically that similar use had been made of the 'mistresses of painters and great men'
in classical antiquity, Arellius being 'remarkable, like Goya, for painting goddesses from improper
models'.

As elsewhere in the book, Yriarte's preconceived ideas about Goya lead him to treat some stories about the artist extraordinarily uncritically. The idea of his drawing *Judith* from life seems almost grotesque today, and somehow detracts from the partly valid points about Goya's treatment of mythological subjects. Later Spanish critics were particularly amused by Yriarte's pseudo-documentary touch about the model's name. Apparently the Frenchman did not realise that Señorita Ramera Morena was the Spanish equivalent of Miss Dusky Whore.

The Black Paintings are necessarily preliminary sketches for realist works, not the finished article. Yriarte is hard-pressed to make the paintings fit into this academic category, but he tries when he sums up the group as a whole:

They are not finished works, but rather furious first drafts; and not even the roughest sketches of Eugène Delacroix can give any conception of them. The dominant notes of the work are terror and exaggeration. When Goya painted a commissioned work he made concessions, and sometimes finished his canvases carefully. But it is easy to understand that, when he was painting his own house, he could give full rein to his taste for loosely knit and ill-defined compositions, and let his liking for free brushwork express itself. The spectator who is prepared for this is able to accept his strikingly crude standpoint and only notices the bravura of his brush, the skilful handling of colour and the energy of his facial expressions. Those who are passionate about polish and used to the laboured products of certain schools of painting, will recoil in horror before these orgies of colour. I will admit that Goya cannot for a moment have used a paint-brush for these frescoes, and that he must certainly have employed a palette-knife and his fingers to create these monsters of a morbid imagination. Such works are quite exceptional in painting, and will always be outside the bounds of any school: a dangerous influence perhaps, on some artists. What we must emphasize—and this is a note for a physiological study of the artist—is that Goya was able to live with this hell, surrounded by these monsters born of a disturbed mind. Those who merely visit the house are horrified or shocked to see the frenzied creations of an instinct that was obsessed with the fantastic. Goya himself felt in his element there, and painted these awe-inspiring fantasies by choice.

In conclusion, if we only regard these paintings as crude sketches, what painter would dream of expecting more of an artist who is so skilful at making his figures float in the air, at fixing them in exactly the right places in relation to one another, so that the picture is there and the eye is satisfied. Need we add that the lack of precise detail in the work, which is usually a subject for adverse criticism, has the advantage of freeing the spectator's mind, so that it can roam unhampered through the vast spaces of the imagination, following the fantastical inspiration of this feverish and anxiety-ridden genius.[51]

The end of this passage is almost pure Baudelaire. Other parts of it are almost pure academicism. But Yriarte did not have the poet's genius for handling paradoxes, and was consequently more at home when dealing with the political rather than the imaginative aspects of Goya's art, in which the relationship between form

A la fin ces Voleurs infames et perdus , Monstrent bien que le crime horrible et noire engeance) Et que c'est le Destin des hommes vicieux
Comme fruits malheureux a cet arbre pendus Est luy mesme instrument de honte et de vengeance, Desprouuer tost ou tard la iustice des Cieux . 11

28. J. Callot: *Les Misères et les Malheurs de la guerre*, No. 11, 1633. Dublin, Trinity College Library.

29. Goya: 'Tampoco', *The Disasters of War*, No. 36, 1810–20.

Tampoco.

and content was less easy to discuss. So far as the etchings are concerned, Yriarte generally followed the interpretations of the more explicitly political commentaries on the *Caprichos*, one of which was lent to him by another French Goya expert, Lefort. Where no commentary existed, as in the case of the *Proverbios* or *Disparates*, he tended to shirk the issue. 'If we were treating the problems of the engravings in the same way as those of the paintings,' he asserts shrewdly, 'we could show that these extraordinary compositions can be explained, and that they are capable of political interpretation like the *Caprichos*.'[52] On the other hand, his view of the *Disasters of War* series is open and challenging—he had been a war artist himself—and his contrast between Goya and Callot, with whose *Misères de la guerre* Goya's etchings had inevitably been compared, is particularly perceptive (Plates 28 and 29). Only a tendency to over-emphasize the national differences behind the artists' view-points, and under-estimate Goya's awareness of the barbarism of the Spanish as well as the French, gives cause for regret.

Callot engraves the *Misères de la guerre*. He shows us camp life, burning towns, people fleeing before armed hordes, convoys of wounded soldiers, young children bereft of their mothers; and yet this only arouses our curiosity. We admire the delicacy of his lines, the superb bearing of his horsemen, the picturesque dress, the decorative rags and tatters, and, distracted by a thousand ingenious details, we contemplate with complete equanimity those pretty scenes of violent disorder that reflect the cavalier manner of the elegant and subtle artist that is Callot. Goya, on the other hand, depicts the *Disasters of War* and shows us the fearful price and terrifying forfeits war exacts: fire, theft and rape. He depicts ravished women, the appalling mutilation of enemy soldiers, the despoiling of churches, piling horror upon horror, sacrilege on sacrilege, and crime on crime. The shock and terror are continuous. Musket and sabre are no longer adequate instruments of destruction, and he puts axes in his enemies' hands. Even women fight, and babes are pulled from their mothers' breasts to swell the numbers of victims. A nightmare grips the imagination of anyone who looks for a moment at this work; it lingers in the mind. Callot has filled his scenes with sunlight, the shadows cast are thin, neatly silhouetted. Light dominates the work. Goya has invoked darkness, and it seems as if the sun dare not light up the fearful butchery. The man from Lorraine tells his story without anger: that is how it was, he saw it, and has depicted it without very much emotion. He is too busy organizing his lines and arranging his composition satisfactorily. The man from Aragon breathes fire and anger. He could not repulse the invader single-handed, so he throws taunts furiously in his face, and stigmatizes him. He makes the enemy impious, cruel, cowardly, pitiless, and with the exaggeration to which his violent nature was prone, he gives him all the vices and keeps all the pity and heroism for his compatriots. Callot is a man of the North, and Goya a man of the South . . .

In my opinion, no bloodier pamphlet against war and the spirit of conquest has ever been written; it is an act of revenge, a violent protest. Every plate strikes a new blow; the point is constantly reiterated: eighty variations on the same appalling theme.[53]

Yriarte's book seems the culminating point of Romantic and post-Romantic views of Goya. No other country produced anything comparable at the period. But then, no other country had such close artistic contacts with Spain.

In England approval of Goya's Romantic qualities tended to be modified by the Victorian critics' concern for academic standards. Richard Ford, for instance, who spent some of the peak years of the Spanish Romantic period in Seville in the 1830s, certainly disapproved of the cool classicism of Goya's *St Justa and St Rufina* (Plate 22) since he described it as a 'David-like abomination'.[54] On the other hand it is equally clear that he found the *Caprichos* lacking in technical polish, since he says that it is a 'slight mistake' for the artist's 'unmechanical countrymen who have had few engravers' to think of him as a combination of Hogarth, Rembrandt and Callot.★ It is true that the small scenes by Goya in the San Fernando Academy in Madrid roused some measure of enthusiasm in Ford, presumably because of their realism and concern for national customs. He considered the *Madhouse, Inquisition Trial, Village Bull-fight* and *Burial of the Sardine* 'among the best productions of modern Spanish art'. But given Ford's low opinion of modern Spanish art, his praise is less significant than it seems.[55]

More positively favourable in his view of Goya was William Stirling, who collected etchings and paintings by Goya and accepted some of Gautier's assessments of his work.[56] 'As a satirist with the pencil', Stirling asserts, 'Goya stands unrivalled in Spain, of which he may be called the Hogarth.' The artist's attacks on the clergy and religious orders are given due space, and Stirling also mentions 'four of his hasty sketches of children at play' in his own possession, 'in which are introduced some small urchins, equipped as miniature friars and pummelling one another with all the ardour of Dominicans and Capuchins bickering about the doctrine of the Immaculate Conception, or the right of vending indulgences'.[57] Goya's technique of painting with 'sticks, sponges, or dishclouts, as with the brush' is mentioned, and Gautier is inevitably quoted on the subject. The political satire in the *Caprichos* is also referred to, and Gallardo's recollection of the artist's caricatures of Godoy in sand is used is used to back up the political angle. In a more superficial way, Stirling discusses Goya and the grotesque, briefly touching on the *Disasters of War, Tauromaquia* and the *Bulls of Bordeaux* lithographs. Romantic material is used, yet Romantic attitudes are not expressed. Stirling was perhaps too academic by temperament to embrace French Romanticism wholeheartedly, and at one point he mocks Gautier with some justice as one who 'prefers antithesis to precision'.

Although the Pre-Raphaelite movement at the same period gave rise to more hostile reactions to Goya, several English comments on his work from the 1860s and 70s follow the French Romantic line rather closely. For H. O'Shea in his *A Guide to Spain* (1865), Goya was 'one of the few really original Spanish painters who struck out a new path': an artist of great imaginative power and a 'truly

★The mildly deprecating irony of this phrase is not offset by references to Goya elsewhere. The painting in San Francisco el Grande in Madrid is 'no better' than the picture by the 'feeble Bayeu'; the cupolas in the Pilar at Saragossa are 'poor'.

national . . . genius'.[58] In 1872, Sir Henry Layard—ambassador to Madrid for the two previous years—also referred warmly to Goya's originality, his facility of execution, his powerful colouring and the simplicity of his style, although he thought that Goya would have reached greater heights had he lived at 'a more favourable time, and had he been placed under higher and nobler influences'[59] (presumably like those of Victorian England). Then, a year later, the most thorough-going purveyor of the French Romantic Goya in England and Ireland came on the scene: William Bell Scott. Scott devoted four pages of his *Murillo and the Spanish School of Painting* (1873) to Goya, and drew heavily on Mathéron and Yriarte for the biographical details. Realism and the mixture of contrasting emotions, beloved of the Romantics, evidently appealed to William Bell Scott personally. A painter of some remarkable industrial scenes, Scott was also enthusiastic about Musset and Baudelaire, and some of his own poems reflect the latter's attitudes.[60] He found realism in the *Disasters of War*, and 'an unique combination of horror and beauty' in the *Caprichos*. He stressed Goya's stylistic independence, his refusal to be dictated to by Church or Court ideologically speaking, and his ability to combine the roles of thinker and creator (Yriarte's Goya 'philosophe'):

> In the opinion of the writer, however startling may be the assertion, Goya is exactly the most interesting genius Spain has produced in art, although he has no value in history. His province is not in any degree definable by the technicalities of the studio; he had not the training of Ribera or Velazquez, nor the assimilative capacity of Murillo; but all the masters of all of the schools of Spain were more or less self-satisfied slaves of the *Lamp*, the Church, that is to say, and the court, but still slaves; and can hardly be said to have done the world any good except by increasing its material wealth. Goya was an inventor, a thinker in the modern manner, and gives us the most vivid and novel sensations, although he serves us with vinegar as well as wine.[61]

Scott's views can hardly have passed unnoticed in England, and must have reached a wide public when they appeared in his article on Goya for the 1886 edition of Bryan's *Biographical and Critical Dictionary of Painters and Engravers*. Earlier editions, like those of 1849 and 1866 had no such article at all, even though the brothers Bayeu were included. Scott's entry gave Goya a Romantic biography and singled out the *Caprichos* as the 'most surprising series of Goya etchings, showing humanity in all stages of brutality and ugliness, with a *mélange* of beauty and demonology quite unexampled'.[62]

Goya's Romantic image, which we have followed from the country of his birth to France, in which he died, and thence to England, obviously survived in Spain despite conservative opposition. It was especially vigorous in the last three decades of the nineteenth century. The temporary collapse of the Spanish monarchy in 1868 lifted some of the constraints, and Goya's politics attracted more open attention. José Caveda, in his *Memorias para la historia de la Real Academia de San Fernando* (1867), written just before the Spanish revolution, noted the way in which Goya's satire struck at 'the sordid intrigues of courtiers' and the 'machinations and deceit

of the highest persons in the state'.[63] Like the French Romantics Caveda admired Goya's imagination and independence; and he quoted Mathéron and Gautier approvingly against the more conservative Viardot. Twenty years later, even the conservative Marcelino Menéndez y Pelayo, in his monumental *Historia de las ideas estéticas* (1887), gave the reader a Romantic appreciation of Goya's 'unique mixture of ordinary realism and inspired fantasy'.[64]

But the two *pièces de résistance* of the Romantic Goya appeared in Spain in 1878 and 1886. The first was the invention of the Spanish novelist Antonio de Trueba (1819–89), who celebrated the bull-fighting, Alba-loving and battle-watching Goya in Chapters 5 and 8 of his *Madrid por fuera*, written in 1873–4 and published in 1878. Trueba gave his information a semblance of authenticity; he claimed that the stories had been given him in the late 1830s (when he was working in his uncle's ironmongery business in Madrid) by Goya's old gardener, Isidro. His assertion that Goya watched the executions of Spanish patriots by French troops on 2 May 1808 from the Quinta del Sordo cannot be true: the artist did not acquire the house in question until 1819. Isidro also confuses Goya's etchings with his paintings. The 'drawings' Goya is supposed to have made on the spot are clearly a mixture of the famous *Third of May 1808* and perhaps Nos. 22 and 23 of the *Disasters of War*. Isidro tells us that the first of the *Disasters* series of etchings was made the day after the executions; yet we know that the earliest plates in the series are dated 1810. The paintings were made still later, and there is little to encourage us to believe Isidro's stories. Nevertheless, Trueba knew how to write good Romantic melodrama, and the theatrical flavour of his description emerges when Goya calls Isidro 'Othello' by mistake (presumably confusing his servant with *Isidoro* Máiquez, an actor friend of Goya who was known for his performance of the Spanish translation of Shakespeare's play). Here are two specimens of Trueba's inventiveness:

> One afternoon Sr. Isidro was talking to me about his illustrious master Don Francisco de Goya. He said: 'My master had two great passions which nothing could shake: bulls and the daughters of Eve. Would you believe it but when he was eighty he still thought he could kill a bull better than his [bull-fighter] friends Romero and Costillares. At that age his eyes would still light up when he went to La Florida and looked at the angels he had painted on the dome of San Antonio, modelled on the most beautiful ladies he knew at the Court of Charles IV. From the time when that witch, the Duchess of Alba, encouraged his attentions and led him astray, my poor old master was easily induced to enjoy himself . . .'

> 'Have you seen the wonderful pictures my master painted of the horrors of war?', Señor Isidro asked us. 'Well, the bell tolling in La Florida reminds me of the very day and night my master first had the idea of painting them. He was burning with indignation. From that very window [in the Quinta del Sordo] he watched the shootings on the hill of Príncipe Pío, with a spy-glass in his right hand and a gun loaded with a handful of shot in his left. My master and I would have been like Daoiz and Velarde [officers who led the rebellion against

the French in the Artillery barracks], if the French had chanced to come in our direction. When it was nearly midnight my master said "Isidro, fetch your gun and come with me." I did as I was told, and where do you think we went to? Well, we went to the hill, where those who had been executed were still lying unburied. I remember it all as if it were yesterday. It was a moonlit night, but the sky was full of black clouds: dark one minute and light the next. My hair stood on end when I saw my master, gun in one hand and sketching pad in the other, going towards the dead bodies.

When my master noticed that I was beside myself with fear, he asked me, "Are you trembling, Othello?"

Instead of answering, "The devil I am", I nearly burst into tears, thinking that my master had taken leave of his senses, since he called me Othello instead of Isidro.

We sat down on a slope at the foot of which the bodies of the dead were lying, and my master opened his sketching pad, placed it on his knees and waited for the moon to go through a patch of cloud which hid it for a moment. At the bottom of the slope there was something panting and grunting and fluttering around. I . . . I confess I was trembling like a reed; but my master was as calm as ever and went on preparing his pencils and paper in the dark. At last the moon shone out, and it was as light as day. We could see a number of corpses lying in pools of blood, some face downwards, others on their backs. Here there was one on his knees as if to kiss the ground; another had his hands raised to the sky as if calling for mercy or revenge. A group of hungry dogs feasted on the corpses, panting greedily and growling at the birds of prey which fluttered in the air above them, prepared to fight for their share of the prize.

Whilst I looked fearfully on at the appalling scene, my master copied it. We returned home and the next morning he showed me the first etching about the war, which I found terrifying.'[65]

The second museum piece of thoroughly romanticised Goya appeared in 1886 in a periodical called *La Ilustración Española y Americana*. Its author was Ildefonso Antonio Bermejo, and he gave his readers a Goya who was a friend of ordinary people, of bull-fighters, gipsy girls and loose-living monks: Goya the defender of unorthodox behaviour, using his influence at court to protect a young man accused of sacrilege for striking a friar—a young man who turns out to be the illegitimate son of the Conde de Campomances to boot. What is more, Bermejo purports to give documentary evidence for all this: letters addressed to Goya, acquired from the artist's descendants.[66] After transcribing some of these letters from the high born and the low in the first part of the article, Bermejo invents a fictitious episode in Goya's life in the second. Although the whole ridiculous fancy was taken seriously by some in the nineteenth century, the story now seems more like the imaginative recreations of Goya's life and times that occur in paintings dating from much the same period: Antonio Pérez Rubio's *Moratín and Goya studying the customs of the people of Madrid* (1871), *The Duchess of Alba in San Antonio de la Florida* (1871), and *Goya and the Bullfighter Pepe-Illo on a romería (or picnic-*

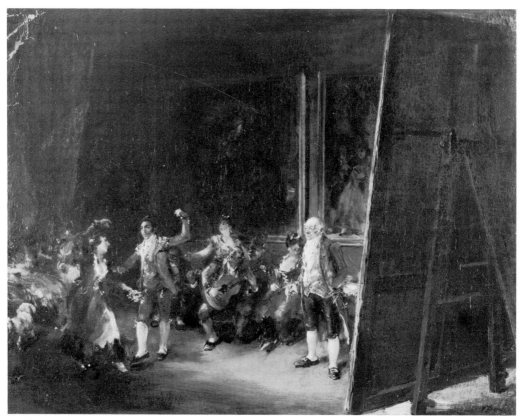

30. Domingo y Marqués: *The Studio of Goya*, 1888. New York, The Hispanic Society of America.

cum-pilgrimage) (1878); or Francisco Domingo Marqués' painting of the artist in his studio (Plate 30) watching *majas* and *majos* dancing *flamenco* (1888), and Casado del Alisal's painting of the same studio subject (1876) showing a model posing for the *Clothed Maja*, while friends of the artist look on (Plate 31).[67]

The Romantic view of Goya proved extraordinarily enduring. Or perhaps it would be truer to say that aspects of Goya's work which the Romantics had particularly admired continued to appeal, even if they were no longer thought of as Romantic. Writers in Spain like Angel Ganivet and Emilia Pardo Bazán preserved at the end of the century the idea that Goya reflected the life of his people. And in 1902, Paul Lafond was still ascribing Goya's greatness to his spontaneity, realism and naturalism. The following year, C. S. Ricketts, in *The Prado and Its Masterpieces*, denied that Goya was a Romantic in the usual sense of that term (involving nostalgia and 'the regret for splendid things'), yet, nevertheless, saw him as an artist 'who found his material at hand': that is, a realist. So Ricketts was still waving one of the many arms of that Vishnu or Shiva-like movement we call Romanticism. The Romantic Goya travelled in space as well as through time. In Russia, the nationalistic elements which had been found in his art appealed to a generation that applauded the exploitation of Spanish folksong by composers like Glinka

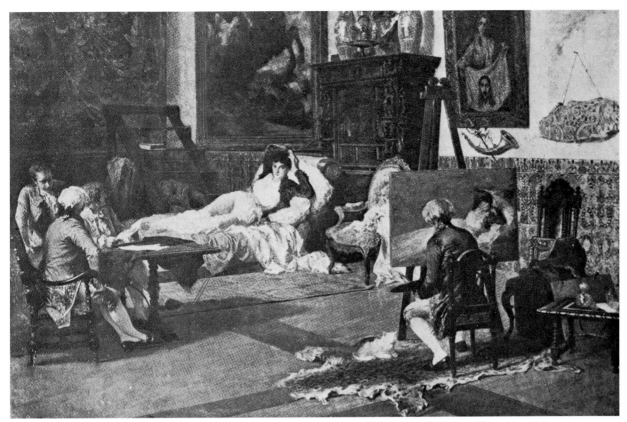

31. Casado del Alisal: *The Studio of Goya*, 1876. Reproduction from *La Ilustración Ibérica*, Barcelona, 1892, 4.

and Rimsky-Korsakov. V. V. Stassow (1884), together with M. V. Watsine, believed Goya to be highly relevant for Russian art, for his sense of real life and emotion as well as his nationalism.[68] In Germany, where Spain had long been at the centre of Romantic traditions, the Romantic Goya flourished equally. In 1880, Hermann Lücke's study in No. 87 of Dr Robert Dohme's *Kunst und Kunstler, Spaniens, Frankreichs und Englands* was full of material from Mathéron and Charles Yriarte. Richard Muther subsequently saw Goya in a typically Romantic light as a realist and chronicler of his people, also as a Promethean spirit, like Goethe and Schiller: one of the great revolutionaries whose works shook the old régime to its very foundations. Muther's views circulated widely, first of all in his *History of Modern Painting* (German edition 1893; English translation 1895–6 and revised 1912; Russian edition, 1899); later, in his book on *Goya*, which was published in German in 1904, and appeared in English and Spanish in 1906 and 1909 respectively. The apparent success of this second book (which has interesting things to say about the Impressionist and Decadent aspects of Goya's work, as we shall see in Chapter 6), suggests that the Romantic legend of Goya continued to appeal long after Romanticism itself had been superseded as a literary movement. In reality, of course, nationalist ideas of art, and theories of the artist as a rebel in society, kicking over

aesthetic, political and moral traces, never lose their power to fascinate. Tall biographical stories about artists die hard too, and the Romantic view of the artist whose private experiences and anxieties mould his art survives readily enough in the modern dress of psychoanalytical theory. Many of the apparently new Goyas we shall find, keeping pace with changing artistic movements, are in reality only the Goyas we have already seen in the course of the present chapter. Muther's passage comparing Goya to Goethe and Schiller,★ and contrasting him with neoclassics like Karstens and David, sums up the Romantic view in suitably heroic language:

A wonderful chance ordained that, in the province of art, the most powerful figure of that storm and tumult, the one artist of the age of the race of Prometheus, to which belonged the young Goethe and the young Schiller, should be born in the most medieval country in Europe, on Spanish soil. Against an art that was more Catholic than Catholicism, courtly and mystical, there came by far the greatest reaction in Goya . . .

Francisco Goya preached Nihilism in the home of belief. He denied every-thing, doubted of everything, even of that peace and liberty which he hoped to be at hand. That old Spanish art of religion and dogma changed under his hands to an art of negation and sarcasm. His attitude is not that of an insolent and impetuous youth, who puts out his tongue at the Academy and strikes at the Academicians' high-powered perruques with audacious hand; it is the attitude of the modern spirit, which begins by doubting of all things which have been honoured hitherto. His Church pictures are devoid of religious feeling, and his etchings replete with sneers at everything which was previously esteemed as authority. He scoffs at the clerical classes and the religious orders, laughs over the priestly raiment which covered the passions of humanity. Spanish art, which began in a blind piety, becomes in Goya revolutionary, free, modern.[69]

★ The parallel first appeared in Muther's *History of Modern Painting*, and a shorter version is found in his *Goya*. The earlier text is quoted.

V. Anti-Romantic Reaction and Aesthetic Opposition

THE more conservative nineteenth-century writers either disapproved of Goya, or worshipped him in their own image. Naturally they rejected the conclusions of most Romantic critics. Mathéron's and Yriarte's Goya was soon weighed in Spanish balances and found wanting. Their first critical assessor from a traditionalist viewpoint was Manuel Zapater y Gómez, a man well versed in the history of Aragonese art and with an intimate knowledge of Saragossa.

Zapater y Gómez had family reasons for being well informed about Goya, and since he had been educated in France it is not surprising that he should also have taken an interest in Goya's French commentators. The family connection with the artist was his uncle, Martin Zapater, an Aragonese noble and man of substance, who had known Goya well from his youth.[1] Goya had painted him twice and written to him frequently. Zapater y Gómez inherited the two portraits, a few other paintings and sketches by Goya, and 132 letters in the artist's hand (Plate 32). There was also a legacy of half a million *pesetas*: £18,750 at the period and perhaps fifteen or twenty times as much today.[2]

Francisco Zapater y Gómez's rich petty noble background led him to assume that Goya had been more respectable than the French Romantics claimed. How could anyone brought up amongst petty noble families not accept their high moral standards? French theories about Goya's youthful exploits in Saragossa itself and the country areas around it seemed absurd to Zapater, and it was not difficult for him to show that Mathéron, who had never been to Goya's birthplace and had taken his facts from geographical dictionaries, had described Fuendetodos in excessively poetic terms. Here, for example, is the relevant Mathéron description: 'There exists in the Kingdom of Aragon, not many leagues from Saragossa, a little town called Fuendetodos. The Huerva, a narrow river, flows at its feet; mountains covered with pines and foliage surround it, and it has a magnificent sky-line. The ruins of a castle built by the Moors add a touch of historic richness to the scene.'[3] Zapater's riposte runs as follows:

> Anyone who actually knew the little town of Fuendetodos, which has a hundred and twenty households in it today, and in which—despite what foreign writers say—there is no river, no valley, no pine-clad hills or poetic shepherdesses; whose life and economy is based on agriculture, and the small industry of wells

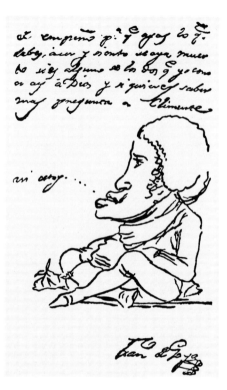

32. Goya: Caricaturesque Self-Portrait from the end
of a letter to Martín Zapater, 2 August 1800,
reproduced in *Museum*, Barcelona, Vol. IV, 1914,
436. Barcelona, Biblioteca Central.

for storing ice; anyone who knew this would understand that Goya's supposed youthful adventures could not possibly have taken place there, particularly in the first half of the eighteenth century, when the noble families of Salvador, Grasa, Aznárez and Lucientes lived in Fuendetodos. Their coats of arms, albeit defaced by time, are still visible on the façades and over the doorways of their houses.[4]

As a substitute for French poetry, Zapater y Gómez offered Spanish prose: selected extracts from the correspondence between Goya and his uncle which were obviously intended to make Goya as nearly as possible the equal and opposite of the Romantic artist. The Romantics had held Goya to be a friend of ordinary people, and fond of associating with actresses and bull-fighters. Zapater y Gómez picks out all the passages in letters which show Goya in contact with the Royal Family and moving in high society: staying with the king's brother in Arenas de San Pedro and enjoying the shooting; taking a delight in watching the procession of royal carriages from the palace to Atocha in Madrid; reporting ecstatically the occasions when he had been received by the king, and first kissed the royal hands— 'I never had such happiness before' (January 1779).[5] The Romantics had believed Goya to be an enemy of the religious orders, a victim of the Inquisition and a sceptic. Zapater y Gómez gives in return a Goya who was an orthodox Catholic, started his letters with a cross, invoked the Virgin of the Pillar in Saragossa, was keen to paint religious images and accept the wise councils of holy fathers: a man who made suitably moralizing remarks when his friend's sister was dangerously ill or his father died. The Romantics believed Goya to be a great womaniser.

Zapater does his best to prove that Goya was a good husband and a faithful family man. Zapater also uses his uncle's correspondence to reveal a Goya who was as near an aspiring bourgeois capitalist as possible: keen to acquire land and run an expensive carriage; pleased when his annual income reached 28,000 *reales* (£222.25 at the period);[6] providing for his relatives and asking advice about investment policy. 'You are clever in money matters and always know what to do, so tell me how I can best place 100,000 *reales* (£1,111.25 approximately at the time). Should I buy bank shares, government bonds, or put it in industry to get the best return on my investment?' (1789).[7]

Zapater y Gómez's facts are, of course, essential to an understanding of Goya as a man. It is no doubt important to know that he bought bank shares, received dividends and thought about profit margins. He even attended the shareholders' meeting at the Bank of St Charles on 24 February 1788—he had twenty-five shares, worth a total of 50,000 *reales*—and he painted portraits of the directors in 1787 and 1788.[8] But Zapater y Gómez failed to realise that letters reflect the personality of the addressee as well as the writer. Goya, like any other letter-writer, tells his friend about things he knows will interest him or flatter his ego. The letters Zapater y Gómez published give us his uncle's Goya, and this is not necessarily the same as Ceán Bermúdez's Goya, Jovellanos' Goya, or Quintana's and Gallardo's Goya.

In instances where we can see the passages Zapater quoted in the context of the whole letters, his bias is evident. There is, for example, a case where he chose a sentence that appears to show Goya as a person with simple tastes and needs. It occurs in a letter Goya wrote when preparing for a journey to Saragossa in 1780 to paint frescoes, and reads as follows: 'My house will not need to have much furniture in it, since once one has a print of Our Lady of the Pillar, a table, five chairs, a frying-pan, a wine-skin, wine, a grill for cooking upon, and light, other things seem superfluous.'[9] The opening of the same letter is rather more Machiavellian, and belies the impression the extract gives of a casual, carefree artist, content with simple faith and simple fare:

> My dear friend. I am delighted you are in good humour and writing to Francisco [Bayeu], and overwhelmed that you so often think of acting in my interest. I shall be going to Saragossa at much the same time as him, since my wife is due to have a child next month at the latest and will hardly be able to set out before. I have not yet found a house to live in. I wrote to Don Martín [Goicoechea?] about it, and he told me that if he could persuade Medinaceli, Aitona's house might well be taken. And that is how things stand at present. I'm ready to rent anything, though I will write to Don Martín about it since he is looking into the matter for me.[10]

In another passage, Zapater y Gómez tells us that Goya had amassed a capital of 5,000 *pesos* as a result of his growing success as a painter and wanted 'to put them to work'.[11] These two facts are extracted from a letter which Goya wrote to Zapater in February 1780. The letter as a whole, however, contains a sudden

switch from initial genuflections towards God and Family to sentimentalized bowing and scraping to Mammon, which rather spoils Zapater y Gómez's epic image of a pious Goya. It runs as follows in translation:

Dear Friend.

I had already heard about your misfortune, and having done my duty as a true friend and commended your worthy aunt to God, I wanted to offer you my condolences by letter. Being away from Saragossa at the moment, I could not be with you in person. Please believe that I should willingly undertake the journey for that end. No words that I can find seem adequate, so I will say no more.

I am delighted that you have the ten thousand *pesos* [£2,222 at the period] your aunt recently gave you, and what is more, that she spoke honourably of you in the will. My dear friend, let me be plain with you. I am enormously grateful for the honour you do me in putting the money at my disposal. But I dare not impose for the present on a man with so many thousands to handle, since over and above the recent ten thousand, there is the money I know you to have invested in land etc.

I have no more than five thousand [£1,111 at the period], and they are yours for the asking. I only wish you had a use for them, so that they could be put to work, and I should be grateful if you would tell me what to do, since you have such a remarkable talent for it. It would hardly be sensible for me to do anything you think unwise!

Please remember me to Luis and your brothers, not forgetting your parents.

<div style="text-align: right">Sincerely yours,
Fran^{co} de Goya</div>

Madrid, 25 February 1780[12]

Apart from conveying the impression that Goya had a greater respect for hierarchies and establishment values than previous critics had thought, Zapater y Gómez also cast doubt on the extent of Goya's involvement with the Spanish Enlightenment—the Goya 'philosophe' of Yriarte's book. Goya, according to Zapater, was 'merely an artist, and as an artist rather than as a man of advanced ideas, he painted portraits of Lord Wellington, Joseph Buonaparte, and, on numerous occasions, Ferdinand VII when he returned from captivity in 1814.' Would he have agreed to paint such different people if he had put ideology before art? As for Zapater's aesthetic judgements, these tended to follow the cautious lines of the more classical art historians. Several sentences of the passage about Goya in his *Apuntes histórico-biográficos acerca de la Escuela Aragonesa de Pintura* (Madrid, 1863),[13] are taken verbatim, though without acknowledgement, from Ceán Bermúdez's views as passed on by Miñano. To these he added some 'national character' touches from the Romantics, so that the *Tauromaquia*, for instance, inevitably became a 'reflection of the character, temperament, and even of the sun of Spain'.

Zapater y Gómez's response to the Romantic Goya was an act of pious rehabilitation—first published by an extreme right-wing Catholic newspaper. Others were

less inclined to question the unorthodox character of Goya's work and simply deplored it. Some of Goya's Romantic virtues now became vices.

His religious attitudes, or lack of them, were an important focus for controversy. The Romantics mostly delighted in the scepticism they attributed to him. Sceptics who were not Romantics were equally pleased. Richard Ford obviously derived amusement from the idea that Goya, carrying Spanish realism to new lengths, asked two prostitutes to pose for his painting of *St Justa and St Rufina* (Plate 22) for Seville cathedral.[14] Those who had a more traditional approach to belief were obviously scandalised, and condemned Goya's religious work on stylistic as well as ideological grounds.

One of the earliest attacks on Goya's religious art came from the German painter and art historian J. D. Passavant. An ardent admirer of Raphael on the basis of his elevated sentiments and fine draughtsmanship, Passavant found both style and content repellent in Goya: the consequence of a serious decline in Spanish taste. The rejection of conventions that Passavant considered appropriate to the expression of religious ideas disturbed him, and in a book on religious art in Spain (1853), he spoke of Goya and his period in the following terms:

> It is very sad to contemplate artistic taste in Spain at the end of the last century and the beginning of the present. A clear proof of its decline can be found in Francesco Goya who was born in 1746 and died in 1828. He was the most celebrated artist in Madrid, yet even the most holy of subjects was treated in a sensual manner by him. His style was insipid and characterless.[15]

Obviously Passavant's antipathy to Goya was deeply rooted. Having studied painting with David in Paris he was not disposed to favour artists who defied academic rules of art and draughtsmanship. When in England he disapproved of Turner's 'straining after extraordinary effects' and 'neglect of all form'.[16] He felt that paintings which only made sense at a distance, as Turner's did, were somehow inadequate, and no doubt found Goya's work unsatisfactory for similar reasons.

Spanish critics soon enlarged on Goya's shortcomings as a religious artist. The Conde de la Viñaza followed Passavant's line, although he thought that a decline in religious belief rather than a fall in artistic standards was responsible for Goya's unidealistic interpretation of religious subjects.[17] Pedro de Madrazo felt that Goya's inadequacies in that area had roots in his psychology or personality. Goya ignored the 'truth and nobility' in human life, while he never failed to emphasize its ugly or ridiculous aspects. For these reasons, akin to those used to attack the realist and naturalist novel at the period, Madrazo held Goya to be incapable of religious inspiration.

> Perhaps this is why his pictures of religious or mystical subjects, for which he had a number of commissions, were seldom successful. In his *The Taking of Christ* for Toledo cathedral, for instance, the Saviour Himself is precisely the least admirable figure. In the dome and other frescoes he painted for the church of San Antonio de la Florida, on the banks of the Manzanares, the miracles of the saint in question are treated without any idealization, as if Goya were depicting

a display by some peripatetic tightrope-walkers. As for the androgynous angels, with their flashing eyes and camellia-coloured skin, they seem more like handsome harlots than heavenly spirits. He also painted, as we have already remarked, frescoes for ceilings and domes in the Pilar cathedral at Saragossa, and in these, as in the other religious paintings, he showed all too clearly his lack of vocation for religious subjects and holy themes. Nothing could be colder or more insipid than the scenes from the life of San Francisco de Borja that he painted for Valencia cathedral. What could be less appropriate than the facial expression he gave to the two saints Justa and Rufina he painted for the sacristy of Seville Cathedral.[18]

Madrazo's comment on the coldness and insipid quality of Goya's paintings in Valencia seems an echo of Passavant. The most influential adverse comments on Goya in the nineteenth century, however, were those expressed by the French critic Louis Viardot (1800–83) in a series of widely read publications.

Viardot was close to Romantic circles in France, and attended the meetings at Nodier's house in the 1820s with Delacroix, Baron Taylor, Hugo, Musset, Dumas, Dauzats and others. He knew at first hand that Goya's imaginative works had been 'much admired by French Romantics'. Having deepened his knowledge of Spain in a visit with the Hundred Thousand Sons of St Louis, and having attacked the theocratic organisation of the Spanish state in his *Letters from a Spaniard* in 1826, he might have been expected to sympathize with much of Goya's work. However, although he recognized the originality and impetuosity of the artist, and admired his paintings of Spanish customs, he was worried by their faults of execution. In his earliest comment on Goya he qualified his praise in a way that is very different from the later approach of Gautier. Speaking of the equestrian portrait of Charles IV in the Prado in his *Études sur l'Espagne*, and accepting that 'the head and bust contain some extraordinarily beautiful touches', he nevertheless felt that the artist had placed the king 'on the back of a pig rather than a horse'.[19] Although the section on Goya in his *Notices sur les principaux peintres de l'Espagne* (1839) is warmer in tone and praises Goya's originality as an artist, describing with some enthusiasm rapid sketches he had dashed off with the flexible point of a knife in his old age, doubts about his draughtsmanship recur. The same reservations in very much the same terms can later be found in *Les Merveilles de la peinture* (1869), which contain virtually a word-for-word transcription of two passages in *Les Musées de Madrid* (1843). The comments made in 1839 run as follows:

Goya was his own master and only took lessons from the dead. His unusual education gave a peculiar bent to his talent—inaccurate, wild and without method or style, but full of verve, boldness and originality. . . . In the vestibule leading to the main gallery of the Madrid Museum, where a few thin sketches by contemporary artists have been grouped together as '*bagatelles de la porte*', you will find Goya's equestrian portraits of Charles IV and María Luisa. These works are doubtless very imperfect, being full of glaring faults of draughtsmanship, especially in the delineation of the horses. But the heads and busts have a singular and unexpected beauty. On the whole, though the paintings prove very defective

under analysis, there is so much vigorous effect, such strength in the brushwork, truth in the colouring and boldness in the touch, that one cannot fail to admire these rare qualities, while regretting the defects which they cannot entirely redeem.[20]

The balance that Viardot strikes between good and bad points in Goya was also struck by several later French critics.[21] In 1855, Paul Mantz believed Goya to be 'the most original if not the most skilful of modern Spanish painters': ignorant, yet committed; misguided, irrational, hasty and unpolished, yet admirable as a caricaturist, as an imaginative artist and as a painter of feminine charms. Mantz found the technique of Goya's *Forge* 'barely tolerable', yet approved of the grace and naturalness of his scenes from the everyday life of ordinary people—'a new genre which he always tackled with the greatest distinction'.[22] Four years later Clément de Ris' remarks about Goya ebbed and flowed in a similar series of antitheses deriving ultimately from Viardot.

> Goya evidently disdained the first principles of his art, *but* he replaced them with fire and dash—the source of his originality—which enabled him to achieve effects no one else would dare to attempt. His draughtsmanship is rudimentary, and shockingly incorrect; yet he always captures movement with singular power. His colour is dull and pale, as if it were covered with a veil; yet the impressions he creates with these crude implements are often realistic and always full of life.[23]

De Ris used the *Charge of the Mamelukes*, hanging in a dark corridor in the Prado, at the time, to exemplify his points. In 1864 yet another follower of Viardot occurs: a certain A. Lavice. Like his predecessors Lavice deplores Goya's technique and admires his originality. In his *Revue des Musées d'Espagne*,[24] Lavice sweeps some major Goya painting aside with pert thrusts. *María Luisa*, in the Prado, is simply 'feeble'; the equestrian portrait of Charles IV 'bad'. The *Portrait of the Family of Charles IV* and an uncatalogued bull-fight are two canvases of 'feeble quality'. The *Majas on a Balcony* (Plate 10) in the Trinity Museum (described as a *Balcony at the Bull-ring*) has an 'original composition' but its technique 'leaves much to be desired'. Exactly the same qualification is made about the small paintings in the San Fernando Academy; and the *Clothed Maja*, like *María Luisa*, is rated 'feeble'. Comments about Goya's bullfight etchings (intermingled with *Caprichos* in the Trinity Museum it would appear) show Lavice taking a high moral view of the topic, and regretting the fact that Goya failed to do likewise.

The concern for a lack of moral taste or elevation which is implicit in Viardot and Lavice, emerges more strongly in an article on 'Modern Art in Spain' written by another Frenchman in 1849, shortly before Passavant made his attack. The author in question was Gustave Deville, who felt that Goya's preoccupation with the seamy side of life and with caricature somehow degraded his art. Deville seems to have been strongly conservative in both art and politics, and only the neoclassic Madrazo receives a measure of praise in his survey. In his view the artist had a cohesive role to play in society; he belonged to a social elite. As for Goya, he wrote:

> Unfortunately, this extraordinary and eccentric man, whose rarer qualities

certainly offset some of his numerous failings, degraded his art by using it for lower emotions. I admit that it is right for a caricaturist to enter the political lists, like a true *guerrillero*, fighting the French invader tirelessly with his mordant wit. But this is hardly the proper role for an artist of undoubted ability, who, had he made the effort, might have become a leading figure in European art.

Goya had no direct influence on painting in his own times. Even today, although some of his compatriots have a moderately good opinion of him, he only enjoys real prestige amongst those who admire him simply because others do so. People of that kind are unaware of the good qualities in his work which have stimulated the interest of artists outside Spain.[25]

So far as France is concerned, disparaging remarks about Goya's technique and aesthetic position continue to be made until the end of the nineteenth century and even in our times. Fernand Petit, in 1877, complained of his careless workmanship and poor finish (although the *Naked Maja* was, apparently to his liking, that is to say, reminiscent of Prudhon's *Zéphyr*). In 1883, the poet Verlaine thought that Goya's realism lacked the aesthetic quality and technical subtlety of Rimbaud's.[26] Théodor Wyzewa, in 1891, went even further. For him, Goya's failings were such that he could not be considered a great artist.

'His works,' Wyzewa wrote, 'which capture the mind as well as the eye in the first instance, soon prove strident rather than strong; their imaginative quality soons palls despite its powerful initial impact; and their realism ultimately seems very superficial . . . Neither in draughtsmanship nor in his use of colour was Goya able to exploit satisfactorily his strong native personality. He tried for effects without taking enough trouble over the means, and so his effects lack any enduring quality. He did not learn early enough the value of judgement, patient, careful work and self-criticism.'[27]★

The fiercest French attack in the second half of the nineteenth century came from Prosper Mérimée in 1869. In a letter dated 16 May, the French writer upbraided his friend, the aristocratic sculptress Duchess Colonna, for admiring Goya. The artist's imaginative gift, even his amorous relationship with the Duchess of Alba, could not redeem his technical shortcomings:

I cannot forgive you for admiring Goya. I had no idea that he had ever been in love with the Duchess of Alba, whom he painted in a yellow shift and transparent dress. But I find nothing in the least pleasing about his paintings or his etchings. It is true that his plates after Velázquez are useful reminders of the original paintings if one knows these already. But how can you possibly consider the *Disasters of War* aesthetically satisfying? He couldn't even draw bulls properly,

★Wyzewa was equally disparaging about the Impressionists. Manet had twenty noble qualities but wasted the lot; others were only skilful machines for making paintings, who could not be expected to develop any originality, since the spark was not in them. Berthe Morisot and Renoir appealed slightly. The former for her elegance and delicacy; the latter for his poetic nature. (*Peintres de jadis et d'aujourd'hui* (Paris, 1903), 217, 334–5, 374ff.)

despite his interest in bull-fighting as an *aficionado*. The *Caprichos* he etched when he was more than half insane have some fairly good imaginative and humorous touches [*drôleries*]. And it is not so much the subjects as the technique of his paintings that disgusts me. If one wants to break academic rules and take a plunge into the realities of ordinary life, one must at least start by copying nature. Goya, on the other hand, would put colours on to his palette without rhyme or reason, and when he found a range of tones to his liking, that was the end of the painting. It would have been better if he had left the patches of colour as they were, and not tried to make figures out of them. Did you go to *Las Delicias*? It's one of the Duke of Osuna's country houses, inherited from his aunt the Duchess of Benavente. Goya painted a series of life-size scenes of witchcraft in it, after the manner of the *Caprichos*. There is a witch changing into a goat that made an impression on me. But to conclude, if one wants to be a realist, in my view one should either follow Velázquez, or leave the whole thing alone.[28]★

Similar views about Goya's defects are found in England at much the same period. In Victorian times, attention to detail, neat draughtsmanship and good technical training were qualities which most critics expected all artists to have, and which Goya seemed to lack. Turner's late paintings of the 1840s were notorious failures by the same token. His *Storm at Sea* was dismissed as 'soapsuds and whitewash', and other pictures were described as 'paintings of nothing and very like'. It is rather surprising therefore that a defender of Turner should have been responsible for the most outspoken attack on Goya and his advocates in England in the second half of the nineteenth century: the painter and writer Philip Gilbert Hamerton.[29]

Hamerton appreciated the need to consider the whole effect of a painting or etching, and recognized that not all detail deserved to be given the kind of attention that Ruskin, for instance, demanded. Ruskin, of course, felt that the best thing to do with a copy of Goya's *Caprichos* was to put it in the fire. He probably found it morally as well as aesthetically hideous since he said that it was 'only fit to be burnt', and he encouraged his friend Ellis to make the appropriate 'burnt sacrifice' of a copy in August 1872.[30] Hamerton burned Goya more publicly in his inquisitorial examination of similar date.

It is difficult to uncover the reasons for Hamerton's intense dislike of Goya's work. For although an over-zealous follower of the Pre-Raphaelites as a practising painter, his taste was reasonably eclectic. He admired Rembrandt's etchings above all, yet approved of the graphic work of contemporaries as different as Méryon and Jacquemart on the one hand, and Turner and Whistler on the other. If the personal qualities of the last two—and their occasional scorn for detail—appealed to him, why did Goya not? Perhaps it was the lack of training[31] and slapdash work which offended him most. A compulsively hard worker himself, always attempting 'too

★The painting of the Duchess of Alba that Mérimée recalls may, in fact, be that of the *Marquesa de Lazán*. He made a copy of it (cf. Ilse Hempel Lipschutz, *Spanish Painting and the French Romantics*, 1972, 112). The witchcraft scene mentioned in the Alameda palace is presumably *The Witches' Kitchen*, now in a private collection in Mexico (Gassier and Wilson 1971, No. 662). It is far from life-size, measuring 45 × 32 cm.

much finish and effect' according to his wife, he seems to have resented artists who were able to achieve rapid results.[32] This resentment certainly marks his first assault on Goya in *Etching and Etchers* (1868):

> As a practical aquafortist (considering for a moment the technical side alone, and without prejudice to what Goya may have done as a painter), I cannot admit that he ever got beyond a rash and audacious dilettantism. It is quite possible that a good painter may be a bad etcher: there are several instances of this amongst our contemporaries; and it is also possible that his etching may bear some of the worst marks of presumptuous amateurship. Goya was original in manner, because he took up the process without profiting by the experience of his predecessors, but ignorance is generally original, for it has no traditions.[33]

A decade later, in 1879, Hamerton returned to the attack, this time inveighing against the Black Paintings. He had seen these at the 1878 Paris exhibition, where they hung on the wall of a corridor leading to the Scandinavian Ethnographic Exposition, next to some bedspreads and curios. Admirers of careful draughtsmanship and conventional values were obviously not going to enthuse over these particular paintings by Goya. The Frenchman, P. L. Imbert, who had described them when they were still on the walls of Goya's Quinta near the Manzanares, reacted adversely both to the style and subject-matter of *Saturn devouring his children*. He considered it a frightening fantasy and 'much too sketchy in its execution'; the whole scene was 'repugnant' and 'of little artistic value'.[34] Others who saw the series at the Paris exhibition felt them to be the work of a madman, and the Italian senator Tullo Massarani wrote that 'nothing appalling is lacking that delirium could ever generate in the diseased mind of demonomaniacs'.[35] Philibert Bréban also reported that they gave rise to 'many criticisms' and 'heated discussions'.[36]

One major new thesis of Hamerton's article was that the enthusiasm felt by some for Goya's work had nothing to do with his art. Politics and personal audacity were responsible for his reputation rather than artistic achievement. For his own part, Hamerton condemned the Black Paintings and much of Goya's work on the grounds of their morbid concern with horror and ugliness, in the same way that his contemporaries condemned the novels of Zola and the Naturalists.[37] While he accepted that Goya's contribution to the liberalization of Spain may have been valuable he believed that he was motivated by recklessness rather than courage, and found his moral position unacceptable. According to Hamerton it was wrong for Goya to satirize vices he practised himself criticizing court circles, for instance, without rejecting their financial support and patronage. Furthermore, you had to have a 'serene and elevated nature' to colour 'tenderly, delicately and purely'. Hamerton ends by lambasting Goya's etchings yet again on technical grounds, and dismissing his technique as a painter on the basis of the Black Paintings. In this way he not only attempted to stem the rising tide of Goya enthusiasm, but sought to drive it back like some aesthetic or moral Canute. A long extract from his article is included in an appendix.[38]

The range of Hamerton's attack on Goya's work is unique. Other Academic

critics tended to confine their sniping to well identified targets like the religious pictures—earlier peppered with shots by Madrazo—and some of the portraits. Gerald W. Smith's piece on Goya in his *Painting, Spanish and French* (1884) is a case in point.[39] Hamerton attacks precisely the aspects of Goya's work many others had admired. He seeks to overthrow the whole Romantic image of Goya with righteous iconoclasm. Unlike Zapater y Gómez, he has no alternative image to put in its place.

Adverse views about Goya of a more limited kind were not uncommon at the end of the nineteenth century. Mrs Margaret L. Woods reports some of them in No. 6 of her series 'Pastels from Spain', which appeared in *The Cornhill Magazine* in September 1900. Her object was to quote extremes and reach a middle way between the enthusiasm of some and the vituperation of others. Although she was used to academic caution, and had married it in the guise of the President of Trinity College, Oxford, she had plenty of sensitivity and impressed William Rothenstein when she met him in Paris as 'a delicate Shelley-like person'. She noted that some of her contemporaries felt Goya's work as a portraitist reduced him to 'the artistic chronicler of the small beer of old Madrid'; others claimed that his portraits were 'hard and ill-drawn', while a few condemned his 'whole technical outfit'.[40]

These comments reflect a post-Ruskinian reaction to Goya, and were not shared by all who moved in English artistic circles. But even admirers found brutality as well as delicacy in his work, and brutality in art was hardly the thing to appeal to the majority of Victorians. Brabazon, for instance, who claimed to have 'preached Goya "to the winds" for years, and no one ever seemed to know anything about him and to care still less' seems to have preferred the Goya closest to Gainsborough.[41] And unreserved praise had to wait for a later generation of English and Irish artists—those who espoused Impressionism, or rebellious spirits like Jack Yeats, for whom most 'great' artists were merely journalists, and only Goya an authentic 'author'.[42] Frederick Wedmore seems to sum up the general feeling in England in the 1890s, when he says that 'Goya—who hesitates at nothing—does not commend himself to the ordinary Briton'.[43]

Although admiration for Goya, even in Britain, grew steadily in the early years of the present century many continued to dislike his art.[44]

The most open expressions of disgust came from the German critic Julius Meier-Graefe, whose enthusiasm waned even as Wedmore's and others waxed. Meier-Graefe (1867–1935) was an important figure not only in the German art world at the turn of the century, but also in France and indeed throughout Europe. He began by writing about the Norwegian Expressionist painter Edvard Munch; became a friend of that key-figure in *Art Nouveau*, Samuel Bing, with whom he 'discovered' Henry van de Velde, and in 1895 founded the very influential periodical *Pan* which he edited. Himself a prolific writer, he became a leading propagandist for modern art, publishing books on Renoir (1911), Manet (1912), Van Gogh (1912), Cézanne (1913) and so on. In his book on *The Development of Modern Art* (1904, English translation 1908), Meier-Graefe echoed the excitement Goya's work produced on Realists, Impressionists and Expressionists in a number of passages.

But already in that work the seeds of antipathy to Goya, which put forth shoots in his later books, were sown. Underlying many of his judgments was a respect for classical ideals, such as control, careful draughtsmanship, spirituality and serenity. He approves of Daumier, for example, as a classicist and contrasts him with Goya, 'whom Mengs was never able to lead into the right road'.[45] He later compares Goya's *Naked Maja* unfavourably with Manet's *Olympia*, because it fails to reach the classical standards of 'emotion recollected in tranquillity'. 'We are silent before the *Olympia*', he writes, 'whereas before the *Maja* we twitch and quiver. The one excites, the other gives the highest art can give: repose.'[46]

When Meier-Graefe actually saw large numbers of Goya's paintings in Spain in 1906 his reaction was more openly adverse. The diary of *The Spanish Journey* presents his progressive disillusionment with Goya, and the reader watches the Goya bucket going deeper and deeper down the well, while that of El Greco mounts on high.

Already, after his first visit to the Prado, Meier-Graefe notes that Goya's paintings strike him as 'far worse than I had suspected'.[47] On another visit, two months later he speaks of 'the indignation which I feel afresh in front of so many pictures by Goya.' As he puts it: 'not even a little pile of ashes of all the admiration I had come with remains.'[48]

Meier-Graefe's criticism of Goya's art centres around two main points, both of them common enough in earlier critics: his apparent inability to finish a work satisfactorily, and his lack of discipline. Too many of Goya's works seemed to have brilliant ideas or approaches, yet to be badly executed. He complains of their inadequacy as paintings, and the fact that they failed to communicate feeling to him. Yet few of Meier-Graefe's points establish anything more than a personal opinion, and he reveals the arbitrariness of his standards particularly clearly when he expresses his admiration for the portrait of the Marquesa de la Solana (then in the Marqués del Socorro's collection and now in the Louvre):

> You cannot conceive anything more daring of its kind which required precisely the qualities which we usually miss so painfully in Goya, good taste and great self-control. A peculiar man. Capable of everything, capable even of hard work, there must have been a hundred different natures in him. There is no connection between this picture and the dreadful scenes from the Casa Goya [i.e. the Black Paintings] in the *souterrains* of the Prado. And into the bargain, they were all said to have been painted at approximately the same period.[49]

Meier-Graefe evidently felt that Goya lacked an analytical mind; he was a clumsy camera, rather than a sensitive individual. Thus he believed that Goya's aristocratic ladies were *really* whores; he could not accept that the artist might have intended to show his subjects in an unfavourable light. 'As Goya was a master of representation we get from him an *unintentional* picture of the manners of the time whose reality is easily penetrable.' 'Goya's aristocratic ladies *somehow betray* their bad "dessous" and their latent profession' in Meier-Graefe's view (my italics).[50]

The logical consequence of Meier-Graefe's position is a rejection of the common view that some of Goya's portraits had satirical aims. He accepts Von Loga's claim that 'the similarity of Queen Marie-Louise to several witches is quite unintentional.'[51] And though he may well have been right that Goya intended no disrespect to most of his upper-class sitters, his feeling that satirical intent is not in Goya's character is obviously wrong. It is difficult to say precisely how his obvious prejudices affected his interpretations of Goya. Did he fail to find life in most of Goya's portraits because he thought eighteenth-century life artificial, or did he deduce the artificality of the period from his own reading of Goya's pictures? Certainly bias of one kind or the other seems to lie behind his comments. He finds the portrait of the Duchess of Alba in the Alba collection 'very poor, like all the pictures of this kind'. Its doll-like, dead quality, merely makes 'an unconscious contribution to the history of the culture of the period', leading us to 'guess at the artificial existence of this fair lady'.[52]

Meier-Graefe's most obviously false assumptions relate to Goya's personality and mental powers. He states that he does not 'blame Goya for his lack of culture but for the disgusting lack of resistance power precisely against his own talent, against every ideal'.[53] But if he does not blame Goya exactly, he certainly assumes that he *was* lacking in culture, and he has caustic remarks to make about a number of his paintings. Inevitably the *St Justa and St Rufina* in Seville cathedral (Plate 22) comes in for a jibe. It is an 'awful Goya of large dimensions . . . like an unconsciously funny oleograph'.[54] The painting of *The Crucifixion* in the San Fernando Academy is a 'stuffed noodle'.[55] The sketches for the Seville saints (then in the Bosch collection, now in the Prado) is equally unsatisfactory, since the artist had not exploited adequately his freedom from convention. Only the drawings in the Beruete and Riquer collections, and the small *Disaster of War* picture in the Traumann collection really arouse his enthusiasm.

His long attack on Goya in the diary brings out all his prejudices about the artist's character:

As far as I am concerned, his giant can devour two people at a time, but it must be in such a way that he makes my mouth water. If he does not succeed in making the exaggeration seem necessary, then he is boring, just as boring as anyone who sucks his thumb . . . Many scenes, for instance the bull-fight in the Academy, are seen from an amusing angle but not one of them is solved. Goya could do everything that he wished to, but he was too lazy to get beyond crude beginnings. His cruelty in the choice of subjects is the same lassitude of thought which makes the bull-fight fascinate his countrymen. His imagination is in reality non-existent. He thinks of conceiving new arrangements in his portraits, . . . he wants to get beyond tradition and to give a new form to his powers. But he contents himself with the good intention, which staring at us unexecuted, leaves us only with the absence of tradition. This picture of de la Paz might, had it been solved pictorially, justify completely the bold conception of the proposition. Why should one not show a general lying among his soldiers

instead of in the usual heroic attitude? Only it would have to be *painting*. The legs in the yellow trousers, however, look doubly shapeless because they look like unshapely wooden fragments and lie there without substance. One only sees them and not the human being. The portrait of Goethe by Winterhalter in Frankfort stands on a higher level because it is not lacking in harmony within its far more modest manner. In the portion to the right of the Goya painting in which he indicates in a few strokes, not only soldiers and horses, but also their atmosphere, one sees how able he was, and this recognition only makes one all the more bad-tempered at the failure of the composition as a whole. The little picture of Munarriz is far better. The flesh painted in thin brush strokes of grey and pink is very much alive in effect. The *Tirana* is disgustingly sickly. The portrait of himself (better than the similar canvas in the Prado) is reminiscent of certain Courbets. The big equestrian portrait of Ferdinand VII is appalling rubbish . . . One may hesitate to accuse a painter because, in spite of the greatest effort, he is unable to do anything better than bad work, but the bad product of a man of great ability is a crime.[56]

A number of critics since Meier-Graefe have shared his assumptions and aesthetic bias. Mostly, their interest lay in fine lines and elegant structures. For such as these, Velázquez would remain a much more influential and infinitely greater Spanish artist than Goya. Obvious cases in England were Roger Fry and Clive Bell. Bell, who evolved his conception of 'significant form' in *Art* (London, 1914)— 'only by form can my aesthetic emotions be called into play'—found no satisfaction in Goya. Giotto, Nicolas Poussin, Ingres, Cézanne, Gauguin, El Greco and Chinese vases all had significant form; Goya, it seems, did not. In Bell's *Landmarks in Nineteenth-Century Painting* (London, 1927), there are only two references to Goya, both of them insignificant: one cliché in connection with Manet, and the other, a mention in a passage where Spain is dismissed, along with Italy, as a possible second-runner to France in the post-1750 painting stakes.[57]

Roger Fry, for his part, felt that Spanish art needed to cultivate 'a more detached attitude' and seek a 'pure art' if it hoped to rival Italy. Velázquez was, therefore, the only great artist in Spain.[58] Goya's moments of control were far too rare, although Fry praised one of them when he spoke of the 'delicacy of touch', subtlety, refinement, harmony and restraint of the *Portrait of Sebastián Martínez* in a note in the *Burlington Magazine* in May 1906.[59] Goya, for Fry, was primarily a source of the joys of life rather than the delights of art: as in his tapestries in the Escorial, for instance, and the 'frescoes' in Valladolid, which Fry was sure that the 'nuns of Santa Clara' were capable of appreciating.[60] The fact that Fry makes two errors of fact about Goya in one sentence suggests that his interest in his work was rather superficial. Goya painted no 'frescoes' in Valladolid at all—and Fry does not comment on those in Madrid or Saragossa—and it was the nuns of Santa Ana (of the Cistercian Order) and not of 'Santa Clara' in Valladolid who had paintings by Goya.

Similar reservations about Goya were expressed in France. The poet Paul Claudel

had little favourable to say about him at all. When visiting the Prado in 1917, he admitted to having 'no feeling of admiration for Goya and Greco'. Sixteen years later, in the United States, he saw 'a superb painting by David', and thought that the French painter's art was 'an art of the intellect' and 'far superior to Goya'.[61] When he described in detail the portrait of *The Family of Charles IV* at an exhibition in Geneva after the Spanish Civil War in 1939, he was struck by its psychological realism, yet deprecated Goya's tendency to concentrate on the ugly things in life. Claudel suggested that Goya had descended to the gutter in his art ('the intense and verminous world of Breughel and Bosch')[62] and had sunk even lower than the Dutch. Ultimately he found the painting antipathetic for religious as well as aesthetic reasons. Goya's work represented 'the infernal carnival of the passions, seeking to avoid the eyes and the image of God.'[63]

Claudel's comments appear to bring us back to the same combination of prejudices that operated in Madrazo in Spain in the nineteenth century. A similar case in Mexico in 1936 was the philosopher José Vasconcelos' religion-based *Aesthetics* (*Estética*), which deplored the crude sensuality, low passions and pessimistic view of man that it found in Goya. In more recent times it is difficult to find writers who are prepared to express their antipathies with comparable forthrightness. An exception within the last ten years or so is Jean-Paul Sartre.

In an introductory essay which Sartre wrote for an exhibition of paintings by Lapoujade in 1961, he refers to Goya's depiction of the horrors of war, and compares his work unfavourably with that of Picasso on the same subject. Sartre holds that aesthetic organisation is essential to the communication of feelings of horror. Picasso's *Guernica*, for instance, succeeds because although 'it will always be a bitter accusation . . . this does not disturb its calm plastic beauty; conversely, its plastic beauty enhances rather than hinders its emotional impact.'[64] Sartre feels that most representations of acts of violence or other horrors of war are sterile, because they merely make the spectator repeat the reactions they would have experienced in the face of the horrors themselves. These representations repel, therefore, and fail to illuminate the spectator. Realism is not enough. Some kind of beauty is necessary if art is to convey feeling, although beauty should not be used to deceive, as Sartre believed it to have been by Titian, for instance, who painted 'comforting terrors, painless suffering, and living corpses'.[65]

Sartre's point recalls that of Prosper Mérimée in relation to Goya's *Disasters of War*. There is also, perhaps, a hint of the great classical doctrines of the French theatre about it. Corneille held, in relation to tragedy, that the poet must sometimes 'enhance the beauty of fine actions, or extenuate the horror of fatal events' in order to please. Sartre's view is expressed in terms of aesthetic distance instead of aesthetic pleasure. Goya, for Sartre, had failed to impose an adequate aesthetic quality or distance on his feelings, and had, in consequence, failed to communicate them. The flux of reality cannot by itself liberate the spectator. Furthermore, the individual preoccupations of the artist, in Goya's case, inhibit the free response which Sartre seeks. Finally Sartre has a more political objection to Goya's art. He finds it uncommitted. 'Uncertain and overwhelmed by revulsion and remorse,

the tormented visionary Goya painted his visions instead of war. This misguided man lost all desire to guide the masses and finally transformed the horrors of battles and mass murders into the naked horror of being Goya.'[66]

It could be argued that Goya's *Disasters of War* and his paintings of the events of 2 and 3 May 1808 make a more than adequate use of aesthetic elements—in terms of colour or tone and composition—to satisfy the requirements of distance Sartre would impose. At the same time he is not the only critic who has found Goya's work wanting in this respect. Zervos, in the issue of *Cahiers d'Art* devoted to Picasso's work between 1930 and 1935, took up a similar position, and spoke of Picasso's 'Cosmic vision' as creating 'something so immensely and profoundly tragic that he leaves Goya and Daumier and Manet behind on quite a different level'.[67]

In defence of Goya it could be claimed that the power of his war pictures lies precisely in the tension they create between their formal beauty and the destructive scenes they depict. Another source of strength is their commitment to man rather than Spain. This is obvious enough in the *Disasters of War* etchings which show that the Spanish and French act with equal barbarism in war. It is equally clear in *The Third of May* and *The Charge of the Mamelukes*, the former of which shows the French as victors and Spaniards as victims, whereas the latter reverses the roles.[68] Possibly Sartre had paid too much attention to Romantic legends about Goya's technique, and allowed the myth to take the place of an unprejudiced reaction to Goya's work. Certainly it is easy to find writers not far removed from Sartre in age and intellect who take diametrically opposed views to his. The most obvious example is that of Wyndham Lewis who put Goya's and Picasso's depictions of war in the reverse order to that of Sartre in 1940. Wyndham Lewis found Goya's 'flesh and blood' approach very much more effective than 'the unalterable intellectuality—the frigidity, the desiccation—of Picasso'.[69] Wyndham Lewis's lack of appreciation for Picasso is perhaps as extreme as that of Sartre for Goya. And who is to say whether their individual make-up, the intellectual traditions of their separate countries, or even the times in which they wrote is responsible?

VI. Impressionists and Decadents

GOYA was an obvious god to place on Impressionist altars. French Romantic artists had venerated him, and, according to Gautier, Delacroix was Goya's grandson stylistically speaking, with Velázquez as his great great-grandfather.[1] The strength of *Hispagnolisme* in French cultural life in the middle of the century ensured the continued ascendancy of Spanish art in general and Goya and Velázquez in particular.[2] Later Meier-Graefe claimed that most of the early Impressionists were 'half Spaniards'.[3]

In 1863 Manet seemed wholly Spanish, thanks to the influence of Goya: 'a Spaniard in Paris, associated in some obscure way with the tradition of Goya', in the words of Paul Mantz.[4] In fact, despite Baudelaire's affirmations to the contrary, Manet's association with Goya was not all that obscure. He was certainly familiar with Goya's bull–fight etchings before he went to Spain, as his *Mlle Victorine in the costume of an espada* shows (Plates 33 and 34).[5] Later echoes of Goya in Manet's etchings, the five versions of *The Execution of the Emperor Maximilian*, and *The Balcony* (Plate 35) are commonplaces of criticism. The response of Manet and others to Goya resensitized the critics. Impressionist theory and practice soon yielded new insights into Goya's art.

Manet's interest in Goya's compositional arrangements led some to reassess his sense of form, or secret geometry. Approval for his subject-matter—particularly his scenes from contemporary life—sharpened. But the major new interests in Goya lay in the area of colour and movement which had a special appeal for Impressionists. The brightness of his colour awakened a sympathetic response, since they had rejected the conventional balances of light and shade, and were brightening their palettes to offset the false effects of studio light and exhibition halls.[6] So the whole concept of Goya's handling of colour came to be revised. A reconsideration of the importance of movement in his work soon followed.

The Romantics had earlier admired Goya's skill as a colourist: the boldness of his brushwork, his disregard for insignificant detail, and what Mathéron called his 'deep harmony and unexpected effects'.[7] But in the 1860s and 70s critics began to be attracted by Goya's play with more strongly contrasting tones (which had not previously appealed), very possibly under the influence of the first wave of Impressionism. The ultimate result was still harmony; but a harmony more akin to the brilliant effects that Manet was seeking. Léon Lagrange's description of Goya's

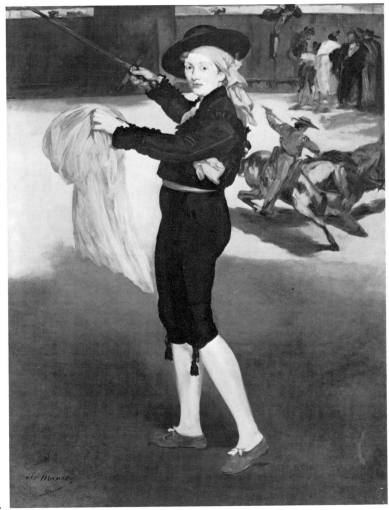

33. E. Manet:
*Mademoiselle Victorine
in the Costume of an
Espada*, 1862. New
York, The Metro-
politan Museum of
Art. Bequest of Mrs
H. O. Havemayer,
1929. The H. O.
Havemayer Collection.

34. Goya: 'El animoso
moro Gazul es el
primero que lanceó
toros en regla',
Tauromaquia, No. 5,
1815–16. Oxford,
Ashmolean Museum.
Francis Douce
Collection.

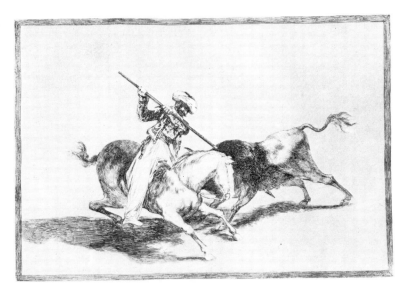

portrait of Ferdinand Guillemardet in 1865, when the picture was new in the Louvre, brings out the point well:

It is the work of a man who was a colourist by temperament, who saw nature's colours in all their richness and variety, and knew how to paint them harmoniously. No French painter has ever related the three colours of the national flag so successfully. Goya throws the hat with its tricolour feathers on to a yellow table, right against the tricolour scarf of the subject of the portrait who is sitting on a yellow chair, dressed entirely in blue. And yet the clashing colours merge in a brilliant concerto which sounds sweet to the eye. The face, which reflects too

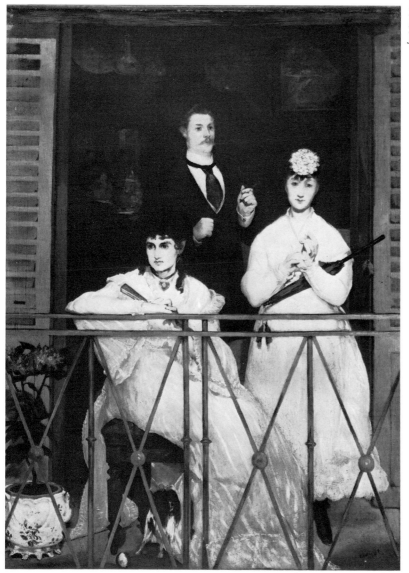

35. E. Manet: *The Balcony*, 1868. Paris, Jeu de Paume.

many of those tones and seems like a reddish stained-glass window, is forgotten in the deep pleasure one feels as the colours glow alive—much as one delights in the capricious play of light passing through translucent water.[8]

The vitality of Goya's colour reinforced the vibrancy of his work for critics at the period. His portraits were particularly alive, and collectors as well as critics considered them the high point of his art. His hastiest sketches in that field, according to Lefort, were 'always breathing, always palpitating with life and spirit',[9] and his portraits of women were especially admired. Their seductive and provocative sensuality, enhanced by the silks, laces and muslins the sitters wore, breathed modernity as well as life into these pictures. The details stressed were precisely those that Baudelaire felt the modern artist should seek: items of dress that emphasize patricularized and transient beauty, rather than the generalized, eternal kind. This aspect of Goya's modernity was the subject of extensive comment in an essay on Goya by Paul Flat in 1890.[10] Two years earlier, a modernity that was nearer to that of the Impressionists, was underlined by the Belgian writer, journalist and art critic Lucien Solvay, in *L'Art Espagnol* (1888).

The year in which Solvay published this book saw the tide of French public opinion begin to turn in favour of Impressionism. In Belgium too, works by French and Belgian Impressionists had been hailed by the *avant-garde* when shown at exhibitions organised by the 'Twenty' group, founded in 1883. Solvay reviewed some of the exhibitions in *La Nation*, and was clearly sympathetic towards the new approaches to reality and the fresh emphasis on light and colour. While he criticized the coolness of Renoir and Monet in 1886 and found a similar lack of emotion in Signac in 1888, he praised the sensitivity of Vogels and Ensor, preferring the less strident harmonies of his countrymen to those of their French counterparts.[11] Although he did not fully approve of Ensor's sketchier pieces, he accepted that technique did not matter if the right effect was achieved. His emphasis on feeling and imagination also made him respond sympathetically to symbolists like Fernand Khnopff.

Goya's depiction of modern life and embodiment of modern attitudes similarly impressed him. Although he makes deprecating comments on Goya's technique he often finds expressive value in the unconventional brushwork, and this distinguishes his comments from Gautier's anti-academicism. He was favourably struck by Goya's Decadent and Impressionist overtones, and his observations about Goya's interest in movement and open-air subjects would be developed by a number of subsequent critics as Impressionist qualities. Points he makes about Goya's use of colour are likewise revealing in the passages which follow his description of Goya's *Majas*:

> In his paintings of the *Maja desnuda* and the *Maja vestida* Goya is entirely original. He owes nothing to anyone, being wholly absorbed in his own sensations. He seems to disregard the practice of previous painters. His observation and study of other artists' work merely provides him with a minimal basis for translating his impressions into art. Because he had faith in nature itself and reacted

emotionally to its overwhelming beauty, his vigorous and exciting work will endure. His faith was pagan, his emotion modern; and this was a new departure in a country so steeped in orthodox traditions as Spain . . .

Goya was 'modern' in a very real and precise sense of the term, and not only in his accent, his way of putting things, his subject matter, or that *je ne sais quoi* which brings him so close to us that he seems our contemporary. He was also 'modern' in his artistic technique: his new concept of the picturesque, and his experiments with colour and light which are so much to our taste these days. It is in this respect that his modernity is not the same as that of other great artists from different periods. They are modern too, in one sense, since their work embodies the quintessence of their time, and it would be absurd to deny it—it would also be pointless to prove it when others have done that already. But there is a slight difference. Goya's modernity—and ours—goes further than the modernity of the great classics. It includes a wider range of subjects, and contains greater quantities of personal feeling, ideas and intentions. It is not so much art for art's sake, as an art which wants to say more and to say something new, in comic or tragic vein, throwing aside the old conventions and restrictions, and concentrating on what is fleeting and seemingly unimportant. Goya's art *is* Modernism: the reality of the world around us; things of the moment.

Another Spanish artist, Goya's friend Paret y Alcázar (1747–99) also had the instinct to oppose the vogue for French style—charming enough in France, no doubt, but unbearable elsewhere in the hands of imitators and plagiarisers. Paret painted, between one shepherdess and the next, scenes of vigorous every-day activity like his small pictures of *A Draper's Shop in Madrid* or his *View of the Puerta del Sol*. But it was Goya who really gave a contemporary feeling and significance to the genre. He had the idea of capturing, in his own impetuous manner, the picturesque and characteristic side of national life. Furthermore, he was not only interested in interior scenes, but also in life in the open air, catching things in movement, fixing them in a few quick and bold strokes of the brush, with all the spontaneity of sketches drawn from life or based on the immediate impression of what was seen. Wild open-air festivities, circus or bull-fighting scenes sprang to life suddenly on his energetic canvases, slashed with violent brushstrokes . . . In these genre paintings Goya is less restrained than in any other part of his work, casting aside the restrictions which would probably have cramped his style . . . What he needed in these cases was drive: energetic brushstrokes that would capture what was in his mind . . . His inaccuracies and his slapdash approach do not matter when his wild energy takes over. His prodigious inventiveness, and brilliantly salacious imagination, shine through. A few touches of colour, an impetuous brushstroke or two in just the right place, and immediately processions can be seen on the move, unruly groups of masked figures dance their disorderly dances before our very eyes—as they do in that extraordinary sketch of *The Burial of the Sardine* in the San Fernando Academy—and the blood of picadors and bull-fighters reddens the sand of the bullring . . . Life continually flows: a feverish and contorted life, born in the

mind of a dreamer or a madman, in which observation turns into caricature, and strangeness into absurdity.[12]

Solvay's last lines in this passage clearly hark back to Romantics like Gautier and Baudelaire. Another Belgian—the novelist and critic Joris-Karl Huysmans—saw Goya's work in unalloyed Impressionist terms at the same period. One point that Huysmans particularly emphasizes is the way in which Goya's impressionist brushwork needs to be read from a distance. Yriarte had earlier commented on the importance of viewpoint for the appreciation of Goya's more sketchy[13] work, and in 1873 Imbert had made a similar point about the Black Painting in which Goya depicts a woman standing by a grave. 'Close to it is a large sketch,' Imbert remarked, 'from a distance a finished portrait.'[14] Huysmans, however, is less concerned with the right viewpoint for its own sake. His central point is the vitality of the painting which results from the artist's use of blobs and dashes of separate and apparently unrelated colour.

The painting which Huysmans described was one of a bull-fight which he saw in the Quai Malaquais galleries in 1887 (Plate 36).[15] The subject, whose Spanishness had appealed to earlier critics, appealed to Huysmans (as to Solvay) for its technique, vitality and movement. Monet's emphasis on the fleeting aspects of nature, taken

36. Goya (or attributed to Goya): *Bull-fight*, c. 1827. National Gallery of Art, Washington, D.C. Gift of Arthur Sachs.

up by other Impressionist artists, may well have sharpened the critics' awareness of Goya's apparent interest in the same point. It is also possible that Huysmans' description was influenced by the scientific use of 'divisionist' brushwork which evolved in paintings by Seurat, Camille and Lucien Pissarro and Signac between 1884 and 1886. Huysmans included his description, together with others of paintings by Turner and Delacroix, in his articles on the 'first campaigns of Impressionism' in *Certains* (1889).[16] It is rich in rhetoric. The typographical imagery, however,—commas, fullstops and diaereses—seems highly appropriate to the reading of an Impressionist picture:

The Goya is a mush of red, blue and yellow, white commas, compotes of vivid colour, laid on in thick coats, hugger-mugger, blocked out with a palette knife, packed in and botched up with the thumb—the whole thing built up in rough blobs from the top of the canvas to the bottom. What is it about? Vaguely one makes out, amidst the hurly-burly of these spots of light, a wooden toy in the form of a cow, dots of white paste crossed through in black, and with a brown diaeresis on top. Then, higher up, inverted commas and full-stops: a whole range of coloured punctuation marks bubbling up on a page against a background of fawn. Standing back the effect is extraordinary. As if by magic the outlines become clear, everything falls into place and the whole scene comes to life. The dots team with activity, the commas whinny, bull-fighters appear brandishing red capes, moving forcefully, knocking into one another, shouting in the searing sunlight. The small cow turns into a powerful bull rushing furiously towards a group which beats a disorganized retreat before its thrusting horns. Towards the back of the ring horses stamp, and the mush of colour from the palette, pushed about with a rag, and drawn out with the thumb, turns into a pululating crowd going wild with excitement, cursing, threatening, cheering deafeningly. The whole effect is simply magical! Figures emerge clearly from the morass: the diaereses are sparkling eyes; the dashes gaping mouths; the inverted commas tense fingers. It is the wildest frenzy that has ever been thrown on to canvas, the most violent scrimmage ever created in paint.

Goya's etchings are incredibly alert, and wildly hashed. But they do not give the slightest hint of the turbulence or ferocity of this painting, this design which takes the bit between its teeth and bolts, this Impressionist's delirium, kneading life itself with its fists, this violent cry, this wild bucking of art.[17]

Other Impressionist traits were naturally looked for and found in Goya's work at the same period.

Working in the open-air was a major tactic of Impressionists and *pleinairistes* following in the less turbulent wake of Jules Bastien Lepage. It had been a common practice of earlier generations of artists to make preliminary sketches out of doors, but the completion of the whole picture in the open was a new development, inspired according to Duret by Manet's *The Railway* in the Paris Salon of 1874.[18] Critics began to deduce from the quality of Goya's light that he had worked in a similar way. The Conde de la Viñaza, for example, argued in his catalogue of Goya

paintings (1887) that the *Clothed Maja* had been painted in the woods near the Pardo palace.[19] Valerian von Loga, author of the most balanced account of Goya's art and life at the turn of the century, also related his style to *pleinairisme*. Von Loga, in fact, believed that there was a long-standing tradition of open-air painting in Spain, going back to El Greco and Velázquez, and he inevitably made much of Goya's mastery of light effects in landscape.[20] He also felt that Goya worked with the same rapidity as the Impressionists. Speaking of his 'pitiless realism', he pointed out the art behind 'all these impressions taken from nature, which seem to owe their origins to a snapshot'.[21] For von Loga, the Black Paintings were particularly close to the Impressionists in technique. It was, of course, well known that the Impressionists had admired them. Goya 'used only a very few colours,' von Loga observed, 'but with an infallible touch and without mixing the paints, as the *pointillistes* were to do later, he laid the colours on, side by side, so that they produced precisely the desired effect'.[22]

Goya's late bull-fight lithographs, with their energetic sense of movement, enhanced by the artist's disregard for detail in the crowds around the ring, also caught the attention of Impressionist painters and critics alike (Plate 37). Fantin-Latour, who thought highly of Goya's art in general, especially admired the rich texture of the *Bulls of Bordeaux*. Some believed that Whistler's wash-drawings on the stone had been influenced by Goya's experiments in the medium. In Chelsea, Lucien Pissarro, with Charles Ricketts and Charles Shannon, spent long sessions studying Goya's bull-fighting prints and discussing his etchings.[23] Their friend, the painter and critic William Rothenstein, reflected this enthusiasm in a perceptive comment on the lithographs, emphasizing the artist's fascination with movement—a central concern of the Impressionists as the horse races of Manet and Degas and the ballet-scenes of Degas and Toulouse-Lautrec, attest:

> These [lithographs] are executed in the most superb style, with a vigour of conception and execution which Goya himself never equalled in his previous work—the whole science of modern composition is to be found in these four drawings—and which has never been equalled since. An artist's early work may generally be said to be his most serious rival, but in the Taureaux de Bordeaux, Goya, at the age of eighty odd years, actually surpassed himself. Movement takes the place of form—the tremendous excitement of the crowds of spectators watching the sweaty drama in the ring, the rush to and fro of the *toreros*, the stubborn strength of the short powerful goaded brute with the man impaled on his horns, the dust and glitter and riot of the scene is rendered in the most extraordinary manner. Three generations of artists have helped themselves with both hands from these prints, but left them not a farthing the poorer.[24]

English critics like D. S. MacColl—the Ruskin of the Impressionists, according to Rothenstein—and S. L. Bensusan, reiterated points of contact between Goya and the Impressionists. MacColl, in *Nineteenth-Century Art* (1902), included Goya with the Titans who had prepared the way for modern art. 'Goya's domineering snatches at expression,' he averred, seemed to anticipate 'half-a-dozen modern styles'.[25] His

37. Goya: 'Dibersión de España', *Bulls of Bordeaux Lithographs*, No. 3, 1825. Madrid, Biblioteca Nacional.

intensity and bravado prefigured Manet, while his 'diabolic inspiration' set a precedent for Félicien Rops, Toulouse-Lautrec and Aubrey Beardsley.[26] Bensusan discussed Goya's technique in some detail, and reproduced twenty-eight photographs of Goya portraits with an article in *The Connoisseur*.[27] He quoted Goya's dictum that 'a picture that gives a true effect is finished', which the Impressionists approved, as well as the standard Romantic material about Goya's dexterity with sponges and thumbs, which the Impressionists saw no reason to disregard.

In Spain itself at the turn of the century, critics also became particularly interested in the relationship between Goya's art and Impressionism, although Alfredo Escobar had posited the Black Paintings as a possible source for Impressionist techniques as early as 1878, in an article in *La Ilustración Española y Americana* for 22 July. In 1900 Silverio Moreno accepted Goya as a definite forerunner of Impressionism, [28] just as earlier critics had seen him as a Romantic born before his time, or a realist *avant la lettre*. In many respects Moreno follows the earlier Romantic views, singling out the artist's personality for comment, and admiring his tapestry cartoons because they captured the realities of everyday Spanish life. He appreciates the originality and inventive power of the etchings too. But his initial discussion of Goya's brilliance as a colourist leads him to compare his technique with the Impressionists. Moreno thought that Goya was more restrained than Manet and his school; and believed that they had something to learn from him in that direction.

The Aragonese master is particularly brilliant at painting the manners and customs of his people, and he tackles these subjects with extraordinary dash and confidence. The unparalleled brio with which he paints these pictures often verges on the brink of temerity. Yet although he tends to be inaccurate in drawing (a regrettably common fault in his work), is sometimes vulgar and coarse, even grotesque at times, the sense of real life which pulsates in his paintings makes us forgive and forget his shortcomings. We note only the harmonious and vivid colouring which enchants the eye and stirs the spirit of the observer, as only the work of the greatest masters can.

Goya is, without doubt, the first Impressionist master in the modern school, and even though his work is far from the more dangerously exaggerated tendencies of our contemporaries, it cannot be denied that he delights in brilliance of colour at the expense of elegant line when he puts his ideas or impressions on to canvas. Above all, he pursues overall effect, seeking it in chiaroscuro contrasts, and when he finds it, he does not bother about correctness of drawing or finish, as the laws of aesthetics would require. Yet he has the enviable ability to achieve a perfect sense of modelling with very little effort, and with no more brushwork than a few impressionistic strokes.

Goya's impressionism, however, unlike that of our own times, keeps within proper bounds and never goes to its more frenzied and exaggerated extremes. The favourite painter of the Infante Don Luis was not primarily concerned with minutiae or careful detail, but he knew that they could not be entirely dispensed with in works of art. When necessary, he would capture them in a single audacious brushstroke, and, with his incomparable mastery and intuition, he would fix in paint the life, realism and truth which brimmed from his palette.

Perhaps when we speak of him in this way we exaggerate a little, and perhaps some would think that it is an insult to the memory of the master to call him an Impressionist. But if that is not the right term, what can we call the man who created the fourteen pictures which once decorated the walls of his country house beside the River Manzanares? How else should we classify the brush which expresses in four sublime yet shapeless strokes the anger which a Spanish artist felt so keenly in the face of the French invasion of 1808, or the pain in his soul when he remembered the cruel fate of those who defended Spanish independence on the 3rd May that year? All these paintings are no more than blobs of colour, fleeting impressions of a genius who tried to match the swiftness of his thought with his brush.[29]

Moreno obviously had reservations about the Impressionists, and there is no doubt that he was writing for a public that shared them. No European country showed much enthusiasm for the Impressionists in the 1890s. Their painting was still very much a minority taste. In Paul Lefort's book on contemporary French painting in the series *Les Chefs d'Œuvre de l'Art au XIXe siècle* (1892), there were only two sentences about Monet, and a bare mention by name for Sisley, Pissarro, Renoir and Berthe Morisot. In Spain the leading Spanish sculptor Benlliure attacked

Impressionism in the same year that Moreno wrote his Goya article, and in November 1901 a group of Spanish Impressionists found it necessary to publish a manifesto defending the French movement.[30] The signatories included painters like Darío de Regoyos, Santiago Rusiñol, Ignacio and Daniel Zuloaga. Also involved was Miguel Utrillo, father of the more famous Maurice. In the periodical *Forma*, which he edited, he soon wrote about Goya from a less defensive angle.[31] He felt that Impressionism had brought to light new aspects of Goya's work, more particularly its treatment of colour and concern with movement. Seen through Impressionist eyes Goya's art acquired a new subtlety, which would appeal to the *Cognoscenti* as well as to the masses:

> The Goya of anecdote, the peculiar Goya, the Goya who painted a war-torn country with shrieks of colour, has been replaced by a Goya of ever-increasing stature: a Goya who possesses all the popular qualities we have already mentioned, but who is also a master of dash and delicacy, a skilful conjuror of suggestive colour combinations, and a patient inventor of aristocratic and idealized light. This Goya brutally dissects the uncultivated. Yet he is also a warm and gentle poet whose sense of delight and beauty is past the understanding of the indifferent masses.[32]

Utrillo went on to suggest that Goya would ultimately be seen as 'the father of the new painting', despite the fact that he lacked the mystical appeal of El Greco or the aesthetic and formal mastery of Velázquez. Artists who thought they were doing something new and original would find that Goya had done it already. If they thought that the depiction of movement was new, Goya had already captured 'the blob of a balloon moving across the blue sky'.[33] If they believed that their colour sense was original, Goya had already demonstrated 'his quite exceptional ability to harmonize subtle tints when he wanted to'.[34] If they felt that the consistency of paint was important, must they not also admire Goya's handling of 'dark and juicy *matière*'?[35]

Utrillo's minority Goya faded as Impressionism became more widely accepted. Around 1908, the novelist Blanca de los Ríos eulogized Goya in Impressionist terms in the opening paragraphs of her short novel *Madrid Goyesco*. 'Anticipating the snapshot and Impressionism,' she wrote, 'he captured unheard of effects of light and action, and with typically Spanish impatience and rage to create, with whiplash brushstrokes and lightning zigzags of colour, he painted what no-one had painted before: movement.'[36] Seven years later there was a series of public lectures on the Impressionist movement in the Athenaeum at Madrid, and Rafael Doménech spoke on Goya, stressing the primacy of light and motion in his work, and rating his *Pest Hospital* (in the Romana collection) a fine example of Impressionism *avant la lettre*.[37]

At this period the message of Goya spread very much in parallel with the message of Impressionism. In Russia, for instance, Alexandre Benois, who had introduced the work of Manet and his followers to the Russian public and who was a great admirer of Degas, wrote about Goya (1911). Some of the more popularizing books

on the artist also pursued analogies between his work and that of the Impressionists. An important book in this respect is Richard Muther's *Goya*, which was published in German in 1904, with an English translation in 1906 and a Spanish version in 1909. Muther had already written sympathetically about the Impressionists in his *History of Modern Painting* (1893–4),[38] but he had failed to see any relationship between their work and Goya in that book. Manet, for instance, is discussed wholly in terms of the influence of Velázquez. Although he accepted that Goya was the first artist in a revolutionary process in art which culminated in Impressionism, he emphasized Goya's realism and decadence and ignored any technical parallels with Manet and his followers. The book on Goya worked out his Impressionist aspects in a positive way, underlining not only his interest in movement—which was, after all, only a facet of his realism—but also his apparently *pointilliste* approach to colour. Presumably he took this point from von Loga, just as he took his decadent Goya primarily from Solvay, as we shall see. Yet despite Muther's lack of new ideas, his packaging was certainly eye-catching. Contemporary references gave his account of Goya topicality. He had a group of ladies in Goya's frescoes for San Antonio de la Florida 'raising their skirts like little *modistes* in the *Journal Amusant*'.[39] Writing of another group—'genuine portraits of well-known beauties of the court'—who seemed to be dancing, he said: 'It is an artistic can-can; it is Casanova transferred to colour'.[40] In the final section of his book he brings together observations about the Impressionist effect of Goya's brushwork, his interest in open-air light and pure colour, and his impact on Manet, summing up most of the points that previous critics had made, and using one or two phrases or suggestions of phrases from Solvay:

> No one else has known like him how to catch and imprison the vibrating pulse of Life. He aims at rendering the most momentary, the most fleeting subjects. He paints in some pictures of a yearly fair the billows of Humanity; he paints girls dancing with castanets, bull-fights, scuffles and street scenes. And how full of suggestion is his work! How wonderfully he has contrived for himself in these fleeting subjects which he wished to present a record as instantaneous as the telegraph, a record in which every touch of the brush possesses the stir of life!
>
> He paints a street scene; and the figures in it are only put in as spots. But these spots have life,—this crowd is speaking to us. He paints Spanish girls dancing with castanets: but every nerve of these dancers is in movement. Neither Boldini nor Sargent has caught these lightning-quick movements with so immediate an insight and energy. He paints a yearly market: and actually we seem to hear the crowd chattering and laughing, as it pushes its way between the booths. He paints a bull-fight: and not only are the movements of the combatants rendered with absolute and unequalled certainty, but even in the seats of the spectators all breathes of life. These thousands of men, who press in front one of the other, and follow the course of the fight with intent eyes, have become in his art a many-headed being, which possesses at that moment one soul, one single pulse.

For Goya always contrives to seize with a few clean, sharp strokes the most striking impression of life. He only needs to take the pencil into his hand, and there come before our eyes processions advancing over the rose-strewn ground, Majas smiling coquettishly, combatants laying fingers on the knife, young couples whirling in a wild dance, or the lances of the bull-fighters dripping red on the sand of the arena. At the same time this masterly creative power is united with the most delicate taste for the *nuances* of colour. While he is often a *plein-air* painter of astonishing truth when he lets his figures move in the full vibrating sunshine, in these last works of his, which are entirely kept within a transparent dark-grey tone, he touches the note of Eugène Carrière's art. And yet again in other works he sets the pure unbroken colours boldly one against another, just like the later *Pointillistes*. Never does he give us an outlined contour: with him the outline disappears, left entirely indeterminate and bathed in light, and in the way in which he selects and gives us only the living points of his subject he brings back our thoughts to the work of Degas.

It is just here, too, that he connects himself most strongly with us moderns. It was in France that, more than eighty years after his death, he found his first admirers. For the generation which had known Byron, the Europe of 1830, prized in him not so much the artist as the wild Bohemian, part artist and part brigand. The school of historical painting which followed, which expressed theatrical emotions in Academic gestures, could even less find connection with the art of Goya. The whole aesthetic movement of the time was entirely hostile to his art. Passavant was the first critic who came to know the Master in his own country, and in 1853 he wrote thus of him: 'Francisco Goya gives us a striking proof of the low condition of Spanish taste in art at the end of the last and the beginning of the present century.'

Only after the turn of the sixties did the age again take Goya into its favour. That prophetic remark by Otto Runge was then fulfilled: 'Light and atmosphere and the movement of life are to be the great problem and the great achievement of modern art.' It became the efforts of artists to see in life itself the movements and the *nuances* of expression which a former age had studied in old pictures. It became their effort to put in the place of those brown tones of the Gallery picture the clear-ringing values of Nature herself.

We all know those first works of Manet—*The Guitarero* and *The Bull-fight*, the *Maja* of the Luxembourg, *The Execution of the Emperor Maximilian* and the *Olympia*. But the direct impulse of all these works may be traced to Goya. He, next to Velázquez, is to be accounted as the man whom the Impressionists of our time have to thank for their most definite stimulus, their most immediate inspiration. The last of the old masters, Goya was at the same time the first of the moderns.[41]

Some of the conclusions of Muther are obviously slightly exaggerated. It is far from true, for instance, that there was 'never a clearly marked outline' in Goya's pictures. On the contrary, he frequently emphasised the contours of his

figures in black. Furthermore, eighty years had by no means elapsed between the death of Goya and the period in which his first French admirers appeared. Nor is there any positive evidence that Goya was ever a *plein-air* painter in the strict sense of the term. Nevertheless, there was concrete evidence that the Impressionists and some *pleinairistes* drew inspiration from his work,[42] and Muther merely underlines relevant elements in the Spanish artist in order to make his impact more understandable and more significant. The comparisons with painters like Eugène Carrière and Boldini, neither of whom were Impressionists, although they both subscribed to the acquisition of Manet's *Olympia* for the Louvre, serve the same purpose of updating Goya's art.

A few years elapsed before a critic took a really close look at Goya's paintings with a view to commenting in detail on Impressionist techniques. The critic in question was a Spaniard, Aureliano de Beruete y Moret (1876–1922). Beruete brought a sharp eye and a shrewd critical sense to the examination and analysis of Goya's work. Both his family background and his education fostered in him an alert yet open-minded approach. He went to the famous Institución Libre de Enseñanza in Madrid as a young man, where educational visits were encouraged and text books banned to make pupils observe and think for themselves. He also benefited at the Institución, no doubt, from his dialogues with such notable teachers as Manuel B. Cossío, the El Greco expert. At home, he was surrounded by the remarkable collection of Spanish paintings belonging to his father, including a number of Goyas. And since his father was a landscape painter of considerable sensitivity—Meier-Graefe thought him a finer Impressionist than Sorolla[43]—he came to know in detail how artists work.

His father's interest in Impressionism and the avant-garde taste of the period and milieu in which he grew up, awakened in him a particular interest in light effects. In an article his father wrote on Sorolla in 1909,[44] he praised the vibrating light which that artist captured in his open-air subjects, using small brushstrokes in the manner of the Impressionists. He also admired Sorolla's harmonious use of colour, and his rejection of browns and blacks in favour of blue, red, violet and yellow in out-door work. At the same time he thought Sorolla right to avoid the 'excesses of many modern painters—who used small brushstrokes indiscriminately for open air subjects and interior scenes—even for portraits painted by studio light'.[45]

When the younger Beruete came to analyse Goya's use of small brushstrokes in the Impressionist manner a few years later, he was less deprecating of their use in portraits. For him, Goya's Impressionism was a late development: preceded by two other phases of originality in the artist's use of colour and brushwork.[46] The first of these saw Goya adopting a limited palette with a preference for greys in his *Portrait of the family of the Duke of Osuna* (1789). The second phase brought a further simplification of the colour range and the use of broader brushstrokes, with paintings like *The Charge of the Mamelukes* and *The Third of May 1808*. Beruete isolated what seemed to him Impressionist techniques in Goya's late portraits. In these he felt that Goya had juxtaposed short, separate brushstrokes on the canvas

to allow the observer to mix the colours with his eye, precisely as the Impressionists tried to do. This kind of detailed analysis of Goya's art marks a significant advance in Beruete's criticism. Other critics had tended to identify Impressionism in Goya with vaguer concepts: the delight in loose and rapid brushwork; the desire to record impressions at one go (as Goya had clearly done in the case of his portrait of the wife of the Infante Don Luis and that of the Infante himself, executed 'between 9 and 12 in the morning of 11 September 1783')[47]; the fascination for movement.

The first painting which Beruete discusses in terms of Impressionistic technique is Goya's *Portrait of a Lady*, sometimes identified with the artist's housekeeper and supposed mistress, Doña Leocadia Weiss. The portrait was at one time in the elder Beruete's collection. It passed through that of the American artist Dannat to the National Gallery in Dublin.

> The lady has an expressive face, is not very young, and smiles slightly. In this work the long oily brushstroke has disappeared entirely. Goya no longer allows the colour to flow on to the canvas from a loaded brush, but applies it with short, separate and unmixed brushstrokes, so that the painting acquires a vitality and a vibrancy lacking in pictures he had executed with broader and more sweeping strokes. This technique—specially developed by Goya at this period—is in my opinion the source of a whole school of painting which grew up many years later, first of all under the name of Impressionism and subsequently with that of *pointillisme*, one of whose objects was to try to avoid flat areas of colour in pictures, in order to make us see paintings as we see nature herself, broken up into a vast number of different tones. The inter-relationship and merging of these colours is the work of the retina of the eye, based on the image formed by the painting itself, although the merging is not a part of the painting. I believe that this innovation of Goya's is of the first importance, and together with other elements of which I shall speak shortly, is the basis of his technique in the later works.[48]

A similar Impressionist point is later made by Beruete about another portrait of a lady now in the National Gallery Dublin. There is considerable doubt about the attribution at the present time, but it is interesting to note that the picture once belonged to Degas' friend Rouart.[49] Also comparable are Beruete's comments on the portrait of *Doña María Martínez de Puga* (Plate 38). Both of these portraits passed through the hands of Sir Hugh Lane, whose passion for Impressionists was as great as that for Goya. *Doña María Martínez de Puga* had been bought by Lane from the Beruete collection.

> There is another very interesting knee-length portrait, signed and dated 1824: that of Doña María Martínez de Puga. She is depicted standing up, wearing a simple black dress, with a kerchief over her arm and a fan in her hand. A watch is fastened at her waist on a little chain looped round her open neck . . . The picture, whose style is very typical of this period, was doubtless one of those that greatly impressed Manet with its simplicity and its direct approach to the human figure. It now belongs to the Knoedler Galleries.

38. Goya: *Doña María Martínez de Puga*, 1824. New York, copyright The Frick Collection.

I also believe that a bust portrait of a lady can be attributed to the same period. Her face and expression are a little strange; her hair is cut short and she wears large pendants in her ears and a shawl around her . . . The subtlety of colouring, the grey tones, and the whole atmosphere of the work are related to the style which Degas was to make so justly famous at the end of the nineteenth century.[50]

A final parallel which Beruete makes between the Impressionists and Goya relates to another late portrait, dating from the Bordeaux period at the end of the artist's life. Painted when Goya was eighty-one, it shows Don Juan de Muguiro, a banker who was related by marriage to the artist's family. The picture belonged to the Condes de Muguiro when Beruete wrote about it, and is now in the Prado.

Juan de Muguiro e Iribarren . . . was a great friend of Goya's, and helped him on more than one occasion. His portrait is knee-length, and he sits facing us with a letter in his left hand. He wears a frock coat and trousers, of a very dark bluish tone, nearly black, has a large bow tie of the period, and a long white shirt front. The face is life size, but slightly reduced; it is a small face as are almost all those Goya painted in the last years of his life. I cannot think why this should be, especially in the case of portraits like that of Muguiro, whom we know to have been a well-built individual.

The remarkable thing about the work is its vibrant technique, carried out in still smaller brushstrokes than any of the previously mentioned paintings. The whole portrait evinces a kind of studied carelessness, as if the artist were trying to avoid the mannerisms which a painter of his experience would inevitably have had, the object being to capture the impression which the person made without putting in anything extraneous, and to vivify the human image so that we have the sensation that he feels, speaks and thinks; in a word, that he is alive.

This effort on Goya's part at that stage of his life is truly extraordinary. It is unlikely that he could have realised that his way of interpreting the human figure would be the starting point for a school of painting which was to fill fifty years of the history of art. The idiosyncracies and excesses of a school— call it naturalism, impressionism, what you will—that would constitute the only new, original and interesting development which painters of the second half of the nineteenth century would leave to posterity.

All the qualities of truth and life which the *fin de siècle* aspired to, are to be found, long before they are found anywhere else, in the late works of Goya.[51]

After Beruete's careful re-definition of Goya's Impressionism, critics found it difficult to stake out new claims in that particular territory, and some of course in the 1920s were already more interested in Goya's Expressionism. A small advance in the analysis of Goya's work from an Impressionist viewpoint was, however, made at that period. This came from Ricardo Gutiérrez Abascal, who wrote under the pseudonym 'Juan de la Encina'. In an article on Goya's *Caprichos* he suggested that Goya's lighting effects were so subtle 'that even the modern masters of lighting like Claude Monet, for instance, can rarely touch him'.[52] More specifically, he pointed out Impressionist elements in Goya's landscapes in a volume intended for the Goya centenary in 1928.

Little attention has been paid to Goya's work as a landscape painter. In my opinion insufficient importance is attached to his landscapes in discussions of his position as a precursor of Impressionism. Not only did he transmit to the Impressionists, first through Manet and later through Renoir, techniques and stylistic approaches to figures and colour; but he also produced landscapes as backgrounds to portraits or other scenes, which can be considered amongst the best and most memorable works for Impressionistic vision and technique. Nor are they as conventional as Beruete suggests on the basis of a fairly arbitrary idea of two Goyas—one eighteenth- and the other nineteenth-century. There may be, and indeed there are, trees in Goya's landscapes which are very sketchily treated, no attempt being made to reveal their true form: trees whose only object is to block out a space, give a particular note of colour, complete or enliven the general tonal composition. But Goya, like the Impressionists, was not very interested in defining precisely the forms of vegetation he encountered. He put all his energy into fixing the right lighting and conveying the subtler nuances of colour. What does it matter if the pines which occur in *The Swing* and *The*

Fall from a Horse [paintings from the Alameda palace of the Dukes of Osuna, now belonging to the Duke of Montellano] are only vaguely delineated. Goya simply put them there for their chromatic and decorative effect. But the backgrounds of these pictures, the mountains in the distance wrapped in marvellous light, are superb landscapes, delicately registered with great intensity of feeling—above all in *The Fall*. They are two landscapes seen by the artist's very eyes and retained in image on his retina with that remarkable clarity Goya had, and which made him an extraordinarily reliable observer ... *The Meadow of San Isidro*, a splendid work, and a marvel of delicate light, is certainly often quoted [when critics are writing about modern landscapes]. But this is far from being an isolated case in Goya's work. It falls naturally between earlier and later landscapes of great number and variety.[53]

Gutiérrez Abascal also adds to the Impressionist Goya when he writes about the late portraits of the Bordeaux period. He more particularly describes *The Milkmaid of Bordeaux* (Plate 39) in Impressionist terms, as many subsequent critics were to do.

> Is not the second portrait of Moratín (probably painted in Bordeaux in 1824) a successful forerunner of those sombre Courbet-like tonalities later in the century? The green of the background, the violet touches in the face, the complex 'divisionist' colours of the clothing—that art which reinforces the underlying formal structure—is not that precisely what Cézanne tried to achieve with varying success? Is not the painting of Muguiro (1827) also one of the same line of works in its technique and colour composition?
>
> *The Milkmaid*, Goya's last work, is not a portrait. But are not the closely woven strands of blue, green, violet and golden colour, the supreme skill with which the colours are laid next to one another in this divided brushstroke picture, and the silent richness of the new harmonies which derive from them, are these not clear foretastes of the new style? Who does not think of Renoir, for instance, when looking at this work, which marks the end of the artist's vigorous life, and heralds or begins a whole new age of art?[54]

Many subsequent critics have made Beruete's and Juan de la Encina's points their own, although there have been a few additions to the so-called Impressionist *œuvre* of Goya since their time. Hans Rothe found a Renoir-like handling of colour tones in the San Antonio de la Florida frescoes in *Las pinturas del Panteón de Goya*, 1944 (Plate 40), and Antonio Beltrán has made similar observations about the Saragossa frescoes in *Goya en Zaragoza* (1974). A number of Spanish critics, however, have merely prolonged the patriotic note which Beruete first sounded at the end of his lectures on Goya portraits: claiming that Spain, despite its loss of political status in the nineteenth and twentieth centuries, had nevertheless fathered the most important movement in modern art. Beruete mostly wrote and lectured on Goya during and just after the First World War, when many Spaniards felt that their country's non-alignment was a sign of weakness. It is hardly surprising that he should make a point of Europe's cultural debt to Spain at such a juncture: a debt

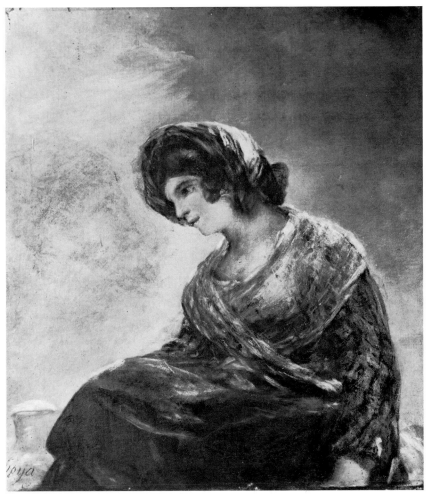

39. Goya: *The Milkmaid of Bordeaux, c.* 1827. Madrid, Prado.

which many European artists openly acknowledged where Velázquez, El Greco and Goya were concerned. Yet this chauvinist streak does not detract from the interest of Beruete's analytical points. And these are far more detailed than those of any other critic.

One more recent critic is, however, worth quoting in relation to Goya's Impressionism: the Frenchman, Noël Mouloud. In an article on the evolution of Goya's style[55] he links Goya's Impressionism to the work of earlier artists; examining its roots rather than its shoots. He tries, in fact, to put the Impressionist aspects of Goya's work into a more precise historical and pictorial perspective. He suggests that Goya used 'techniques established by Flemish artists for luminous effects— Rembrandt's fragmented approach to chiaroscuro and Watteau's detached accents'.[56] He also feels that Goya did not really develop in the direction of the Impressionists. In Mouloud's view he was moving towards strong structure and a dramatic play of colour with a sense of space in depth, towards a poetic and symbolic use of colour rather than towards the surface vibrations of Impressionism. In his analysis

of *The Milkmaid of Bordeaux* he makes some sharp distinctions between Goya's Impressionism and that of the Impressionists themselves:

> Beneath the vibration of colours and luminous effects there lies the deeper direction of the painting: the calm upwards movement of the composition, rising to the rounded shape of the face. There is a development from darkness into light in the figure, and also a chromatic progression from thick dull greens to golden, rose and fawn tones, through a middle range in which the greens are made warmer with brighter touches. Goya has a variety of approaches to spatial relief in his pictures. Without going so far as the revolutionary approach of the Impressionists, and their art of recreating objects in terms of light and tonality, Goya pushes the classical technique of painting a long way in order to accentuate the spatial existence of forms.
>
> There is an inevitable ambiguity in the comparisons one can make between Goya's coloured space and that of the Impressionists or modern painting. In both cases the geometrical bases of classical space are set aside. But in Goya's case, classical treatment of space is not replaced by the two-dimensional surface space of the painting itself. Rather he seeks to reveal the depth of space in a cosmic environment—Baroque space if you like . . . The commonest and most remarkable effect to which Goya's colours and tonalities give rise, is the anchoring of figures in an environment whose bases lie in depth rather than in the horizontal plane—and in this he is close to Rembrandt.[57]

A separate group from the Impressionists, but a parallel phenomenon in late nineteenth-century art and literature were the Decadents. Goya appealed to them as well as to the Impressionists, and it was natural that his work should be examined in their terms.

Maurice Barrès is supposed to have used the expression 'Décadent' for the first time in 1884. Its essence has been defined as 'the taste for death and occultism, the combination of mysticism and eroticism'.[58] This taste could obviously find some satisfaction in the work of Goya: there is no lack of death, eroticism and mysterious (though not mystic) symbolism in it. Huysmans' fictitious dandy Des Esseintes— the embodiment of Decadent values—pored over the more morbid scenes in the *Caprichos* and *Disparates* in *À Rebours*. The German artist Max Klinger was bowled over by them. And although there is relatively little positive evidence of interest in Goya on the part of Decadent artists—Aubrey Beardsley mentions him in passing in one of his letters[59]—Decadent writers and critics certainly admired his powers of sexual evocation, and saw his scepticism in the light of the paganism that was popular in aesthetic circles.

Lucien Solvay, with whose 'modern' Goya we began this chapter, certainly emphasized 'Decadent' as well as Impressionist aspects of his art. His description of the Majas exposed and explored the eroticism of these paintings in a new and open way that was very different from the anti-bourgeois approach of the Romantics.

> Goya has put the same concentration and the same sensibility [as in his painting of the twelve-year old Queen Isabel of the Two Sicilies and the Infanta Doña

María Josefa] into this singular double portrait of a naked and clothed Maja, in the San Fernando Academy. Both are painted in the same pose and are identical with one another—except, of course, for the way they are dressed. In them, Goya is no longer the technically inadequate and undisciplined artist of some of his more official portraits, his religious and genre paintings, whose lack of purpose is reflected in their excessive improvisation and general incompetence. He is an intense and taut artist here, moved by the harmonious lines of a radiantly desirable body. The diaphanous drapery which covers the *Clothed Maja* reveals everything it appears to conceal. In the other painting, the unveiled nakedness of the figure sings the song of the flesh. The draughtsmanship is precise, the moulding of the contours careful and exact, of unusual sinuosity. Her joints are delicate; her head, alive. Voluptuosity and sensual pleasure breathe in every pore of her short but supple arms, her tense breasts, in the subtle pubescent shadow on her belly, in her mobile limbs, indeed in all the vigour of her beautiful body, whose ivory and pearl whiteness stands out against the milk white sheets of a bed that was made for love.[60]

Solvay's flights of lyricism seem more appropriate to a novel than to art criticism. Yet a professional art historian like Richard Muther felt that the pearls were genuine enough to steal, and he poured them out, with the ivory and the milk (but without any acknowledgement) in his *History of Modern Painting* and again in his book on Goya.[61] He also repeated the milder eroticism of Solvay's descriptions of the *Infanta Doña María Josefa* and *Queen Isabel of the Two Sicilies*, and claimed that Goya was 'nervous as a *décadent*'.[62]

The aptness of such purple or mild blue passages for the novel did not escape at least one novelist at the period: Vicente Blasco Ibáñez. He described the *Naked Maja* in a novel which took its title from Goya's painting (1906), and Goya's life and art contributed significantly to the Decadent philosophy expressed. The protagonist, a painter called Renovales, admired Goya's zest for life and love (eros, not agape), and the *Maja* symbolizes the adoption of a life-centred rather than a religion-centred mode: the stirrings of the flesh, rather than the stirrings of the spirit. Blasco Ibáñez, who had an eye for good copy, helped to popularize a Decadent Goya in articles as well as novels. In the newspaper *El Imparcial* in 1907 he preached the Decadent gospel of how the *Naked Maja* came to be painted according to Mariano Goya.[63] The artist's grandson had claimed that the 'sitter' was the protegée of a certain friar called Padre Bavi, said to be a friend of Goya, and Blasco Ibáñez saw no reason to doubt him. So far as the *Maja* herself was concerned he described her in a passage in the first section of Part I of his novel: a period piece of sexual *kitsch*, masquerading as painterly description:

The painter savoured the delights of that naked body, fragilely beautiful, luminous, as if the flame of life were burning inside it, and shining through the pearly flesh. Her firm breasts, provocatively parted and pointed like magnolia flowers of love, held up closed pale pink buds at their tip. A mossy shadow, barely perceptible, darkened the mystery of her sex: light traced out a patch of

brilliance on her smooth round knees, and then discreet shading took over again down to her minute feet, with their delicate, pink, child-like toes.

She was a typical small woman, excitingly beautiful, the Spanish Venus, with no more flesh on her slim and agile frame than was needed to cover it with gentle curves. Her amber eyes, full of provocative fire, stared out at one disconcertingly; at the delicious corners of her mouth lurked the hint of an eternal smile; on her cheeks, elbows and feet, a touch of rose pink heightened that transparency—the glistening brilliance of sea shells which open out the colours of their secret parts in the mysterious depths of the sea.

'Goya's maja! The Naked Maja!'[64]

The other works by Goya which particularly appealed to the Decadents were the frescoes in the church of San Antonio de la Florida (Plate 40). Some earlier critics had underlined the inappropriateness of some of the figures for a religious painting. Decadents now made a virtue of this 'defect'. Solvay emphasized the pagan and erotic qualities of the work, and, like earlier critics, related the story that Goya had put the beauties of the Spanish court, as well as the courtesans, into it in the guise of ambivalent angels. He even related in dialogue form a supposed

40. Goya: San Antonio de la Florida frescoes, 1798. Madrid, San Antonio de la Florida.

conversation between the Duchess of Alba and Goya in which the former complained that Goya had put 'all the whores of Madrid' into the painting, and the latter expressed his willingness to include the Duchess.[65] A strikingly Decadent view of the frescoes, however, came from Richard Muther.

> Amongst them are angels who sit there most irreverently, and, with a laugh of challenge, throw out their legs *à la Tiepolo*. The chief picture represents St Antony of Padua raising a man from the dead. But all that interested him in it were the lookers-on. On a balustrade all around he has brought in the lovely, dainty faces of numerous ladies of the court, his *bonnes amies*, who lean their elbows on the balcony and coquette with the people down below. Their plump, round, white hands play meaningly with their fans; a thick cluster of ringlets waves over their bare shoulders; their sensual eyes languish with a seductive fire; a faint smile plays round their voluptuous lips. Several seem only just to have left their beds, and their vari-coloured, gleaming silks are crumpled. One is just arranging her coiffure, which has come undone and falls over her rosy bosom; another, with a languishing unconsciousness and a careless attitude, is opening her sleeve, whose soft, deep folds expose a snow-white arm. There is much *chic* in this Church picture. One very impudently-behaved angel is supposed to be the portrait of the Duchess of Alba, who was famed for her numerous intrigues.[66]

Muther's imagination must have worked hard on this passage. Certainly the ladies who have just got out of bed are nowhere to be seen in the paintings themselves.[67] Bearing in mind von Loga's assertion that damp and poor light made it easier to study engravings of the frescoes rather than the originals in the 1890s, it seems likely that Muther drew some of his conclusions from photographs and flat-surfaced reproductions. It is easy to misread effects by ignoring the curved surfaces on which the frescoes were painted, and by failing to appreciate the extent to which perspective drawing and foreshortening can be falsified or distorted in reproductions, because they cannot be seen from the proper angle, or at the right height and distance. How many of Muther's readers will have worried about such points in the hey-day of *The Savoy* and *The Yellow Book*?

Decadent aspects of Goya's work were evidently appreciated in England at this period. William Rothenstein's first studies of Goya in the 1890s—two articles in *The Saturday Review*—made rather more of the artist's Decadence than of his Impressionism. Cunninghame Graham had first urged Rothenstein to go to Madrid and look at paintings by Goya, and Sargent had recommended him to look more particularly at the murals in San Antonio de la Florida.[68] Apart from these, Rothenstein singled out the two *majas* and *The Third of May 1808* 'which had so marked an influence on Manet', and the tapestry cartoons.[69] He copied the small painting of a mounted picador in the Prado, admired his technique of painting on a red ground, and bought a copy of *The Disasters of War* in the San Fernando Academy, which he thought 'to be one of the greatest series of etchings ever made.'[70]

His articles included a richly Decadent description of the San Antonio de la

Florida frescoes. Phrases about these 'gorgeously frivolous frescoes' and 'blonde healthy cupids' read rather like Ronald Firbank, and they were dropped when the passage was partially incorporated into Chapter IV of Rothenstein's book on Goya in 1900.[71] These and other modifications[72] make the articles particularly relevant to the study of Naughty Nineties sensibilities. The two paragraphs on the frescoes are, therefore, quoted in full.

> I can remember nothing which gave me so considerable an idea of the insolent cynicism of the man as these paintings. Imagine a coquettish little church, like a boudoir rather than a shrine, tricked out with altar seats and confessionals, and all around Goya's gorgeously frivolous frescoes. One expects an odour of frangipane from the altar rather than incense, and I found myself looking under the seats for some neglected fan or garter ribbon, instead of for Missals and Litanies. And Goya's brilliant frescoes and daring ceiling (who can think of Heaven with the Maja of San Fernando there, and his beautiful duchess and so many others, whom he had loved, or was loved by?)—I say it in some fear of angry protest—are entirely in harmony with this indecorously holy place.
>
> Painted as they were in all the ripeness of his knowledge, Goya surpassed himself in splendour and graciousness of style. There is an atmosphere of warm ivory flesh in a frou-frou of waving draperies, a curving of pink and white arms and legs, a flying about of blonde healthy cupids in all the insolent exhibition of foreshortening, which is most perfectly personal. No Venetian with his noble dignity, no Frenchman with his charming elegance or harsh classicism, could have given us this peculiarly savage grace which the Spaniard has thrown into his work.[73]

Elsewhere in his articles Rothenstein emphasized anticlericalism and dwelt on the sensuality of Goya's life and art. He picks out the 'wantonly feminine qualities' of the Duchess of Alba and that 'delicious *maja* of whom we know so little and would know so much, whom he painted first nude—and such a nude!—and then with clothing, so curiously intimate and tantalizing'. Rothenstein's final phrase on the *Maja* sums up the interrelationship between Goya's life and art in the following terms: 'As the loved lover he painted her, in the pride of his strength and the worship of her sex.'[74]

Rothenstein's book makes Goya less of a Decadent,[75] more of an Impressionist, and decidedly a better artist. The articles had expressed reservations about Goya's technique. Two out of the three paintings recently acquired by the National Gallery, Madrid, had shown that 'Goya was capable of much bad painting'; lack of finish had 'prevented him from becoming a really great painter', even though it accounted for his impact on Manet.[76] The book reveals a growing admiration for Goya's originality as an artist, emphasizing more particularly his handling of texture and design. He draws attention to the subtle use of aquatint in the *Caprichos*, for instance: 'no one, except Turner, has used it with such success.'[77] He singles out the original composition of No. 21 in the *Tauromaquia* series, in which all the figures and action occur in the right-hand side of the engraving; the 'sinister and powerful'

organization of *Saturn* in the Black Paintings, which reminded him of 'the designs of Auguste Rodin'.[78] Above all Rothenstein presented the reader with a Goya who was concerned with overall effect rather than with careful detail; who believed that 'nature composed with even a finer sense of balance than Raphael'; who produced 'an absolutely convincing effect, through his knowledge and intuition, where a more careful and conscious artist would fail'.[79]

This Impressionist Goya was to last much longer everywhere than the Decadent artist with which Rothenstein had begun. He was not alone in sensing a precursor of Decadence as well as Impressionism in Goya in England, and one English reviewer with the initials D.S.M. (presumably D. S. MacColl) spoke in 1896 of the 'magnificently diabolical spirit Goya created in a kind of bitter cruel order of effect'.[80] That this 'diabolical spirit' was what Rothenstein and others called Decadence, seems to be confirmed by MacColl himself, when he speaks of 'the courage of the devil's side' in Aubrey Beardsley.[81] As the preoccupation with form and texture in art, rather than with content, increased, Decadent approaches dated. Ultimately Impressionism also had its day, and the critics moved on once again.

VII. Expressionism and Surrealism

In the 1890s dreams, nightmares and the workings of the unconscious were being dissected by Freud in preparation for his book *The Interpretation of Dreams* (first issued late in 1899, but dated 1900); his bibliography shows the extent of similar research in the previous decade. Less consciously analytical minds looked inwards too. Some poets used a symbolic language which suggested or implied rather than described or defined. The unconscious provided a ready source of inspiration, and more artists re-trod the road to Xanadu. Mallarmé, in one of his prose *Divagations*, for instance, related how the apparently meaningless phrase 'The last but one is dead' ('La penultième est morte') swam into his mind one day as he left his lodging, to form the end of one line of poetry and the beginning of the next. From these he knew that he must set out to discover the poem as a whole.[1]

The last decades of the nineteenth century witnessed a comparable interest in the emotive and evocative quality of line and colour, Gauguin being the major figure in Symbolist painting. In another direction there was a fascination with the irrational in art which seems to foreshadow tendencies that are usually associated with Dadaism and other movements encouraging uninhibited spontaneity from the 1920s onwards. In 1883, Félix Fénéon went to see an exhibition of 'Incoherent Art' at the Galerie Vivienne in Paris.[2] Alphonse Allais was showing a plain piece of white art paper with the title 'Chlorotic Young Ladies' First Communion in Snowy Weather'; and Raoul Colonna de Césari exhibited an 'Incoherent National Flag' (prefiguring some recent art in the United States it would seem). There was also a picture entitled *Rabbit*, in which a real cord emerged from a gentleman's mouth painted on the canvas, to end up round the neck of a live animal eating carrots in a cage in front of the picture; and there were paintings which substituted objects for things they resembled. Mesplès, for instance, showed a valley in which the poplars were goose feathers and the moon a piece of bread. Fabre des Essarts painted a canoe in the form of a skeleton sailing on a sea whose waves had lamprey heads, darting their sucker mouths at the 'boat'. Free association, later an important technique in psychoanalysis and Surrealism, was already being exploited. At the same exhibition Mlle Camille Langlois had transferred to paper 'a mortician's nightmare', and she was by no means the only artist of the period to be interested in macabre dream atmosphere. In France the most prominent worker in this vein was Odilon Redon, whose morbid or poetic mysteries particularly delighted the Belgian novelist Joris-

Karl Huysmans, exciting the senses of Des Esseintes, the protagonist of his novel *À Rebours*: 'His drawings were unlike anything else; most of them went far beyond the normal limits of painting, inventing their own kind of fantasy, a fantasy of the morbid and the mad.'[3]

It was natural that the elements of nightmare in Goya should be reconsidered at this time. Victor Hugo had been one of the first to isolate those kind of qualities in the Spaniard, and Baudelaire's verse on Goya in *Les Phares* had repeated the point in a more memorable way.[4] The Romantics had admired Goya's ability to *invent* nightmares. Nobody at that period would have known the group of Goya drawings in which the artist actually appeared to record nine 'grotesque visions' he had one night, although many would have been familiar with Plate 43 of the *Caprichos*—'The Sleep of Reason produces Monsters'—in which the dark world of nocturnal animals and birds surrounds the artist. So the Romantics did not pursue the relationship between Goya's images and real experience, nor consider their personal connotations for the artist. In fact they responded most readily to concrete images and eulogized Goya's facility for making his fantasies plausible. The new generation, on the other hand, preferred its fantasy to be less explicit and more suggestive, and it is not surprising that Goya's *Proverbs*, *Disparates* or *Dreams* should have had a particular appeal. Huysmans found them nearest to Redon, and thought that their significance was deeper and more mysterious than earlier commentators. A standard view of the *Disparates* believed them to be political allegories, rather like the *Caprichos* but more enigmatic. Huysmans was probably right to seek an understanding of them on a different level.

The fact that Des Esseintes revels in the dark side of Goya's work shows that a new sensibility was being found in the etchings. He is wary of being too enthusiastic about Goya, since his work was becoming more widely appreciated at the time and their appeal for the dandy was diminishing. In Chapter IX of *À Rebours*, however, Des Esseintes rhapsodizes over Goya's prints and finds their dark and depressing atmosphere very much in tune with his own moods:

> As a distraction and to relieve the boredom of an endless succession of hours he turned to his portfolios of prints and laid out his Goyas. Early states of some of the plates from the *Caprichos* series, proofs which he had bought at exorbitant prices in sales and which were recognizable because of their reddish colour, soothed him. He buried himself in them, following the painter's fantasies, totally absorbed by vertiginous scenes in which witches rode on cats, women struggled to pull out the teeth of a hanged man, and bandits, succubi, demons and dwarfs appeared.
>
> Then he looked through all the other series of Goya's etchings and aquatints. The macabre horrors of the *Proverbs*, the violent anger of the scenes of war, and finally the plate of a garrotted man of which he cherished a marvellous trial proof, printed on heavy unsized paper, with visibly thick deckle edges.
>
> The savage energy, the biting and bewildering talent of Goya delighted him. But the universal admiration which his work had finally won deterred him a little,

and he had refused to frame them in the last few years lest, with them hanging on his walls, some imbecile should feel compelled to pass a stupid comment on them and pause in second-hand ecstasy before them.[5]

When not writing under the cover of a fictional character, Huysmans had more reservations about the power of Goya's darker side. The Romantic view of Goya may have influenced his response over-strongly. Certainly, in his essay on *The Monster*, he found Goya's work too full of concrete imagery to prove really suggestive.[6]

> His *Caprices* tend towards satire and he ends up by being simply macabre when he explores the more repulsive subjects such as the one in which a woman tries to pull out a hanged man's teeth. Elsewhere, in his *Proverbs*, he frequently brings witches and demons on to the scene, providing them with human bodies, asses' ears and goat's feet which hardly strike an original note in the uninterrupted history of the monster. Only one of his etchings, in a corner of which a being can be seen, its jaws split into a snout, and a vast eye, like a beacon, in its forehead, seems capable of making us dream in a propitious way today.[7]

An interest in the suggestive side of Goya was also linked to a new preoccupation with his emotive qualities. In England, the critic D. S. MacColl appreciated, as Baudelaire had earlier, the power of the etchings to move us. He particularly focuses on the sense of isolation and impotence evoked by some of the plates, including the *Colossus* or *Giant* (Plate 27) and *Capricho* No. 62 (Plate 60).

> In one etching the Titan appears huge and lonely, seated on a hill top, looking at the moon going down behind the clouds, and a vast prospect of town and river. In another a meagre shape, with dragon's wings, clutches impotently at a rock; in the background two others fold their wings and fall upon the ground; and a famous plate seals all the passion and horror with *Nada* (nothing) and the epitaph *Et c'est pour cela que vous êtes nés!*[8]

Although MacColl lays stress elsewhere on the diabolic aspect of Goya's work, which inevitably reminds us again of Baudelaire, he adds something to the standard comments of the French Romantics, and certainly makes us more aware of the expressive quality of these works than most other critics writing in the heyday of Impressionism.

It is clear from Huysmans and MacColl that there was much in Goya to appeal to and inspire Kandinsky's generation, which saw man turning his gaze from externals in upon himself, and producing the unconsciously motivated 'Improvisation' or 'Composition' in Kandinsky's terms, in preference to the Impression. Apollinaire characterized the new painting of the period in a similar way, when he spoke of it as 'no longer an art of imitation, but *interior* art'.

The rising generation of German artists responded more particularly to the morbid overtones of Goya's darker work. Julius Meier-Graefe, whose later antipathy to Goya has already been discussed, described the impact of Odilon Redon, Munch and Goya in the early years of the twentieth century in Germany, 'as a suggestive

force among the younger artists'. In a chapter on the German etcher and sculptor Klinger, he claimed that 'the artist of the *Caprichos* has wrought havoc among the younger generation of Germans'.[9] Munch himself was certainly under Goya's spell. J. P. Hodin's book on the Norwegian artist underlines the relationship between the two, and notes Munch's admiration for the *Tauromaquia*.[10]

Although Meier-Graefe placed Goya in the Romantic and realist tradition, he sensed a mysticism in his art which impressed him greatly, even before his visit to Spain. He speaks of the *Caprichos* as 'audacious ghost stories' and 'titanic fantasies',[11] and notes the imaginative power in the artist's portraits as well as in overtly fantastic subjects. His ability to convey restless and tormented feelings also struck Meier-Graefe, and this no doubt led him to make a revealing parallel between Goya and the Polish novelist Przybyszewski, who worked in Berlin and was a friend of Strindberg and Munch. 'Goya was the last of the Spaniards, a phenomenon of will and of invention. Like to a harsh, shrill and wholly disconnected tone, he burst suddenly from the flaccid Spanish art of the day, comparable to a Przybyszewski in contemporary literature; dramatic, disconcerting, full of deep, exacerbated emotions . . . most poignant in his bitter self-analysis.'[12]

The growing response to Goya's emotional content can be documented in Expressionist artists at this period as well as in the critics. Nolde is said to have looked on Goya as his master; Max Beckmann's and Franz Marc's engravings are held to have been inspired by the Spaniard's work. Strong evidence of interest can also be found in Max Ernst,[13] and, above all, in Paul Klee.

Klee's *Diaries* are rich in information about his state of mind, his literary, musical and artistic enthusiasms, his personal anxieties. In expressing his feelings in 1901 he already used a phrase that seems to echo Goya's 'The Sleep of Reason produces Monsters'. For Klee at that time, 'sexual helplessness produced monsters of perversion'.[14] And although there is nothing to prove that this is a conscious recollection of *Capricho* No. 43, Klee's desire to express violent feelings, and particularly 'hatred against the bogged-down vileness of average men as against the possible heights that humanity might attain' (1902), meant that he was ready to sympathize with the author of the *Caprichos*. And when in 1904 he spent some time in Munich, Goya's graphic work was certainly a major interest. The relevant entry in his third diary runs as follows:

> I visited the Museum print room several times . . . I was handed an English book about Blake. Karl Hofer had raved about it. It was closer [than Beardsley] to my current point of view. I found Goya's *Proverbios, Caprichios*, and especially the *Desastros[sic] de la guerra* thoroughly captivating. Lily gave me many photographs of paintings by Goya. These were things I laid to good account professionally at the time. It was more necessity than impulse, more a willingness to lay myself open to these things that were signs of the new times. For I have been too much out of touch, after all![15]

The following year, not unnaturally, 'Goya was uppermost in Klee's mind' as Werner Haftmann suggests.[16] A visit to Paris and the Luxembourg confirmed

his enthusiasm for Goya. Although the note in his diary refers to colour and technique rather than content, the adjectives and nouns reflect his appreciation of the expressive quality of tonality, brushwork and composition. 'Velázquez, figures blocked out with pride and considerable *élan*. I far prefer Goya. Ravishing sonorities from gray to black; among them, flesh tones like delicate roses. More intimate formats.'[17]

Klee's reponse to Goya no doubt deepened as he became acquainted with the details of the artist's troubled life. Professor Heilbut lent him Von Loga's book in 1906, and he was soon totally absorbed. In May he noted in his diary: 'Goya hovers around me; that probably is the main trouble; but it must be overcome.'[18]

It is hardly surprising that there are slight hints of Goya's graphic work in Klee at this period. The latter's etching entitled 'Two Aunts, Nudes with Crests' of 1908 is strongly reminiscent of the two main witches in *Capricho* No. 71 ('Si amanece, nos vamos'); the forms are equally acid.

The first critic of importance after Meier-Graefe to see Goya's work in a new light as a result of the Expressionist response was also German: August Mayer. Mayer published numerous articles on Goya, an important book on his work, and he also referred to him in other books on Spanish art that he wrote between 1911 and 1934. His article on 'Goya's Expressionism' appeared in Volume 30 of *Kunstchronik* in February 1919, and he drew a number of parallels between Expressionists and Goya in his book on Goya in 1921. He linked Goya's art firmly to that of both Strindberg and Munch, the two Scandinavians who, as John Willett has recently said, 'helped to shape not only [the] ideas and attitudes [of the Expressionist movement], its concern with extreme despair, with human relationships at the point of highest tension, and, in Strindberg's case, with dreams and visions of the beyond—but also its actual artistic forms'.[19]

Mayer's interest in Expressionist qualities led him to a revaluation of certain of Goya's works, which acquired a new importance and relevance in consequence. The earliest Goya paintings in which he found Expressionist traits were the small pictures painted immediately after Goya's serious illness in 1793. The paintings for the Quinta del Sordo, the various series of etchings (with the exception of the *Tauromaquia*), and more particularly the *Disparates*, continued the same vein and intensified the Expressionist trends. Mayer, in fact, felt that the paintings of the 1790s constituted a revolution in Goya's whole approach to art: a revolution which was 'expressionist' (inward) rather than 'impressionist' (outward) in character.

There can be no doubt that he underwent a great spiritual change during illness. Detached from the impulse compelling him to continual artistic production in the capital, where in spite of all care for the artistic level of his work he was forced in many cases to comply with the ideas of employers, or to use traditional methods, Goya in his year of illness, began to review his artistic beliefs. Instead of an evolution thereafter follows a revolution. Regardless of other opinions, working more independently than he had been allowed to even in his work for the house of Osuna, Goya now paints according to his own outward and inward vision and impulse in a new 'free style', which intentionally breaks with the

older art of the 18th century. Nevertheless these pictures done 'from observations' are not merely naturalistic and impressionist. He has indeed made use of his observations from nature, but the composition, the rendering of form, the painting, contain as much of Expressionist as of Impressionist art. This can be discerned in the *Carnival Scene*, painted in 1810. But the *Lunatic asylum* has absolutely nothing in common with 'Impressionist' art.

The scene of the *Flagellants* is above all a creation where imagination plays an important part—indeed such processions were forbidden from 1777.

The clue to what Goya meant by 'observation', is afforded to us by a sentence in the introduction (never printed), to his *Caprichos*. Here he defends the artist 'who alienates himself completely from nature, expressing forms or movements which had previously existed only in imagination'. He sharply turns against the work of a 'mere copyist of nature'.

Goya was strong enough to renounce all former art formulas, to create slowly a language of his own, to build a new and original world of vision. The new pictures are just as much 'Caprichos' in their kind as the new etchings, expressly so called. The word 'Capricho' taken in its etymological sense means a sudden, unexpected wayward fancy, and Ceán Bermúdez, in his critical valuation of Goya's altar piece of the Saints Justa and Rufina in Seville, speaks of the new element in Goya's art as a creation of new ideas together with a new, unexpected and brilliant method of rendering those already generally accepted.[20]

Mayer further contrasts Impressionist and Expressionist qualities in Goya when discussing the etchings. 'The *Tauromaquia* is the chief document of Goya's "Impressionism"', Mayer declares. 'In the *Disparates* he exhibits on a like scale his "Expressionism".' Summing up his feelings about the latter series Mayer writes as follows:

It would be useless to try to explain the meaning of the different plates. It is part of the character of these visions that they cannot be interpreted with exactitude, their meaning may be construed in different ways. What can be clearly recognized may however be shortly stated. Plate 1 seems to illustrate a theme, formerly treated by Goya in a tapestry cartoon, that of a male puppet tossed in a blanket. Here however everything is more grotesque, fantastic and ghostly, just as the *Pilgrimage of San Isidro* in the Alameda became the weird and dreamlike representation in the Quinta. As in the Quinta paintings the proportions are unnatural. Most plates show clearly enough that we are not looking at creatures of our own flesh and blood. Plate 2 depicts the terrors inspired by a ridiculous apparition. Plate 19 is a variation of this subject.[21]

Mayer next disputes the validity of certain specific interpretations of these plates, be they political or mythological, and criticizes those who condemn the *Disparates* on the grounds of their lack of beauty or taste. He finds the artist's feelings strongly expressed in them, and this is what matters. Different individuals will naturally respond to them in different ways. Mayer clearly prefers works to be mysterious, imaginative and unrealistic, and he finds these qualities even in Goya's

two landscape etchings, as well as in the Black Paintings which seem to him the high point of Goya's art. Mayer's discussion of the Black Paintings is naturally of major significance, as previous generations of critics had found them hard to appreciate. Mayer admired them on aesthetic as well as thematic grounds, for in these paintings Goya simplified his colour and detail more than ever before, and plunged deeper into the world of dreams.

These wall-paintings, like the cabinet pictures executed in 1794, Goya did for his own pleasure and not for the general public. They are most important evidence of his artistic ideal in his old age. Here we recognize the impulse to monumentality, to immensity of form, no more to be accounted for by the aged master's failing sight than in the cases of Titian and Rembrandt. We find, combined with growing greatness of form, a simplification, and omission of all detail and a concentration of colour. A greater simplification of colouring can hardly be imagined; black, white, brown; and yet a richness has been attained, unsurpassed even by Daumier's creations, which objectively and subjectively resemble these works. I have already stated my opinion of Beruete's idea, that the subjects of these wall-paintings were not meant to be taken seriously, that the artist had perhaps wanted to get a laugh at his visitors' expense and to startle them; there can be no question at all of such a thing. The world with which old Goya surrounded himself was that of which he dreamt. He reveals his dreams of the night and his spiritual visions of the day. Here the lonely old master is at his best. Naturally his contemporaries did not understand, nor did his admirers of two following generations in the ages of Daumier and Manet. It was only in the days of Munch that the general public gradually came to a comprehension of this artistic language. Goya could not surpass these creations and imposed restraint upon himself in other work intended for sale to the general public.[22]

For a summary of Mayer's views of Goya's Expressionism we cannot do better than quote extensively from the concluding section of the work:

After the crisis of 1793 Goya always unites impressionist and expressionist rendering in his art. Even the manner in which the picture is blocked out is characteristic of this. The apparently 'naïve' reproduction of a piece of nature taken at random is not accentuated. On the contrary, attention is drawn to careful composition. The structure is built on a more classical plan than in the work of modern impressionists like Degas and Manet who have produced artistic results in accord with their true Gallic rationalism.

Goya as an impressionist renounces all false plasticity of form, all shading productive of sculpturesque effects. But this impressionistic suppression of all non-essential detail characterizes only part of Goya's art. Certainly he was one of the first who reproduced the surrounding world as reflected in the eye of the beholder, who painted things as he saw them, not as he knew they were supposed to be. But this was not enough. He was one of the first who tried to render activity and motion in the modern sense. Here also he did not reproduce mere externals, such as the whirr of the spinning-wheel and the grind-stone—in

continuation of the work begun by Velázquez—but underlined dynamic power, giving an expressive force to movement. This is one of the chief factors in Goya's art. He does not only try, like Constable and Manet, to produce a coloured picture from nature on canvas by the simplest means; he wanted chiefly to show the spirituality, the soul underlying matter. For the sake of the necessary emphasis he tried to attain a certain height of emotional strain, forceful activity, powerful monumentality, and even had recourse to exaggeration, to grotesques and fantasies. Goya thus became not merely the precursor of Daumier and of Manet and their followers, but in a measure the ancestor of Cézanne and Munch.

Motion as such plays a great part in Goya's creations. He never lets the persons of his portraits keep quite still. He puts a fan or a lyre, a sheet of music or a letter, a pencil or a whip, into their hands, and makes active exertion the strong point of his compositions. Vitality is his chief aim. There is variety of movement everywhere: shooting and scuffling, packing and carving, sweeping and polishing, stabbing and fighting, beating and hanging, imploring and threatening, begging and pulling, writing and gesticulating, escaping and writhing, violent embraces and desperate wrestlings, dancing and whirling through the air, swinging and tumbling, climbing and flying—all this we find in most admired disorder. To all these activities, from drawing on a stocking and trying on a hat, down to a fantastic plunge into the deep or a witch's ride through the air, the artist imparts a deeper meaning. We find this careful delineation of movement in the early tapestry designs for 'Winter'. Here the artist renders by few but effective means the march of men in the teeth of an icy wind, their battle with the winter storm. The rhythm of their motion and the bend of trees shaken by wind tell the whole story. However violent the action may be we never get an impression that this transitory movement is rendered by the artist only for its own sake.

A comparison of the 'Execution of the Emperor Maximilian' by the French impressionist Manet, with its model, the 'Execution of Revolutionary Madrid burghers by the French in the night of May 3rd 1808' by expressionist Goya, may serve to elucidate the fundamental difference between the two views of art, and at the same time will reveal the deep feeling for 'action' in Goya's picture. In spite of the dramatic subject Manet achieves no impression of stress, and the actors in the tragedy are made to appear unmoved for the sake of obtaining a single momentary impression. All conforms to picturesque rhythm and to the striving after a level picture as seen from afar off and there is no attempt to give that underlying spiritual idea which was Goya's chief aim in his 'Execution'. Although Goya does not emphasize contours, his mode of rendering forms brings out certain motions which somehow reveal to us the inner life of the figures. In these flickering, compressed, threatening and vanishing surfaces the spiritual contents, the psychic expression is the more forcibly brought to light as Goya desists from placticity and plastic roundness. Like Tintoretto he makes not the head only but the whole body the exponent of the spiritual idea. This is exemplified in the 'Execution' of which we have just been speaking, and in its companion picture, 'Street-fighting on the Puerta del Sol'; in the strange genre pictures,

connected with the Duchess of Alba; and in the portrait of Queen Maria Luisa in the Munich Pinakothek, where the head and pose denote lust of power and wantonness, the woman seeming to become an embodiment of vice rising from an abyss of sin.

Goya's expressionism is seen in drawings with the same, or even greater, force than in paintings. In the Caprichos his imagination begets visions for the plates, and his conscious expressionism is manifested remarkably. Take for instance No. 16, where the harlot turns away from her begging mother. The violence of this turning away and the strength of outward and inward aversion is denoted by an 'unnatural' position of the feet, making us feel intensely the acute bodily and spiritual wrench. We also suggest a passing reference to the 'Apparition' with huge hands in No. 49, and the unforgettable caricature of a vain old coquette in front of her looking-glass, No. 55. No. 80 with monks hideously forcing open their mouths is unsurpassed in expressive force by any caricature of Daumier's.

The effect of Goya's expressionism is yet more powerful in the 'Desastres de la Guerra' than in the Caprichos. Here he makes of universal importance things seen in his Aragonese home during the terrible days of the wars of independence. With what force impressions become expressions, how little can his art be termed illustration, or the rendering of an impression! By the artist's presentation the scenes become all mankind's cry for deliverance, an immense accusation of war,

41. Goya: *Disparates*, No. 4, 1814–24. Glasgow, Pollok House. Stirling-Maxwell Collection.

a gigantic explosion of rage, a questioning of incomprehensible Fate. This spirit-
ualisation and ethical pathos, preached anew in our own days, flows through
Goya's 'Desastres' as in no other work. The plates of despair, Nos. 15 and 26
('One cannot bear to see such things') with the mere hint at gun-barrels and
soldiery depicted as blind instruments of murder, the Tragedy of war, No. 30,
where chaos born of war is set before one's eyes in almost futuristic language and
in concentration of form which amounts to genius, are yet surpassed by plates
which represent things cosmic, transcendental, eternal, such as No. 69, where a
dead man comes to life and writes the cruel, heart-rending word, 'Nothing'.
Goya's title is 'Nothing, he will tell you so himself'. The two last plates, Nos.
79 and 80, breathe even more than the others this pathos, 'Truth is dead' and
'Will she ever come to life again?'.

Nos. 4 and 1 of the Proverbios remind one of Nolde. No. 4 (Plate 41) shows a
gigantic peasant, dancing with castanets, and No. 1 of the series shows women
tossing a puppet and a dead donkey in a blanket. The women's attitude in this
plate—to say nothing of the fantastic effect of the whole—is somewhat unnatural.
This unnaturalness is strange from the impressionist's point of view, but is easily
explained artistically from that of the expressionist. Mention must also be made
in this connection of two fantastic landscape etchings, one with trees and the
other with a water-fall, and also of a very strange giant. All these works are
purely imaginative, and lead us into a world which does not actually exist round
about us, but of whose reality the artist manages to convince us.[23]

Mayer's analysis was influential in its time. Not only were his conclusions available
in Spanish and English translations, but he also wrote a short introduction to a
book on Goya which was published in Italy in 1933. Other critics took up his
views. In Spain, Bernardino de Pantorba's biographical and critical essay (*Goya*,
1928) quoted his conclusions extensively, and the great Catalan writer on aesthetics
Eugenio d'Ors, in the first volume of his *Epos de los destinos*, entitled *Goya's Life* (*El
vivir de Goya*, 1943), also accepted the idea that the *Disparates* at least was Ex-
pressionist in character.[24] In 1946 Fernando Jiménez-Placer produced a detailed
analysis of Expressionism in the *Disparates* which went further than Mayer, focusing
on the rich variety of grotesque and misshapen forms in the work, and the dominant
notes of duplicity and terror.[25] Finally a more totally Expressionist interpretation
of Goya was to leave the presses after the Second World War in France, when
André Malraux's *Saturne* came out in 1950.

Before turning to Malraux, however, something must be said about the growing
interest in Goya's psychology at this period, which added a new complexity and
mystery to interpretations of his work.

Some psychological theories about Goya are related closely to Spanish racial
characteristics; others are strictly medical opinions. Both of these are left for later
chapters. But given the interest in the unconscious shown by artists and writers
in the 1920s, it was inevitable that Freudian or Jungian approaches would sooner
or later be applied to Goya by critics as well as by doctors and psychiatrists.

Concern for Goya's art as an expression of his unconscious is implicit in the admiration—albeit qualified—of Meier-Graefe in Germany, and in the comments of C. Gasquoine Hartley (Mrs Walter Gallichan) in England at much the same period. The latter, who was one of Havelock Ellis's followers, chiefly saw Goya's art, like all art produced by Spaniards, as a manifestation of the Spanish character: 'dramatic seriousness' and 'passionate egotism'.[26] Goya was, typically, 'passionate in everything', and this seems a continuation of Baudelaire's and Havelock Ellis's lines of argument. But Mrs Gallichan goes further than either of her predecessors when she describes the Black Paintings as 'a revelation of Goya's inner thoughts',[27] although she discounts the possibility that they reflect a private neurosis (a thesis which others were later to develop)—'it was not that he loved the horrible *because* of its horror'.[28]

In the 1920s Surrealism brought about a significant change in the attitude to the relationship between the work of art and the artist's unconscious. It was, after all, a primary aim of Surrealists to establish a relationship between the two. André Breton's *Second Manifesto* (Paris, 1930) spoke of the need to 'short-circuit' the artist's contact with the material in his unconscious mind, and techniques of automatic writing were increasingly practised with this end in view. At the same time Surrealist theorists believed that their methods were not new. As David Gascoyne said in *A Short Survey of Surrealism* (London, 1935) 'surrealistic art has existed at all times and in all countries'. Gascoyne cited Goya, along with Uccello, Bosch, Breughel, Blake, El Greco and others, in evidence of the truth of his assertion. The work of Goya and these other precursors evinced the lack of concern for form and the rejection of 'the mere reproduction of the bald external appearance of logical reality' which were the primary Surrealist qualities. Some Surrealists believed that Goya had intentionally exploited the world of dreams as they now sought to do, and a selection of the *Caprichos* was included in the 'Fantastic Art' section of the International Surrealist Exhibition in New York in 1936.[29]

Goya was to become a major influence on Spanish Surrealists. Looking back on the movement in 1961, the poet Rafael Alberti felt that there had been a strong vein of Goya in it in Spain. Spanish Surrealism had been more 'explosive' than the French variety in consequence. Three major Spanish Surrealists soon interpreted Goya's work in the light of their own theory and practice: Alberti himself, García Lorca and the novelist and essayist Ramón Gómez de la Serna.

Lorca includes several references to Goya in his essay on *Duende* which he first gave as a lecture in Cuba in the Spring of 1930. *Duende* is the inner spirit which a work or artist must have in order to communicate emotion. It is deeper and more mysterious than inspiration, style or polish. Essentially it comes from within rather than from without, external inspiration for Lorca being more an affair of muses or angels than of *duende*.

The inward quality of *duende* naturally links it with Expressionist and Surrealist theories. *Duende* is in the blood, in folklore and traditional dance; Lorca also finds it in 'Goya's dark fantasy' and 'chimeras'. The passage in which Goya is first seen

as an artist with *duende* is worth quoting in full. The term 'dark spirit' is used for *duende* in the translation:

> The real struggle [of the artist] is with the dark spirit.
>
> We know the various paths by which we may seek God: from the primitive route of the hermit to the subtle approach of the mystic. Through a tower, like St Theresa; or by three roads, like St John of the Cross. In the long run God will send their first thorns of fire to those who seek him, even if they are driven to cry out with the voice of Isaiah: 'Truly Thou art a hidden God'.
>
> But there are no maps or easy ways for finding the dark spirit. We only know that it burns the blood like a topical application of glass, consuming and inflaming. It rejects the gentle geometry we have learnt, and breaks styles. The dark spirit made Goya, who had been a master of greys and silvers and the rose tints of the finest English painters, lay on terrible bitumen blacks with knee and fist. The dark spirit stripped the Catalan poet Verdaguer naked to face the ice of the Pyrenees. It drove Jorge Manrique to lie in wait for death on the desolate plains round Ocaña. It dressed the delicate body of Rimbaud in the coarse green trappings of the circus. It gave Count Lautréamont dead fishes' eyes at dawn on the boulevard.[30]

Lorca's *duende* is almost as mysterious as the subject of a Surrealist painting. But it is clear that it is to be found in Goya's later works, presumably in the Black Paintings, and that it expresses a powerful emotional charge. The same set of paintings for the Quinta and the etchings attracted other Surrealists. Gómez de la Serna detects evidence of a Surrealist approach in them and in the *Disparates* above all. Goya's work, for him, reflects the artist's unconscious and the collective unconscious of Spain. He emphasizes the dream sources of some of the *Caprichos'* images, and underlines the artist's obsessions. Goya's personal suffering and psychic experience explain his genius for Gómez de la Serna. When he was spurned by the Duchess of Alba, Goya 'believed that he would lose his artistic powers; yet art like the wound in the poet's heart or blindness in a nightingale, increases the outpourings of genius when it feels the pangs of love.'[31] A drawing like the one entitled *Dream of Lying and Inconstancy* (Plate 43) is a product of a disturbed mind.[32] The frescoes on the dome of San Antonio de la Florida (Plate 22) are conceived by Gómez de la Serna to have been done in the heat of inspiration, in a burst of automatic painting, drawing the images from within rather than imposing them from without. He imagines Goya finding liberation in the unconscious, as the Surrealists did. 'The artist's spirit needed mystery from time to time', he declares, 'as a refuge from the routine monotony of ordinary life.'[33]

In the section on the *Proverbs* or *Disparates*, Gómez de la Serna writes in the following terms:

> In his *Proverbs* or *Disparates*, Goya makes an exploratory flight through forbiddingly dark skies.
>
> The finest evenings of his life are spent penetrating a mysterious universe,

writing it express letters and sending it appeals for help.

It is not a religious mystery that one finds in his work. Rather he looks for new areas of mystery, scaling the highest points in the landscape, from which unusual phenomena can be seen.

The chief magnetic force acting on fantasy, working upon it in the reverse direction from gravity and pointing its head to the sky, is the force which drives us to intuit, glimpse or even touch things which are above human existence.

It is this which brings us to surrealism from time to time: a surrealism which has always been at work in Spanish minds. Because our spirit is especially realistic, its excursions into fantasy have always been made from a base of realism, so that the creations of Spanish genius turn out to be surreal rather than superfantastic. Ours is a time of thirst and aspiration. We need to disturb life, make it problematical, create our own miniature monsters, reach beyond the normal possibilities, seeking a kind of delirious rhythm which will raise us above everyday life.

After a period of naturalism in which everything tended to be seen in terms of clear-cut mathematics, we feel impelled to bifurcate reality, burst its limits, tremulate it . . .

We must exercise the rights of miniature monsters and drive reality mad. Humour is the way to do it since the surreal grin (very different from the unreal) is half serious and half tragic.

Goya is nearest to this mysterious realism in his *Proverbios* or *Disparates*, the pages of his work which dived deepest into heights and depths previously unplumbed: those which even to-day we explore in our planes and submarines. These powerful, disquieting, superb proverbs spring from collective fears and fights in which monsters come down on to the plains.

These plates are larger than the *Caprichos*; like strange squares opening out from the hemmed-in alleys of his drawings. The fact that they have no ultimate explanation makes them all the richer in meaning . . .

In my view Goya reaches his greatest heights in his *Disparates*: capital letters engraved and adorned for a book which has yet to be written; a formidable book for which he has provided the first letters of chapters which the next generations will write.[34]

Given the circulation of such views it is not surprising that works like the *Caprichos*, which had previously been thought to contain explicit political and moral symbolism, should now be seen, more like the *Disparates*, as mysterious products of the artist's subconscious. In 1923 Pierre Paris spoke of the monstrous dreams in Goya's work, and echoes of his engravings were soon found in those of Chagall. Lord Derwent, in 1930, held that the *Caprichos*, as well as the Black Paintings, reflected 'reality passed through the dyeing-vats of nightmare', and he described the former as a 'cryptic hybrid between a nightmare and a satire'.[35] The *Disparates* more obviously drew the spectator 'towards those regions between sleeping and waking', and in 1935 the Spanish art historian Manuel Gómez Moreno suggested that all four series of Goya etchings corresponded to physical and mental crises in

the artist's life. One of Goya's apparent obsessions—the theme of the persecuted maiden—was traced in Italy by E. Mottini in an essay entitled 'Goya, bitter and violent', and Herbert Read found the 'direct contact with the deeper players of the mind' which arose from the 'extreme fantasies' of Goya's 'mad' phase, barely tolerable. Amongst single paintings later picked out by critics for Surrealist treatment is *The Colossus*. Juan Antonio Gaya Nuño, writing at the time of the tercentenary of Goya's birth, felt that a fantastic or dream element emerged in the figure of the giant towering above the realistic panic of the crowd in the foreground. Elsewhere he noted the Dalí-like quality of the padlocks fixed to ears in the *Caprichos* and sensed the Surrealist in the Goya drawings that refer explicitly to dreams and visions.[36]

Then the Second World War focused attention anew on psychiatry as people bent or warped under unaccustomed stresses or used their knowledge of anxiety to apply pressures to others.

Aldous Huxley's essay on Goya, written as Foreword to the *Complete Etchings of Goya*, came out in 1943. Inevitably it had most to say about *The Disasters of War* series. But the exploration of the unconscious mind by Goya in some of the *Caprichos* and nearly all the *Disparates* gave rise to some powerful comments on the nature of their impact on the spectator.

> In certain other etchings (in the *Caprichos*) a stranger and more disquieting note is struck. Goya's handling of his material is such that standard eighteenth-century humour often undergoes a sea-change into something darker and queerer, something that goes below the anecdotal surface of life into what lies beneath—the unplumbed depths of original sin and original stupidity. And in the second half of the series the subject-matter reinforces the effect of the powerful and dramatically sinister treatment; for here the theme of almost all the plates is basely supernatural. We are in a world of demons, witches and familiars, half horrible, half comic, but wholly disquieting inasmuch as it reveals the sort of thing that goes on in the squalid catacombs of the human mind . . .

> [In the *Disparates*] there are other plates in which the symbolism is less clear, the allegorical significance far from obvious. The horse on a tight-rope, for example, with a woman dancing on its back; the men who fly with artificial wings against a sky of inky menace; the priests and the elephant; the old man wandering among phantoms. What is the meaning of these things? And perhaps the answer to that question is that they have no meaning in any ordinary sense of the word; that they refer to strictly private events taking place on the obscurer levels of their creator's mind. For us who look at them, it may be that their real point and significance consist precisely in the fact that they image forth so vividly and yet, of necessity, so darkly and incomprehensibly, some at least of the unknown qualities that exist at the heart of every personality.[37]

Huxley in these passages does not attempt to explain why certain images more particularly affect us. After the war André Malraux did.

Malraux already saw Goya as a key figure in the development of modern art in his

Voices of Silence, that vast project of a book on which he was working from 1936 to 1951. In it Goya frequently 'foreshadows modern art', or indeed '*is* modern art': using brushstrokes poetically or expressively rather than merely to imitate the external world; replacing reality-orientated subjects with emotionally-orientated ones; moving away from the political outcry of *The Third of May 1808* to the poetic protest of *Saturn*. This development showed Goya's willingness to 'subdue all things to his style' as the truly modern artist must. His greatness lay in his peculiar ability to express a human victory over the blind force of destiny 'by recapturing the nightmare visions of primeval man'.[38]

The same main lines of argument recur in Malraux's other works on Goya. In 1947 he wrote a preface for an edition of Goya drawings from the Prado, stressing the importance of the artist's inner world. 'He was almost brutally sensitive to the demons of terror which are recognizable as common to us all.'[39] Later in the same essay Malraux claimed that Goya's 'exterior vision was merely the focus—a sharp one—for the accusing shapes he bore within himself'.[40] In *Saturn* Malraux's conclusions again related to Goya's exploitation of the subconscious. The sense of the loneliness of his personal vision, and his challenge to his cultural environment were further developed. Goya was the embodiment of *anti-destin*: affirming the Self, yet transcending it. He was a prophet of art and humanity in a world which had lost its religious values.

Expanding some of the points of his earlier essays, Malraux shows how Goya ignored or even destroyed the moralizing style of previous caricaturists in his own early caricatures. He seeks deeper roots for his expression in the unconscious mind, and in the mirror drawing series goes beyond mere wit to reach into 'the anti-chamber of mystery'.[41] Progressively eliminating the frivolous, decorative lines with which he first tried to please his public, Goya increasingly isolated himself stylistically from his audience. The *Caprichos* themselves hover between reality and dream in Malraux's view—a kind of 'imaginary theatre'. Malraux also finds obvious material for psychoanalysts to explain in the large hand of Goya's 'Duendecitos' (*Capricho* No. 49), and in faceless figures. He also imagines possible interpretations of Goya's plucked chickens, which he believes 'the unconscious seems to bring up from its deepest depths'.[42]

Two passages are central to Malraux's thesis. The first of them describes the technique of Goya's drawings after the Peninsular War in terms which inevitably remind us of the automatic writing techniques of surrealist poets. In a later passage about the *Disparates* and the Black Paintings, Malraux speaks of the way in which Goya involves the spectator in some of his fantastical subjects or actually paints an innocent bystander looking at 'a world that [fantasy] renders *surrealistic*'.[43] The second key passage occurs in this later section.

> Most of [his brush drawings], executed for his own amusement or like a writer taking notes, are of a few figures, or single ones; in such cases his style allies itself to the *Caprichos*. The designs of the 'compositions' are no longer gratuitous, and we instinctively class them among the preparatory sketches to the *Disasters*, the *Tauromachia*, or the *Disparates*, for his design cannot give full scope to its function

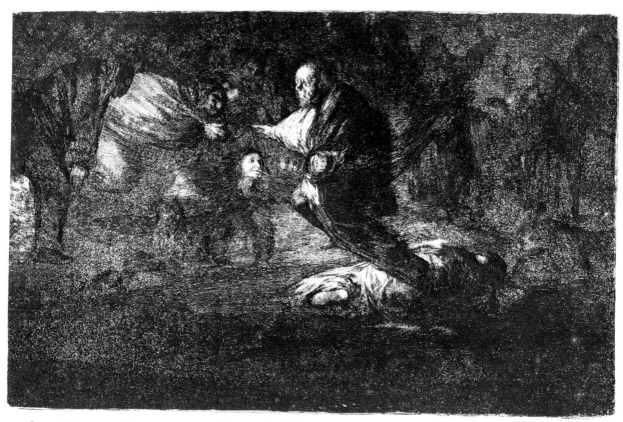

42. Goya: *Disparates*, No. 18, 1815–24. Glasgow, Pollok House. Stirling-Maxwell Collection.

except when it has none, that is to say, when it depicts a single figure. Certain drawings contain several figures, drawings in which light and concentrated colour play an important part which cannot be classed in sequences, seem to be on the way to becoming pictures. I do not believe that they are 'studies' but rather that Goya, who followed his obsessions, 'let them come'; the drawing of *Saturn* is one of Goya's moments of obsession, not a study for the House of the Deaf Man.

His important drawings, moreover, carry in almost every case the mark of recollection. None of them is evidence that he has spent his life making sketches in prison cells. He was permanently on the look-out for shapes but he was not subservient to them. Selection was called in by his feeling. What he saw only clarified the indistinct accusing shapes that he carried within him. Let us only remember the cry of Daumier, who to all appearances found sketching so simple! 'You know perfectly well that I cannot draw from nature!'

He began the *Disparates*, that is, the Madnesses; feminine madness, matrimonial madness, the madness of poverty and of carnival, flying madness, common madness, the madness of fright, raging madness, sheer madness, and the *Old Man straying among phantoms* [Plate 42]. There is no more comedy and old women with mirrors but majestic apparitions, the spectre of war, murder, monsters, men sewn up in sacks, and the figure with three legs and two heads symbolizing marriage and perhaps love. Undoubtedly Goya has shown himself in these works to be

the greatest interpreter of anguish the West has ever known. Once his genius had hit upon the deep melody of the song of Evil it mattered little whether in the depths of the night his multitudes of shades, his throng of owls and witches, returned to haunt him or not.[44]

Malraux goes on to link this vein in Goya's later work with age-old manifestations of mysterious beliefs: carnival, saturnalia and so forth. Goya's art becomes a representation of these deeper realities rather than of the superficial world of external appearance, and Malraux's second important passage describes this in the following terms:

> No artist, not even Baudelaire, has revealed so clearly the power of the ir-remediable. Goya wanted the world to admit that it was only an appearance, a deception perhaps; he expressed it by a colouring which denies its colouring. The 'dark paintings' of the 'House of the Deaf Man' obviously do not possess the glowing colours of the pictures which are contemporary with them; but the latter deny reality as much as the former, which call them forth—and are insepar-able from them. So as to destroy not only this reality but also the style through which it claimed to be glorified Goya made use of the system of correspondences and allusions that we have seen, and turned into discords every one of the essen-tial harmonies on which the ordering of the world was based. The world was nothing but a dictionary from which he chose words simply for the hints their richness gave of times earlier than history. It has been said that he was dreaming; rather, he was excavating. The supremacy of this art is undoubtedly due to the ease with which he moves in the lost domain where we think we discern the source of our bondage. For the first time (in how many centuries!) an artist heard welling up inside himself a message which was nothing but the never-ending song of darkness.[45]

This pursuit of an internal mystery leads Goya in Malraux's view to the rejection of the conscious and the rational and a discovery of the unconscious. But it also leads him 'to the conquest of his personal style', and it is this which ultimately makes him a true modern. Goya's questioning of the values of his own society and his rejection of the concept of a harmonious universe gave rise to a change in the function of painting. Goya's sense of colour, for instance, 'is not employed to make a statement of what is, but of what *he* is; to some degree it is used to ask a question. It is not in the service of a rational world or of an ordered one.'[46]

Malraux is finally able, therefore, to see Goya's painting as one which discovers its own laws, declaring 'the pre-eminence of the resources peculiar to painting over those of representation; the right to draw and paint, not to achieve an illusion or to express a spectacle in the strongest possible way, but so as to express painting itself.'[47]

Malraux's interpretation of Goya is full of penetrating insights. Some details can of course be challenged, particularly his comments on the *Caprichos*. Those plucked birds, for instance, in No. 20 can as readily be related to the word-play which is typical of the series as a whole, as to anxiety dreams. 'Plucking' in Spanish slang

('desplumar', 'descañonar'), is the same as 'fleecing' in English. These gallants have been 'fleeced' by the prostitutes—amongst other things. The spectator is invited to recognize their folly (Goya's Spanish contemporaries laughed at them), as well as to sympathize with their terrible suffering. But no writer has penetrated into the darker side of Goya in modern times in a way which enables the reader so clearly to participate. Malraux helps us to feel where others who use a psychological approach merely explain.

Malraux's book is the culmination of Expressionist and Surrealist approaches to Goya. To summarize the interrelationship between Surrealism and Goya's work, and to give two contrasting interpretations and evaluations of the psychological aspects of his art, we can turn to two other essays, both written in the 1940s. One of them by the Spanish art critic Enrique Lafuente Ferrari, sees Goya's exploration of the unconscious as one of his most fruitful contributions to subsequent developments in the history of art. For Lafuente, Goya's pathfinding in the Surrealist ranges was more valuable than the meanderings of the Surrealists themselves: more honest and less self-conscious; more subtly perceptive. The other critic, the German Hans Sedlmayr, is less enthusiastic; expressing disapproval of Surrealism and lamenting certain similar trends in Goya's art.

Lafuente Ferrari's eulogy of the psychological vein in Goya comes in his *Antecedentes, coincidencias e influencias del arte de Goya* (1947), and reads as follows:

> Goya, torch in hand, has brought light to the caves of man's dreams and desires; he plumbed in advance of his time the heart of man and the mysterious depths of the human spirit, finding the very paths which art was soon to follow . . . Goya with this action brought to its climax a process which in my view best defines the historic role of our artist, his visionary attack on unexpressed realities, previously unheard of in art. Goya is aware of his inner life, his subconscious imagination, the world of dreams, and dares to give them artistic status, making them worthy of pictorial representation. In his etchings, in his drawings, and in many of his paintings of the late period, dream imagery enters the realm of Goya's work with a surprising vigour.
>
> The Surrealist art of our own times, which springs from an authentic discovery on Goya's part, only systematizes the same principle *ad nauseam*. It falls into conventionalism, pedantic mannerisms and *parti pris*, and in most instances no longer even draws on authentically first hand material, but simply follows an uninspired exhibitionist recipe.[48]

Sedlmayr's approach is very different: deeply critical in relation to the Surrealists, whom he particularly identified with the destruction of religious, moral, aesthetic and rational values in the modern world; more pessimistic about the significance of Goya's exploration of the unconscious.

Sedlmayr developed his views of Goya as part of a large scale analysis of the disintegration and dehumanization he thought was characteristic of modern society. The ideas for his book, which was ultimately called *Verlust der Mitte*, were first sketched out in the 1930s, and more specifically elaborated in university lectures he

gave in 1941 and 1944, so his pessimistic viewpoint is not surprising. He examined the art of the past to find the source of the breakdown of values in contemporary society. And the theories which underlie his analysis are part psychological, part religious and part historical. In the postscript at the end of his book, he describes the method by which he 'takes works of art as symptoms of a disturbance in the condition of man, whether individually or collectively'.[49] The book 'diagnoses from the facts of art that the disrupted relationship with God is at the heart of the disturbance'.[50]

Sedlmayr sees Goya as an early example of an artist becoming isolated from broad social commitment and religious belief. His art is a subjective expression of despair, and a rejection of order and logic. Goya, in fact, is a 'lonely antagonist of reason', expressing doubts 'as to the dignity and true nature of man', possessed by 'terrible and tormenting dreams and visions'.[51] Sedlmayr obviously accentuates the side of Goya which had appealed to the Expressionists: the etchings and the Black Paintings. His reference to the *Caprichos* as *Dreams* is particularly indicative of his biased approach. Few critics today would find the *Caprichos* as devoid of precise allegorical or metaphorical significance as Sedlmayr implies. His comments, in fact, have the usual shortcomings of *zeitgeist* approaches. A preconceived idea is read into the artist's work. Aspects of it which do not fit are simply ignored, and there is an inevitable lack of accuracy over detail. Yet if there is greater precision in the writings of many of the academic critics examined in the next chapter, there is often a lack of the desire and pursuit of the whole which fires Sedlmayr. He looked at art for an explanation of the disintegration of societies he saw around him. He looked up to artists, because they faced their despair and gave it expression. His vision must move us, even if we remain unconvinced.

> The more we study the art of Goya the more intense grows our conviction that, like Kant in philosophy and Ledoux's architecture, he is one of the great pulverizing destructive forces that bring a new age into being. In Goya's art certain characteristics force their way to the surface, they are symptoms of what have become the decisive trends of modern painting, but there is more to him than that. Court painter though he was and officially working for the Court, even as Ledoux still worked for the *ancien régime* and dedicated his great architectural works to two monarchs, Goya nevertheless is the embodiment of the new type of the 'exposed' artist in the sense outlined above. The new element in his art has no connection with the public sphere, but derives from a completely subjective province of experience, from the dream.
>
> For the first time an artist, taking refuge neither in disguise nor pretext, gives visible form to the irrational. The two series '*Sueños*' ('Dreams') and '*Disparates*' ('Madnesses') are the real keys not only to his own work but to the most essential thing in modern art. And '*Disparates*' are also the frescoes with which he decorated the walls of his country house, and not a few of his pictures.
>
> Here for the first time an artist has thought something worthy to be put on canvas, which derives directly from the depths of the dream world and the irrational. Nothing could surely be more mistaken than to suppose that these series were created to improve or instruct the world or to brand some politician.

The elemental power of these visions would never be understood in terms of so innocuous and idealistic an explanation. It was not the kingdom of ethics which gave them birth, nor can they be thought of as a species of pictographs. It is true that they speak in a kind of *idioma universal*, a language common to mankind, but there is nothing allegorical or metaphorical about them, no cryptic meanings which the beholder is expected to decipher, though such meanings were of course subsequently read into them by others and also by Goya himself. It is well known that this series of drawings were given new titles when they were published; '*Sueños*' became '*Caprichos*', a class of drawing with which the public was familiar, and one which was represented in Spain by the '*Capricci*' of G. B. Tiepolo. The '*Disparates*' became '*Proverbios*' or proverbs, and the different drawings were given titles which gave them an allegorical significance. The original titles were for the most part probably unintelligible to Goya himself, and were doubtless based on associations or 'disguises' of the dream world which so often prove meaningless to the waking mind. They must, as must the dreams themselves, be psychologically interpreted, they must, that is to say, be referred, not to some general and recognized association of ideas, but to a purely individual one, which is valid for this one man alone. Baudelaire expresses this brilliantly in what he says about Goya's 'love of the incomprehensible'. This is the link with all those modern movements whose 'iconography' derives similarly not from some universal association, but from some purely individual working of the dream self—movements which could all be lumped together under the name 'oneirism', a name which one of them actually assumed. Psychoanalysis will one day attempt to write their 'iconography'. The general theme of these dreams, however, is the world of the monsters, of the demons, of the Infernal—Incubus and Succubus.

Once Hell was a clearly defined province of the world beyond. All the hideous products of the imagination by which the mind could be tormented were banished into pictures of that place and thus objectivized. The eruption of Hell into this world was a real and external thing, and it was thus that the painter would portray it in pictures of the tempting of the saints and of those dehumanized human beings that mocked and tormented Our Lord.

In the other case, however, the one here before us, this world of the monstrous had become part of man's inner world. It exists within man himself, and this brings us to a new conception of man, in so far as man himself becomes demoniac. It is not merely a matter of his outward appearance, it is that man himself and all his world have been delivered to a demon empire. Man is on the defensive. It is Hell that has the overwhelming power, and the forces that man can marshal against it are feeble and despairing.

In the visions of the '*Sueños*' and '*Proverbios*' we see every disfigurement by which man can be made hideous and every temptation by which his dignity can be assailed; we see demons in human form and beside them bewitched creatures of every kind, monstrosities, ghosts, witches, giants, beasts, lemurs and vampires. Chronos devouring his children seems like a nightmare personified as he squats, a naked giant, on the edge of an oppressed world, and yet this

Pandemonium of unclean spirits has a kind of raging vitality. These are no creatures of artistic fantasy—these are bloodless realities that have been personally experienced.

For what comes to light so visibly and directly in the 'Sueños' and 'Disparates' puts its impress in greater or less degree on all Goya's later work, affects both his choice of subjects and his treatment of them. In his famous pictures of the horrors of war he prophetically develops a conception of war that at the time was wholly new and shows us the raging of demons in human form 'brutally showing us man no longer as something made in the image of God, but as a creature whose humanity has departed from him, showing him then when he is dead, as a thing, a carcass, something men throw away'. These words of Hetzer are anything but an overstatement. Goya's bull-fighting pictures, for instance, are certainly no glorification of the Spanish national sport, they are simply yet another portrayal of the cruel madness of the mob, and of men brutalized. Processions and the Inquisition are similarly treated and it is in these pictures that for the first time in human art, we see human beings as an amorphous mass. It is—most significantly—at this time that the madhouse is recognized as a fitting theme for the artist . . .

The peculiar means he employs are determined by his subjects, and both are equally novel . . . Often the background becomes so flat and so devoid of character, that one wonders whether one is not looking at a stage backdrop—or a painted background like those used by photographers. It is a very significant fact that Goya was the first painter to use lithography and exploit its somewhat crude potentialities—his manner of working a red crayon is very much on a par with this. In his second series it is plain to see that his 'drawings' are really monochrome paintings; there is a fiery red water-colour wash—a thing extraordinary in itself and most significant—and a wild fury of line that makes for complete dissolution of form . . .

That Goya escaped madness is due to the fact that in the midst of the terrible visions which weighed upon his soul he could still cling to the pattern of the human form. He realizes it most perfectly in his 'Christ on the Mount of Olives', a picture in which Christ's features so strangely resemble Dostoevski, and in which He stands forth as the prototype of man in the condition of ultimate desolation and supreme spiritual need. There is a sort of secular version of this. It is that sheet from the *Desastres de la Guerra* which shows man kneeling in despair before the darkness of the void. But here there are no ministering angels.[52]

VIII. Psychological and Pathological Interpretations

SEDLMAYR's psycho-philosophical analysis of modern society took Goya's work as a symptom of a general disturbance. It has naturally been taken as a symptom of a more particular disturbance, in the artist's own psyche, by doctors. For analysts of this variety, Goya's work is not so much interesting for its own sake as for the condition it indicates. Doctors have, nevertheless, sometimes illuminated the creative process and, in Goya's case, they have certainly helped to explain the power of his work and the nature of its impact.

There is nothing new about a concern for an artist's medical history. But the 1920s and 1930s saw a considerable growth of interest in the relationship between art and personality. Freud himself wrote about Leonardo, analysed Michelangelo's *Moses* and studied delirium and dreams in Jensen's novel *Gradiva*. Ernst Kretschmer discussed artists, writers and composers in his efforts to correlate body build and physical constitution with mental attitudes and character (*Körperbau und Charakter*, 1921). It was during this period that doctors began to take a professional interest in Goya, 'examining' the man and his work, and putting forward medical and psychological diagnoses.

The earliest specialist analysis of Goya's physical and mental state came from a professor at the University of Saragossa, Dr Roya Villanova, in 1927.[1] It was written as an inaugural address for a course in Pathology and Clinical Medicine, and gives a well-documented account of Goya's medical history so far as this could be deduced from the artist's letters to Martín Zapater and reliable biographies. Dr Rova Villanova made one or two errors of fact and mistook the date of some letters. But, on the other hand, he brought to light some new medical evidence about Goya's illness in 1819, apparently obtained from a descendant of Señor Arrieta, the doctor who saved his life on that occasion. Dr Roya's main suggestion is that Goya suffered progressively from arterio sclerosis after 1787. This condition led to a crisis in the artist's health in the 1790s. The 1819 episode seems to have been due to typhoid fever, which Goya may also have had in 1777; and there is evidence of rheumatic problems and partial paralysis, since the waters of Plombières and Bagnères in France, which were prescribed for Goya, alleviate these complaints. Dr Roya treats Goya's deafness as a separate issue, attributing it to the effects of otitis after measles in childhood.

Following Ernst Kretschmer's analysis of body types, Dr Roya also identifies Goya as cycloid and pyknic. The latter type is usually associated with diabetes, rheumatism and arteriosclerosis, and therefore tends to confirm the diagnosis which Dr Roya had based on the artist's medical history. The mental states associated with the pyknic include sociability, affability, generosity, wit, vehemence and melancholy—allowing the diagnostician a fair margin for error—and Dr Roya finds no evidence that Goya was schizoid or psychotic. Finally the doctor turns to the artist's work and produces some rather less telling comments. The size of his family explains his own fondness for painting children; his personal medical history leads him to take an interest in medical subjects.

A new medical theory was advanced in the 1930s by another Spanish doctor, Daniel Sánchez de Rivera. According to his diagnosis, which continues to find support, Goya suffered from syphilis. This view was first put forward in an article entitled 'Goya's Illness' ('La enfermedad de Goya') which he wrote in 1932 or 1933.[2] The ill-health referred to in various letters, the short life of most of his children, the oblique terms in which contemporaries described his ailment, all seemed to support his case. Sickness of body led to mental infirmity. Yet the pathological signs Dr Sánchez de Rivera finds in certain of Goya's etchings and paintings will hardly convince the present-day reader. Goya's *Crucifixion*, for instance, and *The Last Communion of St Joseph Calasanz*, seem as abnormal to him as the Black Paintings; and he fails to appreciate the fact that distortion and ambiguity are everyday concomitants of satirical art. It is difficult, frankly, to share Dr Sánchez de Rivera's obsession with *Capricho* No. 4, which he cannot conceive to be anything other than the product of a sick person. In the face of the overgrown, finger-sucking booby he asks 'What can it all be, if not something absurd, abnormal, in a word, pathological?'.[3]

Dr Sánchez de Rivera's theories came out in book form after the Spanish Civil War in 1943, and other doctors soon added their comments from similar and different viewpoints. Dr Joaquín Aznar Molina, for instance, suggested that Goya's deafness had sharpened his visual perception and powers of memory, and so accounted for the particularly fine work he produced after 1792.[4] (Ceán Bermúdez had put forward a similar view in the artist's lifetime.) He also traced the impact on Goya's work of various kinds of illness, mental as well as physical. He talks of the depression which the dethronement of Charles IV and the collapse of his aristocratic protectors may have induced; the physical pain which endarteritis or arteriosclerosis may have caused; and the mental suffering brought on by envy, setbacks in his career, frustrated love for the Duchess of Alba, and the loss of all his children with the exception of Javier. Aznar Molina sums up Goya's temperament in terms of hypersensitivity, and argues that he was basically a generous, warm and sociable person, whose character was periodically altered in the direction of violence as a result of physical or mental suffering.

In May 1946 Dr C. Blanco-Soler read his psychological sketch of the Duchess of Alba to the Real Academia de la Historia in Madrid. In this he advanced a new interpretation of the artist's psychological make-up. Blanco-Soler felt irascibility

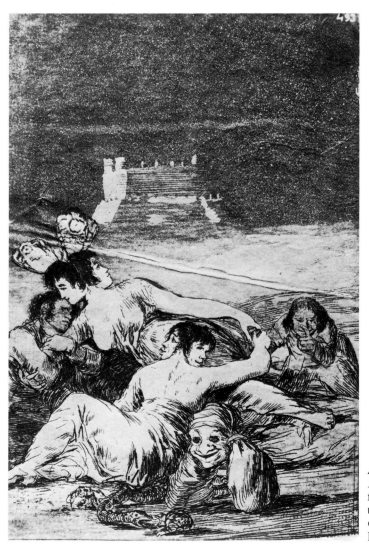

43. Goya: *Dream of Lying and Inconstancy*, 1797–8. One of five additional plates made at the same time as the *Caprichos*. Madrid, Biblioteca Nacional.

to be a basic characteristic of Goya, and thought that the artist put all his feeling into his work and so had little capacity for love. He supports his case from time to time by reference to sexual symbolism. This, for instance, is his comment on the etching the *Dream of Lying and Inconstancy* (Plate 43), which had previously been taken by critics as evidence of Goya's love for the Duchess:

[The etching] is a mental image of his desires. He cannot put out of his mind his obsession for [the Duchess]: obsessions would easily be formed by a temperament such as Goya's. If we bear Freud's ideas on symbolism in mind, we can soon find a large number of details in the drawing that indicate Goya's sexual excitement. The serpent in front of the open mouth of the frog; the rocky landscape, and the river which seems to flow by the foot of the castle's walls. Since all sexual symbolism is unconscious, that of Goya's *Capricho*, albeit packed with sexual references, was equally so. At the same time there may be a conscious

element too; one which tends to suggest that his passions were unrequited: the proud and impregnable fortress (the Duchess); the difficulty of crossing the river and scaling the castle walls (the Duchess), etc.[5]

Blanco-Soler believes that the duchess was fundamentally narcissistic. Hence the exacerbation of Goya's frustrated desire. In a later study (1947) wholly about the artist's psychological and physical make-up, Blanco-Soler defines Goya's temperament as that of an athlete in whom outbursts of anger are common. He rejects the syphilis theory, and suggests that Goya's art is an obvious manifestation of paranoid obsessions (following on his deafness) and recurrent attacks of schizophrenia.

Blanco-Soler's specific interpretation of the *Dream of Lying and Inconstancy* needs to be looked at coldly before the butterfly wings on the lady at the centre of the etching encourage us to take off into Freud's dreams of flying. Admittedly his approach is less extreme than Frederick S. Wight's in whose Freudian analysis of Goya (also dating from 1946), the artist's father and mother loom large, surfacing in this print as elsewhere in his work.[6] But emblem books suggest that a less pathological explanation of the etching's symbolism is possible; in fact there is no doubt that emblem books can offer an explanation for most of Goya's symbols in this instance. Butterfly wings are traditionally associated with fickleness; two-faced figures need no comment; and the frogs and serpent are 'old symbols of sinful appetite' as José López-Rey puts it.[7] The theme, according to the same critic is human deceit, and the castle an emblem of love. Alternatively, with the same basic symbols, we might read the etching as a satire on Godoy's political and amorous *mores* rather than as a reflection of Goya's own passions. In that case the two-faced figures would be doubly appropriate, since the Janus-face (to indicate foresight and hindsight) was a feature of the Prince of the Peace's coat of arms. The etching would then refer to Godoy's affairs with María Luisa and another lady (Pepita Tudó perhaps), both of whom had relationships with others. The castle would become a traditional emblem of power, which Godoy was seeking deceitfully through the queen.

Whatever we may feel about Blanco-Soler's explanations of individual Goya works, his general theory of Goya's schizophrenia subsequently found support from other professional psychiatrists. An attempted explanation of the content of Goya's more enigmatic engravings as products of a schizoid imagination occurs in Francis Reitman's *Psychotic Art* (1950).[8] Reitman found pathological elements in Goya's life-history and felt that schizophrenia was a probable key to his behaviour pattern. He then went on to 'explain' the 'aesthetically incomprehensible' in Goya's *Caprichos* and *Disparates* in terms of illness.

> Goya's life-history shows flights of obscure motivation, when he is restless, bumptious and over-active; in contrast it shows at least two retirements of equally obscure motivation, when he is deadened, withdrawn and full of pain. These swings of mood can plausibly be evaluated as expressions of an illness of the manic-depressive type. If one makes use of the crude body-type theory of Kretschmer, Goya's constitution—so far as can be judged from portraits, in-

cluding the one by himself—was of the pyknic variety, which would also favour the diagnosis of a manic-depressive psychosis. His death from apoplexy, a disease characteristic both of pyknics and of manic-depressives, points in the same direction. In accordance with this, in his elated mood his pictures are of pleasant colouring and are descriptive and realistic, features stated by Kretschmer to be typical of the cyclothymes . . .

More decisive support is given to a diagnosis of schizophrenia by the designs he made during his autistic periods. A very brief indication of their appearance has already been offered. So far as content is concerned it appears that they are 'romantic' or phantastic rather than descriptive and realistic. But closer examination of these etchings reveals some features of greater diagnostic importance. The 'Caprichos' and the 'Sueños' have only vague contact with external reality; they depict the inner experiences of Goya, and the engraving 'Sopla' indicates the kind of experiences they were. At this period the belief in witches had disappeared from Spain and witch-hunts no longer took place; consequently the source of the theme is endogenous to the artist. 'Ya tienen asiento' is almost vulgar and very crude in its sexuality; the symbolic factors in it are dominant, just as they are in the metamorphosed doctor and patient and in all the others as well. The 'Proverbios' show a still more marked alienation from reality, representing a world of pure phantasy. They depict disturbed spatial relations and they show obvious displacement and pictorial condensation; in them body-parts are cut off, multiplied and divided. In Plate 4, for instance, detached heads with chattering teeth give melody to the rhythm of the castanets; the discrepancy in the size and grouping of the figures suggests unreality. In Plate 16, instead of detached body-parts, multiplication of body-parts is depicted: heads are doubled, the man in the foreground seems to have four arms, and there are displacements of body-parts. Reality and unreality lose their boundaries. Plate 7 shows in abundance pictorial condensation of the shapes of men and women or human and animal into one. Compositions of such a kind . . . are *pathognomic* of schizophrenic experiences.

Goya's illness also finds expression in the titles of his engravings and in his subsequent attitude towards them. Each picture of the 'Caprichos' has a title, which is organically linked to the design in a way similar to that 'writing in' of schizophrenic drawings . . . The inscription on the title page as originally planned by Goya has been noted [i.e. the second version of Plate 43 of the *Caprichos*— 'The Dream of Reason']. Another etching Goya merely called 'Tooth Hunting'; this depicts a disgusting and fearful scene. When recovering from his illness, however, Goya dallied over the publication of his 'Caprichos'; and before they were published he made alterations in the titles. On the title leaf he wrote 'Phantasy without reason produces monstrosities; purified, however, they bring forth true art and create wonder.' Ultimately he replaced the title page with a rather unimaginative self-portrait. Under the 'Tooth-Hunting' he wrote: 'Is it not pitiful that people still believe in such stupidities?' The superficiality of those remarks in no way harmonizes with the pictures and the original titles; it is possible to explain this by the fact that after his illness Goya could no longer understand them com-

pletely. They were alien to him because their function was anchored in his illness, which, when he recovered from it, became to him incomprehensible; hence he tried to rationalize the documents of his illness with titles, which would restore contact with reality once more. Goya's retrospective attitude to his engravings, this subsequent lack of understanding, so it seems, of his own own work, corresponds more to what we see in schizophrenics than in manic-depressives. Present-day developments in psychiatry have blurred many of the former diagnostic entities; often it would be hair-splitting to discuss whether a case should be labelled recurrent schizophrenia or manic-depressive psychosis with schizophrenic features. What seems to be significant is that those aspects of Goya's work which are aesthetically incomprehensible can be readily understood when psychiatric considerations are introduced. At that point the interpretative and speculative work of the pathographer is concluded. However, it would be alluring to extend the ideas developed in the previous chapter to this examination of Goya. Some of the designs, such as Plate 5 of the 'Proverbios', deliberately convey loss of boundaries between reality and unreality and alterations in the temporal system; others depict marked disturbances of the body image and the spatial system. But because we lack an adequate clinical history such a commentary must be reluctantly abandoned.

Reitman's analysis of some of the *Caprichos* and *Disparates* is undoubtedly interesting. But it seems to make a very arbitrary division between what is explainable and what is not; what is normal and what pathological. The clearest error lies in Reitman's expectation of a descriptive relationship between Goya's captions and the content of the engravings, where the nature of satire requires ambiguity, irony and understatement. His comments do not really increase our understanding of the significance of Goya's engravings although they perhaps explain the disturbing quality some of the images have.

A development in the appreciation of the heightened aesthetic power of the psychotic artist occurs in articles by Professor G. M. Carstairs, two of which refer to Goya: 'Art and Psychotic Illness' and 'The Frontiers of Madness'.[9] Carstairs speaks of the sharpness of perception of both schizophrenics and artists, and shows how a psychotic or neurotic state can increase awareness, even though only against a background of dread. Having shown that the contrasting atmosphere in Piranesi's prints could be attributed to a manic-depressive state, Carstairs goes on to discuss Goya:

> The great Spanish painter Francisco Goya . . . was another man in whom spells of furious energy alternated with fits of black despair. Like Piranesi, he was an impetuous, quarrelsome man, involved in duels and pursued by irate husbands. He is remembered for his ruthlessly candid appraisal of the pride and folly of the very society of which he was an idol.
>
> At times he was seemingly almost overwhelmed by the malignant folly of mankind, as when he created his series of etchings *The Disasters of War*, a sardonic commentary upon the Napoleonic invasion of Spain; at times too, in his Caprichios

he hinted at disturbing personal visions, as in the title page *The Sleep of Reason begets Monsters.*

It is possible to suggest cruelty and violence without explicitly portraying them in action. Indeed, in his ironical court portraits Goya was an adept at doing just that.

In many of his etchings, however, he dwells emphatically upon the most sordid details of physical suffering, and moral degradation, as if to insist upon the unredeemed depravity which—at least at such times—he believed to lie at the root of human nature. He was an early exponent of 'black humour', as he himself recognized; but in some of his most savage pictures this gives way to a fierce castigation of his own, and his fellow-creatures' baser impulses.

This combination of pessimism, of preoccupation with cruelty, hopelessness and pain, and of self-accusation is very characteristic of the mood of a person suffering from depression.

We know that Goya's career was punctuated by periods of withdrawal from activity, and inner preoccupation. Insomnia is the almost invariable accompaniment of this form of illness; and indeed darkness and night attend many of his lugubrious fantasies. It is noticeable too, that when these become unbridled there is a recurrent imagery of transfixion of the anus by swords, spears and other piercing implements, while bloodthirsty, cannibal witches are also portrayed.

Here we have an all too literal expression of the oral-aggressive and anal-sadistic fantasies which are the (usually unconscious) accompaniment of severe depression.

Goya lived to be over 80, and even in his old age he was beset by fits of melancholy, during one of which he painted the series of *Pinturas Negras*, of which one of the most terrible is *Chronos devouring his Children*; with macabre humour Goya chose to hang this picture in his dining room.

Melancholia is a condition which we can readily understand for we have all sometimes felt depressed. But schizophrenia brings about bizarre and quite unfamiliar distortions of reality. In its early stages it can sometimes stimulate a more intense, though usually rather sinister awareness of the mystery behind normal phenomena. One is compelled to wonder in what does this 'mystery' lie: perhaps it is an attribute of the beholder.[10]

Another diagnosis of Goya in terms of schizophrenia is that of Dr Rouanet in 1960. While he felt that the artist's paranoia led him to pursue originality, he held that it was schizophrenia which drew him towards a world of fantasy. Hallucinatory periods would have been followed by phases of exhaustion, and Rouanet believed that these cycles were reflected in Goya's work. The exhaustion found expression, for example, in Goya's more morbid and demoniacal *Caprichos*, such as No. 47 ('Obsequio al maestro') and No. 59 ('Y aun no se van'. Plate 24). The mysterious visions of the *Disparates* also fitted the schizophrenic theory in Rouanet's view.★

★The schizophrenic theory is still favoured. A recent case in point is Bernard Dorival's article about the Black Paintings, 'Le Testament spirituel de Goya' (*Journal de Psychologie normale et*

But his medical interpretation of Goya was not based solely on psychological factors. Rouanet held that the poverty of Goya's childhood and his sense of social status constituted strong motivating forces in his development. Rouanet also accepted earlier theories about Goya's probable bout of syphilis in 1792, argued the importance of the Duchess of Alba's death for his psychological state once again—the Duchess was 'the only deep love in Goya's stormy life'—and took account of the heart attack of 1819.[11]

Two years after Rouanet's book was published, in 1962, a new version of Goya's medical history appeared. This was in Terence Cawthorne's article 'Goya's Illness' in the *Proceedings of the Royal Society of Medicine*. Mr Cawthorne found grounds for dismissing the syphilis theory, and held that Goya, like Dean Swift, may have suffered from a state like Menière's disease, which affects the ears and the sense of balance, producing giddiness, sickness, deafness and partial blindness. The actual diagnosis suggested by Mr Cawthorne is the Vogt-Koyanagi syndrome. This resembles 'Havada's disease and sympathetic ophthalmia'.[12]

Cawthorne felt that Goya's condition could have affected his output as a painter in two ways. In the first place, it could have caused him to change his subjects and the atmosphere of his pictures from 'gay to macabre, from colourful to sombre, and from pleasant dream to ghastly nightmare'. Alternatively, the deafness which stemmed from his illness could have led him to rebel against his fate, and this encouraged 'morbid thoughts, engendered by the vagaries of his private life and the turn of public events in Spain, then at the mercy of a corrupt administration and later exposed to the ravages of the Peninsular War.'

Mr Cawthorne does not really come out clearly in favour of either of these possibilities, and he describes rather than interprets the pattern of Goya's life.

Another doctor who rejected the earlier syphilis and schizophrenia theories in the 1960s, but whose medical solution was different from Cawthorne's, was Dr José Riquelme Salar. In his *Biological Profile of Goya* (*Perfil biológico de Goya*, 1964), he suggested that an 'undulating' or recurrent depression might be more consistent with the known medical facts than previous diagnoses. He envisaged a pattern of depression that affected the artist organically and induced crises. Dr Riquelme also argued that Goya was afflicted by strong resentments, which sometimes expressed themselves in a passive way, but sometimes took a vengeful, violent form. The motives for these resentments, according to Dr Riquelme, lay in the artist's deafness, the rejection of his love by the Duchess of Alba, and in what Dr Riquelme calls his 'exile' in Bordeaux. But apart from the matter of Goya's deafness, there is little to support these hypothetical motives. Dr Riquelme argues that Goya was 'too old' for the Duchess,[13] whereas there is no evidence whatsoever that he was, nor is there anything to show, for that matter, that a man of Goya's

pathologique, No. 2, avril–juin 1975, 173–90). M. Dorival feels that Goya's isolation from deafness after 1793 together with his schizophrenia strengthened his misanthropy. Like Rouanet, Dorival does not exclude external factors impinging on Goya's life. Coming on top of the medical condition they led Goya to the deeply pessimistic world-view that finds expression in the Black Paintings.

age (fifty) is seriously disadvantaged in affairs of the heart, or indeed the repro-ductive system. As for the 'exile' in Bordeaux, it was of Goya's own choosing, and not a period of unbearable isolation, since Leocadia Weiss was living with him most of the time, and long-standing friends like Leandro Fernández de Moratín were close at hand.

A more recent view, from an American psychiatrist, Dr William G. Niederland, attributes Goya's illness and ensuing change of style to lead poisoning. Basing his conception of the artist's technique on Gautier's description (which he holds to be 'a contemporary source'), Dr Niederland believes that Goya paid dearly for his bold brushwork, and according to Boyce Rensberger, in an article in the *New York Times*,[14] was exposed to 'several times as much splashing and vaporizing lead compounds as other painters'. As a result 'Goya could have absorbed into the bloodstream sufficient levels of poisonous lead to cause the brain damage and other debilitating symptoms' which occurred in the 1790s. Dr Niederland maintains that Goya's symptoms were more consistent with those of 'fulminating lead encephalopathy, a disease whose major symptoms go away, as did Goya's, after removal of the environmental source of lead', than with syphilis or any psychotic illness. Unfortunately there seems to be no adequate evidence to show that Goya used less lead carbonate based pigment in the years after 1792 than he had before, and it seems difficult to argue that what Dr Niederland calls Goya's plunge into 'a harsh, often merciless and vengeful view of the world without and within' should have been due to this cause alone.

Most recent biographers advance these medical views with a natural wariness. The illness of 1792–3 is for Douglas Cooper 'a severe physical and mental break-down' (1963).[15] Pierre Gassier wisely suggests that it may be advisable 'not to attempt a "modern" diagnosis of Goya's illness but to establish one in the manner of Molière's doctors, by stating that the patient almost died, was temporarily paralysed and lost his sense of balance, but that his strong constitution and his sanguine tempera-ment enabled him to win through, although he lost his hearing for ever.'[16]

On one point, however, doctors and most (though not all) critics agree. The illness of 1792–3 marked a significant stage in Goya's development and enabled him to penetrate further through surface appearances and encouraged him to evoke the world inside him as well as the world outside. The Spanish philosopher and poet Unamuno in a poem written in 1928 saw Goya's deafness as the clue to his understanding of the tragedy or comedy of existence. In terms of the Philoctetes story, as applied to the role of the artist in society by Edmund Wilson, the illness was Goya's wound and necessary if he was to bear his bow. It made him more sharply aware of the contentions, anomalies and discords of life which are, in Edmund Wilson's terms, the 'prime provokers' of art. Perhaps it was also responsible for giving him a new toughness to rub against his tenderness: that tension which Henry Moore believes to exist in Goya as in other major artists—'Goya would make beautiful tender portraits of children', he observes 'and yet painted the violent *Saturn devouring one of his children*[17] (on his own dining-room wall!).' Not all the fruitful tensions of art spring from within, however. Edmund Wilson rightly sees

them as also stemming from 'all treachery, violence, frustration, all the outbreaks of our barbarous nature and the unlooked-for disasters which befall us at the mercy of unknown forces'. Goya's illness and his psychological states compounded other tensions in the world around him. He experienced the betrayals, prisons, disasters and barbarities of the real world as well as those he conjured in his imagination. Like his contemporaries he expressed attitudes to tyranny and war, the treachery and folly of individuals and societies, and the extent to which his work is political or interpretable in the light of political theory must now be explored.

IX. Racial and Political Interpretations

THE previous chapter looked at some attempts to interpret Goya's life and art in terms of his psychological make-up and physical condition; his individual feelings and his personal circumstances. Other accounts naturally lay more stress on the environmental factors affecting the nature and evolution of his work. The Romantics themselves had been particularly concerned about the relationship of the artist and his society, and in Spain they had tended to despise eighteenth-century writers and painters who failed to embody national traditions or reflect the Spanish character. The decline of Spanish art and letters believed to have taken place in the eighteenth century was sometimes attributed to a loss of national identity in the ruling class. After all they had imported French culture into Spain and aspired to be citizens of the world. The theory was that the lower classes alone had preserved a vigorously national art and culture in Goya's time.[1] A lower-class Goya was, therefore, a natural upholder of Spanish traditions, and his work was frequently discussed as a manifestation of national character. When new theories about the Spanish temperament were evolved, Goya was naturally measured to see if they fitted him.

A particularly influential analysis of Spanish psychology at the turn of the century was that of Angel Ganivet.[2] He believed the basic quality of Spain, rooted in its geographical characteristics, to be independence. In his *Idearium español* of 1897, he suggested that Goya's art was a manifestation of that spirit:

> Some time ago I wrote that Goya was an ignorant genius, and I wrote this with some trepidation, since I knew that this opinion must seem wild or paradoxical when judged by the usual artistic criteria, even though it was, and is for me, exact. In precisely the same way I believe that Velázquez was as ignorant as Goya, although he is not only a genius but the greatest painter the world has ever known. I am not worried about the lack of any of the much vaunted 'Classical Rules' in their work, nor do I find in them the kind of ignorance which gives rise to anachronisms, distortions of character, biased interpretations of historical events, anatomical monstrosities or any of the other defects which ruin the whole effect of a painting. What I do feel to be lacking is technical awareness. To put it more plainly, the artist does not know when the work is finished, since his only guide is his inspiration. Genius is a very unreliable faculty, and the hand which is guided by it rarely finishes off a work well. The work of

art 'exists' at any given moment in the process of its creation, but there is only one moment when it is 'finished'. The inspired artist's hand stops at an arbitrary or fortuitous moment; not when the pitch of perfection has been reached. This arbitrariness leads great geniuses to produce highly original creations on occasion, works which are recognized universally as the masterpieces of their time. But when arbitrariness is systematically accepted by mediocre minds—or even by great ones—it can lead to shocking failures. Original works of this kind cannot raise the art of the country in which they are produced to new heights. On the contrary, they help to form bad taste and encourage the decline or debasement of the ideal.

It should not be thought that Velázquez and Goya were the only ones to have this trait. It is constant and universal in our country, and springs spontaneously from our love of independence.[3]

Ganivet's view of Goya and Velázquez no doubt comforted Spaniards. It was good to know that the national character was resilient in the 1890s when material circumstances seemed unpropitious. A Spain which had an independent spirit could do without colonies. If it had produced masterpieces in the past, why should it not produce them again in the future?

So far as Goya was concerned, his art continued to be seen as a manifestation of national qualities both inside and outside Spain. The French critic Lafond felt his naturalism to be 'typical of his country, and of his race', and also believed that the 'passionately instinctive' quality in his art had a characteristically Spanish flavour to it.[4] He identified this as the manifestation of 'une sorte d'électricité animale, pour ne pas dire bestiale'.[5] In 1906, the novelist Emilia Pardo Bazán also saw Goya's work as a reflection of darker Spanish forces as well as of national 'spontaneity'.[6] In an article published in *La Lectura*, Pardo Bazán sketched Goya's life, discussed his social and political ideas and traced hypothetically his reaction to changing times. The history of Goya's thought and the progressive development of moral, social, philosophical and political ideas in his work, she wrote, 'is probably more interesting than his novelistic life.' 'That is the point which links Goya's art most closely with his country's history, and it is certainly in this respect that he can be said to represent us.'[7] Emilia Pardo Bazán's sense of Goya's relevance to her own times emerges at this point. She sees Goya's age as a period of pessimism rather like that of the late nineteenth century, and she calls it Nietzschean. In her view his satire is dark yet conscious, rather than unconscious. Its violence, on the other hand, reflects a Spanish spirit and not personal bitterness, as she suggests in the following passage:

The works of Goya cannot be satisfactorily explained simply on the basis that their author advanced political views, or criticized this or that. It must be accepted that there was a special structure in his genius, which is latent in his early work, and only fully revealed in certain historical circumstances. Goya was not in pursuit of Beauty. He has been called a naturalist, but perhaps he ought to be called an inverted idealist, a passionate collector of ugly things; not ordinary

ugliness, but expressive, abnormal and violent ugliness: Romantic ugliness. He also possessed a particular gift for capturing criminal atmosphere, and he was very successful in recording scenes of violence and law-breakers. Only his disciple Fortuny rivalled him in this respect, in his inimitable painting of *The Kidnapper*.

Goya's art lacks delicate feelings, serenity and finish, and its ideal is, I insist, the ideal of the Spanish race. Unlike the Greeks, or the Italians of the sixteenth century, the Spanish are not remarkable for a deep aesthetic sense. Goya's art, I repeat, reveals Iberian tendencies with a frightening and savage energy. Cruelty, bloodthirstiness, violence, gloom, horror, heroism, the more sinister Romanticism, plebeian realism, the picaresque, superstition and sadism are all displayed in Goya's work with violent chiaroscuro contrasts, daring draughtsmanship and fevered imagination run riot. If the truth be told, Goya exaggerates instead of attenuating this aspect of Spain.

Monstrosity, insanity, brutality, violent madness, perversity, torture, black magic, all attracted him as an artist, even though he condemned them in the whiplash phrases which comment on his drawings. Drama, or rather melodrama, attracts him, since emotion in Goya is material not spiritual. His depiction of people being dragged along, garroted, imprisoned and tortured, his inquisitorial victims in their *coraza*, and his view of a miserable humanity overwhelmed by suffering and terror is stated in terms of caricature, which is spine-chilling rather than laughter-provoking. It can be said of Goya's *Black Work* that it reveals its author to be an amoral though not immoral satirist: one who sees the world in the grip of two inexorable powers, Chance and Violence. Only momentarily do we find a ray of hope in Goya's work, a hint of a clear dawn; and it is a dawn of an intellectual rather than emotional hope. Behind the satirist lies the worshipper of the goddess Reason. For Goya the redemption of the world will be the work of the mind of man.[8]

Subsequent Spanish critics have tended to veer closer to Ganivet's conception of Goya as a reflection of Spanish individualism than to Emilia Pardo Bazán's view of the Spanishness of his violent, dark spirit. Some have even harked back to the earlier Romantic position which saw Goya's Spanishness above all in his realism.

Twentieth-century critics and writers outside Spain have been equally interested in the Spanishness of his work. For Havelock Ellis he is 'a man of Aragon', 'the very type of the shrewd and keen Aragonese peasant', in whose work 'a genuine and energetic renascence of the Spanish spirit'[9] is to be found:

On the whole, with his versatile aptitudes and wide-reaching interests, Goya represents the Spanish temper and Spanish interests more comprehensively than any other Spanish painter. He has finally escaped from the control of the Inquisition, which fettered his predecessors, and is a little intoxicated with his freedom. Religion, the prime interest of old Spain, is a negligible element in his art. It is, indeed, a fact of some significance in estimating the spiritual outlook of Spain, that since Zurbarán there has been no great Spanish religious painter.

Goya touched Spanish life vividly and alertly on every other side; he has all the
fantastic energy of Spain, some of his pictures are like pungent political pamphlets,
he illustrated fully all the aspects of Spanish popular and festive life, technically
in a versatile and experimental way which is always interesting, though, except
in a few occasional sketches and etchings, it seldom reaches consummate achieve-
ment . . . And while he was at heart and in life a typical Spaniard, Goya was
also a nervous and restless modern, indeed with some claim to be accounted
the earliest of modern painters.[10]

Havelock Ellis particularly identifies the vigour, versatility and audacity of Goya
with his Spanish background. But his general conception of the Spanish character
is a mixture of personal observation and received ideas.

In a similar way it is hard to know what significance to attach to Ellis's recog-
nition of the Aragonese peasant in Goya's features. It seems as if Ellis may have
been led to this conclusion by his knowledge of Goya's biography rather than by
his personal familiarity with Spanish regional physionomy. He refers to Goya as
'the son of poor labourers', as was commonly believed to be the case at the period.
If he had known as we do today that Goya had a less humble background, would
he have reached the same conclusions? It is as difficult to be precise about regional
as about national character. In the eighteenth century the Aragonese were noted
for their obstinacy, and the myth may have helped to engender this quality in
those who lived in Aragon. Shrewdness and keenness were qualities more to be
found in Catalonia according to writers of that period. More recent commentators,
on the other hand, have found a still wider range of 'Aragonese' traits in Goya.
The historian Ricardo del Arco, who comes from Aragon himself, claimed that
'Goya painted as he did because he was Aragonese'.[11] His frankness and sincerity
were prime regional characteristics in Arco's view, and ones that he shared with
other men of the region, like the Latin poet Martial, and the seventeenth-century
Jesuit Gracián. Other commentators have different views.[12]

Apart from some general points about national qualities in Goya's art, Havelock
Ellis had curious comments of a more specific kind to make about the *Naked Maja*.
The shape of that lady has worried many critics. Does the head really fit the body?[13]
Did Goya actually see the lady naked, painting her perhaps in the perspective
appropriate to a picture over a door? Or did he, in fact, as John Berger suggested
a few years ago, depict her with clothes on and then peel them off with the eye
of his imagination?[14] Ellis inclines to a basically realist position, as did many of
his contemporaries: Goya painted what he saw. And what he saw could be explained
in terms of Spanish anatomy! Emilia Pardo Bazán subscribed to a similar view when
she argued that the 'disproportionately small size of [the maja's] extremities' were
a racial characteristic, deriving from 'the cloistered, pent-up life' of Spanish women.[15]
Havelock Ellis finds ethnic reasons for the shape of the Maja's bosoms and waist.
According to him, the Spanish female chest

is found to be shorter and broader at the base—at the level, that is, of the lower
end of the breast bone—so that she requires, according to Caramandel, a different

shaped corset, while at the same time there is a greater amplitude and accentuation of the hips in relation to the figure generally. These characteristics of the Spanish women are well illustrated, it has been said, by a comparison between the statue which Falguière modelled after Cléo de Mérode and the distinctively national Spanish type represented in Goya's *Maja Desnuda* now in the Prado.[16]

New books about the Spanish national character appear from time to time, and sometimes lead to a revised view of Goya's Spanish qualities. The philosopher Unamuno's *Del sentimiento trágico de la vida* is a case in point, and V. S. Pritchett used it extensively when writing *The Spanish Temper* (London, 1954). That Spaniards are obsessed with death is a commonplace, but Unamuno gave death a special significance, and it is in the context of this supposedly national preoccupation that Pritchett placed Goya.

> In Spanish painting and sculpture the theme of death is treated again and again by every artist. The gloom of the mortuary, the luxury of a lying-in-state, is their favourite subject. The preoccupation is common in Catholic art, but no Catholic artists in other countries have had so exclusive a passion; it appears also in non-religious painting. Goya's pictures of the terror and madness of war owe their dramatic force not only to the carnal realism, but to the sense of the life-and-death struggle, to the sense of life corroded at the height of its contest by mortal decay. In how many ways (Goya seems to have asked himself) can human beings be shown meeting their death?[17]

Observations of this kind can narrow the meaning of art, but V. S. Pritchett was led to an important observation about Goya's *Disasters of War* as a result of his interest in a Spanish sense of 'life-and-death struggle'. He notes particularly the beauty of Goya's suffering bodies, and comments very relevantly on the tension this creates within the work. At the same time he sees an empathetic quality in his art which he feels to be peculiarly Spanish:

> Realism in Spaniards proceeds out of hot blood, not coolness. When Goya draws scenes of war, he feels the madness of action, its giddy and swooning movement, the natural boiling up of all human feeling towards crisis and excess, and it is in this state of mind that his eye becomes receptive to detail. Once again: psychological realism is not psychological analysis or speculation after the event, but the observation of the event in the tremor and heat of occurrence. Goya does not draw torture, rape, murder, hangings, the sadism of guerrilla war-fare rhetorically, patriotically, or with a desire to teach, but he is as savage in his realism or his satire as the war itself. He is identified with it, and eventually he was driven out of his mind by acts which he could not forget. The nightmares themselves are horrible in their animality.
>
> The terrifying quality of Goya's *Disasters of the War* springs, in part, from the comeliness and vanity of the human victims, from their complacency. There are no standard figures, but a great gallery of diverse characters whose ruling passion is clear in their faces. Each one palpably lives in his senses and, in the moment

of death, their horrified eyes see the loss of the body. Goya's realism marries fury, insanity, corruption, whatever the state or passion is, to the body; it gives body to the sadism, the venom, the thieving, the filthy-mindedness, the smugness, the appalled pity of massacre.[18]

Pritchett's theory of the hot-blooded realism of the Spaniard probably arises out of a broader myth of the Latin races: that of amorous passion and the Don Juan syndrome. Pritchett is not alone in seeing Goya as one who drew water from what he called 'the bottomless well of Spanish vitality and exuberance'.[19] but he does not apply the sexual side of this to his interpretation of Goya, as do some other critics.

There are at least two striking cases of Goya admiration based on vague notions of the typically Spanish virility (*machismo*, *hombría*) of his work. The earlier of the two is the Australian Blamire Young's commentary on Goya's *Proverbs* (1923). The dedication of the book reveals a Spenglerian sense of the decline of Western Civilization, and there is more than an inkling of D. H. Lawrence's writings of the post First World War period in Young's exaltation of masculinity as an antidote to the 'state of funk' in the Anglo-Saxon world:

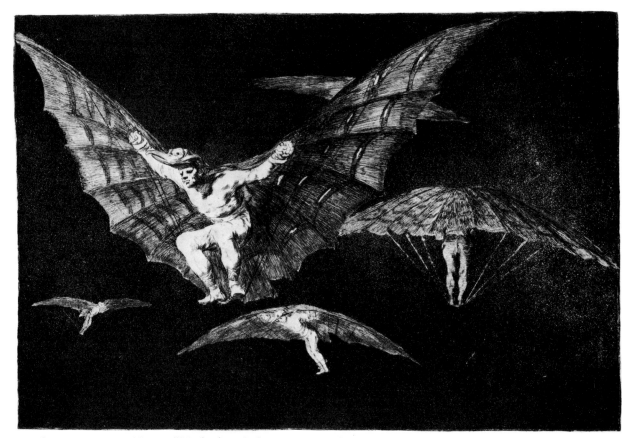

44. Goya: *Disparates*, No. 13 ('Modo de volar'), *c.*1815–16. Glasgow, Pollok House. Stirling-Maxwell Collection.

Spain needs no calf-bound testimonial from me, nevertheless for the love I bear her, greater even than my love for Australia, I dedicate to the Spirit and Soul of Spain this book, in which I have been able to reveal some further details of the mind of her illustrious son, and so added another jewel to her crown.

In these degenerate days Spain has preserved more than any other nation the essential traditions of humanity and has successfully resisted the attempts of outsiders to feminize her and bring her into line with their own emasculated ideals.

May Spain keep her natural characteristics untouched—her bull-rings, her virility, her women—for her inspired and magnificent brutality may yet be needed to accomplish the reinvigoration of an enervated Europe.[20]

Young's interpretations of the *Proverbios* generally reject the political line of some earlier commentators on the work, plumping for broader symbolism. He is particularly alert to athletic or virile implications. Thus in describing the enigmatic plate of *Flying Men* (Plate 44) he suggests that the bird man in the foreground is 'a muscular, fearless, clean-living man with strong resolute features, determined mouth and well-shaped intellectual head . . . [who] represents the higher development of humanity that Goya knew'.[21] The same approach is applied, in a way which inevitably reveals more about the writer than about Goya, in Young's long discussion of the etching of a *Colossus* (Plate 27). Much of his view of the plate hangs on his reading of the shadow on the giant's back as 'fur'. He particularly attacked Beruete for failing to see this! Noting the absence of 'fur' in the light areas on the body he asserts that 'the growing light of dawn had some mysterious power to remove the fur with which the man is covered'. [22] He goes on to interpret the scene in the following terms:

The suggestion is clear that Man was not always man, that it is the light of knowledge, slowly spreading and enveloping him, touching him with thought as it were with the magic wand, that strips from him the garment of the beast, the lingering animal covering that belonged to him in the dim past, that hung about him in his infancy, and which he trails after him into the burgeoning day. No fallen angel here, no undischarged debtor to some legendary benefactor, no 'poor relation' cringing to some exclusive and well-to-do deity, only the aboriginal child of earth's primal generation, emerging from his fawnhood and his fears to grasp the kingdom to which he finds himself the long lost heir.[23]

At the end of his commentary on this plate Young suggests that prints of the *Giant* should be hung in every classroom in the country instead of *The Child Samuel at his Prayers*, or maps of the Holy Land. 'One imagines', he continues, 'that a nation which kept before the eyes of its children a conception of human life so exalted and hopeful would reap later on a bountiful harvest of manliness and courage.'[24] Young envisages that a period of twenty-five years of Goya will bring about this change; the same period which 'was required by Germany to teach her people to become Pan-Germans'.[25] It is impossible, when reading some of Young's

comments, not to recall that an Aryan movement with a similar cult of manliness was rising in Germany at the time he was writing.

Young's study of what he calls the 'elaborate word-picture-puzzles' of the 'Great Spaniard' Goya, no doubt gives the would-be interpreter pause.[26] It was another twenty years before an even more idiosyncratic view was ventured: that of Agustín de la Herrán.[27] In the meantime there was at least one other potent myth-maker, like Young, who saw Goya in the image of Spanish virility at much the same period. This was the American novelist Hemingway. Goya is mentioned on a number of occasions in *Death in the Afternoon* (1932), but the passage at the end of Chapter 17 is the one which interests us here. Turning from bull-fighting to art, Hemingway begins by mocking Julius Meier-Graefe rather unfairly for judging El Greco better than Velázquez or Goya on the basis of religious painting. He implies that El Greco was a homosexual, whose apostles and virgins are ambivalent. At the end of the chapter Hemingway characterizes Goya in a way that suggests he is the antithesis to El Greco; more like the typical protagonist of a Hemingway novel in fact: tough, earthy, potent and skilful; a bull-fighter, at the virile centre of Hemingway's ideal Spain. The passage, which starts by contrasting Goya with Velázquez, also implies that the former lacked a certain class consciousness that Hemingway finds in the latter:

> Velázquez believed in painting, in costume, in dogs, in dwarfs, and in painting again. Goya did not believe in costume, but he did believe in blacks and in greys, in dust and in light, in high places rising from plains, in the country around Madrid, in movement, in his own cojones, in painting, in etching, and in what he had seen, felt, touched, handled, smelled, enjoyed, drunk, mounted, suffered, spewed-up, lain-with, suspected, observed, loved, hated, lusted, feared, detested, admired, loathed and destroyed. Naturally no painter has been able to paint all that, but he tried.[28]

Hemingway's view of Goya is part Spanish myth and part politics. Goya's manly acceptance of unvarnished reality is also, in a sense, a reflection of his kinship with ordinary people: the People. Very different from Velázquez and his world of princes and aristocrats.

Where Hemingway only hints at a political or class affiliation in Goya, other commentators put politics nearer the centre of Goya's art. Widespread belief in Goya's liberal sympathies has led artists and critics alike to see his work in a political light on a number of occasions. In 1832 a coloured lithograph based on Goya's *The Sleep of Reason produces Monsters* was published in France with the title *Le Cauchemar de Louis-Philippe*.[29] The hapless monarch is shown slumped over a table while dark symbols of revolution crowd the air around him, imitating the nocturnal birds in *Capricho* No. 43. In Spain, the September Revolution of 1868 and the temporary establishment of a republic in Spain brought political interpretations of Goya to the fore.

Goya could now become a saint in the Republican calendar, and this he appears to have done quite literally in the *Civil Calendar for 1870* (1869), which set out to list

'the holy martyrs who defended the independence and liberty of Spain'. Goya was cited on the anniversary of his death (16 April), in the following terms: 'St Francisco Goya y Lucientes, famous painter and admirable patriot, died in Bordeaux in 1828, aged 82. He was one of the most distinguished victims of the despotic reign of Ferdinand VII.'[30]

Liberals now began to praise Goya more plainly. Emilio Castelar, a leading liberal politician, had already seen Goya as a realist capable of social comment in his novel *Ernesto* (Madrid, 1855, Chapter 43), as well as an artist who reflected (in typically Romantic fashion) his people's passion for bull-fighting. Now, in a review of Charles Yriarte's book he went much further. Goya was the perfect expression of the eighteenth century in terms of art: 'an extraordinary man, who broke artistic conventions, mocked religious fanaticism, and made his pencil (like Voltaire's pen) into a weapon against the Inquisition, against censorship, against monasticism, against torture, against absolutism, indeed against all the crimes which the winds of revolution swept away.'[31] Castelar also saw Goya as one of a long line of Spanish artists and writers who refused to accept passively the controls imposed on society by police, government and Inquisition, and who produced an art of protest. Freer discussion of other anti-establishment aspects of Goya's art followed. The *Naked Maja* came out of its dark room in the San Fernando Academy, and the novelist Pérez Galdós soon had Goya painting one of the more advanced countesses in the nude in *The Court of Charles IV*,[32] one of the novels in his first series of *National Episodes* set in the years between Trafalgar and the end of the Peninsular War. Cruzada Villaamil's book on Goya's tapestries (1870) celebrated the artist's concern for ordinary people. And in 1887 the text of the more political manuscript commentary on the *Caprichos* was published for the first time in the Conde de la Viñaza's book on Goya, from the copy in the collection of the Liberal politician and dramatist Adelardo López de Ayala. By 1902, S. L. Bensusan could claim in 'A Note upon the Paintings of Francisco José Goya' that his work was acclaimed by anarchists, and in 1910 James Huneker was to describe him as both anarch and courtier: a 'coarse-fibred democrat of genius'.[33] Political cartoonists and artists have continued to find inspiration in Goya's prints and paintings in the course of the present century.★

The interpretation of Goya's portraits of aristocrats and the Royal Family has

★In the Spanish periodical *Gedeón* on 3 May 1908, there was a version of Goya's *The Third of May 1808* in which Don Antonio Maura and his Home Secretary, La Cierva, were depicted as members of the firing-party, shooting at the Spanish people (Plate 45). Presumably the cartoon was a comment on the brutal repression of the Catalan nationalists that year. In 1910, cartoonists in the same periodical used Goya's tapestry design *Blind Man's Buff* (*La gallina ciega*, Plate 13) to mock the directionless activities of the Liberal Party. Two contemporary artists have returned to *The Third of May 1808* in the last thirty years. Picasso echoed the scene in his *Massacre in Korea* which he painted in the spring of 1951, showing a party of soldiers shooting at a group of women and children, and underlining the suffering caused to ordinary people by invading armies (Plate 46). More recently, in 1970, the conflict between forces of law and order and the minority in Northern Ireland, gave rise to Robert Ballagh's *Goya. The Third of May 1970* (Plate 47). This was painted at the end of 1969 and into 1970 after the events of August 1969. An evident parallel is intended between the presence of French troops on Spanish soil in 1808 and English troops in Ireland in the 1970s.

45. Caricature from *Gedeón*,
3 May 1908. Madrid,
Biblioteca Nacional.

been particularly affected by the development of his political image. The French novelist Léon Bloy praised Goya's ability to penetrate beyond the surface of his sitters—in a passage which the painter Rouault quoted in *Les Chroniques du jour* in 1931—asserting that 'he mocks the high Spanish officials of his time to such a degree that we delight to see their human frailty beneath their decorations'.[34]

An early protagonist of this view was the German writer Max Nordau in the book on *Great Spanish Artists* he seems to have written during his period in Spain:

> What Goya thought of the monarchy, the aristocracy and the social hierarchy, is plain to be seen in his portraits of the King and Queen and the higher members of the nobility. His models are depicted with great daring and satirical intent, as if they were idiots, dolls and harlequins. Their pictures reveal an infinitely more biting sarcasm than those of Velázquez, Goya's great precursor. Whenever Goya painted persons of the highest social rank bearing the external trappings of their privileged station, he resorted to caricature rather than portraiture.[35]

In Max Nordau's view there was satirical *intention* in Goya's portraits. Other critics attribute the unflattering effect of Goya's portraits of the royal family and the

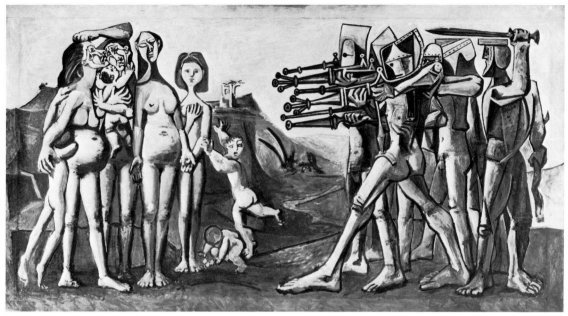

46. (above) Picasso: *Massacre in Korea*, 1951. Property of the artist's heirs.

47. (below) Robert Ballagh: *Goya. 3rd May 1970*, 1969–70.

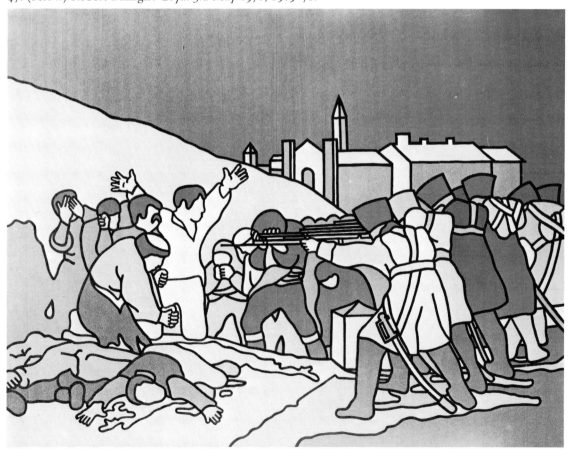

aristocracy to his ability to see people as they 'really' were: to artistic integrity rather than political preoccupations. This approach holds Goya's portraiture to have reached a height of 'psychological realism'. And it is in the light of this view that the German philosopher Oswald Spengler asserted that Goya's portraits were each individually worth more than a whole biography.[36] Lord Derwent's book *Goya: An Impression of Spain* (1930) has a similar standpoint:

> The portrait of the reigning royal family done by Goya in 1800 is a most fantastic piece of *unconscious* patriotism. Portents of art, the clothes, the light gliding over the silks and the crimson cloth, over the bare chests and arms; the experience of a rich lifetime poured into this purely official portraiture; a courtly flourish in the brilliance of it all—and yet, never did kingship receive a shrewder blow.[37]

In all these cases conclusions about Goya's portraits are extraordinarily hypothetical, and very difficult to support with concrete evidence as opposed to personal impressions. Most of the known facts can be twisted to suit the particular line of the individual critic. If one points out that Charles IV and María Luisa liked Goya's portraits of them, and argues that he could hardly have intended them satirically, another will claim that it is ironic (and highly likely) that the Spanish king and queen lacked the wit to perceive the sarcastic edge of Goya's work.

Another proponent of the 'unintentional' view of Goya's aristocratic portraits was Julius Meier-Graefe, who wrote: 'There is a grain of truth in the dishonesty of the pomp of Goya's grandees'.[38] But for him Goya was as corrupt as the society he depicted and incapable of consciously satirizing it:

> Every society has the art which it merits. Goya might have found the greatest opposition amongst his countrymen, but he belonged to the other camp. His conviction as an artist was no less corruptible than the political opinion of his contemporaries, but it was honest in so far as he did not lie more than the others. As he was a master of representation, we get from him an unintentional picture of the narrowness of the time whose reality is easily penetrable. His lack of subjectivity makes him comparatively genuine.[39]

Faced with condescending passages such as these, we can well understand Hemingway's aggressive response to Meier-Graefe. Critics of more politically aware periods tend to take a rather different view.

The 1920s and 1930s, which saw a great development of interest in Goya (with an obvious climax in the centenary of his death in 1928) also saw an intense polarization of attitudes to right and left in Europe leading to the open conflict of the Spanish Civil War. Left-wing writers mostly found much to admire in Goya's apparent sympathy with working people and his involvement in the liberal cause, although in 1936, the Mexican philosopher and minister of education, José Vasconcelos, deplored Goya's lack of faith in the regeneration of the masses through revolution. The Spanish novelist Baroja, who respected Goya's ability to keep in with any régime, even saw Goya's witchcraft *Caprichos* at this period as 'apparently contain-

ing references to political and social situations rather than Spanish customs'.[40] Particularly sensitive to this side of Goya were those intellectuals and art critics who had suffered at the hands of oppressive right-wing régimes or observed their development personally. An early case is that of the Czech novelist, dramatist and essayist Karel Čapek. In his *Letters from England* (Prague, 1924) he expressed his conception of the challenge of democracy, and he protested against the Fascism of the 1930s and the German threat to Czechoslovakia in *Power and Glory* (1937). The chapter on Goya in his *Letters from Spain* (1931) is called 'Goya o el reverso' (Goya or the Reverse), and follows immediately after a section on 'El Greco or Devotion'. The key-word is revolution: political, sexual, and moral.

In the Prado at Madrid there are dozens of pictures and hundreds of drawings by him, and so for the sake of Goya, if for nothing else, Madrid is a great place for a pilgrimage. Neither before nor after him was there a painter who pounced upon his age with so ample a clutch, with such intense and ruthless verve, and portrayed it, searing side and all; Goya is not realism, Goya is onslaught; Goya is revolution; Goya is a pamphleteer multiplied by a Balzac.

His most exquisite work: designs for Gobelins. A rustic fair, children, paupers, an open-air dance, an injured bricklayer, a brawl, girls with a jug, a vintage, a snow-storm, games, a working-class wedding; sheer life, its joys and sorrows, playful and evil scenes, a solemn and also a blissful spectacle; such teeming life, as lived by the people, had never before surged forth in any cycle of paintings. It produces the effect of a folk-song, a frisky *jota*, a winsome *seguidilla*; it is a specimen of rococo, but now quite humanized; it is painted with a particular delicacy and relish which is surprising in so fierce a painter as this. Such is his attitude towards the people.

Portraits of the royal family: Carlos IV, bloated and listless, like a bumptious, dull-witted jack-in-office; Queen María Luisa, with rabid and gimlety eyes, an ill-favoured harridan and an arrant virago, their family bored, brazen and repulsive. Goya's portraits of kings are not far short of insults. Velázquez did not flatter; Goya went as far as to laugh Their Highnesses to scorn. It was ten years after the French Revolution, and a painter, without turning a hair, told the throne what he thought of it

Maja desnuda: the modern revelation of sexuality. A barer and more carnal nudity than any which had preceded it. The end of erotic pretence. The end of allegorical nudity. It is the only nude by Goya, but there is more exposure in it than in tons of academic flesh.

Pictures from Goya's house: it was with this appalling witches' sabbath that the artist decorated his house. It consists almost entirely of mere black and white painting feverishly flung on to the canvas; it is like hell illuminated with livid flashes of lightning. Sorceresses, cripples and monstrosities: man in his dark wallowings and his bestiality. You might say that Goya turned man inside out, peering through his nostrils and his yawning gullet, studying his misshapen vileness in a distorting mirror. It is like a nightmare, like a shriek of horror and protest. I cannot imagine that this caused Goya any amusement: he more likely

struggled frenziedly against some of it. I had an uneasy feeling that the horns of the Catholic devil and the cowls of the inquisitors protrude from this hysterical inferno. At that time the constitution had been abolished in Spain and the Holy Officium restored; from the convulsion of the civil wars and with the help of the fanaticized mob the dark and bloody reaction of despotism had been installed. Goya's chamber of horrors is a ferocious shout of disgust and hatred. No revolutionary ever affronted the world with so frantic and virulent a protest.

Goya's sketches: the feuilletons of a tremendous journalist. Scenes from life in Madrid, weddings and customs of the lower classes, *chulas* and beggars, the very essence of life, the very essence of the people; *Los Toros*, bull-fights in their chivalrous aspect, their picturesque beauty, their blood and cruelty. The Inquisition, a fiendish church mummery, fierce and caustic pages from a lampoon; *Desastres de la guerra*, a fearful indictment of war, a document for all time, pity which is truculent and ferocious in its passionate directness; *Caprichos*, Goya's wild outbursts of laughter and sobbing at the hapless, ghastly and fantastic creature which arrogates an immortal soul to itself.

Reader, let me tell you that the world has not yet done justice to this great painter, this most modern of painters; it has not yet learnt the lesson he teaches. This harsh and aggressive outcry, this violent and thrilling quintessence of mankind; no academic dullness, no aesthetic trifling; when a man can 'see life steadily and see it whole,' *really* see it, I mean, then he is the doer of deeds, he is a fighter, an arbiter, a fire-brand. There is a revolution in Madrid: Francisco Goya y Lucientes is erecting barricades in the Prado.[41]

Čapek's Goya is not really very far from the revolutionary artist beloved of the Romantics: he is not deeply political. But in the thirties the social and anti-hierarchical aspects of Goya's work continued to seem the most relevant, and the Royal Portraits found new ironic interpretations. The Northern Irish Poet Louis MacNeice captured a common view in the *Autumn Journal* he wrote in 1938, wondering at the same time about the social effectiveness of satire. The outcome of the Spanish Civil War was still in the balance, and his memory dredged up recollections of Spain. He recalled how:

> . . . in the Prado half-
> wit princes looked from the canvas they had paid for
> (Goya had the laugh—
> But can what is corrupt be cured by laughter?)[42]

In her introduction, to the catalogue of the Exhibition 'From El Greco to Goya' in aid of the Spanish Red Cross the same year, Enriqueta Harris wrote: 'His portraits of the Royal Family portray not so much the physical expression of their weak and despicable characters at the contempt in which the artist held them.'[43] But by 1938 a more profound political analysis of Goya was in the course of preparation. The sociologist responsible for it was Francis Klingender.

Born in Germany in 1907 Klingender had been brought up in German schools

and only came to England with his parents after the First World War in the mid-1920s. He graduated in Economics and Sociology at the London School of Economics and went on to do research for a doctorate on *The Black-Coated Worker in London* in the early thirties. His first book was an expanded version of this—*The Condition of Clerical Labour in Britain* (London, 1935), but his artistic background—his father was a painter and sculptor—no doubt encouraged him to look more particularly at the role of the artist in society. He decided, therefore to undertake 'theoretical and historical studies designed to elucidate the role of art as one of the great value-forming agencies in the social structure and social change'.[44] His approach was that of a dedicated Marxist, and much of his work on art was concerned with what Marx himself had described as the 'Alp' of the tradition of past generations weighing upon 'the brain of the living'. The pressures of society and history on the artist lay at the centre of his investigation.

Klingender's first important study of Goya was an essay primarily concerned with the *Caprichos*: 'Realism and Fantasy in the Art of Goya', published in the first number of *The Modern Quarterly* (January 1938).[45] This journal was designed to contribute 'to a realistic, social revaluation of the arts and sciences', promoting 'studies based upon the materialistic interpretation of the Universe, and [. . .] the mutual relations between intellectual activity and the social background'. Klingender's Marxist and humanist proclivities found an obvious outlet there.

The article began by tracing the tradition of realism in Spanish art which Klingender believed Goya to have rediscovered. The principle was therefore very much that of Marx himself: that men, at times of revolutionary crisis 'conjure up into their service the spirits of the past, assume their names, their battle-cries, their costumes, to enact a new historical scene in such time-honoured disguise and with such borrowed language'.

Realism had a more precise meaning for Klingender than it had for Čapek. It was a national response to a specific historical situation, 'born out of the social struggles of the middle classes and their productive conquest of the material world'.[46] At the back of the essay lay the idea that Goya's work could be seen as a reflection of a historical phase in which bourgeois capitalism was overthrowing the remnants of the feudal system and preparing the way for the rise of the working class: the antithesis to the thesis in Marx's Hegelian triad. Klingender felt that the Hapsburgs had perpetuated the feudal situation, spurning an alliance with the middle classes in which democratic realism could flourish. The result in art had been the triumph of mystical exaltation (St Ignatius of Loyola, El Greco) and the defeat of realism, which became 'coldly analytical' in Velázquez or 'passionately pleading' in Cervantes.[47] In Klingender's view the Spanish democratic realist tradition was only rediscovered by the rationalist intellectuals in eighteenth-century Spain. They used it as a propaganda weapon to reform society in works like Padre Isla's satire on irrational preachers, *Fray Gerundio* (Part I, Madrid, 1758), during the reign of Charles III. And in the vacillating régime of Charles IV there were still opportunities for its use, although these became intermittent. 'The progressive bourgeois intellectuals learned to place their trust no longer in the faith of princes, but in the

invincible order of their own rationalism and of the social order it implied',
Klingender wrote of this period.[48]

Goya's physical breakdown in 1792–3 is seen by Klingender as a reaction to
pressures to conform on the one hand and pressures to revolt on the other. But the
artist emerged from his illness with a clear democratic commitment. Klingender's
article examines the expression of this commitment in the *Caprichos* in one of the few
analyses of the work which makes a serious effort to interpret the overall structure
of the series: its sequence, as well as its individual pages.

> From his appalling struggle Goya thus emerged with an entirely new con-
> ception of his basic theme, the people. For the first time he saw them as they
> really were, brutalized and crushed by a degrading superstition concealing from
> them the reality of their exploitation. And with his basic attitude his style had
> changed. An art, based on the observation of reality, but transformed by the
> creative activity of fantasy and invention, is far removed from mere naturalism.
> Goya himself was fully aware of this . . . [His] new style is a style of imaginative
> concentration which reveals the quintessential reality of a given theme, not by
> copying its outer form, but by the selective emphasis of its basic characteristics.
> Its most profound embodiment are the Caprichios, the first designs of which
> were drawn during the concluding months of 1793. And again Goya specifically
> defined the content of this work, for he informs us that for the Caprichios he
> selected the themes most conducive to ridicule and stimulating to the artist's
> fantasy *'from the mass of extravagances and follies common to all society, and from
> the prejudices and eminent frauds, sanctioned by custom, ignorance or interest'*.
>
> The eighty etchings of the series are grouped into two main sections of thirty-
> six and thirty-eight designs respectively, each commencing with a self-portrait,
> and divided by an intermediary sequence of six plates (Nos. 37–42). Adopting
> Goya's own definition, we can describe the first main group as a gallery of
> human 'extravagances and follies', mainly illustrated by the relations between
> the sexes in a society, where love is perverted and degraded to a commodity of
> the market place . . . Its sombre theme is infinitely varied in modulation and
> tension. The whole is divided into a number of shorter sequences developing a
> given idea, such as secret assignations or prostitution, from a more playfully
> satirical comment to a macabre climax (e.g. Nos. 5 to 10: flirtation leading to a
> terrifying abduction and to the two final plates in the first of which the woman
> lies lifeless in the lap of her lover, while in the other the man, killed in a duel,
> sinks into the arms of the woman; or the prostitution sequence, Nos. 19–24,
> ending with the two frightful Inquisition scenes).
>
> Interspersed between these variations of the main theme are single plates
> illustrating other aspects of human misery: bad education, the miser, bandits,
> the drunkard whose house is on fire, the obviously symbolic quack dentist. And
> again there are instances where the dramatic tension is strained almost to
> breaking point, as e.g. in the terrifying *Hunt for Teeth*—a girl breaking out the
> teeth of a hanged man to use them as a love charm. The deep social feeling of

the whole sequence is movingly revealed in the two prison plates (both character-istically enough including women prisoners) Nos. 32 and 34: 'They are over-come by sleep; do not awaken them. Perhaps sleep is the only consolation of the unfortunate.'

The style of this first section of the Caprichios in predominantly realistic, despite the monumentality and formal perfection of the designs. The themes also are real ones, symbolism is rarely employed, and even caricature is relatively restrained. But there can scarcely have been a more provocative subject than this approach to sex in a society ruled by Maria Louisa and her minions . . . although [Goya] himself invariably stressed the universal rather than the personal significance of his work.

Valid as this claim certainly is, the two approaches of necessity merge, where a particular individual, by his position and actions, becomes the representative *par excellence* of a species. This was the case of Godoy as the embodiment of incompetent favouritism. Thus the six plates leading from the 'extravagances and follies' to the 'prejudices and frauds' exposed in the concluding sequence, are undoubtedly a sardonic commentary on the history of Godoy. The tran-sitional significance of the theme is also underlined by the form of these designs, for, although their style is still realistic, their content is throughout symbolical. In all of them the chief role is played by an ass (twice accompanied by a monkey), who displays his sham nobility, erudition, and variety in a ridiculously pompous manner. Again there is a stirring climax when the donkey seated as a doctor at the bedside of a patient gravely asks: 'of what illness will he die?'.

It is in the concluding section of the Caprichios that fantasy and symbolism expressed in turbulently grotesque imagery, reign supreme. Like the first part, it commences with a self-portrait. But this time the artist has fallen asleep over his work at his desk, while behind and around him fantastic monsters arise in the gloom. The side of the desk facing the spectator bears the inscription which serves as the title of this article: 'The sleep of reason produces monster.' And in his commentary Goya expanded this idea: 'Fantasy abandoned by reason pro-duces impossible monsters: united with her, she is the mother of the arts and the source of their marvels.'

Devils, sorcerers, witches, monsters, half man—half beast, the terrifying visions of a horrible nightmare, haunt the thirty-eight concluding plates of the Caprichios. But they are not the idle fancies of a neurotic imagination. They are fantastic shapes masking the real, the concrete forces of evil in the society in which Goya was living: the organized exploiters of the peoples' faith and loyalty, the church, the aristocracy, the bureaucrats, all whose parasitical existence is based on the 'frauds, sanctioned by custom, prejudice or interest . . .'.

It would be futile to attempt a detailed identification of each one of these designs, for in a dream familiar figures mingle with strangers significant only through the general mood they evoke . . . But the most profound of the Caprichios, the design in which their stirring message is most powerfully pro-claimed, is Plate 59 [Plate 24]. A huge stone slab, whose crushing weight bears down

on the group below, cuts diagonally across the composition. Below it a man is lying asleep, while others wrangle or crouch in dumb resignation. The weight that will crush them all is supported with desperate effort by a single figure, gaunt and emaciated, resembling a skeleton rather than a living being, while behind him an old woman, worn out by toil, clutches her hands in terrified expectation: 'And still they do not move . . .'.

'The Sleep of Reason produces Monsters'—'Fantasy United with Reason is the Mother of the Arts and the Source of their Marvels'. Reason and fantasy, realism and exaltation, these are the elements the unceasing conflict of which, resolved in the marvellous union of creation, gave rise to every single work produced by Goya after he recovered from the ordeal which closed his youthful period of optimism. In the last section of the Caprichios fantasy, the element of exaltation reigns supreme. But it is not the exaltation of escape, the fervent mysticism of a transcendental wish fulfilment. It is exaltation rooted in reality: the exaltation of struggle against the monsters who perverted the simple faith of the people into a means for their exploitation. Religion and loyalty tainted by greed and suppression assume the shape of a vicious satanism. Its terrifying ogres assail the artist, when reason sleeps, when no ray of hope appears to penetrate the gloom of despotism triumphant. It is Goya's greatness that he was never crushed by these forces of darkness, that he never succumbed, like so many artists of his time, to the opiating influences of a satanic mysticism. His reason firmly rooted in the soil of reality, always retained the ultimate control over the monsters that haunted his imagination. For even in periods of the darkest gloom Goya never lost his exalted faith in the ultimate victory of freedom.[49]

This passage from Klingender's article shows how far his work on Goya is from being insensitively political in its approach. His appreciation of aesthetic factors which are relevant to interpretation is considerable, and his Marxist commitment does not bias his interpretation unconvincingly, even if the patterns he finds in the *Caprichos* are occasionally neater and more precise than the work itself seems to justify.[50]

The same approach to Goya's work as a whole was applied by Klingender in a book he completed in 1940, although it was not published until eight years later: *Goya in the Democratic Tradition* (1948). Historical sections on Spanish society alternate with sections on important aspects of Goya's art in this book: exemplifying the impact of the one on the other. 'It has been my aim,' Klingender finally declares, 'to indicate the underlying rhythm in the development of Goya's outlook and to trace its origin, and the origin of Goya's style in the social history of his time'.[51] The way in which some of the tapestry cartoons suggest a swing towards 'stirring social appeal' around 1790, is carefully brought out,[52] and later works are found to have a central concern with the reality of Goya's times. For Klingender, 'Goya's sober materialism . . . is evident even in the *Disparates*', and 'he repeatedly went out of his way to prove how little he had succumbed to the satanic mysticism which seems to pervade that work'.[53] Even in his greatest religious paintings he views the church not as something mystical, but as the expression of 'the genuine

feelings of the people' and as an organisation which should minister to their needs. Klingender finds the pictures Goya painted for the Escuelas Pías in Madrid in 1819 particularly significant. Given the principles of free universal education which St Joseph of Calasanz held, and his concern with teaching method, 'it is not difficult to understand why Goya should have felt deeply moved, when he paid tribute to one whose inspiration was so profoundly akin to his own.'[54] He relates the small painting of Christ in the Mount of Olives, which Goya also painted for the Escuelas Pías, to other kneeling images in Goya's work, and suggests that he did not choose Christ as an embodiment of personal suffering as late Romantics so often did. His religious pictures 'do not express the despair of an artist seeking to escape from his social isolation'; they are 'profoundly "popular" and democratic'.[55]

Klingender sees, however, that the mystical and religious elements in Goya's work are momentary affairs, and that he constantly returns from the *vita contemplativa* to the *vita activa*. In this respect his comments on the *Disasters of War* series are naturally relevant. The war is visualised as a rising of the Spanish people which enabled Goya to abandon the fantasy of the *Caprichos*:

> Goya's *Disasters of the War* are documents of a great social movement. Together with the drawings and paintings of his last years they are the culmination of his realism. But they do more than mirror reality: they interpret and call to action.
>
> Goya's method of disclosing the truth is documentary but not photographic. He shows the actual but only in so far as it is significant. Where he alters its image, it is for the purpose of enhancing its truth. Nothing could characterise this war between the largest and best-disciplined army of the world and a 'rabble' of peasants more strikingly than his device of giving to the French soldiers—all the soldiers in the *Disasters* are French—a statuesque immobility even in the wildest action scene, while the Spaniards are full of vital movement. Nor could anything more clearly indicate on which side Goya's sympathies lay. And that he did not forget the social in the midst of the national struggle is shown by the plate in the famine sequence which he entitled 'If they are of different descent'. For in this plate Goya opposes the starving poor to the well-dressed bourgeois, separating the two by a policeman. All the scenes he depicts occurred, but they occurred a hundred times, and, what is most important, they are typical of this war. Even the Agustina plate derives its stirring appeal, not from its anecdotal quality, but from the fact that war is not a respecter of age or sex, or of the sanctity of the home, that in a revolution women, no less than men, are called upon to play their part in the struggle for freedom.
>
> In the *Caprichos* Goya had shown the world as a stage on which men play their parts controlled by forces, whose identity is concealed from them by the power of an illusion. There is little or no spatial depth in the designs. The figures move detached and imposing in the lime-light of the proscenium. The geometrically simple designs still show a trace of classical formalism.
>
> The *Disasters* show the people in action. Every figure, every movement is intelligible only as part of a wider social process whether present or past. Isolated figures and large-scale foreground compositions are rare. The groups, usually

placed in the middle distance, are intimately related to the landscape in which their actions take place. The brutal reality depicted no longer admits the poise and tonal harmony of the *Caprichos*, it demands violent contrasts of light and shade and the chaos of struggle. Where calm reigns, it is the calm of death. The rhythmic sequence of the *Disasters* differs in a similar way from that of the *Caprichos*. The exquisite balance and variation of the latter is replaced by a violent alteration of action clashing with immobility. The sequences of passive agony are overwhelming precisely because of the monotonous repetition of a single theme—just as the 'año de hambre' was monotonous with its succession of death-groans, corpses, and carrion-carts.

In short, it is impossible to compare the two great cycles of Goya's etchings on abstract aesthetic grounds. Judged by its own standards each is supreme. But their standards differ, because each expresses a different phase in the history of the revolution.

In the rising of the Spanish people reality had discarded its fantastic mask. The social struggle revealed itself naked and undisguised. That is why Goya no longer had to search for strange shapes 'which have never existed in nature'. The reality before him was stranger than the wildest fancy; above all it was more significant and compelling. Therefore realistic observation reigns supreme in the style of the *Disasters*. But fantasy and invention have not been discarded . . . It was Goya who first drew, not only the objective experiences of war, but rather those experiences reinforced by the emotions and the passions they aroused within himself as a feeling and suffering human being and a Spanish patriot . . .

In spite of all its horrors and disasters Goya recognized the positive significance of the struggle: the heroic awakening of his people after centuries of dumb enslavement. By their deeds the people, however immature and ensnared in the nets of reaction, had given substance to what, until then, was but the wish-dream of a small group of intellectuals. For, however cruel the immediate outcome, however bitter the experience of howling delirium drowning the voice of liberty and acclaiming the Inquisition—the foundations of feudal repression had been shaken by the great revolution of the Spanish people. And the seeds had been sown for a new and happier society cherishing the sacred heritage of freedom.[56]

Goya in the Democratic Tradition has had a considerable impact in Eastern and Western Europe. It was warmly welcomed by Georges Bataille in France when it first appeared, because Marxist criticism was still in its infancy there, and traditional criticism had paid 'scant attention to the social and economic conditions and the class tensions obtaining at the time when a work is produced'.[57] A Czech translation came out in 1951, and a German version in 1954. Vratislau Effenburger drew on the work in a short essay on Goya in 1961, included in the Czech edition of Lion Feuchtwanger's Marxist novel about the artist to which we shall return in another chapter.[58] Evidently in Russia, where art critics are not likely to skimp social and economic conditions, the German translation of Klingender's work has been influential. The debt of M. I. Shakhnovich is substantial; he terms Klingender 'the

most progressive English art specialist' even though he quarrels with some of Klingender's comparisons between art and literature.[59] I. M. Levina, in the book she published on Goya in 1958 also shows her appreciation of Klingender's contribution. His work as a whole continues to prove immensely stimulating, although recent historical research suggests that there was more ambiguity in Goya's approach than Klingender sometimes allows, and less optimism than he often finds. Since, as Bataille said, 'nobody can deny that the contemporary economic context of a work of art is as relevant for its study as the description of the work itself and the biography of the artist', Klingender's analysis of Goya in the light of Spanish history is likely to be widely read for many years to come.[60]

In the past fifteen years, two West European critics have taken Klingender's Marxist line and modified it in the light of recent research on the Enlightenment in Spain, and on Goya's contacts with leading intellectuals like Jovellanos. Hubert Damisch's influential essay 'L'Art de Goya et les contradictions de l'esprit des Lumières' (1963) saw Goya's crisis in the 1790s as a natural response to the predicament of the Spanish Enlightenment at that period. How could the Enlightened élite relate their ideals to the realities of the proletariat, as Marx himself put it? Goya's position, according to Damisch, was exacerbated because the élite lost its sense of reformist direction in the aftermath of the French Revolution, at precisely the moment when he had achieved high social status through his art. After his illness he reached a deeper understanding of reality through dream and the irrational, which was also, in itself, a protest against the narrow view of reason held by the élite. Gwyn A. Williams' *Goya and the Impossible Revolution* (1976) makes Goya's crisis a sexual as well as a socio-political one in the 1790s. He draws heavily on Edith Helman's work on the ideology of Goya's Enlightened friends, and shows how closely Goya's illness in 1792–3 can be identified with the Spanish political crisis, which deepened as the French Revolution moved towards regicide. Williams explains the shift into graphic art and into private rather than public work after 1800–3 as a move towards 'anti-social portraiture': paintings that depict the people rather than the ruling classes. But like other recent critics he perceives the conflict of attitudes towards the masses within Goya's work, strikingly illustrated by *Caprichos* 42 and 63, the first of which shows two peasants humping upper-class donkeys on their shoulders, while the second views the proletariat as mules themselves. Although Williams follows Klingender in feeling that Goya turned to realism and the People in the 1790s, and away from idealism and the élite, he also believes that Goya was ultimately pessimistic about change. In this way the artist's work is the iconography of 'a necessary but impossible revolution'.

Some of the East European approaches merit independent comment. I. M. Levina, in particular, developed lines of her own, and was one of the first Russians to investigate Goya after the Spanish Civil War, which had triggered a number of Russian essays on Spanish art.[61] Her viewpoint, no doubt, owes something to Lenin's article on 'Tolstoy as Mirror of the Russian Revolution', which argues that a really great artist must reflect some of the essential aspects of the revolution.[62] Following Marx himself, she identifies the Spanish revolutionary movement in

Goya's lifetime with the war against France between 1808 and 1814, and sees Goya's *Disasters of War* as a work that expressed solidarity with the struggle of the Spanish people to liberate Spain from a centuries-old feudal yoke as well as from France. Goya, in the *Caprichos*, she felt, with rather more justice, was the scourge of the Inquisition, the court and the hierarchical system in general, who ultimately discovered 'an authentic realist art'.[63] Levina accepts, however, that not all Goya's work can be seen in such heroically Soviet terms. He was, after all, a court painter to three Spanish monarchs as well as the artist of the people. Contradictions were inevitable.

Having developed these ideas in two books in the 1950s—*Goya and the Spanish Revolution 1820–3*, and *Goya and the Spanish Revolutions of the early Nineteenth Century* (dissertation, 1953)—Levina seems to have changed her line, conceivably as a result of reading Klingender. She now felt that Goya could be identified with his more progressive contemporaries who were 'trying to step into the struggle against the dark forces of reaction'.[64] Although such ideas do not represent a great advance on the nineteenth-century Liberal interpretation of Goya found in Castelar, there is some sense of balance in Levina's arguments. A recent Rumanian critic, Vasile Florea (1975), who shares some of Levina's views, loses the latter's sense of balance and exaggerates the anti-religious significance of Goya's art. Identifying the Catholic church in Spain with absolutism and tyranny, Florea sees some of Goya's work as a protest against religious oppression on behalf of ordinary people. This brings him nearer to a Marxist approach that is more heavily tipped to the left and at times blatantly propagandistic: Shakhnovich's *Goya against the Papacy and the Inquisition* (1955).[65]

For the final word we must go to the other end of the political spectrum, for Goya has not lacked for fascist and proto-fascist interpreters. The strange contribution of Blamire Young has already been mentioned, but in Spain itself extreme right-wing attitudes to art more particularly flourished immediately after the Civil War. An anonymous article called 'Goya or the deep sense of Spain' ('Goya o el sentido profundo de España'), which appeared in the General Franco-phile 'glossy' *Vértice* in 1939, certainly has overtones of Falangist ideology in it. Goya is seen as the embodiment of national character. His work has an exemplary heroic quality about it, spiritualizes reality, and extends Spain's artistic empire into France by conquering the Impressionists. A striking line in a generally vague piece suggests that Goya acquired a new vision as a result of 'the horrifying spectacle of the People fighting and being punished for it'.[66] Can the author have hoped that Spanish artists would acquire a new vision in the same way from the Civil War one hundred and thirty years later?

A similar emphasis on the nationalistic and spiritual qualities of Goya's work is found in Francisco Pompey's *Goya. Su vida y sus obras* (1945) in which the rejection of the Left is more palpable than the advocacy of the Right. For this critic, Goya's democratic spirit was religious rather than political: equality before God rather than French *égalité* and *fraternité*. His liberalism, by the same token, was 'not the Republican position of an unbeliever or an International Marxist atheist, but the

posture of one who failed to follow the authentic traditions of his country—the posture of a Catholic who neglects to practise the precepts of the Church.'[67] The deviance was only superficial, of course, for Pompey believed that Goya was 'a Catholic in his soul'.[68] Apparently the *Caprichos* reflected his 'patriotic and nationalistic essence'.[69]

This amalgam of religion and nationalism also informed several essays on Goya in Spain at the time of the tercentenary celebrations of the artist's birth (1946). The Caudillo was backing plans for a Goya museum in a new wing of the Prado at the time, and his Minister for Education upheld Goya as a symbol of Spain in the Falangist newspaper *Arriba* on 31 March 1946. Goya's renown, according to Sr. Ibáñez Martín, was yet another sign that Spain 'held an undisputed place in the upward progress of spiritual values'.[70] Spaniards should be proud of his 'authentic national significance'. In the same special issue of the newspaper, Valentín de Sambricio emphasized Goya's patriotism ('Goya no fue *afrancesado*'—'Goya did not collaborate with the French'), and found complete proof of his 'ardent Spanishness' in the *Disasters of War*. Another art historian to contribute to the same number of *Arriba*, the Marqués de Lozoya, recognized how strong the temptation was for Spaniards at a time of post-war isolation and embattled nationalism, to reduce Goya to an exclusively Spanish phenomenon: a painter of bulls and *majas* and local customs.[71]

A particularly exotic Spanish fruit of that epoch was Agustín de la Herrán, who published some twenty books and tracts on Goya between 1947 and 1971. He raised the religious and nationalistic qualities of Goya to new heights in *La Carátula de Goya* (1956), where reason is hard put to follow him. Taking paintings and etchings by, or attributed to, Goya, he stood them on end and turned them upside down, patiently scrutinizing them for symbolic animals and hieroglyphs. Naturally he found what he was looking for—incredibly crudely drawn—in the hair of Goya's sitters, on their shirt-fronts and in their laps, muttering their mystic message in Cabbalistic numbers and shapes. Herrán's conviction was that Goya based his art 'on a poetic interpretation of Pythagorean doctrine'.[72] His work had to be studied, therefore, under headings like Theology, Philosophy and Ethics, and in subsections like The City of God.[73] Herrán's 1956 book bears a revealing quotation from General Franco on the title page: 'What is important to us is content in general; the outward form is a matter of indifference, and we want forms to adapt themselves better to our content'.[74] This recipe for dictatorship can, it appears, be used in aesthetics. Agustín de la Herrán has proved adept at remoulding Goya's form to take his own incredible ideological brew.

X. Academic Approaches

IN the previous chapters Goya has been seen from a large number of different perspectives. Often the viewpoint has been more obvious than the view, and criticism has revealed more about the critics than about Goya. Art historians who try to keep themselves out of the picture, however, are just as revealing and no less personally motivated than those who do not. (Only an object can be really objective, as Unamuno said). Academic critics presumably find satisfaction in descriptive rather than evaluative roles. The value of their contribution depends on the accuracy of the description and documentation: in irrefutable facts. These can bring about changes in our approach to an artist as radical as any fluctuations of taste or shifts in aesthetic fashion.

Nearly all the catalogues raisonnés of Goya's paintings and etchings have made a useful contribution to the study of his work and detailed knowledge of it. Piot's catalogue of the etchings (1842) was the first essay in descriptive analysis, and the most recent examples are contained in books by Tomás Harris, Pierre Gassier and Juliet Wilson, and José Gudiol.[1] The publication of catalogues and biographical documents, however, is not the only academic way of getting the facts straight. Facts which relate to the style and content of a work are as relevant for the interpreter as facts about its technique, and much has also had to be done in Goya's case to clarify political and cultural allusions.

Early speculation about the meaning of the *Caprichos* was rather wild. But a serious and restrained attempt to identify specific references to events and personalities in the *Disasters of War* series was made as early as 1866 by Enrique Mélida.[2] Later, at the turn of the century, when the general public was all too ready to find references to Goya's politics and love-life in practically every etching and painting, Araujo Sánchez attempted to marshall facts over a wider area and debunk some of the more extravagant Romantic myths.[3] Reactions to Araujo's work have not generally been favourable. He tends to be negative rather than positive in his approach; pointing out errors in the theories of previous critics rather than venturing views of his own. In fact his intention was explicit in this regard. 'The aim of this study', he writes at the end of the introduction, 'is to examine impartially the work of this interesting artist, and explain my points of disagreement with those who have written about him before.'[4]

This looks a fair academic approach, and although some of Araujo's conclusions are patently wrong,[5] his demolition work on the more persistent Romantic legends

was salutary. He was particularly adroit at puncturing inflated stories about the Duchess of Alba and Goya's bull-fighting activities. A *maja* and two men in one of the tapestry cartoons, for instance, were commonly identified with the Duchess and two friendly bull-fighters—Pedro Romero and Costillares or Pepe-Hillo. Araujo (following Viñaza) points out that this was absurd, since the Duchess was thirteen or fourteen and Pepe-Hillo nine when the cartoon was painted.[6]

His comments on some of the *Caprichos* were also useful. He was not convinced by commentaries like the one published by Lefort (see Chapter 3), which found numerous references to specific individuals in the work: María Luisa, the Duchess of Alba, Godoy and so on. Araujo showed that other interpretations were equally meaningful for these plates. Where the French commentary saw allusions to María Luisa's sex-life in *Caprichos* Nos. 19 and 20, Araujo found feasible references to common prostitutes, stemming from the linguistic connection between the fowl depicted and women of the streets (Spanish *polla*; French, *poule*: a hen or whore).[7]

Ultimately, however, Araujo used evidence very nearly as selectively as those he attacked. He was less impartial than he intended, and it does not seem to have occurred to him that *Caprichos* Nos. 19 and 20 might have been alluding to María Luisa and common prostitutes at one and the same time. Like Zapater, he held that Goya had not been politically-minded, basing his opinion on theories of Goya's scepticism. He also believed that this scepticism went much further than Mathéron had thought, and led to a deeply-rooted pessimism.

> His satires are a complaint rather than a mocking process. Nowhere can he find happiness, everywhere he sees only struggle and misery, which is what he depicts for preference. Perhaps he believed that a few of the evils he bewailed would be remedied some day long after he himself was dead; but the remedy would come from human rather than divine agencies, and would be brought about by education. That is why he sees the idleness of members of religious orders as an obstacle to progress. When 'Truth is dead' [*Disasters* No. 79], it is the men of the church who crowd round to cover up the grave and prevent the resurrection of the truth they fear: ¿Si resucitara? ('Will she rise again?').
>
> A man who thinks in this way cannot be a liberal, nor a patriot either. In the French republicans and *philosophes*, who certainly influenced him, Goya found the same vices and miseries as in other people. When they put the theories they preached into practice, they had to fight conventions and abuses, and the conflict was bound to cause harm, even if it did not last long and the final result was beneficial.
>
> Those who believe that it is possible to improve and educate mankind simply by persuasion are sentimentalists, and Goya was one of them. They prefer not to have recourse to revolution or force; they hope that vested interests will not resist progress; and believe that the law is as plain to everyone else as it is to them.[8]

Perhaps Araujo was the kind of total sceptic he believed Goya to be. Perhaps he saw in Goya the Schopenhauerian despair at the passions of men which many of his contemporaries felt so acutely. He certainly struggled to get at the truth and

suggested that Goya did so too, and his appreciation of Goya's capacity to convey movement and tension—the sense of latent life—still seems valuable. Starting from the positions of Solvay or Muther, he went much further than they did in finding life and energy, even violence, in all Goya's work from the early tapestry cartoons to the paintings of his later years.

In Germany, Valerian von Loga attempted a similar revaluation of the artist: demythologizing Goya after the work of myth-making Romantics. William Rothenstein met him at the turn of the century in Berlin. 'Very thorough he was', Rothenstein wrote, 'and he had found out many things which threw fresh light on Goya's life.'[9] Amongst his most important discoveries were the letters Goya wrote to Bernardo de Iriarte in 1793, expressing the desire to paint more imaginative pictures. He also printed a number of other unknown Goya letters, and greatly increased his contemporaries' knowledge of Goya's work as well as his life. One of the beneficiaries of his research was the artist Paul Klee. Professor Heilbut (author of studies of Naturalism and the German Impressionist Liebermann) lent him a copy of von Loga's book as an earnest of his intention to write an article on some of Klee's etchings. 'If he doesn't keep his word', Klee wrote in his diary in April 1906, '—and he will be able to send me back the engravings only when he has some good news to tell me—I shall have the handsome biography of Goya instead'. A few months later von Loga was Klee's 'best reading'.[10]

Since von Loga's time there have been many significant contributions to documentary knowledge of Goya from art historians like August Mayer, Narciso Sentenach, Francisco Javier Sánchez Cantón and Xavier de Salas.[11] Particularly important publications in the last thirty years have been Valentín Sambricio's study of Goya's tapestries (1946)[12] which includes copies of 281 documents; the marqués del Saltillo's essay on Goya's family (1952)[13] and Jutta Held's exceptional discovery of Goya's memorandum on the teaching of art in the San Fernando Academy (1966).[14] We should also mention Lafuente Ferrari's essay in *Antecedentes, coincidencias, e influencias del arte de Goya* (1947), which not only examined afresh problems of the influence of other painters on Goya, and of Goya's own influence, but also brought together facts about Goya's family and a number of early articles about his work.

The discovery of new factual material about Goya's life and work invited further examination of current *idées reçues*. Pierre Paris (1923)[15] and Gutiérrez Abascal (1928)[16] maintained the sceptical approach of Araujo Sánchez, and the Spanish philosopher José Ortega y Gasset wrote a particularly lucid exposition of the case against the biographical legends of the Romantics:

> Other people's lives have to have been scrutinized carefully for several generations before they can be properly known. A number of different interpretations need to have been tried and a range of cautious generalizations have to have been deposited in the collective unconscious together with other relevant material for the understanding of a person. To put the problem another way: anything we say about another person's life is bound to be provisional, and may be pure invention.

So far as Goya is concerned, very little was known about him when he died. But the extraordinarily original and evocative quality of his work called for a biography. There had to be a personality behind it. Inbred curiosity makes us seek the cloud from which the lightning comes. Since Nature abhors a vacuum, Goya's life had to be invented to make up for the lack of reliable facts about him. Consequently his biographies, with only one or two exceptions, were, until well into the present century, examples of contemporary myth-making and proof of mankind's continued ability in that direction. The typical thing about mythical thought is that it converts the effects which require explanation into their cause, personifying them. Following this principle, the biographies of Goya we have referred to confuse Goya himself with the personalities he painted or drew. Goya's life thus ends up by being a mere duplicate of his creative work. And when he has painted a female figure, for instance, and actual identification is out of the question, the myth makes do with the next best thing and takes Goya to have been the lover of the lady portrayed.

Patient research has for some time been destroying this mythical biography piece by piece. But the legend is so deeply rooted that the scholars who are busy knocking down one or other of its turrets frequently scurry for cover into some other corner of the imaginary and Romantic edifice. The consequence is that anyone who tries to be fairly radical in his approach to the reality of Goya's life cannot avoid polemic with interested parties.

It would obviously be useful to study the origins of the Goya legend in detail. There would be a variety of advantages in this. In the first place the research would identify the strands of a modern myth. Secondly, it would clear the myth out of the way. And thirdly, it would probably throw new light on Goya's real life.[17]

Ortega's work is often more brilliant than precise. His Goya essays in themselves do not solve any biographical problems; they merely restate them in striking terms. Yet Ortega also made a contribution to the study of Goya's painting as well as to his biography, by drawing attention to the importance of *facture* as an expressive element in his works.[18] Proponents of the Intentional Fallacy (that it is fruitless to pursue the intentions of an artist or writer) will not think much of the passage in question. In the light of the more recent work of Anton Ehrenzweig,[19] however, which emphasizes the ease with which we forget the meaning of individual brush-strokes and allow the broader patterns of a painting to dominate and simplify our reactions, Ortega's observations are decidedly relevant.

One of the major Goya myths to preoccupy critics in the present century holds that he was a passionate but uneducated man of the people. Linked with this view is the conception of Goya as a spontaneous and instinctual creator, with a powerful sensory awareness and fantasy but little rational capacity: an artist who neither knew nor cared about artistic precedents. A significant development away from this position resulted from José López-Rey's articles in the *Gazette des Beaux-Arts* in 1944 and 1945, subsequently published in Spanish as *Goya y el mundo a su alrededor* (1947).[20] In these and later articles and books López-Rey has stressed Goya's contacts with

intellectual movements, his knowledge of art and art theory, and the rational organization of his satirical work. In relation to the *Caprichos* he was, in 1953, the first critic to draw attention to the probable importance for Goya of J. C. Lavater's *Essays on Physionomy*, which discussed the connexion between facial characteristics and character, and examined parallel traits in men and animals. In the same work López-Rey also traced Goya's development from recording Beauty to creating Caricature and emphasized the rational quality of his satire. Three years later in *A Cycle of Goya Drawings* (1956), he investigated the attitudes to religion and society expressed in a group of drawings, and related them to the intellectual currents of the time, clarifying a number of obscure allusions. López-Rey never minimizes, however, the emotional quality of line, colour and texture. In a recent essay he rightly condemns the tendency to reduce Goya's art to purely literary terms.[21] His attack on the superficial accounts of the artist, which placed an amorous relationship with the Duchess of Alba at the heart of his life and work, was particularly valuable. It occurs in the section called 'Goya in the society of learned people' in his book on Goya's *Caprichos* (1953):

> The overemphasis laid on Goya's relation with the Duchess of Alba as the key to the understanding of his art during the period we are considering has led most writers to lessen the artist's stature and to obscure at the same time the place he made for himself in Spanish society. In view of this, it seems advisable at this point to make a brief parenthesis in order to recall facts which may help to dispel the still current notion that Goya, for all his genius as an artist, was an unlearned man, and that his reputedly bizarre personal ways, of which there is no proof, were mainly responsible for his success in a society given to profligacy.
>
> From what we know, Goya indulged in the gratifications afforded by eighteenth-century society, which, in Spain as elsewhere, regarded love, particularly in its illicit forms, as a fashionable amenity. It is equally certain that the artist enjoyed the company of learned men, and that these had a genuine admiration not only for his painting but also for his opinions on works of art, whether of the present or the past. Moreover Goya, who long after his return from Italy occasionally included Italian expressions in his correspondence and captions for drawings, worked so wholeheartedly to learn French that in 1787 he could take pleasure in addressing a long letter in that language to his schooldays friend, Don Martín Zapater. So earnest an effort can only be explained on account of his intellectual curiosity sharpened in the contact with men of learning, among whom French books, even those of a philosophical tinge forbidden by the Inquisition, were widely read.
>
> Born in 1746, Goya was able to transform the moral, intellectual and political changes which took place in the world around him before the turn of the century into spiritual experiences of his own. As a young man he had made his artist's pilgrimage to Rome, and come back with undying memories of Italian and, it would seem, of French art. While making his way in Madrid society, and by his art attaining his social ambitions, including membership in the Royal Academy of Fine Arts and the appointment as Court Painter, he certainly had opportunity

to observe human nature and society, as his letters tell. With his introduction to
the higher circles of the Court and to the royal family, he won admiration not
only as a painter but also as a man who was at ease whether in a hunting party
or in a salon. In 1790, he could write with pride: 'from the Sovereigns down
everyone knows me' at the court. And in fact he frequented both aristocratic
and literary *tertulias* or salons, where philosophy, history, religions, the arts,
Spanish and foreign literatures, politics, economics, the new science of aesthetics,
and every other branch of human knowledge were discussed with the sense of
their cogent interrelation, or real encyclopedism, which then prevailed among
cultivated men . . .

 Such was at least an important sector of the society where Goya cut a figure
of his own, and where he came to know the Duchess of Alba. It would be a
thankless task to try to ascertain to what extent he was indebted to his learned
friends for his views on art, or they to him. It should be stated, however, that
the art historian Ceán twice cited Goya with the purpose of lending authority
to his own opinions on art and connoisseurship . . .

 In closing this parenthesis, we may conclude that Goya's learned contemporaries
regarded him as an artist if knowledge and judgement—which is not to imply
that they saw a scholar in him.[22]

Another important contribution to our knowledge of Goya's cultural and in-
tellectual contacts comes from Professor Edith Helman. Her early articles on Goya
established relationships between his work and certain contemporary Spanish
writers such as the two Moratíns, Cadalso, Jovellanos and Padre Isla. Literary
sources she has found for some of Goya's works have enabled her to throw light
on the artist's creative process and originality. The fruit of her researches appeared
in a series of articles published between 1955 and 1960, recently reprinted,[23] and
then was included in a larger and more comprehensive study entitled *Trasmundo
de Goya* ('Goya's Background') in 1963. A passage from her book, on *Capricho*
No. 50 (Plate 49), 'Los Chinchillas', shows very clearly how she pinpoints literary
echoes in Goya, and uses her discoveries to illuminate the work itself:

 Capricho No. 50, *Los Chinchillas* [Plate 48], is just such a scene of a tragicomical
 and farcical kind. In it we find two male figures, immobilized by cardboard
 heraldic costume; their eyes are shut, their mouths gape, and their ears are
 fastened with heavy padlocks. One of them lies on the ground, a rosary in his
 right hand. The other is standing and is girded with sabre or sword. The latter
 also carries beneath a kind of tabard or surcoat, something which reaches down
 to the ground: a large scroll of parchment, perhaps—presumably the patent of
 his nobility.

 In my article on this *Capricho* published in the Spanish periodical called *Goya*,
 I believe I was able to prove that the artist had got the idea for this engraving
 from a comedy of character called *El dómine Lucas* (*Magister Lucas*) by Cañizares,
 one of the most widely performed and admired dramatists of Goya's times. The
 ridiculous figure which one of the central characters cuts—the younger Chinchilla

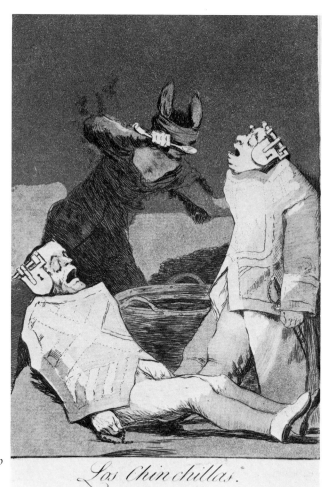

48. Goya: 'Los Chinchillas', *Capricho*
No. 50, 1799. Oxford, Ashmolean
Museum. Francis Douce Collection.

—is frequently called to mind in discussions about noblemen obsessed with
their lineage at the period. Moratín for instance remarks that 'our Domine Lucas
would also have his counterparts in Newton's country'.

Goya, when he made the first preliminary drawing for this etching (Plate 49),
undoubtedly recalled a particular burlesque moment in the play, and even includes
its scenery, representing the inside of a house. All the characters who appear in the
scene of the play are present. In the second preliminary sketch, which is closer
to the etching, the scenery has been eliminated, and the number of characters
has been reduced to the bare essentials, that is, the two Chinchillas. The prompter
has been changed into a figure half-man, half-ass, and feeds the Chinchillas with
ignorance and superstition.

By comparing the two drawings and the engraving with the scene in the play
which gave rise to them, we can follow the creative process of Goya, eliminating
inessentials and distorting appearances with pen and imagination. From the first
drawing which reproduces fairly faithfully the scene from the play, the con-
ception changes in the second drawing and then again in the etching itself,
whose characters are no longer the humorous and amusing caricatures of the

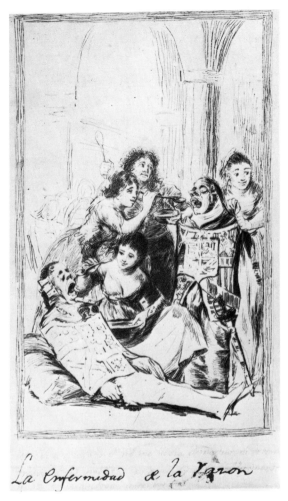

La Enfermedad de la Razon

49. Goya: 'La Enfermedad de la Razón,
1797–8. Pen and sepia ink drawing which is
believed to have been etched. Related to
Capricho No. 50. Madrid, Prado.

play, but dehumanized beings, fossilized relics of some distant period in the past, left permanently behind, isolated from the real world by their own useless, chimeric and absurd existence based on heraldry and patents of nobility. Goya's Chinchillas are monsters born of the dream of reason, the products of nightmare, as the artist himself suggests in the almost illegible words he wrote under the first preliminary drawing in sepia ink: 'Nightmare . . . dreaming that I could not untie myself . . . of nobility in which . . .' And these monstrous beings who renounce their human nature, stopping their ears and dreaming their dreams of nobility, go beyond the frontiers of caricature or the satire of external and objective reality, because they are products of another dimension of reality, the free imagination of the artist.[24]

Mrs Helman's effective study of the relationships between preliminary drawings and etchings has been made easier as a result of the printing of excellent modern editions of the four series which reproduce both prints and drawings. Sánchez-Cantón produced the *Caprichos*, Lafuente Ferrari the *Disasters of War* and the *Tauromaquia*, and Camón Aznar the *Disparates*.[25] But her research does not only

throw light on individual *Caprichos*. In the same book she suggests probable links between the plates which depict men as asses in the *Caprichos* (Nos. 37–42) and a certain Dr Ballesteros' illustrated *Memoirs of the Noble Asinine Academy* (*Memorias de la insigne Academia Asnal*) published in 1792.[26] She also points to parallels between the ideas of Goya and those of his contemporaries, particularly Jovellanos, and reveals new ways in which his paintings can be related to contemporary problems. She sees a possible link between the *Injured Mason* tapestry cartoon, for example, and accidents on eighteenth-century building sites, which gave rise to edicts on the erection of scaffolding in 1778 and 1782. A more controversial aspect of her work is her opposition to the view that Goya's originality was connected with his illness in the early 1790s.[27] She rejects earlier theories about the radical effects of his deafness on his work, arguing that Goya was original in both technique and conception before his illness whenever he worked for himself—in the early self-portraits, for instance. She finds the same small brushstrokes in them that other critics had found in his later work, often associated with Impressionism. In support of her theory about Goya's early preoccupation with originality she cites the statements he made when his designs for a dome in the Pilar Cathedral at Saragossa were to be referred to his brother-in-law Francisco Bayeu. But although these appear to support the case it must be remembered that Spanish artists had long attached importance to independent work as opposed to guided activity or actual copying. It was the ability to draw original work rather than copy that qualified them to be artists rather than craftsmen, and this reflected their social status as well as their artistic integrity.

Mrs Helman and López-Rey have both made major contributions to our knowledge of Goya as a man of the Enlightenment, and increased our understanding of his creative processes. Both have also written illuminatingly on his style. López-Rey has particularly sought to clarify Goya's relationship to the various approaches and theories of his period. In articles written in 1944 and 1945 he constantly returned to the question of Goya's development and his rejection of Rococo solutions. López-Rey went on to perceive that Goya's conception of art was comparable with the Picturesque in the 1790s, and in his fundamental essay on 'The San Antonio de la Florida Frescoes'—which also contained much new information about Goya's fresco technique, as we shall see—he set out the analogies between Goya's work and the theories of Uvedale Price very clearly:

> In this cupola painting Goya seems to have forsaken the rococo tradition as expressed by Palomino and still found in Tiepolo's ceiling. His figures, which are standing on the ground, are more than life-size (over 7 feet) while the diameter of the cupola is comparatively small: 19.7 feet. They crowd around the balcony, some of them leaning on the balustrade. But the balustrade here does not encircle the figures; on the contrary, it is itself encircled by their crowding around. The two impish children climbing the banister slant towards the inside, thus clearly suggesting the space behind the balcony, as does the mantle thrown across the handrail at a point just opposite. Goya's aim was not to convey an idea of ver-

ticality, but rather to impose upon the spectator an idea of horizontality, which is carried out by the different planes developing inwards from the balustrade . . .

There is thereby achieved in the whole an expression of limited space, within the bounds of which rugged, huge figures—angelic as well as human— move about, very different from the airiness of the rococo. Indeed, Goya, while following in his practice the precepts of a rococo treatise [that of Palomino], embodied in his work a vision of roughness and compactness which was foreign to that tradition. What was new in these frescoes is not the inclusion of popular types in the narrative of the miracle, or the playfulness of the angels, which may be found in much earlier paintings, but it was rather brought about by the whole shaping of the composition.

Should we wish to define the character of this work of Goya's by a con- temporary word, we could point out a coincidence—without hinting at influences —between its embodiment and what a late eighteenth-century English critic was trying to embrace in his understanding of a leading characteristic in both art and nature much under discussion at the time. In fact, in 1794, just four years before Goya painted the frescoes we are considering, Uvedale Price pub- lished his *Essays on the Picturesque*, in which he set out to distinguish one character for which he felt it necessary to coin a new word, *picturesqueness*, from those of beauty and sublimity . . . Price accepts Edmund Burke's distinction between the sublime and the beautiful. However, . . . he finds that there is a character which 'fills up the vacancy between the sublime and the beautiful, and accounts for the pleasure we receive from many objects, on principles distinct from them both'. This character—the picturesque—taken from the art of painting although not 'having exclusive reference to it', unveils the charm of what other- wise should be considered as ugly in nature. Thus, to Price, picturesqueness, which he does not define as neatly as Burke defines the sublime and the beautiful, is actually the captivating character which prevails in nature against the rationalistic distinctions of sublimity and beauty.

Moreover, to Price, 'picturesqueness when mixed with either of the other characters, corrects the languor of beauty, or the tension of sublimity'. It seldom happens that picturesqueness and beauty are 'perfectly unmixed', and it is only 'for want of observing how nature has blended them, and from attempting to make objects beautiful by dint of smoothness and flowing lines, that so much insipidity has arisen'. If the principal charm of smoothness, which is allied with beauty, is that it conveys the idea of repose, 'roughness, on the contrary, conveys that of irritation, but at the same time of animation, spirit and variety'. And roughness—a word which Price uses as synonymous with ruggedness—and sudden variation, joined to irregularity, 'are the most efficient causes of the picturesque'.

Furthermore, while greatness of dimension is a powerful cause of the sublime, which is 'founded on principles of awe and terror', and 'never descends to any- thing light or playful, the picturesque, whose characteristics are intricacy and variety, is equally adapted to the grandest, and to the gayest scenery'. This being

so, in order to give picturesqueness to what, like the boundless ocean, inspires sensations of awe, one must destroy infinity, which is one of the most efficient causes of the sublime, 'for it is on the shape and disposition of its boundaries, that the picturesque must in great measure depend'.

Goya in his *San Antonio de la Florida* frescoes created a work of art which in the light of Price's ideas we may venture to call picturesque. There the varieties of form and tint, as well as those of light and shade, are united in an intricacy of recesses and projections overshadowing the flowing lines which may be found in the playful representation of the Glory, within whose close boundaries any suggestion of infinity is absent; the features of its inhabitants are heavily pencilled so as to depart from the idea of beauty as much as they are pervaded with picturesqueness; this character is even more strongly accentuated in the cupola where a well surrounded area crowded with figures whose modelling abounds in recesses and projections and abrupt lights and shades, completes the sensation of ambient compactness. The singularity of these frescoes by Goya consisted in his freeing the realm of art from any rationalistic idea of beauty or sublimity, by taking into it the rough, intricate varieties of nature, and, at the same time, cutting off any adumbration of boundlessness from the ambit of the work of art, thus apparently subjecting it to the compass of nature.[28]

Elsewhere López-Rey found elements of the picturesque in Goya's *Naked Maja*.[29]

A rather different approach to style has evolved among German critics in the course of the present century. Scholars there were more especially concerned with style as an expression of the philosophical climate of an age (Time-Spirit or *Zeitgeist*).

It is instructive to compare the simple Goya-as-Romantic view of a late nineteenth-century critic like Richard Muther with the more sophisticated analysis of Goya (also as a Romantic) by Max Dvořák in his essay on the *Disasters of War* published in the 1920s.[30] Dvořák's comparison of Goya and Callot is also very different from earlier parallels between these artists, and particularly emphasizes their separate cultural backgrounds and Time-Spirits. Callot is seen as the product of a scientific age; Goya as the product of a period of subjective sensibility. In this way Dvořák relates the emotive force of Goya's work to his age rather than to his expressive ability or drive as an individual. The analysis appears to be based on historical fact and history of ideas, and it has certainly appealed to Marxists. The danger of such an approach, however, lies in reading the time-spirit into an artist's work. Certainly the decorative quality of Callot's art remains unnoticed and unexplained in the course of Dvořák's discussions:

This realistic depiction of war was not entirely new [in Goya], however. Nearly two centuries earlier Jacques Callot, in his *Misères de la Guerre*, depicted war in a similar manner to Goya: neither idealizing nor heroizing it, but showing its true and terrifying likeness. In this, Callot was linking up with the older tradition of naturalistic art in the Netherlands and Italy. Yet, in his rational approach to war, he was inspired by new developments in man's view of the world—especially the new system of natural sciences—that the seventeenth

century witnessed. In the light of this change, phenomena which had a bearing on culture came to be regarded, not as something predetermined by an established supernatural world order, nor in terms of some absolute and *a priori* religious, philosophical or artistic concept of the world, but as a fact of nature, as a document for men to draw upon in their interpretation of the mysteries of existence and mankind's historical development, useful for their self-orientation in the turmoil and chaos of life. Callot's etchings exerted a great influence over the entire period that followed, especially in the field of illustration. Indeed, it would not be difficult to trace the threads which lead from the seventeenth-century French realist to Goya, an artist in whom two great currents in the development of modern European art were merged: the painterly and impressionistic, on the one hand; and the representational and realistic on the other.

Nevertheless the *Desastres* were new in comparison with all earlier depictions of war. Goya's pictures of war are not only an objective war chronicle. They are, at the same time, a personally committed statement. The subject of his narrative is conceived with a national emphasis. The events, for him, testify to the severe ordeal which his country had to undergo, in which he bore his share with a compassionate heart—something that one could seek in vain in earlier pictures of war. But other ideas and feelings have a part to play, too, and they originate in the reflective attitude of the individual in the face of the struggles and suffering of humanity. Outbursts of anger, feelings of pity, horror or despair, passionate protests and resignation, inner distress and anxious questioning, give these deeply moving scenes of war their true substance. The realistic outward form these feelings take is transmuted into a commentary compiled from subjective, psychic experiences triggered off by war itself. Where does this process begin?

It is well worth our taking another look at another series of the master's etchings, the even more famous *Caprichos*. These 'spontaneous ideas' are painted fantasies with underlying philosophical and satirical themes. They are caricatures and fanciful inventions, whose protagonists are men from various social classes or fairy-tale figures: men with animals' heads, witches, or monsters of all manner of shapes and sizes. Some of the scenes in which this cast is assembled are reminiscent of Bosch, others of spectres from a Walpurgis-night on the Brocken, and yet others might bear comparison with Shakespeare's *A Midsummer Night's Dream*. The form was not new, for such *capricci* and *scherzi di fantasia* had long been popular. To this Goya added a drastic portrayal of various aspects of life, with a secondary meaning that has excited the curiosity of critics ever since and led to a strange notion of Goya's personality. Let this serve as an informative example of the speed with which a legend can be formed, and a warning about how cautious one must be in accepting biographical information, even when it coincides closely with known events.[31]

Dvořák goes on to infer that the Romantic interpretation of Goya's life, as given by Yriarte and Muther, was poured into an iconoclastic and revolutionary mould, because the enigmatic nature of the *Caprichos* suggested it. For his own part, Dvořák

argues that the etchings originated less from specific political or religious situations than from Goya's deep private concern with the nature of man. The *Caprichos* are, therefore, seen by Dvořák as a kind of personal confession, akin to Goethe's *Wilhelm Meister*, and a product of the same climate of ideas:

> Every so often, to free himself from brooding and the accompanying spiritual depression, Goya took up his crayon and translated his ideas into pictures. This version of their genesis, is also confirmed by Goya's commentaries on individual plates. These take the form of short maxims, which appear almost banal in their generality, but which, in their pictorial correlates, are among the finest inventions of the human spirit. They are the *confiteor* of a profound soul—albeit a simple soul without literary sophistication, but one with an abundantly rich inner life. It is therefore highly remarkable that these personal confessions evolved at the same time as *Wilhelm Meister's Apprenticeship*, that novel where, for the first time, one individual's inner life is set up as a norm for judging the world and existence. 'And so I started upon that course which throughout my life I could never abandon—namely, the strategy of transmuting whatever delighted or tormented or otherwise occupied me, into a picture or a poem.' These words of Goethe's might be applied *mutatis mutandis* to Goya. Indeed, the correspondence here is no accident; it is a symptom of the change that was taking place in the entire intellectual life of Europe—a change which signified a new introspection on the part of man. Ever since Petrarch, lyric poetry had been influenced by subjective emotions and experiences and the subjective life of the spirit. But in this period—in contrast to the Middle Ages with its other-worldly ideals, to the Renaissance with its materialistic cult of the sensory world, and to the Age of Enlightenment with the pre-eminence of abstract reason—psychic experience became the major source of inspiration for all the arts. It was a source not only for the dominant motifs in the arts, but, more important, for the interpretation and elucidation of life and its problems. This psychocentric bias, this spirit of a new kind of reflection, which seeks truth in the inner life, not only pervades Goya's *Caprichos* but also underlies the war chronicle he produced. The latter work is a paraphrase of the havoc wrought in a sensitive spirit by the shadow of war. This distress, combined as it is, in passionate protest, with urgent pleas for a new and better humanity, is akin to Hölderlin's, Lord Byron's or Leopardi's —only the desolate soil that nurtured it is different.[32]

In the same tradition as Dvořák is Theodor Hetzer's essay 'Francisco Goya and the crisis of art around 1800'.[33] Dvořák's Goya is a product of egocentric Romanticism; Hetzer's is similarly linked with the eighteenth century's rejection of earlier philosophical, religious and political systems. His careful contrast of Velázquez and Goya illustrates the difference between the world-pictures of the two artists. The detail of the comparison is illuminating whatever one may think of the validity of Hetzer's conclusions:

> In his early period Goya made several etchings after paintings by Velázquez.

By comparing these versions we can get to the heart of the pictures and the problems they raise.

First let us compare Goya's copy of *Don Sebastián de Morra* [Plate 50] with Velázquez's original [Plate 51]. The first point to note is that the expression of the head is intensified by Goya to give it an almost animal appearance. The sad face of Velázquez's painting has become a stupid, sinister one with a blank stare. Our attention is concentrated on the head even more—yet another example of that distortion and over-emphasis of content we find so often in Goya. But how is it achieved? By isolating the figure from the background, by negating the order which is still intact in Velázquez; by focusing composition on the figure, and by creating a tension between man and his surroundings. In both Velázquez's and Goya's versions the figure is set against a dark, neutral background. Yet in the Velázquez, this background belongs to the world of nature and the realm of the spirit, and is in harmony with man's physical and spiritual existence. It is man's habitat and refuge. Goya's background, on the other hand, is menacing. It has the disquieting aspect of infinity, and is inimical to man, and not his home. This disquieting aspect increases the sense of helplessness in the fool. By what means does Goya achieve this? In the first instance by his use of contour, which isolates the figure, and his line-drawing, which sets up contrasts. The contour has more of a dynamic, moulding function than Velázquez's; it is more detailed. There is a vast contrast between the details of the figure and the utterly monotonous background. Goya also brings out the plastic properties of the figure more than Velázquez, and leaves the spatial properties of the background less defined. Velázquez places an aureole round the figure and further confines the picture, internally, by gradually intensifying the darkness of the background nearer the edges. Goya's darkness is the same all over. The picture stops at the edges, but it is not given its definition by them. In this respect it is like the *Maja* too. A further point is that, in Velázquez, everything is integrated according to the underlying mathematical order of the canvas; in Goya it is not. The fastening of the coat in Velázquez's picture is set in the vertical plane, exactly in the centre of the picture. In Goya's etching this line bulges out and is broken up into smaller units by the accentuated buttons. In Goya, this line is part of the figure alone. In Velázquez, it is also an element of a higher order, namely the order of the picture as a whole. For Velázquez, then, man is subordinate to a higher order, and the picture represents the world order. ('. . . Comme la barbarie est l'ère du fait, il est donc nécessaire que l'ère de l'ordre soit l'empire des fictions—car il n'y a point de puissance capable de fonder l'ordre sur la seule contrainte des corps par les corps. Il y faut des forces fictives. L'ordre exige donc l'action de présence des choses absentes, et résulte de l'équilibre des instincts par les idéaux.' Paul Valéry, *Variété*, II, 53–54, Préfaces aux *Lettres persanes*.) The matter does not simply end here, however. This line is just the most immediate expression of a ubiquitous order, which is no longer felt or acknowledged by Goya. In addition to Velázquez's vertical there is a horizontal line, in the background on the right, one third of the way up, on a level with the lap. In the

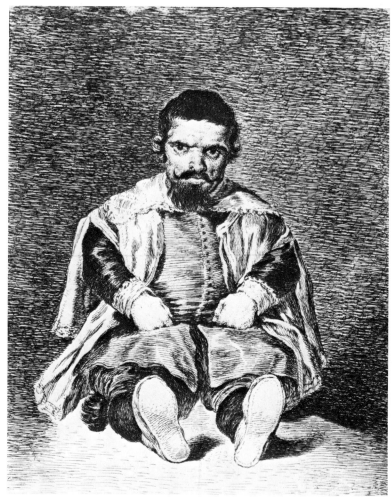

50. Goya: Etching of
Velázquez's portrait of
Sebastián de Morra,
1778. Madrid,
Biblioteca Nacional.

figure's sitting posture the static, architectural principles are emphasized; and
this sitting posture is complementary to the spatial order in the picture, which
is, in its turn, complementary to the underlying order of the canvas. Giotto's
unity of man, body, canvas area and space within the picture, are here preserved
intact. But, in addition, all Velázquez's contours are related to this general or-
ganization of the canvas; they are all experienced as intrinsic to the canvas as a
whole and not just to the figure. The particular is integrated into the general,
every individual form is connected with the whole. All areas of the canvas are
related and co-ordinated on a level beyond the representational. Mathematics
and ornament both represent the higher reality underlying the world of appear-
ances. Now none of this is left in Goya's version—neither the horizontal plane of
the lap, nor that of the background, nor the co-ordination of all the contours
and areas on an abstract level. Particularly noteworthy is the way the line of the
ground on the right is changed from a horizontal to a firm diagonal leading right
up to the figure. A line of the composition that had hinted at an order into which
the figure is integrated is no longer tolerated. Indeed, this line, along with the

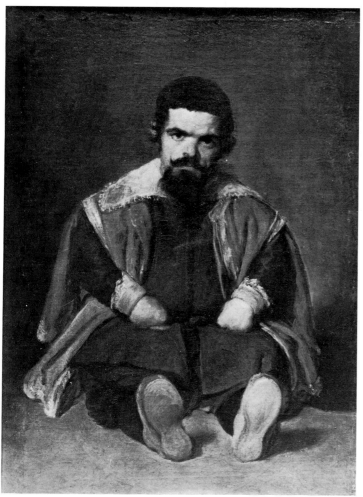

51. Velázquez: *Portrait of Sebastián de Morra*, c. 1643. Madrid, Prado.

border between different areas of brightness on the left, now adds to the heightened impact of the isolated figure. It is the striking impact made by the figure that is Goya's chief concern.[34]

Later in the same essay Hetzer discusses the *Tauromaquia* series of etchings in a brilliant passage which suggests various ways in which Goya's conception of pictorial space and composition can be related to earlier precedents and later approaches.

The most mature artistic achievements of Goya, and at the same time the most modern in their form, are the late etchings of the *Tauromaquia* series, and the *Toros de Burdeos* lithographs which date from the last years of his life. Here, too, the new and striking quality of the content is prominent, but it is no longer quite to the same extent the sole inspiration, and the social criticism and exciting topicality are absent. Likewise, it is no longer bizarre configurations and powerful motifs that are the focus of interest, but rather the impact of the print as a picture. This impact as a picture, however, is due to all that Goya had acquired in his

practice of emphasizing motifs, and it is totally different from the picture in earlier periods. It rests on a subtle balance of concentrated motifs and areas of blankness ... No. 21 of the *Tauromaquia* shows a surging crowd and a wealth of contradictory movement at the bottom on the right, which is contrasted with the vast emptiness of the rest of the picture. The bull, which has caught a man on its horns and thus caused the people to flee in blind panic, is parallel to the plane of the picture and fits into the format of the whole. The flight of the woman in the foreground, right, is complemented by the barrier; that of the bright figure to the left gives us a clear idea of the picture's breadth, and, furthermore, this bright figure complements the brightness of the left-hand side of the picture. The most meticulous artistic calculation is at work, as in every great work of art. The same applies to Nos. 25 and 30. Nevertheless, the serenity of Goya's late pictures, and their pictorial impact, is fundamentally different from the earlier pictorial unity which Goya had destroyed. For even here the picture is conceived not as representing an eternal order and its laws, but as a means of defining a motif within skilfully chosen limits. The emphasis is more than ever on momentariness, uniqueness and motif. In the way these aspects are brought within the framework of a picture, in the way appearances are confronted with nothingness, the wit and acumen at work in comprehending the situation is made particularly telling. If at earlier periods the motif was an integral part of the picture, in No. 30 we see very clearly that the picture has been conceived with the motif as its starting point and its constant focus. The shadow on the ground inside the arena, the way it curves, serves to accentuate the duel between matador and bull.

This picture does not show a self-contained world, but highlights one point, one situation. The spectators are indistinctly drawn, they are a crowd. A subtle pleasure is derived from using the unity and self-sufficiency of the work of art to let us sense the utterly unlimited and unstructured nature of the world. Life consists of elements that are juxtaposed and contemporaneous, any one of which we can concentrate upon at will. This delight in emphasizing the accidental and arbitrary nature of things, and at the same time creating an ordered work of art from it, can be carried to the extreme where we admire the artist like a magician or a conjuror, who sets himself the most difficult feats to accomplish, only to show how well he can pull them off. No. 4 of the *Toros de Burdeos* shows a detail of the arena which cuts diagonally right across the format of the picture, and yet a perfectly ordered work of art is constructed from it. Such problem-solving made an impression on Manet and Degas. And of all artists it was Degas who excelled in making his work as complicated as possible for himself. Yet he still achieved a perfect whole, with an astonishing precision and balance which calls for our admiration. To preserve the sheer vividness of the random detail, yet to have supreme mastery as an artist—that is what attracted the brilliant talents of the nineteenth century. We cannot deny such art our admiration, but there is a definite virtuosity about what we are admiring. The great artist of earlier epochs remained unassertively behind his work, in which he would offer his interpretation

of the coherent order and unity of the world. The great artist of the nineteenth century demonstrates what he can do. Bravura plays a large part. Not until Cézanne does there emerge another artist whose concern is to interpret the world and not take issue with it.[35]

The point of Hetzer's comparison of Goya and Velázquez was to show how their work reflected radically different concepts of the connection between art and reality. Other critics have been concerned in a different way with Goya's relationship with other artists: establishing *rapprochements* in their work, and identifying what Goya might have learned from their stylistic precedents.

Goya's self-confessed admiration for Rembrandt was an obvious lead. It was a commonplace of nineteenth-century criticism. But in the 1920s Otto Benesch examined Goya's interest in Rembrandt in a new and more penetrating way.[36] Benesch felt that Goya's ability to organize emotional material, imposing formal, sometimes cubic, structures on them, recalled Rembrandt. Goya's way of building with light and shadow in the etchings was 'a brilliant revival and continuation' of the latter's work.[37] In fact Goya's whole conception of art, and indeed his philosophy, echoed Rembrandt's in Benesch's view. Discussing Goya's self-portrait of 1816, he suggested that the features showed a Rembrandtesque paradox. They revealed a 'lifetime of pain and passion'. Yet 'the creator and shaper has triumphed over all the vicissitudes of time'.[38] The painting reflected suffering and resignation in the same proportions as Rembrandt's self-portraits. The underlying idea that art was 'a means of moulding life' seemed common to them both. Ultimately, Benesch's parallels led him to see Goya as a Classicist rather than a Romantic in his approach: one who imposed form even where the work appeared to be most enigmatic and chaotic, as in the Black Paintings.

Benesch's sensitive study of Goya's inheritance from Rembrandt has not been equalled. But more concrete details about Goya's debts to Rembrandt have come to light since Benesch's essay on the topic was first published. In 1934, Enrique Lafuente Ferrari noticed that one of the prints in the National library at Madrid had a note on the back to the effect that 'Goya borrowed 8 Rembrandt etchings on the 21 May';[39] Sánchez Cantón later revealed that there were ten etchings by the Dutch master in the inventory made of the contents of Goya's house in 1812.[40] We now know that Ceán Bermúdez, who claimed to have eighteen Rembrandt engravings in his own collection, lent some to Goya when he was working on the *Caprichos*.[41] Miss Trapier found tangible proof of the impact of one of them in Goya's drawing called *The Bath*, which seems to be modelled on Rembrandt's etching called *The Woman with the arrow* (sometimes *Tarquin and Lucretia*),[42] and she also commented (as have others) on the Rembrandtesque treatment of some of the subjects of Goya's portraits.[43] The most universally recognized Rembrandt-esque touches are still those in the painting of *Christ being taken captive* in Toledo cathedral, whose lighting and faces reminded Gautier of Rembrandt (1842). Yet Noël Mouloud and Otto Benesch in a second essay (1960), have taken the study of this influence rather further; and Mouloud suggests that Goya's whole sense of space owes much to Rembrandt.[44]

A less rich field of study is Goya's awareness of English and French art. He certainly had a print after Reynolds in his collection, made drawings after Flaxman's illustrations for the Divine Comedy, and perhaps drew inspiration from Gainsborough in some of his portraits.[45] Hogarth is obviously the first English name to conjure with when Goya is mentioned. But there is all too little detail in parallels and contrasts between the two at present. So far as French art is concerned, Goya is known to have used a print after a painting by Simon Vouet as the basis for an early painting of the *Burial of Christ*. And it has been argued that he may have been influenced by works of Michel-Ange Houasse, Fragonard and Gabriel de Saint-Aubin.[46] Some of Goya's satirical subjects occur in French as well as in English prints. He also thought he could tell a Poussin when he saw one.[47]

More obviously influential so far as Goya was concerned were the theories and paintings of A. R. Mengs. Sánchez Cantón and Lafuente Ferrari have set out in broad outline the relationships between the two artists.[48] In Goya's early tapestry cartoons the groups were pyramided and the figure posed very much according to Mengsian principles. Even at the end of his life, long after Goya is usually believed to have put Mengs out of his mind, he described the style of his miniature paintings on ivory as 'nearer to Velázquez than to Mengs'.[49] So the latter was still a theorist he considered important.

The impact of Italian art on Goya is equally significant. A few specific sources have been found, and Lafuente Ferrari, when he surveyed European influences on Goya in 1946, felt that artists like Corrado Giaquinto and Giambattista Tiepolo, who worked in Spain, affected his general development considerably. More particularly Lafuente suggested that the rapidity with which Goya worked and the fluidity of his brushstrokes owed as much to Italian precedents as to Spanish. He finds affinities between Goya's frescoes in Saragossa and the work of Luca Giordano, and is illuminating on probable points of contact between Goya and the Venetian School.

> The links between Goya and Tiepolo lie, one would assume, in the influence of the strongly colourist approach of the latter, his incitement to audacity and unrestrained delight in colour. If we are right in this, Goya's discovery of Tiepolo would have liberated him from the boringly painstaking and narrow artistic precepts of Mengs and his followers, their obsession with drawing and detail, their preference for cold colours and porcelain techniques, surface polish and reflections . . .

Goya could hardly be an exception to the rule which has always brought Spanish painters particularly close to the Venetian masters. And in that respect, Goya can be seen to continue the traditions of Navarrete, El Greco and Velázquez, despite the many differences between the eighteenth-century master and these artists. So far as the 'veta brava' is concerned [the trend towards boldness in Spanish art] Goya could have found an admirable precedent in the Venetian school itself in Tintoretto. Both painters are Romantics, passionate about life and movement. Tintoretto's sense of dynamism was to some extent inherited from Michelangelo, who poured the grandiosity of the classics into Baroque moulds. That of Goya is

imbued with a modern feeling, a restless search for the expression of the passions, a tragic sense of life. But both love excessive effort, the expression of energy and violence. Various parts of Tintoretto's work recall the spiritual climate and the fever of Goya's creations. As a concrete instance we might also mention *The Forge of Vulcan* by Robusti in the Doge's palace at Venice. The movement and energy of those beautiful, naked and vigorous figures of the gods remind us of the tensile qualities of Goya's late painting *The Forge*, now in the Frick Collection in New York.

Sánchez Cantón some time ago pointed to the Tiepolo fresco in the Villa Montarini as a possible source of Goya's *Majas on a Balcony* [Plate 10]. But whatever we feel about this, it is clear that Goya learned from Venice not just details or concrete themes, but above all a delight in rebelling against the academic art of his time, and moral support for the audacity of his colours, positively bubbling up on on his palette and waiting to spread themselves on the canvas.

The frescoes in the Madrid Palace which were the last great work of the patriarch of the Venetian School, must have impressed the young Goya, helping him to clarify his own ideas and providing him with arguments in support of his personal inclinations, as against the theories of the Academy and conventional wisdom. Goya must also have seen greater possibilities for his work as an engraver in the delicate silver tones of Tiepolo's *Capricci* than in the crude scholastic products of those who had been sent to study engraving in France by the academy. Goya found his own way to originality as an etcher in these compositions by Tiepolo. They reflected the artist's fantasies and were not just exercises in technical virtuosity.[50]

Lafuente Ferrari finds the older Tiepolo's impact particularly strong in Goya's tapestry cartoons, and he also explores the possible relationship between Lorenzo Tiepolo's paintings of scenes from everyday life and those of Goya.

The work of subsequent critics has necessarily led to some modification of Lafuente's position. In 1954, Roberto Longhi suggested that Goya was far closer to Corrado Giaquinto and to Luca Giordano (Neapolitan Baroque) than to Tiepolo and the Venetians. He also traced a clear link from this tradition to Goya through Antonio González Velázquez (a pupil of Giaquinto) whose small dome and pendentives in the Spanish Church of the Trinitari Calzati in the Via Condotti in Rome, seem to prefigure Goya's later work in San Antonio de la Florida.[51] More recently, Mariano Juberías Ochoa has taken Longhi's point about the Luca Giordano connection further. He has shown convincingly how close to Goya are the feminine angels and bare limbs in the frescoes Giordano painted for the Church of San Antonio de los Portugueses in Madrid.[52]

As relevant as stylistic studies for an understanding of Goya are those concerned with his iconography. A shift in our general attitude to Goya has certainly resulted from recent work of this kind. An early essay on Goya's use of Ripa's *Iconologia* came from Martín S. Soria in 1948,[53] and the impact of emblems on Goya was soon studied by George Levitine and others.[54] A suggestive discussion of the Black

Paintings in relation to iconographic traditions was provided by Diego Angulo,[55] and a more detailed study of the same series of paintings (and others) from a similar stand-point led to the book entitled *Goya, Saturn and Melancholy* (1962), by the Swedish art historian Folke Nordström. This work shows how Goya assimilated iconographic precedents and departed from them. By investigating Goya's sources —especially in Ripa, which nearly all painters used as a handbook to allegory in the seventeenth and eighteenth centuries—he was ultimately able to underscore Goya's independence and originality. For he demonstrated exactly how far Goya went beyond his sources.

In all the six paintings in the dining-room on the ground floor of the *Quinta del Sordo* we have thus found motifs associated with Saturn the planet god, who is represented on the wall at the far end of the room, facing the entrance. It seems perfectly clear to me that it is Saturn and none other who is the dominant figure in this mighty series of wall paintings, and around whom all else revolves.

Saturn's connection with Goya and his personal circumstances has been referred to several times already. In addition to what has been said we would here merely stress the part played by melancholy in the whole. In *Capricho 43* we have seen how Goya represented melancholy by symbolic postures and nocturnal animals, but as this state of mind is also associated with night or dusk the composition became a nocturnal scene as well, and in combination with this we can say that from a purely emotional point of view Goya's aquatint is especially evocative of a certain melancholy. This impression is further intensified in the case of the *Quinta del Sordo* paintings. In one way or another the motifs are linked with Saturn, who rules the melancholic temperament. The colouring is also identified symbolically with both Saturn and melancholy as already mentioned. But what makes these paintings really great works of art is the intensity of emotion which they adequately express. Goya had earlier given proof of his ability to breathe life into symbols and allegories. The symbolic animals on the canvases of the four pen drawings in the Museo del Prado seem as life-like as the people standing in front of them. The symbolic animals wheeling round the slumbering man in *Capricho 43* are such an integral part of the night atmosphere and of the other devices which stir the imagination in this composition that we do not think of them in the first place as symbols of the melancholic temperament but as an important ingredient for the emotional apprehension of the picture. Similarly, the painting of Saturn, for example, grips us on account of its motif but chiefly because of the intensity of the figuration and the unfathomable depths of terror which it conveys.

The composition as a whole is also very fascinating to study. The Saturn and Judith pictures on the front wall are placed together, but at the same time in their compositions they are turned away from each other. The entire series with the six paintings on the walls of the room is divided into two parts, one with the Saturn picture as the chief composition together with the *Witches' Sabbath* and *La Manola*, the other with the Judith picture together with *La Romería de San Isidro* and *The Old Deaf Man*. The first group of paintings, beginning at the entrance

into the room, shows on the wall to the left the melancholic woman leaning against the block of stone, a personification of *La Melancholia*, in the middle of the group the terrible *Witches' Sabbath* with the black he-goat, and to the right as a climax Saturn himself eating his own children. He is turned towards the Sabbath picture. Just as the melancholic mind destroys the sound sense, 'the sleep of reason produces monsters' such as the Witches' Sabbath, so, too, does the god of Melancholy, Saturn, destroy his own children. The old deaf man, on the other hand, is standing leaning against his stick when the accompanying man yells something into his ear. This yelling is also a pervading characteristic of the central motif within this group, the *Romería de San Isidro*, where the lament of the lonely lady to the right is transformed into the somewhat ecstatic song of the guitar-playing man and his fellows and the tongue-tied fright of the man farthest to the left upon seeing the cold-blooded *Judith*, a symbol of the cruel retaliation of Justice, with the head of Holofernes in front of them.

In its entirety this series of paintings in the dining-room shows us the cruelty of Life, Time and the melancholic genius as dark and destroying forces, and Justice as cruelty. It is an absolutely pessimistic view of life, created by a deaf and isolated old man during a long course of sore years and events.[56]

Other iconographical approaches concentrate less on emblematic meanings than on the pictorial relationship between one work and others on the same subject or with similar composition. A recent work of major importance in this field is Jutta Held's study of Goya's tapestry cartoons in the context of the work done by other artists for the Royal Factory.[57] Critics used to exclaim about the popular subjects of Goya's cartoons, and deduced a special concern for ordinary folk and national pastimes from them. They also exclaimed about his interest in dramatic subjects. Now it is possible to see how closely his subjects and their treatment are related to the work of other artists and official policy. It is also possible to see how far dramatic subjects were fashionable, and painted by other artists too. In consequence, what is conventional in Goya's cartoons, what is part of a larger iconographical plan— hunting and pastoral scenes for country palaces—and what is original and particular to Goya, can be seen in an infinitely clearer light.

Such contrastive studies also serve to sharpen our awareness of the individual qualities of the works compared. Two particularly illuminating studies have been written on Goya's debts to popular art forms from this point of view: one, on the six small paintings which depict the capture of the Bandit Maragato by Fray Pedro de Zaldivia; the other, on *The Third of May 1808* and related scenes from the *Disasters of War* series. The first of these is Eleanor Sherman Font's essay 'Goya's source for the Maragato series'; the second, E. H. Gombrich's review article 'Imagery and Art in the Romantic Period'.[58]

Eleanor Font relates in her essay how she discovered advertisements in Madrid newspapers for 1806 announcing a printed account and several engravings of the capture of the bandit Maragato by Fray Pedro Zaldivia (Plates 52 and 53). She shows that Goya must have known the printed account (*Noticia*) and may well have been

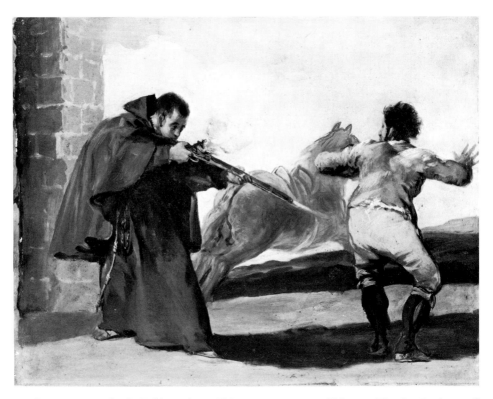

52. Goya: *Fray Pedro de Zaldivia shoots El Maragato*, 1806–7. Chicago, The Art Institute of Chicago. Mr and Mrs Martin A. Ryerson Collection.

familiar with some of the popular engravings and *aleluyas* (broadstreets with pictures in story sequence). She draws her conclusions in the last pages of her article in the following terms:

Before the inception of the photograph and the halftone, artists collected portfolios of engraved reproductions of famous paintings and plaster copies of renowned sculpture to draw upon for ideas in their work. Goya himself owned paintings and engravings from the brush and burin of other artists and probably had access to the large library and art collection of his in-laws, the Bayeus. Although he evidently consulted the *Noticia* and saw many prints about the bandit and the monk that flooded the Madrid bookshops, Goya does not seem to have owned any of them, judging from the inventory taken in October 1812 of his possessions and those of his wife, Josefa, in their house on Calle de Valverde

Current events in Spain were of lively interest then as they are now, and the astounding feat of a humble monk subduing single-handed a dangerous bandit had Madrid agog for details. That no less a personage than Goya, established as a painter to the King, should put his brush to illustrating the episode is not surprising for, despite his association with the royal family and the nobles whose portraits he was constantly painting, he was a man of the people. Departing from the bitter satire used in the *Caprichos* etchings of the church, he evidently was so

Riasgo de Valor de Fr. Pedro Zaldibia en la prision que hizo del Maragato el 10. de Junio.

t lam de Guarda y Benterrillo à dos leguas de Oropesa donde el Maragato incerro à Fr. Pedro, al Pastor, tres hombres, y dos Mugeres, b. Ato de Carneros del Pastor C.Niño de lo que Comio à la puerta. d. El Maragato pide unos Zapatos, sale Fr. Pedro à darle unos se los deja caer, y al bajarse el Maragato le agarr u quita la Escopeta. E. Da caer otra del Caballo, Fr. Pedro le espanta con el Cañon, huie el Maragato le dispara le p.va el muslo y ace F.Guarda, que salieron al b

53. Anonymous print of Fray Pedro de Zaldivia shooting El Maragato, *c.* 1806. Madrid, Biblioteca Nacional.

impressed by the monk's bravery that he employed no caricature in his panels, but presented the lay brother in a sympathetic manner . . .

The scenes in Goya's panels, arranged in correct sequence according to the *Noticia*, seem to confirm the belief that the artist had read the pamphlet. The omission of non-essential incidents and details only serves to accentuate his artistry. Where the prints are anecdotal, Goya's paintings are dramatic. His depiction of Fray Pedro closely matches the etched Gamborino portrait and the anonymous portrait with vignette. Goya's monk wears the cowled, short cape shown in two of the prints. The bandit's jacket is painted light blue and the buckskin breeches, described by Araujo, are yellowish buff. In the Society's *aleluya* [that in the collection of the Hispanic Society of America] the jacket also is coloured blue but in the Madrid library's collection such prints as are tinted show the jacket either black or reddish in colour.

By reversing the order of panels one and two and of four and five in their catalogues of Goya's work, Araujo and Beruete indicate that they were not cognizant of the pamphlet.

Sketches or etchings by Goya of the episode or portraits of the two men do not seem to exist. If woodcuts and engravings, whether single or in the form of *aleluyas*, ever were made from Goya's series, they are yet to be found. The paintings in the Art Institute of Chicago were dashed off with verve and evident

enjoyment. Their very clearness and attention to important detail could signify
that the painter had both the *Noticia* and one or more of the popular prints from
which to construct his own conception of the dramatic scene.[59]

It is obviously possible to disagree with Eleanor Font in some points of detail.
Although it is clear that there is no caricature element in Goya's set of paintings of
Fray Pedro and the Bandit, it is far from certain that he presented the lay-brother
in 'a sympathetic manner'. It could be argued that the friar's pious features become
decidedly less benevolent in the second half of the wrestling match, when he begins
to get the upper hand over the bandit. It is hard not to feel that there is a certain
irony in the recording of a reversal of roles between friar and bandit, and we do
not need to have recourse to the reasons Miss Font proposes for Goya's interest
in the subject. Certainly it is by no means certain that Goya was a man of the
people, as she asserts, following the Romantic tradition. Nevertheless, Miss Font's
article is invaluable in its analysis of the way in which Goya avoided the unnecessary
anecdotal detail which cluttered the popular versions of the subject.

E. H. Gombrich's article makes similarly relevant points about Goya's possible
acquaintance with certain Napoleonic War prints by the English artist, R. K. Porter

54. *Buonaparte Massacring 3,800
men at Jaffa*, print after R. K.
Porter, 1803. London, The
British Museum, Department of
Prints and Drawings.

(Plate 54). He takes much further than Miss Font parallels and contrasts between Goya's work and that of an essentially popular artist, drawing particular attention to their fundamental differences. The article is a review of Volume 8 of Mrs M. D. George's *Catalogue of Political and Personal Satires preserved in the Department of Prints and Drawings in the British Museum*, and Professor Gombrich refers to this work in the opening sentence of the passage we quote:

Among the anti-Napoleonic prints of the year 1803, Mrs George lists various plates illustrating atrocities perpetrated by Buonaparte. They bear the signature of R. K. Porter, a poor artist but an interesting figure. A pupil of Benjamin West, Porter seems to have been very active in various patriotic schemes. In 1805 he displayed his powers in a huge panorama of the battle of Agincourt on more than 2,800 sq. feet of canvas. This Romantic showpiece of a patriotic theme was displayed at the Lyceum, the same place where Philipsthal had conjured up his Phantasmagorias. Porter then went to Russia and published illustrated travel books on Russia and Persia. He also accompanied Sir John Moore on his un-successful expedition to Salamanca, which ended in the evacuation of Corunna, and finally married a Russian Princess.

What is interesting in the propaganda prints conceived in his facile melo-dramatic idiom is their date and their motif. They anticipate by some nine years Goya's terrifying scenes of Napoleonic massacres in and after the Spanish wars. It is tempting to speculate if the two could have met. There is a tradition that Goya went to Saragossa in the autumn of 1808 to paint scenes of the war which had broken out—during the very same months, that is, when Porter was attached to Sir John Moore for the identical purpose. But the tradition is unsubstantiated. It is possible that Porter may have distributed his prints in Salamanca and that this is the way in which they reached Goya, but it is not necessary to make this assumption. We know that British propaganda prints were circulated (and copied) in Spain and we need not strain our historical imagination to explain the connection between these violent designs and Goya's grandiose compositions. It is not only the tenor and the character of the episodes with their mixture of horror and defiance which are similar but also many individual features: the protruding eyes and violent distortions of the victim's face, the effective contrast between pointing guns and helplessly kneeling figures, the abbreviated forms through which the masses of similar victims are conveyed while attention re-mains focused on the principal scene—all these recur in many variations in the paintings and etchings of Goya's war scenes.

A detailed comparison between Porter's crude atrocity prints and Goya's heartrending protests against human cruelty only serves, of course, to enhance the magnitude of Goya's achievement. But it does more. It helps us to adjust our assessment of the historical role of these works. Recent descriptions of Goya's anti-Napoleonic compositions have stressed the documentary realism of this phase of his development. They have represented these creations as a revolutionary break with tradition and as the true beginning of the nineteenth-century approach

to art which sees in the painter the eye-witness who fashions his work out of his personal experience. The existence of Porter's prints does not altogether disprove this interpretation but it shows up its dangers. The very idea of 'documentary realism' requires qualification. These are not scenes at which a Spaniard and a patriot could easily have been present and survived. But even if Goya should have been eye-witness to one or the other of the terrible episodes he portrayed (and this cannot be proved) he might never have recorded his experience in visual shape had not the existing type of atrocity imagery, as exemplified in Porter's prints, provided the crystallizing point for his creative imagination. We realise today more and more how long and tortuous is the road from 'perception' to 'expression'. The original genius who paints 'what he sees' and creates new forms out of nothing is a Romantic myth. Even the greatest artist— and he more than others—needs an idiom to work in. Only tradition, such as he finds it, can provide him with the raw material of imagery which he needs to represent an event or a 'fragment of nature'. He can re-fashion this imagery, adapt it to its task, assimilate it to his needs and change it beyond recognition, but he can no more represent what is in front of his eyes without a pre-existing stock of acquired images than he can paint it without the pre-existing set of colours which he must have on his palette.

Seen in this light the importance of imagery for the study of art becomes increasingly apparent. In tracing the motifs, methods, and symbols of these modest productions we not only study the pale reflections of creative art, but the nature of the language without which artistic creation would be impossible.[60]

This passage is an admirable example of the way in which iconography can enhance understanding of an artist's approach to his art and his ideas. Some points Gombrich raises hypothetically can be substantiated—Goya's visit to Saragossa in 1808, for instance, is referred to in the proceedings of the Royal Academy of San Fernando,[61] and attested by Lady Holland's journal which alludes to war drawings by Goya in General Palafox's rooms in Saragossa.[62] More recent attempts have been made to relate Goya's war art to that of other contemporaries, and Goya's *The Third of May* has, for example, been contrasted with a print of the same subject by González Velázquez.[63] The firing squad group and the victim with outstretched arms occurred in González Velázquez almost certainly before Goya made his painting. The serried rank of the firing squad is almost a cliché, of course, and appears already in the seventeenth-century engravings of *Les Misères de la Guerre* by Callot. But the difference between Goya and González Velázquez is as great as that between Goya and Porter. In González Velázquez's print, the execution is only one incident among many. French soldiers strip the bodies of the dead on the left, beat a man on the ground with a rifle butt, lead off Spaniards to be shot, as well as carry out the execution itself in the background. Consequently the central event is lost in a welter of anecdote. For González Velázquez, in fact, the whole point was the variety of circumstances depicted. Each episode was numbered (as were also the buildings in the background) and a key was provided. The object was to create artistic journalism or a historical document. Goya, by contrast, is far

less concerned with precise historical detail and real buildings in the distance. He realized that the single detail of the execution is more than adequate when the aim is to reflect with emotion on human suffering or terrifying experience.

War prints and the Bandit Maragato story are not the only cases of contacts between Goya and popular forms of art. Links have been found between some of Goya's *Caprichos* and popular prints, and it has been suggested that the mysterious lighting and atmosphere of Goya's *Disparates* may have their roots in the Phantasmagoria shows held in Madrid.[64] But iconographical studies generally focus on the artist's subject and approach rather than his materials, and it is time to turn to these.

So far as the technique of the etchings is concerned, Goya's ability to use aquatint to particularly good effect was well recognized in the nineteenth century. Charles Blanc wrote a powerful eulogy of the expressive force of Goya's etchings in his *Grammaire des Arts du Dessin* (1867):

> What is normally just an engraving process becomes a means of expression for Goya. In his *Disasters of War* and *Caprices*, aquatint contributes a great deal to the shape and character of things. Here it casts a veil over a portion of a print and adds mordant to the satire by allowing the spectator to imagine even more serious sources of moral corruption. There it spreads dank shadows over the tragic spectacle of invasion and emphasizes the horror of the scene by adding an element of mystery. While some etched figures stand out starkly against the brilliant whiteness of the paper, others are only dimly seen—hidden by a sinister half-tint. Goya's engravings make such a deep impression in that case that one might think that his proofs were not covered with aquatint at all, but blood.[65]

In this instance, Blanc was embroidering one of Gautier's old themes, and a more precise appraisal of the richness of Goya's technique had to wait until more recent times. His tonal variety, the subtlety of which has been noted by Picasso,[66] was achieved by processes described in a range of catalogues of Goya's etchings and lithographs, none so brilliant, however, as the most recent: Tomás Harris's *Goya. Engravings and Lithographs* (1964).

Tomás Harris, like William Rothenstein at the turn of the century, was an artist himself, as well as a critic and scholar. He brought much specialized knowledge to the description of Goya's prints, and in a number of cases attempted to reproduce Goya's etchings for himself, in order to work out experimentally how Goya had achieved certain effects. His description of Goya's working methods is masterly:

> Goya worked on his least complex engravings in the following way. The copper plate was first etched and, on removal from the acid bath, one or more proofs were taken from the freshly bitten plate. These working proofs were sometimes retouched by Goya with pen, pencil or charcoal to guide him in the additions he intended to make to the plate. For small corrections and additions and to give greater contrast to certain passages he would normally use the drypoint and burin. Having completed his drawing on copper, Goya then applied the comparatively new technique of aquatint, just as he would apply wash to

the preparatory drawings. The aquatinting was sometimes burnished to produce highlights and halftones, and this brought the working stages to an end.

By means of aquatint, Goya achieved unparalleled effects which are sometimes similar to the most delicately handled water-colour washes and at other times seem almost to have the relief of impasto in oil paint. Goya was the first Spaniard to master this technique which he first used in 1778 in the engravings of the 'Infante Don Fernando', 'Barbarroxa', 'Las Meninas', 'Don Juan' and 'Ochoa' after paintings by Velázquez. His few engravings in pure aquatint, Plates 32 and 39 of the *Caprichos* and the unique proof of a 'Woman in prison' in the Biblioteca Nacional, Madrid, are unsurpassed masterpieces in this medium. Generally speaking, artists do not take proofs of aquatint plates before the process of biting is complete, since this involves removing the resin ground; but in certain cases Goya did do so and then regrained and re-bit the plate in order to darken certain areas [cf. *Caprichos*, Plate 1]. Proofs of some of the *Caprichos* show that in some plates of mixed technique, Goya took proofs before and in the course of burnishing the aquatint, e.g. Plates 12, 13, 17, 56 and 74.

Goya seems also to have been one of the first major artists to use the technique of lavis [a process whereby the unprotected copper-plate is corroded by acid so that the disturbed surface will hold ink and print as a wash] which appears in some of his engravings in the *Desastres* series, and the extraordinary inventiveness of his engraving methods in this series suggests that he may well have discovered the technique for himself. Certainly, he made use of lavis in every possible way, sometimes even combining it with aquatint.

Goya's method of working was never very systematic and he used his engraving technique with the greatest possible freedom in order to obtain the effects he was seeking. He would generally etch, aquatint and burnish his plate in a perfectly normal way, retouching with the drypoint or burin at any stage; but there is evidence to suggest that in some of the *Desastres* engravings Goya may have adopted the completely unorthodox method of spraying the entire plate with aquatint and biting it, then etching the design and finally burnishing out the halftones and highlights ... Goya used the scraper and burnisher with extraordinary facility, even removing large areas of aquatint from a plate so completely that its original existence is only known from a proof taken in the course of work, e.g. Plate 31 of the *Caprichos*. Similarly, with reference to Goya's use of aquatint, it is often misleading to count the number of tones in order to find the number of times he stopped out and re-bit the plate, because of the fact that he sometimes regrained with another aquatint after having taken a proof of the first. An interesting case is Plate 1 of the *Caprichos* where the proof in the Biblioteca Nacional, Madrid, shows a medium grain aquatint evenly bitten over most of the area which is aquatinted in the final state. Goya must have decided that the aquatint was too weak and he superimposed another grain which covered the highlights which had been left on the inner edges of the lapels, and spread over the outline of the chin. The second aquatint was lightly bitten and hardly succeeded in darkening the tone of the original. In the biting of the second grain

the minute islands of the originally protected surface of the plate were bitten away so that the grain is less well defined and prints without specks in the final state; moreover, it was flattened in the second biting and became less resistant to wear. . . . Another instance which shows how misleading it is to draw conclusions from the finished state alone is Plate 11 of the *Caprichos* where the aquatint is in two tones, pale in the foreground and darker in the sky. One would normally assume that the darker tone was made by re-biting the original grain, but the working proof in the Prouté collection, Paris, shows that the dark tone was the first to be bitten and that after taking the proof Goya regrained the plate and bit it to produce the light tone over the figures and foreground. . . . To examine proofs and final impression together is like being in the artist's studio while he is at work on the creation of a masterpiece. In Goya's case extremely few working proofs have survived although it is inevitable that in all cases where he used various techniques on the same plate, he must have taken proofs in the course of work. From the number of plates which are known only from one or two working proofs it would appear that Goya was inclined to be impatient in his handling of the acid bath and lost some of his finest plates in an endeavour to improve them in a further biting.[67]

Harris's analysis of Goya's methods in individual plates constantly illuminates his creative process. There are occasional instances where Harris's conclusions are doubtful, and it seems unlikely that Goya discovered *lavis* for himself, since his great friend Ceán Bermúdez describes it in some detail in the catalogue he made of his collection of etchings.[68] But Harris's study brings out in an entirely convincing way Goya's tireless interest in new techniques, his anxiety to get exactly the effect he wanted, and his inevitable impatience. The omissions and errors of earlier descriptions of the various states of Goya's engravings are highlighted by Harris's careful work. Goya himself emerges from the book as an intensely original engraver and an energetic experimenter; by no means an artist who was satisfied with a hasty or rough-and-ready effect. The English painter Walter Sickert, while appreciating Goya's technical mastery, attributed some of his success to fortuity. He described No. 32 of the *Caprichos* as 'a meeting point of supreme passion, supreme skill and supreme luck, the sort of conjecture that happens once in a century'.[69] Harris, on the other hand, suggests that luck and conjecture played an insignificant part in Goya's art of engraving.

Concerning Goya's practice and technique as a painter, much has been done since the nineteenth century to modify the sponge-and-rag image beloved of the Romantics. A case where the argument turned literally on Goya's possible use of sponges is that of the frescoes in San Antonio de la Florida (Plate 40). In this instance, the matter was cleared up by José López-Rey, whose conclusions were subsequently confirmed by Ramón Stolz.[70] Goya's son had described the paintings as frescoes; Araujo as paintings in tempera; and Beruete had thought their technique a mixture, and basically original. Beruete held that much of the background painting had been executed with sponges, and supported his argument by reference to the bills

for artist's materials submitted by Don Manuel Ezquerra y Trápaga to Goya in June, July, August and October 1798. The bill for 30 July certainly contained $1\frac{3}{4}$ lbs of 'fine washed sponges'. But López-Rey showed that the bills more probably indicated that Goya was following the advice on fresco painting given in Antonio Palomino's *Practice of Painting* (*Práctica de la Pintura*, Madrid, 1715–24).[71] Goya definitely knew the book since he had depicted it lying decoratively on the floor along a diagonal in his portrait of the Conde de Floridablanca. Palomino mentioned that sponges were useful for cleaning purposes, and no doubt that was why Goya wanted them. For López-Rey this did not mean that the frescoes were purely conventional; merely, that their originality did not lie in the technique with which the paint was actually applied. Subsequently, Ramón Stolz, a fresco artist himself, and the man responsible for restoring Goya's work in Saragossa and Madrid, emphasized the brilliance with which Goya used the traditional methods. He also showed how Goya drew on his intuition as well as his knowledge of art in San Antonio de la Florida, often modifying the broad compositional lines he had roughly marked in the wet plaster when he actually applied the paint. Recently, Pierre Gassier and Juliet Wilson have founded on both López-Rey and Stolz their claim that Goya 'upset all the iconographic traditions and stylistic rules regarded as essential to this kind of religious painting' in the San Antonio de la Florida frescoes. He reversed the normal arrangement of the worlds of men and angels—placing men *above* the angels—and worked without the detailed sketches which other artists transferred section by section.[72]

Although Beruete was clearly wrong in his theory about these frescoes, many of his detailed comments about Goya's method of painting are still worth reading. His description of Goya's technique in the tapestry cartoons is particularly informative.

The canvas Goya used at this period is usually a cloth of not very thick weave but with rather pronounced grain. Exceptionally he used tablecloth. In some of his canvases the stitching he had to do is obvious; it was difficult at the time to buy cloth of the right size for large pictures. The preparation of the canvas, once it was mounted on the stretcher, started with a coat of thin glue, to bind the web of the material together and conceal the weft. Then a coat of coloured tempera was applied, and finally, a last coat of fairly thick oil paint on top of this base, to cover the grain of the cloth entirely and leave a completely smooth surface.

The colour Goya used was the same for both the first layer of tempera and the last of oil: red clay, the colour called 'Seville earth', mixed with white, giving a brick-coloured tone, or baked red clay, with no other colours in it at all, and no tinge of vermilion or carmine. It can be seen that the colour of this base grew lighter as time passed. In the earliest cartoons—the *Dance in San Antonio de la Florida*, for example, which was painted in 1777—the base consists almost entirely of Seville earth, with a warm red tone. Subsequently he added more and more white to it lightening it considerably, so that in *Blind Man's Buff*, for instance, which is one of the late cartoons, painted in 1791, the tone is cold pink, and a

fairly pale colour, although the materials used remain basically the same [. . .]

Let us take *Blind Man's Buff* as a subject of special study from the point of view of the artist's technique. One immediately notices that the painter has used the background colour a good deal in a number of passages. To explain. The colour of the background, which is not strong and in a way neutral, is used by the artist as a background colour (I cannot find a better way of saying it) for a variety of other colours in several parts of the canvas. Goya often only covers it with very thin veils of paint. If we look at the skirt of the *maja* facing us on the extreme left, we find that there are only very light touches of colour on top of the base. The colour of the priming remains the same of course, but it takes on different nuances as a result of the colours veiling it. In the part on the right, where the process can be followed most clearly, a pale grey tone predominates, with decorations of cobalt blue on top, harmonizing and fusing completely with the background tone. This subtle yet simple effect was no doubt achieved in a matter of minutes. There are only three elements in it: the background, which is there from the start; the grey tint, and the touches of cobalt. Yet the impression given is one of high finish. Such rapidity of execution could only succeed because the background colour was used. The same observation applies to the skirt of the other *maja*, the one with her back to us in the centre of the picture. Her skirt is composed simply of two tints and two colours: pure white and a grey, which is produced by adding a very little black to the same white. The light transparent effects of the skirt, particularly in the parts which fly in the air, are achieved entirely with the background colour.[73]

Beruete goes on to show how this use of background colour is also responsible for a sense of great harmony in the canvas as a whole. But he produced no systematic study of Goya's use of colour, and this had to wait until Jutta Held wrote her book on the topic in 1964.[74]

These, like other analyses of Goya, frequently return to the old subject of Goya's originality, and they have helped to define more precisely the extent and nature of his artistic independence. Much remains to be done, particularly on the artist's compositional organization. In that field there has been all too little since the stimulating essay by Oskar Hagen in 1936 (reworked in 1943) which pointed out traditional Spanish arrangements in his work, and noted his willingness to allow his patterns to be conditioned by particular moods in an original way.[75] On the other hand there has been a spate of recent and valuable work on the drawings. Pierre Gassier and Juliet Wilson, in their book on Goya, show very clearly how he came to consider drawings as pictures in their own right, and developed their expressive quality.[76] Other artists had certainly treated drawings as independent works of art and found a ready market for them in the eighteenth century. Goya, however, gave them titles or ironic captions, and grouped them together in albums in meaningful sequences. In this manner he was an innovator in the art of drawing as well as in the arts of painting and engraving.

But with Goya's originality it is almost inevitable that we enter the realm of hypothesis and leave the neater groves of Academe.

XI. Epilogue

THIS book has been primarily concerned with the reactions of critics to Goya. The response of artists and writers in their own creative work is a separate but related subject. Just as generations of critics sometimes share a view of Goya, or stress a particular aspect of his work, so do groups of artists. The favourable response of Romantic and Realist artists—which José Llovera synthesized in a painting entitled *Goya and His Times* (Plate 55)—has been mentioned earlier; also the way in which Impressionists were excited by Goya's colour and brushwork, his commitment to movement and everyday things, occasionally his compositional structures. At the end of the nineteenth century, Rops, Ensor, Munch and other delineators of the morbid and the macabre acknowledged Goya as their progenitor. And in our own times the etchings and paintings which were held to have Expressionist and Surrealist qualities have proved an inspiration to Expressionist or Surrealist artists. In the 1940s Goyesque notes were found in Oskar Kokoschka; in Denmark, in 1959, Richard Mortensen drew twenty variants on the two central figures in No. 46 of the *Disasters of War* ('Esto es malo'); and ten years later, Antonio Saura, the Spanish painter, exhibited a series of imaginary portraits of Goya, based on the Black Painting in which a dog gazes up at empty space or sinks into sand (Plate 56).[1] In Surrealist vein, in 1948, Pierre Roy worked Goya's themes into a painting called *Hommage à Goya*, now in the Musée Goya at Castres. One or two of Goya's paintings have fascinated generation after generation of artists, as seems to have been the case of the two versions of *Majas on a Balcony*. Often, of course, different works have stimulated different painters. The *Caprichos* worked their spell on Forain in the early years of the century; Modigliani and Matisse were inspired, on more than one occasion, by the *Naked Maja*. In 1940, in France, Bernard Lorjou produced a violent variation of Goya's *Love Letter* in the Lille Museum; and in 1950, George Grosz's appreciation of the depths of Goya's satires could be seen when he expressed the hope that his own works would be regarded, like Goya's, not as annotations of the class struggle, but as 'eternally living documents of human stupidity and brutality'.[2]

Novelists, poets, dramatists and musicians, even stage designers and film directors, have been drawn to Goya's art or to his life.[3] Some of their views, notably those of Baudelaire, Wyndham Lewis and Aldous Huxley seem a natural part of Goya criticism. The occasional references of others, like Verlaine, Claudel, Unamuno, Karel Čapek, Louis MacNeice and Hemingway, either reflect the particular sym-

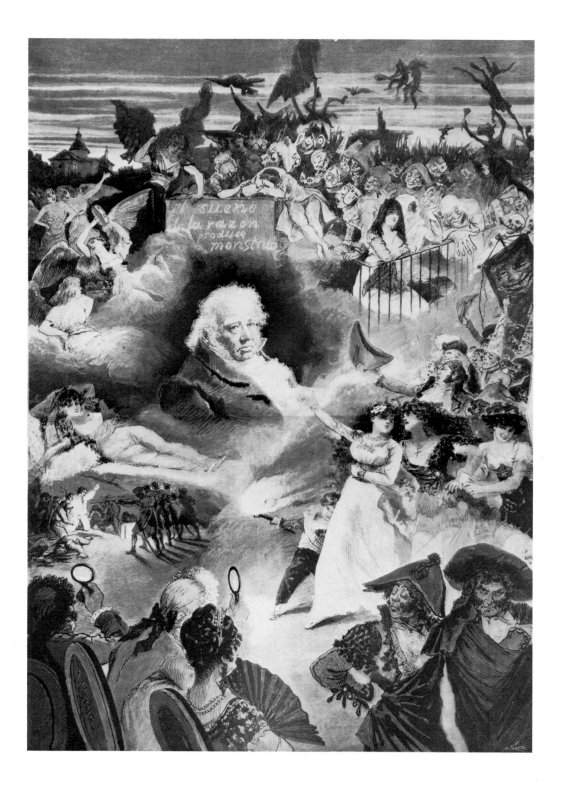

55. José Llovera: *Goya and His Times*, 1885. Reproduced in *La Ilustración Española y Americana*, 1885, I, 288–9. British Library, Colindale.

56. Antonio Saura: *Imaginary Portrait of Goya*, 1969. Paris, Galerie Stadler.

pathies and antipathies of these writers, or express attitudes to Goya that were common in their times. The present chapter surveys briefly Goya's fortune in the arts which were not his own.

Novels which mention Goya *en passant* from Balzac onwards are legion. Another day's journey perhaps for some other traveller. Only those which use his work or life in a more fundamental way are worth a mention here. Apart from Victor Hugo's *Hunchback of Notre-Dame* (1830), which he described as a Caprice because of its Goya-like use of the grotesque, the earliest known Goya fiction dates from the post-Romantic period. The Goya episodes of Antonio Trueba and Ildefonso Bermejo have already been discussed. They date from the 1870s and 80s. The same decades saw a Goya fancy from the fertile quill of the Spanish historical novelist Manuel Fernández y González. His immensely successful tales tended to be set in distant times which he found 'more romantic, primitive and beautiful' than his own. Not for him the historical novel that found the roots of modern social and political problems in the past. In the case of Goya, he exploited the bull-fighting myths and made the artist the protagonist of one of a series of vignettes in *Las Glorias del toreo* (*The Glories of Bull-fighting*, 1879).[4] Fernández y González makes Goya prepare for his Italian journey by disguising himself as a *matador*, and sends him to Andalusia with the famous Pedro Romero to kill bulls in the ring at Seville. Perhaps this kind of extravaganza seemed less far-fetched at a time when many believed that Goya had proved his passion for bull-fighting by painting the walls of a bull-ring: a work in the brick, so to speak, rather than on panel or canvas.[5]

A few twentieth-century novels in Spain used Romantic Goya material on a secondary level. Blasco Ibáñez, with his Decadent celebration of the *Naked Maja*, pointed the way, and in 1908 Blanca de los Ríos' *Madrid Goyesco* underlined the Spanish extremes of passion and exaltation in her characters by reference to Goya. In France at the same period Marguerite Hein wrote fictional sketches based on a large number of *Caprichos*, interpreting them freely and personally as it seemed to her natural to do.[6] After this the emphasis shifted from Goya's work back to the man himself.

The first twentieth-century novel in English to make Goya the protagonist was the American Marion Chapman's *The Loves of Goya* (London, 1937). Chapman made the painterly activity of the protagonist subsidiary to the 'amours and brawls and dark adventures' of this 'hot-headed idealist and cold-headed revolutionary'. For Chapman, the artist was 'a Dionysian—who dynamited his way through the raw indelicacies of the eighteenth century' in the pugnacious prose of the foreword. 'Where stabbing and scuffling and dancing was,' wrote Chapman, 'there was Goya!'

The stabbing and scuffling and dancing continued in two novels written at the time of the bicentenary of Goya's birth in 1946.[7] First came Max White's *In the Blazing Light* (1946), which added some dark tones to the canvas: a few fits of the 'horrors' from Goya and the *Disasters of War* as the concluding episode. Next there was *Saturn's Child* by Eric Porter (1947). Although Porter provided a good deal of genuine detail about Goya's art, fictitious aspects of his life and amours still

dominated the novel. Mentions of bull-fighting and fisticuffs occur in Chapter I;
the first intercourse takes place in Chapter 2 (Marion Chapman had been quicker on
the draw); and Goya's wife falls spectacularly to her death through a broken bannister
rail on the last page. Some of the episodes suggest that the novel was written with
film rights in mind. Almost inevitably there is love-making with the Duchess of
Alba, and by a nice touch of unconsciously transvestite humour, Porter changes the
name of the painter Asensi Juliá to Julia Asensi, making him Goya's *female* assistant
for the frescoes in San Antonio de la Florida.

The most recent Goya novel is just as Romantic and equally inaccurate: Stephen
Marlowe's *Colossus* (1972). Goya's life is given modishly in a series of untranquil
recollections, which pass through the artist's mind on his way to fight a duel with
Godoy in Paris in the 1820s. Despite the cinematic narrative form, the descriptions
of Goya's early technique are pure nineteenth-century: full of 'trowelling colour',
sponges and rags, from Gautier. Marlowe's Goya is also the familiar blend of Great
Lover (of bulls as well as women) and Great Sceptic. The possible number of Goya's
illegitimate children rises in consequence, and the Duchess of Alba affair is balanced
by an early high-life conquest of Marlowe's own invention. There is a basic Heming-
way message about the need for *cojones* in politics, life in general, and art as well as
bed.

Lion Feuchtwanger's earlier novel about Goya cannot be taken so lightly. First
published in German in 1951 (*Goya*), the English translation appeared in 1952, with
the title *This is the hour*. The book has a similar pattern to Feuchtwanger's master-
piece *Jew Süss* (Munich, 1925), examining the corruption and ultimate collapse of
an exploitational social system against the background of eighteenth-century history,
religious and racial prejudice. Just as Jew Süss himself is annexed to the establishment,
yet conscious of its decadence and inhumanity, so is Goya. The novel follows the
artist's life over a relatively short period of time, and focuses attention on the
1790s and early 1800s (immediately after the French Revolution). It shows Goya's
development from a time-pleasing portrait painter to a fearless witness to truth
and critic of his society. In the early stages of the novel there is a tension between
Goya's revolt against classicism (which he realizes is not adequate to express 'the bad,
the dangerous, the supernatural [and] that which lurks behind')[8] and his involvement
with the Spanish royal family and the favourite Godoy. Already, however, he is a
friend of those who protest against the establishment: notably Jovellanos who
urges him to be 'fired with indignation at the Court and its corruption'.[9] In the
small scenes of an Inquisition trial, a mad-house, and *The Burial of the Sardine*, he
finally faces and challenges the reality of Spanish society in Feuchtwanger's terms.
Other reflections of his new-found directness and sincerity are the *Naked Maja*, the
etching of a garroted man, and the series of paintings about the capture of the
Bandit Maragato. Feuchtwanger takes the first of these paintings—the *Maja*—
to be a portrait of the Duchess of Alba, following a nineteenth-century legend, and
this supports the view that it is a piece of social realism. In these paintings Feucht-
wanger makes Goya express his identity with the ordinary Spanish people. They,
in their turn, enthuse over his frescoes in San Antonio de la Florida. Goya is said to

have a 'realistic peasant intelligence' in this novel.[10] The *Royal Family Portrait* is naturally a series of caricatures, and the *Caprichos* are a confrontation with the false religious and social values of the artist's country.

Feuchtwanger's novel, in fact, places a decidedly Marxist slant on Goya's art, seeing it as a product of its time and its society, and exalting its social realism. There are some anachronisms and distortions of historical fact, and most of the poetic tailpieces to chapters, which focus on the stage reached in Goya's development, are disappointing. The richness of characterization of *Jew Süss* is missing too. Yet the novel presents a more interesting and intelligent view of Goya in relation to his time and his environment than most other novels and plays based on the artist.

<div align="center">★ ★ ★</div>

The earliest play about Goya was as Romantic in its approach to the artist as in its conception of drama. It was written in verse in the first decade of the century by the Spanish poet Francisco Villaespesa and called *La Maja de Goya* (Goya's maja). Set in the year of the rising against the French invasion in 1808, the play begins in the meadow of San Isidro. It is full of sentimental patriotism and was wittily attacked by the novelist Ramón Pérez de Ayala in jingly verse parodying the original.[11] *Majas* and bull-fighters dance *flamenco* and thrum guitars, a little virile aggression takes place, and a beautiful gipsy (the *Maja* herself) comes on the scene to be accosted first by Pedro Romero in search of a mistress, and then by Goya in search of a model. The second act begins in the *maja*'s house; later, bombs burst and guns fire outside. Scenes from the rising are acted out: the *maja* contrives to fire a cannon, and appears to drop dead during the shootings of the Third of May. She is only wounded, however, and Goya finally carries her off to finish his portrait of her as The Naked or Clothed Maja. At the last stroke of the brush, she dies.

A contrast to Villaespesa in attitudes to Goya, from much the same period, can be found in Alfred Noyes' First World War play, *Rada. A Belgian Christmas Eve* (London, 1915). Noyes' Goya is the critic of human behaviour, the biting satirist, rather than the amorous patriot. The play, which is set in German-occupied Belgium, opposes two views of man: a materialist interpretation, identified with Nietzsche, Schopenhauer and the Germans; and an idealist interpretation, identified with Christian beliefs, the Belgians and the British. Goya is used to flesh out the picture of the destructive and brutalizing force of war. Four of the *Disasters* illustrate the printed text of the play, and Goya's ideas and images are woven into certain key passages. Some of the Goya references relate to anti-clericalism and scepticism, priests 'balancing themselves on the tightrope over the jaws of the crowd', for instance, echoing *Disasters* No. 77 ('Que se rompe la cuerda!').[12] But the majority echo the monstrous nature of war itself. One of the characters conjures up *Disasters* No. 72 ('Las resultas', printed opposite p. 56) when he criticizes the German soldiers for allowing themselves to be duped into believing that war is beneficial,

> that this black vampire, sucking at our breasts, is good.[13]

Subsequently the text carries reminiscences of Goya's hanged men (*Disasters* No. 36,

'Tampoco'), the symbolic 'Farándula de charlatanes' (*Disasters* No. 75) and the plates that depict piles of corpses (*Disasters* Nos. 22 and 23):

> They've burned the little cottage,
> There's a man
> Hanging above the bonfire by his hands,
> And heaps of dead all round him.
> Come and see!
> It's terrible, but it's magnificent,
> Like one of Goya's pictures. That's the way
> *He* painted war.[14]

Having borrowed some of Goya's more shocking visions of destruction and betrayal, Noyes goes on to hope that Truth will return and Justice be re-established in the wake of the war. His attitudes to these topics seem close to Nos. 79 and 80 of the *Disasters of War* ('Murió la verdad' and 'Si resucitará?'), where Justice with her scales weeps at the burial of Truth. Noyes religious convictions perhaps lead him to a more optimistic and less questioning view than Goya's:

> Peace? We steel us to the end.
> Hope betrayed us long ago.
> Duty binds both foe and friend.
> It is ours to break the foe.
> Then, O God! that we might break
> This red Moloch for Thy sake;
> Know that Truth indeed prevails,
> And that Justice holds the scales.
> Father, hear,
> Both for foe and friend, our prayer.[15]

Despite the sentimentality of some of the attitudes in the play, Noyes has certainly appreciated the intensity of Goya's indictment of the horrors of war, and his recognition that war makes all men equally barbarous. Noyes also sensed the power of the enigmatic and symbolic plates of the series, although he uses one of the more literal ones—No. 26 ('No se puede mirar') as his frontispiece. This plate, indeed, which shows a group of civilians mown down by an invisible execution squad, supplies the basic tragic subject of the play.

In Goyesque drama since Noyes, the dark and the light have alternated. In the centenary year, 1928, Goya was the protagonist in a cheerful piece by Modesto Alonso entitled *Goya returns* (*Goya que vuelve*). At the same time, however, Ramón del Valle-Inclán felt inclined to write a play in his grotesque style (an *esperpento*) as a homage to the artist. Valle-Inclán valued the emotional quality of Goya's distortion and learnt much from it, even if most Spanish dramatists simply turned to Goya for picturesque subject matter at the period. Goya was a character in Fernando Delgado's *The Maja in the Cape* (*La Maja del capote*) in 1944; he also figured in two plays about eighteenth-century Spanish actresses: Antonio Ruiz

Castillo's *María Antonia la Caramba* (1951) and Juan de Orduña's *La Tirana* (1958). Recently there was a comedy called *Goya* by Soler Fando, first performed in the Ateneo at Valencia in 1970.

Two Spanish plays relating to Goya written in the last twenty years deserve more detailed comment. The earlier of the two was by Lorca's friend Rafael Alberti, who has also used Goya material in his poetry as we shall see. In his *Noche de guerra en el Museo del Prado* (1956, 'Night in the Prado Museum in wartime'), Alberti drew on Goya's etchings for Peninsular war atmosphere and points of social criticism. The whole play is an 'etching' in Alberti's terms and draws parallels between the Civil War situation of 1936 and the popular uprising of 1808 which was followed by the Peninsular War. Most of the characters step down from the paintings in the past to show different reactions to war and social injustice, but the basic setting is November 1936. The Goya references are central: Godoy is called the *Generalísimo* (i.e. as if he were Franco), and the corrupt rulers of Goya's times are paralleled with those who sought power in the uprising of 1936. Alberti uses certain Goya paintings as back projections—*The Third of May 1808*, *The Meadow of San Isidro*, a drawing from the *Tauromaquia* series, three Black Paintings, several *Disasters*, *Godoy*, and the Bordeaux period drawing with the caption 'Little Donkey walking on two legs'. He also refers to *The Burial of the Sardine* and weaves the epigraphs of the *Disasters* into the dialogue. Sixteen *Disasters* are referred to in this way by my count: Nos. 4, 5, 13, 14, 16, 18, 26, 28 (twice), 37, 38, 39, 44, 55, 60 (?), 61, 65, and 76.

Back-projections are also used extensively in the Goya play by the leading Spanish dramatist Antonio Buero Vallejo, *El sueño de la razón* (1970). The play is set during the persecution of the liberals which followed the end of the Peninsular War, and Goya is shown as an old man, tended by his doctor, Arrieta, and his mistress, Leocadia Weiss. The artist's view of existence and his obsessive dreams are at the heart of the work: filled with images of despair, surrounded by threatening voices and the worries of waning powers, yet facing life with stoicism rather than fear. Like other protagonists of Buero's plays, Goya is not only a person who attacks hypocrisy wherever he finds it, but a man who refuses to compromise. A constant preoccupation of Buero's is the need to face the truth however bitter, and there is a Christ-like quality in some of the characters in his plays who suffer as a result of their honesty. Goya cannot easily accept the idea that he should run away from danger and escape to France with Doña Leocadia:

> But why the hell should I go? This is my house, and this is my country! Of course I have never been back to the Royal Palace [since the war], and Nosey doesn't like my portraits of him . . . What's the news from Madrid? No, don't bother to tell me. Persecution. Police informers and accusations . . . Spain. It isn't easy to paint. But I shall go on painting! Have you noticed the walls? [Goya refers to the Black Paintings] Terror? No. Sadness perhaps.[16]

Buero places Goya clearly in an undemocratic society, and his situation is exacerbated by the eternal problems of age, frustrated sexual desire, human brutality, incomprehension and persecution. There are naturally oblique references to present-

day Spain in this as in other historical dramas by Buero. Yet the problems he makes
Goya face are universal ones, and his view is consistent with current biographical
interpretations of the artist, even though he makes some conscious or unconscious
anachronisms, assuming, for instance, that Martín Zapater, the friend of Goya's
youth and middle years, was still alive after the Peninsular War.

<p style="text-align:center">★ ★ ★</p>

The same range of attitudes to Goya that we find in novels and plays occurs in
films. The first projected Goya film dates back to the Goya centenary in 1928. It
was to have been made by Luis Buñuel, who later drafted a scenario entitled *Goya
and the Duchess of Alba* in his Hollywood period (1944–6). Buñuel tried to sell the
idea to Paramount, failed, and only his rough script survives.[17] The relationship
between Goya and the Duchess never seems to lose its appeal, but Buñuel, as one
might expect, makes it painful as well as passionate. The difference of their social
class creates tensions; both are too proud to capitulate easily or to suffer the pangs of
jealousy gladly. The plot is a typical Buñuel compound of violence and love
(involving María Luisa also), set against a background of corrupt and tyrannical
court life. Goya and the Duchess are victims of their society and of themselves,
though they have the courage to struggle against the conventions that surround
them. The ironies of life are bitterly emphasized. Love leads to Goya's deafness
(because he tries to mend the broken wheel of the Duchess' coach in adverse weather
conditions). And the Duchess only realizes the full strength of her love for Goya
when she is dying.

Buñuel's personal involvement with his subject—sharing with Goya an Aragonese
background, deafness and belief in the freedom of the artist—make it a matter for
regret that the film was never made. There are occasional references to Goya in
some of Buñuel's films, and his recent *Phantom of Liberté* (1975) uses the fearful
image of *The Third of May 1808* on more than one occasion. The unfeeling rank
of the firing squad in Goya's painting seems entirely relevant to Buñuel's attack
on meaningless order and hollow convention.

Since Buñuel's frustrated attempt, four films at least have been based on Goya's
life. In 1958, Henry Koster made *The Naked Maja* about the inevitable relationship
with the Duchess of Alba (Plate 57). It was a costume spectacular with Italian and
American stars. Anthony Franciosa played Goya and Ava Gardner the Duchess;
one verdict was 'elaborately mounted but intrinsically dull'.[18] Two 1970 films
had higher pretensions. One of them was the work of the Spanish novelist and
director Nino Quevedo. The other was made by Konrad Wolf, with East German
and Russian backing.

Nino Quevedo certainly hoped for a commercial success, and the various
women in Goya's life were given due prominence: Josefa Bayeu, the Duchess of
Alba, the *Maja* and Leocadia Weiss. But the central interest of the director was the
artistic personality of Goya, and, in the Expressionist tradition, his art is shown to
express his anxieties and aspirations: his emotional life. A significant feature of the
film (which is shot in colour), is a series of Goya 'nightmares' made in a negative
process which produces black and white contrasts reminiscent of etchings. These

57. Still from *The Naked Maja*, film by Henry Koster, 1958.

dream sequences are based on the *Caprichos* and *Disparates*, the two series of etchings which psychologists and psychiatrists have used most frequently for their analyses. Quevedo tries to integrate the moments of visual and intellectual interest in the film. The scene in which the Duchess of Alba visits Goya in the church of San Antonio de la Florida is not simply an exercise in titillation. 'In this scene and others shot in San Antonio, Goya expresses key ideas which explain his aims as a painter. He speaks of the mission of art, his conception of painting, of the new lines and colours which reflect the inspiration of his turbulent spirit'.[19] The film is more open-minded about Goya than many interpretations (Plate 58). It was well researched and presents the contradictions and conflicting views which his life and art manifest. As the introduction to the film put it: 'There is a different Goya for every view-point. A bourgeois Goya, and a Goya who was a revolutionary; a man of the people, and an Enlightened friend of the men of the Enlightenment; a religious person, yet anticlerical; a Spanish patriot, yet one who was suspected of supporting the French; mean and noble; clumsy, yet a genius.'[20]

The second film about Goya made by a Russo-German team in 1970, was more committed to the artist's revolutionary side. The script-writer Vagenshtein based

58. Still from *Goya,* film by Nino Quevedo, 1970.

his scenario on Lion Feuchtwanger's novel, and explained his conception of the film in the following terms:

> One reason for making a film about Goya is very obvious. In the whole of modern European history it is hard to find anyone who exemplifies more powerfully the eternal problem of the artist and society. The career and personality of Goya reflect many of the problems of our own times. Goya, both in Feuchtwanger's novel and our filmscript, is a man of his times, who is fully representative of his own country. But he is absorbed by the challenges which preoccupied his contemporaries in the early nineteenth century, and which continue to concern us today: war and peace; people and power; the mission of art and the status of the artist; the rights of the citizen; and man's search for happiness . . .[21]

Despite the political undertones of Vagenshtein's own comments, the film does not neglect visual sources of inspiration, nor the artist's technique (Plate 59). More than a hundred reproductions of Goya's paintings, etchings and drawings were used, and the film ends with a 'kind of apotheosis', a collage of shots designed to make 'an organic synthesis of the works of Goya, embodying the sufferings of the people in a single, final document'.

The most recent Goya film returns to the Expressionist position. It was produced in 1975 by the Spanish director Rafael J. Salvia and based on an epic poem in three

59. Donatas Banionis as Goya in the film by Stefan Wolf, 1970.

acts by the art critic and writer José Camón Aznar. The film moves from Goya's early optimism, reflected in the tapestries, to the pessimism of the Black Paintings and the *Disparates*, via the dramatic interpretation of the Peninsular War.[22]

<p align="center">★ ★ ★</p>

Musicians have naturally shown a less explicit interest in Goya than writers, dramatists and film producers. A Spanish operetta about the artist called *The Prince of Madrid* (*El Príncipe de Madrid*) was composed by Francis López in 1968. Rather earlier, in 1934, Rodríguez Hernández wrote music for an intermezzo based on Goya's *The Swing*. But the only Goya work of note in musical terms is Enrique Granados's brilliant suite for piano entitled *Goyescas*, supposedly inspired by the artist's paintings and tapestry cartoons. The work had as a sub-title *Los majos enamorados* (*Majos in love*), and the first four pieces—'Los requiebros', 'Coloquio en la reja', 'El fandango de candil' and 'Quejas o la maja y el ruiseñor'—were printed in 1912. A second part followed in 1914 consisting of two more pieces: 'El amor y la muerte' and an Epilogue titled 'Serenata del espectro'. The existence of a story-line or 'programme' behind the music seems fairly clear. The pieces progress from a lover's advances and courting to a dance after which the *maja* is apparently abandoned. In the second part the *majo* dies (killed by a jealous love of the *maja* perhaps), and his ghost continues to serenade the girl in the epilogue. Little of this can be linked in a positive way with Goya, although *majos* courting and fighting

and *majas* in love occur in the tapestry cartoons and drawings, while in the *Caprichos* there is one plate—No. 10—whose title coincides with No. 5 of Granados's *Goyescas*. The Romantic view of the artist as painter of the ordinary people and their passions is present, and it is significant that Granados's only other Goya piece outside the *Goyescas* is called 'The *Maja* of Goya'. But the style of the *Goyescas* is that of all Granados's music: rich in colour and drama and full of folk-song overtones. It pursues emotion and atmosphere rather than form—'with fantasy' is a not uncommon instruction to the performer—and in that respect the work seems closer to the Impressionist view of Goya than any of the creative writers of Granados's period. Given the narrative sequence implicit in the pieces it is not surprising that the composer was commissioned to make an opera of the *Goyescas* for performance in Paris in 1914. The war led to a postponement, however, and the opera was first produced in the Metropolitan Opera house in New York in January 1916. Granados wrote two extra pieces for that occasion—'El Pelele' and 'Intermezzo'—the first of which is certainly the subject of a tapestry as well as paintings and drawings by Goya. But for the most part the link between Goya's paintings and Granados's pieces lies in the general subject matter and the emotion rather than anything more precise. The *Goyescas* are much further from their supposed sources than, for example, the variants on Goya's themes painted by the two Lucases.

<div align="center">★ ★ ★</div>

The widest response to Goya has come from poets. Some of the artist's contemporaries expressed in verse the admiration they shared with others for Goya's portraits (Francisco Gregorio de Salas and Leandro Fernández de Moratín), and for his tapestry cartoons (José Moreno de Tejada). Three Spaniards at least picked out in poems the caricaturesque and fantastic elements in Goya's work during the artist's lifetime. Jovellanos, in a long satirical poem, found it hard to imagine fantastic knights more extraordinary in nature than Goya's inventions; Gallardo makes a comparable reference to the imaginative power of the *Caprichos*; and Vargas Ponce mentions Goya in the context of a satirical poem—'La proclama de un solterón'. Mor de Fuentes, as we have seen, expressed in poetry the idea of a common role shared by art and literature which had been a central theme in Goya's own advertisement for the *Caprichos*. Quintana wrote a more general eulogy of his art.

French Romantic poets, like French Romantic critics, focused their attention on the strange world of the *Caprichos*. Hugo speaks of the 'gnomes of Goya' in a passage which also refers to 'Rembrandt's sorcerers' and the 'various devils, veritable nightmare monks, which Callot mockingly used to torment St Antony'.[23] A deeper and more tortured reaction to the same work, is that of Baudelaire. 'Les Phares' has already been quoted, but it is evident that a number of poems in *Les Fleurs du mal* could have been inspired by Goya's *Caprichos*. The clearest case is that of 'Duellum', which is palpably based on *Capricho* No. 62—'Quien lo creyera!' (Plate 60)[24] Goya's own commentary describes the scene in question as a struggle between witches, enmity being characteristic of evil natures. Baudelaire reads a

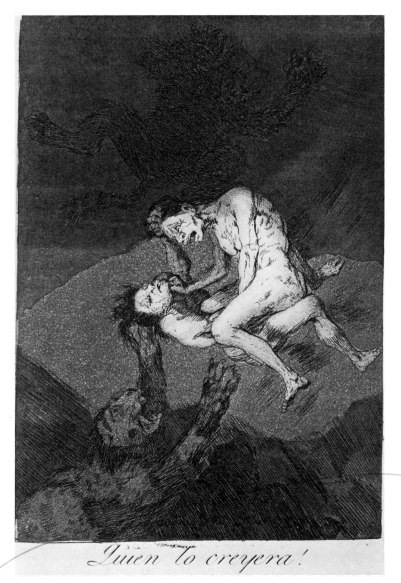

60. Goya: 'Quien lo creyera!', *Capricho* No. 62, 1799. Oxford, Ashmolean Museum. Francis Douce Collection.

lover's conflict into the same plate, with a typical mixture of violent desire and loathing, copulation and battle:

> Deux guerriers ont corru l'un sur l'autre; leurs armes
> Ont éclaboussé l'air de lueurs et de sang.
> Ces jeux, ces cliquetis du fer sont les vacarmes
> D'une jeunesse en proie à l'amour vagissant.
>
> Les glaives sont brisés! comme notre jeunesse,
> Ma chère! Mais les dents, les ongles acérés,

Vengent bientôt l'épée et la dague traîtresse.
—O fureur des cœurs mûrs par l'amour ulcérés!

Dans le ravin hanté des chats-pards et des onces
Nos héros, s'étreignant méchamment, ont roulé,
Et leur peau fleurira l'aridité des ronces.

—Ce gouffre, c'est l'enfer, de nos amis peuplé!
Roulons-y sans remords, amazone inhumaine,
Afin d'éterniser l'ardeur de notre haine!

Two warriors leap to the attack, their arms
Spatter the air with flashes and with blood.
These clashes of steel on steel are the alarms
Of youth that's prey to new-born bawling love.

Their weapons are soon spent, love, like our youth,
And then they avenge their fickle dagger and sword
With steely finger-nail and tearing tooth.
How ripe hearts rage when cankered by amours!

In a ravine which pards and wild-cats haunt,
Clipped in a foul embrace our heroes fall,
And leave their flesh to bloom on barren thorns.

The hollow is a hell our friends frequent!
So let us lie there and perpetuate,
My heartless Amazon, our pangs of hate!

Alfred de Musset was equally stimulated by Goya's *Caprichos*, both visually and sensually. He copied *Capricho* No. 31 ('Ruega por ella'), and in his poem 'L'Andalouse' ('The Andalusian Girl') described a stocking being pulled on in terms which inevitably recall *Capricho* No. 17 ('Bien tirada está').[25] The same wicked but alluring *majas* appealed to the lesser known Romantic poet Roger de Beauvoir. They form the central image of a poem he dedicated 'À Goya' not long after he returned from a period in Spain.[26] In it he nostalgically mourns the passing of the spirited *manolas* of Goya's time, contrasting them with the young and unromantic prostitutes of the Madrid he knew: 'Frail bodies, thin with poverty, girls of thirteen, led on by their mothers, shivering with hunger at street corners, and selling their precocious love at the lowest prices.' Death takes the place of love at the end of the poem and Goya's brighter world (idealized by de Beauvoir) disappears.

Those girls from your Madrid, who stole my heart,
The ones depicted in your mocking art,
Fans in their hands, white roses in their veil—

Walking in pairs beneath the Prado's stars
And looking furtively for foreigners—
No longer stroll along your green boulevard!
Instead of painted sirens in their swarms
That dark men long to take in lusty arms
(A beauty spot beside eyes black and bright)
Manolas now walk only out at night.

In his collected poems (*Les Meilleurs Fruits de mon panier*, 1862), the same poem becomes the second of two addressed to Madrid and is retitled 'Manolas'. Another longer poem with the title 'L'Écolier de Goya'[27] in the same basket of fruit purports to describe a painting by Goya which cannot be identified, but which is full of sombre low life detail, contrasting bandits, drunk monks and prostitutes. Roger de Beauvoir speaks of the 'great Goya' in this second poem as a 'more violent Salvator'—presumably thinking of Salvator Rosa whose *Witch of Endor* had been mentioned by Gautier in his 1842 Goya article.

The Goya beloved of the Romantics, creator of seductive women, and devotee of bull-fights, continued in France later in the century in poems written by the sculptor Zacharie Astruc. He composed a terrible sequence of five indifferent sonnets on Goya's *Maja* entitled 'La femme couchée de Goya', and inserted a speech by Goya's ghost into a dramatic poem on bull-fights, seen predictably as an expression of the heroism, passion and quixotism of Spain.[28] Others at the same period concentrated on Goya's realism. Verlaine did so when he compared Rimbaud and Goya in *Les Poètes maudits*, and Maurice Rollinat followed suit in a sonnet called 'The Thief' ('Le Voleur' from *Les Nevroses*), describing a blind organ-grinder, who is about to be robbed, as 'a true Goya touched up by the morgue'.

In the poetry of the Nicaraguan Rubén Darío, a leader in the field of Spanish and Spanish-American letters at the turn of the century, Goya is once again the pretext for an almost religious eulogy of the Romantic creator. The form of his poem *A Goya*—three-line stanzas with a single rhyme for each verse—is arty, and the content ambiguous and all-embracing, occasionally synaesthetic. Darío's Goya touches the whole range of human experience, and mixes the light and the dark in life, dream and reality in the best traditions of the Romantic muse. To be slightly demented is an artistic necessity for Darío's Goya. Here are a few stanzas, somewhat loosely translated:

To Goya

Your mad hand limns
the outline of the witch
huddled in the shadows,

And learns an abracadabra
from the goat-footed devil
with twisted grimace.

A Muse proud and confused—
angel, spectre, medusa:
such is your muse . . .

The dead yellow light
of the terrifying nightmare
gleams in your chiaroscuro,

or makes your brush light up
red lips of honey
or carnation blood.

Your feminine angels
have murderous eyes
in their heavenly faces.

With capricious delight
you mingled the light of day
with dark, cold, night.[29]

Some later twentieth-century Spanish poets have repeated Darío's formula for Goya. Emilio Carrere's *Fiesta de Verbena* is a piece of eighteenth-century atmospherics in the Verlaine manner which Darío had translated into Spanish. Almost inevitably the Duchess of Alba turns up in it, with her 'beautiful, devilish and angelic face immortalized by the magical sorcerer's brush of Goya'.[30] Another trend in poets as well as critics is the Goya-as-painter-of-his-people syndrome. Emiliano Ramírez Angel (1883–1928?) wrote a poem entitled *August Night in the poor quarter of Madrid* ('Noche de agosto en los barrios bajos'), in which the tough working-class Spaniards who dance and sing, go to bull-fights and dream of revolution, are 'the great-grandchildren of beloved Goya'.[31] A poem which evokes the past of Madrid—*Madrid de capa y espada* ('Cloak and Dagger Madrid') by Luis Fernández Ardavín (b. 1892)—necessarily brings in Goya's tapestries, the Duchess and Goya himself, 'with an obstinate Aragonese frown on his face'.[32]

None of these poems has much individual quality about it. Perhaps the first twentieth-century Goya poems which really make a direct impact are three sonnets on Goya paintings by the Spaniard Manuel Machado. These well up from a Parnassian spring to exploit the visual possibilities of poetry and the cross-fertilization of one art form by another. A number of Spanish poets wrote 'picture poems' at the period, and Machado's sonnets on Charles IV and María Luisa were themselves preceded by poems on the same subjects by his friend Antonio de Zayas (1902).[33]

Apart from the skill with graphic detail and atmosphere in these poems, Machado also subtly suggests attitudes to the subjects of the two royal portraits. In his sonnet on Charles IV, for instance, he becomes progressively more ironic, implying the weakness of the king by showing his activity in a feeble light at the end of the

poem. Machado gives us first the hunting rifle, then the retriever, then the passions for sex and the chase of the courtiers. In the sestet, three lines describe the stags and rabbits as if they were courtiers also, and only too willing to attend the hunt. Finally the king himself comes in, naïvely and happily putting them to death. The whole development of the sonnet is anti-climatic. Machado moves from the details of the painting itself (*Charles IV in Hunting Dress*) to an interpretation of the king as an insignificant character.

Machado's sonnet on *María Luisa* deals with the equestrian portrait in the Prado. Irony is the key-note here too. The poem undermines the queen progressively by revealing the advance of age beneath her outward youthfulness. Yet it does not impute to Goya a satirical view of the queen, but rather sees pathos in the contrast between the kept-up appearances of an ageing woman and the mortality beneath the surface. The irony is at the expense of human pretentiousness:

> Looking at the way
> this supple and still alert body tries to be young,
> the dashing tilt of the hat,
> and the fire in her eyes which has not yet gone . . .
>
> She still carries herself well, she still
> looks regally attractive,
> this arrogant old lady, this Amazon,
> on a better horse than seems wise.
>
> And it makes no difference that her head
> (a little bit wild) is losing its hair,
> her mouth is sinking, and her sight grows dim . . .
>
> In her uniform—red and black—she will always be
> desirable and fair:
> María Luisa of Bourbon and of Spain.[34]

Equally successful is the last of the trio of Goya sonnets by Machado: *The Third of May 1808*. It contrasts powerfully the cold cruelty of the firing squad and the suffering of ordinary people, making their death a symbol of the inevitability of human pain in a harsh, perhaps godless, universe. Machado may be following the common view of Goya's scepticism here. He also puts into the poem two echoes of the *Disasters of War* series—typical perhaps of his documentary approach to his subjects: No. 44 ('Yo lo vi'—I saw it myself), and No. 14 ('Duro es el paso!'—The way is hard), in which a monk points to the sky when speaking to a man who is about to be executed, as in line 11 of the sonnet. His opening phrase—'He saw it himself'—obviously takes Goya's *Disaster* No. 44 at its face value, although, in reality, the phrase has a rhetorical ring about it which Machado and others tend to miss. It is common in the emotional poetry of Goya's period and serves to emphasize feelings as well as make a more literal point:

He saw it himself . . . Black night, hellish light
Stench of blood and powder, human groans . . .
Some, arms outstretched, hold
a crucified gesture of eternal pain.

A lantern on the ground lights up
—with a terrible yellow halo—
the serried ranks of rifles,
monotonous and brutal in the half-light.

Oaths and moans . . . Momentarily,
before the voice of command is heard,
a monk points to the implacable sky.

And in a convulsive, dying pile,
half finished off, the cannon-fodder falls
in endless waves of bodies on the ground.[35]

Each new generation of Spanish poets seems to produce poems based on Goya pictures. Rafael Alberti, a friend and contemporary of Lorca, included a long poem to the artist in his collection entitled *A la pintura* (To Painting, 1945–52), and there are other references to Goya in the same collection. His popular subjects and elegant ribbons are referred to in the poem to the colour 'Green'; his brilliant tones in 'Yellow' and 'Red'; sashes and delicate materials in 'Blue'. In the 'Black' poem Goya's capacity for arousing horror is evoked, and the darker side of Goya's work dominates the *Goya* poem itself. Yet Alberti knew the whole range of the artist's sensibility and had actually copied a number of paintings by him in the Prado in 1917. The power of the poem derives precisely from Alberti's awareness of Goya's conflicting views of life, and he conveys this by juxtaposing opposites in a kind of continuous oxymoron. The enumerative form recalls that of many surrealist poems which bombard the reader's senses with images that the unconscious alone can synthesize. This poses difficulties for the translator, particularly in the jingly middle section where the bitter ironies are heightened by rhyme. There are lines of a wit and compression which it is quite impossible to render satisfactorily in English. The two lines 'Y la gracia de la desgracia. Y la desgracia de la gracia' mean more than 'The laughing at misfortune and the misfortune of laughing'. 'Gracia' in Spanish means beauty and grace as well as wit; 'desgracia' can imply disgrace. My version misses some of this word play, which is closely allied to the visual punning of some of Goya's own *Caprichos*. That series of etchings is, in fact, frequently recalled towards the end of the poem. Alberti uses the captions of Plates 49, 48, 78, 2, 80 and 64, in that order; also the half-title of the unpublished etching 'Dream of Lying and Inconstancy'. He creates lines of his own with these, as he does with the captions of *Disasters* in his *Night in the Prado Museum in Wartime* (1956). It is interesting to note that Goya himself had taken the caption of No. 2 from a verse satire by his friend Jovellanos.[36]

Goya

Gentleness, rape,
laughter, blows,
blood, smiles,
holiday, hanging.
Light and dark are being chased
by a madman with a knife.

I'll keep his eye safe, while the house burns.
I'll sink my teeth into her head.
I'll make your humerus crack, and yours too.
I'll swallow the snail that picks your ear,
And as for you—

I'll bury your legs
and nothing else
in mud.
 One leg,
 The other
 leg.
 Thumps.

Fly!
Wait behind and see!
Die without having to die!

Light in a surgery ward!
Joy in a blind bull-ring!
Awful dread of being dead.
Time when all things decay
and Spain gone goof collapses,
and a broomstick rides away.

 Flight.
The devil with old hag's breasts.

 At the fight—
Pedro Romero.
Yellow
from bleeding to death,
Pepe-Hillo.
And the heads
of the duchess's tails.

The female Bourbon folly
with her consort Bourbon fool.
The cunning
hand of the Inquisition.
The harum warning
of the scarum
execution.
The cabbaged
cardinal with the nosiest
nose.
The sunset
over the meadow of San Isidro,
and the man, cloak over face,
in the top hat.
The laughing at misfortune
and misfortune of laughing.
The poetry
of bright colours in painting,
and the shadows.
The carnival mask
who can't wait to ask,
and dances in the procession.

Mask, death,
dearth, court,
police, puke,
hunger, glut,
bull, sleep,
peace, war.

Where do you come from, flowering broom, sleek beast,
long-swept horns,
red and black?
Where do you come from,
funeral foetus,
unreal
royal
folly,
sketch,
high
sky—
blue,
pink cloud,
grove,

mauve
silk,
jubilant
silk?

Hobgoblins. Spies.
Make haste, they're waking.
They say 'I will' and hold out their hand
for the taking.
The hour has struck.
 Gaudeamus!
 Have a good journey!
Dream of lies.
 And a burial
positively makes the landscape petrified.

Artist,
in your timeless art,
Wit must weep,
and Horror laugh.[37]

Since 1948 several sets of Goya poems have come from the pen of Ildefonso Manuel Gil, a poet who has always had an eye for solitude, suffering and death, and who no doubt finds an echo of these feelings in Goya.

Outside Spain poets have written of Goya too. Louis MacNeice saw irony in Goya's royal portraits in his *Autumn Journal*.[38] W. H. Auden thought that Goya's preoccupation with man was more important than Cézanne's obsession with apples in his *Letter to Lord Byron*, first published in 1937.[39] Earlier, Aldous Huxley had written two poems inspired by Goya: one entitled 'Morning Scene' in his collection *Leda* (1920); the other called 'A Highway Robbery' which he published in *The Cicadas and Other Poems* (1931). The first of the two seems perhaps to be based on a drawing rather than a painting, despite its use of colour adjectives—one from the Madrid Album in the Prado, conceivably, in which a man looks at a woman lying on a bed, with older women standing and sitting behind (Gassier and Wilson, No. 431). Alternatively, Huxley is embroidering a Goyesque theme, starting with the *Naked Maja*, or even Capricho No. 9, and juxtaposing beauty and animal passion in a typically Goya way. Whichever is the case, Huxley merely takes Goya as a *point d'appui*: a means towards his own original end.

Morning Scene

 Light through the latticed blind
Spans the dim intermediate space
With parallels of luminous dust

To gild a nuptial couch, where Goya's mind
Conceived those agonising hands, that hair
Scattered, and half a bosom bare
And, imminently above them, a red face
Fixed in the imbecile earnestness of lust.[40]

Huxley's other Goya poem is entitled more clearly 'Picture by Goya', and is
presumably concerned with the *Attack on the Coach* that Goya painted on a panel
for the Dukes of Osuna. Huxley finds irony in the painting's portrayal of violence
in an Arcadian setting. Goya shows human brutality and coarse emotion where
the Pastoral convention would have placed peace, aristocratic pastimes, and elegant
poses in the Watteau manner. Goya nevertheless reveals the truth about life in his
picture. Man is unable to escape from his limitations; he has not the faith to view
his situation with a proper detachment, and faith might in any case be destructive
of life ('arsenical benediction'). The fairground of life—naturally present on a
country green—is a frightening affair seen from man's earthbound level; it reflects
man's instinct for tinsel and destruction rather than beauty and love. Goya's
picture thus becomes the motive for a lament on human nature in ironic terms:

Picture by Goya

A Highway Robbery

It is a scene of murder—elegant, is it not?
You lutanists, who play to naked Queens,
As summer sleep or music under trees,
At luncheon on the grass—the grass on which
The country copulatives make sport, the pale
Grass with the tall tubed hats, the inky coats
And rosy, rosy among the funeral black
(*Memento Vivere*) a naked girl.
But here the sleepers bleed, the tumbling couples
Struggle, but not in love; the naked girl
Kneels at the feet of one who hesitates,
Voluptuously, between a rape and a murder.

Bandits angelical and you, rich corpses!
Truth is your sister, Goodness your spouse.
Towering skies lean down and tall, tall trees
Impose their pale arsenical benediction,
Making all seem exquisitely remote
And small and silent, like a village fair
Seen from the hill-top, far far below.

> And yet they walk on the village green to whom
> The fair is huge, tumultuous, formidable. Faith
> Lies unremembered beneath the feet of dancers
> Who, looking up, see not the sky, but towers
> And bright invading domes and the fierce swings,
> Scythe-like, reaping and ravaging the quiet.
> And when night falls, the shuddering gas-flares scoop
> Out of the topless dark a little vault
> Of smoky gold, wherein the dancers still
> Jig away, gods of a home-made universe.[41]

One last more recent poet remains to be quoted: the Russian Voznesensky (b. 1933). Like earlier writers, and particularly Wyndham Lewis, he was obviously moved by the *Disasters of War* series of etchings. Writing on Picasso in *The Kenyon Review* in 1940 Wyndham Lewis had claimed that 'when Goya drafted into a set of wonderful plates his accumulated sensations of disgust and anger at the devastation of Spain by the French armies, he produced something that was not coldly cut out of cardboard, but had flesh and blood, and struck the thing aimed at as effectively as a physical missile'.[42] The Russian poet not only felt the force of Goya's attitudes as Wyndham Lewis did, he also had a personal reason for associating his feelings of revulsion about war with those of Goya. Voznesensky's father used to carry a little book of reproductions of etchings by the Spanish artist in his knapsack during the Second World War.[43] This union of personal and artistic experience led to Voznesensky's most famous poem: 'I am Goya' (1959). In it Voznesensky is not adopting commonplaces about the artist, nor seeing him through a distorting glass as the Impressionists and Expressionists did. He speaks through Goya as it were. Neither of the two English versions I know captures the pattern of assonances in the original which gives the poem its strong speaking voice. But Stanley Kunitz's translation gives some idea of its impressive quality:

> I am Goya
> of the bare field, by the enemy's beak gorged
> till the craters of my eyes gape
> I am grief.
>
> I am the tongue
> of war, the embers of cities
> on the snows of the year 1941
> I am hunger.
>
> I am the gullet
> of a woman hanged whose body like a bell
> tolled over a black square
> I am Goya

O grapes of wrath!
I have hurled westward
the ashes of the uninvited guest!
and hammered stars into the unforgetting sky like nails.
I am Goya.[44]

Goya is indeed the tongue of war. He speaks of other sources of human suffering too, and their causes in human behaviour, social and political attitudes and the nature of things. Goya is also the tongue of beauty and joy. There is laughter as well as anger in his work; hope and despair. We listen to the tongue, we try to interpret it. We say what we see in the pictures. We say how line or colour or texture seem to be. Yet still in the end, as Wittgenstein said: 'Whatever we see could be other than it is. Whatever we can describe at all could be other than it is.'

Quoted Sources of Goya Material

I. Biographical and critical sources in chronological order

1771 *Diario Ordinario di Roma*, No. 8288, 3 August. Refers to Goya's painting for a competition organized by the Parma Academy. (A. Hyatt Mayor, 1955)

1772 *Mercure de France*, I, January, 145–6. Second reference to the Parma competition painting. (Paul Mantz, 1851–2)

1778 *Gaceta de Madrid*, 28 July. Announcement of the publication of nine of Goya's etchings after paintings by Velázquez. (Tomás Harris's Catalogue, 1964, Nos. 5, 6, 7, 8, 10, 13, 14, 15 and 16)

 Gaceta de Madrid, 22 December. Announcement of two more etchings by Goya after Velázquez. (Harris, Nos. 4 and 9)

 Letter from P. P. Giusti to the Austrian High Chancellor referring to Goya's etchings after Velázquez. (María del Carmen Velázquez, 1963)

 Antonio Ponz, *Viaje de España*, VIII, Madrid. A further reference to the etchings after Velázquez. Brief mentions of works by Goya also occur in other volumes

1788 [J. Fr. Bourgoing], *Nouveau Voyage en Espagne, ou Tableau de l'État Actuel de cette Monarchie, ouvrage dans lequel on a présenté avec impartialité tout ce qu'on peut dire de plus neuf, de plus avéré & de plus intéressant sur l'Espagne, depuis 1782 jusqu'à présent*, Paris. A second impression appeared in French in 1789; English translations were published in London 1789 and Dublin in 1790. A second edition, without variants in the Goya passage, appeared in French in Paris in 1797. Cf. 1803 for further editions

 Gaspar Melchor de Jovellanos, *Elogio de Don Ventura Rodríguez leído en la Real Sociedad de Marid en 1788*, Madrid, 1790. Reference to Goya's portrait of Ventura Rodríguez

 Sexta Junta general del Banco Nacional de San Carlos celebrada en la casa del mismo banco el día 24 de febrero de 1788, Madrid. Goya's name occurs in the list of shareholders attending the meeting. Together with Don Luis Lorenzo he held twenty-five shares

1789 Gaspar Melchor de Jovellanos, 'Reflexiones sobre el boceto del cuadro llamado "La Familia".' Essay dated 14 December discussing a sketch of Velázquez's *Meninas* then in Jovellanos' possession. Goya's knowledge of Velázquez's technique is praised. Jovellanos may have intended to publish the piece in a periodical. (Julio Somoza, 1885)

1798 *Diario de Madrid*, 17 August. Goya's portrait of Don Andrés del Peral praised. (E. F. Helman, 1964)

1799 *Diario de Madrid*, No. 37, 6 February. Announcement of the publication of the *Caprichos*

1799–1800 Letters from María Luisa to Godoy referring to various portraits of the Royal Family by Goya. (Carlos Pereyra, 1935)

1800 Juan Agustín Ceán-Bermúdez, *Diccionario histórico de los más ilustres profesores de Bellas Artes en España*, Madrid, Viuda de Ibarra, 6 vols. References to Goya under Luzán Martínez (III, 56); Torrigiano (V, 69); Velázquez de Silva (V, 178); and Calderón de la Barca (VI, 63)

1801 Jovellanos' diary describes paintings by Goya in Aragonese churches and collections. (El Marqués de Lozoya, 1946)

1803 J. Fr. Bourgoing, *Tableau de l'Espagne Moderne*, Paris, Levrault, 3 vols. The third edition, which adds a note on Goya's work as a portrait painter. Fourth edition (1807) and English reprint of Spanish edition (1808) followed

1805 Letter from Vargas Ponce to Ceán Bermúdez dated 8 January expresses a wish to be painted by Goya. (El Marqués de Seoane, 1905)

1806 J. D. Fiorillo, *Geschichte der künste und wissenschaften seit der wiederherstellung derselben bis an das ende des achtzehnten jahrhunderts*, Vol. IV of *Geschichte der zeichnenden künste von ihrer wiederauflebung auf die neuesten zeiten*, Gottingen

1808 Letter from Count Joseph de Maistre to the Chevalier de Rossi contains a critical reference to Goya's *Caprichos*. (Joseph de Maistre, 1859)

1809 Lady Holland's diary for 29 April refers to Goya's drawings of the ruins of Saragossa and the heroes and heroines of the siege. (*The Spanish Journal of Elizabeth Lady Holland*, 1910)

1811 *Semanario patriótico*, Cadiz, No. 51, 27 March, 24–27. Article on Goya's *Caprichos* by Gregorio González Azaola. (E. Harris, 1964)

 Nataniel Jomtob [i.e. A. Puigblanch], *La Inquisición sin máscara*, Cadiz. Foot-note references to Goya's covert criticism of the Inquisition in Plates 23 and 24 of the *Caprichos*. An English translation by William Walton 'from the author's enlarged copy' was printed in London in 1815

1812–13 Nicolás de la Cruz y Bahamonde, *Viaje de España, Francia e Italia*, Cadiz, Vols. X–XIV. References to various Goya paintings in Madrid and Cadiz, and a report of his views on a Poussin in Sanlúcar when visiting the Duchess of Alba there

1815 Count Jacob Gustaf de la Gardie's diary for 2 July records his impressions of a visit to Goya's studio. (Per Bjorström, 1962)

1816 *Diario de Madrid*, 28 October; *Gaceta de Madrid*, 31 December. Announcement of the publication of Goya's *Tauromaquia*

1817 [J. A. Ceán Bermúdez], *Análisis de un cuadro que pintó D. Francisco Goya para la Catedral de Sevilla*, [Madrid], Imprenta Real y Mayor. The essay is believed to have been published separately after it had appeared in the periodical *Crónica científica y literaria*, No. 73, 9 December. (Angel González Palencia, 1946)

Mercure de France, February, 292–3. Article mentioning Goya by 'Le Bachelier de Salamanque' (i.e. Bartolomé José Gallardo). (A. Rodríguez-Moñino, 1954)

Poesías del P. Basilio Bogiero, Madrid, Imprenta de Burgos. Comparison of Bogiero and Goya in D.L.G.P.'s introduction. Reprinted in the second edition in 1826

1818 Letter from Count Brunetti to the Comtesse d'Albany concerning drama and painting in Spain. Refers critically to Goya's imitators. (Léon-G. Pélissier, 1902)

1823 J. A. Ceán Bermúdez, *Historia de la Pintura*, I—dated 15 February 1823. Reference to the effect of deafness on Goya's art. MSS of the Real Academia de Bellas Artes de San Fernando, Madrid

1824 J. A. Ceán Bermúdez, *Historia de la Pintura*, IV—dated 11 May 1824. Ceán recalls giving Rembrandt etchings to Goya when he was working on the *Caprichos*. In Vol. V—dated 31 August 1824—Ceán describes seeing Goya paint with the point of his palette knife and his fingers

1824–8 Letters from Leandro Fernández de Moratín to various friends refer to Goya in France. (Moratín, *Obras póstumas*, 1867)

1825 Frédéric Quilliet, *Les Arts italiens en Espagne ou Histoire des artistes italiens qui contribuèrent à embellir les Castilles*, Rome. Reference to Goya as a fresco painter and 'philosophical' artist. (Xavier de Salas, 'Precisiones sobre pinturas de Goya', 1968)

1826 J. Taylor [i.e. Baron Taylor], *Voyage pittoresque en Espagne*, Paris. Although the title page is dated 1826 in some copies, and the work began to be issued in serial form that year, the passage which refers to Goya on pp. 115–16 most probably dates from 1838

1827 *Arte de ver en las bellas artes del diseño según los principios de Sulzer y de Mengs,*
 escrito en italiano por Francisco de Milizia, y traducido al castellano con notas e
 ilustraciones por D. Juan Agustín Ceán-Bermúdez, Madrid. Notes LII and
 XCVI refer to Goya

1828 *Noticia de los cuadros que se hallan colocados en la Galería del Museo del Rey*
 nuestro señor, sito en el Prado de esta Corte, Madrid, 67–8 and 80

 Sebastián de Miñano, *Diccionario geográfico-estadístico de España y Portugal,*
 Madrid, X, 83 (article on Saragossa). Miñano quotes a passage from Ceán
 Bermúdez's unpublished *Historia de la Pintura* mentioning Goya

1831 Henry D. Inglis, *Spain in 1830,* London, 2 vols. On pp. 244–5 of Vol. I,
 Inglis finds Goya better than his contemporaries but far below Velázquez
 and Murillo in stature. He believes the artist to be still alive and in retirement
 in Bordeaux

 Revue Encyclopédique, I, April 1831, 328–31. Strong praise of Goya's work
 as a reflection of his people in Ad. M.'s review of 'A Young American'
 [i.e. A. Slidell Mackenzie], *A Year in Spain,* London. Slidell himself appears
 to make no reference to Goya, despite a strong interest in Spanish customs
 and national characteristics

1832 [Javier Goya] Biographical sketch of Goya in the report of the San Fernando
 Academy Prizegiving: *Distribución de los premios concedidos por el rey nuestro*
 señor . . . hecha por la Real Academia de San Fernando . . ., Madrid, 91–3

1834 'Peintres Espagnoles. Francisco Goya y Lucientes', *Le Magasin Pittoresque,*
 324–5. (E. Lafuente Ferrari, *Antecedentes . . .,* 1947)

1835 Valentín Carderera, 'Biografía de D. Francisco Goya, pintor', *El Artista,*
 II, 253–5. (E. Harris, 1969)

 [B. J. Gallardo], *El Criticón,* No. 1, Madrid, 41. Reference to Goya's idea of
 making drawings based on *Don Quixote.* (A. Rodríguez-Moñino, 1954)

 Louis Viardot, *Études sur l'Histoire des Institutions, de la littérature, du théâtre*
 et des Beaux-Arts en Espagne, Paris, 389

1836 Manuel Godoy, *Cuenta dada de su vida política . . . o sean memorias críticas y*
 apologéticas, Madrid. References to Goya and the *Caprichos:* II, 255; III,
 374–5

1838 Valentín Carderera, 'Goya', *Semanario pintoresco,* No. 120, 631–3. (E.
 Lafuente Ferrari, *Antecedentes . . .,* 1947)

 Théophile Gautier, 'Les Caprices de Goya', *La Presse,* 5 July

 José Somoza, 'El pintor Goya y Lord Wellington', *Semanario pintoresco.*
 Reprinted in *La Colmena,* London, I, 1842, 302–3

1839 L. Viardot, *Notices sur les principaux peintres de l'Espagne,* Paris, 305–8

1842 Théophile Gautier, 'Fran^{co} de Goya y Lucientes', *Le Czbinet de l'Amateur et de l'Antiquaire*, i, 337–45

Eugène Piot, 'Catalogue raisonné de l'Œuvre gravé de Goya', *Le Cabinet et de l'Amateur et de l'Antiquaire*, i, 346–66

José Somoza, 'El retrato de Pedro Romero', *Obras . . . Artículos en prosa*, Madrid, 55ff

1843 Théophile Gautier, *Tra los Montes*, Paris, 2 vols

L. Viardot, *Les Musées d'Espagne, d'Angleterre et de Belgique*, Paris, 155–6; 167–9. 2nd edition, 1855; 3rd, 1860

1845 Richard Ford, *A Hand-Book for Travellers in Spain, and Readers at Home*, London, 2 vols. 2nd edition, 1847; 3rd, 1855; 4th, 1869; 5th, 1878; 6th, 1882; 7th, 1888; 9th, 1898

Théophile Gautier, *Voyage en Espagne*, Paris. Gautier's 1842 article included as Chapter XI. Further editions Paris, 1870, 1881, 1894, etc. An English translation entitled *Wanderings in Spain* was published in London in 1851, with a second edition in 1853

1848 Sir Edmund Head, *A Hand-Book of the History of the Spanish and French Schools of Painting*, London. Includes the extract from Miñano (1828)

William Stirling [later Sir William Stirling-Maxwell], *Annals of the Artists of Spain*, London, III, 1260–70. 2nd edition in 4 vols., London, 1891. Goya passage reprinted in *Stories of the Spanish Artists until Goya by Sir William Stirling-Maxwell*, selected L. Carreño, London, 1910, 262–70

1851 *Archives de l'Art Français*, 1851–2, ii, 319. Paul Mantz draws attention to the reference to Goya in the *Mercure de France* for 1772

J. Vallent, 'Goya', *Encyclopédie du XIXe siècle*, Paris. (E. Lafuente Ferrari, *Antecedentes . . .*, 1947)

1853 J. D. Passavant, *Die Christliche Kunst in Spanien*, Leipzig. Spanish translation with annotations: *El arte cristiano en España*, trans. C. Boutelou, Seville, 1877.

1854 Ramón de Mesonero Romanos, *Nuevo Manual histórico-topográfico-estadístico descripción de Madrid*, Madrid. Mentions the *Majas on a Balcony* in the Trinity Museum ('one of the most polished works by this celebrated artist'), and the 'beautiful and capricious' paintings on the walls of Goya's house

1855 Paul Mantz, 'Goya', *Dictionnaire de la conversation et de la lecture*, 2nd edition, Paris, X, 414

1857 Charles Baudelaire, 'Quelques caricaturistes étrangers', *Le Présent*, 15 October

1858 Charles Baudelaire, 'Quelques caricaturistes étrangers', *L'Artiste*, 26 September. Reprint of *Le Présent* article with minor variants. Subsequently included in *Curiosités esthétiques (Œuvres complètes*, II), Paris, 1869

Laurent Mathéron, *Goya*, Paris: Spanish translation by G. Belmonte Müller, Madrid, Biblioteca Universal (Colección de los mejores autores antiguos y modernos nacionales y extranjeros, CXXVI), 1890. Reprinted with the trans. were V. Carderera's Goya biography from *El Artista* (1835); an extract from José Caveda's *Memorias para la historia de la Real Academia de San Fernando* (1867); Madrazo's Goya article from the *Almanaque de la Ilustración* (1879 for 1880); poems to Goya by Leandro Fernández de Moratín and Manuel José Quintana. The Spanish translation was republished in Madrid, 1927 and Barcelona, 1941

1859 *Mémoires politiques et correspondance diplomatique de Joseph de Maistre*, ed. Albert Blanc, Paris, 306. (cf. 1808)

Clément de Ris, *Le Musée Royal de Madrid,* Paris

1860 Valentín Carderera, 'François Goya, sa vie, ses dessins et ses eaux-fortes', *Gazette des Beaux-Arts*, vii, 215–27

1863 Valentín Carderera, 'François Goya, sa vie, ses dessins et ses eaux-fortes', *Gazette des Beaux-Arts*, xv, 237–49. In the same volume Paul Mantz associates Manet's work with that of Goya

1863 Charles Gueullette, *Les Peintres espagnols. Études biographiques et critiques sur les principaux maîtres anciens et modernes*, Paris, Chapter 12

Enrique Mélida, 'Los Desastres de la Guerra. Colección de ochenta láminas inventadas y grabadas al aguafuerte por D. Francisco Goya', *El Arte en España*, ii, 266–81

Francisco Zapater y Gómez, *Apuntes histórico-biográficos acerca de la Escuela Aragonesa de Pintura*, Madrid

1864 Champfleury, *Histoire de la caricature moderne*, Paris, 59 and 83

M. Lavice, *Revue des Musées d'Espagne. Catalogue raisonné*, Paris

1865 Gustave Brunet, *Étude sur Francisco Goya, sa vie et ses travaux. Notice biographique et artistique accompagnée de photographies d'après les compositions de ce maître*, Paris, Bordeaux

Edmond et Jules de Goncourt, *Fragonard* (L'Art du XVIIIe siècle), Paris, Lyon. Refers briefly to Goya's painting with a spoon. English translation by Robin Ironside: Edmond and Jules de Goncourt, *French XVIII Century Painters*, London, 1948

Gazette des Beaux-Arts. Léon Lagrange praises Goya's portrait of Guillemardet in the Louvre

Enrique Mélida, 'Los Proverbios. Colección de Diez y ocho láminas inventadas y grabadas al aguafuerte por D. Francisco Goya', *El Arte en España*, iii, 313–16

H. O'Shea, *A Guide to Spain*, London. Subsequently expanded to include Portugal. Thirteen editions by 1905

1867 Charles Blanc, *Grammaire des Arts du dessin*. Eight editions by 1895; English translation 1874

José Caveda y Nava, *Memorias para la historia de la Real Academia de San Fernando y de las Bellas Artes en España, desde el advenimiento al trono de Felipe V hasta nuestros días*, Madrid

Charles Yriarte, 'Francisco de Goya', *Revista de Bellas Artes*, i, 31 March, 202–4

——'Goya en Rome', *Revista de Bellas Artes*, i, 243–4.

——*Goya: Sa Biographie, les fresques, les toiles, les tapisseries, les eaux-fortes et la catalogue de l'œuvre, avec cinquante planches inédites d'après les copies de Tabar, Bocourt et Ch. Yriarte*, Paris

1867–8 Leandro Fernández de Moratín, *Obras póstumas . . . publicadas de orden y a expensas del gobierno de S.M.*, Madrid, 3 Vols. References to Goya in Vol. II, 446; and Vol. III, 7, 8, 10, 18, 20, 22, 28, 32, 40, 49, 54, 55, 73, 75, 86, 91, 95, 96, 118–19, 252, 255, 258, 269, 309, 354

1868 G. Cruzada Villaamil, 'La casa del sordo', *El Arte en España*, vii, 265–7. The article seems to have been published in the December issue

P. G. Hamerton, *Etching and Etchers*, London. 2nd edition, with minor revisions to the Goya passage, 1876; 3rd, 1880

Francisco Zapater y Gómez, *Goya. Noticias biográficas*, Zaragoza, a cargo de Manuel Sola, Paso de Torres-Secas, No. 6. Two editions were published with this imprint, one with 79 pages of text, the other with 67. The shorter volume is believed to be the genuine first edition. A later, undated edition, was also published in Saragossa (Tipografía La Académica), and the text was also reprinted in the *Colección de 449 reproducciones . . .*, Madrid, 1924

1869 *Calendario civil para 1870 formado con los santos mártires defensores de la independencia y libertad de España*, con notas históricas y críticas, Madrid. Goya is the 'saint and martyr' for Saturday 16 April. (E. Lafuente Ferrari, *Antecedentes . . .*, 1947)

E. Castelar, 'Goya por Carlos Iriarte', *Revista de España*, x, 161–70. The review of Yriarte's book is dated Paris, 15 February 1868

Georges Duplessis, *Les Merveilles de la gravure*, Paris. English trans., London, 1871; and New York edition 1876

Louis Viardot, *Les Merveilles de la peinture*, 2e série, Paris

1870 Gregorio Cruzada Villaamil, *Los Tapices de Goya*, Madrid

1872 Letter from John Ruskin to F. S. Ellis dated 19 September alludes indirectly to their burning of a copy of Goya's *Caprichos*. (John Ruskin, *The Works*, XXXVII, 1909)

The Quarterly Review, cxxxiii, July and October, 485–6, article V: review of

'Discurso de Pedro de Madrazo and Arte de la Pintura por Francisco Pacheco'. Known to have been written by A. H. Layard

1873 A. J. C. Hare, *Wanderings in Spain*, London. 8 further editions were published in London between 1874 and 1906, and a similar number in New York

William Bell Scott, *Murillo and the Spanish School of Painting*, London

1874 Baron Charles Davillier, *L'Espagne*, Paris. References to Goya's *Tauromaquia*, the vitality and realism of the *Maja vestida* and the Velázquez-like *Picador on horseback* in Chapters 5, 29 and 30

1875 P. L. Imbert, *L'Espagne. Splendeurs et misères*, Paris. 2nd edition, Paris, 1876. The first part of the section 'Autour de Madrid' describes the author's impression of the Quinta del Sordo in 1873

1877 Paul Lefort, *Francisco Goya. Étude biographique et critique, suivie de l'essai d'un catalogue raisonné de son œuvre gravé et lithographié*, Paris

Fernand Petit, *Notes sur l'Espagne Artistique*, Lyon, 62–3, 68, 74

Louis Viardot and others, *A Brief History of the Painters of All Schools*, London. References to Goya on pp. 229–30 translated from Viardot's earlier publications in French

Charles Yriarte, 'Goya acquafortiste', *L'Art*, année III, ii.

1878 Alfredo Escobar, 'La Exposición Universal de París', *La Ilustración Española y Americana*, No. xxvii, 22 July, Vol. 2, 43–4

Antonio de Trueba, *Madrid por fuera*, Madrid

1879 P. G. Hamerton, 'Goya', *The Portfolio. An Artistic Periodical*, x, 67–72; 83–6; and 99–103. The article appears in the fourth, fifth and sixth issues for 1879. It was republished with two minor revisions in Hamerton's *Portfolio Papers*, London, 1889, 119–60

Pedro de Madrazo, 'D. Francisco Goya y Lucientes', *Almanaque de la Ilustración Española y Americana para 1880*, año VII, 16ff.

1880 Hermann Lücke, 'Diego Velazquez. Francisco Goya.', in Dr Robert Dohme's *Kunst und Künstler. Spaniens, Frankreichs und Englands*, Leipzig, No. LXXXVI

1882 Cipriano Muñoz y Manzano [Conde de la Viñaza], 'Don Francisco de Goya y Lucientes. Apuntes biográfico-críticos', *Revista contemporánea*, xli, 153–78; 340–52; and 427–38

1884 Félix Fénéon, 'L'Art du XVIIIᵉ siècle', *La Libre Revue*, January

——'À l'Exposition d'Édouard Manet', *La Libre Revue*, April

Gaspar Melchor de Jovellanos, 'Reflexiones sobre el boceto del cuadro llamado "La Familia"', published in Julio Somoza, *Jovellanos. Nuevos datos para su biografía*, Madrid, 150–7. (cf. 1789)

Pedro de Madrazo, *Viaje artístico de tres siglos por las colecciones de cuadros de los reyes de España*, Barcelona

Gerard W. Smith, *Painting. Spanish and French*, New York–London

V. V. Stassow, 'Goya', *Vestnik izyashchnykh iskusstv*, II

1886 Ildefonso Antonio Bermejo, 'El Azotado', *La Ilustración Española y Americana*, ii, No. 25, 7ff

Marcelino Menéndez y Pelayo, *Historia de las ideas estéticas*, Madrid, III (in 2 vols.), Chapter 4

William Bell Scott, 'Goya', in Michael Bryan, *A Biographical and Critical Dictionary of Painters and Engravers . . .*, new edition, ed. Robert Edmund Graves, London, I, 588–9

1887 Joris-Karl Huysmans, 'Goya et Turner', article collected subsequently in *Certains*, Paris, 1889

Lucien Solvay, *L'Art Espagnol*, Paris

Conde de la Viñaza, *Goya. Su tiempo, su vida, sus obras*, Madrid

1888 S. Jacquemont, 'Les maîtres espagnols et l'art naturaliste', *Revue des deux mondes*, lxxxix, 378–413

1889 *Art et Critique*, 14 December. Félix Fénéon's appraisal of Huysmans' *Certains* with Goya reference

1891 Paul Flat, *L'Art en Espagne*, Paris, 183–218

T. de Wyzewa, *Les Grands Peintres de l'Espagne et de l'Angleterre*, Paris

1892? T. de Wyzewa, *La Peinture étrangère au XIXᵉ siècle* (Les Chefs d'Œuvre de l'art au XIXᵉ siècle, Vol. 4), 113ff

1893 R. Muther, *Geschichte der Malerei im XIX Jahrhundert*, Munich, I, 55ff. English trans., *The History of Modern Painting*, 3 vols., London, 1895–6, I, 66–79; revised edition in translation. London–New York, 1912, 4 vols., I, 43–53

1895 Z. Araujo Sánchez, 'Goya', *La España Moderna*, lxxiii (January), 20–45; lxxiv (February), 64–90; lxxv (March), 101–34; lxxvi (April), 74–115. In volume form: *Goya*, Madrid, n.d.

1896 D. S. MacColl, 'Portrait Painters at the Grafton Gallery', *The Saturday Review*, lxxxii, 28 November, 560b–2a

William Rothenstein, 'Goya', *The Saturday Review*, lxxxii, 5 September, 252b–4a; 19 September, 307b–8b. These essays were incorporated, with significant revisions, into Rothenstein's book on Goya in 1900

1897 Angel Ganivet, *Idearium Español*, Madrid

1900 Silverio Moreno, 'Goya', *Revista contemporánea*, cxviii, 53–64 and 163–76

William Rothenstein, *Goya* (The Artist's Library, No. 4), London

E. Tormo, 'Las pinturas de Goya', *Revista de la Asociación Artístico-Arqueológica-Barcelonesa*, año IV, No. 20, 585–600; No. 21, 617–25. Reprinted in *Varios estudios de arte y letras*, Madrid, 1902

Margaret L. Woods, 'Pastels from Spain: Portraits by Goya', *The Cornhill Magazine*, ix, 289–304

1902 S. L. Bensusan, 'Goya: His Times and His Portraits', *The Connoisseur*, ii, January–April, 22–32; iv, September–December, 115ff

——'A Note upon the Paintings of Francisco José Goya', *The Studio*, xxiv, 155ff

Léon-G. Pélissier, *Le Portefeuille de la Comtesse d'Albany (1806–1824)*, Paris. Includes a letter from Brunetti to the Comtesse with strongly antagonistic views about Goya and his imitators. (cf. 1818)

Paul Lafond, *Goya. Étude biographique et critique suivie des catalogues complets*, Paris

D. S. MacColl, *Nineteenth-Century Art*, Glasgow

1903 C. Gasquoine Hartley, 'Francisco Goya', *The Art Journal*, July, 207–11

C. S. Ricketts, *The Prado and Its Masterpieces*, Westminster

Valerian von Loga, *Francisco de Goya*, Berlin, G. Grote'sche Verlagsbuchhandlung. Spanish translation in *La España Moderna*, June–November 1909: ccxlvi, 71–101; ccxlvii, 15–39; ccxlviii, 5–31; ccxlix, 80–106; ccl 38–53; ccli, 73–99. 2nd German edition, Berlin, 1921

1904 C. Gasquoine Hartley, *A Record of Spanish Painting*, London, 275–89

J. Meier-Graefe, *Entwicklungsgeschichte der modernen Kunst*, Munich, 3 vols. 2nd ed., Munich, 1913–23. English version: *Modern Art. Being a contribution to a new system of aesthetics*, trans. F. Simmonds and G. W. Chrystal, London, 1908, 2 vols.

R. Muther, *Goya*, Berlin. English trans., London, 1906 and Spanish version, Madrid, 1909

1904–5 M. Utrillo, 'Lugar de Goya en la pintura', *Forma*, i, 259–79

1905 Marqués de Seoane, *Correspondencia entre D. José de Vargas Ponce y D. Juan Agustín Ceán Bermúdez . . .*, Madrid. Includes a letter from Vargas Ponce asking Ceán to persuade Goya to paint his portrait for the Royal Academy of History. (cf. 1805)

1906 Emilia Pardo Bazán, 'Goya', *La Lectura*, año VI, ii, 233–52

Roger Fry, 'Some recent acquisitions of the Metropolitan Museum, New York', *The Burlington Magazine*, ix, No. 38, 141

Frederick Wedmore, *Whistler and Others*, London

1907 Julius Hofmann, *Francisco de Goya. Katalog seines graphischen Werkes*, Vienna

Paul Lafond, *Nouveaux Caprices de Goya. Suite de trente-huit dessins inédits*, Paris

M. Utrillo, 'Un pintor de su tiempo', *Forma*, ii, 447–8

1908 A. Benois, *Fransisko Goya*, St Petersburg

A. F. Calvert, *Goya. An Account of his Life and Works*, London

Pierre D'Achiardi, *Les Dessins de D. Francisco Goya y Lucientes au Musée du Prado à Madrid*, Rome, D. Anderson, trans. Edmond Barincou, 3 issues

Havelock Ellis, *The Soul of Spain*, London

1909 John Ruskin, *The Works*, ed. E. T. Cook and A. Wedderburn, London, vol. XXXVII (The Letters of John Ruskin 1870–89), 53. Ruskin's letter to F. S. Ellis dated 19 September, 1872, with oblique references to Goya's *Caprichos*. (cf. 1872)

Royall Tyler, *Spain. A Study of Her Life and Arts*, London–New York

1910 *The Spanish Journal of Elizabeth Lady Holland*, ed. The Earl of Ilchester, London, 324–5. Reference to Goya's drawings of the ruins of Saragossa and of Agustina Aragón, and their destruction by French troops in diary for 29 April 1809. (cf. 1809)

J. Huneker, *Promenades of an Impressionist*, New York. Another edition in 1925

J. Meier-Graefe, *Spanische Reise*, Berlin. 2nd edition, Berlin, 1923. English version: *The Spanish Journey*, trans. J. Holroyd-Reece, London, 1926

1912 Frederick Wedmore, 'Goya', *Painters and Painting*, London, n.d.

1914 Anselmo Gascón de Gotor, 'Goya y Zaragoza', *Museum*, Barcelona, iv, 434–40

Mrs Henry Head, *A Simple Guide to Pictures*, London

1915 Rafael Doménech Gallisa, 'Goya y el Impresionismo', *Boletín de la Sociedad Española de Excursiones*, xxiii

A. L. Mayer, 'Goyas Briefe an Martin Zapater', *Beiträge zur Forschung, Studien und Mitteilungen aus dem Antiquariat Jacques Rosenthal*, No. 1, Munich, 39–49

1916 Aureliano de Beruete y Moret, *Goya, pintor de retratos*, Madrid. English translation by Selwyn Brinton, London, 1922

1917 Aureliano de Beruete y Moret, *Goya. Composiciones y figuras*, Madrid

1918 Aureliano de Beruete y Moret, *Goya, grabador*, Madrid

1919 Salvador Dalí, 'Los grandes maestros de la pintura: Goya', *Studium*, Figueras, 1 January

A. L. Mayer, 'Goyas Expressionismus', *Kunstchronik und Kunstmarkt*, xxx, No. 18, 370–3

1921 A. L. Mayer, *Francisco Goya*, Leipzig. English translation, London, 1924; Spanish version, Barcelona, 1925

1922 Loys Delteil, *Le Peintre Graveur illustré*, Vols XIV and XV: Francisco Goya, Paris

1923 Roger Fry, *A Sampler of Castile*, Richmond

A. L. Mayer, 'Dibujos desconocidos de Goya', *Revista Española de Arte*, xi, 376–84

Pierre Paris, 'Pour mieux connaître Goya', *Revue des deux mondes*, VIIe période, xvii, 635–58; 884–901

Narciso Sentenach y Cabañas, 'Goya Académico', *Boletín de la Real Academia de Bellas Artes de San Fernando*, xvii, 169–74

Blamire Young, *The Proverbs of Goya*, London

1924 Otto Benesch, 'Rembrandts Vermächtnis', *Belvedere*, v, 148–76. In English 'Rembrandt's Artistic Heritage', *Gazette des Beaux-Arts*, xxxiii, 1948, with a second part in *Gazette des Beaux-Arts*, lvi, 1960. Both essays—the second one revised, were republished in English in *Collected Writings of Otto Benesch*, ed. Eva Benesch, I, *Rembrandt*, London, 1970

Aureliano de Beruete y Moret, *Conferencias de Arte*, Madrid

Colección de cuatrocientas cuarenta y nueve reproducciones de cuadros, dibujos y aguafuertes de Don Francisco de Goya precedidos de un epistolario del gran pintor y de las Noticias biográficas publicadas por Don Francisco Zapater y Gómez en 1860 [sic], Madrid

'Juan de la Encina' [i.e. Ricardo Gutiérrez Abascal], *Crítica al margen*, 1ª serie, Madrid

1926 Ricardo del Arco, *Por qué Goya pintó como pintó*, Conferencia pronunciada en el Aeneo de Zaragoza el día 4 de febrero de 1926 (Publicaciones de la Junta Organizadora del Centenario de Goya, I), Saragossa

Ventura Bagüés, *Don Francisco el de los toros* (Publicaciones de la Junta Organizadora del Centenario de Goya, IV), Saragossa

1927 Clive Bell, *Landmarks in Nineteenth-Century Painting*, London

Pedro Beroquí, 'Una biografía de Goya escrita por su hijo', *Archivo Español de Arte y Arqueología*, No. 7, 99–100

Campbell Dodgson, 'Some undescribed states of Goya's etchings', *The Print Collectors' Quarterly*, xiv, 30–45

Ramón Gómez de la Serna, 'El gran español Goya', *Revista de Occidente*, xvi, No. 47, 191–203

Max Nordau, *Los grandes maestros del arte español*, trans. R. Cansinos Assens, Barcelona

Dr R. Roya Villanova, 'Goya y la medicina' (Lección inaugural del curso de patología y clínica médicas de 1927–8), *Universidad*, Zaragoza, IV, No. 4, 969–92

1928 Aureliano de Beruete y Moret, *Goya. Goya, pintor de retratos. Goya, composiciones y figuras, y Goya, grabador*, compendiada por F. J. Sánchez Cantón, Madrid

'Juan de la Encina' [i.e. Ricardo Gutiérrez Abascal], *Goya en zig-zag*, Madrid, n.d.

J. Ezquerra del Bayo, *La Duquesa de Alba y Goya*, Madrid. Reprinted in Madrid, 1959

Ramón Gómez de la Serna, *Goya*, Madrid, Atenea (Ediciones 'La Nave', 3). Republished in 1930. A new and enlarged edition of the work was made in 1937 and reprinted in 1943. This also appeared in the Colección Austral in 1945, 1950 etc.

Valerio Mariani, 'Primo centenario dall morte di Francisco Goya—disegni inediti', *L'Arte*, xxxi, 97–108

Bernardino de Pantorba, *Goya. Ensayo biográfico y crítico*, Madrid

F. J. Sánchez Cantón, 'Los dibujos del viaje a Sanlúcar', *Boletín de la Sociedad Española de Excursiones*, xxxvi, No. 1, 13–26

——'Goya en la Academia', Lectura en la Real Academia de Bellas Artes de San Fernando de Madrid, 11 April 1828, Madrid

Luis G. Valdeavellano, 'Las relaciones de Goya con el Banco de San Carlos', *Boletín de la Sociedad Española de Excursiones*, xxxvi, No. 1, 56–65

Various articles of biographical interest were published in the periodical *Aragón* (Saragossa), No. 31, April

1928–50 X. Desparmet-FitzGerald, *L'Œuvre peint de Goya*, Paris

1929 Max Dvořák, 'Eine Illustrierte Kriegschronik', *Gesammelte Aufsätze zur Kunstgeschichte*, Munich, 242ff

E. Mottini, 'Goya amaro e feroce', *L'anima e il colore, saggi d'arte*, Rome–Milan

1930 Juan Allende de Salazar, *Discurso leído por D. Juan . . . en el acto de recepción pública en la Real Academia de Bellas Artes de San Fernando el día 8 de junio de 1930 y contestación del Excmo. Sr. D. Elías Tormo*, Madrid

Karel Čapek, *Výlet do Spanel*, Prague. English version: *Letters from Spain*, trans. Paul Selver, London, 1931, with reprints the same year and in 1932

Lord Derwent, *Goya. An Impression of Spain*, London

A. L. Mayer, 'Echte und falsche Goya-Zeichnungen', *Belvedere*, xi, No. 1, 215–17

F. J. Sánchez Cantón, *Goya*, trans. Georges Pillement, Paris. Revised and published in Spain in 1951. English ed., 1964

1931 William Rothenstein, *Men and Memories. Recollections*, London, Vol. I. Details of Rothenstein's first visit to Spain, and the development of his interest in Goy as a result of contacts with Cunninghame Graham. Vol. II, 1932; Vol. III, 1939

Xavier de Salas, 'Lista de los cuadros de Goya hecha por Carderera', *Archivo Español de Arte y Arqueología*, vii, 174–8

F. J. Sánchez Cantón, 'La estancia de Goya en Italia', *Archivo Español de Arte y Arqueología*, vii, 182–4

Campbell Dodgson, *Los Desastres de la Guerra, etched by Francisco Goya y Lucientes*, Oxford

1932 Roger Fry, *The Arts of Painting and Sculpture*, London

Theodor Hetzer, 'Francisco Goya und die Krise der Kunst um 1800'. Essay written in this year but not published until 1950

1935 Jean Adhémar, 'Essai sur les débuts de l'influence de Goya en France au XIXe siècle', Introduction to Exhibition Catalogue of the Bibliothèque Nationale, Paris: *Goya. Exposition de l'œuvre gravé, de peintures, de tapisseries, et de cent-dix dessins du Musée du Prado*

Emiliano M. Aguilera, *Las Pinturas negras de Goya. (Historia, interpretación y crítica)*, Madrid, n.d.

Cartas confidenciales de la reina María Luisa y de Don Manuel Godoy con otras tomadas del Archivo reservado de Fernando VII, del Histórico Nacional y del de Indias, Introducción y notas explicativas por Carlos Pereyra, Madrid, n.d.

Manuel Gómez Moreno, 'Las crisis de Goya', *Revista de la Biblioteca, Archivo y Museo del Ayuntamiento de Madrid*, xii, No. 45, 11–23

A. L. Mayer, 'Some unknown drawings by Francisco Goya', *Old Master Drawings*, ix, No. 33, 20–2

D. Sánchez de Rivera, 'La enfermedad de Goya', *Revista Española de Arte*, xii, No. 5, 241–8. The article is dated December 1934

1936 A. A. Sidorov, *Goya*, Moscow–Leningrad

José Vasconcelos, *Estética*, Madrid–Mexico

1937 Herbert Read, *Art and Society*, London. 2nd edition 1945, reprinted 1946, 1947 and 1950; 3rd edition 1956; 4th edition 1967

1938 Enriqueta Harris, Introduction to Exhibition Catalogue, *From Greco to Goya*, Tomás Harris Ltd, in aid of the British Red Cross Society's Spanish Relief Fund

F. D. Klingender, 'Realism and Fantasy in the Art of Goya', *The Modern Quarterly*, i, No. 1, 64–77

Charles Poore, *Goya*, New York

Harry B. Wehle, *Fifty Drawings by Francisco Goya* (The Metropolitan Museum of Art Papers, No. 7), New York

1939 V. I. Broski, *Francisco José de Goya y Lucientes*, Moscow–Leningrad

Paul Claudel, 'La Peinture Espagnole', essay on the exhibition of paintings from the Prado held in Geneva, written in September and October. With title 'Le Prado à Genève', *Revue de Paris*, 15 December and 1 January 1940. Reprinted in *L'Œil écoute* (1946) and *Œuvres en prose*, Paris, 1965

'Goya o el sentido profundo de España', *Vértice*, May, No. 22, 3–7

1940 Wyndham Lewis, 'Picasso', *The Kenyon Review*, Spring number. The article includes a comparison of Picasso's approaches to war with Goya's. (Reprinted in *Wyndham Lewis on Art*, 1969)

1942 Leonardo Estarico, *Francisco de Goya. El hombre y el artista*, Buenos Aires

1943 Eugenio D'Ors, *Epos de los destinos. I: El vivir de Goya*, Madrid. Originally published in French (1926), the book was revised in 1934 and again in 1942

Oskar Hagen, *Patterns and Principles of Spanish Art*, Wisconsin

Aldous Huxley, *The Complete Etchings of Goya*, New York. Introduction reprinted with the title 'Variations on Goya' in *Themes and Variations*, London, 1950, 209–24

José Llampayas, *Goya. (Su vida, su arte y su mundo)*, Madrid

D. Sánchez de Rivera y Moset, *Goya. La leyenda, la enfermedad y las pinturas religiosas*, Madrid

1944 José López-Rey, 'A Contribution to the Study of Goya's Art: The San Antonio Frescoes', *Gazette des Beaux-Arts*, xxv, No. 926, 231–48

Hans Rothe, *Las Pinturas del Panteón de Goya*, trans. Manuel Gutiérrez Marín, Barcelona

Xavier de Salas, *Goya. La Familia de Carlos IV*, Barcelona

1945 Philip Hofer, 'Some undescribed states of Goya's *Caprichos*', *Gazette des Beaux-Arts*, xxviii, No. 943, 163–80

I. M. Levina, *Goya*, Leningrad

José López-Rey, 'A Contribution to the Artist's Life: Goya and the World around him', *Gazette des Beaux-Arts*, xxviii, No. 943, 129–50

Francisco Pompey, *Goya. Su vida y sus obras*, Madrid

1946 Dr Joaquín Aznar Molina, *Goya visto por un médico*, Saragossa

Dr. C. Blanco-Soler, *Esbozo psicológico, enfermedades y muerte de la duquesa*

María del Pilar, Teresa Cayetana de Alba. Conferencia dada en la Real Academia de la Historia el día 10 de 1946, Madrid

J. A. Gaya Nuño, 'La estética íntima de Goya', *Revista de ideas estéticas*, No. extraordinario dedicado a Goya, iv, Nos. 15–16, July–December, 468ff

Angel González Palencia, 'El estudio crítico más antiguo sobre Goya', *Boletín de la Real Academia de la Historia . . . del bicentario del nacimiento de Don Francisco de Goya*, 75–83

Paul Guinard, Introduction to Exhibition Catalogue: *Goya y el arte francés*, Instituto Francés de España, May–June, Madrid

José Ibáñez Martín, 'Goya, símbolo español', *Arriba*, 31 March, special centenary supplement with unnumbered pages

F. Jiménez-Placer, 'El poema goyesco de los "Disparates"', *Revista de ideas estéticas*, No. extraordinario dedicado a Goya, iv, Nos. 15–16, July–December, 340–77

E. Lafuente Ferrari, *Goya. El Dos de Mayo y los Fusilamientos*, Barcelona

Marqués de Lozoya, 'Goya y Jovellanos', *Boletín de la Real Academia de la Historia conmemorativo del bicentario del nacimiento de Don Francisco de Goya*, Madrid, 95–103

——'Casticismo y universalidad de Goya', *Arriba*, 31 March

A. Ruiz Cabriada, *Aportación a una bibliografía de Goya*, Madrid

Valentín de Sambricio, *Tapices de Goya*, Madrid. Apparently issued in 1948

——'Aspectos inéditos de la vida de Goya: Goya no fue afrancesado', *Arriba*, 31 March

F. J. Sánchez Cantón, 'Cómo vivía Goya', *Archivo Español de Arte*, xix, 73–109

——'Goya pintor religioso', *Revista de ideas estéticas*, iv, 277–306

1947 Dr. Blanco-Soler, *Goya, su enfermedad y su arte*, Madrid

E. Lafuente Ferrari, *Antecedentes, coincidencias e influencias del arte de Goya. Catálogo ilustrado de la exposición celebrada en 1932 ahora publicado con un estudio preliminar sobre la situación y la estela del arte de Goya*, Madrid

Goya. Drawings from the Prado, introduction by André Malraux, trans. E. Sackville-West, London

José López-Rey, *Goya y el mundo a su alrededor*, Buenos Aires

Frederick S. Wight, 'Revulsions of Goya: Subconscious Communications in the Etchings', *Journal of Aesthetics and Art Criticism*, v, September, 1–28

1948 Jean Adhémar, *Goya*, trans. Denys Sutton and David Weston, London–Paris

F. D. Klingender, *Goya in the Democratic Tradition*, London. 2nd edition,

London and New York, 1968. Czech translation, Prague, 1951; German translation, Berlin 1954; Portuguese translation, Lisbon, 1967

Hans Sedlmayr, *Verlust der Mitte. Die bildende Kunst des 19 und 20 Jahrhunderts als Symptom und Symbol der Zeit*, Salzburg. English version, *Art in Crisis. The Lost Centre*, trans. Brian Battershaw, London, 1957

M. S. Soria, 'Goya's Allegories of Fact and Fiction', *The Burlington Magazine*, xc, 196–200

1949 Georges Bataille, 'L'Œuvre de Goya et la lutte des classes', *Critique: Revue générale des publications françaises et étrangères*, 851–3. Review of Klingender's book

E. H. Gombrich, 'Imagery and Art in the Romantic Period', *The Burlington Magazine*, xci, No. 555, 153–8. Reprinted in *Meditations on a Hobby Horse*, London, 1963 (reprinted 1965, 2nd edition 1971, 120–6). Included in F. Licht, *Goya in perspective*, New York, 1973

E. Lafuente Ferrari, 'Goya y el arte francés', *Goya (Cinco Estudios)*, Saragossa, 45–66

F. J. Sáchez Cantón, *Los Capriches de Goya y sus dibujos preparatorios*, Barcelona

Martín S. Soria, 'Las miniaturas y retratos-miniaturas de Goya', *Cobalto*, No. 2, 1–4

1950 Theodor Hetzer, 'Francisco Goya und die Krise der Kunst um 1800', *Weiner Jahrbuch für Kunstgeschichte*, xiv, 7–22. Reprinted in Hetzer's *Aufsätze und Vorträge*, 1957, I, 177–98; English translation in F. Licht, *Goya in perspective*, New York, 1973, 92–113

André Malraux, *Saturne. Essai sur Goya* (La Galerie de la Pléiade, 1), Paris. English translation by C. W. Chilton, London, 1957

M. Núñez de Arenas, 'Manojo de noticias—La suerte de Goya en Francia', *Bulletin Hispanique*, lii, Nos. 3–4, 229–73

José Ortega y Gasset, *Papeles sobre Velázquez y Goya*, Madrid

Francis Reitman, *Psychotic Art*, London

1951 José Camón Aznar, *Los Disparates de Goya y sus dibujos preparatorios*, Barcelona
Catharina Boelcke-Astor, 'Sobre la adquisición y estampación de los "Desastres de la Guerra" y de los "Proverbios"', *Archivo Español de Arte*, xxiv, No. 95, 263–4

José López-Rey, *Goya*, London

F. J. Sánchez Cantón, *Vida y obras de Goya*, Madrid. Revised and updated version of the 1930 French publication. Edition in English with further revisions, Madrid, 1964

1952 E. Lafuente Ferrari, *Los Desastres de la Guerra de Goya y sus dibujos preparatorios*, Barcelona

Marqués del Saltillo, *Miscelánea madrileña, histórica y artística, Primera serie: Goya en Madrid, su familia y allegados (1746–1856)*, Madrid

1952–3 Catharina Boelcke-Astor, 'Die Drucke der Desastres de la Guerra von Francisco Goya unter Zugrundelgung der Bestände des Berliner Kupferstichkabinetts', *Münchner Jahrbuch fur Bildenden Kunst*, 3rd series, iii–iv, 253–334

1953 E. Lafuente Ferrari, 'Los toros en las artes plásticas', in *Los Toros. Tratado técnico e histórico*, ed. José María de Cossío, Madrid, Vol. II. Subsequent editions include 3rd edition, Madrid, 1961

José López-Rey, *Goya's Caprichos. Beauty, Reason and Caricature*, 2 vols

1954 P. Gassier, 'Les dessins de Goya au Musée du Louvre', *La Revue des Arts*, iv, No. 1, 31–41

Roberto Longhi, 'Il Goya romano e la cultura di Via Condotti', *Paragone*, v, No. 53, 28–39

J. Milicua, 'Anotaciones al Goya joven', *Paragone*, v, No. 53, 5–27

V. S. Pritchett, *The Spanish Temper*, London

A. Rodríguez-Moñino, *Goya y Gallardo*, Madrid. Reprinted in *Relieves de erudición*, Madrid, 1959

V. Sambricio, 'Les Peintures de Goya dans la chapelle du Palais des Comtes de Sobradiel à Saragosse', *La Revue des Arts*, iv, 215–22

F. J. Sánchez Cantón, *Museo del Prado: Los dibujos de Goya*, Madrid, 2 vols

——'Una nota para el epistolario de Goya', *Archivo Español de Arte*, No. 108, 327–30

1955 E. F. Helman, 'Los "Chinchillas" de Goya', *Goya* (Madrid periodical). Reprinted in Professor Helman's *Jovellanos y Goya*, Madrid, 1970

——'Padre Isla and Goya', *Hispania*, xxxviii, No. 2, 150–8. Reprinted in *Jovellanos y Goya* (1970)

——'The Elder Moratín and Goya', *Hispanic Review*, xxiii, 219–30. Reprinted in *Jovellanos y Goya* (1970)

A. Hyatt Mayor, 'Goya's "Hannibal Crossing the Alps"', *The Burlington Magazine*, xcvii, No. 630, 295–6

E. Lafuente Ferrari, *Goya. The Frescos in San Antonio de la Florida in Madrid*, trans. Stuart Gilbert, Geneva–Paris–New York. Spanish and French editions were also published simultaneously

G. Levitine, 'Literary Sources of *Capricho 43*', *Art Bulletin*, xxxvii, 55–9

M. I. Shakhnovich, *Goya protiv papstva i inkvizitsii*, Moscow–Leningrad

E. du Gué Trapier, *Goya. A Study of His Portraits 1797–9*, New York

Condesa de Yebes, *La Condesa-Duquesa de Benavente. Una vida en unas cartas*, Madrid. Includes documentation relating to the Osuna family's patronage of Goya

1956 Agustín de la Herrán, *La Carátula de Goya* (Serie del Aguila, 1), Bilbao

José López-Rey, *A Cycle of Goya Drawings*, London

Noël Mouloud, 'L'Évolution du style de Goya: La convergence de ses recherches techniques et symboliques', *Revue d'Esthétique*, ix, 282–304

1957 C. Ferment, 'Goya et la Fantasmagorie', *Gazette des Beaux-Arts*, 6ᵉ période, xlix, No. 1059, 223–6

1958 E. Crispolti, 'Otto nuove pagine del taccuino "Di Madrid" di Goya ed alcuni problemi ad esso relativi', *Commentari*, ix, No. 3, 181–205

Eleanor Sherman Font, 'Goya's Source for the Maragato Series', *Gazette des Beaux-Arts*, 6ᵉ période, lii, No. 1078, 289–304

E. F. Helman, '"Caprichos" and "Monstruos" of Cadalso and Goya', *Hispanic Review*, xxvi, No. 3, 200–22. Reprinted in *Jovellanos y Goya* (1970)

I. M. Levina, *Goya*, Leningrad–Moscow

José Ortega y Gasset, *Goya*, Madrid

E. Sayre, 'An Old Man Writing—A Study of Goya's Albums', *Boston Museum Bulletin*, lvi, 116–36

1959 E. F. Helman, 'The Younger Moratín and Goya', *Hispanic Review*, xxvii, No. 1, 103–22. Reprinted in *Jovellanos y Goya* (1970)

George Levitine, 'Some Emblematic Sources of Goya', *Journal of the Warburg and Courtauld Institutes*, xxii, 106–31

E. du Gué Trapier, 'An Unpublished Letter by Goya', *The Burlington Magazine*, ci, No. 670, 27

1960 E. F. Helman, 'Goya, Moratín y el Teatro', *Insula*, xv, No. 161, April. Reprinted in *Jovellanos y Goya* (1970)

——'Goya y Moratín hijo: Actitudes ante el pueblo', *Revista de la Universidad de Madrid*, ix, No. 35, 591–605. Reprinted in *Jovellanos y Goya* (1970)

Fritz Novotny, *Painting and Sculpture in Europe 1780–1880* (The Pelican History of Art), Harmondsworth. Chapter 7: Francisco de Goya (1746–1828), 79–84

G. Rouanet, *Le Mystère Goya: Goya vu par un médecin*, Paris, n.d.

E. du Gué Trapier, 'Only Goya', *The Burlington Magazine*, cii, No. 685, 158–61

1961 Diego Angulo Iñíguez, 'El "Saturno" y las pinturas negras de Goya', *Archivo Español de Arte*, xxxv, 173–7

Luis Auguet, 'Goya en la filatelia', *Mundo Hispánico*, No. 164, November

Nigel Glendinning, 'The Monk and the Soldier in Plate 58 of Goya's *Caprichos*', *Journal of the Warburg and Courtauld Institutes*, xxiv, 120–7

George Levitine, 'The Elephant of Goya', *The Art Journal*, xx, 145–7

Folke Nordström, 'Goya's Portrait of the Four Temperaments', *De Artibus Opuscula XL. Essays in Honor of Erwin Panofsky*, New York, 394–401. Reprinted with other essays in Nordström's *Goya, Saturn and Melancholy. Studies in the Art of Goya*, Stockholm-Göteborg-Uppsala, 1962. Included in F. Licht, *Goya in perspective*, New York, 1973

Jean-Paul Sartre, 'The Unprivileged Painter: Lapoujade', Essay in the Exhibition Catalogue for the Galérie Pierre Domec, Paris, 10 March–15 April. English translation in Jean-Paul Sartre, *Essays in Aesthetics*, trans. Wade Baskin, London, 1964. Goya's approach to war in his art is compared unfavourably with that of Picasso in this essay

1962 Per Bjurström, 'Jacob Gustaf De la Gardie och Goya', *Meddelander frän Nationalmuseum*, Stockholm, No. 86, 77–81

Terence Cawthorne, 'Goya's Illness', *Proceedings of the Royal Society of Medicine*, lv, March, Section of the History of Science, 213–17

Nigel Glendinning, 'El asno cargado de reliquias en los *Desastres de la Guerra* de Goya', *Archivo Español de Arte*, xxxv, No. 139, 221–30

——'Goya y las tonadillas de su época', *Segismundo*, ii, No. 1, 105–20

Folke Nordström, *Goya, Saturn and Melancholy. Studies in the Art of Goya*, Stockholm-Göteborg-Uppsala

Antonio J. Onieva, *Goya*, Madrid

1963 Charles Bouleau, *Charpentes. La Géométrie secrète des peintres*, Paris

G. M. Carstairs, 'Art and Psychotic Illness', *Abbottempo*, Book 3, 15–21

Douglas Cooper, 'Goya', *The Sunday Times Colour Magazine*, 8 December

Hubert Damisch, 'L'Art de Goya et les contradictions de l'esprit des Lumières', *Utopie et Institutions au XVIIIe siècle. Le Pragmatisme des Lumières*, ed. P. Francastel, Paris–The Hague, 247–57

Nigel Glendinning, 'Nuevos datos sobre las fuentes del *Capricho* No. 58 de Goya', *Papeles de Son Armadans*, xci, 13–29

——'Goya and Arriaza's "Profecía del Pirineo"', *Journal of the Warburg and Courtauld Institutes*, xxvi, 363–6

——'¿La Nevada, de Goya en un poema de su época?', *Insula*, No. 204, 13

Edith Helman, *Transmundo de Goya*, Madrid

Royal Academy of Arts in London, *Goya and His Times*, Catalogue of the Winter Exhibition 1963–4

X. de Salas, 'Sobre la bibliografía de Goya. (La polémica Carderera-Cruzada

Villaamil)', *Archivo Español de Arte*, xxxvi, No. 141, 47–63

F. J. Sánchez Cantón, *Le Pitture nere di Goya alla Quinta del Sordo*, Milan. Editions in Spanish and French were published the same year. For the English edition, see 1964

E. du Gué Trapier, 'Unpublished Drawings by Goya in the Hispanic Society of America', *Master Drawings*, i, 11–20

References to Goya's etchings after Velázquez, in the correspondence of P. P. Giusti (1778) in María del Carmen Velázquez, *La España de Carlos III de 1764 a 1776 según los embajadores austríacos*, Mexico

1964 John Berger, 'The Maja revealed', *The Sunday Times Colour Magazine*, 20 September, 20–4

Enriqueta Harris, 'A Contemporary Review of Goya's "Caprichos"', *The Burlington Magazine*, cvi, No. 730, 38–43

Tomás Harris, *Goya. Engravings and Lithographs*, Oxford, 2 vols.

Jutta Held, *Farbe und Licht in Goyas Malerie*, Berlin

Edith Helman, 'Identity and Style in Goya', *The Burlington Magazine*, cvi, No. 730, 30–7

Bernard Myers, *Goya*, London

Dr. José Riquelme Salar, *Perfil biológico de Goya*, Alicante.

X. de Salas, 'Sobre un autorretrato de Goya y dos cartas inéditas sobre el pintor', *Archivo Español de Arte*, xxxvii, No. 148, 317–20

——Sur les tableaux de Goya qui appartinrent à son fils', *Gazette des Beaux-Arts*, lxiii, 99–100

——'Portraits of Spanish Artists by Goya', *The Burlington Magazine*, cvi, No. 730, 14–15

——'A Group of Bullfighting Scenes by Goya'. *The Burlington Magazine*, cvi, No. 730, 37–8

F. J. Sánchez Cantón, *Goya and the Black Paintings*, with an appendix by X. de Salas, London

Eleanor Sayre, 'Eight Books of Drawings by Goya—I', *The Burlington Magazine*, cvi, No. 730, 19–30

Denys Sutton, 'Goya: Apostle of Reason', *Apollo*, lxxix, No. 23, 70ff

E. du Gué Trapier, *Goya and his Sitters*, New York

1965 Jutta Held, 'Francisco de Goya. Literatur von 1940–1962', *Zeitschrift für Kunstgeschichte*, 246–57

1966 G. M. Carstairs, 'The Madness of Art', Part 2 of *The Frontiers of Madness*, in *The Observer Colour Magazine*, 12 June, 15–25

José Gudiol, *Goya*, London

Jutta Held, 'Goyas Akademiekritik', *Münchner Jahrbuch der Bildenden Kunst*, 214ff

E. F. Helman, 'Fray Juan Fernández de Roxas y Goya', *Homenaje a Rodríguez-Moñino. Estudios de erudición que le ofrecen sus amigos e discípulos hispanistas norteamericanos*, Madrid, I, 241–52. Reprinted in *Jovellanos y Goya* (1970)

José López-Rey, 'Goya de cuerpo', *Liber Amicorum Salvador de Madariaga*, ed. H. Brugmans and R. Martínez Nadal, 359–66

Eleanor Sayre, 'Goya's Bordeaux Miniatures', *Boston Museum Bulletin*, lxiv, 84–123

1968 E. Pardo Canalís, 'La Iglesia Zaragozana de San Fernando y las pinturas de Goya', *Goya*, No. 84

X. de Salas, 'Precisiones sobre pinturas de Goya: *El Entierro de la Sardina*, la serie de obras de gabinete de 1793–1794 y otras notas', *Archivo Español de Arte*, xli, No. 161, 1–16

1969 Enriqueta Harris, *Goya*, London

Joël Isaacson, 'Manet and Spain', Introduction to Exhibition Catalogue *Manet and Spain*, Michigan, Ann Arbor

Wyndham Lewis on Art. Collected Writings 1913–1956, ed. W. Michel and C. J. Fox, London.

1970 Nigel Glendinning, 'Portraits of War', *New Society*, No. 390, 19 March, 474–7

José Gudiol, *Goya. 1746–1828. Biografía, estudio analítico y catálogo de sus pinturas*, Barcelona, 4 vols. Editions in English and Spanish

Edith Helman, *Jovellanos y Goya*, Madrid

Priscilla E. Muller, 'Goya *The Family of Charles IV*: An interpretation', *Apollo*, xci, No. 96, February, 132–7

José F. Pérez Gállego, 'Goya entre el Este y el Oeste', *Heraldo de Aragón*, 11 October.

1971 Pierre Gassier and Juliet Wilson, *Goya. His Life and Work*, London

'The Riddle of Goya's Infirmity', in *The Adventure of Art*, ed. Félix Martí-Ibáñez, New York, n.d.

Jutta Held, *Die Genrebilder der Madrider Teppichmanufaktur und die Anfänge Goyas*, Berlin

1972 J. Baticle, 'Eugenio Lucas et les satellites de Goya', *La Revue du Louvre*, No. 3, 3–16

Ilse Hempel Lipschutz, *Spanish Painting and the French Romantics* (Harvard Studies in Romance Languages, XXXII), Cambridge, Mass.

W. G. Niederland, 'Goya's Illness: A case of lead encephalopathy?', *New York State Journal of Medicine*, 72, 413–18

Boyce Rensberger, 'Goya's Grotesquery laid to lead's use', *New York Times*, 28 February 1972, 33

Eric Young, 'An Unpublished Letter from Goya's Old Age', *The Burlington Magazine*, cxiv, No. 833, 558–9

1973 Pierre Gassier, *Les Dessins de Goya: Les Albums*, trans. Robert Allen and James Emmons and published with the title *The Drawings of Goya: The Complete Albums*, London

F. Licht, *Goya in Perspective*, New York

Xavier de Salas, 'Sur deux miniatures de Goya récemment retrouvés', *Gazette des Beaux-Arts*, VI^e période, lxxxi, March, 169–71

E. Sayre, 'Goya's Titles to the *Tauromaquia*', *Festschrift für Hanns Swarzenski*, 511–21

1974 Mariano Juberías Ochoa, 'La pintura en el Madrid de Goya', *Villa de Madrid*, xii, No. 44, 34–41

Xavier de Salas, 'Dos notas, a dos pinturas de Goya, de tema religioso', *Archivo Español de Arte*, xlvii, No. 188, October–December, 383–96

E. Sayre and others, *The Changing Image: Prints by Francisco Goya*, Boston

1975 Bernard Dorival, 'Le Testament spirituel de Goya', *Journal de Psychologie normale et pathologique*, No. 2, April–June, 173–90

Vasile Florea, *Goya*, Bucharest. English translation published in London the same year

Pierre Gassier, *Les Dessins de Goya*, II, trans. James Emmons, and published with the title *The Drawings of Goya: The Sketches, Studies and Individual Drawings*, London

Nigel Glendinning, 'The Strange Translation of Goya's "Black Paintings"', *The Burlington Magazine*, cxvii, No. 868, 465–79

E. Lafuente Ferrari, 'Las cartas de Goya a Zapater y los epistolarios españoles', *Homenaje a la memoria de Don Antonio Rodríguez-Moñino 1910–1970*, Madrid, 285–328

1976 Nigel Glendinning, 'Variations on a Theme by Goya: *Majas on a Balcony*', *Apollo*, ciii, No. 167, 40–7

Gwyn A. Williams, *Goya and the Impossible Revolution*, London

II. List of Quoted Artistic and Literary Reactions to Goya's Work

1799 *Semanario de Zaragoza*, 25 February, 133–6. Poem by José Mor de Fuentes dedicated to Goya: 'Hermandad de la pintura y de la poesía. A mi paisano

y amigo Don Francisco Goya'. Reprinted in *Poesías de D. Joseph Mor de Fuentes*, Tercera parte, in 1800

ca 1800 Francisco Gregorio de Salas writes a four line epigram praising Goya's ability as a portrait painter: 'La Naturaleza excedes . . .' First printed in *Epigramas y otras poesías*, Madrid, 1802. Numerous reprints

1804 José Moreno de Tejada, *Excelencias del pincel y del buril*, Madrid. A didactic poem apparently including a description of Goya's tapestry cartoon *Winter* (or *The Snowfall*). Passage reproduced in *Insula*, No. 204, 1963, 13

1805 Probable date of composition of Manuel José Quintana's poem to Goya. The text was first printed in an unidentified periodical in the second half of the nineteenth century and included with the Spanish translation of Laurent Mathéron's *Goya*, Madrid, 1890

Probable date of Gaspar Melchor de Jovellanos' poem 'Respuesta al mensaje de Don Quijote . . .', which alludes in passing to Goya's imaginative powers. Printed in *Mélanges à la mémoire de Jean Sarrailh*, Paris, 1966, I, 379–95

1814 José Vargas Ponce's poem 'Proclama de un solterón' announced in the *Gaceta de Madrid* on 15 August. This satirical poem contains an implied tribute to Goya's imagination. Second edition, Madrid, 1830

1815 Bartolomé José Gallardo's poem 'El verde gabán o el rey en berlina', in *O Portuguez*, London, iii, No. 17, 493–500. References to Goya's imaginative powers. Reprinted by A. Rodríguez-Moñino in *Goya y Gallardo*, Madrid, 1954

1824 Delacroix records seeing 'the Goyas' (presumably the *Caprichos*) in his *Journal* for Friday, 19 March. According to the same source he made some caricaturesque lithographs in the Goya manner on the evening of Wednesday 7 April

1825 Leandro Fernández de Moratín's poem 'Silva a D. Francisco Goya' published in his *Obras líricas*, London, 208–9, and Paris, 454

1827 Alfred de Musset copies *Capricho* No. 17, which also inspires a passage in his poem 'Andalouse'

1830 Victor Hugo uses the caption of No. 64 of the *Caprichos* ('Buen Viage') as the ironic epigraph for No. XXVIII of *Les Feuilles d'automne*: 'A mes amis S-B et L.B.'

1831 Hugo refers to Goya in *Notre-Dame de Paris*. Théophile Gautier links Goya's name with that of Callot in his poem 'Albertus', published in 1832

1832 Anonymous French political cartoon called *Le Cauchemar de Louis Philippe*, based on Goya's *Capricho* No. 43, probably published about this time

Delacroix records seeing two Saints by Goya (i.e. *St Justa and St Rufina*) in Seville cathedral on the morning of Friday 25 May, in an entry in his

Journal. Earlier the same year Delacroix had felt Goya 'throbbing about him in Algiers'.

Ramón de Mesonero Romanos, 'El día 30 del mes', written in August 1832 and published in *Cartas españolas*, vi, associates Goya's *Caprichos* with the extreme grotesque

1838 Ramón de Mesonero Romanos, 'La Exposición de pinturas', *Semanario pintoresco*, 30 September, 720. Speaks of elderly painters who claimed they had accompanied Goya to bull-fights

1839 Victor Hugo's poem 'Ce qui se passait aux feuillantines vers 1813' written in May 1839, refers to Goya's 'gnomes' (*Caprichos* No. 49?), associating them with Callot's devils and using the phrase 'vrais cauchemars de moine'.

1846 Passing reference to Goya's *Tauromaquia* in Alexandre Dumas' account of his travels in Spain

1848 Hercules Brabazon's first visit to Spain, including a period in Madrid copying Velázquez and 'searching for more Goyas'

1849 Roger de Beauvoir's poem 'À Goya' in *L'Artiste,* 5ᵉ série, iii, 15 May, 57

1851 Ramón de Mesonero Romanos, 'Madrid en feria', *La Ilustración*, September. Refers to the 'expressive quality' of Goya's paintings of Madrid festivities

1855 Emilio Castelar's novel *Ernesto. Novela de costumbres* refers to Goya in Chapter XLIII, apparently recalling his satirical depiction of society

1857 Charles Baudelaire's poem 'Les Phares', containing a stanza about Goya, appeared in the first edition of *Les Fleurs du Mal*, Paris. The manuscript was sent to press at the beginning of February and the book was published in July

1858 Baudelaire's poem 'Duellum', inspired by No. 62 of the *Caprichos*, appeared in *L'Artiste*, 19 September. Subsequently it was included in the second edition of *Les Fleurs du Mal*, Paris, 1861

1859 Letter from Baudelaire to his friend Nadar in May enthusing about copies of the Naked and Clothed Maja in the possession of Moreau, a picture dealer in Paris. Remarking their 'galant et féroce' quality, he notes that the majority do not appreciate Goya's sense of beauty

1862 Roger de Beauvoir's Goyesque poems 'Les Manolas' and 'L'Écolier de Goya' published in *Les Meilleurs Fruits de mon panier. Poésies*, Paris

Ramón de Mesonero Romanos, 'La vida en Madrid—carácter de los habitantes' in *Tipos, grupos y bocetos de cuadros de costumbres* (Obras jocosas y satíricas del 'Curioso Parlante', vol. I), Madrid, compares the 'manolos' of Goya and Ramón de la Cruz

Manet uses a *Tauromaquia* print as a model for a background group in *Mlle Victorine in the costume of a bull-fighter*. A copy of the *Clothed Maja*, which

Baudelaire had seen and urged Nadar to photograph in 1859, may well have inspired the pose of Manet's *Young Woman in Spanish Dress Lying Down* the same year

1865 Letter from Manet to Fantin-Latour, dated 28 May, speaking of paintings by Velázquez and Goya in Madrid

1867 Manet's *Execution of the Emperor Maximilian* draws inspiration from Goya' *The Third of May 1808*

1868 Manet models *The Balcony* in some measure on Goya's *Majas on a Balcony* Henri Regnault, in Spain from just before the September revolution until March 1869, rejects Goya in the first instance, but later speaks of 'a fine Goya' in the National (Trinity) Museum in Madrid. He also refers to *The Burial of the Sardine* at the San Fernando Academy, and is known to have admired the *Tauromaquia* and *Disasters of War*

1869 Prosper Mérimée takes the Duchess Colonna to task for approving of Goya's work, in a letter dated 16 May

1871 Antonio Pérez Rubio's paintings evoking Goya's life and work: *Moratín and Goya studying the customs of the people of Madrid* and *The Duchess of Alba in San Antonio de la Florida*

1873 Benito Pérez Galdós, *La Corte de Carlos IV*—a novel in the first series of *Episodios Nacionales*—describes Goya painting a court lady undraped

1876 *The Studio of Goya*: a painting by José Casado del Alisal showing Goya at work on the *Clothed Maja*. The artist was to praise Goya's originality, realism and imagination in his inaugural address on admission to the San Fernando Academy in 1885

1874 Emilio Castelar, *Historia de un corazón*, Madrid. Part II, entitled *Ricardo*, cites Goya as an enthusiast of the bull-fight in Chapter VII

1875 Letter from Eugène Fromentin to his wife, written on 19 July, refers to Goya and Franz Hals as objects of the misguided admiration of younger painters. (Cf. Pierre Blanchon, *Eugène Fromentin. Correspondance et Fragments inédits*, Paris, 360–1)

1878 Another Goya painting by Pérez Rubio: *Goya and the Bull-fighter Pepe-Illo on a 'romería'*

1879 Manuel Fernández y González, *Las glorias del toreo*, Madrid. The novelist romances about Goya's supposed bull-fighting activities, making him tour Andalusia with the famous *matador* Pedro Romero, whom Goya painted

1883 Paul Verlaine's essay on Rimbaud, published in the periodical *Lutèce* in the autumn, compares the poet's realism favourably with that of Goya. The essay was republished in *Les Poètes maudits* in the spring of 1884

1884 Joris-Karl Huysmans, *A Rebours*, Paris. Reference to the protagonist Des Esseintes' collection of Goya prints, with decadent aesthete overtones. The growth of Goya's popularity begins to devalue his work for the dandy

1885 J. Llovera's Goya pot-pourri, 'Goya y su tiempo', published in *La Ilustración Española y Americana*, Part I, 288–9

Odilon Redon's series of lithographs *Hommage à Goya*

1888 Francisco Domingo Marqués's painting, *The Studio of Goya*, complete with *flamenco* dancers and castanets.

1889 Edvard Munch studies the work of Goya in Paris

1891 André Gide sees 'Goyas' in Brussels and notes his impressions in his *Journal* for the month of August

Pisarro studies Goya's bull-fight prints with Ricketts and Shannon in London

1892 Renoir in Spain claims that 'Goya's *Royal Family* is worth the trip by itself'

1894 Letter from Aubrey Beardsley to William Rothenstein with reference to Goya photographs. (Cf. *The Letters of Aubrey Beardsley*, ed. Henry Maas, J. L. Duncan and W. G. Good, London, 1970)

1900 *Blanco y Negro*, No. 466, 7 April, reviews a performance of *tableaux vivants* by a group of young Madrid aristocrats. Four *tableaux* were based on paintings by Goya

1904 Paul Klee's *Diary* refers to his interest in Goya prints at Munich, during the month of October: *Proverbs*, *Caprichos* and *Disasters of War*

1905 Rubén Darío's poem 'A Goya' published in *Cantos de vida y esperanza. Los Cisnes y Otros poemas*, Madrid

1906 V. Blasco Ibáñez, *La Maja desnuda*. A novel written in Madrid between February and April. The central character, an artist, is influenced by Goya's painting and attitude to life

Paul Klee enthuses about Von Loga's book on Goya. He was given a copy on Good Friday, and writes about it in his *Diary*

1908 Zacharie Astruc includes a sequence of five sonnets on Goya's *Maja*, 'La Femme couchée de Goya', and other Goya poems in *Les Alhambras*, Paris

Gedeón, No. 649, Madrid, 3 May: Political caricature based on a parody of Goya's *The Third of May 1808*—'Las víctimas del 3 de mayo (y del 12 de enero y del 20 de octubre)'

Blanca de los Ríos de Lampérez, *Madrid Goyesco (Novelas)*, Madrid

1909 Marquerite Hein, *À l'École de Goya*, Paris. A set of fictional sketches based on Goya's *Caprichos*. The stories are evolved from Goya's etchings in the following order: Nos. 74, 55, 2, 48, 27, 6, 31, 22, 72, 32, 45, 15, 14, 61, 34, 28, 7, 8, 10, 3, 41, 19, 5, 12, 16, 4 and 50 together, 64, 71

1910 *Gedeón*, No. 756, Madrid, 22 May: Caricature based on Goya's tapestry
 cartoon 'Blind Man's Buff'—*La gallina ciega*—attacking the directionless
 activities of the Spanish liberal party

 Francisco Villaespesa's play in verse, *La Maja de Goya*, set in 1808, performed
 and published for the first time at about this date

1911 Manuel Machado's poems on three Goya paintings, written the previous
 year, published in *Apolo. Teatro histórico*, Madrid. Many years later, in
 1946, they were given a public reading in Madrid by the poet during the
 bi-centenary celebrations.

1912 André Gide refers to Goya's *Proverbs* (or *Disparates*) in his *Journal* on 29
 January

 Enrique Granados, *Goyescas*, first part of *Los Majos enamorados*, for piano,
 published by Dotesio, Madrid

 Paul Klee sees Goyas in the Durand-Ruel and Bernheim collections in
 Paris, according to the entry in his Diary for the 16 April

 Walter Sickert goes about carrying Goya's *Disasters of War* with him

1914 Enrique Granados, *Goyescas*, second part of *Los Majos enamorados*, for piano,
 published by Dotesio, Madrid

1915 *Goyescas*. An Opera in three Tableaux. Text by Fernando Periquet. Music by
 Enrique Granados, published by Schirmer, New York

 André Gide shows Goya drawings to his friend Labasque, according to the
 entry for 2 October in his *Journal*

 Alfred Noyes, *Rada. A Belgian Christmas Eve. With four illustrations after Goya*,
 London. Noyes weaves Goya's *Disasters of War* into the text of the play as
 well as using four plates as illustrations

1917 Paul Claudel refers to Goya in the January entry of his *Journal*: 'No admira-
 tion for Goya'

 Ronald Firbank, *Caprice*, London. Aesthetes at the Café Royal refer to Goya
 and Velázquez in this novel

1920 Aldous Huxley's poem 'Morning Scene', with a Goya reference in it, pub-
 lished in *Leda*

1921 Letters from Mark Gertler to Carrington enthuse about Goya's 'sense of
 paint'—1 and 17 January. (Cf. *Selected Letters*, ed. Noel Carrington, London,
 1965, 194–5)

1928 Modesto Alonso's play *Goya que vuelve*

1929 Two short poems about Goya written by Miguel de Unamuno

1930 Paul Claudel's *Journal*, 25 February, refers to Goya. 'Ravishing' Goya in the
 Mellon collection

Federico García Lorca finds 'duende' (the Dark Spirit) in Goya, in a lecture given in Cuba in the spring, subsequently published with the title 'Teoría y juego del duende'

1931 Aldous Huxley's poem 'A Highway Robbery. Picture by Goya', printed in *The Cicadas and Other Poems*

Georges Rouault quotes Léon Bloy on Goya in *Les Chroniques du jour*, April

1932 Ernest Hemingway, *Death in the Afternoon*, London. Contrast between the virility of Goya and the effeminacy of El Greco in Chapter XVII

Karl Hans Strobl, *Goya und das Löwengesicht*, Leipzig

Paul Valéry's article on Corot includes Goya among colourists who can do without colour, and whose approach to painting is 'poetic' (like Rembrandt and Claude)

1933 Claudel, in his *Journal*—January—finds the art of David superior to that of Goya

1934 Ronald Firbank, *The Artificial Princess*, London. A character regrets that Goya never painted fans in Chapter 2

Gerardo Garate del Río, *El Columpio*: a play based on a tapestry by Goya with music by Hipólito Rodríguez Hernández, printed in Saragossa

1935 Pío Baroja, 'Los demonios de Carnaval', *Vitrina pintoresca*, Madrid

1937 Reference to Goya in W. H. Auden's 'Letter to Lord Byron', section III, stating a preference for his art, which shows a human commitment, over purer, aesthetic, approaches

1938 Louis NacNeice's poem 'Autumn Journal', section VI, finds mockery in Goya's portraits of the Royal Family

1940 At about this date Bernard Lorjou paints a violent version of Goya's *Young women with a Letter* in the Lille Museum

Louis MacNeice recalls his visit to Madrid in 1936 and his impressions of the Goyas in the Prado in the draft of his unfinished autobiography (cf. *The Strings are False*, Chapter XXXII)

1944 Fernando Delgado, *La Maja del capote*: a play in which Goya appears as a character

Filippo de Pisis' lithograph, *Omaggio a Goya*, reflecting the artist's admiration for Goya as a vigorous painter of everyday people and objects, published in December in *Sei Litografie*, Venice

1944–6 Luis Buñuel drafts a Goya scenario: 'Goya and the Duchess of Alba' (cf. J. Francisco Aranda, *Luis Buñuel. Biografía crítica*, Barcelona, 1970, 362–83)

1947 Eric Porter, *Saturn's Child*, London. A novel about Goya. French translation, *La Vie passionnée de Francisco Goya*, Paris, 1956

1948 Pierre Roy paints a Surrealist *Hommage à Goya*, now in the Musée Goya, Castres

1950 George Grosz claims that the universality of his own satire is comparable to that of Goya's

1951 Lion Feuchtwanger, *Goya oder Der Arge Weg der Erkenntnis*, Frankfort. English translation, *This is the Hour. A novel about Goya*, trans. H. T. Lowe-Porter and Frances Fawcett, London, 1952; Czech trans. Emanuel and Emanuela Tilschovi, Prague, 1966

Picasso takes some compositional lines for his *Massacre in Korea* from Goya's *The Third of May 1808*

Antonio Ruiz Castillo's play *María Antonia la Caramba*, whose protagonist is a Spanish actress of the second half of the eighteenth century, makes Goya one of the characters

1953 Rafael Alberti's poem to Goya published in *A la pintura*, Buenos Aires, Losada

1956 Rafael Alberti's play *Noche de guerra en el Museo del Prado* uses Goya references and back-projections

1957 Jack Yeats' views on Goya reported in Terence de Vere White, *The Fretful Midge*, London, 117–18

1958 Henry Koster's film about Goya: *The Naked Maja*

Juan de Orduña's play *La Tirana*, about an actress painted by Goya, makes the artist one of the characters

1959 Richard Mortensen bases fifteen plates on Goya's *Disasters of War* No. 46, 26–9 March. (Cf. *Sandhedens Øjebbik*, Copenhagen, 1965)

Andrei Voznesensky writes his poem 'I am Goya'. Printed in *Mozaika*, Vladimir, 1960; *Scrivo come amo*, Milan, 1962; *Antimiry*, Moscow, 1964; *Akhillesovo serdtse*, Moscow, 1966. Authorised translation into English in *Selected Poems*, London, 1966; version by Stanley Kunitz in *Antiworlds and The Fifth Ace*, London, 1968

1964 David Wevill's poem 'Goya's "Snowfall"', in *Birth of a Shark*, London

1966 *Henry Moore on Sculpture*, ed. Philip James, London, includes some reactions to Goya's approach to art

1969 Series of 'Portraits imaginaires de Goya' by Saura exhibited at the Stadler Gallery in Paris

1969–70 Robert Ballagh's painting *3rd May. Goya 1970*

1970 Goya films by Nino Quevedo (Spain) and Konrad Wolf (East Germany)
 Goya plays by Antonio Buero Vallejo (*El sueño de la razón*) and Soler Fando
 (*Goya*)

1972 Stephen Marlowe, *Colossus. A Novel about Goya and a world gone mad*, New
 York. London edition, 1973

1975 Goya film based on an epic poem by José Camón Aznar, directed by Rafael
 J. Salvia

APPENDIX I. Text of Goya Articles

I. Ceán Bermúdez's Article On Goya's *St Justa and St Rufina* (1817)

Analysis of a picture painted by Don Francisco Goya for Seville Cathedral

> Nosse quid in rebus natura creavit ad artem pulchrius.
> *De Arte Graphica. C. A. Du Fresnoy.*

ONE of the most effective ways of encouraging the study of the Fine Arts is to describe and analyse works designed to be seen by the general public. The picture which Don Francisco de Goya y Lucientes, Director of the Royal Academy of San Fernando and First Painter to the King, has just finished deserves to be examined for its intrinsic merit and for the importance of the place in which it is to hang.

The Chapter of Seville Cathedral commissioned the picture for one of its altars. At first Goya, who had paid three visits to the city, and had seen and studied closely the works that all the most famous Andalusian artists of the sixteenth and seventeenth centuries had painted for the cathedral, modestly declined the invitation to compete with them. His friends, however, who were confident of his ability, finally pressed him to accept a commission which could bring him nothing but honour if the Chapter and connoisseurs were pleased with it. Despite his advanced years, he extended himself to the utmost, drawing on his vast knowledge of the theory and practice of art and its varied techniques, to satisfy the public's expectations.

The canvas measures three yards twenty-eight inches in height by two yards seven inches wide [these measurements are in Spanish yards, the approximate equivalent of 3.15 m × 1.83], and it represents the Holy Virgins and Martyrs Justa and Rufina, two sisters who were born in Seville, and later became the patron saints of the city. Experienced artists know only too well how difficult it is to arrange a simple composition with only two isolated figures, standing side by side, of similar age, the same sex and social position, wearing identical dress, and having the same symbolic attributes. Such compositions tend to produce a sense of monotony, and it is hard to avoid this.

Artists of experience also know the care that must be taken over the precise outlines of the two main characters, when there are no advancing or retiring figures in the foreground to break into their contours, as is possible in pictures which have many figures in them. They will be aware that the absence of minor characters makes the contrast of light and dark more difficult, although such contrasts are essential to make the central figures stand out. And they will be familiar with the problems that arise when two figures stand on the same ground and against the sky, as if they had been cut out or printed. Goya overcame these difficulties and others too by giving the matter much thought, and by working out the problems alone with his deafness, as the deaf-and-dumb artist Navarrete did, in similar isolation, when painting his pairs of apostles for the Escorial.

Before Goya made his preliminary sketches, he collected the information that every painter needs if he wants to avoid anachronisms and other errors of fact. He carefully read the accounts of the martyrdom of the two sisters written by St Isidore and bequeathed to the church in Seville. Once he was thoroughly acquainted with the faith, fortitude and love of God which characterized the saints, he set to work to devise forms, poses, facial expressions and emotions which would reflect precisely those virtues.

He researched the proposed site for the painting: the space available, height and lighting; and having fixed upon the appropriate horizon line, angle of light and viewpoint, he set out with the aid of symbols of martyrdom, potters' ware befitting the saints' profession, and other specially necessary accessories, to depict a subject with two figures that would have required five or more if he had painted the act of martyrdom itself.

He placed the two saints in a central position, a little larger than life size: Justa on the right and at an angle to the centre; Rufina on the left viewed from the front and a step behind her sister [Ceán Bermúdez uses left and right here to refer to the saints' and not the spectator's view]. Each has a different feeling about her, and their heads are at different angles; both look up towards heaven, yet no angels or other allegorical figures are used. The faint light that falls on them gives an adequate indication of the glory that passes man's understanding. Both hold palms and earthenware vessels: Justa with both hands, and Rufina with the palm in her right hand and a vessel in her left. The former holds these objects close to her breast, with an emotion that is also expressed in her uplifted eyes; the latter holds them apart as if in an ecstasy or trance. And both go barefoot, since Diocletian ordered them to be led unshod up the slopes of the Marian mountains as a test of the constancy of their faith. Also appropriate to the subject is the wild lion which licks St Rufina's feet, more appropriate in fact than Raphael's depiction of the beast in the famous picture of the Virgin of the Fish. Raphael's lion was only an attribute of St Jerome, whereas here the animal is factually connected with the martyrdom of the saint.

In front of the saints are strewn the head and fragments of the idol of the goddess Salambona or Venus. This the two sisters had destroyed and trampled underfoot with a burning zeal, on the day when the Gentiles were celebrating their shameless rites in honour of Adonis in Seville. In the distance the tower and the cathedral of this city can be dimly seen, indicating the place where the saints suffered martyrdom, and also making a concession to the popular tradition which placed the Giralda beside them.

This is the *Composition* of the picture. The subject is idealized, and Goya has used the licence which an artist may take to bring together events which occurred on several days, so that there is one action and a single moment of time. Yet he has done this without introducing any gross anachronism, and without making any sacrifices so far as the facts of the case are concerned. The verisimilitude and accuracy are greater, in fact, than those of the painting by Raphael to which we have already referred.

If there is not the same correctness in the drawing in Goya's canvas (for the divine Sancio was inimitable in that respect), it is much more correct than other works painted by Goya. The proportions of the two figures are graceful and their postures decorous. Their heads, necks, feet and hands, are mid way between nature and the figures of classical antiquity, in the manner of Guido Reni. The rest of their limbs, though decently covered by their tunics and the thick cloth of their overgarments, recall the naked figure. The folds of their dresses are widely spaced, well selected and contrasted, and their are no small creases. Those of their mantles, on the other hand, which are long and narrow, caught up in their arms and reaching the ground behind them, take the shapes you would normally expect to find in adornments of that kind and use. Although these mantles or stolls would normally only be worn by Roman matrons of the noble class, the epic painter was right to deck his heroines in them. By so doing, he raised them out of the humbler class to which they were born, and gave them the elevated status they enjoy in paradise.

The expression, pose and perspective of the lion seem as if they had been copied from nature, even though this is impossible in Madrid at the present time. Yet it must be confessed that Goya has a particular gift for imitating the different characteristics, proportions and individual peculiarities of animals, which he observes and studies particularly closely. The head and fragments of the idol were obviously taken from Greek or Roman models, such as presently serve for drawing practice in our Academies. The originals themselves were in all likelihood casts of Venus, since gentle maidens had no difficulty in breaking them. Their perfection and artistry is consistent with the style and standards of the reign of the Emperor Diocletian; and the Turdetans worshipped the goddess at that period in Andalusia. Nothing need be said of the shadowy outline of the tower and the cathedral. These and the ground on which they are built would be immediately recognized by anyone who has been to Seville.

In his handling of facial expression—the most philosophical part of painting, which the artist must have at his command to bring his figures to life—Goya gave a powerful indication of the delicacy of the saints' feelings, expressing them with great naturalness and without any affection. In order to interpret their feelings, the spectator must predispose himself in the same way as the artist who conceived them and gave them expression. Once he has done this he cannot fail to identify the powerful expression in St Justa's eyes with the desire to see and join her maker; and that of St Rufina's with an unprotesting acceptance of the will of her Redeemer. Nor will he fail to recognize that the hands and postures of both saints are consistent with these feelings, as we suggested when describing the picture's composition. He will also perceive that the beast has lost his wildness, is bending the front feet and stooping to lick the left foot of the Virgin beside it, showing its harmless intentions in its hind quarters, benevolence in the swing of its long tail, and supernatural respect in every inch of its body. Such philosophical ideas as these, however, which are the product of an enlightened imagination, and such artistic beauty (resulting from a balanced composition, care and correctness in the drawing), would be colourless indeed were there no tints to enliven them.

Colouring is central to painting: the touchstone by which even the most careful and correct draughtsman may be judged a failure. So hard is it to succeed, that the rules of art and the severest precepts of correct taste are insufficient for the complete mastery of colour. It is not a matter of the brightness and beauty of the colours in themselves, since if this were the case the Chinese would certainly be superior to us. Rather it is a question of the harmony achieved by all the colours when they are seen together. And who better to create this accord than one who is unable to hear the sound of a voice or a bell, and so seeks harmony in everything he sees, with no noise to distract him? In the same way, a blind man, with his sharp sense of hearing, will find harmony in musical instruments or in the modulations of the human

voice itself. Total and absolute deafness gave Goya in his misfortune a wonderful gift that cannot normally be acquired without a great sacrifice of this kind.

The artist's mastery of this harmony is evident in the local colours of the saints' raiment. Although the tones are different they relate easily and closely to one another and are in harmony, without the artist's needing to have recourse to any exaggerated affinities. His mastery can be seen in the virginal beauty of the colouring of the saints' faces, necks, hands and feet, whose red and bluish tints unite gently with the predominant white tones; in the colouring of their hair—dark in St Justa's case, and fair in St Rufina's; in the tones appropriate to the lion; in those of the varied terrain, and the overcast sky. It can also be seen in all the other details, which accord perfectly with the predominant tone of the whole picture—fairly bright in some parts, and quieter in others.

The distribution of light and shade is a matter of *Chiaroscuro*, which affects each object individually and all together. The objects are thrown into relief, and the large shadows enable Goya to achieve what is called the *effect* of the painting—that is, the impact of the whole work, which can only be appreciated from a certain distance and not too close to the picture. How many canvases and panel paintings with large scale figures, famous for the artists who painted them, lack this effect, because they were finished in a meticulous and heavy-handed way, without the vigorous *brush-strokes* which do so much to enliven the picture! Strokes, which were quite unknown in modern painting until the age of Polidoro Caravaggio in Lombardy, Giorgione, Titian and Tintoretto in Venice, Rubens and Van Dyck in Flanders, Rembrandt in Holland, and Zurbarán and Velázquez in Andalusia. Those of Don Francisco on the figures of his saints and the lion are so energetic that they create a magical illusion for the person who is looking at them, almost persuading him that the figures breathe.

The philosopher and painter Girodet in his *Considerations on Originality in the Arts of Drawing*, published in an extract in this periodical, on Friday 6th June this year, says that 'the creation of new ideas', such as those we have pointed to in the conception of this painting, 'the adoption of ideas which are already generally accepted, but applied in an ingenious, unexpected and out of the ordinary way, are the principal bases of originality'. If we add to this the fertile creative genius of Goya, his innate and unshakeable vocation for an art in which he had no guide apart from nature herself, his talent for revealing the beauties of nature, his complete command of his brushes, the harmony and clarity of his colouring, and his bold and extraordinary style, will not this entitle him to the glorious title of Original Painter? All Spaniards and foreigners rightly conceded him this title for his treatment of ridicule and caricature in his *Caprichos*, and even for his way of drawing and engraving them. But will not the painting of St Justa and St Rufina give him a name for originality in treating the heroic and sublime subject of our religion?

The Chapter of Seville Cathedral can in part offset with this work the loss of the admirable pictures which were stolen during the French invasion. It can be placed side by side with works by Pedro Campaña, Vargas, Roelas, Cano, Zurbarán, Murillo and other leading Andalusian artists, which contribute so much of great value to the adornment of this magnificent church.

II. Valentín Carderera's Article on Goya in the *Semanario Pintoresco Español* (1838)

ACCORDING to some would-be experts, 'a young artist should imitate Nature, and look at her in his own way'. Such a doctrine would be perfectly acceptable if everyone was exceptionally talented and able to recognize the feeble quality of many highly praised works of art. The young artist in question would have to be like Goya, and there are all too few young students of his calibre.

Would Goya have been what he was if, after growing up in Fuente de Todos and attending the Saragossa Academy around 1758, he had stayed longer in that city than was necessary to learn the rudiments of art? If, from Madrid where he was taught the maxims of Luca Giordano and Corrado Giaquinto, Goya had gone to Rome, not as a poor student, full of passion and enthusiasm, but as the holder of one of His Majesty's imposing scholarships to copy and imitate (as hundreds of students from different European countries did) the works of Conca, Trevisani and Benefiali which were then in vogue, would he have come back a Goya? I very much doubt it. He would have returned a Don Francisco Goya, and shortly afterwards we should have seen one of his paintings gracing the professors' room in the San Fernando Academy: some characterless allegory, or an Adonis leaving Venus, with lifeless, cold, colourless figures . . .

How presumptuous and ignorant this wayward young man would have seemed to the worthy directors of the Rome Academy!

Of course Goya looked at the work of Raphael and admired it; he studied him in order to find out how to look at Nature herself. But once initiated into her great mysteries he never looked at Raphael again. He had the genius to realize that the combination of the real with the sublime was not for him, and he made do with reality itself, which is more than enough when an artist has a sharp sense of it.

The style which his servile contemporaries admired attracted him still less. They only saw things through their teachers' eyes, according to academic principles; which is why this was the worst period for European painting. Trivial and pointless subjects; carefully balanced compositions, coldly calculated; loose and mannered drawing; colours as false as those of a chameleon—flesh tints as pink as roses or apples: paintings of the boudoirs of Pompadours and DuBarrys in fact. That is how painting was then—with the exception of Mengs and the Roman Cades.

Goya's affection for his family, his conviction that it was not necessary for him to spend long in Rome, and his slender financial resources, soon made him return home. It was not long before he showed clear signs of talent and revealed the full extent to which he had profited from his own particular methods of study in Rome. The first works in which his ability was really evident were his early pictures for the Royal Tapestry Factory. Mengs, who was in charge of the work, recognized his good qualities and remarkable facility.

These are certainly amongst the most beautiful and original works to come from Goya's brush. What truth there is in those scenes of ordinary life, those bull-fighters and manolas, muleteers and country picnics! The fact is that this was Goya's favourite type of picture, together with his witches' sabbaths and bandit scenes, in all of which he showed an outstanding naturalness and extraordinary air of truth to life. But how could the artist paint such a wide variety of subjects? Goya was able to identify himself closely with the life and

typical feelings of the people he painted. He put on special clothes when there was a bullfight —wide-brimmed hat, close-fitting doublet, a cloak over one shoulder and sword under his arm—and would go to the ring in the company of Bayeu and Torra, dressed in similar garb. He took the trouble to make the acquaintance of the leading bullfighters. In the same way, Pinelli, in his time, avoided the aristocrats and the rich English. He would go off to sketch the finest of his immortal compositions in the pleasant slopes of the Palatine hills, sitting on some elegant capital that had once adorned the palace of the Roman Emperors, and pledging the health of pretty country girls from across the Tiber, as he worked and meditated, glass in one hand and pencils in the other. Goya too has left us a vast number of works in this popular vein, the product of his fertile imagination. The bullfighting, banditry and witchcraft scenes which are in the Alameda palace of the Duke of Osuna are especially famous; and Don Francisco Mariátegui, a distinguished architect, owns four of the most finished works by Goya in this genre. Don Andrés del Peral also had a large collection, and other connoisseurs and members of Goya's family have works that are full of the artist's originality and humour.

Many of the pictures we refer to, particularly those in the Tapestry Factory, are characteristic of his earlier work. Their composition is extremely natural, without the least pretentiousness or academic affectation, and this in itself is high praise. The scenes are realistically and brilliantly lit: very different from his later and more restrained treatment in this respect. If there is no great restraint or stylishness about his draughtsmanship, the truth and facility of his overall effects more than make up for it. Amongst the historical subjects of his early period can be classed the large painting for the church of San Francisco el Grande, and a life-size *Crucifixion* for the same convent, which earned him the title of academician in the Royal Academy of San Fernando. Amongst the portraits can be included a large composition of the whole of the Infante Don Luis's Family, which is in the collection of the Condes de Chinchón; a portrait of Charles III in hunting dress, the property of the Conde de Sástago; one of the Conde de Floridablanca, in which the artist included a self-portrait; and finally, two of the Duchess of Alba. All of these portraits are full-length and in Madrid, together with many others it would take too long to mention individually.

His second style, in which Goya showed himself to be an exceptional artist, is remarkable for the effective use of chiaroscuro, the superb sense of space between figures, and finally, the realistic and luminous colouring, whose harmonious treatment was entirely his own. Having developed a keen interest in Rembrandt, Goya made his scenes darker, yet the illuminated sections produce an astoundingly powerful effect as a result. Always a close observer of Nature, he came to understand the space between figures as admirably as Velázquez, his favourite painter, and he would treat minor passages in a sketchy way so that they would not spoil the ensemble. He painted strongly lit surfaces with solid blocks of colour, unmixed by the brush, and sometimes applied the paint with the flexible point of a palette knife. Although he was very experienced, his deceptive fluency and those daring touches which have proved dangerously seductive to the younger artists of our own day, were carefully planned and worked out in advance. What more? In many of his pictures the last bright touches were applied by artificial light. All his skills shine forth magnificently in the fine picture in the Prado of Charles IV and the whole of the Royal Family, in which he portrays himself in the act of transferring the scene to canvas. Although he was already one of the king's painters in 1789, their Majesties appointed him First Painter in 1799, as a reward for this work which was widely acclaimed.

The pictures he painted for Valencia cathedral, depicting two scenes from the life of San Francisco de Borja, are full of beautiful effects. How tender and suggestive the Duke of Gandía and Marqués de Lombay's farewell to his family, as he gives up for ever his splendid

palace to immure himself in a joyless cloister! The companion picture to this one, awesome in subject, is no less powerful.

The Marqués de Santa Cruz has the sketches of both these paintings in his collection.

Goya's portraits are too celebrated to need more praise. Normally he painted the heads in a single session lasting an hour, and he obtained the best likenesses by this method. Particularly notable and interesting are the two portraits of General Urrutia, the one of Azara the natural-ist, those of the Duke of Osuna, Villanueva the architect, Moratín, Máiquez, and many other distinguished Spaniards.

There is hardly a Spanish grandee or person of any rank who has not some portrait by Goya in the family. It was a kind of apotheosis to be painted by such a celebrated and dis-tinguished artist, and how many names would already have disappeared without trace had their owners not had the ambition to sit for him!

Of his work in tempera and fresco painting the beautiful and original figures in San Antonio de la Florida are shining examples. Some of them are recognizable portraits. The two small domes in the Pilar at Saragossa are other cases, as are those paintings on the walls of a country retreat Goya had near the banks of the river Manzanares, in which there is hardly a wall that is not full of caricatures and works of fantasy, including the walls of the staircase. Sometimes his visitors were a pretext for such work.

In his last years Goya was still able to produce interesting work. The beautiful composi-tion of *San José de Calasanz* in the church of San Antonio Abad is a case in point; so is the picture of *St Justa and St Rufina* he painted for Seville cathedral, and the canvas in which he portrayed himself near death, attended by the distinguished Dr Arrieta. The latter is shown in the act of giving him a potion, and with his help Goya survived for several years more.

Some loss of skill is inevitable in the period of physical decline, and the great artists are no exception to this rule. It is no wonder that nearly all Goya's late work contains weaker and less well-drawn touches. Printer's black is over-used in these pictures, to rather crude effect. At the same time he did many drawings at this period, and some of them are so fine in their detail that they could be the work of a young man of twenty. When Goya was forty-three he went deaf, and from 1822 his health got visibly worse. In 1824 he was obliged to go to Paris with the King's permission and he ended his days in Bordeaux, where he died on the 16 April 1828, a few days before the great Moratín, at the age of 82.

Goya has been singularly original in concentrating on the weaker and more comic side of mankind and nature. Hogarth often needed to explain his pungent satire in words. Goya far exceeded the English painter. With two strokes he caught the essence of the person he wanted to hold up to ridicule and that person was recognizable despite the disguise. If the *true* key was available to many of the *Caprichos* (which he purposely made obscure) what subtle and ingenious satires we should find in them, and how biting at times! In keeping the key from us he was only prudent, although his temperament and character kept him impervious to the dangers with which powerful, and fortunately fairly generous people, might have threatened him.

Not content with painting these subjects on canvas, he also published them in etchings which are now very rare. Less so were his eighty *Caprichos*, in the same manner, etched with a graver that was more full of vitality and the picturesque than the engravings of Stefano della Bella, almost rivalling Rembrandt. With the same process but in a larger size he produced a beautiful collection of bull-fights, another of Velázquez's paintings, and some single plates. Foreign connoisseurs have long prized them more highly than our own people, and today we find his *Duendecitos* and policemen reproduced and transformed in engravings and lithographs arriving from abroad which make no attempt to conceal their plagiarism.

We must not conclude these ill-written lines without pointing out the constant modesty and uncertainty of Goya, even in his moments of greatest triumph, and in his best period. When he looked at some works by painters of the past, he would exclaim: I know nothing! Only those whose knowledge is really vast will make such an admission.

III. Charles Baudelaire on Goya's *Caprichos* in *Le Présent* (1857)

IN Spain, a remarkable man has opened up new horizons for the comic spirit.

I should first of all recommend anyone interested in Goya to read the excellent article on him by Théophile Gautier in the *Cabinet de l'Amateur*, subsequently included in a volume of the latter's miscellaneous works. Gautier is well qualified to appreciate artistic sensibility, and so far as the technical processes of engraving are concerned—a mixture of etching and aquatint with some retouching in drypoint—the article in question has all the relevant information. I merely want to add one or two comments on the extraordinary new element which Goya has introduced into the Comic, to wit, the Fantastic.

Goya's approach to the Comic cannot be easily categorized, in the French manner, either as 'pure Comic' ['*Comique absolu*'] or 'applied Comic' or satire ['*Comique purement significatif*']. Certainly he often indulges in violent satire, and sometimes, transcending this, presents an essentially comic view of life. Above all, however, he approaches things from the standpoint of fantasy; or rather, he depicts them in fantastic or imaginative terms.

The *Caprichos* is a remarkable work for its technique as well as for the originality of its ideas. Imagine someone looking at the *Caprichos* with interest, and an appreciation of art, but without any idea of the historical situations to which a number of the plates allude: a straightforward, artistic individual who has never heard of Godoy, Charles IV or María Luisa. In spite of his ignorance the work will make a profound emotional impact on his mind, partly because of its original style, technical mastery and supreme art, but also because of the atmosphere of fantasy in which Goya steeps all his subjects.

In intensely individual works we find something of the quality of a recurring or obsessional dream, which keeps interrupting our sleep. This is the quality that marks the work of the true artist. It makes even works of an apparently ephemeral nature, like caricatures which depend on contemporary events, live on. It is this quality in my view that differentiates historical and artistic caricaturists: the Comic that is light and ephemeral and the Comic that endures.

Goya is always a great artist, and often frightening. To the fundamentally gay and jocose spirit of Spanish satire, with its hey-day in Cervantes' time, Goya has added something very much more modern, or rather a quality which has been particularly sought after in modern times, namely, a love of the indefinable, a feeling for violent contrasts, for what is terrifying in nature, and for human features which have acquired animal-like qualities as a result of their environment. It is curious to note that this spirit has manifested itself in the train of the great critical and satirical movement of the eighteenth century. Voltaire would

have been grateful simply for the idea of all Goya's caricatures of monks (the poor maestro would not have got much out of the rest of the work)—monks yawning, monks gorging, monks with square murderous heads preparing for matins, monks with cunning, hypocritical, sly and deceitful heads, like birds of prey in profile. It is strange that this monk hater has dreamed so frequently of witches, sabbaths, devilry, children cooking on a spit, and I know not what else: all the orgies of the dream-world, all the exaggerations of halucinatory images, and, in addition, all those slim, white Spanish girls, whom the inevitable old hags wash and make ready for their covens, or for the evening's prostitution—the sabbath of civilization! Light and darkness; reason and the irrational are played against each other in all these grotesque horrors. What an extraordinary sense of the comic!

I recall particularly two incredible plates. One shows a fantastic landscape, a mixture of rocks and cloud. Some lost and uninhabited corner of the sierras, perhaps, or a patch of primeval chaos? In the centre of this vile stage, a violent battle is in progress between two witches flying through the air. One sits astride the other; lambasting and overpowering her. These two monsters roll through a darkened atmosphere. All the ugliness, all the moral degradation, all the vices which the mind can imagine are written on their two faces which seem half beast, half human, as is common in Goya—though the technique he uses to achieve the effect is inexplicable.

The other plate shows an unfortunate being—a solitary, desperate human atom, trying his hardest to escape from his tomb. Maleficent devils, hundreds of loathsome Lilliputian gnomes unite their efforts to keep down the lid of the half-open grave. These vigilant watchmen of death join forces against the recalcitrant soul which wears itself out in the impossible struggle. This nightmare scene is enacted against the full horror of an indescribable and featureless background.

At the end of his life, Goya's eyesight had grown so feeble that they say his pencils had to be sharpened for him. Nevertheless, even at that stage he produced some large lithographs of considerable importance, including bull-fights full of massing figures. These wonderful plates—miniature versions of huge canvases—give new evidence of the force of the law which rules the destinies of great artists, and which decrees that their life runs in some inverse proportion to their intelligence. They gain on the one hand what they lose on the other, and grow younger all the time, gaining in strength, vigour and daring, until they reach the very edge of the tomb itself.

In the foreground of one of these lithographs, in which an admirable sense of tumult and confusion reigns, a maddened bull—one of those vengeful creatures which attack the dead with unprecedented violence—has ripped the seat of the trousers of one of the combatants, who, wounded but not killed, drags himself heavily along on his knees. The formidable beast, which has already torn the unfortunate man's shirt to shreds with its horns, and exposed his naked posterior, now lowers his head again in a menacing way. And yet the crowd is hardly moved at all by this scene of blatant carnage.

The chief merit of Goya lies in his ability to create credible monstrosities. His monsters are viable, harmoniously proportioned. No one has dared to go further than he in the direction of grotesque reality. All these contortions, bestial faces, and diabolical grimaces, are profoundly human. Even from the technical point of view of natural history, it would be hard to fault them, every inch of them is so well-knit and so carefully integrated into the whole. In a word, it is difficult to say precisely at what point reality and fantasy are knitted together and joined. The border-line between the two is so skilfully crossed that the subtlest analysis cannot trace it; the art behind it is so natural, yet so transcendental also.

IV. Extracts From P. G. Hamerton's Article on Goya in *Portfolio* (1879)

. . . THE first remark to be made is, that the celebrated 'frescoes' are not frescoes at all, but simply oil paintings. M. Yriarte tells us, in his biography of the painter, that he decorated his country-house with these inventions, and executed them directly upon the wall. When he wrote his book, a successful but expensive attempt had been made to remove one mural painting, not by Goya himself, but by his son; and in those days it was the general opinion that when the house was pulled down the paintings would perish with it. Since then they have been saved by the care of Goya's admirers, and the Baron Erlanger has become their happy possessor. Thanks to him, we, who have not been to Goya's *quinta* by the Manzanares, have now ample materials for knowing the painter when most himself; for when an artist decorates his own house it may always be safely presumed that he expresses his inmost self, since he is working for his own gratification. The reader is requested to pay especial attention to this in the present instance. The so-called 'frescoes' were not hasty compositions, intended to pass out of the painter's sight and be forgotten by him, like some of the innumerable fancies of Gustave Doré; they were the permanent decoration of Goya's principal rooms—his reception-rooms —which were often crowded by visitors of high rank in the society of Madrid . . . What, then, under such circumstances, did Goya produce for his own continual contemplation? Forms of beauty and grace? visions of an artist's—a poet's—paradise? the fulfilment of those ideal longings which the actual world suggests indeed but can never satisfy? Not so, his mind did not rise to any pure or elevating thought, it grovelled in a hideous Inferno of its own—a disgusting region, horrible without sublimity, shapeless as chaos, foul in colour and 'forlorn of light,' peopled by the vilest abortions that ever came from the brain of a sinner. He surrounded himself, I say, with these abominations, finding in them I know not what devilish satisfaction, and rejoicing, in a manner altogether incomprehensible by us, in the audacities of an art in perfect keeping with its revolting subjects. It is the sober truth to say, that in the whole series of these decorations for his house, Goya appears to have aimed at ugliness as Raphael aimed at beauty; to have sought awkwardness of composition as Raphael schemed for elegance of arrangement; to have pleased himself in foulness of colour and brutality of style as Perugino delighted in his heavenly azures, and Bellini in his well-skilled hand. The motives, in almost every instance, are horrible;—*Saturn devouring his Offspring*, *Judith cutting off the Head of Holofernes*, *A Witches' Sabbath*, *Two Herdsmen savagely fighting*. A group of hideous men, scarcely human, is entitled *The Politicians*, and there is a group of coarse women wildly laughing by way of a pendant. Then we have a procession of Inquisitors, and a terrible mysterious picture, which M. Yriarte calls *Asmodeus*. One composition in the series relieves the eye by the spectacle of a popular festival, but it is made horrible by a group of diseased and filthy beggars, to which it serves simply as a background. There is a separate portrait of a woman, not repulsive for a wonder, and also a separate portrait of a man with a long white beard. This man is listening, terrified, to the suggestion of a frightful being who is whispering in his ear. Of all these things the most horrible is the *Saturn*. He is devouring one of his children with the voracity of a famished wolf, and not a detail of the disgusting feast is spared you. The figure is a real inspiration, as original as it is terrific, and not a cold product of mere calculating design.

This description may give some faint and feeble idea of the gallery with which Goya surrounded himself at his country-house . . .

His mind did not always dwell upon such subjects, but it seems to have recurred to them when at perfect liberty. Goya was a court painter, and in that quality depicted the *beau monde* of his time; he even tried his hand at religious painting as a matter of business, but his real delight was in horror, as we see quite plainly from his numerous etchings, the *Caprices*, the *Disasters of War*, and others, all executed by him in the free energy of private and personal inspiration. He painted one hundred horrible pictures. Moral horror seems to have been as attractive to him as physical; he illustrated every turpitude and every vice in a spirit of ferocious satisfaction. His admirers speak of him as a great moralist, but this is likely to mislead. The attitude of a moral censor can only be maintained by one who has some morality of his own, and Goya had none. His personal character was in many ways as repulsive as his art.

After this beginning the reader may ask why such a subject should be chosen for treatment here? The answer is, that this is one of those cases in which a reputation forms itself to the injury of art, and ought to be actively resisted, as the physician opposes resistance to incipient disease. The fame of Goya has already poisoned art criticism in Spain and France, and it is beginning to spread to England, where it is already partly accepted on the credit of French and Spanish writers. It is time, therefore, to show plainly what Goya really was.

The celebrity of the artist is in great part political, and not artistic, in its origin; it is also partly a protestation against religious tyranny, which Goya hated, and resisted in his own way with considerable effect in Spain. In a word, Goya, besides being an artist, was a great Spanish Liberal just at a time when the forces of religious and political tyranny were still powerful enough to make Liberalism creditable, and yet sufficiently weakened for Liberalism to be possible. The friends of liberty, both in Spain and France, are therefore strongly prejudiced in his favour, and it is a most powerful element of success, even in art, to get an active and growing political influence on the side of one's private reputation. The purely negative character of Goya's religious opinions, which in England might have made the difference in social influence and respectability which exists between a Gladstone and a Bradlaugh, has no such effect amongst the Liberals of the Continent, but is rather a recommendation than otherwise. The few who care for the interests of art may wish to judge of it independently of politics and religion; but who and what are they to contend against the enthusiasm of the multitude? Goya was on the side of the Revolution, an audacious enemy of tyranny, hypocrisy, stupidity, and superstition; consequently he was a great painter, and one of the most accomplished etchers who ever lived!

M. Charles Yriarte fully confesses, on the second page of his biography, how greatly, in the formation of his own opinions about Goya, political considerations have had the preponderance:

'*We should hold cheap this enormous artistic production, if there were nothing in it but a plastic charm. What matters the execution!* the idea is there—a line engraved without effect, without much artistic effort, and the plate becomes a poem, a terrible weapon, a burning brand. Let us reflect for a moment that the time when Goya accomplished his task of destruction, although contemporaneous with the French Revolution, is relatively separated from us by a space of two centuries, since he lived in a country devoted to all superstitions and all slaveries. The effort was greater than our own, and *we ought to admire* those who were the first to utter words of independence and cries of liberality in the midst of that nocturnal gloom.'

'We ought to admire.' Certainly we ought to admire every courageous effort in a good cause; all I say is, let us keep our admirations distinct, and not say that a man was a good artist because he has an important place in the political history of his country. The qualities of artist and politician are in themselves distinct, and they ought to be kept so. The error of

confounding them may in this instance be pardonable in a Spaniard, but not in a foreigner. 'Le cri poussé par Goya,' says M. Yriarte, 'est le cri national.' . . .

The career of Goya is, in many respects, one of the most extraordinary in all biographical history. It is especially remarkable for the manifest contradiction between his daily life and the nature of his political influence. He was at the same time a courtier, and a revolutionary satirist and propagandist. Though he was a productive artist, and very industrious and energetic in the pursuit of his profession, he does not owe his position to art alone; and it is impossible to say what his reputation might have been if he had depended exclusively upon art, as Turner did, without pushing himself at Court and into political notoriety. He would not have been altogether unknown, but his fame might have been confined to his own country.

This violent agent of the Revolution not only held a place at Court, and lived amongst great people, but he founded a fortune and a title, for his son was made a Marquis—the Marquis del Espinar—in honour of him. There is nothing in the history of art and political propagandism more curious than this.

Another very astonishing thing in Goya's life is the way in which the courtier in him protected the radical, and the artist protected both. The Inquisition had its eye on him from the beginning, recognizing in his terrible powers as a satirist a dangerous influence against itself; and at length, after the publication of a set of his etchings, *The Caprices*, he was called upon to appear before the 'sacred' tribunal. The King interfered to protect him, although the Queen herself was severely satirized in one of the plates,* and he actually bought the coppers, paying in exchange for them an annual pension of 125*l.* to Goya's son—a very handsome payment for a set of caricatures.

This sketch of Goya's life would be incomplete without a closer examination of his character. It was, as we have seen, far from being exemplary, but, at the same time, it had strong qualities. It was virile always, both in its virtues and its vices. Goya was not a 'half-man', but really a man, full of masculine courage, energy, and resource. We of the North may be unfair to him simply because his nature was so very Southern in its ardent manifestations. An Englishman might have equal energy, and do an equal amount of work, but he would scarcely throw himself into his work with the same forgetfulness of everything but his object. Byron is the only Englishman I can think of as comparable to Goya in ardour, yet even Byron remained the artist when most in earnest, and Goya sacrificed art to thought without hesitation, thinking nothing of the means, or the manner, when the moral or political purpose interested him, or even when an idea was urgent for immediate realization. It has been said that Byron's energy was Satanic, but the word might be still better applied to Goya, who really does remind us of an infernal force. We have seen already how he delighted in frightful and diabolical subjects, and how he selected them for the decoration of his house. This is a mere nothing in comparison with the quantities of revolting subjects illustrated in his different etchings and other compositions. It is not easy to understand the exact condition of Goya's mind in reference to these horrors. He hated tyranny and cruelty with his whole soul, but, instead of shrinking from the visible evils which they produced, he would deliberately sit down to illustrate them in horrible detail. He looked upon human meanness, baseness, rapacity, violence, oppression, with a strange mixture of indignation and grim satisfaction, being really angry at these vices, and yet happy as a satirist to find such opportunities for the exercise of his talent. It was his pleasure to degrade humanity far below its own level by giving to his caricatures a degree of hideousness which no artist except himself could possibly have imagined. I am not forgetting the studied ugliness of some heads by Lionardo; but that is as nothing in comparison with the imaginations of

Goya, for you see at once in Lionardo's ugliest drawings that the faces are only plain human faces whose defects have been dwelt upon and enlarged, whereas Goya's are real inventions of a diabolical genius, and they make you shudder as real demons would if you could see them. He had generally a moral purpose of some sort, and inculcated his lesson with a bitterness of temper which looks like snarling contempt for the human race. Bitter irony, mockery approaching to ferocity—these, and not tenderness or pity, are the prevailing attitudes of Goya's mind towards the suffering and the wretchedness of the world. His brain was full of scorn and incontinent of hatred. There are natures which must have somebody to hate as there are natures which must have somebody to love. Goya was a born hater and despiser, and as there was plenty in the world about him which was both hateful and despicable, his instincts had ample satisfaction. At the same time, there can have been few Spaniards more despicable than himself, notwithstanding all his manly qualities. The vices which he mercilessly lashed in others, with the exception of cruelty, were conspicuous in his own life. He stigmatized immorality, and was himself one of the most immoral men in Spain; he contemned political subserviency, and was himself a political Vicar of Bray, paying court to anybody, Bonaparte or Bourbon, who sat on the Spanish throne, that he might keep his place and pension. He satirized his sovereign and accepted his protection at the same time—a protection without which he would have found himself in the claws of the Inquisition. Even his onslaughts against hypocrisy were accompanied by a certain degree of hypocrisy in his own case, for did he not conform to the religious usages of the Court, though he had no religious belief? and are not these usages at all times strict in Spain? and were they not especially strict under Charles III—a sovereign of monastic piety, who maintained in religion as in morality the most rigorous etiquette?

The baseness of Goya's personal character did not prevent him from rendering real services to the cause of political Liberalism and humanity in Spain. He did a work there which has been done in England and France by well-known caricaturists, whose productions, in comparison with his, are as lemon-juice to pure vitriol. He is not alone in this work in Europe, but he was alone in it in the Spain of his time. There was still great need for a dissolving agency, for the old powers were still strong enough to be dangerous to human welfare. The Inquisition, which we too readily look upon as an evil now far behind us in the past, was in active operation in the latter part of the eighteenth century. In its last decade a woman was burnt alive for witchcraft by command of the Holy Office, and there was a real auto-da-fé at Seville, Goya being then nearly fifty years old. He himself had been on several occasions so nearly within the grip of the Inquisition, that he felt the shadow of its occult power hanging over him, and he could realize the nature of its evil influence much more adequately than we can—we, who have never experienced it, and only read about it in books.

The really animating force in Goya's mind was hatred and not hope. He was not one of those enthusiasts who look forward to a blissful future for humanity; nevertheless, there is in one of his plates a gleam of anticipation of better things. 'In a plate,' says M. Yriarte, 'which is entirely unpublished, the copper having been probably confiscated by the Inquisition, or hidden from fear, the artist represents a symbolical figure in the form of a young woman, surrounded by radiance, and kindly receiving an old man, exhausted, bent to the earth, overcome by weariness, and hardly able to endure the weight of his burden. She shows him the brightening sky, inundated with gleams of light, the future coming on, a future at once splendid and happy, with plenty, justice, peace, serenity, and strength. Flowers and children fall from the sky, and flutter about in its symbolical ir-radiations. At the foot of the figure a lamb seeks refuge, and a child in a cradle is sheltered

under the folds of her robe.' Evidently this design expresses a hope for the future of the common people, the people bent down with toil and having so little of the light, the grace, the beauty of life, in the immediate present. The set of plates on *The Disasters of War* are a consecutive series of denunciations against the cruelty of an invasion. They were suggested by the French invasion of Spain, and exhibit every imaginable evil which such a contest brings in its train. Some touches of a tenderer humanity may be found in other plates by Goya, but these are extremely rare. The most noticeable of them is a plate representing four women in a gloomy cell, who are lost to all sense of suffering in the happy forgetfulness of sleep. 'Do not wake them,' says the inscription under the drawing; 'sleep is often the only good of the unfortunate.' A set of plates, called *The Prisoners*, is a protest against the ill-usage to which prisoners are always subject in semi-barbarous states. Goya's inscriptions under these etchings are so many lessons to governments: 'If he is a criminal, judge him, and do not prolong his sufferings'; 'Get possession of his person, but do not torment him'; and so on: maxims which exactly express the doctrines of our own prison philanthropists.

The extreme courage exhibited by Goya at different times of his life belonged rather to a certain recklessness and effrontery of disposition than to elevation of mind; but in estimating his character we have to give him credit for it. . . .

Of his conduct as a husband we know little, except that he lived in a constant succession of adulteries, and often with married women. One of these left home and children for him, and went to live with him for two months in his studio. His adulteries were, in fact, almost as much a part of his celebrity as his pictures, and he knew the value of them in an immoral city and age as a means of getting himself talked about. It was one of his characteristics to intrigue with women in all ranks of society, from the common people, through the different ranks of the middle classes, up to the highest nobility of Spain, and even to royalty itself, for he was an especial favourite of the dissolute Queen Maria Luisa, and we know what, for such a woman, a male favourite is. The *liaison* with the Duchess of Alba is historical, and adds immensely to the *éclat* of Goya's fame in Spain, where every one associates his name with hers. She was beautiful, high-spirited, imperious, and a duchess, and she does not seem to have concerned herself in the least about the publicity of their connexion. In a thoroughly immoral state of society such a conquest, so far from being a disgrace to a man, adds vastly to his reputation. Another of Goya's conquests was a well-known bookseller's wife in Madrid, and his popular celebrity was enhanced by *liaisons* with beautiful women in the lowest classes. What his wife thought of all this we are left to conjecture . . .

We have now done with the man, leaving him to such immortality as he may have deserved, but the artist remains to be considered. There is a certain difficulty for me here, which may be stated frankly, as a critic should never pretend to more knowledge than that which is really his. I have never been in Spain, and only know Goya as an artist through his etchings, through the engravings from his works, and the 'frescoes' from his country-house, which now belongs to Baron Erlanger. This is comparatively little, because Goya was an immense producer, and left hundreds of pictures behind him which are only to be seen in Spain . . . In all his works which are directly or indirectly known to me I am unable to detect any evidence of that sweet enjoyment of natural beauty which is given only to the pure in heart. You often find him working energetically out of hatred, often as a matter of business, hardly ever out of an artist's love for a subject which has won his affection. Again, not only did Goya work without affection for his subjects, but it seems to me that he had little delight in the exercise of the arts which he practised. I am quite certain that he never felt the real pleasures of an etcher: he uses the etching-needle merely for his political purpose, as so many people use the pen in writing, without any idea of the artistic capabilities of the

instrument and the art. M. Yriarte praises his etchings to the skies, declares that he is 'universellement admiré comme aquafortiste', that he had 'dompté le cuivre', that 'tous ceux qui s'occupent de l'art l'exaltent': to all which wild laudations I give this plain and simple answer, that Goya was to a really cultivated etcher what a peasant fiddling in an ale-house is to Joachim interpreting Beethoven. Of the resources of etching—its pianos and its fortes, its harmonies and oppositions, its tender cadences and its notes of triumphant energy—Goya lived in Philistine ignorance. If his etchings had been good, he would never have endured to spoil them by heavy aquatint. He was as unskilful in aquatint as in etching proper, but he could lay a coarse, flat shade, which served in some measure to hide the poverty of his performance with the needle . . .

Of Goya as a painter I cannot speak quite so decidedly, because his admirers would tell me that he can only be studied in Spain. They say that he has some good qualities of rapid execution and light, agreeable colour, which in some instances, as in *The Family of Charles IV*, *La Maja*, and *Manolas in a Balcony*, reach exquisite and original harmonies. Of this I cannot say anything more than that Goya's rapidity with the brush would of itself tend to preserve a pleasant freshness in his tints, if at any time his perceptions were healthy enough for freshness of colouring. Such colouring as I have seen of his is foul and filthy to the last degree, and I have a difficulty in understanding how a man so restless, so irritable, and so degraded by mental and physical vice, could at any time colour tenderly, delicately, and purely. I have believed hitherto that the power of fair colouring was reserved for serene and elevated natures, but there may be exceptions to the rule, if it is a rule. One technical detail is known, which is that Goya laid in all his later pictures with printers' ink, which is scarcely a colourist's preparation. The so-called 'frescoes' look as if they had been painted with a mixture of soot, mud, whitening, and candle-grease . . .

Goya in all his practice scorned the refinements of execution, and everything which belongs to the technical business of the artist. He expressed his thought as directly as possible without taking technical conditions into account, and it is, perhaps, this very eagerness and haste to express himself that have won for him the sympathies of literary men who value the thought, the idea, as he did, and care as little as he cared about the arts of painting, etching, and lithography. The means to him mattered nothing; artistic excellence very little: what he really cared about was to get his idea expressed whilst it was still hot from his volcanic brain. It is narrated, that when in the fervour of composing a pen-and-ink drawing he would daub about the ink with his fingers if the pen could not do the work fast enough. He toiled always in a rage, and gave himself no time for the precautions of a careful workman. He did not try to please people; his art was the result of a need in his nature, an imperious need of utterance at all costs.

APPENDIX II

Goya's Finances: Eighteenth-Century Spanish Money and its Value

THERE are a number of references to sums of money earned or invested by Goya in the text of the present book. Readers will naturally want to know the relative scale of the figures involved. An extremely rough and ready method of converting Spanish *reales* into eighteenth-century English pounds is to divide by 100. A more sophisticated calculation can be based on the sterling equivalents provided by contemporaries. In Tables 1 and 2 some figures for 1761, November 1785, June 1786, 1792, 1795, 1804 and 1845 are given. These are taken from the following sources: 'Noticia de las monedas extranjeras', *Itinerario de las carreras de postas de dentro y fuera del reino* (Madrid, 1761). *Memorial literario, instructivo y curioso de la corte de Madrid* (1785–6). Wyndham Beawes, *Lex Mercatoria Rediviva: or a complete code of commercial law. Being a general guide to all men in business*, 5th edition (London, 1792). *Almanak mercantil o Guía de comerciantes* (1795 and 1804). Richard Ford, *A Hand-Book for Travellers in Spain, and Readers at Home* (London, 1845).

The figures suggest that the exchange value of Spanish money rose sharply in relation to sterling in the 1790s, perhaps after the French Revolution. But the purchasing power of Spanish money in Spain cannot be said to have increased at the same period. The price of wheat went up in 1794–5, 1797–8 and 1802–3, reaching a peak in 1804. Earlier less significant peaks in cereal prices in Spain occur in 1763–4, 1766–7 and 1788.

For comparative purposes, economic historians sometimes like to use the prices of commodities. The *Memorial literario* tells us that in January 1785, two Spanish pounds of bread (fractionally more than two English pounds) cost 28 *maravedís* (0.82 *reales*; 0.21 *pesetas*; nearly 2 old pence). At that date a pound of veal cost 2 *reales* (0.50 *pesetas*; just over $5\frac{1}{4}$d); and a pound of beef 1 *real* and 30 *maravedís* (1.88 *reales*; 0.47 *pesetas*; almost exactly 5d). Figures for daily wages are also instructive. In Goya's time, the standard day's pay for an agricultural worker was about 6 *reales* (1.5 *pesetas*; nearly sixteen old pence). The minimum daily wage for a Spanish worker in October 1976 was 380 *pesetas*, i.e. 253 times as much.

To obtain an idea of the relationship of sums mentioned to Goya's total income, it is useful to consult background figures for the artist's average annual earnings. A rough guide to these is given in Table 3 below. The lower figure (A) is the income revealed by the Tax Books in Saragossa, the accounts of the Tapestry Factory, and payments known to

have been made by the Royal Treasury, the Academy of San Fernando, the Academy of History, the Infante Don Luis, the Dukes of Osuna, the Council of Military Orders, the Bank of San Carlos, some religious organizations and a few other sources. A higher, conjectural figure (B) is the result of adding to (A) Goya's likely income from portraits and paintings other than those whose price is known. The assumption has been made that Goya normally charged upwards of 2,000 *reales* for a bust portrait, and between 4,000 and 10,000 for one that was full-length. Certain problems arise in connection with the artist's basic salary in the 1790s and after 1808. It is not clear what stipend Goya drew as an *Honorary* Director of the San Fernando Academy; nor what his wage was as a court painter under Ferdinand VII. Tentative maximum and minimum figures for the latter period have been extrapolated from the salaries he is known to have drawn between 1800 and 1808.

Table 1: Pound sterling equivalents in reales *and* pesetas

	1761	1785	1786	1792	1795	1804	1845
Reales	90.3528	101.8059	99.3565	44.44	95.6471	49.9918	95.6418
Pesetas	22.5882	25.4515	24.8391	11.11	23.9118	12.4980	23.9105

Table 2: Conversion Table: Reales *in pounds sterling and dollars at* $4 = £1

		1761	1785	1786	1792	1795	1804
300 *reales*	£	3.32	2.95	3.02	6.75	3.14	6.00
	$	13.28	11.80	12.08	27.00	12.56	24.00
2,000 *reales*	£	22.14	19.65	20.13	45	20.91	40
	$	88.56	78.60	80.52	180	83.64	160
4,000 *reales*	£	44.27	39.29	40.26	90	41.82	80.01
	$	177.08	157.16	161.04	360	167.28	320.04
8,000 *reales*	£	88.54	78.58	80.52	180	83.64	160.03
	$	354.16	314.32	322.08	720	334.56	640.12
10,000 *reales*	£	110.68	98.23	100.65	225	104.55	200.03
	$	442.72	392.92	402.60	900	418.20	800.12
15,000 *reales*	£	166.02	147.34	150.97	337.50	156.83	300.05
	$	664.08	589.36	603.88	1350.00	627.32	1200.02
28,000 *reales*	£	309.90	275.03	281.81	630	292.74	560.09
	$	1239.60	1100.12	1127.24	2520	1170.96	2240.36
84,000 *reales*	£	929.69	825.10	845.44	1890	878.23	1680.28
	$	3718.76	3300.40	3381.76	7560	3512.92	6721.12
178,864 *reales*	£	1979.62	1756.91	1800.22	5270.85	1870.04	3577.87
	$	7918.48	7027.64	7200.88	21083.40	7480.16	14311.48

A crude way of putting the figures in the table above into twentieth-century terms, would be to multiply them by a factor between ten and twenty.

Table 3: Goya's average annual income in reales *and pounds sterling*

	1771–9	1780–9	1790–9	1800–8	1810–23
	(1761 exchange)	(1786 exchange)	(1795 exchange)	(1804 exchange)	(1845 and 1804 exchange)
A	11,588 rs £128.25	29,500 rs £296.91	19.830 rs £207.32	53,710 rs £1074.38	39,118–58,100 rs £409.01– 607.47 £782.49–1162.19
B	17,811 rs £197.13	36,750 rs £369.88	37.530 rs £392.38	79,821 rs £1596.68	48,975–65,642 rs £512.07– 686.33 £979.66–1313.06

Comparing Goya's income with that of some of his contemporaries, we find that a Colonel in an Infantry Regiment earned 15,900 *reales* a year in the 1760s, and that Captains in 1792 earned 8,400 *reales* per annum. The dramatist Leandro Fernández de Moratín earned his living as a jeweller in the 1780s. His total income in 1780 was 4,829 *reales*; in 1781, 8,871 *reales*; and in 1782, 10,467 *reales*. His total expenditure in these years was 884 *reales*, 3,132 *reales*, and 1,194 *reales*. In 1794, Moratín was spending between 10,000 and 11,000 *reales*.

Notes to Text

Notes to Chapter I

1. Cf. Goya's report to Pedro Cevallos on the restoration of paintings in the Royal collection by Angel Gómez Marañón, in *Colección de 449 reproduciones de cuadros, dibujos y aguafuertes de Don Francisco de Goya . . .*, 1924, 63. For an English translation of the report, cf. Enriqueta Harris, *Goya*, 1969, 29–30.

2. Captain S. E. Cook, *Sketches in Spain during the Years 1829, 30, 31 and 32* (London, 1834), I, 169. Richard Ford attacked the Prado's restorers even more violently in his *Hand-Book for Travellers in Spain, and Readers at Home* (1845). Ford held that 'Spanish pictures ought never to be much cleaned'. Pedro de Madrazo defended the cleaning programme in his *Catálogo de los cuadros del Real Museo de Pintura y Escultura de S.M.*, 3rd ed. (Madrid, 1850).

3. Cf. *Goya and His Times*, Catalogue of the Royal Academy of Arts' Winter Exhibition 1963–4, No. 96.

4. Cf. Valentín de Sambricio, *Tapices de Goya*, 1946, 250, 255, 266–7, 269 and 270 (Catalogue Nos. 41ᵃ, 44ᵃ, 54, 54ᵃ and 56).

5. *Francisco de Goya* (Berlin, 1921), 98.

6. *Forma*, I (1904–5), 164.

7. An eighteenth-century English traveller described the Pillar as 'spacious, lofty, light, elegant and cheerful', and spoke of the 'elegant paintings in compartiments' on the domes (Joseph Townsend, *A Journey through Spain in the years 1786 and 1787* (London, 1791), I, 206). The cathedral is not often 'cheerful' today, and there is possibly less light from aisle windows and lanterns than there was in Goya's time. The frescoes were restored after the Civil War in 1940 by Ramón Stolz, and were photographed at the time (cf. E. Lafuente Ferrari, 'La situación y la estela del arte de Goya', in *Antecedentes, coincidencias e influencias del arte de Goya*, 1947, 35). They were cleaned and restored (and photographed) again in 1969.

8. E. du Gué Trapier described the results of the cleaning process in 'Only Goya', *The Burlington Magazine*, cii, No. 685, 1960, 158–61. An anonymous note was published the previous year describing the work: 'Painting on and scraping off: El Greco and Goya', *Art News*, lviii, No. 7, 1959, 32.

9. Priscilla E. Muller, 'Goya's *The Family of Charles IV*: An Interpretation', *Apollo*, xci, No. 96, 1970, 132–7.

10. Cf. Marqués del Saltillo, *Miscelánea madrileña, histórica y artística*, Primera serie. Goya en Madrid: su familia y allegados (1746–1856), 1952, 20. The pessimistic opinion of experts about the removal of the Black Paintings is reported in Charles Yriarte's *Goya*, 1867, 92, and in G. Cruzada Villaamil's article 'La casa del sordo', *El Arte en España*, 1868, 265.

11. Emiliano M. Aguilera, *Las pinturas negras de Goya. (Historia, interpretación y crítica)*, Madrid, n.d., (1935?), 30.

12. A print of the photograph is in the Witt Photographic Collection of the Courtauld Institute. The negative was probably made immediately before restoration. It is usually assumed that the transfer was made in 1873, shortly after Baron Frédéric-Emil d'Erlanger bought the house. In fact, however, there is no clear evidence that the work was carried out then, and the transfer may have taken place as late as 1877. Laurent's negative, which clearly antedates restoration, could hardly have been made in 1873 since it fails to show detail which a visitor was able to see early that year.

13. P. L. Imbert, *L'Espagne. Splendeurs et misères*, 1875, 329. In Imbert's time the manola's face was 'nearly a uniform tone of strong pink', the eyes were 'two black dots', the nose 'fairly successfully conveyed by a finger stroke', and the mouth 'another stroke cross-wise dipped in red'. The face, which was 'redder than the dazzlingly white and transparent neck and bosom', gave the whole painting 'a most unusual feeling'.

14. The copy may have been made to facilitate

the photographer's task. It was a common practice to make copies in the second half of the nineteenth century when the original was too poorly lit to be photographed easily. Laurent must have made his negative before 1870 since the caption refers to him as plain 'J. Laurent' and not 'J. Laurent y Compañía'. Laurent's firm became a company in 1870, when he had already been working in Madrid for ten years. The owner of the Quinta del Sordo in the 1860s, Rodolphe Coumont, is known to have been interested in the paintings and to have had a set of photographs made between 1863 and 1867. The copy and the negative may both date from this period. Prints of the copy were offered for sale with the title 'La Maja d'après la fresque de la Quinta de Goya' in the catalogue of photographs published in 1879: *Guide du touriste en Espagne et en Portugal . . . Catalogue des Chefs-d' uvre de peinture ancienne et moderne . . . ;* J. Laurent et Cie., Madrid: Carrera de San Gerónimo, 29; Paris, Rue de Richelieu, 90; Stuttgart, Mr B. Schlésinger, Königsstrasse, 60, 1879, No. A 1239.

15. Aureliano de Beruete y Moret, *Goya*, 1928, 159, note 1.

16. The fact that the Infante Don Sebastián's collection was placed in the National Museum almost from its inception is attested by Ramón de Mesonero Romanos's *Nuevo Manual histórico-estadístico y descripción de Madrid* (Madrid, 1854). In the same work he notes the presence in the Museum of Goya's *Majas on a Balcony*—'one of the most beautifully finished works of this notable artist'. Viardot's *Les Musées d'Espagne, d'Angleterre et de Belgique* (1843) mentions it as the only Goya painting in the collection when he was writing. However, there is evidence that other Goyas belonging to the Infante were there at some stage, and his *Nun* and *Monk* bore the numbers 76 and 78 in the inventory of the Trinity Museum according to the *Catálogo ilustrado de la exposición de pinturas de Goya, celebrada para conmemorar el primer centenario de la muerte del artista* (Madrid, 1928), Nos. 90 and 91. Some of the Infante's pictures were returned when he recognized the constitution in 1859. They were then hung in the gallery of his house in the Calle de Alcalá, where the general public could view them if they presented a card. In 1865, according to H. O'Shea's *A Guide to Spain*, 1865, 297ff, the Infante's paintings were still divided between the Museum and his house. But at that juncture the *Majas on a Balcony* was already back in the Infante's private gallery, and O'Shea described it as a 'charming composition', measuring 2m × 127cms. Two

Disasters of War paintings by Goya were also stated by the Conde de la Viñaza to belong to the Infante's collection (*Goya*, 1887, 275): Nos. 936 and 939 in Gassier and Wilson's Catalogue III, now lost. Their authenticity has been doubted, and neither Mesonero Romanos, nor Viardot, nor O'Shea mentions them. The Infante Sebastián also owned prints by Goya. There is no way of proving whether the *Caprichos* exhibited in the Trinity Museum were his or not. He certainly owned at least two of Goya's lithographs (*The Duel* and the *Vito Dance*), and possessed proof copies of a number of *Disparates*, with titles written in the artist's own hand (cf. *Goya: Drawings from the Prado Museum and the Lázaro Galdiano Museum, Madrid . . . 12 June–25 July 1954*, London, Nos. 79, 82, 86, 94–7, 176 and 177).

17. The vicissitudes of the Black Paintings in the Prado have been admirably documented by X. de Salas in his appendix to F. J. Sánchez Cantón's *Goya and the Black Paintings*, 1964. The sixth edition of the Prado Catalogue (1889) —the first to mention the paintings' accession—give an inaccurate account of their provenance. Cf. Z. Araujo Sánchez, *Goya*, n.d. (1895?), 98.

18. Cf. Goya's letter to Cayetano Soler offering the plates of the *Caprichos* to the King, 7 July 1803, in *Colección de 449 reproducciones . . .*, 55. Goya says: 'They were only on sale to the public for two days, at a price of a gold ounce piece for each copy. Twenty-seven copies were sold, and the plates are capable of printing up to five or six thousand copies. Those who most want to buy them are foreigners, and for fear that they should fall into foreign hands after my death, I should like to present the plates to my lord the King, for his Chalcography.' The gold ounce piece was 'generally worth more than £3 .6s.' according to Richard Ford (1845).

19. Cf. Nigel Glendinning, 'Goya and England in the Nineteenth Century', *The Burlington Magazine*, cvi, No. 730, 1964, 7.

20. Ilse Hempel Lipschutz, *Spanish Painting and the French Romantics*, 1972, 262.

21. *The Journal of Eugène Delacroix*, trans. Walter Pach (London, 1938), 70; and Lipschutz, *op. cit.*, 96.

22. *The Journal of Eugène Delacroix*, 71. Lemercier was the author of the satirical poem *Panhyprocrisiade* which Delacroix was reading at the time.

23. Michel Florisoone, 'Comment Delacroix a-t-il connu les *Caprices* de Goya?', *Bulletin de la Société de l'Histoire de l'Art Français*, 1957, 131–44.

24. Lipschutz, *op. cit.*, 90–1.

25. Tomás Harris, *Goya. Engravings and Lithographs*, 1964, I, 12, 107; II, 449.

26. Cf. *The Burlington Magazine*, cvi, No. 730, 1964, 12.

27. Paul Mantz, 'Goya y Lucientes', *Dictionnaire de la conversation*, 1855, X, 414. The list of paintings in the Galerie Espagnole has recently been reprinted by Lipschutz in Appendix A, *op. cit.*, 1972, 219ff. The eight Goyas are as follows: 97, Un Enterrement; 98, Dernière Prière d'un condamné; 99, *Manolas* au balcon; 100, Femmes de Madrid en costume de *Majas*; 101, Forgerons; 102, Lazarille de Tormes; 103, Portrait de la Duchesse d'Albe; 104, Portrait de Goya. Goya's work in the Galerie Espagnole was attacked for its mediocrity by some (Lipschutz, 393), but impressed others. Jules Michelet was one of the latter (cf. his *Journal*, Paris, 1962). Michelet remarks, when recording his visit to the Louvre on 23 June 1839: 'I noticed, for the first time, some Goyas'. The paintings which struck him were No. 97 ('the whole work full of extraordinary vigour'), and 'une Espagnole moderne', perhaps No. 103 ('a queen and a prostitute at one and the same time').

28. *Lettres de Prosper Mérimée à la Comtesse de Montijo*, I, 1839–53, Paris, 1930, 60 (XXXVII, Paris, 25 March 1843). Mérimée had copied Goya's painting of the Marquesa de Lazán when in Madrid (1830). His version is reproduced by Lipschutz, *op. cit.*, 112.

29. *Œuvres complètes de Charles Baudelaire*, Correspondance générale recueillie . . . par M. Jacques Crépet (Paris, 1947), II, 310.

30. Cf. *Le Musée Goya à Castres*, guide, 4th ed. (Castres, 1972), No. 48.

31. On American collectors, see Aline B. Saarinen, *The Proud Possessors* (New York, 1968).

32. Jean Adhémar, *Goya*, trans. Denys Sutton and David Weston (London–Paris, 1948), 30. Also *Goya y el arte francés*, Catalogue of the exhibition held at the Instituto Francés en España in 1946, 6.

33. *Catalogue of the Art Treasures of the United Kingdom Collected at Manchester in 1857*, Paintings by Ancient Masters, Nos. 869–72.

34. Cf. William Bell Scott, *Murillo and the Spanish School of Painting*, 1873, 94.

35. H. O'Shea, *A Guide to Spain*, 1865, 282.

36. Cf. J. Baticle, 'Eugenio Lucas et les satellites de Goya', 1972, 12.

37. *Antecedentes, coincidencias e influencias . . .*, 272–3.

38. *Ibid.*, 278.

39. Cf. *The Burlington Magazine*, cvi, No. 730, 1964, 13 (Note 47) and 38.

40. Cf. Enriqueta Harris, 'Sir William Stirling-Maxwell and the History of Spanish Art', *Apollo*, lxxix, No. 23, 1964, 74.

41. Cf. J. Adhémar, *Goya*, 1948, 31. The photographs from the major Goya series of etchings reproduced in Brunet's book are *Caprichos* Nos. 1, 5, 7, 11, 16, 27, 28, 40 and 42; *Tauromaquia* Nos. 16, 18, 19 and 20; and *Disasters of War* Nos. 3 and 5.

42. Cf. Paul Lefort, *Francisco Goya. Étude biographique et critique*, 1877, 16 (Note 1). Lefort refers to Laurent's photographs of Goya paintings in the Alameda palace of the Dukes of Osuna.

43. *El Arte en España*, vii, 1868, between pages 264 and 265; viii, 1869, facing p. 35.

44. *Frescos de Goya en la Iglesia de San Antonio de la Florida grabados al aguafuerte por D. José M. Galván y Candela* (Madrid, 1888).

45. Cf. Luis Auguet, 'Goya en la filatelia', *Mundo Hispánico* No. 164, 1961, 66–7; José A. Vicenti, *Catálogo NETO. Filatelia española 1850–1971*, 6th ed.

46. C. Gasquoine Hartley, *Things seen in Spain* (London, 1916), 251.

47. C. S. Ricketts, *The Prado and Its Masterpieces*, 1903, 58 and 66. Ricketts together with his friend Shannon collected some prints and drawings by Goya (cf. Burlington Fine Arts Club, *Catalogue of an Exhibition of Spanish Art including pictures, drawings and engravings by Goya* (London, 1928), Nos. 2, 7, and 17).

48. Cf. E. M. Aguilera, *Las pinturas negras de Goya*, n.d., 1935?, 36.

49. Two of the paintings on ivory were exhibited at the *Exhibition of Spanish Art*, 1928 (Nos. 11 and 15, both lent by General Archibald Stirling); another two at the *Goya and His Times* Exhibition (Royal Academy of Arts), London, 1963–4 (Nos. 122 and 123). Four were shown at the *From Greco to Goya* Exhibition, 1938 (Nos. 25–8). In the United States examples were included in *The Art of Francisco Goya*, Art Institute of Chicago, 1941; *Water Colours of an earlier day*, Fine Arts Gallery, San Diego, 1941; *Spanish Masters*, UCLA Art Council, Los Angeles, 1960; *Spanish Masters*, Fine Arts Gallery of San Diego, 1960. The two major studies of the miniatures are Martín S. Soria, 'Las miniaturas y retratos-miniaturas de Goya', *Cobalto*, 2, 1949, 1–4; and Eleanor Sayre, 'Goya's Bordeaux Miniatures', *Boston Museum Bulletin*, lxiv, 1966, 84–123. A more recent contribution is X. de Salas, 'Sur deux miniatures de Goya récemment retrouvés', *Gazette des Beaux-Arts*, lxxxi, 1973, 169–71.

50. 'François Goya, sa vie, ses dessins et ses

eaux-fortes', *Gazette des Beaux-Arts*, vii, 1860, 215–27.

51. Jutta Held, 'Francisco de Goya. Literatur von 1940–62', *Zeitschrift für Kunstgeschichte*, 1965, 246–57.

52. See below, 183, and note.

53. Ludwig Wittgenstein, *Tractatus Logico-Philosophicus*, trans. D. F. Pears and B. F. McGuinness (London, 1963), 117.

Notes to Chapter II

1. His father was a gilder, his grandfather (Pedro de Goya) a notary, and his great-grandfather and great-great-grandfather were both master builders. One of his great-aunts married a glover.

2. The different styles and titles are clear in the Tax books relating to local trades and crafts in Saragossa. Cf. Municipal Archives, Saragossa: *Cabreo de industrias*, 1772, Doradores and Pintores.

3. The 'de' seems to have been used fairly frequently in his family—by his grandfather and great-grandfather, for instance—although his father did not use it. Goya did not use it, either, at the start of his career.

4. It has long been maintained that Goya studied at the school of 'Padre Joaquín' in Saragossa. The deduction was first made by Francisco Zapater y Gómez in 1868 from a reference in a letter from Goya to his friend Martín Zapater. But the letter, in fact, only refers to *Zapater's* schooling, not Goya's. If it is valid to infer that Goya also studied with Father Joaquín, then it may well be that the school in question was the Escuelas Pías (Piarist Institute), which was evidently flourishing in the 1740s since it acquired new buildings at that period. Furthermore, the director of the college in 1770 was certainly '*Padre Joaquín* de Jesús y María. The other public school in Saragossa belonged to the Jesuits.

5. When seeking the post of Royal Painter (Pintor de cámara) in 1779, Goya refers to his period of study in Rome and states that 'he travelled and resided there at his own expense'. (Cf. Facsimile reproduction of the document in *Catálogo de la exposición conmemorativa del centenario de Goya*, Madrid, June 1946, No. 69, Pl. XXXI.)

6. J. Gudiol, *Goya*, 1970, I, 29, Note 16.

7. References to his entry for the competition organized by the Royal Academy of Arts of Parma in 1770–1, speak of him as 'a pupil of Signor Francesco Vajeu'. Cf. *The Burlington Magazine*, xcvii, No. 630, 1955, 295–6; and

Mercure de France, 1772, I, 145.

8. Sambricio, *op. cit.*, Document No. 39. Cf. also Documents Nos. 19, 49 and 56.

9. Cf. *Diccionario histórico de los más ilustres profesores de las Bellas Artes en España . . .*, 1800, V, 178.

10. Cf. Condesa de Yebes, *La condesa-duquesa de Benavente. Una vida en unas cartas*, 1955.

11. Sambricio, *op. cit.*, Document No. 194.

12. Cf. Luis de Valdeavellano, 'Las relaciones de Goya con el Banco de San Carlos', *Boletín de la Sociedad Española de Excursiones*, xxxvi, 1928, 56–65; also *Sexta Junta General del Banco Nacional de San Carlos celebrada en la casa del mismo banco el día 24 de febrero de 1788*, 1788, 6.

13. Acción Real Vitalicia dated 26 May 1794.

14. Marqués del Saltillo, *Miscelánea madrileña, histórica y artística. Primera series, Goya en Madrid: su familia y allegados (1746–1856)*, 1952, 13–14.

15. id., 16. The estate measured 14 'fanegas' and 10 'celemines' according to the deed of gift drawn up by Goya on 17 September 1823. Using the metric equivalents given in the *Guía de comerciantes* for 1803, the area works out as 71,097.69 sq. metres (7.11 hectares) or 17.57 acres. Equivalents of earlier and later dates produce rather different figures. According to them, the area could be as little as 13.24 acres (5.36 hectares), or as much as 23.98 acres (9.33 hectares).

16. Ceán Bermúdez's translation of Francisco de Milizia, *Arte de ver en las bellas artes del diseño . . .*, 1827, 172 (Note XCVI).

17. Jovellanos was certainly responsible for writing a favourable report to the Council of the Military Orders on the paintings by Goya they had commissioned, and he wrote to Goya to that effect on 11 October 1784. Cf. F. Zapater y Gómez, *Goya. Noticias biográficas*, 1868, 33–5. For further references, cf. Nigel Glendinning, 'Jovellanos en Bellver y su "Respuesta al mensaje de Don Quijote"', *Mélanges à la mémoire de Jean Sarrailh*, 1966, I, 394.

18. The award of the Order was announced in the *Gaceta de Madrid*, 19 March 1811; his gift of 21 'varas' of canvas in the same paper two years previously on 11 October 1808. Other reflections of Goya's changing position are discussed in P. Gassier and J. Wilson, *Goya*, 1971, 212ff.

19. The relevant documents were published by Sambricio, *op. cit.*, Documents 230–48, cxlix ff.

20. Archivo Histórico Nacional, Madrid, Inquisición, Leg. 449, No. 3—'Denuncia del fiscal por pinturas deshonestas', 1814.

21. *Ibid.* There were several Palominos in the

San Fernando Academy in the eighteenth century. I have not so far identified one with the Christian name 'Manuel'.

22. There is documentary evidence that Goya's wife bore him five children in Madrid. Only one survived. Cf. E. Lafuente Ferrari, *Antecedentes, coincidencias e influencias del arte de Goya*, 1947, 288–9.

23. It is difficult to know precisely how far Goya was able to overcome the grave disability of his deafness in communicating with others. In the mid-1790s, Ramón de Posada found him stone deaf and had to write down the things he wanted to say. Later he appears to have used sign language. Yet at least one contemporary— Juan Carnicero, to whom Goya gave the preliminary sketch for *Truth, Time and History* (now in the Museum of Fine Arts, Boston)— suggests that Goya came to understand those that spoke to him almost perfectly. Either his powers of comprehension grew impressively, or the truth lies somewhere between the extremes. (Cf. Charles Yriarte, *Goya, Sa Biographie, les fresques . . .*, 1867, 34.)

24. The sum is first mentioned at the meeting of the Academy of San Fernando on 6 November 1808. Goya evidently wrote to ask for the money on 27 May 1814 and again on 28 October 1816. The Academy meeting on 3 January 1829 notes that Goya's son, Javier, repeated the demand after his father's death.

25. Per Bjurström, 'Jacob Gustaf De la Gardie och Goya', *Meddelander från Nationalmuseum* (Stockholm), No. 86, 1962, 77–81.

26. Marqués del Saltillo, *Miscelánea madrileña*, 1952, 108–9, Document No. 21.

27. *Ibid.*, 109–10 (Document No. 22).

28. Cf. Gassier and Wilson, *op. cit.*, 248, and Eric Young, 'An Unpublished Letter from Goya's Old Age', *The Burlington Magazine*, cxiv, No. 833, 1972, 558–9.

29. Vicente Llorens gave an admirable account of the liberals in exile in his book *Liberales y Románticos. Una emigración española en Inglaterra (1823–1834)* (Mexico, 1954).

30. José Duaso's career is well documented in Enrique Pardo Canalís' article 'Bosquejo histórico de Don José Duaso', *Anales del Instituto de Estudios Madrileños*, iii, 1968, 253–80.

31. Gassier and Wilson, *op. cit.*, 343. Cf. also *Epistolario de Leandro Fernández de Moratín*, ed. René Andioc, Madrid, 1973, 597 (Letter No. 309, 23 October 1824).

32. Cf. *Epistolario de Leandro Fernández de Moratín*, 672 (Letter No. 370, 15 November 1826).

Notes to Chapter III

1. Cf. M. H. Abrams, *The Mirror and The Lamp: Romantic Theory and the Critical Tradition* (Oxford, 1953).

2. The importance of the artist's personal temperament had long been recognized. On 3 August 1766, when prizes were awarded after a competition at the San Fernando Academy in which Goya himself took part, Vicente Pignatelli said that 'nothing can be expected from an artist who lacks imagination, and the guidance of a great painter or sculptor will never make a pupil excellent unless his temperament and the climate in which he works enable him to translate his ideas on to canvas or express them in statuary.' This is little more than an affirmation of the commonplace that artists are born and not made. But in 1802, José Luis Munárriz, translator of Hugh Blair and a member of the Academy, went much further at an academy prize-giving: 'To put life into pictures,' he declared, 'the imagination must hold the brush and the heart must guide it. The Spirit must find joyous images . . . and the Heart, which alone knows how to appeal to the Heart, must strike chords that will arouse our sympathies and our feelings . . . You need a great measure of strength of purpose and wariness to avoid being slavish imitators! The arts cannot progress by imitation alone. Had we never gone further than that we should still be sailing on rafts . . . Those who refuse to invent, and are satisfied with the imitation of the work of others, are feeble in spirit.'

In the 1780s and 90s, many Spaniards were uncertain how far originality should be pursued in art. León de Arroyal attacked the concept in an epigram published in 1784, yet on the title page of his *Tauromaquia* published in 1816, Goya was proud to declare himself an 'original painter'. Individuality was certainly praised in the 1790s. Goya's friend Jovellanos wrote, in a letter to Vargas Ponce dated 11 December 1799, that 'Nature has given every man a style, in the same way that she has given him facial features and character . . ., and no one who tries to change it will escape Nature's punishment . . . Recover your personality; write as you speak; compose as you write' (G. M. de Jovellanos, *Obras, I: Epistolario*, ed. J. Caso González (Barcelona, 1970), 127). Vargas Ponce had himself enthused about the originality of Rembrandt in August 1790, and attributed his appeal to that quality: 'Stubbornly following his own natural instincts [Rembrandt] produced original plates, whose very singularity is

responsible for the earnestness with which connoisseurs seek to acquire them today. Those masses of conflicting burin strokes, irregular and unmethodical lines, produce such a striking effect, and have so much dash and spirit in them, that artists are filled with wonder, seeing how he gets closer than almost anyone else to the true object of engraving, namely, to represent objects through light and shade, bringing out the contrasts with masterly skill. His so-called "One hundred guinea" print, and his *Descent from the Cross*, which is even worthier of the money, are shining examples of his rare ability' (*Discurso histórico sobre el principio y progresos del grabado leído a la Real Academia de San Fernando . . . el 4 de agosto de 1790, 19*).

3. *Noticia de los cuadros que se hallan colocados en la Galería del Museo del Rey . . ., 1828,* 67–8.

4. Cf. Extract from *Diario Ordinario di Roma,* No. 8164, 26 May 1770, quoted by A. Hyatt Mayor in *The Burlington Magazine,* xcvii, No. 630, 1955, 295–6.

5. Extract from *Diario Ordinario di Roma,* No. 8288, 3 August 1771, quoted in *The Burlington Magazine,* xcvii, No. 630 1955, 295–6.

6. *Ibid.*

7. Conde de la Viñaza, *Goya,* 1887, 157–8.

8. *Ibid.,* 158.

9. Sambricio, *Tapices de Goya,* 1946, Document No. 16.

10. *Ibid.,* No. 39. Cf. also Nos. 19, 49 and 56.

11. *Ibid.,* No. 49.

12. *Ibid.,* No. 56.

13. Antonio Ponz, *Viage de España,* 1778, Prólogo.

14. *Obras de Don Rafael Antonio Mengs . . . ,* ed. J. N. de Azara (Madrid, 1780), 266.

15. María del Carmen Velázquez, *La España de Carlos III de 1764 a 1776 según los embajadores austríacos,* 1963, 176.

16. Cf. Nigel Glendinning, 'Jovellanos en Bellver y su "Respuesta al mensaje de Don Quijote"', *Mélanges à la mémoire de Jean Sarrailh,* 1966, I, 393–4

17. Cf. Letter from Jovellanos dated 14 December 1789 in *Obras de Jovellanos,* Biblioteca de Autores Españoles (Madrid, 1956), LXXXVII, 156.

18. Cf. E. Lafuente Ferrari, *Antecedentes, coincidencias e influencias del arte de Goya,* 1946, Appendix 3—'Un documento inédito de Goya', 321.

19. *Colección de 449 reproducciones, de cuadros, dibujos y aguafuertes de Don Francisco de Goya,* 1924, 31.

20. *Ibid.,* 32.

21. *Nouveau voyage en Espagne, ou Tableau de l'Etat Actuel de cette Monarchie,* 1789, I, 249.

22. Cf. J. F. Bourgoing, *Tableau de l'Espagne Moderne,* 1803 (3rd ed.), I, 289–90. Bourgoing's observations about Goya were soon followed by those of a German critic: J. D. Fiorillo, in *Geschichte der zeichnenden künste von ihrer Wieder-auflebung auf die neuesten zeiten,* IV (Gottingen, 1806), 411, 420 and 433–4. Fiorillo draws heavily on Ceán Bermúdez's *Dictionary* and Ponz in addition to Bourgoing himself. He speaks of Goya as an 'appreciated' artist and finds his cupola in Saragossa beautiful. He rephrases Ceán's entry on Goya's pupil Vicente Calderón de la Barca, whose portraits, like Goya's, were 'skilful and bold in their handling of brushwork'.

23. *Colección de los epigramas y otras poesías críticas, satíricas y jocosas de Don Francisco Gregorio de Salas* (Madrid, 1802), 15. The epigram is not in Salas' *Poesías,* I (1797), although epigrams up to the fifth before it are printed there.

24. Cf. 'Elogio de don Ventura Rodríguez', in *Biblioteca de Autores Españoles* XLVI (Madrid, 1858), 388b, Note 16.

25. *Cartas confidenciales de la reina María Luisa y de don Manuel Godoy* (Serie de los archivos secretos de la historia, dirigida por Carlos Pereyra) (Madrid, n.d.), 233, 235, 236, 284, 304 and 310.

26. Cf. *Diario de Madrid,* 1798, quoted by Edith Helman, in 'Identity and Style in Goya', *The Burlington Magazine,* cvi, No. 730, 1964, 33. I use Mrs Helman's translation.

27. *Colección de 449 reproducciones . . . , 1816,* 27–8.

28. Conde de la Viñaza, *op. cit.,* 162–3.

29. *Ibid.,* 163.

30. *Ibid.,* 163–4.

31. *Ibid.,* 164–5.

32. *Ibid.,* 164–5.

33. *Ibid.,* 168–73. A rough draft of this memorandum now in the Lázaro Galdiano Museum, Madrid, has been studied by Edith Helman, *op. cit.,* 30–7.

34. Conde de la Viñaza, *op. cit.,* 166–7.

35. Biblioteca de la Universidad de Zaragoza, MSS, Faustino Casamayor, *Años políticos e históricos,* I, 155–6.

36. *Correspondencia epistolar entre D. José de Vargas y Ponce y D. Juan Agustín Ceán Bermúdez durante los años de 1803 a 1805* (Madrid, 1905), 58, No. 24.

37. Cf. Léon-G. Pélissier, *Le portefeuille de la Comtesse d'Albany (1806–1824),* 1902, 391 (Letter No. 189).

38. Cf. *Arte de la pintura,* ed. F. J. Sánchez Cantón (Madrid, 1956), II, 183.

39. Cf. Jutta Held, 'Goyas Akademiekritik', 1966, 214ff. An English translation is included in Appendix II of Enriqueta Harris's *Goya*, 1969, 28–9.

40. The MS from the British Museum, Egerton 585, was first reproduced by Valerian von Loga in *Francisco de Goya*, Berlin, 1903. 1921 ed., 162–3; Note 172.

41. Xavier de Salas, 'Precisiones sobre pinturas de Goya . . .', *Archivo Español de Arte*, xli, 1968, 1–16.

42. V. von Loga, *Francisco de Goya* (Berlin, 1921), 163–4.

43. *Ibid.*

44. Cf. Glendinning, *op. cit.*, I, 383

45. Cf. facsimile reproduction in Edith Helman, *Trasmundo de Goya*, 1963.

46. Cf. Jovellanos' diary for 7 April 1801, quoted by Edith Helman, *op. cit.*, 105.

47. *Ibid.*

48. Cf. Nigel Glendinning, '¿"La Nevada", de Goya, en un poema de su época?', *Insula*, No. 204, 13. It is interesting to contrast Moreno Tejada's fragment with a twentieth-century interpretation of the same scene: David Wevill's 'Goya's "Snowfall"', from the collection of poems entitled *Birth of a Shark* (London, 1964). Wevill sees the same figures patiently enduring forces of nature that are cruel and threatening. He views the scene with a pessimistic eye, although he admires the 'man-striving struck patience' with which mankind seeks to stave off destruction it cannot avoid. Moreno Tejada, more optimistically, concentrates on the artistic achievement in itself, and the pleasure the work of art arouses in spite of its gloomy subject.

49. *Semanario de Zaragoza*, 25 February 1799, 133–4.

50. *Ibid.*, 134–5.

51. The poem was first published in a Madrid periodical and then included in the first Spanish edition of Laurent Mathéron's *Goya*, trans. G. Belmonte Müller (Madrid, 1890), 173–6. Sánchez Cantón's suggestion that the poem was written after Meléndez Valdés's death (1817), and probably after the publication of the 1821 edition of Quintana's poetry, has little to recommend it. He argues that the allusion to Meléndez as the 'immortal' could only have been written posthumously. Yet in fact this reference occurs in a passage where Quintana is writing his own epitaph, and fixing the high points of his life: his friendship with Goya and Meléndez Valdés's encouragement. No dating could be based on this fictional passage.

52. Cf. Per Bjurström, 'Jacob Gustaf de la Gardie och Goya', *Meddelander frän National-museum* (Stockholm), No. 86, 1962, 77–81.

53. *Poesías del P. Basilio Bogiero*, 1817, xi. The first critic to draw attention to this reference appears to have been Angel Vegue y Goldoni in *Temas de arte y de literatura* (Madrid, 1928), 161. It was given wider currency by Antonio Rodríguez-Moñino in *Goya y Gallardo*, 1954, an essay that was republished in the same author's *Relieves de erudición* (Madrid, 1959).

54. J. A. Ceán Bermúdez, *Historia de la pintura*, MSS de la Real Academia de San Fernando, VI, 261.

55. In his unpublished *Historia de la pintura* he attacks Hieronymus Bosch from this point of view for his 'monstrosities' (MSS, I, 230); nor does he like El Greco's 'extravagances, his ashen tones and the hardness of his style' (id., VI, 50).

56. *Ibid.*, IV, 124.

57. *Ibid.*, VI, 50.

58. Cf. *Diccionario histórico de los más ilustres profesores de las Bellas Artes en España*, V, 68–9, 178. Also J. López-Rey, *Goya y el mundo a su alrededor* (Buenos Aires, 1947), 64.

59. *Historia de la pintura*, IV, 132.

60. *Ibid.*, I, 69.

61. *Ibid.*, V, 168.

62. Cf. Sebastián de Miñano, *Diccionario geográfico-estadístico de España y Portugal*, X (Madrid, 1828), 83. Part of the extract was quoted by Sir Edmund Head in *A Hand-Book of the History of the Spanish and French Schools of Painting*, 1848, 218.

63. Marqueses de Arany y de la Cenia y D. Antonio Ayerbe, *Cuadros notables de Mallorca . . . Colección de Don Tomás de Verí* (Madrid, 1920), 110–11. The letter is reproduced in facsimile between pp. 107 and 109. I have used the facsimile where the reading is different from the printed transcription. Since the present book was written Xavier de Salas has printed extracts from the letters in the second of 'Dos notas, a dos pinturas de Goya, de tema religioso', *Archivo Español de Arte*, xlvii, No. 188, 1974, 390–6.

64. *Ibid.*, 118–19.

65. Cf. *The Journal of Eugène Delacroix*, trans. W. Pach (London, 1938), 125 (entry for 25 May 1832); and *Le Cabinet de l'Amateur et de l'Antiquaire*, 1842, I, 339.

66. 'La pintura española en la primera mitad del siglo XIX', *Museum*, V, 1916–17, 108. Xavier de Salas studies adverse views of the painting (*op. cit.*).

67. Article reproduced in facsimile in A. González Palencia, 'El estudio crítico más antiguo sobre Goya', *Boletín de la Real Academia de la Historia*, 1946, 78–83.

68. *Historia de la pintura*, VI, 333.

69. Ceán Bermúdez' translation of Francisco de Milizia, *Arte de ver en las bellas artes del diseño según los principios de Sulzer y de Mengs*, 1827, 145, Note LII.

70. Cf. Condesa de Yebes, *La condesa-duquesa de Benavente*, 1955, 24.

71. Cf. Glendinning, *op. cit.*, lines 59–64.

72. Vargas Ponce, 'Proclama de un solterón', in *Poetas líricos del siglo XVIII*, vol. 3 (Madrid, 1875) (Biblioteca de autores españoles, LXVII), 606.

73. M. J. de Larra, *I: Artículos de costumbres*, ed. J. R. Lomba y Pedraja (Madrid, 1942), 170.

74. For biographical information about González Azaola, cf. Enriqueta Harris, 'A Contemporary Review of Goya's "Caprichos"', 1964; *Gazeta de Zaragoza*, 12 September and 10 October 1807; *Gazeta de Madrid*, 20 December 1814; and files in the *Estado* section of the Archivo Histórico Nacional, Madrid (viz. 51-A, 100–2; 5512, No. 46; and 5295, No. 212). There is a sardonic description of him as a deputy in the Spanish *Cortes* in *Condiciones y semblanzas de los señores diputados a Cortes en la legislatura de 1820–21*, Gibraltar, 1821, 62–3.

75. Cf. Archivo Histórico Nacional, Madrid, Estado, Leg. 3239 No. 36. The title of the French work in question was *Convention entre le gouvernement français et le Pape Pie VII; avec les discours du Citoyen Portalis et les articles organiques des cultes*, Paris, 1802.

76. *Semanario Patriótico*, 1811, 24–7. The Spanish text and an English translation were published by Enriqueta Harris, *op. cit.*, 42. I have used some of the phrases of Enriqueta Harris's translation.

77. The advertisement appeared in the *Diario de Madrid*, 1799. For a facsimile reproduction, see Helman, *op. cit.*

78. Cf. Antonio Rodríguez-Moñino, *Goya y Gallardo*, 1954, 11. Reproduced in *Relieves de erudición* (Madrid, 1959).

79. Cf. the López de Ayala commentary, first reproduced by the Conde de la Viñaza, and more recently, by Edith Helman in *Trasmundo de Goya*, 1963, 221, 226 and 234.

80. Nataniel Jomtob, *La Inquisición sin máscara*, 1811, 441–2, Note 3.

81. Eleanor Sayre *et al.*, *The Changing Image: Prints by Francisco Goya*, 1974, 56.

82. Manuel Godoy, *Cuenta dada de su vida política*, 1836, III, 374–5.

83. Cf. Georges Cogordan, *Joseph de Maistre* (Paris, 1894). De Maistre asserted that he had sought to prove that 'l'Inquisition est en soi une institution salutaire, qui a rendu les services les plus importants à l'Espagne' in his *Lettres à un gentilhomme russe sur l'Inquisition Espagnole*. The same work shows that he was familiar with Puigblanch's *La Inquisición sin máscara*, and had some personal Spanish contacts (cf. *Considérations sur la France . . .* (Brussels, 1838), 357, 384).

84. *Mémoires politiques et correspondance diplomatique de Joseph de Maistre*, ed. Albert Blanc (Paris, 1859), 306. If De Maistre thought that Goya had produced his *Caprichos* in 1807, as seems to be the case, it is not surprising that he believed the work to contain transparent criticisms of María Luisa. In July and October 1807, Prince Ferdinand (later Ferdinand VII) had alluded to his mother's relationship with Godoy in letters to the Emperor Napoleon. In the same letters he sought the Emperor's protection and expressed his desire to marry into the Buonaparte family.

85. Paul Lefort, *Francisco Goya*, 1877, 38–41, Note to p. 38.

86. The reference to Don Tomás Morla, who is described as 'at present Governor of Andalusia' (a post he had obtained after the Roussillon campaign of 1792–3 and continued to hold in 1808), could have been taken from a number of printed sources. But I know of no similar references that a forger could have used about the man called Acuña, whom the manuscript describes as responsible for the political education of Godoy. The manuscript is mistaken when it claims that 'Acuña is now archbishop of Santiago'. Pedro Acuña de Malvar (b. 1755), who had been Secretary of State in 1791 and presumably trained Godoy in that capacity, was Ecclesiastical Governor of the Archdiocese of Santiago from 1784, but never Archbishop. The archbishop was, in fact, Acuña's uncle, Sebastián Malvar y Pinto, the person responsible for his nephew's ecclesiastical appointment. Pedro Acuña died in 1814, leaving his library and tapestries to Santiago Cathedral. The tapestries included ten by Goya (cf. Sambricio, *op. cit.*, Nos. 13, 17, 24, 25, 26, 28, 32, 33, 34 and 37; also Salustiano Portela Pazos, *Decanología de la S.A.M. Iglesia Catedral de Santiago de Compostela* (Santiago, 1944), 402ff). Despite the error in the Acuña reference, the information in the manuscript is consistent with a specialized knowledge of Spain at the relevant period.

87. Cf. W. Stirling, *Annals of the Artists of Spain*, 1848, III, 1266.

88. *El Criticón*, No. 1, 1835, 41. Cf. Rodríguez-Moñino, *op. cit.*, 8–9; reproduced in *Relieves de erudición*, 1959. A French critic who described Goya as a philosophical painter during the artist's lifetime was Frédéric Quilliet. In his book *Les Arts italiens en Espagne*, 1825, he speaks

of Goya as 'a well-known painter, and truly a fresco artist as well as a pure philosopher' (Salas, 'Precisiones sobre pinturas de Goya . . .', *Archivo Español de Arte*, xli, 1968, Nos. 161–4, 14–15).

89. *El Censor*, No. 21, 23 December 1820, IV, 230–1.

90. *Obras póstumas de D. Leandro Fernández de Moratín*, 1867, III, 55, Letter to Juan Antonio Melón dated 28 June 1825.

91. *Ibid.*

92. Javier Goya wrote two biographical sketches of his father and extracts from both have been used for the present purposes. The earlier and shorter piece, which provides the framework and order of the material given here, was sent to the Secretary of the San Fernando Academy on 13 March 1831. It was substantially the text printed in the *Proceedings* of the Academy the following year (*Distribución de premios . . . de . . . 1832*, 1832, 91–3), although the Secretary made minor emendations. Some of these are explained by the presence of Ferdinand VII at the prize-giving; others are stylistic. Mengs' approval is made to 'accredit the value' of the tapestry cartoons; the pictures painted with a palette knife are held to be 'admirably effective when viewed from a proper distance'. The text of the sketch and the manuscript variants (presumably the Secretary's corrections) were printed in the *Colección de 449 reproducciones . . .*, 1924, 60.

The second and longer sketch is more anecdotal. Valentín Carderera used it for his early biography of Goya (*El Artista*, 1835). First printed by Pedro Beroquí in *Archivo Español de Arte y Arqueología*, iii, No. 7, 1927, 99–100, it has been published in an English translation by Enriqueta Harris in *Goya*, 1969, 23–4. I have intercalated some passages from it into the 1831 text, using Enriqueta Harris' translation almost entirely: namely, from 'he only worked for one session each day' to 'an expression which he often used himself'; and from '[The *Caprichos*] which he engraved' to 'the enlightenment of Spaniards in his times'. The list of notable paintings is different in the two sketches. The 1831 text mentions only the religious paintings, including the *Last Communion of St Joseph Calasanz*, and omitting the lost painting destined for America. Both texts refer to the frescoes in Saragossa and San Antonio de la Florida.

Notes to Chapter IV

1. Cf. José Somoza, *Obras . . . Artículos en prosa*, 1842, 'El retrato de Pedro Romero', 55.

2. The Junta Particular of the Real Academia de San Fernando held on 11 November 1806 heard that Cosme Acuña had used insulting language to Maella, and had laid violent hands on the Director when leaving the building by the main staircase. On 7 January 1807 the King ordered Acuña to be dismissed from the Academy. One student also wounded another in one of the Academy's rooms on 9 October 1807.

3. *Obras en prosa y verso de D. José Somoza*, ed. J. R. Lomba y Pedraja (Madrid, n.d., 1904?), 102. Originally published in the *Semanario Pintoresco Español*, 1838, 633.

4. The phrase occurs in Quintana's poem 'A Luisa Toldi' written in 1795 (*Poesías de Manuel Josef Quintana* (Madrid, 1813)—'Yo lo ví, lo sentí'); also in Cienfuegos' poem 'En alabanza de un carpintero llamado Alfonso' (*Poesías*, ed. J. L. Cano, Madrid, 1969, 166—'Yo le ví . . . yo le ví . . .').

5. Father López's notes were published by the Conde de la Viñaza in his *Goya*, 1887, 463. They contain interesting comments on the style of Goya's frescoes for the Pilar, and refer to the painter's use of 'bamboo knives he had invented' to paint a set of *Horrors of War*. There is a version of the story about the clash with the Duke of Wellington.

6. The article which appeared in *El Artista*, II, 253–5, has been reprinted in E. Lafuente Ferrari's *Antecedentes . . .*, 1947, 302–5; it was earlier included in José Simón Díaz's index to *El Artista* (Colección de Indices de Publicaciones periódicas, I) (Madrid, 1946), 47–50. An English translation can be found in Enriqueta Harris, *Goya*, 1969, 24–7.

7. He is entered in the tax returns as *Don Francisco Goya* (cf. for example, Archivo del Ayuntamiento de Zaragoza, *Contribución de Zaragoza*, 1773, No. 1755). His father, on the other hand, is entered as plain Joseph Goya (cf. *Contribución de Zaragoza*, 1771, No. 2111).

8. Cf. E. Lafuente Ferrari, *op. cit.*, 305–8.

9. Cf. Salas, 'Sobre la bibliografía de Goya', *Archivo Español de Arte*, No. 141, 1963, 47–63.

10. *Catálogo y descripción sumaria de retratos antiguos de personajes ilustres españoles y extranjeros de ambos sexos coleccionados por D. Valentín Carderera y Solano* (Madrid, 1877). Two Goya portraits occur: No. 327 is the actress Rita Luna, and No. 328 an unknown man. Both had been acquired by Carderera before 1840 (cf. Salas, 'Lista de cuadros de Goya hecha por Carderera', *Archivo Español de Arte y Arqueología*, vii, 1931, 174–8).

11. Piot himself acknowledges Carderera's

assistance (*Le Cabinet de l'Amateur et de l'Anti-quaire*, i, 1842, 346). A number of references to Carderera occur in Prosper Mérimée's correspondence, cf. *Lettres de Prosper Merimée à la Comtesse de Montijo, mère de l'Impératrice Eugénie* (Paris, 1930), I, 340; and J. Baticle, 'Eugenio Lucas et les satellites de Goya', *La Revue du Louvre*, No. 3, 1972, 5.

12. Charles Yriarte, 'Goya acquafortiste', *L'Art*, année III, ii, 1877, 5.

13. Reproduced by E. Lafuente Ferrari, *op. cit.*, 301–2.

14. Motte advertised two collections of Goya prints in the *Bibliographie de la France*, No. 2, 8 January 1825. Listed as No. 33 were *Caprichos* Nos. 14, 12, 32, 18, 40, 52, 15, 23 and 43 (in that order). No. 40 was 'a portfolio of Spanish caricatures by Goya'. This contained *Caprichos* Nos. 10, 14, 15, 18, 24, 32, 40, 45, 52 and 55. Cf. Tomás Harris, *Goya*, 1964, I, 12–13; II, 449.

15. Reproduced by E. Lafuente Ferrari, *op. cit.*, 308–9. A copy of the periodical is displayed in the Musée Goya, Castres.

16. For information on Taylor's *Voyage pittoresque* . . ., cf. A. Rumeau, 'Mariano José de Larra et le Baron Taylor; Le "Voyage pittoresque en Espagne"' in *Revue de littérature comparée*, xvi, 1936, 477–93. Rumeau discusses the Spanish writer Larra's involvement in the project in August 1835. The information Taylor gives about paintings by Goya in the Prado certainly belongs to the early 1820s since the equestrian portrait of María Luisa is described as the only Goya painting in the collection. This impression could only have been obtained from the catalogue published in 1824, which included María Luisa (No. 284) but omitted Charles IV and the *picador*, which had been listed in the 1821 catalogue and in the 1823 catalogue published in French. The probability is that the omission was due to a printing error and not to any temporary removal of the paintings from the gallery. The 1828 catalogue lists all three again, with the numbers 279 (María Luis), 319 and 320 (Charles IV and the *picador*). With regard to the passage about the Goyas in the Louvre, this could not have been written much after the Spanish gallery had been opened in January 1838, since there is no reference to the paintings of *Lazarillo de Tormes*, *Majas on a balcony*, *Young women with a letter*, and *The Forge*, all of which were listed in the published catalogue of the collection later that year. The *Allegory* by Goya seems to have been lost. It was No. 170 in the Sale catalogue of Louis-Philippe's pictures.

17. J. Taylor, *Voyage pittoresque en Espagne* (Paris, n.d., 115–16). The same edition sometimes carries a title-page dated 1826 (Paris, Librairie de Gide fils, Rue Saint-Marc No. 20). But the Goya passage cannot have been written at that date in its totality.

18. Cf. Edmond and Jules de Goncourt, *French XVIII Century Painters*, trans. Robin Ironside (London, 1948), 289.

19. Cf. *Le Cabinet de l'Amateur* . . ., i, 337–45, and Théophile Gautier, *A Romantic in Spain* [*Un Voyage en Espagne*], trans. Catherine Alison Phillips (London, 1926), 11, 32, 72, 105, 250 and 283. The translation is based on the first edition. Part of the *Cabinet* article appeared in *La Presse* on 5 July 1838 with the title 'Les Caprices de Goya', cf. M. C. Spencer, *The Art Criticism of Théophile Gautier* (Geneva, 1969), 79, Note 52.

20. Cf. the section 'Junio' of *Un año en Madrid* in Ramón de Mesonero Romanos, *Escenas matritenses*, ed. F. C. Sainz de Robles (Madrid, 1945), 930. Mesonero speaks of accompanying Gautier during his first visit to Madrid. Mesonero's references to Goya suggest that he saw him above all as a painter of grotesques, popular characters and Spanish festivities (cf. 109, 200, 846, 873). In his *Nuevo Manual de Madrid* (Madrid, 1854), he also speaks of the 'beautiful and imaginative [or capricious] works' painted on the walls of his house (*Obras de Mesonero Romanos*, III, Biblioteca de Autores Españoles, cci (Madrid, 1967), 422).

21. Cf. 'La exposición de pinturas', *Escenas matritenses* (Madrid, 1945), 610.

22. *Le Cabinet de l'Amateur* . . ., i, 339.

23. Yet another French variation on the *Magasin pittoresque* theme of Goya's unconventional painting techniques can be found in Laurent Mathéron's *Goya* (1858), which asserts that Goya painted scenes of 2 May 1808 with a cloth dipped in mud on a wall in the Paseo del Prado, for the delectation of passers-by.

24. Cf. *A Romantic in Spain* (London, 1926), 32.

25. *Voyage en Espagne* (Oxford, 1905), 63. The quotation does not appear to have been present in the first edition.

26. Piot, *op. cit.*, 344. Other evidence that Goya's *Tauromaquia* was a work to be conjured with in France in the middle of the century occurs in Alexandre Dumas' reference in his account of travels in Spain (1846)—*From Paris to Cadiz*, trans. A. E. Murch (London, 1958), 48—and extensive mentions in the travels of Jean Charles Davillier (1874).

27. It is interesting to note the slight difference of interpretation of 'Y aun no se van' between Gautier and Baudelaire. Gautier emphasizes the

tragic efforts of ghosts that seek to escape from the tomb; Baudelaire feels that the soul is being victimized by malignant supernatural forces. Gautier's soul is surrounded by companions striving against the same fate. Baudelaire sees an isolated individual persecuted by those around him, presumably interpreting the scene in a more obviously subjective (and distorted) light. Baudelaire may have been relying on an inaccurate recollection of the plate, and was probably describing it from memory, but I do not believe that he was confusing it with Gautier's description of the 'Nada' plate from the *Disasters of War* as Klingender suggests (*Goya in the Democratic Tradition*, 1948, 221). More probably his personality encouraged him to recall a sense of persecution in the plate.

28. *The Journal of Eugène Delacroix*, trans. Walter Pach (London, 1938), 469.

29. *Le Cabinet de l'Amateur . . .*, i, 340–1; 342–3. The plate 'Buen viage' which Gautier mentions at the end of the passages quoted had earlier struck Victor Hugo, who took it (with explicit, though probably humorous reference to Goya) as the epigraph for one of his *Feuilles d'Automne*, 1830.

30. Jules Michelet, *Journal* (Paris, 1962), I, 303.

31. Jean Adhémar, *Goya*, 1948, 28.

32. 'Quelques caricaturistes étrangers', from the collection *Curiosités esthétiques*, in Baudelaire's *Œuvres*, ed. Y.-G. Le Dantec (Paris, 1932), II, 206–9. Baudelaire's point about the universality of Goya's satire was repeated by Champfleury in his *Histoire de la caricature moderne* (Paris, n.d.), 83. Recently Baudelaire's views have extensively influenced Fritz Novotny in his *Painting and Sculpture in Europe 1780–1880*, 1960, so far as his view of Goya is concerned.

33. Information about Mathéron was kindly supplied by the Director of the Municipal Archives in Bordeaux in the form of a number of photocopies of newspaper cuttings. The most interesting reminiscence is contained in the *Petite Gironde* in the second week of January 1906. I have followed the practice of these articles in writing an acute accent on the 'e' in Mathéron.

34. Laurent Mathéron, *Goya*, 1858, no pagination—Section 1; cf. Spanish translation by Müller, 1890, 13–14.

35. *Ibid.*, Section 3; Spanish translation, 27–8.

36. *Ibid.*, Section 1; Spanish translation, 10–11.

37. *Gazette des Beaux-Arts*, 1863, 243.

38. In the text of his book Mathéron described the miniatures on ivory which Goya had painted in Bordeaux, and he passed on many details about the artist's technique contained in Carderera's articles, which were presumably little

known in France. It has been possible to find indirect support in sources such as these for some of Mathéron's most quoted anecdotes and Goya *dicta*. The affirmation that Goya had claimed to have no masters 'other than Nature, Velázquez and Rembrandt', for instance, need not be discounted, since it is a compound of the artist's own entry in an early edition of the Prado Museum catalogue (1828), and Javier Goya's biographical sketch of his father, which stated that he was a 'student of Velázquez and Rembrandt whom he venerated, yet above all a student and observer of Nature, which he said was his real master'. Mathéron's description of Goya's fondness for finishing his paintings by artificial light—'with his head crowned with candles'—came from Goya's family via Carderera. Perhaps he got from the same source, or from Brugada, the dictum that 'neither line nor colour exist in Nature; there is only sunlight and shadow'. There is still, in fact, a core of useful material in Mathéron's book, for all its poetry and fiction.

39. Cf. for information on Carderera's composition of these articles, Salas, 'Portraits of Spanish Artists by Goya', *The Burlington Magazine*, cvi, No. 730, 1964, 14–15.

40. *Gazette des Beaux-Arts*, 1860, vii, 225–6.

41. Cf. postscript to a letter to Juan Antonio Melón, 7 October 1825, in *Obras póstumas de D. Leandro Fernández de Moratín*, 1868, III, 73.

42. An informative article on Charles Yriarte appears in the Espasa-Calpe Encyclopaedia. Alarcón has several references to him in his *Diario de un testigo de la guerra de Africa* (especially in Chapter 30), for whose first edition Yriarte made the illustrations. There are also references in Alarcón's *De Madrid a Nápoles* (Chapter 5ff). For Pedro Antonio de Alarcón's connections with Cruzada Villaamil, cf. *Obras completas de D. Pedro Antonio de Alarcón* (Madrid, 1954), 1865. Cruzada's sympathies with the 1868 revolution in Spain emerge very clearly in his *Los Tapices de Goya*, 1870—a book which was still capable of provoking ultraconservatives in the 1940s (cf. D. Sánchez de Rivera y Moset, *Goya*, 1943, 106).

43. *La Société Espagnole* (Paris, 1861), 104–5.

44. Charles Yriarte, *Goya* (Paris, 1867), 5.

45. *Ibid.*, 28.

46. *Ibid.*, 67–8. It is clear that Yriarte's belief in Goya's scepticism leads him to misunderstand Ceán. The context makes it plain that Ceán is talking about the 'faith, love and constancy' of the two saints and not of Goya himself. He is describing the way in which the artist had documented himself about the martyrs with a

view to reflecting the virtues appropriate to them in the painting. This Yriarte mistranslates in the case of the words italicized. In the article as a whole, Ceán, in fact, makes precisely the kind of point about Goya's 'enlightened' view of religion which Yriarte might have been expected to approve.

47. R. Ford, *A Hand-Book for Travellers in Spain and Readers at Home*, 1845, 254.

48. Yriarte, *op. cit.*, 88. L. Viardot in *Les Musées d'Espagne* . . ., 1839, puts forward the theory about the clothed maja's identification with the Duchess of Alba in his section on the San Fernando Academy in 'Les musées de Madrid'. This is believed to be the earliest mention of the theory in print. The legend inevitably persisted long after Yriarte's time. Baron Davillier gave it new currency in his *L'Espagne* (1874, ch. XXIX), since it fits with his general conception of Goya as a realist. Other nineteenth-century critics mentioned it because it fitted their idea of Goya as a forerunner of the 'Décadents'. Even in the twentieth century explanations are advanced to deal with the difference between the face of the *maja* and that of the Duchess in known portraits of her. One view is that the face was made, intentionally, unlike the Duchess. Another holds the *maja* to be more like the Duchess than her portraits, which would have had to idealize her features according to the conventions of her period.

49. Letter to Nadar dated Honfleur, 14 May 1859, *Œuvres complètes de Charles Baudelaire*, Correspondance générale, ed. Jacques Crépet (Paris, 1947), II, 310–11. Baudelaire went on to state that the beauty of these Goyas 'was generally very little appreciated'.

50. Yriarte, *op. cit.*, 93.

51. *Ibid.*, 95–6.

52. *Ibid.*, 121.

53. *Ibid.*, 115.

54. Ford, *op. cit.*, 254.

55. *Ibid.*, 736.

56. On Stirling-Maxwell, cf. Enriqueta Harris, 'Sir William Stirling-Maxwell and the History of Spanish Art', *Apollo*, lxxix, No. 23, 1964, 73–7.

57. William Stirling, *Annals of the Artists of Spain*, 1848, III, 1264–5.

58. H. O'Shea, *A Guide to Spain*, 1865, 283.

59. *The Quarterly Review*, cxxxiii, No. 266, 1872, 486. The article is unsigned. On Sir Henry Layard, cf. his *Autobiography and Letters* (London, 1903), 2 vols.

60. Cf. *Autobiographical Notes of the Life of William Bell Scott*, ed. W. Minto (London, 1892), II, 170.

61. W. B. Scott, *Murillo and the Spanish School of Painting*, 1873, 96. For the passage about the *Caprichos*, cf. 94–5.

62. Michael Bryan, *A Biographical and Critical Dictionary of Painters and Engravers*, 1886, I, 588–9.

63. Cf. edition published in Belmonte Müller's translation of Mathéron's *Goya* (Madrid, 1890), 141.

64. *Historia de las ideas estéticas en España*, in *Obras completas de Menéndez y Pelayo* (Santander, 1957), III, 549. Menéndez y Pelayo was interested enough in Goya to own a copy of the *Caprichos* now in the Biblioteca Menéndez y Pelayo in Santander. The copy is a first edition and previously belonged to Modesto del Valle, Madrid.

65. Antonio de Trueba, *Madrid por fuera*, 1878, 164–5.

66. Ildefonso Antonio Bermejo, 'El Azotado', *La Ilustración Española y Americana*, 1886, ii, No. 25, 7ff. Bermejo seems to have specialized in falsifications and published at least one about Godoy. F. J. Sánchez Cantón expressed understandable reservations about the letters when he republished them in 'Una nota para el epistolario de Goya', *Archivo Español de Arte*, No. 108, 1954, 327–30.

67. Cf. E. Lafuente Ferrari, *op. cit.*, 219.

68. V. V. Stassow, 'Goya', *Vestnik izyashchnykh iskusstv*, II, 1884.

69. Richard Muther, *The History of Modern Painting* (London, 1895), I, 65–6. Cp. Muther's *Francisco de Goya*, English trans. (London, 1905), 53ff. 'Goya alone seems to belong to that Promethean race which included the young Goethe and the young Schiller. He is the only artist who can be said to enter that group of revolutionaries, through whose writings the old world was torn from its foundations. With the fierce crash of the thunder and the earthquake the Time Spirit advances through his works; and those Sphinx questions, which the epoch set itself to answer, are mirrored as gigantic problems in his paintings.'

Notes to Chapter V

1. Martín Zapater was created a Noble of Aragón in 1789, and was rich enough at that period to maintain the city's grain supply at his own expense when corn was short. He leased lands belonging to the Castellanía de Amposta, the Barony of Figueruela, and the Encomiendas of Aliaga and Saragossa, and in 1779 his annual assets already reached a total of 136,000 *reales*.

His tax liability jumped from 8,250 *reales* in 1780 to 60,000 between 1790 and 1795. He was a deputy of the City Council after elections in 1783–4, 1785–6 and 1789–90, but was a man of taste as well as public standing, and a moving spirit in the foundation of the Academy of Fine Arts of St Louis in Saragossa. He was elected the first Counsellor of the Academy in 1801. It has been argued that he attended the same school in Saragossa as Goya. But it should be noted that Zapater appears to have been seven years younger than Goya. Their early contact can hardly have been close.

2. Faustino Casamayor's *Años políticos e históricos* (MSS of the University of Saragossa) refers to Zapater's death at the age of fifty on 25 January 1803. Casamayor also speaks of the education Zapater had provided for his nephews in France, and the bequest of 200,000 *duros* (a million *pesetas*) he was believed to have left them. He also owned a 'magnificent house' in the Parish of St Giles, on the famous street called the Coso.

3. L. Mathéron, *Goya*, 1858, no pagination, Section II; Spanish translation 1890, 16. Mathéron no doubt took his information from Pascual Madoz's *Diccionario geográfico* (Madrid, 1850), which would have told him that Fuendetodos was on the right bank of the River Huerva and had a Moorish castle.

4. Cf. 'Noticias biográficas de Goya que escribió Don Francisco Zapater y Gómez', in *Colección de 449 reproducciones . . .*, 20.

5. *Ibid.*, 24.

6. *Ibid.*, 36.

7. *Ibid.*, 40.

8. 'Accionistas que concurrieron a dicha junta general', *Sexta Junta General del Banco Nacional de San Carlos celebrada en la casa del mismo banco el día 24 de febrero de 1788* (Madrid, 1788), 6. Fifteen of Goya's share certificates survive—endorsed to other individuals in November and December 1788. Cf. Luis G. de Valdeavellano, 'Las relaciones de Goya con el Banco de San Carlos', *Boletín de la Sociedad Española de Excursiones*, xxxvi, 1928, 56–65.

9. *Colección de 449 reproducciones . . .*, 26.

10. A photographic reproduction of the letter, which is in the Museo Provincial de Bellas Artes, Saragossa, can be found in *Aragón*, iv, No. 31, 1928, 73.

11. *Colección de 449 reproducciones . . .*, 24.

12. MS in the collection of the Hispanic Society of America, New York, reproduced and transcribed by E. du Gué Trapier in 'An unpublished letter by Goya', *The Burlington Magazine*, ci, No. 670, 1959, 27. An excellent study of Goya's letters to Zapater appeared after the completion of the present book. It is E. Lafuente Ferrari's 'Las cartas de Goya a Zapater . . .', 1975, 285–328.

13. Zapater y Gómez, *Apuntes . . .*, 1863, 37–40.

14. Ford, *op. cit.*, 254.

15. J. D. Passavant, *Die Christiche Kunst in Spanien*, 1853, 118.

16. J. D. Passavant, *Tour of a German Artist in England* (London, 1836), I, 262–3.

17. Cf. Conde de la Viñaza, *Goya*, 1887, Chapter 6, 73ff.

18. Pedro de Madrazo's article on Goya in the *Almanaque de la Ilustración* for 1880, was reproduced in the Spanish translation of Mathéron's *Goya*, 1858 (1890), 163–4. It has also been reproduced by E. Lafuente Ferrari, *op. cit.*,312–15. Madrazo criticizes Goya further from an anti-realist or idealist standpoint in his *Viaje artístico de tres siglos por las colecciones de cuadros de los Reyes de España*, 1884. He speaks of 'the extravagances of his realism', his 'harsh naturalism', and the 'shocking realism' of his followers. Zeferino Araujo puts Madrazo's views in proper perspective in his *Goya*, 1895?, 69–71.

19. Viardot, *Études sur l'Histoire des Institutions, de la littérature, du théâtre et des Beaux-Arts en Espagne*, 1835, 389.

20. Viardot, *Notices sur les principaux peintres de l'Espagne*, 1839, 306–7.

21. Viardot's views gained wide currency in *Les Musées d'Espagne, d'Angleterre et de Belgique*, 1843. The text of this formed the basis for the Goya section in *A Brief History of the Painters of all Schools*, trans. from Viardot and other authorities and published in English in 1877. The short Goya entry in Vallent's *Encylopédie du XIXe siècle* (vol. XIII, 1851) is very close to Viardot, and so is the chapter on Goya in Charles Gueullette's *Les Peintres espagnols*, 1863. Chapter 12 balances Goya's powers of imagination (particularly in the *Caprichos*) against poor draughtsmanship in a typically Viardot fashion. A certain similarity of ideas is detectable in George Duplessis' *Les Merveilles de la gravure*, 1869. While Duplessis defends Goya as an engraver of whom Spain may be 'justly proud' and feels that his reputation is 'enhanced when he is studied through his engravings', he clearly shares Viardot's misgivings about the paintings. He held that the merits of many of his portraits and paintings, 'especially those of sacred subjects, have been much exaggerated'. Duplessis thought that 'he did not value beauty highly enough', and found that the 'magic charm of chiaroscuro' in his

engravings did not entirely conceal 'incorrect-ness of drawing', that cardinal sin of nineteenth-century art.

22. Cf. Mantz, *Dictionnaire de la Conversation et de la lecture*, 1855, X, 414.

23. Quoted by M. G. Brunet in *Étude sur Francisco Goya, sa vie et ses travaux*, 1865.

24. A Lavice, *Revue des Musées d'Espagne*, 1864, 80, 218 and 227.

25. Deville, 'De l'Art Moderne en Espagne', *L'Artiste*, 5e série, ii (1848–9), 137.

26. Cf. F. Petit, *Notes sur l'Espagne Artistique*, 1877, 62–3, 68, 74. In his article on Rimbaud in *Les Poètes maudits*, Verlaine finds the 'little picture' of the poem 'Les Effarés', 'du Goya pire et meilleur'. He considers 'Les Chercheuses de Poux' equally Goyesque—'du Goya lumineux exaspéré, blanc sur blanc avec des *effets* roses et bleus et cette touche singulière jusqu'au fantastique'. He rates Rimbaud more highly than Goya, however, 'both for emotional heights and for the melody of skilful rhymes' (Cf. *Œuvres complètes*, IV (Paris, 1920), 23–5).

27. T. de Wyzewa, *Les Grands Peintres de l'Espagne et de l'Angleterre*, 1891, 86. Wyzewa's dislike of Goya and Turner is diametrically opposed to Huysmans' enthusiasm for the same pair of artists. However, it was not so intense that he could not modify it a little, so far as Goya was concerned. In 1892 he published a book on *La Peinture étrangère au XIXe siècle*, which shows Goya in a rather more favourable light. His feelings 'seduce us by their strange and morbid qualities, which are entirely original and which make Goya a man of our times'.

28. Prosper Mérimée, *Correspondance générale*, ed. M. Parturier (Toulouse, 1961), 2e série, VIII, 493–4.

29. Hamerton made his own drawings of three French scenes recorded by Turner in order to measure more precisely the nature of Turner's distortion of reality and the effects he achieved.

30. Cf. Ruskin's letter to F. S. Ellis, 19 September 1872, in John Ruskin, *The Works*, 1909, XXXVII, 53 and Note 3.

31. Hamerton was a stickler for training and points out an evident lack of it in Bewick in his *Drawing and Engraving. A Brief Exposition of technical principles and practice* (London, Edinburgh, 1892), 92.

32. In Mrs Hamerton's view, Hamerton's paintings were 'unluckily greatly influenced by the Pre-Raphaelites'. The details in them were, to her way of thinking, 'what unripe fruit is for the teeth'. Hamerton was inevitably shocked by Impressionism in the 1860s, particularly by

Manet's *Déjeuner sur l'Herbe*, and he thought that Whistler's *Woman in White* was an example of 'supreme ugliness'. Although he later felt some admiration for Monet's and Renoir's abilities as colourists and grudgingly approved of Degas, in general he saw Impressionism as an 'evil development . . . where simple daubing is substituted for painting'. He wrote angrily in *Man in Art* (London, 1892) of one impressionist picture 'in which the lady wears yellow gloves that fit her badly, and the gloves have been simply sketched in colour and left so, with perhaps five minutes' work to each of them . . . a business-like economy of time'. On Hamerton's critical position in the 1860s, cf. Merle Mowbray Bevington, *The Saturday Review. 1855–1868* (New York, 1941). For a more general article, cf. James Kissane, 'Art Historians and Art Critics—IX: P. G. Hamerton, Victorian Art Critic', *The Burlington Magazine*, cxiv, No. 826, 1972.

33. P. G. Hamerton, *Etching and Etchers*, 1868, 290. In subsequent editions Hamerton modified his first sentence to include a qualified eulogy of Goya's etching *The Prisoner*. George Duplessis' rather favourable comment in *Les merveilles de la gravure*, 1869, may have led him to alter his views.

34. P. L. Imbert, *L'Espagne. Splendeurs et misères . . .*, 1875, 329.

35. Cf. Xavier de Salas' appendix to F. J. Sánchez Cantón's *Goya and the Black Paintings*, 1964, 81.

36. *Ibid.*, 80.

37. It is interesting to note that Hamerton disliked Balzac's novels. Most kinds of realism met with his disapproval. Manet's *Olympia*, which he thought 'vulgar, though natural', ultimately seemed 'almost indecent' to him (cf. *Man in Art* (London, 1892), 41).

38. Hamerton, *The Portfolio*, 1879, x, 68–70; 83–6; 100–3. When he republished the text he made one slight modification to the last paragraph of the extract quoted, substituting 'Goya in *black and white* scorned the refinements of execution' for 'Goya *in all his practice . . .*'. Presumably, since he had never been to Spain and did not know Goya's paintings except the Black Paintings, he felt the need to restrict the scope of his remark to the etchings with which he was familiar. Actually, in the course of the article, he shows no reluctance to judge Goya as a painter from what he knows of him as an etcher. This is no different, in his view, from judging Oldham on the basis of an intimate knowledge of Rochdale.

39. Smith, *Painting. Spanish and French*, 1884, 76–8.

40. Mrs Margaret L. Woods, 'Pastels from Spain, No. VI, "Portraits by Goya"', *The Cornhill Magazine*, New Series, ix, 1900, 289–90. For Rothenstein's view, cf. R. Speaight, *William Rothenstein* (London, 1962), 40.

41. William Rothenstein, *Men and Memories*, I, 1931, 188. On Brabazon's interest in Goya, cf. C. L. Hind, *Hercules Brabazon Brabazon 1821–1906* (London, 1912), 48–54.

42. Hilary Pyle, *Jack B. Yeats* (London, 1970), 107–8. Also 126 and 167.

43. Cf. the article by Wedmore on Rothenstein's drawings in *The Studio*, November 1895, quoted in R. Speaight, *William Rothenstein* (London, 1962).

44. In 1909 Royall Tyler called Goya 'that most unequal of painters' and thought his frescoes in the Aula Dei at Saragossa were executed by 'a rash process, typical of Goya' (*Spain*, 1909, 255 and 305). Mrs Henry Wood echoed Tyler's phrase about the inequality of Goya's painting in 1914 (*A Simple Guide to Pictures*, 197). On the other hand, C. S. Ricketts, who recognized that Goya had the power 'to appeal strongly and to repel with equal force', felt that he had 'come to stay' as 'an original and potent fact' (*The Prado and Its Masterpieces*, 1903, 58). Wedmore maintained, in an essay written in 1912, that Goya was 'a person that intelligent people study, that nearly all intelligent people more or less enjoy today' (*Painters and Painting*, n.d., 1912?, 74).

45. Meier-Graefe, *Modern Art*, 1908, I, 156.

46. *Ibid.*, I, 259. Meier-Graefe finds *The Third of May 1808* equally 'beneath Manet's level' in *The Spanish Journey*, trans. J. Holroyd-Reece (London, 1926), 313.

47. Meier-Graefe, *The Spanish Journey*, 1926, 51.

48. *Ibid.*, 312.

49. *Ibid.*, 109–10.

50. *Ibid.*, 102. A similar view of the predominantly intuitive nature of Goya was expressed by the Catalan writer and art critic Eugenio D'Ors, who referred to Goya as 'mere temperament, not spirit; a man of instinct, not genius' (cf. E. Lafuente Ferrari, *op. cit.*, 30). D'Ors, however, admired Goya's artistic freedom and imaginative power in *El vivir de Goya* (written in 1926), even though he suggested with ironic satisfaction, that he had to buy his freedom with sweat and money 'as all liberty has to be bought'. D'Ors later attempted to distinguish between Goya and his imitators in *Goya y lo goyesco* (Valencia, n.d.).

51. *Ibid.*, 307.

52. *Ibid.*, 307.

53. *Ibid.*, 313–14.

54. *Ibid.*, 172.

55. *Ibid.*, 311.

56. *Ibid.*, 65–6.

57. Clive Bell, *Landmarks in Nineteenth-Century Painting*, 1927, 138 and 166. Confirmation that few aesthetes were at all enthusiastic about Goya in the post-war period can be found in the novels of Ronald Firbank. Firbank's sharp parodies of aesthetic values often depend on references to cult names. In the early novel *Caprice* (1917) it is true that the aesthetes at the Café Royal, in the Impressionist tradition, dispute as to whether they are going to Spain to see Velázquez or Goya when Miss Sinquier wants to go to Croydon. But later novels show little warmth for Goya. The largest haul of allusions to Spanish art can naturally be found in *The Eccentricities of Cardinal Pirelli* (London, 1926), in which the nearest we get to Goya is the Café Goya in Chapter 9. Elsewhere there is a Madonna of the Mule-Mill attributed to Murillo in the Dun-Eden palace, and a dozen old Zurbaráns flap austerely in their frames in the cell of Cardinal Pirelli himself, in the monastery of the Desierto. The college chaplain is Father Damien Forment (presumably named after the early sixteenth-century artist), and His Eminence also has an El Greco Christ and an ivory crucifix by Alonso Cano, which he offers, as an alternative to his Velázquez, to a young faun in the last chapter. El Greco seems to rate most references in Firbank's work, and occurs again in *The Artificial Princess* (1934) together with Félicien Rops and Gerard Dow. This last novel, in fact, offers proof that Goya was insufficiently aesthetic for Firbank's characters, when the Baroness murmurs desperately at the end of Chapter 2: 'What a pity that Goya never painted Fans.' By 1934 Goya was, nevertheless, a more likely name for aesthetes in England to drop. Even Roger Fry accepted that 'the isolated figure of Goya' had brought about a revival in Spanish art as extraordinary as that of Tiepolo and Canaletto in Italy: a revival that contained 'modern elements' and yet was 'in harmony with the great style of the seventeenth century' (*The Arts of Painting and Sculpture*, 1932). Against this background it is easy to see the force of Max Beerbohm's witty jibe, whose precise date and provenance is unknown to me:

I find I can often enjoy a
Half-hour with the glories of Goya.
At the end of that time
I acknowledge that I'm
Averse from the glories of Goya.

58. Roger Fry, *A Sampler of Castile*, 1923, 9.
59. Roger Fry, 'Some recent acquisitions of the Metropolitan Museum, New York', *The Burlington Magazine*, ix, No. 38, May 1906, 141.
60. Roger Fry, *A Sampler of Castile*, 1923, 66.
61. Paul Claudel, *Journal* (Paris, 1968), I, 366, and II, entry for 6–14 January 1933.
62. *Œuvres en prose* (Paris, 1965), 214.
63. *Ibid.*, 215. Claudel admired the young girl in the brown shawl by Goya in the Mellon collection in 1930 (*Journal*, I, 900). Yet even in that case the poet seems to have admired the beauty of the female in question rather than the art of Goya.
64. Jean-Paul Sartre, *Essays in Aesthetics*, trans. Wade Baskin (London, 1964), 74.
65. *Ibid.*, 73–4.
66. *Ibid.*, 74.
67. Cf. Gino Severini, *The Artist and Society*, trans. Bernard Wall (London, 1946), 5.
68. Cf. E. Lafuente Ferrari, *Goya. El Dos de Mayo y los fusilamientos*, 1946, 34.
69. *Wyndham Lewis on Art. Collected Writings 1913–1956*, ed. Walter Michel and C. J. Fox (London, 1969), 352.

Notes to Chapter VI

1. Théophile Gautier, 'Une Galerie Romantique', *Journal Officiel*, 14 February 1870, reprinted in the auction catalogue of the Edwards sale: *Collection des Tableaux Modernes de M. Edwards, Hotel Drouot 7 March 1870* (Paris, 1870), 22.
2. For a short note on Hispagnolisme cf. John Richardson, *Édouard Manet. Paintings and Drawings* (London, 1958), 44ff. Major sources of information are: Jean Adhémar, 'Essai sur les débuts de l'influence de Goya en France au XIXe siècle', *Goya Exposition de l'Œuvre gravé, de peintures, de tapisseries*, 1935; Paul Guinard, 'Romantiques français en Espagne', *Art de France* No. 2, 1962, 79–206; Paul Guinard's introduction to the Exhibition Catalogue *Goya y el arte francés*, Instituto Francés en España (Madrid, n.d., 1947); Juan Allende-Salazar, *Discurso leído por Don Juan . . .*, 1930; and Lafuente Ferrari, *Antecedentes . . .*, 241ff.
3. J. Meier-Graefe, *Modern Art*, 1908, I, 258. Meier-Graefe believed that a significant change in the attitude to Spanish art came before Manet from Courbet, who 'brought about a new and rich development by the resolute appropriation of the Spaniards'. The Belgian Evenepoel followed in Manet's footsteps to Spain; Sargent and Besnard were 'unimaginable without Spain'.
4. Quoted from the *Gazette des Beaux-Arts* (1863) by Phoebe Pool in her introduction to *The Complete Paintings of Manet* (London, 1970), 8. For further information on Manet's Spanish contacts, cf. Léon Rosenthal, 'Manet et l'Espagne', *Gazette des Beaux-Arts*, 5ᵉ période, XII (1925), 203–14; Théodore Duret, *Manet y España* (Paris, 1927); Joël Isaacson, 'Manet and Spain', 1969, 9–16.
5. *The Complete Paintings of Manet*, 9; Richardson, *op. cit.*, 14 and 119 (Note on Plate 10). The picador fighting a bull in the background of Manet's *Victorine en costume d'espada* is patently based on No. 5 of Goya's *Tauromaquia* etchings so far as the conjunction of horse and bull is concerned. The figures at the barrier perhaps echo figures in No. 19 and No. 30 of the same series. It is possible that Manet may have known Goya's drawing for No. 5, which was in Charles Yriarte's collection. Bull-fighting sources other than Goya also influenced Manet according to Isaacson, *op. cit.*, 14.
6. Cf. Théodore Duret, *Manet and the French Impressionists*, trans. J. E. Crawford Flitch (London, 1910), 43. Eugène Fromentin also attests the extent to which the 'young French School' had turned to Goya (and also to Franz Hals) by 1875 in a letter to his wife from Amsterdam written on 19 July that year (Pierre Blanchon, *Eugène Fromentin. Correspondance et Fragments inédits* (Paris, 1912), 360–1). Although Fromentin himself appears to have owned a painting by Goya or attributed to him (No. 129 in Valerian von Loga's catalogue) he was unimpressed by his work in 1875, and thought that younger artists merely approved of his work because it appeared to justify 'some of their doctrines and many of their own imperfections'. The young had not scrupled to make Goya and Hals 'chefs de file, et de faire d'eux des hommes de génie, qu'ils ne sont pas du tout'.
7. Laurent Mathéron, *Goya*, 1858, Section VIII; Spanish edition, 66.
8. Quoted by Paul Lefort, *Francisco Goya*, 1877, 14.
9. *Ibid.*, 15.
10. Cf. Paul Flat, *L'Art en Espagne*, 1891, 183–218. Baudelaire's conception of the modern artist is outlined in his essay on Constantin Guys in *L'Art Romantique* (1869).
11. Cf. Lucien Solvay's articles in *La Nation*, 14 February 1886, 16 February 1887 and 22 February 1888, reviewing 'Le Salon des XX'. I am grateful to Madame F.-C. Legrand, Director of the Musées Royaux des Beaux-Arts de Belgique, for these references.

12. Lucien Solvay, *L'Art Espagnol*, 1887, 262ff. Solvay was considered one of the best art critics in Europe by A. de Gubernatis in his *Dictionnaire international des écrivains du jour* (Florence, 1891), 1787b.

13. Charles Yriarte, *Goya*, 1867, 87. Earlier a story had circulated in Spain in relation to Goya's frescoes for the Pilar cathedral in Saragossa, which contrasted Goya's interest in effects viewed from a distance with Francisco Bayeu's preoccupation with close views (cf. 'Noticias tradicionales de D. F. Goya, dadas por el P^e D. Tomás López, monje de la Cartuja de Aula Dei', printed in the Conde de la Viñaza, *Goya*, 1887, 465).

14. P. L. Imbert, *L'Espagne . . .*, 1875, 329. An English note about the sketchy technique of Goya from much the same period comes from A. J. C. Hare, *Wanderings in Spain*, 1873, 4th ed. 1883, 214. Hare visited Spain in 1871–2.

15. It is possible that the painting in question was *The Bull-fight* formerly in Arthur Sachs' collection and now in the National Gallery of Art, Washington (reproduced by José Gudiol in colour in his *Goya*, 1966, facing p. 164). Doubts have been expressed about the authenticity of this painting, as also about that of the *Divided Bull-ring* now in the Metropolitan Museum, New York. The latter painting was also in France at about the right date, having been sold in the Salamanca sales. It had also been engraved for *L'Art* by Mordant (cf. Exhibition Catalogue, *Goya y el arte francés* (Madrid, n.d.), No. 43).

16. The phrase is Félix Fénéon's. Cf. *Œuvres* (Paris, 1948), 268.

17. J.-K. Huysmans, *Certains* (Paris, Plon, n.d.), 199–200. In *Œuvres complètes* (Paris, Crès, n.d.), X, 179ff.

18. Théodore Duret, *Manet and the French Impressionists* (London, 1910), 70.

19. Conde de la Viñaza, *Goya*, 1887, 287 (No. XLIX). Viñaza speaks of the picture as having been painted 'en el bosque del Prado'. Most critics believe 'Prado' to be an error for 'Pardo' in this instance.

20. Cf. the Spanish translation in *La España Moderna*, ccxlvii (1909), 18.

21. V. von Loga, *Francisco de Goya* (Berlin, 1921), 122. (*La España Moderna*, ccl, 48).

22. *Ibid.*, 130–1 (*Ibid.*, ccli, 75).

23. W. S. Meadmore, *Lucien Pissarro. Un cœur simple* (London, 1962), I, 59.

24. W. Rothenstein, *Goya*, 1900, 35.

25. D. S. MacColl, *Nineteenth-Century Art*, 1902, 44.

26. *Ibid.*

27. Cf. S. L. Bensusan, 'Goya: His Times and his Portraits', *The Connoisseur*, ii, 1902, 22–32; iv, 1902, 115ff. Bensusan also wrote 'A Note upon the Paintings of Francisco José Goya'; *The Studio*, xxiv, 1902, 155ff.

28. Silverio Moreno, 'Goya', *Revista contemporánea*, cxviii, 1900, 53–64 and 163–76.

29. *Ibid.*, 55–6.

30. Cf. Dámaso Alonso, *Poetas españoles contemporáneos* (Madrid, 1952), 141, Note 29 (quoting the manifesto in *Juventud. Revista popular contemporánea*, I, No. 6, Madrid, 30 November 1901).

31. *Forma*, I, 1904–5, 259ff: 'Lugar de Goya en la pintura'.

32. *Ibid.*, I, 260.

33. *Ibid.*, II, 447 ('Nuestro Goya, para quien toda la naturaleza era color, supo fijar la fugitiva mancha de un aeróstato rayando el azul del cielo . . . El cuadro de Goya que posee el Museo de Agen . . . es una advertencia para los pintores que queriendo hacer nuevo o moderno caen en lo viejo').

34. *Ibid.*, I, 269.

35. *Ibid.*, I, 269.

36. Blanca de los Ríos de Lampérez, *Madrid Goyesco (Novelas)*, in *Obras completas* (Madrid, 1912), 11–12. The novel was first published in 1908.

37. A summary of Doménech's lecture appeared in the *Boletín de la Sociedad Española de Excursiones*, XXIII, 1915, 81–2.

38. R. Muther, *Geschichte der Malerei in XVIII und XIX Jahrhundert*, 1893–4. English translation, 1895–6.

39. R. Muther, *Francisco de Goya* (English translation) (London, 1905), 33.

40. *Ibid.*, 33.

41. *Ibid.*, 57ff.

42. Renoir discovered the brilliance of Goya's colour effects in Madrid in 1892, and he enthused particularly over the ceilings of San Antonio de la Florida and the *Portrait of Charles IV and his Family*. Cézanne and Van Gogh both copied Goya in their youth, and Degas once owned a drawing by Delacroix based on one of the *Caprichos*. Toulouse-Lautrec sketched a title-page for a new edition of Goya's *Disasters of War*, and the American painter William Turner Dannat, who was a pupil of Carolus Duran and worked in Paris, had five Goya paintings at one time in his collection, among them the fine portrait of *Don Andrés del Peral*, now in the National Gallery, London. *Pleinair* painters who were not Impressionists also admired Goya. Díaz de la Peña preached Goya to Monticelli, Millet and the Barbizon school,

and the Russian artist Marie Bashkirtseff, a follower of Jules-Bastien Lepage, was excited by Goya as well as by Velázquez when she went to Madrid in 1881. The German painter, sculptor and engraver Max Klinger discovered Goya's etchings in Paris and was bowled over by them; the Swedish artist Zorn confessed he learnt all his engraving from Goya. Collectors at the period reflect a similar conjunction of enthusiasms for both Goya and the Impressionists. Durand-Ruel, the leading Paris dealer in Impressionist paintings had four portraits by Goya in his own collection. One of his sources of capital, the Levantine banker Edwards, who made his fortune in Constantinople, also had five Goyas in his gallery in Paris before 1870, and possessed six paintings by Jongkind and Manet's *L'Enfant à l'Épée*. Henri Rouart, who once owned the famous *Dancers at the practice bar* by Degas, also possessed drawings of nine fantastic scenes by Goya, an unidentified painting attributed to him, and the Degas-like young lady also attributed to Goya now in the National Gallery, Dublin. The sculptor-poet Zacharie Astruc, friend of Manet and Fantin-Latour, had a scene of brigands by Goya among his Spanish pictures, and at a sale in 1878 had sold four more: *Children playing at being monks*, *Children playing soldiers*, a still-life and a painting of a young girl. Other notable collectors with Goyas as well as Impressionists at the turn of the century were the American Havemayer and the Irishman Sir Hugh Lane. The Russian Ivan Stchoukine, who lived in Paris and was a friend of Degas and Zuloaga (presumably also a relative of the merchant Serge Stchoukine responsible for founding the Pushkin museum in Moscow and endowing it with excellent Impressionist paintings), had some seven paintings by Goya in his collection and one by Eugenio Lucas attributed to Goya when von Loga made his catalogue. Sickert told his friend William Rothenstein about them when the latter was preparing his book on Goya in the 1890s, and seventeen works attributed to Goya were sold in the Stchoukine sale in 1908. In Germany Professor Heilbut, who was subsequently responsible for fostering an interest in Goya in Paul Klee, also had a painting by Goya in his collection, according to von Loga.

43. Cf. J. Meier-Graefe, *The Spanish Journey*, trans. J. Holroyd-Reece (London, 1926), 54. Beruete is described as 'a follower of Monet', and placed 'head-and-shoulders above Sorolla'.

44. Cf. *Eight Essays on Joaquín Sorolla y Bastida* (New York, 1909), 2 vols. The article by Beruete seems to have been written by the father rather than the son. It is not included in the bibliography of Aureliano de Beruete y Moret in the latter's *Conferencias de Arte*, 1924, 11–13.

45. *Eight Essays on Joaquín Sorolla*, I, 77.

46. The first critic to divide Goya's work into stylistic periods was not in fact Beruete, but Elías Tormo in his essay 'Las pinturas de Goya', *Revista de la Asociación Artístico-Arqueológica-Barcelonesa*, ii, 1899–1900, 586–600; 617–25. Beruete's analysis is, however, on a different basis to Tormo's.

47. Cf. Conde de la Viñaza, *op. cit.*, 227 (No. XXXIII). The Infante's wife was painted in one hour according to Viñaza's version of the transcription on the back (No. XXXI, 226): between 11 and 12 in the morning of 27 August 1783.

48. A. de Beruete y Moret, *Goya*, ed. F. J. Sánchez Cantón (Madrid, 1928), 81–2; *Conferencias de Arte*, 323–4. An alternative English translation by Selwyn Brinton in A. de Beruete, *Goya as Portrait Painter*, (London, 1922), 165–6.

49. *Goya as Portrait Painter*, 175.

50. A. de Beruete y Moret, *Goya*, 85; *Conferencias de Arte*, 328–9; *Goya as Portrait Painter*, 173 *and* 175.

51. *Conferencias de Arte*, 335–6; *Goya as Portrait Painter*, 186–7.

52. Juan de la Encina, *Crítica al margen*, 1924, 61.

53. Juan de la Encina, *Goya en zig-zag*, 1928, 31–2.

54. *Ibid.*, 99.

55. Noël Mouloud, 'L'Évolution du style de Goya: La convergence de ses recherches techniques et symboliques', *Revue d'Esthétique*, ix, 1956, 282–304.

56. *Ibid.*, 283.

57. *Ibid.*, 293.

58. Cf. Philippe Jullian, *Dreamers of Decadence. Symbolist Painters of the 1890s*, trans. Robert Baldick (New York, 1971), 37.

59. In a letter to William Rothenstein dated approximately May 1894, Beardsley writes 'I have just got some rather jolly photos from Goya' (*The Letters of Aubrey Beardsley*, ed. Henry Maas, J. L. Duncan and W. G. Good (London, 1970), 70).

60. Lucien Solvay, *L'Art Espagnol*, 1887, 262.

61. Cf. *The History of Modern Painting*, 1893, English trans. 1895, I, 73–4; *Goya*, English translation (London, 1905), 21.

62. Cf. Solvay, *op. cit.*, 261–2; and R. Muther, *The History of Modern Painting*, I, 73; the 'decadent' reference I, 66.

63. Cf. A. de Beruete y Moret, *Conferencias de*

Arte, 248–9. Charles Yriarte also gives the same story in his *Goya*, 1867, 88.

64. V. Blasco Ibáñez, *La Maja desnuda* (Valencia, n.d., 1916?), 20.

65. Solvay, *op. cit.*, 260.

66. Muther, *op. cit.*, I, 71–2.

67. It is just conceivable that Muther mis-interpreted the angle and foreshortening of an angel on the arch joining the choir and the main chapel (Plate 3 of José M. Galván's engravings of the frescoes, Madrid, 1888). In Galván's plate, the angel in question could be seen as a reclining female rather than an ascending figure.

68. R. Speaight, *William Rothenstein* (London, 1962), 74.

69. *Men and Memories*, 1931, I, 224.

70. *Ibid.*, I, 178, 224.

71. The first sentence of the paragraphs quoted was altered to read: 'I can remember nothing which gave me so clear an idea of Goya's cynicism.' The last sentence of the first paragraph became: 'One's nostrils, expect an odour of frangipani rather than incense, and it must be admitted that Goya's frescoes do not strike a discordant note in this indecorously holy place.' The second paragraph disappeared almost entirely, except for a reference to 'angels perhaps a little daring in their foreshortening'.

72. A passage contrasting Rossetti's and Goya's attitudes to women in the second article was also omitted. It reads as follows: 'Later, Rossetti, worshipping women, painted them as the lover, lending them qualities, completed, of which they had but a breath, a suggestion; moulding their lips more as he felt them on his own than as he saw them, drawing their hands with long cool fingers as they seemed touching his, clothed them after his own desire; so Goya, his antithesis, painted them, too, as he loved them—*as they were*: impudent, with the strong knowledge of their sex upon them, with flowers in their hair, and those shawls, with which Spanish women are all so closely associated in our minds, strong on their feet as his laundresses by the Manzanares, languorous and playful as in his "Déjeuner sur l'herbe", mysterious and fascinating as his Manolas on the balcony: it is always the feminine side of woman he worships. Even when he boldly takes a convention from a Master, he ever gives them something of his own smaller but more vivacious temperament, taking some goddess from Titian, out of her making a *petite femme*, a Du Barry from the Venus of Milo! It was, perhaps, for these more wantonly feminine qualities that he gave up so much for the Duchess of Alba, or that delicious Maja of whom we know so little

and would know so much, whom he painted first nude—and such a nude!—and then with clothing, so curiously intimate and tantalizing. As the loved lover he painted her, in the pride of his strength and the worship of her sex.' The nearest we get to this in the book is as follows: 'But the restlessness of his temperament made him inclined to seize on a characteristic rendering of pose and feature. A Miss Linley Goya could not give us, but something very like the delicate wantonness of a Perdita we may discover in more than one of his canvasses. He delighted in the very particular beauty of Spanish women; in their proud manner of walking, of wearing a mantilla, a flower; in their elaborate fashion of dressing the hair. He never tired of painting the high-heeled Moorish-pointed shoes in vogue in his day among Spanish ladies.' (*Goya*, 1900, 15).

73. *The Saturday Review*, 1896, 252b–4a.

74. *Ibid.*, 308a.

75. The cynical attitude to religion expressed in the articles is toned down in the book, although Rothenstein speaks of the 'daring anticlericalism' of Goya's painting of *El hechizado por fuerza* in the National Gallery, London. He was, in fact, mistaken about this painting, which is basically an illustration of a scene from a play by Antonio de Zamora (1660?–1728), satirizing superstition.

76. *Saturday Review*, 1896, 308b.

77. William Rothenstein, *Goya*, 1900, 22.

78. Cf. *Ibid.*, 22–3, 14.

79. *Ibid.*, 27. An English critic who was a friend of Rothenstein and obviously agreed with his view was Charles Ricketts. In a passage praising Goya's preliminary studies for the etchings, he writes: 'They show to what point Goya is one of the world's artists. It is by his power of design—that he excels even more than by his vivacity of workmanship and his marvellous if unequal gift of expression' (*The Prado and Its Masterpieces*, 1903, 64)

80. D. S. MacColl, 'Portrait Painters at the Grafton Gallery, *Saturday Review*, 1896, 562a.

81. *Ibid.*

Notes to Chapter VII

1. Stéphane Mallarmé, *Divagations* (Paris, 1949), 'Le démon de l'analogie', 28–30.

2. 'Les Arts Incohérents', *La Libre Revue*, November 1883, in Félix Fénéon, *Œuvres*, ed. J. Paulhan (Paris, n.d., 1948), 97ff.

3. J.-K. Huysmans, *A Rebours* (Paris, 1947), 85.

4. Cf. J.-B. Barrère, *La Fantaisie de Victor Hugo* (Paris, 1949), I, 369. Also C. W. Thompson, *Victor Hugo and the Graphic Arts (1820–1833)* (Geneva, 1970), 68ff.

5. Huysmans, *op. cit.*, 133–4. For the impact of Huysmans' novel cf. Paul Valéry, *Œuvres*, (Paris, 1960), II, 1186.

6. J.-K. Huysmans, *Certains* (Paris, n.d.), 147–8.

7. Huysmans was perhaps thinking of the animal head on the left in No. 10 of the *Disparates*, or that on the right behind the dancing figure with castanets in No. 4. Both of these figures repeat yet exaggerate open-mouthed effects to be found in the *Caprichos* (Nos. 13, 26, 45, 49, 58, 62, 63, 79 and 80). The greedy, lascivious or violent expressions of these earlier figures become more mysterious in the *Disparates*. Later André Gide was to associate the *Disparates* with a scene of 'fantastic unreality' in January 1912 (cf. *The Journals*, trans. Justin O'Brien, I (London, 1947), 314).

8. D. S. MacColl, *Nineteenth Century Art*, 1902, 44ff.

9. J. Meier-Graefe, *Modern Art*, 1908, II, 143. Cf. also II, 100, on the joint impact of Goya and Munch.

10. Cf. J. P. Hodin, *Edvard Munch* (London, 1972), especially 52 and 108.

11. Meier-Graefe, *op. cit.*, II, 143.

12. *Ibid.*, I, 259.

13. Cf. 'An Informal Life of M. E. as told by himself to a young friend', in Giuseppe Gatt, *Max Ernst* (London, 1970). It has also been suggested that Ernst's painting of 'The Swans singing while Reason sleeps' constitutes an explicit reversal of Goya's 'The Dream of Reason produces Monsters' (*ibid.*, 24).

14. Cf. *The Diaries of Paul Klee* (London, 1965), No. 170—Bern, 5 August 1901.

15. *Ibid.*, 122—No. 420.

16. Werner Haftmann, *The Mind and Work of Paul Klee* (London, 1967), 38.

17. *The Diaries of Paul Klee*, 181.

18. *Ibid.*, 204—No. 768.

19. John Willett, *Expressionism* (London, 1970), 12.

20. August L. Mayer, *Francisco de Goya*, trans. Robert West (London, 1924), 57–8.

21. *Ibid.*, 101.

22. *Ibid.*, 72.

23. *Ibid.*, 112–14.

24. Cf. Bernardino de Pantorba, *Goya*, 1928, 82ff.; Eugenio D'Ors, *Epos de los destinos, I: El vivir de Goya*, 1943, 217. D'Ors seems to have added this comment when revising his biography of Goya (originally published in 1926) in 1934. But it may have been added just

before the publication of the Spanish edition in 1943.

25. F. Jiménez-Placer, 'El poema goyesco de los "Disparates"', *Revista de ideas estéticas*, No. extraordinario dedicado a Goya, iv, No. 15–16, 1946, 340–77.

26. Cf. C. Gasquoine Hartley, *Things seen in Spain* (London, 1911), 222 and 232. Also *A Record of Spanish Painting*, 1904, 276.

27. C. Gasquoine Hartley, *A Record of Spanish Painting*, 1904, 287.

28. *Ibid.*

29. Cf. Marcel Jean, *The History of Surrealist Painting*, trans. Simon Watson Taylor (London, 1960), 272. Although Salvador Dalí wrote an article at the age of fifteen for the first number of the Figueras periodical *Studium* (1 January 1919) which saw Goya's work in Romantic terms, reflecting the aspirations of the Spanish people and the artist's own feelings and ideals, Dalí's interest in Goya was never very deep. If he found him 'full of emotion and spirituality' in 1919, he subsequently felt his art to be irrelevant. In an interview with Mrs Helen F. Grant and Rosa Leveroni at Port Lligat in September 1972, Dalí stated that Goya 'interested him less and less as time went on, because he was an expressionist'. Instead of creating reality, Goya had produced 'caricature, sarcasm and satire'. Veláquez appealed to Dalí because he could see things in an objective light; Goya, who commented on what he saw, was alien to him.

30. F. García Lorca, *Obras completas* (Madrid, 1955), 'Teoría y juego del duende', 39. There is another reference to Goya on p. 44.

31. Ramón Gómez de la Serna, *Goya* (Madrid, n.d., 1943), 161.

32. Gómez de la Serna, *Goya* (Buenos Aires, Colección Austral, 1950), 118. The passage does not occur in the Madrid 'La Nave' edition, and was probably added to the original text in 1937.

33. Gómez de la Serna, *op. cit.* (Madrid, 'La Nave'), 195–6.

34. *Ibid.*, 145ff.

35. Lord Derwent, *Goya. An Impression of Spain*, 1930, 7 and 57. The Black Paintings are described as the work of a 'mind diseased' on p. 106.

36. Cf. Herbert Read, *Art and Society*, 1937, 226; and J. A. Gaya Nuño, 'La estética íntima de Goya', *Revista de ideas estéticas*, No. extraordinario dedicado a Goya, iv, Nos. 15–16, 1946, 468ff. and especially 470.

37. Aldous Huxley, *The Complete Etchings of Goya*, 1943, 13–14. Reprinted in *Themes and Variations* (London, 1950).

38. André Malraux, *The Voices of Silence*, trans. Stuart Gilbert (London, 1954), 631.

39. *Goya. Drawings from the Prado*, Introduction by André Malraux, trans. E. Sackville-West, 1947, xx.

40. *Ibid.*, xxvii. A similar phrase occurs in *The Voices of Silence*, when Malraux asserts that the fantastic in Goya does not stem from albums of Italian *Capricci* 'but from the underworld of man's lurking fears'.

41. André Malraux, *Saturn. An Essay on Goya*, trans. C. W. Chilton (London, 1957), 68.

42. *Ibid.*, 53. In his earlier essay Malraux had emphasized Goya's sensitivity to 'humiliation, nightmare, rape, gaol' (*Goya. Drawings from the Prado*, xx).

43. *Ibid.*, 136.

44. *Ibid.*, 125–8.

45. *Ibid.*, 141–2.

46. *Ibid.*, 161.

47. *Ibid.*, 161. See also Denis Boak, *André Malraux* (Oxford, 1968), 178–9.

48. E. Lafuente Ferrari, *Antecedentes . . .*, 1947, 140.

49. Hans Sedlmayr, *Art in Crisis. The Lost Centre*, trans. Brian Battershaw (London, 1957), 260.

50. *Ibid.*, 261.

51. *Ibid.*, 200, 204.

52. *Ibid.*, 117ff.

Notes to Chapter VIII

1. Dr. R. Roya Villanova, 'Goya y la medicina', Lección inaugural del curso de patología y clínica médicas de 1927–28, *Universidad* (Saragossa), IV, No. 4, 1927, 969–92.

2. D. Sánchez de Rivera, 'La enfermedad de Goya', *Revista Española de Arte*, xii (1934–5), No. 5, 241–8.

3. *Ibid.*, 246.

4. Dr Joaquín Aznar Molina, *Goya vista por un médico* (Saragossa, n.d.), 22ff.

5. Dr. C. Blanco-Soler, *Esbozo psicológico, enfermedades y muerte . . .*, 1946, 25.

6. Frederick S. Wight, 'Revulsions of Goya: Subconscious communications in the Etchings', *Journal of Aesthetics and Art Criticism*, v, September, 1947, 1–28.

7. José López-Rey, *Goya's Caprichos*, 1953, I, 170.

8. Francis Reitman, *Psychotic Art*, 1950, 143ff. Kretschmer body-type analysis was earlier applied to Goya by Dr Roya Villanova (1927) and Blanco-Soler in *Goya, su enfermedad y su arte* (1947). At a later date Dr. Riquelme

also held Goya to have had a cyclothymic constitution, leading to 'alternations of melancholy and heightened imagination, aggravated by his deafness'. Riquelme also felt that Goya 'over-compensated in his art for an inferiority complex compounded of the fears and doubts created by his malady'. Cf. 'The Riddle of Goya's Infirmity' in *The Adventure of Art*, ed. Félix Martí-Ibáñez (New York, n.d., 1970?), 394–6.

9. G. M. Carstairs, 'Art and Psychotic Illness', *Abbottempo*, 15–21, and Part 2 of *The Frontiers of Madness*, entitled 'The Madness of Art', in *The Observer Colour Magazine*, 12 June 1966, 15–25.

10. 'Art and Psychotic Illness', *Abbottempo*, 16–17.

11. Docteur Gaston Rouanet, *Le Mystère Goya*, n.d., 1960, 28ff. The syphilis theory was also considered a strong possibility by no less a diagnostician than the late Gregorio Marañón, as well as Sánchez de Rivera (cf. Valentín de Sambricio, *Tapices de Goya*, 1946, 178).

12. Terence Cawthorne, 'Goya's Illness', *Proceedings of the Royal Society of Medicine*, lv, 1962, 213–17.

13. *Perfil biológico de Goya*, Alicante, 1964, 29.

14. Cf. *The New York Times*, 28 February 1972, 33.

15. Douglas Cooper, 'Goya', *The Sunday Times Colour Magazine*, 8 December 1963, 29.

16. Pierre Gassier and Juliet Wilson, *Goya. His Life and Work*, 1971, 106.

17. *Henry Moore on Sculpture*, ed. Philip James (London, 1966), 42.

Notes to Chapter IX

1. Cf. for example, Francisco Giner de los Ríos, 'Desarrollo de la literatura moderna', *Estudios de literatura y arte* (Madrid, 1876), 184 and 228.

2. The dramatist Jacinto Benavente alludes ironically to enthusiasm for Ganivet amongst young Spanish intellectuals at the turn of the century in his article 'Libros gratos', reprinted in *Teatro del pueblo* (Madrid, 1909), 215–17.

3. Angel Ganivet, *Idearium español* (Buenos Aires, 1949), 64–5.

4. Paul Lafond, *Goya*, 1902, 2 and 9.

5. *Ibid.*, 9.

6. Cf. Emilia Pardo Bazán, 'Goya', *La Lectura*, año 6, II, 1906, 236 and 246ff.

7. *Ibid.*, 244.

8. *Ibid.*, 246–7.

9. Cf. Havelock Ellis, *The Soul of Spain*, 1908, 129–31.

10. *Ibid.*

11. Ricardo del Arco, *Por qué Goya pintó como pintó*, 1926, 8.

12. C. Gasquoine Hartley believed Spanish individualism to be 'a love of independence, a kind of passionate egotism, and a clannish preference for small social groups'. She felt that the Spanish character spoke 'in every Spanish picture' and held the one aim of all Spanish artists to be 'dramatic seriousness' (*Things seen in Spain* (London, 1911), 222, 232). The German Hispanist, Karl Vossler, on the other hand, found typical Spanish realism in Goya, but thought that his Aragonese background gave him the 'good sense' which prevented him from treating ideals and supernatural phenomena as things remote from everyday life (cf. 'Transcendencia europea de la cultura española' in *Algunos caracteres de la cultura española*, trans. Carlos Clavería, Buenos Aires, 1942).

13. The idea that the Maja's head did not join the body naturally was put forward in the Prado catalogue by F. Alvarez de Sotomayor (cf. *Goya and His Times*, Catalogue of Royal Academy of Arts' Winter Exhibition 1963–4, No. 85).

14. John Berger, 'The Maja Revealed', *The Sunday Times Colour Magazine* 20 September 1964, 20–4. The same theory was advanced earlier by Antonio J. Onieva in his *Goya*, 1962, 40ff. The Spanish poet Antonio Machado offers a humorous psychological explanation for these views when he suggests that the *Clothed Maja* inevitably made the spectator think of the naked one. 'Why did Goya paint her clothed?', he asks in *Juan de Mairena*. 'So that you can imagine the female almond, *in puris naturalibus*, as we Latinists say, through the drapery. Ah!' (Manuel and Antonio Machado, *Obras completas* (Madrid, 1951), 1153). On stylistic grounds it is usually argued that the *Naked Maja* was painted earlier than the clothed version.

15. Cf. Pardo Bazán, *op. cit.*, 242.

16. Ellis, *op. cit.*, 70.

17. V. S. Pritchett, *The Spanish Temper*, 1954, 60.

18. *Ibid.*, 104.

19. *Ibid.*, 105.

20. Blamire Young, *The Proverbs of Goya*, 1923, Dedication.

21. *Ibid.*, 55.

22. *Ibid.*, 145.

23. *Ibid.*, 145–6.

24. *Ibid.*, 155.

25. *Ibid.*

26. *Ibid.*, 154.

27. Agustín de la Herrán, *La Carátula de Goya*, 1956. See below, 197.

28. Ernest Hemingway, *Death in the Afternoon* (London, 1958), 194–5. Quoted in part by Charles Poore, *Goya*, 1938, 67.

29. Cf. Ilse Hempel Lipschutz, *Spanish Painting and the French Romantics*, 1972, 75.

30. E. Lafuente Ferrari, *Antecedentes . . .*, 1947, 331.

31. 'Goya por Carlos Iriarte', *Revista de España*, x, 1869, 162. In Castelar's own collection there was at least one Goya painting: a replica or copy of *The Water-Carrier*. The subject— a woman of the people—naturally appealed to Castelar, who felt that Goya himself was a man of the people, sharing common Spanish enthusiasms such as bull-fighting, cf. *Ricardo* (Buenos Aires, 1952), 59. Castelar also appreciated the satirical power of Goya's work. In *Ernesto* (ed. Buenos Aires, 1942, 35), he speaks of Madrid as a 'frightening painting by Goya'.

32. Cf. *La Corte de Carlos IV*, 1873, Chapter 23.

33. Cf. *The Studio*, xxiv, 1902, 155b; and James Huneker, *Promenades of an Impressionist*, New York, 1910, 112.

34. Cf. Pierre Courthion, *Georges Rouault* (London, 1962), 98–9.

35. Cf. Max Nordau, *Los grandes del arte español*, trans. R. Cansinos Assens (Barcelona, n.d.), 326. The satirical 'faithfulness' of the *Royal Family Portrait* had been earlier commented upon by C. Gasquoine Hartley, 'Francisco Goya', *Art Journal*, July 1903, 209.

36. Cf. José Llampayas, *Goya*, 1943, 25.

37. Derwent, *op. cit.*, 48–9.

38. Julius Meier-Graefe, *The Spanish Journey*, trans. J. Holroyd-Reece (London, 1926), 101–2.

39. *Ibid.*, 102.

40. Cf. *Vitrina pintoresca* (Madrid, 1935), 219. Baroja also admired Goya's ability to get on well with all governments 'despite the fact that he was considered a revolutionary'. Baroja goes on to remark ironically that 'there is naturally no danger in being a revolutionary in painting' (cf. Sebastián Juan Arbó, *Pío Baroja y su tiempo* (Barcelona, 1963), 705). Another admirer of Goya's ability to make satirical points and yet avoid criticism for it, was Jacob Epstein. 'How Goya ever "got away" with his superb portraits of the Spanish Royal Family', he writes, 'is still an inexplicable mystery.'

41. Karel Čapek, *Letters from Spain*, trans. Paul Selver (London, 1932), 46–50.

42. Cf. *Collected Poems. 1925–1948* (London, 1949), 131. MacNeice did not, in fact, believe

that Goya was concerned to attack the monarchy and believed him to be an opportunist rather than an artist of revolutionary principles. He attacked the Marxist interpretation of Goya in Chapter XXXII of his unfinished autobiography (ca 1940), cf. *The Strings are False* (London, 1965), 160–1.

43. *From Greco to Goya*, 1938, 9.

44. Cf. Francis D. Klingender, *Art and the Industrial Revolution*, ed. and revised by Arthur Elton (n.p. London?, n.d.), ix.

45. Klingender, 'Realism and Fantasy in the Art of Goya', *The Modern Quarterly*, 1938, i, No. 1, 64–77.

46. *Ibid.*, 65.

47. *Ibid.*, 66.

48. *Ibid.*, 70.

49. *Ibid.*, 72ff.

50. Klingender suggests, for example, that the prostitution sequence runs from Nos. 12–24. Yet Edith Helman has shown that No. 26 ('Ya tienen asiento') is also, in part, about prostitutes (cf. *Trasmundo de Goya*, 1963, 82–3); and it could be argued that No. 21 is more concerned with the activities of the police than with those of the prostitutes they victimize.

51. F. D. Klingender, *Goya and the Democratic Tradition*, 1948, 212.

52. *Ibid.*, 62ff.

53. *Ibid.*, 174.

54. *Ibid.*, 185.

55. *Ibid.*, 188.

56. *Ibid.*, 150–3.

57. Georges Bataille, 'L'Œuvre de Goya et la lutte des classes', *Critique: Revue générale des publications françaises et étrangères*, 1949, 851–3.

58. Lion Feuchtwanger, *Goya oder Der Arge Weg der Erkenntnis*, trans. into Czech by Emanuel and Emanuela Tilschovi (Prague, 1966).

59. Shakhanovich, *Goya protiv papstva i inkvizitsii*, 1955, 44–5.

60. *Critique*, 1949, 851–3.

61. A book on Goya by A. A. Sidorov was published in Russian in 1936 (cf. Shakhanovich, *op. cit.*, 76); another, by V. I. Broski, followed in 1939.

62. I. M. Levina, *Goya*, 1958, 11, quotes from the article in question.

63. Levina, *Goya*, 1945, 3–4.

64. Levina, *Goya*, 1958, 5.

65. See, for example, the following passage (*Goya against the Papacy and Inquisition*, 393): 'Progressive Spaniards ... see their ally in Goya. Goya is alive in the struggle against "Black Spain", alive in the exploits of the people, who are preparing for fresh battles and efforts against Francoism; is alive in the hope

of all honourable Spaniards for the liberation of their native land from Fascist tyranny.'

66. *Vértice*, 1939, 3–7.

67. Francisco Pompey, *Goya*, 1945, 15.

68. *Ibid.*, 19.

69. *Ibid.*, 122. Similar reflections on the nationalistic quality of Goya's work occur on p. 105.

70. José Ibáñez Martín, 'Goya, símbolo español', *Arriba*, Sunday 31 March 1946, special Goya centenary supplement with unnumbered pages.

71. Valentín de Sambricio, 'Aspectos inéditos de la vida de Goya: Goya no fue afrancesado'; Marqués de Lozoya, 'Casticismo y universalidad de Goya', *Arriba*, 31 March 1946.

72. Agustín de la Herrán, *op. cit.*, 5–6.

73. *Ibid.*, 6–7.

74. *Ibid.*, [3].

Notes to Chapter X

1. Piot, who had accompanied Gautier to Spain in 1840, published his catalogue immediately after the latter's Goya article in *Le Cabinet de l'Amateur et de l'Antiquaire*, i, 1842, 346–66. He listed 166 prints in all. So far as the engravings were concerned, the next major advance was Paul Lefort's *Francisco Goya*, 1877. In the present century Loys Delteil added new though not always reliable material in his catalogues of Goya's graphic work (2 parts, 1922), and these remained the standard work until the publication of Tomás Harris's *Goya*, 1964. Early milestones in the descriptive study of the paintings were the catalogues in Mathéron's and Yriarte's books (1858 and 1867); Gregorio Cruzada Villaamil's detailed account of the tapestries and their cartoons (1870), and the Conde de la Viñaza's catalogue (1888). The Conde de la Viñaza also made a significant contribution to the documentation of the artist's life: tracing the conflicts between Goya and the authorities of the Pilar Cathedral in Saragossa, drawing information from the personal file in the Palace Archive in Madrid, from documents in the State Archives at Simancas and Alcalá, and from manuscripts in the British Museum and the private collection of Valentín Carderera. Viñaza's useful work on the paintings was superseded by Von Loga's book in 1903 (reprinted in 1921). A Goya catalogue which appeared just before Von Loga's was Paul Lafond's (1902), and in that same year E. Tormo studied the chronology of Goya's paintings ('Las pinturas de Goya y su clasificación crono-

lógica', *Varios estudios de arte y letras*, 1902). A. F. Calvert published a book on Goya with catalogue in 1908, but the next major development was A. L. Mayer's *Francisco Goya* (1921). Mayer accepted a large number of dubious Goyas, and the standard study soon became that of X. Desparmet Fitz-Gerald (1928–50). This has recently been superseded by the catalogues of Pierre Gassier and Juliet Wilson (1970 and 1971) and José Gudiol (1970). Gassier has also published a catalogue of Goya's drawings in two volumes, 1973 and 1975.

2. Enrique Mélida, 'Los Desastres de la Guerra', *El Arte en España*, ii, 1863, 266–81.

3. Z. Araujo Sánchez, *Goya* (Madrid, n.d.). A. Ruiz Cabriada, in his *Aportación a una bibliografía de Goya*, 1946, implies that the edition is dated 1896. I have not seen a dated edition. Since the work appeared in serial form early in 1895 (in *La España Moderna*), it may well have been issued as a volume later the same year. The serialized extracts appeared in *La España Moderna*, lxxiii (January 1895), 20–45; lxxiv (February 1895), 64–90; lxxv (March 1895), 101–134; lxxvi (April 1895), 74–114.

4. *Ibid.*, 7–8.

5. Araujo accepts the importance of social and environmental factors in determining an artist's work, but is wrong to describe Goya as 'a son of the people', and deduce from the fact that he spent 'the first years of his life in a village and then in a provincial capital' that he lacked social finesse or sophistication. He also argues fallaciously that Goya's spelling indicates a poor education. Goya's mother's family were certainly *hidalgos*, and he only lived in the village of Fuendetodos for a very short period, although he had relations there. In March 1747 (only a year after Goya's birth) his parents were living in a street called the Morería Cerrada in Saragossa and raising money to improve the property. Furthermore Saragossa could not be dismissed as a 'provincial capital' in the eighteenth century. The term was obviously pejorative when Araujo used it. Madrid and Barcelona both expanded greatly in the course of the nineteenth century. But in the eighteenth century Saragossa was the second city in Spain. In 1760 Giuseppe Baretti said that 'no town in this kingdom, except Madrid, abounds so much in nobility and rich people, of whom four hundred keep their coaches as I am told' (*A Journey from London to Genoa, through England, Portugal Spain and France*, III (London, 1770), 259). Strategically placed mid-way between Barcelona and Madrid, it struck travellers as a beautiful city, with wide, straight, well-built streets. There

was a Royal Commercial Company there in the middle of the century, and industry as well as agriculture. The Aragonese canal improved communications and export facilities to the Mediterranean.

6. Araujo Sánchez, *op. cit.*, 16–17. Araujo also deals effectively with some of Yriarte's errors. Yriarte had maintained that Goya had been in Rome in the 1770s with Antonio Ribera, a certain Velázquez, and David. Araujo shows that Ribera did not go to Rome until 1811, Antonio González Velázquez was already back from the Holy City in 1753, and David was not there until 1775 by which time Goya was in Madrid.

7. *Ibid.*, 36.

8. *Ibid.*, 68.

9. William Rothenstein, *Men and Memories*, II, 1932, 23.

10. Cf. *The Diaries of Paul Klee*, ed. Felix Klee (London, 1965), 202.

11. Cf. A. L. Mayer, 'Goya's Briefe an Martin Zapater', *Beiträge zur Forschung, Studien und Mitteilungen aus dem Antiquariat Jacques Rosenthal*, No. 1 (Munich, 1915), 39–49; F. J. Sánchez Cantón, *Goya*, 1930; 'Goya en la Academia', Discursos leídos en la sesión extraordinaria, 1928, 9ff; 'Cómo vivía Goya', *Archivo Español de Arte*, xix, 1946, 73–109; X. de Salas, *Goya: La familia de Carlos IV*, 1944; 'Sobre un autorretrato de Goya . . .', *Archivo Español de Arte*, xxxvii, 1964, 317–20; 'Sur les tableaux de Goya qui appartinrent à son fils', *Gazette des Beaux-Arts*, lxiii, 1964, 99–110; 'Precisiones sobre pinturas de Goya: *El Entierro de la Sardina*, la serie de obras de gabinete de 1793–4 y otras notas', *Archivo Español de Arte*, xli, 1968, 1–16; and Salas's appendix to *Goya and the Black Paintings*, 1964, by F. J. Sánchez Cantón (preceded by Italian, French and Spanish editions in 1963); Narciso Sentenach y Cabañas, 'Goya académico', *Boletín de la Real Academia de Bellas Artes de San Fernando*, xvii, 1923, 169–74. Other studies of interest relating to aspects of Goya's life and artistic career are Joaquín Ezquerra del Bayo's monograph on the artist's contacts with the Alba family, *La Duquesa de Alba y Goya*, Madrid, 1927 (reprinted 1959); the Condesa de Yebes's documentation of the Osuna family contacts in *La Condesa-Duquesa de Benavente*, 1955, and M. Núñez de Arenas research on Goya's period in France, 'Manojo de noticias— La suerte de Goya en Francia' *Bulletin Hispanique*, lii, Nos. 3–4, 1950. Goya's own captions for the *Tauromaquia* series have recently been discovered and studied by Eleanor Sayre in 'Goya's Titles to the *Tauromaquia*', *Festschrift*

für Hanns Swarzenski, 1973, 511–21.

12. Valentín de Sambricio, *Tapices de Goya*, 1946 [1948].

13. Marqués del Saltillo, *Miscelánea madrileña, histórica y artística*, 1952.

14. 'Goyas Akademiekritik', *Münchner Jahrbuch der Bildenden Kunst*, xvii, 1966, 214–24.

15. Pierre Paris, 'Pour mieux connaître Goya', *Revue des deux mondes*, xvii, 1923, 635–58; 884–901.

16. Cf. Juan de la Encina, *Goya en zig-zag* (n.d., 1928?).

17. Cf. José Ortega y Gasset, *Goya*, 1958, 54–5. Most of the material was first collected in *Papeles sobre Velázquez y Goya*, 1950.

18. Cf. Ortega, *op. cit.*, the section 'Pinceladas son intenciones' ('Brushstrokes are intentions').

19. Cf. Anton Ehrenzweig, *The Hidden Order of Art. A Study in the Psychology of Artistic Imagination* (London, 1967).

20. José López-Rey, 'A Contribution to the Study of Goya's Art: The San Antonio de la Florida Frescoes'; *Gazette des Beaux-Arts*, xxv, 1944, 231ff; *ibid.*, 'A contribution to the Artist's Life: Goya and the World around him', *Gazette des Beaux-Arts*, xxviii, 1945, 129ff. Also *Goya y el mundo a su alrededor*, 1947.

21. López-Rey, 'Goya de cuerpo', 1966, 359–66. An equally salutary warning about 'literary interpretations' of art came from P. G. Hamerton in the nineteenth century. 'Thoughtful and learned people', he wrote, 'become deeply interested in one picture because it alludes . . . to something they know by books, and they pass by with indifference better works that have no literary associations.'

22. López-Rey, *Goya's Caprichos*, 1953, I, 11–13. Still more detail on Goya's intellectual background came from the same scholar in *A Cycle of Goya Drawings*, 1956.

23. Edith Helman, *Jovellanos y Goya*, 1970. Other scholars have contributed to the study of Goya's literary sources. G. Levitine, for instance, investigated 'Literary Sources of *Capricho* 43' (*Art Bulletin*, xxxvii, 1955, 55–9). Analogues have been found for Goya's use of the term 'Capricho' in Spanish *tonadillas* where the word often means a picture with a moral point, and sources have been discovered for *Caprichos* 53 and 58 in popular poetry and fables (cf. Nigel Glendinning, 'Goya y las tonadillas de su época', *Segismundo*, iii, 1962, No. 1, 105–20; *ibid.*, 'The Monk and the Soldier in Plate 58 of Goya's *Caprichos*', *Journal of the Warburg and Courtauld Institutes*, xxiv, 1961, 120–7; *ibid.*, 'Nuevos datos sobre las fuentes del *Capricho* No. 58 de Goya', *Papeles de Son Armadans*, xci, 1963, 13–

29). It has also been suggested that the first idea for Goya's *Colossus* and one of the Black Paintings may have come from a poem which was on everyone's lips in Spain at the time of the Peninsular War (cf. Nigel Glendinning, 'Goya and Arriaza's "Profecía del Pirineo"', *Journal of the Warburg and Courtauld Institutes*, xxvi, 1963, 363–6), and it has been argued that Nos. 66 and 67 of the *Disasters of War* series should be seen as two parts of a fable—La Fontaine's 'L'Âne portant des reliques' or its Spanish translations and imitations—with probable political significance (cf. Nigel Glendinning, 'El asno cargado de reliquias en los *Desastres de la guerra* de Goya', *Archivo Español de Arte*, xxxv, No. 139, 1962, 221–30). The present writer has also drawn attention to the fact that the captions of two Goya drawings are somewhat ironically taken from the section of the Cathechism which reminds the Christian of the way in which the virtues can be used against the vices. The drawings in question are on pp. 75 and 76 of the Madrid Album (Gassier and Wilson, Catalogue II, 433 and 434), and the titles read 'Humility against Pride', 'Generosity against Avarice' ('Humildad contra Soberbia'; 'Largueza contra Avaricia'). Goya's drawings do not entirely suggest that the Virtues in question will win the battle.

24. Edith Helman, *Trasmundo de Goya*, 1963, 199–200.

25. Cf. F. J. Sánchez Cantón, *Los Caprichos de Goya y sus dibujos preparatorios*, 1949; E. Lafuente Ferrari, *Los Desastres de la Guerra de Goya y sus dibujos preparatorios*, 1952; José Camón Aznar, *Los Disparates de Goya y sus dibujos preparatorios*, 1951. The bull-fight engravings and their preparatory drawings were reproduced by E. Lafuente Ferrari in an essay entitled 'Los toros en las artes plásticas' in *Los Toros. Tratado técnico e histórico*, 1953. In the third edition (1961) which I have consulted, the section on the *Tauromaquia* runs from pp. 765–838.

26. Cf. Helman, *op. cit.*, 63ff.

27. Cf. Edith Helman, 'Identity and Style in Goya', *The Burlington Magazine*, cvi, No. 730, 1964, 30ff.

28. Cf. *Gazette des Beaux-Arts*, 1944, xxv, 244–8; also J. López-Rey, *Goya y el mundo a su alrededor*, 1947, 24–5; and 54ff.

29. Cf. J. López-Rey, *Goya*, 1951, 12.

30. Max Dvořák, 'Eine Illustrierte Kriegschronik', *Gesammelte Aufsätze zur Kunstgeschichte*, 1929, 242ff. Doses of time-spirit are to be found earlier in Richard Muther's *Goya*, 1904.

31. Dvořák, *op. cit.*, 244ff.

32. *Ibid.*, 248–9.

33. Theodor Hetzer, 'Francisco Goya und die Krise der Kunst um 1800', *Aufsätze und Vorträge* (Leipzig, 1957), 177–98. Previously published in 1950 and written in 1932.

34. *Ibid.*, 186ff.

35. *Ibid.*, 196ff.

36. Otto Benesch, 'Rembrandts Vermächtnis', *Belvedere*, v, 1924, 148–76. An English version was published later — 'Rembrandt's Artistic Heritage', *Gazette des Beaux-Arts*, xxxiii, May, 1948. The German essay appears in a new translation in *Collected Writings of Otto Benesch*, ed. Eva Benesch, I, 'Rembrandt' (London, 1970), 57–82.

37. *Collected Writings of Otto Benesch*, I, 1970, 77.

38. *Ibid.*, 76.

39. E. Lafuente Ferrari, *Grabados y dibujos de Rembrandt en la Biblioteca Nacional* (Madrid, 1934), 29.

40. F. J. Sánchez Cantón, 'Cómo vivía Goya', *Archivo Español de Arte*, xix, 1946, 73–109.

41. Cf. Chapter III, 55.

42. E. du Gué Trapier, *Goya and His Sitters*, 1964, 39.

43. *Ibid.*, 39–41.

44. Cf. Noël Mouloud, 'L'Évolution du style de Goya . . .', *Revue d'Esthétique*, ix, 1956, 282–304. Otto Benesch's later study of the impact of Rembrandt on Goya highlights their similarities and differences, and underlines the former's importance for the latter's work from the 1790s onwards. Cf. *Collected Writings of Otto Benesch*, ed. Eva Benesch, *op. cit.*, 159–70.

45. E. du Gué Trapier, *Goya. A Study of his Portraits 1797–9*, 1955, 16. Miss Trapier compares the compositional scheme of Gainsborough's portrait of Karl Friedrich Abel to Goya's *Francisco Saavedra* (Courtauld Institute Gallery, London). André Malraux contrasts Goya and Gainsborough in his *Saturn. An Essay on Goya* (London, 1957), 150, yet he reproduces the portrait of Mrs Richard Brinsley Sheridan which has obvious points of comparison as well as contrast with Goya's *Joaquina Candado* and the *Condesa de Fernán-Núñez*.

46. Cf. Gassier and Wilson, Catalogue I, 12. Sánchez Cantón pointed out the Vouet source in 'Goya, pintor religioso', *Revista de ideas estéticas*, 1946, iv, 277–306. Other relationships between early Goya paintings and etchings after Vouet and the Italian Marrata were discussed by V. Sambricio in 'Les peintures de Goya dans la chapelle du Palais des Comtes de Sobradiel à Saragosse', *Revue des Arts*, 1954, 215–22, and by José Milicua in 'Anotaciones al Goya joven', *Paragone*, v, 1954, 5–27. Also valuable on French

contacts with Goya are E. Lafuente Ferrari's *Antecedentes . . .*, 1947, 95ff; the same author's 'Goya y el arte francés', in *Goya*, 1949, 45–66; and Denys Sutton, 'Goya: Apostle of Reason', *Apollo*, lxxix, No. 23, 1964, 70.

47. The Conde de Maule ascribed to Goya the attribution to Poussin of a painting in Sanlúcar. Cf. Nicolás de la Cruz y Bahamonde, *Viage de España, Francia, e Italia*, 1805–13, XIV, 115.

48. F. J. Sánchez Cantón, *Mengs en España*, conferencia dada el 5 de abril de 1927 (Madrid, 1927), 11–13; E. Lafuente Ferrari, *op. cit.*, 73ff.

49. Cf. Goya's letter to Joaquín Ferrer dated Bordeaux, 20 December 1825, reproduced by V. von Loga, *Francisco de Goya* (Berlin, 1921), 171–2.

50. E. Lafuente Ferrari, *op. cit.*, 89–90.

51. Roberto Longhi, 'Il Goya romano e la cultura di Via Condotti', *Paragone*, v, No. 53, 1954, 28–39.

52. Mariano Juberías Ochoa, 'La pintura en el Madrid de Goya', *Villa de Madrid*, xii, No. 44, 1974, 34–41.

53. M. S. Soria, 'Goya's Allegories of Fact and Fiction', *The Burlington Magazine*, xc, 1948, 196–200.

54. Cf. 'Some Emblematic Sources of Goya', *Journal of the Warburg and Courtauld Institutes*, xxii, 1959, 106–31; 'The Elephant of Goya'; *The Art Journal*, xx, 1961, 145–7. Other reminiscences of Ripa are noted by Gassier and Wilson, *Goya*, 1971, 138 and note to Catalogue No. 1398. Folke Nordström has more particularly studied Goya's debts to Ripa in articles collected in *Goya, Saturn and Melancholy*, 1962.

55. Diego Angulo Iñíguez, 'El "Saturno" y las pinturas negras de Goya', *Archivo Español de Arte*, xxxv, 1961, 173–7.

56. Folke Nordström, *op. cit.*, 218ff. Alternative readings of the Black Paintings come from Pierre Gassier and Juliet Wilson, who see the 'Manola' or 'Doña Leocadia' as the key figure, leading the spectator from the real world to a descent into hell in the subsequent paintings. Lawrence Gowing has also stressed interrelationships between the paintings in a review article (*The Burlington Magazine*, No. 762, 1966, cviii, 487–8). His theory about the pairing of paintings is mostly convincing, although he inadvertently misplaces 'Judith' which enables him to balance neatly a male side against a female side in the ground-floor room.

57. Jutta Held, *Die Genrebilder der Madrider Teppichmanufaktur und die Anfänge Goyas*, 1971.

58. Cf. *Gazette des Beaux-Arts*, 6ᵉ période, lii, 1958, 289–304; *The Burlington Magazine*, xci, No. 555, 1949; and *Meditations on a Hobby Horse* (London, 1963) (reprinted 1965, 2nd edition 1971), 120–6.

59. *Gazette des Beaux-Arts*, 1958, lii, 302–4.

60. *The Burlington Magazine*, xci, No. 555, 1949, 158.

61. Cf. *Juntas particulares de la Real Academia de San Fernando*, 2 October 1808, which states that Goya 'must shortly go to Saragossa, where he has been summoned by Palafox to examine the ruins of that city and paint the glorious deeds of her inhabitants in the course of their heroic defence of the city.'

62. Cf. the entry dated 29 April [1809] in *The Spanish Journal of Elizabeth Lady Holland*, 1910, 324–5.

63. Cf. Nigel Glendinning, 'Portraits of War', *New Society*, No. 390, 19 March 1970, 476.

64. C. Ferment, 'Goya et la Fantasmagorie', *Gazette des Beaux-Arts*, 6ᵉ période, xlix, 1957, 223–6. Ferment also linked the Black Paintings to the Phantasmagoria. A comparison between Goya's work and the Phantasmagoria was also implied by the painter's friend Gallardo (cf. A. Rodríguez-Moñino, *Goya y Gallardo*, 6–8). Professor J. E. Varey's articles on the Phantasmagoria point out the existence of shows in Madrid from the 1806 period by 'Mr Martin' and others, including the famous Robertson (Cf. *Theatre Notebook*, ix, No. 4 'Robertson's Phantasmagoria in Madrid, 1821 (Part I)').

65. Charles Blanc, *Grammaire des Arts du Dessin* (Paris, 1867), 686.

66. Picasso's interest in the technical aspect of the *Disasters of War* etchings arose from a commission to produce illustrations for the work of the seventeenth-century poet Luis de Góngora. He described Goya's practice of stopping out the plate with resin and rebiting to deepen the contrasting tones. He particularly admired the 'granulated speckled effect' which made his blacks 'never opaque . . . never flat and uniform but full of tiny white holes' (Françoise Gilot and Carlton Lake, *Life with Picasso* (London, 1965), 179).

67. Tomás Harris, *Goya*, 1964, I, 40–1. Important technical studies of etchings prior to Harris's book in the present century include Campbell Dodgson's edition of *Los Desastres de la Guerra* based on the proof set belonging originally to William Stirling (1933); the same author's article on 'Some undescribed states of Goya's etchings', *The Print Collector's Quarterly*, xiv, 1927, 30–45; Philip Hofer's article 'Some undescribed states of Goya's *Caprichos*', *Gazette*

des Beaux-Arts, lxxxvii, No. 2, 1945, 163–80; editions of the four series with their preliminary drawings and studies by Sánchez Cantón, Enrique Lafuente Ferrari and José Camón Aznar (Barcelona, 1949–53); and Catharina Boelcke-Astor's articles 'Die Drucke der Desastres de la Guerra von Francisco Goya', *Münchner Jahrbuch der Bildenden Kunst*, iii–iv, 1952–3, 253–334, and 'Sobre la adquisición y estampación de los *Desastres de la Guerra* y los *Proverbios*', *Archivo Español de Arte*, xxiv, No. 95, 1951, 263–4.

68. Cf. Biblioteca de Menéndez y Pelayo, Santander, MS 245—'Catálogo racionado de las estampas que poseía Dn. Juan Agustín Ceán Bermúdez . . . formado por él mismo. Introducción'—'more picturesque and useful is the other method called *lavis* (*a la aguada*), since it imitates drawings done with pencil, Chinese ink or liquid rust.'

69. Quoted by Bernard Myers, *Goya*, 1964, 32.

70. Cf. José López-Rey, 'A Contribution to the Study of Goya's Art: The San Antonio de la Florida Frescoes', *Gazette des Beaux-Arts*, xxv, 1944, 231ff. Ramón Stolz's technical study of the frescoes was published in *Goya. The Frescos in San Antonio de la Florida in Madrid. Historical and Critical study by Enrique Lafuente Ferrari*, trans. Stuart Gilbert (New York, 1955).

71. J. López-Rey, 'A Contribution . . .', 239. According to Valentín de Sambricio, all Goya's bills for painting materials in fact included sponges, not only those for the frescoes (cf. E. Lafuente Ferrari, *Antecedentes . . .*, 1947, 29 Note 2, and 30).

72. Gassier and Wilson, *Goya. His Life and Works*, 1971, 144ff. See also López-Rey's article, *Gazette des Beaux-Arts*, xxv, 1944, 241ff. E. Lafuente Ferrari in his 1955 essay on the frescoes noted the importance of Goya's rejection of a scheme which placed angels above the scene in the cupola. Theodor Hetzer discusses other aspects of the frescoes' originality in 'Francisco Goya und die Krise der Kunst um 1800', *Aufsätze und Vorträge*, Leipzig, 1957, 180ff.

73. Aureliano de Beruete, *Goya*, 1928, 119–21.

74. Jutta Held, *Farbe und Licht in Goyas Malerei*, 1964.

75. Oskar Hagen, *Patterns and Principles of Spanish Art* (Wisconsin, 1943), 249ff. Subsequent work of interest on individual Goya paintings from the point of view of composition can be found in Charles Bouleau, *Charpentes*, 1963.

76. Gassier and Wilson, *op. cit.*, especially Chapter 6, 230ff. Pierre Gassier has subsequently produced a study and catalogue of Goya's drawings in two volumes: *Les Dessins de Goya: Les Albums* (*The Drawings of Goya: The Complete Albums*, London, 1973); and *Les Dessins de Goya, II* (*The Drawings of Goya: The Sketches, Studies and Individual Drawings*, 1975). Important earlier publications on Goya's drawings are: Pierre D'Achiardi, *Les Dessins de D. Francisco de Goya y Lucientes au Musée du Prado à Madrid*, 1908; Paul Lafond, *Nouveaux Caprices de Goya. Suite de trente-huit dessins inédits*, 1907; A. L. Mayer, 'Dibujos desconocidos de Goya', *Revista Española de Arte*, xi, 1923, 376–84; Valerio Mariani, 'Primo centenario dalla morte di Francisco Goya—disegni inediti', *L'Arte*, xxxi, 1928, 97–108; F. J. Sánchez Cantón, 'Los dibujos del viaje a Sanlúcar', *Boletín de la Sociedad Española de Excursiones*, xxxvi, 1928, 13–26; A. L. Mayer, 'Echte und falsche Goya-Zeichnungen', *Belvedere*, xi, No. 1, 1930, 215–17; *ibid.*, 'Some unknown drawings by Francisco Goya', *Old Master Drawings*, ix, No. 33, 1935, 20–2; Harry B. Wehle, *Fifty Drawings by Francisco Goya*, 1938; André Malraux, *Goya Drawings from the Prado*, with an *essai de catalogue* by Pierre Gassier, 1947; Pierre Gassier, 'Les Dessins de Goya au Musée du Louvre', *La Revue des Arts*, iv, No. 1, 1954, 31–41; F. J. Sánchez Cantón, *Museo del Prado: Los dibujos de Goya*, 1954; José López-Rey, *A Cycle of Goya Drawings*, 1956; Enrico Crispolti, 'Otto nuove pagine del taccuino "Di Madrid" di Goya ed alcuni problemi ad esso relativi', *Commentari*, ix, No. 3, 1958, 181–205; E. Sayre, 'An Old Man Writing—A Study of Goya's Albums', *Boston Museum Bulletin*, lvi, 1958, 116–36; E. du Gué Trapier, 'Unpublished Drawings by Goya in the Hispanic Society of America', *Master Drawings*, i, 1963, 11–20; E. Sayre, 'Eight Books of Drawings by Goya—I', *The Burlington Magazine*, cvi, No. 730, 1964, 19–30.

Notes to Chapter XI

1. On the 'morbid and macabre', cf. James Huneker, *Promenades of an Impressionist* (New York, 1910), 121; on Oskar Kokoschka, cf. Leonardo Estarico, *Francisco de Goya. El hombre y el artista* (Buenos Aires, 1942), 241; on Antonio Saura and other contemporary Spanish painters in relation to Goya, cf. Alan Milburn, 'Some Modern Spanish Painters', in *Studies in Modern Spanish Literature and Art presented to Helen F. Grant* (London, 1972), 120.

2. On the fortunes of the *Majas al balcón*, cf. Nigel Glendinning, 'Variations on a Theme by Goya: *Majas on a Balcony*', *Apollo*, ciii, No. 167, 1976, 40–4; on Lorjou's painting, cf. K. E. Maison, *Art Themes and Variations* (New York, n.d.), 197 (No. 251); on George Grosz, cf. Hans Hess, *George Grosz* (London, 1974), 240. An English artist who admired the *Maja desnuda* was Mark Gertler (cf. his letter to Carrington, 1 January 1921, in *Selected Letters*, ed. Noel Carrington (London, 1965), 194–5).

3. There are three recorded instances of Goya-inspired stage sets. It appears that Sarah Bernhardt was particularly impressed by *The Third of May 1808*, and modelled her production of the last scene from Sardou's *La Tosca* on it. The group of soldiers executing Mario, the background and colouring of the clothes were all derived from Goya (cf. A. de Beruete y Moret, *Conferencias de Arte*, 1924, 361–2). Two modern Spanish plays have used back-projections of Goya paintings: Rafael Alberti's *Noche de guerra en el Museo del Prado* (1956), and Antonio Buero Vallejo's Goya play *El sueño de la razón* (1970).

4. Cf. Ventura Bagüés, *Don Francisco el de los Toros*, 1926, 7–8.

5. *Ibid.*, 16.

6. Marguerite Hein, *À l'École de Goya* (Paris, 1909). The prose sketches take twenty-nine of the *Caprichos* in the following order: 74, 55, 2, 48, 27, 6, 31, 22, 72, 32, 45, 15, 14, 61, 34, 28, 7, 8, 10, 3, 41, 19, 5, 12, 16, 4 and 50, 64, 71.

7. Two novels about Goya which I have not seen are Karl Hans Strobl's *Goya and the Lion's Face* (Goya und das Löwengesicht), Leipzig, 1932; and M. Schneider's *Don Francisco de Goya. Ein Leben unter Künstlern und Königen* (Leipzig, 1952).

8. L. Feuchtwanger, *This is the Hour. A Novel about Goya*, London, 1952, 38.

9. *Ibid.*, 67.

10. *Ibid.*, 47.

11. Ramón Pérez de Ayala, *Las Máscaras* (Buenos Aires, Colección Austral, 1944), 167–71. The only copy I have seen of Villaespesa's play is undated. It was published in Madrid by V. H. de Sanz Calleja.

12. Alfred Noyes, *Rada. A Belgian Christmas Eve*, with four illustrations after Goya (London, 1915), 15–16.

13. *Ibid.*, 59.

14. *Ibid.*, 68.

15. *Ibid.*, 80–1.

16. Antonio Buero Vallejo, *El sueño de la razón*, first published in *Primer acto*, No. 117, February 1970, 28ff. The quotation is taken

from the Madrid, Alfil, 1971 ed., 24. Another contemporary Spanish dramatist who is known to be an admirer of Goya is Fernando Arrabal (cf. his *Théâtre*, I (Paris, 1968), 14).

17. Cf. J. Francisco Aranda, *Luis Buñuel. Biografía crítica* (Barcelona, 1970), 362–83.

18. *Movies on TV*, ed. Steven H. Scheur (London, n.d.), 237.

19. Cf. José Pérez Gállego's article 'Goya entre el este y el oeste', *Heraldo de Aragón*, 11 October 1970.

20. *Ibid.*

21. *Ibid.*

22. Cf. *España cultural*, No. 23, 1 February 1975, 'Presentación de la película "Goya"'.

23. Cf. J.-B. Barrère, *La Fantaisie de Victor Hugo* (Paris, 1949), I, 146 and 369. Also C. W. Thompson, *Victor Hugo and the Graphic Arts (1820–33)* (Geneva, 1970), 68ff.

24. Cf. Paul Guinard, 'Baudelaire, le Musée Espagnol et Goya', *Revue d'Histoire Littéraire de la France*, avril–juin 1967, lxvii, No. 2, 324.

25. Cf. Ilse Hempel Lipschutz, *Spanish Painting and the French Romantics*, 1972, 151ff.

26. *L'Artiste*, 15 May 1849, 5ᵉ série, III, 57.

27. Cf. Roger de Beauvoir, *Les Meilleurs Fruits de mon panier. Poésies*, Paris, 1862, 155–8. The reference to Salvator Rosa in Gautier's article occurs in *Le Cabinet de l'Amateur et de l'Antiquaire*, i, 1842, 341.

28. Cf. Zacharie Astruc, *Les Alhambras* (Paris, 1908), 51–4 and 114–17. In one of Astruc's prose works a lady kissing a monk's hand evokes the 'scènes picaresques de Goya' ('La Chartreuse de Miraflores', *Romancero de l'Escorial* (Paris, 1883), 316).

29. Rubén Darío, *Cantos de vida y esperanza*, 1905: Otros poemas, xxviii, 'A Goya'.

30. Cf. Federico Carlos Sainz de Robles, *Historia y antología de la poesía castellana* (Madrid, 1946), 1145–6.

31. *Ibid.*, 1202.

32. *Ibid.*, 1263–5. Nostalgia for the past and for Goyesque *manolas* is also a feature of Angel Falquina's 'Verbena sentimental' published in *Cosmópolis*, No. 35, December 1930.

33. Cf. Gordon Brotherston, *Manuel Machado. A Revaluation* (Cambridge, 1968), 121.

34. Manuel and Antonio Machado, *Obras completas* (Madrid, 1951), 109.

35. *Ibid.*, 110.

36. *Poesías de Gaspar Melchor de Jovellanos*, ed. J. Caso González (Oviedo, 1961), 237—'Sátira primera a Arnesto'.

37. R. Alberti, *A la pintura*, 1953, 110–13 ('Poema del color y de la línea' (1945–52), No. 34). In *Poesías completas* (Buenos Aires, 1961), 681–4.

38. Louis MacNeice, *Collected Poems. 1925–48* (London, 1949), 131.

39. W. H. Auden, *Collected Longer Poems* (London, 1968), 61. 'I dread this like the dentist, rather more so: / To me Art's subject is the human clay, / And landscape but a background to a torso; / All Cézanne's apples I would give away / For one small Goya or a Daumier.'

40. *The Collected Poetry of Aldous Huxley*, ed. Donald Watt (London, 1971), 108.

41. *Ibid.*, 135.

42. *Wyndham Lewis on Art. Collected Writings 1913–56*, ed. W. Michel and C. J. Fox (London, 1969), 352.

43. Cf. Andrei Voznesensky, *Antiworlds and the Fifth Ace* (London, 1968), xiii, Introduction.

44. *Ibid.*, 3.

Index